THE TOUCH OF THE ARTIST

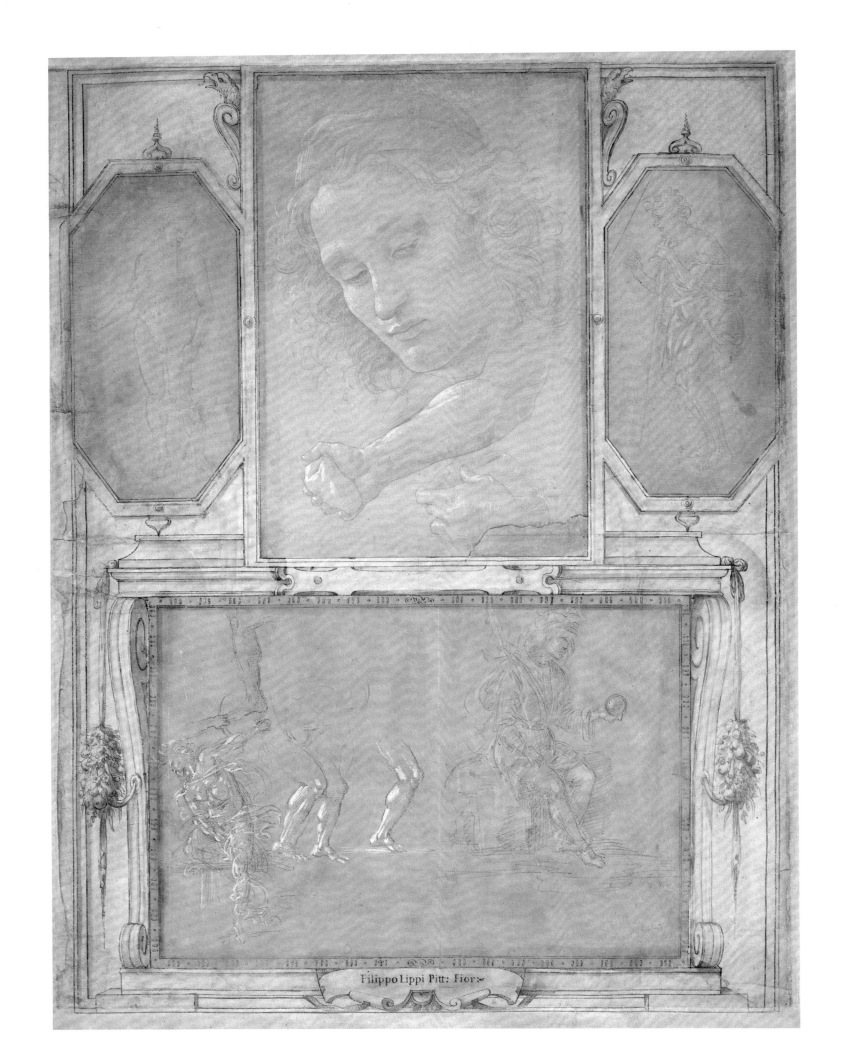

Filippo Lippi Pitt: Fior:

# THE TOUCH OF THE ARTIST

Edited by
Margaret Morgan Grasselli

National Gallery of Art
*Washington*

Distributed by
Harry N. Abrams, Inc.
*New York*

Exhibition Dates:
National Gallery of Art, Washington
1 October 1995 – 28 January 1996

This book was produced by the
Editors Office, National Gallery of Art
Frances P. Smyth, *Editor-in-chief*
Tam Curry, *Editor*
Margaret Bauer, *Designer*

Type was set in Adobe Minion and
Adobe Formata by Studio 405, Washing-
ton, and printed on Mohawk Superfine
by Balding + Mansell, Peterborough,
England

Hardcover distributed by Harry N.
Abrams, Inc., New York. A Times Mirror
Company

Many of the artists' biographies included
here were adapted, with kind permission
of The Ian Woodner Family Collection,
Inc., and The Metropolitan Museum of Art,
from those published in *Woodner Collec-
tion: Master Drawings* (New York, 1990).

**LIBRARY OF CONGRESS CATALOGING-
IN-PUBLICATION DATA**

The touch of the artist: master drawings
from the Woodner collections / edited by
Margaret Morgan Grasselli.

Includes bibliographical references and
index.

p. cm.

ISBN: 0-8109-3882-0 (Abrams hardcover)
ISBN: 0-89468-218-0 (NGA paperback)

1. Drawing, European — Exhibitions.
2. Woodner, Ian — Art collections —
Exhibitions.
3. Drawing — Private collections — United
States — Exhibitions.
I. Grasselli, Margaret Morgan, 1951–
II. National Gallery of Art (U.S.)

NC225.T68 1996
741.94'074'753 — dc20     95-23191

**ILLUSTRATIONS**

*Front Cover:* Cat. 21
*Back Cover:* Detail of cat. 92
*Frontispiece:* Recto of cat. 9
*Page 6:* Detail of cat. 47
*Page 394:* Detail of cat. 91

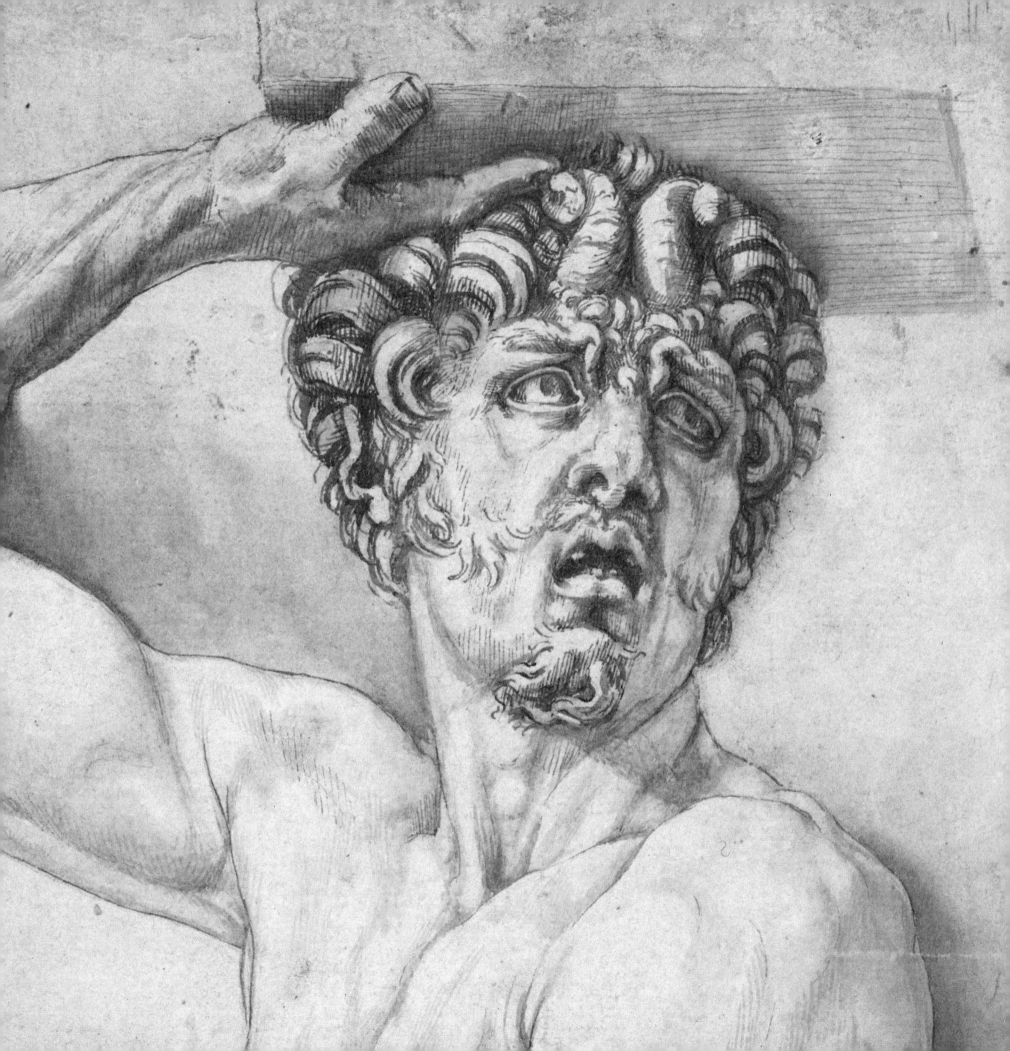

# Foreword

This exhibition celebrates the extraordinary collection of European master drawings formed by Ian Woodner as well as the exceptionally generous gifts that Ian and his daughters, Dian and Andrea, have made to the National Gallery of Art over the years. The acquisition of the core of the Woodner collection represents an enormous stride in the National Gallery's continuing effort to build a great national collection of master drawings.

In the biography that follows, Noël Annesley recounts Ian Woodner's life and collecting history. It is still astonishing to reflect upon how many great and rare works of art were available from the 1950s through the 1980s, and how many opportunities Woodner recognized and seized. As an artist himself, he had a special sensitivity to the distinctive and intimate character of master drawings, purposefully reflected in the exhibition's title, *The Touch of the Artist*.

Ian Woodner's relationship with the National Gallery of Art began through architecture. Having worked for John Russell Pope in 1925 and studied at the École des Beaux-Arts in the late 1920s, Woodner deeply appreciated the grand and classic aspects of Pope's design for the new National Gallery. His business activities often brought him to Washington from the late 1930s on, so he was able to watch the actual construction, and he frequently praised the building's fine details of execution and craftsmanship.

Like many in the art world, Woodner followed the development of the Gallery's collections during the 1940s, 1950s, and 1960s. As a collector in his own right, his relationship to the Gallery took a more personal turn in the 1970s. Encouraged by Andrew Robison, the Andrew W. Mellon Senior Curator, and J. Carter Brown, now director emeritus, Woodner made his first donation of an old master drawing in 1978, to be followed by more such gifts through the next decade. In 1982 he joined the Gallery's Trustees' Council. He was especially pleased with the installation of his collection here in 1984 and kept in close touch with the Gallery about his acquisitions and their relation to the Gallery's collection and needs.

By the late 1980s Woodner and the National Gallery were seriously discussing arrangements for his entire collection to come to Washington, including drawings, sculpture, and paintings. The issues were complex, and many meetings and tours of spaces ensued. The discussions included Dian and Andrea Woodner, who were enthusiastic supporters of the proposal. After two years of concrete plans and the collector's clear desire to proceed, Woodner died suddenly on 1 November 1990 before the final contractual revisions were completed.

Innumerable issues of business and estate, as well as the pain of personal loss and grief, dominated the next months. Yet by the end of July 1991 Dian and Andrea,

with extraordinary generosity, proposed that we attempt to preserve the core of the most important part of the Woodner collections, the master drawings, at the National Gallery of Art. Studying Woodner's one thousand drawings and defining the "core" became the cooperative task of Dian and Andrea with Andrew Robison. The 143 drawings they selected to come to the Gallery give rich representation to Woodner's special love for the intense and moving works of the Renaissance, both in Italy and in Germany, and also provide a survey of five centuries of exquisite draftsmanship.

By October 1991 the Gallery was able to announce publicly that it had completed the arrangements with Dian and Andrea Woodner for twenty-three present gifts and two major purchases along with a deposit of the remaining 118 drawings at the National Gallery with the intention that further gifts would be made in future years. Indeed, in September 1993 nine masterworks from these deposits were given to the National Gallery, including drawings by Dürer, Raphael, and Rembrandt.

This exhibition contains a generous selection of more than 100 works, chosen from all of the Woodner drawings at the National Gallery, including Ian Woodner's lifetime gifts and the further donations arranged by Dian and Andrea. It is a stunning display of works in many different styles from different schools and centuries. What unites them is the sensitive taste and drive of the collector. Thus this is truly a memorial to one of the outstanding collectors of this century.

This exhibition and catalogue have been prepared under the supervision of Margaret Morgan Grasselli, the Gallery's curator of old master drawings. Many other members of the staff are indicated in the acknowledgments that follow. We are grateful to all of them for their efforts.

It is a privilege and pleasure for the National Gallery to celebrate two generations of the Woodner family and their great devotion to the nation's art collection, which will serve as a beacon and example to future artists, scholars, collectors, and all those who appreciate rare and beautiful works of art.

EARL A. POWELL III
*Director, National Gallery of Art, Washington*

# Acknowledgments

When asked to coordinate the Woodner exhibition and catalogue, I never guessed what a complex undertaking it would prove to be. The successful completion of the project has depended on the cooperation and contributions of an amazing number of people from both inside and outside the National Gallery.

My first, most profound thanks go to Dian and Andrea Woodner, whose generosity and vision made this exhibition possible. As a curator, I am deeply grateful for their commitment to the National Gallery of Art and for their wish to preserve the core of the Woodner collection of drawings here; but I am also personally honored by their friendship and encouragement. I trust they will be pleased with this tribute to their father's great achievement.

It was our goal from the start to make this new catalogue of the Woodner drawings different from its various predecessors, not only in appearance but also in organization and content. For the first time the drawings are presented in chronological order, thus underscoring the collection's great strength in works of the Renaissance, for example. In addition, to ensure that the catalogue would reflect the latest thinking on each drawing, we asked fifty-two scholars from Europe and North America to write entries on the drawings in their areas of expertise. To each of these authors I extend my deepest gratitude. They responded generously and collegially to our invitation to join this project and, as we had hoped, offered new information, interpretations, correlations, and even attributions—no mean feat considering how much has already been written about many of these drawings!

We are greatly indebted to Noël Annesley for writing the introductory biography on Ian Woodner, whom he knew as both a friend and a collector. He threw himself wholeheartedly into the task, gathering anecdotes and reminiscences from Woodner's family and friends, then weaving them together into an affectionate and human portrait of one of the great collectors of the twentieth century. Playing an important role in this effort was Terence Rodrigues, who was closely involved in researching, writing, and revising the introduction. Responsible for typing the various drafts was the unfailingly helpful and cheery Judy Woodham, Mr. Annesley's secretary. It was a pleasure to work with each of them.

In the four years since the Woodner drawings arrived at the National Gallery, my colleagues and I have naturally been very dependent on the staff at the Woodner Collections for answers to all sorts of questions. They have supplied countless file photographs, xeroxes of acquisition records, extra copies of earlier Woodner catalogues (especially the almost unobtainable Spanish version that accompanied the Madrid exhibition of 1986–1987), and other useful materials. Beginning in 1991, Jennifer Jones

and Anna Riehl responded to every query and request with speed and grace; more recently, during preparations for this exhibition, Susan Hapgood, Elizabeth Obert, and Serafino Yannucci have earned special thanks for all their efforts on our behalf.

We are also grateful to all of the collectors, dealers, scholars, museum colleagues, and auction house representatives here and abroad who provided expert advice and assistance to authors of this catalogue; and who assisted us in obtaining photographs for auxiliary reproductions, often on very short notice. Their help had a significant effect on the quality and usefulness of the catalogue.

Scores of colleagues at the National Gallery contributed to the realization of the project. First, I offer my profound thanks to Andrew Robison, the Andrew W. Mellon Senior Curator. I am grateful to him not only for his faith in me but also for his welcome counsel and guidance throughout the many phases of this complex enterprise. No less heartfelt is my gratitude toward my associates and friends in the department of old master drawings, Judith Brodie and Ann MacNary, who were key players in every aspect of the production of both the catalogue and the exhibition. I cannot adequately express the extent of my debt to them but can say only that I would have been lost without their constant support and all their hard work. Renée Maurer, David McMullen,

and Mireille Cronin bore the brunt of the secretarial duties generated by this project and kept work on the catalogue humming.

Over the past two years a series of excellent interns put together exhaustive files on each of the exhibited drawings. In so doing, Rachel Meyerson, Paula Warrick, Elizabeth Bloch, Jennifer Schipf, Julia Dabbs, and Sandra Persuy provided vital assistance to catalogue authors and at the same time created a useful resource for future scholars working on the Woodner drawings.

The Gallery's paper conservators Shelley Fletcher, Judy Walsh, and Yoonjoo Strumfels studied each drawing in the Woodner collection, checking and correcting technical information and measurements, and making sure each work was ready for exhibition. Their assistant Carol Eggert checked every drawing for watermarks, made Beta-radiographs of each one, then searched for equivalents that would help establish dates for the various papers. For color reproductions in the catalogue, all of the drawings were newly photographed by Dean Beasom and Robert Grove, a time-consuming task that they approached with their customary attention and goodwill. Colleagues in the library and the photographic archives provided further assistance toward production of the catalogue. Translation duties for the entries written in foreign languages, meanwhile, were entrusted to Alison

Luchs (German), Frances Kianka (Italian), and Kimberly Jones (French), who combined accuracy with creativity in rendering the texts into English.

Editor-in-chief Frances P. Smyth oversaw contractual and copublishing arrangements for the catalogue. We are delighted that Harry N. Abrams, Inc., will be distributing the hardcover volume along with a companion catalogue of drawings from Chatsworth. Editing the contributions of more than fifty authors was a challenge that Tam Curry met with grace and aplomb. Her sensitive and intelligent editing of the texts preserved the individual voices of the authors while clarifying the expression of their ideas. The catalogue was designed by Margaret Bauer, who came up with some exciting, innovative ideas for the presentation of the entries and illustrations, and who managed the infinite details of production with remarkable dedication, resilience, and good humor.

For the exhibition, Hugh Phibbs, Elaine Vamos, and the Gallery's staff of matters and framers worked extraordinarily hard to present the drawings to best advantage, while Gaillard Ravenel, Mark Leithauser, Gordon Anson, John Olson, and the staff of the department of installation and design have ensured that the drawings would be exhibited logically and with style. Thanks go to the registrar's office and the art handlers, who helped with preliminary layouts of the exhibition and installed the draw-

ings with their usual efficiency and care. Planning for the exhibition has also benefited from the cooperation of many other departments at the Gallery, from the offices of the secretary and general counsel, the treasurer, and the administrator, to those of exhibition programs, education, and public relations. I have welcomed, moreover, the moral support of my colleagues in other curatorial offices and in the division of prints, drawings, and photographs. It is a privilege to work with such a talented and collegial group of people.

MARGARET MORGAN GRASSELLI
*Curator of Old Master Drawings*

*Ian Woodner, c. 1985*

# A Biography of Ian Woodner

As this exhibition opens, almost five years will have passed since the death of the man whose achievements as a collector it commemorates. Many who come to see it will reflect on the series of exhibitions that preceded it and feel surprised, even cheated, that the collector himself is not present to act as host, a role he had come to relish when so many of the great museums of the world exhibited his treasures during the last ten years of his life.

A catalogue of this kind, composed of learned entries on the individual drawings by scholars from around the world, would be expected to carry a tribute, albeit a brief one, to the collector. Such tributes, especially when the subject is still alive, can come perilously close to hagiography. Andrew Robison of the National Gallery of Art, with the enthusiastic support of Ian Woodner's daughters, Dian and Andrea, has encouraged me to attempt something more ambitious. While Woodner gave a number of interviews, particularly toward the end of his life, and while aspects of his long career are a matter of public record, he was quite reticent on the subject of his early years. This seemed an opportunity, therefore, to gather some facts and some impressions of a remarkable man and in the process to develop a sketch of his life, his personality, and his achievements.

In the context of an exhibition of drawings, after all, a sketch seems quite appropriate. I am grateful to his many relatives, friends, and colleagues who have talked to me while I was preparing this. In addition to their comments I have been able to consult a brief autobiographical summary of Woodner's life up to 1950.

In this century, now almost over, there have been many instances in the United States of men and women rising to fame and fortune from impoverished beginnings, and there are no doubt more spectacular examples than Ian Woodner. The grinding poverty of his childhood, however, seems to have nourished in him a fierce ambition to succeed both in business and in artistic endeavor. He was born Israel Silverman in New York City on 25 January 1903. His parents, Nathan Silverman and Eva Woodner, were both immigrants born in Poland who had arrived separately in New York in about 1894, met there, and married soon afterward. His mother was by all accounts much the more forceful character, possibly toughened by the experience at age three of seeing her own mother killed by a Russian soldier. Ian, to use the name he later adopted, was the third child of six. Just before his first birthday, the family moved to Minneapolis, where he grew up. His father was a tailor, somewhat indolent, quiet, even melancholic, and though he succeeded in opening his own shop, he was improvident as well as impecunious. Ian went to Grant School, a public grade school, and attended Hebrew classes in the evenings. From age nine, he recalled, he sold newspapers with his brothers on the streets of Minneapolis, cleaned shoes, and further supplemented the family income with sales of bruised fruit. He was allowed to keep one cent in six of his earnings. Asked what he wanted to be when he grew up, he was very young when he answered "an architect," without knowing quite what that meant. Later he spoke frequently of his mother's powerful influence: she was illiterate, even to the extent of signing her name with an *X*, yet possessed of a strong, if untutored, aesthetic sensibility.

Woodner went to North High School in Minneapolis, taking courses in mechanical drawing, mathematics, and art as well as history, Latin, and physics, with the intent of studying at the School of Architecture at the University of Minnesota. He excelled in mathematics and mechanical drawing but was otherwise an average student. He prospered at the university, however, and graduated in 1924 with a bachelor of science degree in architecture. As head of the class, he received the Medal of the American Institute of Architects.

For a year Woodner was an instructor in architecture at Montana State College. He then gained a tuition fellowship at Harvard University Graduate School of Architecture. In the summer of 1925 he worked in New York City for the architect John Russell Pope on the design of the Roosevelt Memorial. His three years at Harvard widened his horizons immeasurably. In 1927 his unusual talents were recognized, and he received a Sheldon fellowship, an Appelton traveling fellowship, and a Nelson-Robinson fellowship for travel and study in Europe. That summer he was the instructor in architectural design at Harvard.

In the fall of 1927 Woodner made his first visit to Europe: he took lodgings in Paris, which was to remain his favorite city—he always pronounced the name with a certain reverence. He attended the Atelier de Frasse at the École des Beaux-Arts as an *auditeur libre* and traveled in France and Italy, visiting museums, studying the great architectural monuments, and making watercolor sketches of them. A two-month bicycle trip through Normandy and Brittany was a highlight. This halcyon period was interrupted by the death of his younger brother, Julius, in a car accident, and he returned to the United States.

In 1929 Woodner represented Harvard University in the Paris Prize Competition for Architecture, a national competition organized by the Beaux-Arts Institute (now known as the National Institute for Architectural Education). While he received only second prize, the chairman of the jury was sufficiently impressed to provide him with funds to enable him to return to Europe and enroll at the École des Beaux-Arts, this time as an official student. He lived in a modest apartment on the Île de la Cité near the Pont Neuf.

So his extended education continued. While still a boy, Woodner had shown a precocious talent as a figure draftsman and watercolorist, and Clarke Daniel, a friend from this period in Paris, suggests that Woodner would have preferred to be a painter rather than an architect. Daniel and his two brothers were likewise Americans in Paris and fellow students with Woodner,

though considerably younger. He recalls that Woodner as a young man was tall and powerfully built (despite having diminutive parents), and he was striking in appearance, with a swarthy complexion, black hair, prominent eyes under heavy lids, and a gap between his two front teeth like the British film star Terry Thomas. Already he affected the Clark Gable-type moustache etched centrally above his upper lip. In personality he was shy, reserved, and intense, far from a lively conversationalist—indeed liable to be communicative only on the subject of art and his own painting. Always short of money, he frequently relied on Daniel's mother for meals. Nonetheless he somehow managed to travel all over Europe and the Middle East, including Palestine, Syria, Greece, and Turkey. His stay in Egypt coincided with a time of high tension between Jews and Arabs. When Daniel asked him how he kept out of trouble, Woodner replied that with the Arabs he was an American and with the Jews he was a Jew.

Back in Paris, Woodner picked up occasional work as an architectural designer. In January 1932 he went off to the island of Majorca, in concert with many expatriates in Paris during the depths of the Depression, to take advantage of the plummeting value of the peseta. There he spent six months painting the olive trees and the sea until his family somehow raised enough money to bring him back to the United States. His niece, Beverly Elkin, remembers his returning with three suitcases packed with postcards of the buildings and pictures he had seen.

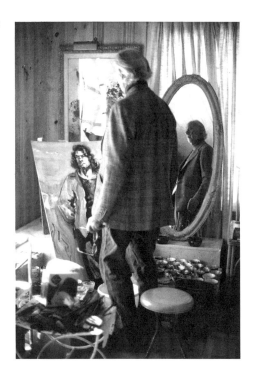

It was high time he found regular employment. His parents' marriage, always stormy and punctuated with separations (or rather ejections when his mother threw his father out of the house), had finally broken up. His parents having Americanized their own names, he now became Ian (after flirtation with the name Raoul) Woodner-Silverman, eventually dropping Silverman altogether. Six months of odd jobs for architects in Minneapolis followed. Then he spent a few months painting in Woodstock, New York, before settling in New York City in 1934 and working for Robert Moses, the commissioner of parks under the Work Projects Administration. He helped design the Central Park Zoo, a source of great pride to him, and one reason, apart from his love of animals, why visits to the zoo were among the comparatively few family outings his daughter Andrea remembers from her childhood.

Woodner moved into a duplex apartment in the Colonial Studios at 39 West 67th Street, which remained his home until he

died fifty-six years later, an unusually long stay at the same address for a New Yorker.

I dwell on some of the details of Woodner's burgeoning career as an architect because it seems clear that he could have achieved eminence in that calling had he so chosen. After further work with Moses in 1936, he became an assistant to the board of design for the 1939 New York World's Fair. With a classmate from Harvard and another architect, he won a competition to design one of the largest buildings at the fair, Pharmacy Hall. He proposed murals for each end of the building and suggested that Michael Loewe, an artist whom he had met through his sister, Beverly, produce one of the 100 by 40 foot murals and that Willem de Kooning, a friend of Loewe's, produce the other. The commission cost $3,000. Woodner also participated in a project for the fair by Salvador Dalí. The *Dream of Venus* was to be a surreal construction that would be entered through leglike columns and would feature a tank with living mermaids.

Woodner continued to be associated with the World's Fair until it closed at the end of 1941. While he consistently wanted to be his own master, he needed first to gain financial independence, and as early as 1937 he had approached the Daniel family in Washington, DC, to see if he could join their real estate development business, as that seemed a way to channel his architectural training into material success.

Meanwhile, Woodner had met Ruth Gillerman through his sister Beverly, who lived with him on West 67th Street. Ruth and Beverly had been students at the National Academy of Dramatic Arts. Woodner married Ruth on 17 May 1942. He had a close, if complicated and sometimes turbulent, relationship with his gifted sister, and Beverly remained part of the ménage even after his children were born. Beverly was a fascinating woman—a beautiful witch by some accounts, an artist with a particular gift for sculpture, a mistress to many film stars and creative people, with a wide social following—and she would act as hostess for her less gregarious brother, who enjoyed her show business connections.

Ruth came from a Jewish family of modest circumstances, was strikingly beautiful, and was an accomplished actress who achieved success in television drama. Though she was of strong character, she found it difficult to combine marriage and motherhood with the competitive demands of Woodner's professional ambitions, his other interests, and his numerous relations, to whom he became a kind of paterfamilias, both critical and supportive.

Soon afterward Woodner was offered the opportunity to establish a housing project in Wilmington, Delaware. He raised the money with friends to buy the land and developed it with government support for housing to accommodate people working in Wilmington's war-related industries. He went on to complete another government-backed housing project in the Seat Pleasant area of Maryland, and in 1944 the Jonathan Woodner Company was established, named after his infant son. Woodner explained that he used Jonathan's name rather than his own not for dynastic reasons but because he thought that at the end of the war he would return to architectural practice, and "in those days you were looked down upon if you were an architect associated with the business end of building…." He discovered, however, that he "enjoyed being in all aspects of building—the selection of land, the determination of its use, the financing, the marketing—and the rewards were much greater…." He was fortunate, too, to find in Paula Vial, herself an immigrant from Poland, someone to help him with the details of the operations. She played a vital part in expanding the business and remained a friend for the rest of his life.

**2**

15

**3.**

*With Andy Warhol in October 1971*
*(Photo: Sam Shaw)*

Woodner's combination of talents—and, it has been suggested, his readiness to operate by his own rules—brought him success in his new profession. Around this time he began to collect art, though his family's recollection is that cash remained scarce so that a picture acquired could mean a holiday shelved. Wallace ("Wally") Holladay, whose wife Wilhelmina Cole ("Billie") Holladay founded the National Museum of Women in the Arts in Washington in 1987, is still involved in real estate in the Washington area and remembers with affection how Woodner hired him in 1947 from the Federal Housing Administration. "Woody," as his friends called him (or "Wood," as he shortened it because he did not waste a syllable on the telephone), delegated responsibility for Washington projects to Holladay, who stayed for five years, in complete harmony with his dominating employer. For Ruth, however, with their three children, Jonathan, Dian, and Andrea, there was little in the way of family life. The prospering company, with many developments under way around the country, meant long separations, eventual estrangement, and long and bitterly contested divorce proceedings that resulted in Woodner's gaining custody of the children. He did not marry again, though he greatly admired women and was seldom seen on a public occasion without an elegant female companion. His business, his painting, and his collecting seem to have taken precedence. He was, to be sure, immensely fond of Jonathan ("Jon") and brought him into

the business. Jon eventually relinquished his "hippy" lifestyle and assumed responsibility for the Washington office, but he never lost his passion for racing cars and airplanes. He concluded a number of successful building projects before his tragically early death in a flying accident.

Woodner's daughters may have seen very little of their father while growing up, and they could find him intimidating and gruff as well as affectionate, warm, and playful. But his consuming passion for art and for his own painting inspired them, and they came to appreciate and share the intensity of his pursuit of beauty in all its forms. Every city they visited together was combed for museums, few concessions being made to youthful pursuits.

The list of properties developed by the Jonathan Woodner Company is a very long one, whether large individual buildings, multi-house complexes, shopping centers, or other developments. In many cases Woodner was personally involved with the design. Two projects that afforded him particular satisfaction were "The Woodner," the largest apartment building in the United States at the time of its opening and among the most luxurious, also the recipient of the Washington Board of Trade's Award in Architecture in 1953; and quite recently the renovation of the old Evening Star building in Washington, which received the 1990 Modernization Award from *Buildings* magazine.

Woodner was always interested in the commercial side of art collecting and

numbered the distinguished dealer Sam Salz among his friends. For a time he even owned an art gallery on Madison Avenue in New York, where he exhibited the work of contemporary artists as well as his own. In the early 1940s he knew many Europeans who had recently fled from Hitler, and with them he bought and sold minor impressionist paintings. He collected impressionists himself, formed a fine group of Cycladic works and other antiquities, bought some old master pictures, and pursued his passion for Redon, with whose imaginative world he felt a peculiar affinity and whose style and technique he sought to emulate in his own work, especially his flower paintings.

Gradually, though, he became attracted to the field of old master drawings. In the 1950s he would buy regularly at the Savoy Galleries, a small auction house in New York, now defunct, where lesser old master drawings were "recycled" from sales in Europe. He discovered that by collecting drawings rather than pictures he could afford to own works by the great masters whom he most admired. Moreover, he felt that drawings brought him more closely in touch with the artist than paintings and had a sense of immediacy that reflected the moment of inspiration.

In Rome in 1956, Woodner recalled, he bought a portrait drawing by Raphael, ostensibly from the Esterhazy Collection in Budapest. At $3,500, it was expensive. Alas, when he showed it to John Gere at the British Museum in 1962, it was revealed to be a nineteenth-century copy. Woodner

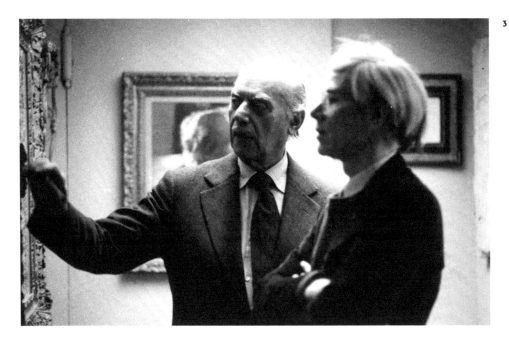

Thus when William Schab approached Woodner in about 1969 about mounting an exhibition of Woodner's drawings at the Schab Gallery, the collector was enthusiastic. As Konrad Oberhuber recalls, the black-tie reception was attended by many celebrities, among them Andy Warhol—not previously known as a drawings devotee but perhaps a friend of Beverly's—with Woodner unashamedly basking in the limelight. Schab's son Frederick supervised the production of an elaborate catalogue, and a pattern was set for future exhibitions. Woodner added so many drawings in the next few years that a second showing was arranged at the Schab Gallery, and this one traveled to several museums outside New York.

In the 1970s Woodner continued to buy. Flamboyant by comparison with many of his painstaking rivals, he was a bold, even impetuous collector, responding immediately to the beauty and interest of a sheet as he saw it, preferring to pounce on his prey and ask questions afterward. His increasing confidence in his own judgment made him splendidly independent and disrespectful of "experts," though he could devote much time to attempting to bring them around to his point of view. For a man of rather few words, he developed a rich and expressive series of phrases as he sought to explain his instinctive and sensual rather than cerebral responses to works of art and to defend what seemed to some controversial, even indefensible attributions. Along with some mediocre drawings, he also began to gather many masterpieces,

suffered this setback calmly, however, as three years before he had made the purchase that marked a turning point in his direction as a collector. He first encountered the William H. Schab Gallery of New York in acquiring antiquities from the collection of Jacob Hirsch, and it was this firm that offered him in 1959 a large and highly finished study of a *Satyr* (cat. 47), an exceptional work by Benvenuto Cellini, the great Florentine sculptor from whose hand only a small number of drawings survive.

Woodner enjoyed telling the story of this purchase. For two years the drawing had been owned by the London dealer Hans Calmann and lacked any attribution until an Italian visitor pointed out that the inscription "alla porta di fontana Bellio…" could refer to Fontainebleau. The link was then established with Cellini's scheme to decorate the Porte Dorée, the principal entrance to the palace of François I, with a flanking pair of satyrs. The drawing had been acquired by Schab and sent on approval to Jacob Bean, curator at the Metropolitan Museum of Art, but the price was questioned and the work returned. The price of

$18,000 also seemed huge to Woodner, who had scarcely heard of the master, let alone encountered a drawing by him, but he intuitively recognized its exceptional quality, made a down payment, and arranged to settle the balance in a year. Two days later the Metropolitan's president Robert Lehman came into the Schab Gallery and was dismayed and astonished to find the drawing had been sold. Woodner, emulating Cellini's own boastfulness, was later to refer to it as the most famous drawing in the world. Dürer's *Praying Hands* surely has a better claim—and one could think of others—but the Cellini sheet, in its power, beauty, and rarity was undoubtedly a star at the celebrated showing of *Drawings from New York Collections: The Italian Renaissance* in 1965–1966, when Bean, who worked with Felice Stampfle of the Morgan Library to select the drawings for exhibition, could ruefully reflect upon a narrow miss. The Cellini, a Holbein portrait drawing bought from Schab a year later, and a handful of other significant purchases persuaded Woodner to focus more closely on this area of his collecting—with admirable effect.

17

*Pointing out a detail of the*
*Vasari page at Harvard University,*
*April 1985*

and the range of his preferences began to emerge. While he admired landscape, he was particularly attracted to figure studies and portraits, and he delighted above all in the contours and expressiveness of the early Italian Renaissance. A large sheet of studies from Sir Ilay Campbell's collection, bought in 1974 as attributed to Agnolo Gaddi (cat. 2), reflected these preferences. There was also much to tempt him in notable collections such as Gathorne-Hardy's, Hirsch's, and Hatvany's, which appeared at auction during this period. A survey of the dates of acquisition of the majority of the drawings in the current exhibition indicates just how far his taste and discernment improved during the last fifteen years of his life.

Far from slowing down, indeed, Woodner's levels of energy and curiosity sharply increased as he moved into his eighties. Fortunately he needed little sleep. Never much of a reader, on his own admission, he remained a tireless visitor to museums and exhibitions, and he pored over the illustrations of every book and catalogue he could find.

Nonetheless, just as the Cellini purchase and its aftermath stimulated the earlier phase of Woodner's collecting, it may be fair to say that the appearance on the market in 1981 of a red chalk study of Cleopatra by Rembrandt marked another. I was the auctioneer and was quite taken by surprise at the exuberance of the bidding battle between Woodner and Robert Light, who, it later transpired, was the agent for the J. Paul Getty Museum, making the first purchase to launch George Goldner's campaign to

build a drawings collection (indeed for a while this superb Rembrandt nude *was* the old master drawing collection at Malibu, as some wags observed). At £300,000, this represented a new level of activity for Woodner, who was mortified to be "robbed" of his prize. At a consoling lunch afterward, Goldner, who was well aware of the dramatic improvement to Woodner's collection in the recent past, suggested a new exhibition, which would start at the Getty, where it would surely stimulate interest in the museum's new venture, and then proceed to other museums. He, Goldner, would edit the catalogue, and Konrad Oberhuber, with his team of students from the Fogg, would prepare most of the entries. With the resulting exhibition began the series of displays from the Woodner collections, gradually expanding in scope and content, that have taken place at many of the leading museums of the world.

The gestation of the Getty catalogue was not without its problems. The team of scholars, which included Andrew Robison

and Edmund Pillsbury as designated hosts for the exhibitions at Washington and Fort Worth, would visit Woodner's home in New York to examine and describe the drawings, and lively debates would develop over the selection and attribution. The walls were festooned with drawings, other sheets were in stacks against the walls, and the closets were bursting with more works. On one memorable occasion the partisan owner kept breaking off a tense telephone discussion with his lawyer to take issue with the opinions he overheard from the next room. Once acquired, the drawings became almost members of the family, like cherished children about whom nothing derogatory could be said.

Woodner was incensed by what he considered some unduly cautious descriptions of personal favorites that appeared in the finished publication of the Getty catalogue. Any breaches were rapidly healed, however, by the acclaim that greeted the exhibition when it appeared in Malibu in 1983, at the Kimbell Art Museum, in aug-

mented form at the National Gallery of Art in 1983/1984, and then, with further additions, at the Fogg in early 1985. Each stop was marked by lavish opening ceremonies that were to become a hallmark of a Woodner exhibition, which may have reflected some of the attraction to show business that had earlier prompted Woodner to support two films and a Broadway play. The showing at the Fogg was also the occasion of an international symposium devoted to the study of old master drawings. It attracted a crowd of fellow collectors, scholars and specialists, museum curators, dealers and auctioneers through whose activity the collection had been built. Many of Woodner's family and friends were also invited, contributing to the celebratory atmosphere. The symposium was suggested and in large part organized by Walter Strauss, the owner of Abaris Books, who had published a monograph on Goltzius engravings and a six-volume compilation of Dürer drawings and who had been friendly with Woodner for some years, as well as by Konrad Oberhuber, who brilliantly combined the roles of drawings curator at the Fogg and professor of art history at Harvard University. It yielded a series of provocative lectures and seminars, eventually published by Strauss. Woodner's magnificent drawings and his generous sponsorship made him the center of attention, which he enjoyed unaffectedly; he was also motivated by a distinctly philanthropic desire to share his prized possessions with the widest possible public.

This occasion, with the interest in old master drawings it expressed, was given further impetus by an unprecedented sale that had taken place at Christie's in London the summer before. In July of 1984, seventy-one drawings from Chatsworth came up for auction. They were of an overall quality not previously encountered on the market, and Woodner then made the purchase that even more than the Cellini has come to symbolize his collection. He had first seen the so-called Vasari sheet (cat. 9, 9a-9j), with its assemblage of exquisite metalpoint and pen studies generally attributed to Filippino Lippi, in the exhibition of Chatsworth drawings that traveled to the United States in 1962–1963, and it made a lasting impression. He never dreamed it would come up for sale, and when shown it a few months before the auction, he fell silent before expressing amazement at what he took to be an inflated presale estimate of £600,000. Like many collectors and institutions, he was concerned about the enormous resources of the Getty Museum, to which he had earlier had to surrender the Rembrandt drawing. In any event, he outbid them for the Vasari sheet, paying £3,240,000 (a sum narrowly exceeded by the Raphael head that Mrs. Johnson bought a few lots later). He admitted afterward—perhaps to the alarm of the bankers supporting the purchase—that when he started to bid he had little idea of how far he would go. He also bought the first lot, a group of three philosophers by Bandinelli, as well as a tiny caricature by Leonardo (cat. 11), but, to his

chagrin, he lost to the Getty a Raphael metalpoint study for *Saint Paul at Lystra*. Nor could he afford to pursue the Rembrandt landscapes that followed.

Inevitably, by virtue of its imposing size and its beauty, the Vasari sheet has become the centerpiece, the "crown jewel" in the collector's words, of every exhibition of Woodner's drawings since. And in the frequent interviews that Woodner gave afterward, he dwelt on the parallels he perceived between himself and his Florentine predecessor. Vasari, he argued, similarly combined the activities of painter, architect, and drawings collector. Many came to support the attribution to Botticelli of the only watercolor among the two sides of figure studies, and that gave him further pleasure.

Since the possibility of further exhibitions had been broached in 1981, Woodner had consciously stepped up his buying activity, though he seems never to have had a "wish-list" as such nor the desire to build a collection that included works by all of the most famous draftsmen (he acquired very few drawings by artists of the Italian baroque, for instance). On the one hand he had limited resources, and on the other hand he could be captivated by the next thing he saw. Nowhere was his individual approach better exemplified than in a sale of July 1982 when he bought three drawings, each of high quality but sharply different in character. They are all in the present show: the mid-fifteenth-century profile portrait of a boy attributed to the Veronese artist Giovanni Badile (cat. 5),

exquisitely drawn in pen and brown ink; a silverpoint horse's head then newly identified as Raphael (cat. 32); and the wing of a blue roller, in vivid watercolor and gouache, tantalizingly close to Dürer (cat. 59). The latter is among the most beautiful productions of its epoch, even though not everyone was convinced by arguments some scholars urged on Woodner to prove it was by Dürer. He enlarged color reproductions of various wing studies associated with the master and ranged them side by side, often upside down, to show the superior brushwork of his own version. Only Dürer himself, Woodner asserted, would have used such a quantity of precious lapis lazuli. The collector never tired of demonstrations of this kind, for he loved the drawings and wanted to convert the infidels.

In 1986 the unexpected dispersal of the collection of John Gaines, one of the liveliest competitors for Chatsworth drawings, gave Woodner the chance to acquire drawings that had eluded him in earlier sales: one of the choicest Rembrandt landscapes from Chatsworth (cat. 72), a red chalk sketch by Carpaccio (cat. 27), and two red chalk fragments by Raphael for *Christ's Charge to Saint Peter* (cat. 34). Woodner had no hesitation about reducing the number of his Raphael drawings by reuniting these two as a single work, as he said, quite rightly, they belonged together. He then added Raphael's *Marble Horse on the Quirinal Hill* (cat. 33) and Van Dyck's *Mystic Marriage of Saint Catherine* (cat. 65) at the second Chatsworth sale the next summer.

These recent purchases were late arrivals for the Royal Academy exhibition in London in the autumn of 1987, the splendid catalogue of which, succeeding those prepared for the Albertina, Haus der Kunst, and Prado showings, served as the basis for the Metropolitan Museum's edition in 1990. Woodner's by-then famous appetite as a collector had opened the doors to a number of collections during this period, and Walter Strauss' knowledge of German and Swiss holdings led to the acquisition, privately, of fine drawings by Dürer as well as by Baldung and other German masters in whom Woodner had earlier shown comparatively little interest.

Woodner's collecting ended, in fact, only with his death in 1990 at the age of eighty-seven. We may feel sure that he would have approved of his daughters' arrangements, which have brought a high proportion of his drawings to Washington, a city with which Woodner was closely associated throughout his life, and to the national gallery for a country of which he was proud. He enjoyed a long friendship with J. Carter Brown, director emeritus of the National Gallery, who spoke eloquently and with almost filial affection at Woodner's funeral, as well as with Andrew Robison, with whom the collector had frequent discussions about acquisitions and drawings on the market. Woodner served for many years on the Trustees' Council of the National Gallery and proved an enlightened patron. He thought of it as the "Museum of the People of the United States."

Strauss himself was a late example of a type of "facilitator" whom Woodner attracted and used throughout his life. However dedicated a collector, Woodner still had to run a business. Strauss must take credit for locating many fine drawings and helping Woodner realize several notable achievements in his last decade. A second symposium accompanied the Royal Academy exhibition, rather more serious and productive than the first, and it was likewise made available in published form. Woodner's funds also enabled Abaris Books to complete the invaluable *Illustrated Bartsch*, which he then presented to many museum libraries. He made numerous other gestures in support of museums, architecture, and the arts in general that were widely reported. No one could begrudge Ian Woodner his glorious Indian summer. "Life begins at eighty," he would often say. The man who spoke so quietly in restaurants that a companion had to strain to hear him was called upon to make speeches at dinners in his honor all over the world. He was recompensed for a difficult and impoverished childhood by an old age in which he was able to buy drawings from the world's foremost private collection and to stay as a friend in the great house, Chatsworth, from which they came. It is happily arranged that this exhibition of masterworks from the Woodner Collections effectively reunites Woodner's Chatsworth drawings with another superb display of drawings from that source.

Woodner was surprisingly casual about the presentation of his drawings

until quite late in the growth of the collection; it was, after all, the images themselves that he deemed important. Frames, for instance, were given little consideration. With the increasing demands for exhibitions, however, he came to realize the need to appoint a full-time curator, who relates how, in the face of an imminent invasion of the apartment by photographers, Woodner produced a jar of instant coffee and together they applied the moistened powder to tone down the chips and cracks to the wood and plaster—not a procedure, I imagine, that will be part of the preparation for the current exhibition. While Woodner was, as many will remember, fastidious about his own appearance, with a penchant for elegant suits with rather wide lapels, striped shirts, and lavender ties from Jermyn Street, his pursuit of beauty did not extend to his office surroundings, where he liked things to remain the same. His desk was a low skyscraper of catalogues, architectural blueprints, and contracts, interspersed with photographs of objects sent to tempt him and a welter of other papers: he would rummage among these to show a visitor the evidence for his latest discovery—and always find it.

How fortunate Woodner was, too, to be able to continue to express his talent as a painter in tandem with his other activities. Almost every weekend he would go out to his simply furnished house in East Hampton, with its wonderful garden, another expression of his lifelong search for beauty. There, surrounded by flowers, he would rise very early in the morning to paint the scene, or, in another mood, to work on a probing self-portrait. He would brood, perhaps, over yet further additions to the collections he so enjoyed sharing with the European as well as the American public—another great Goya drawing, possibly a Rembrandt (to name the artist who, I think, moved him most deeply), a Mantegna (to compensate for the one that "got away" in the Hatvany sale), a Michelangelo, even another Redon or Picasso. "Art," he said the night before he died, "is all there is."

As an introduction to the Royal Academy and Metropolitan Museum catalogues, Nicholas and Jane Shoaf Turner contributed an illuminating essay on "Private Collections of Old Master Drawings in America in the Twentieth Century." In the last decade of his life, when, as he put it, Woodner developed "the true urge to have a *great* collection," he was in the habit of introducing himself, without apparent irony, as "the greatest collector of drawings in the world." Posterity will be better able to judge his stature by comparison with his illustrious predecessors and contemporaries. What is beyond dispute is that no one responded more passionately to drawings than he and his influence will long survive his passing. *Si monumentum requiris, circumspice.*

NOËL ANNESLEY

## Exhibitions and Catalogues of the Woodner Collections

**WOODNER, NEW YORK 1971–1972**
*A Selection of Old Master Drawings before 1700*, William H. Schab Gallery, New York; Los Angeles County Museum of Art; Indianapolis Museum of Art.

**WOODNER, NEW YORK 1973–1974**
*Old Master Drawings from the 15th to the 18th Century*, William H. Schab Gallery, New York; Los Angeles County Museum of Art; Indianapolis Museum of Art.

**WOODNER, MALIBU 1983–1985**
*Master Drawings from the Woodner Collection*, J. Paul Getty Museum, Malibu; Kimbell Art Museum, Fort Worth; National Gallery of Art, Washington; Fogg Art Museum, Harvard University, Cambridge (an expanded checklist published for the Fogg presentation includes works added to the show for this venue only and is cited as *Woodner, Cambridge 1985*).

**WOODNER, MUNICH AND VIENNA 1986**
*Die Sammlung Ian Woodner*, Graphische Sammlung Albertina, Vienna; Haus der Kunst, Munich (the catalogue for the Munich presentation includes several drawings added to the show for that venue only and is cited as *Woodner, Munich 1986*).

**WOODNER, MADRID 1986–1987**
*Dibujos de los siglos 14 al 20: Colección Woodner*, Museo del Prado, Madrid.

**WOODNER, LONDON 1987**
*Master Drawings: The Woodner Collection*, Royal Academy of Art, London.

**WOODNER, NEW YORK 1990**
*Woodner Collection: Master Drawings*, Metropolitan Museum of Art, New York.

**WOODNER, WASHINGTON 1993–1994**
*Nine Old Master Drawings: New Gifts from the Woodner Family Collection*, National Gallery of Art, Washington (no catalogue).

## Publications about Ian Woodner and the Woodner Collections

Joseph T. Butler, "Old Master Drawings from the Woodner Collection II," *Connoisseur* 186 (1974), 56–57.

Axelle de Gaigneron, "Ian Woodner, amateur américain de réputation mondiale, commente quelques oeuvres majeures de sa collection," *Connaissance des Arts* 310 (1977), 100–107.

Axelle de Gaigneron, "Les nouveaux choix de Mr. Woodner," *Connaissance des Arts* 348 (1981), 74–79.

Lynn R. Matteson, "Old Master Drawings from the Woodner Collection." *Pantheon* 41 (1983), 386–387.

Bruno de Bayser, "Rêves de collectionneur," *Connaissance des Arts* (December 1984), 72–79.

Souren Melikian, "A Master Collector, Ian Woodner: An Eye for the Future," *Art & Auction* 10, no. 4 (November 1987), 80–87.

Paul Cummings, "Interview: Ian Woodner Talks with Paul Cummings," *Drawing* 9, no. 5 (1988), 106–110.

## Note to the Reader

Measurements refer to sheet size and are given in centimeters followed by inches in parentheses; height precedes width.

Abbreviated references cited in the Notes, Exhibitions, and Literature sections of the entries are given in full at the end of the book.

In the artists' biographies, *q.v. (quod vide)* indicates that a work (or works) by that artist is included elsewhere in this catalogue, together with a biography of the artist.

FOURTEENTH AND FIFTEENTH CENTURIES

# 1  Two Studies of Saint Christopher and a Study of an Aedicule

**Second quarter of the 14th century, pen and black ink with black wash on vellum, 154 x 216 (6 ¹/₁₆ x 8 ½)**

**Inscribed at upper right in pen and brown ink:**
*Propensus, extensus vel festinus / Propensius, fes-*
*tinanter / Propyciatorium, ain pethauss vel gnad-*
*hauss vel stad / Quamobrem, quare et [cetera?]*
*[adverbium?] Etiam pro ergo ponitur / [commune?]*
*[est?] / Quominus, quosque / Quodsi, set si / Quo-*
*dammodo, etlicher weiss / Extimplo, subito et dum*
*statim ubi quidam dicunt / extemplo [illegible]*
*Tempus non timpus saltem / dices neque saltim*
*Extemplo non extimplo / docet artis amicus /*
*[illegible line] / Apud [per?] [denarium?] escribitur*
*sicut apud [presentem?] / Ad per denarium*

**Woodner Collections**

This sheet is evidently a fragmentary survival from a medieval model book, but it cannot be linked with certainty to any of the model books listed in R. W. Scheller's survey.[1] The draftsman has most likely recorded here details of a scheme of church decoration, not necessarily his own work, for possible future use. The figure of Saint Christopher was of course very common in decorative programs both inside and outside medieval churches.[2] It was often painted on a gigantic scale near the entrance to a church, as at Augsburg Cathedral, a position that reflected the saint's status as the patron of travelers and the protector against sudden death.[3]

Scholars have reacted variously to this sheet, which is not unusual in considerations of late medieval drawings. As no other known drawings appear to relate directly to the present drawing stylistically, affinities must be sought in works in other media. Otto Pächt, Gerhard Schmidt, and Ulrike Jenni, all of whom have made a close study of illuminated manuscripts, have seen in this drawing the influence of English and French draftsmen of the second quarter of the fourteenth century.[4] The figures of Saint Christopher have been compared to illuminations by the so-called Majesty Master, the artist responsible for the second part of the Psalter of Robert de Lisle.[5] According to an inscription in de Lisle's hand, he gave the psalter to two daughters who were nuns in the Gilbertine priory of Chicksands in Bedfordshire in 1339, from which one may conclude that the illuminations were executed before that date. Certainly the draperies in the Woodner drawing have much in common with those in the psalter, but such details had a wide currency across Europe north of the Alps. All the same, specific details referred to in the Woodner collection catalogues—the "sharp profile and squarish head" of the saint on the left, for instance—have a stronger link with the first hand in the psalter, the so-called Madonna Master. One should look in particular at the king on the right of folio 127r for an excellent comparison. Yet the head of the other Saint Christopher on the sheet is more akin to some of those done by the Majesty Master. See the head of Christ in the *Coronation of the Virgin* on folio 134v (fig. 1). One must bear in mind, of course, that the draftsman of the model book could well have been recording in these two figures the work of different artists.

The Woodner drawing seems to lack the suavity of either hand responsible for the de Lisle psalter, or of other English works with which one might associate it, such as the painting of c. 1300 on the sedilia in Westminster Abbey. Rather, the technique of pen and black wash was characteristic of drawings from central Europe in the fourteenth century, especially Bohemia and Austria. Konrad Oberhuber originally drew attention to this in Woodner catalogues. He noted the technical and stylistic similarities to Bohemian drawings of the first half of the century, citing the *Passionale Abbatissae Cunecundis* of c. 1320 as an example, though the best of its drawings are far superior in execution and emotional content to the present work.[6] He saw the aedicule as an example of the Giottesque elements that spread north into Czech and Austrian art of the time. If this were so, the design of the structure has been much simplified in comparison with any Italian precursors and was most likely copied from a Giottesque painting made in central Europe. Of surviving Czech wall paintings, only one cycle of paintings includes architectural features and borders similar in character to those of this aedicule: depictions of the Apostles on

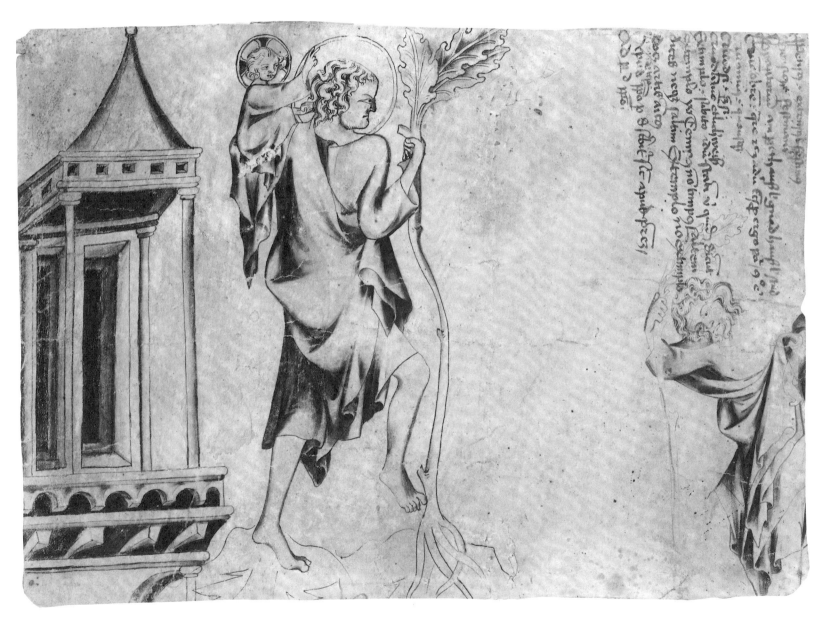

1

**FIGURE 1**

Majesty Master, *The Coronation
of the Virgin,* folio 134v from
the Psalter of Robert de Lisle,
British Library, London

the nave walls in the church of Saint John
the Baptist at Jinovichouv Hradec (c. 1350).[7]

Oberhuber's most telling comparison
is with the series of scenes (fig. 2) painted
directly on the wooden reverse of the enamel
altarpiece by Nikolaus von Verdun (1181) fol-
lowing its reinstatement in 1331 after the fire
at Klosterneuberg, which is now thought
to have been in 1330.[8] There is a general simi-
larity between many of the figures in the
paintings and the left-hand Saint Christopher,
especially the undefined relation of the
limbs to the bodies concealed in voluminous
draperies. The most striking kinship is to
be found in the stern countenances and sur-
prised expressions of the Apostles in the
*Death of the Virgin.* The identity of the artist
responsible for these paintings is unknown,
but he was unquestionably the leading mas-
ter of his day in that part of Europe, and as
he was strongly influenced by Tuscan art
of the period, it is possible that he traveled
there at some stage of his career. He must
have been the first important panel painter
to transmit this Italian influence to Austria
and the surrounding regions.

The right-hand Saint Christopher in
the Woodner drawing, with his bending at-
titude, seems to have been copied from a
carved figure, perhaps like those on either
side of the southern doorway to the choir of
the Cathedral at Freiburg-im-Breisgau.[9] On
the left of the doorway is a statue of Saint
Christopher carrying an affectionate Christ
Child and striding through the flood; by his
gently swaying stance, he draws attention to
the standing figure of the Virgin holding a

similarly affectionate Child on the right of
the doorway. Although slightly later in date
than other works with which the Woodner
sheet has been compared—that is, c. 1360—
the Freiburg statues suggest the possible
nature of the source of the right-hand Saint
Christopher. There were strong artistic links
between south Bohemia and eastern Austria
and the Upper Rhineland, but perhaps an
appropriate example closer to Klosterneu-
berg will be discovered before long.

The inscription on the recto in a late
medieval hand is part of a glossary in Latin,
with meanings given in a south German
dialect, which indicates that at an early stage
it was in the possession of someone from
Bavaria, Austria, or Bohemia. The studies of
flowers on the verso (fig. 3) are too slight
for any useful comment. • *John Rowlands* •

### NOTES

1. Scheller 1963.

2. Anderson 1951, 144–145, gives 186 examples of medieval paintings of Saint Christopher surviving in British churches.

3. In the later middle ages superstitious people believed that if they saw Saint Christopher's image they would not die on that day. Erasmus derided this notion, along with other fictions fostered by the mendicant orders. See Erasmus 1971 ed., 125–126.

4. These united opinions are recorded in successive Woodner exh. cats. from 1986 onward.

5. British Library, Arundel 83.II; see Sandler 1986, 2:43–45, no. 38.

6. University Library, Prague, XIV.A.17; see Drobná 1956, 24–27; Urbánková and Stejskal 1977.

7. Dvořáková et al. 1964, 133, pls. 49, 50.

8. The fire was earlier thought to have been in 1332, following the Kleine Klosterneuberger Chronik. See Pächt 1929, 5–7, pls. 1–3; exh. cat. Vienna 1979, 443–446, no. 239a–d; Prokopp 1983, 31–33.

9. See exh. cat. Cologne 1978, 1:300–302.

### PROVENANCE

(Hans M. Calmann, London); Woodner Collections (Shipley Corporation).

### EXHIBITIONS

Woodner, Malibu 1983–1985, no. 37; Woodner, Munich and Vienna 1986, no. 40; Woodner, Madrid 1986–1987, no. 49; Woodner, London 1987, no. 38; Woodner, New York 1990, no. 48.

### LITERATURE

Oberhuber 1983, 78, 80 (repro.).

**FIGURE 2**
South German, c. 1330/1331, *Easter Morning,* reverse of altarpiece by Nikolaus von Verdun, Stiftsmuseum, Klosterneuberg

**FIGURE 3**
Verso of cat. 1

# 2 Studies of Kneeling Saint Francis and Other Figures

**c. 1390/1410, brown wash heightened with white on green prepared paper, cut, reassembled, and laid down, 409 x 248 (16 ⅛ x 9 ¾)**

**Inscribed on the volute at center left in pen and brown ink: *Giotto / fiorenti / no*; and by the same hand on the volute at center right in pen and brown ink: *mori l'anno / 1336, è sepol / to in Sta. / Maria / del fiore***

**Woodner Collections**

The drawing is pieced together from several fragments mounted on a larger sheet (432 x 270 mm) with ruled margins. The uppermost fragment, measuring 180 x 140 mm, is trimmed at the right along the silhouette of the kneeling Saint Francis, and a strip of brown paper is inserted beneath the cut profile to simulate the shaft of the Cross, which the saint emotionally embraces. A vertical cut or tear through the saint's left arm does not significantly interrupt the drawn surface, whereas four irregular horizontal tears along the left edge are more intrusive and suggest that this may have been the original left edge of the sheet when it was entire. The larger lower fragment, measuring 230 x 247 mm, has been cut and repaired several times, all the inserted repairs apparently cut from some other part of the same sheet. A vertical cut 65 mm from the left edge runs the full height of the fragment and may follow an old crease or fold in the original sheet. Two rectangular inserts complete the upper and lower corners of the left edge. A triangular insert at the

center of the top edge interrupts the profile of the central seated figure and inappropriately substitutes a fully frontal head and shoulders, possibly reprised from the right-hand figure. The folds of the figure's robes that continue in white across the bottom of this triangle are modern. An irregular, flame-shaped insert at the bottom center results in only minor discontinuities in the legibility of the two lower figures. The surface of the drawing is much abraded throughout but, with the exception of the repairs noted above, is largely unretouched. Eliding the transition from the larger lower fragment to the smaller upper fragment are two volutes with inscriptions, drawn in pen and ink on later paper and pasted to the mount.

The subject and attribution of the studies on this sheet have elicited a range of opinions over its distinguished history. Ascribed to Giotto by the unknown seventeenth- or eighteenth-century collector who cut it into its present fragmentary configuration and mounted it, it appeared under that name at the sale of the drawings of John Clerk, Lord Eldin, in Edinburgh in 1833. In more recent literature it has almost without exception been assigned to Giotto's chief pupil and closest follower, Taddeo Gaddi (c. 1300–1366), based in part on the similarity of its technique and the general resemblance of its form to a well-known drawing in the Louvre representing the *Presentation in the Temple* (inv. 1222), widely attributed to Gaddi and related to his fresco of the same subject in the Baroncelli

Chapel, Santa Croce, Florence. This attribution seemed to find confirmation in the close relationship between the pose of the kneeling Saint Francis portrayed twice on the Woodner sheet—once filling nearly the entire upper fragment, and again on a slightly smaller scale at the bottom left of the lower fragment—and the same figure embracing the foot of the Cross in Taddeo Gaddi's fresco of the *Lignum Vitae* in the refectory of Santa Croce (fig. 1). Even Degenhart and Schmitt, who preferred a generic classification of the Woodner sheet as Florentine, c. 1340, acknowledged the relationship between the drawing and the fresco and adduced the latter as evidence for dating the former.

Several considerations militate against an attribution for the Woodner sheet to Taddeo Gaddi, however, or even to an artist of his generation or immediate following. The pose of the kneeling Saint Francis corresponds only approximately to that in the Santa Croce fresco, where the saint is turned more decidedly back into depth, while the handling of the profile and draperies in the drawing is markedly more linear than the solid volumes and prismatic facets typical of Gaddi's figures. A comparison of the technique of the drawing to that of the Louvre *Presentation in the Temple,* correctly recognized as not being autograph but probably originating in Gaddi's workshop or among his close following,[1] or to that of a drawing of the *Martyrdom of Saint Minias* in the Pierpont Morgan Library (fig. 2), probably produced in the following genera-

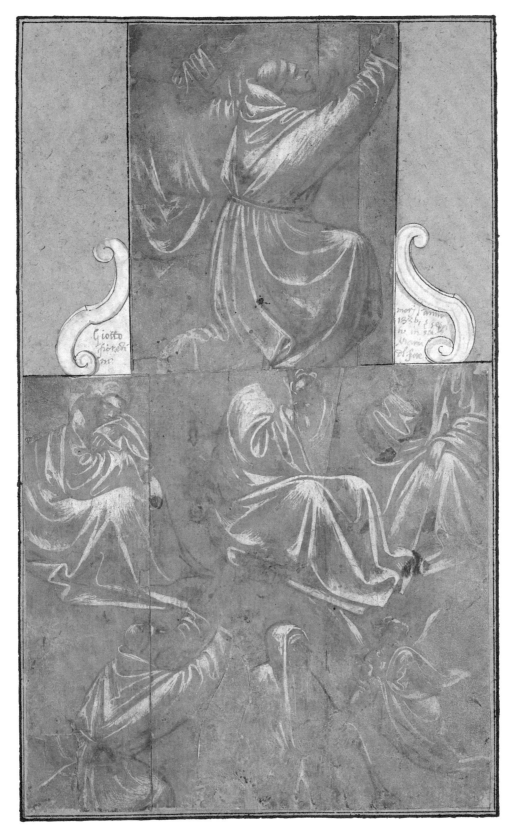

2

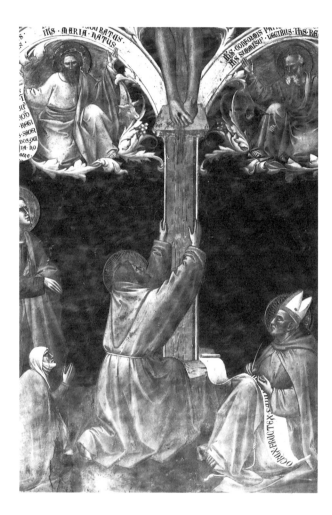

**FIGURE 1**

Taddeo Gaddi, *Lignum Vitae* (detail),
Museo dell'Opera, Refectory of Santa
Croce, Florence

tion but recently attributed to Taddeo Gaddi himself,[2] reveals a wholly different conception of line and use of white for modeling. The artist of the Woodner sheet employs broadly cursive, looping strokes and swirls, almost coarsely delineating form and randomly deploying highlights and shadows, in contrast to Taddeo Gaddi's (and his imitators') sharply characterized outlines and precise, refined hatching with white highlights. These three drawings are superficially related in their use of nearly identical media and in being among the few drawings of their type to survive from the fourteenth century but are otherwise irreconcilable in their graphic intentions.

Though it may be assumed that the kneeling figure at the top of the Woodner sheet is indeed meant to represent Francis embracing the foot of the Cross, the subject is not rare in fourteenth-century painting: Taddeo Gaddi's fresco may be the best-known example, but it is not even certainly the prototype for numerous other versions.[3] Furthermore, the imperfectly legible study behind Saint Francis in the upper fragment of the Woodner sheet is only in part a reprise of the draperies of the same figure. Directly behind Saint Francis' head and cowl appears the habit of another Franciscan with raised arm, resting his head in his hand as though sleeping. Unlike the three seated figures disposed across the top of the lower fragment, clearly meant to represent the sleeping Apostles from an Agony in the Garden, this figure wears a habit and cowl, not a robe, and was undoubtedly intended

to represent one of the sleeping companions of Francis in a scene of the Stigmatization of the Saint or a Vision of the Fiery Chariot. The two figures at the bottom right of the lower fragment, a seated Virgin looking upward and a flying angel with hands clasped that glances over its left shoulder, derive from an image of the Crucifixion. The implication that this sheet was either conceived as preparatory to an extensive cycle of Franciscan and Passion imagery, or copied from such a cycle, finds no point of reference in the surviving works of Taddeo Gaddi or of any other Florentine artist of the first half of the fourteenth century.

The iconography of the Virgin seated on the ground in an image of the Crucifixion is rare in Florentine painting before the early years of the fifteenth century. Also, the unusual canon of proportions of the figures on the Woodner sheet—with small heads and hands relative to the extreme elongation of the bodies; the stiff articulation of their poses, including the improbable angle at which Saint Francis' head is lifted, with his forehead parallel to the ground; and the broad rendering of the folds of their draperies—finds parallels primarily among Florentine artists at the end of the fourteenth and the beginning of the fifteenth centuries, specifically among artists in the following of Taddeo Gaddi's son, Agnolo Gaddi (d. 1396). The Woodner sheet, which relies heavily on the artistic vocabulary of Agnolo Gaddi without offering specific citations from his work, seems to have been

**FIGURE 2**

Florentine School, *Martyrdom of Saint Minias,* The Pierpont Morgan Library, New York

**NOTES**

1. Ladis 1982, 246.

2. Bellosi 1985, 12–18. An attribution for the Morgan sheet to the Orcagnesque master Cenni di Francesco di Ser Cenni (advanced in Boskovits 1968a, 278; and Boskovits 1975, 291) is likely to be correct.

3. Degenhart and Schmitt 1968, 1: pt. 1, p. 69, reproduces a copy of Gaddi's fresco from the late fourteenth century in the church of San Francesco, Pistoia. See also Neil 1988–1989, 83–110; and Krüger 1992.

4. See Boskovits 1968b, 21–31; and Boskovits 1968c, 3–13.

**PROVENANCE**

John Clerk, Lord Eldin, Scotland [1757–1832] (sale, Edinburgh, Winstaley and Sons, 14–29 March 1833, lot 225); Sir Archibald Campbell, Argyll, Scotland [1769–1848]; Sir Ilay Campbell (sale, London, Christie's, 26 March 1974, lot 54, as attributed to Gaddi); Woodner Collections (Shipley Corporation).

**EXHIBITIONS**

Glasgow 1953, no. 41; Los Angeles 1976, no. 2 (as attributed to Gaddi); Woodner, Malibu 1983–1985, no. 1 (here and subsequently as Gaddi or Circle of Gaddi); Woodner, Munich and Vienna 1986, no. 1; Woodner, Madrid 1986–1987, no. 1; Woodner, London 1987, no. 1; Woodner, New York 1990, no. 1.

**LITERATURE**

Degenhart and Schmitt 1968, 1: pt. 1, pp. 68–70, no. 25, pt. 3, pl. 50 (as Florentine, c. 1340); Ragghianti Collobi 1974, 2: fig. 15 (as Florentine, end of 14th century); Russell 1984, 279 (as Gaddi).

influenced as well by Agnolo's prolific contemporary, Spinello Aretino (c. 1346–1410). Among the known artists in the following of these two painters, Mariotto di Nardo (doc. 1394–1431), in his earliest career, offers the greatest number of productive comparisons to the author of the Woodner sheet, but none substantial enough to propose a confident attribution.[4]

Ragghianti Collobi's suggestion (1974) that the Woodner drawing once formed part of Giorgio Vasari's *Libro de' Disegni* is based exclusively on the presence of the inscribed volutes decorating the mount. These, however, bear no relationship to the architectural decoration supplied by Vasari to drawings with a demonstrable provenance from his collection. Though the elongated wormhole at the lower left of the Woodner sheet may be taken to imply that it once formed part of an album, the exceptional wear it has endured, the horizontal creases and tears along the left edge of the upper fragment, the cut fold in the lower fragment, and the repairs along all its edges suggest that it was preserved as a loose sheet for many years and may not have been bound into an album prior to being mounted in its present form, sometime probably in the seventeenth or eighteenth century. • *Laurence B. Kanter* •

# 3  Initial Q with a Procession of Children

c. 1430s, tempera and gold leaf on parchment,
224 x 218 (8 13/16 x 8 9/16)

**Woodner Collections**

Born to a wealthy Florentine
family, Strozzi apprenticed in
Fiesole with the illuminator
Battista di Biagio Sanguigni
(1393–1451). The two artists lived
together until Strozzi's marriage
in 1438 and remained closely
associated even after that date.
Active as both a panel painter
and an illuminator, Zanobi
Strozzi was perhaps the most pro-
lific and influential miniaturist
working in Florence in the sec-
ond third of the fifteenth century,
yet the precise outlines of his
artistic personality remain un-
clear and he is not infrequently
considered only as a follower
of Fra Angelico (c. 1400–1455).
Recently he has also been identi-
fied, correctly, as the painter
once known as the Master of the
Buckingham Palace Madonna.
Strozzi is buried in Santa Maria
Novella, Florence.

Within the frame of an initial letter *Q* fifteen children in robes of blue, yellow, green, red, purple, and gold march from left to right across a stony landscape backed by rocky cliffs and two trees. One of the children climbs a tree at the right, while most of the others hold placards with indecipherable texts. The initial is decorated with pink and blue acanthus foliation, enlivened with accents of orange, gold, green, and gray. Its spandrels are painted with a mosaic inlay pattern framed in blue moldings, and the surrounding gold ground is filled with a running frieze of stamped rosettes.

The initial *Q* begins the introit to the Mass for the first Sunday after Easter, known as Low Sunday or Quasimodo Sunday: "Quasi modo geniti infantes, alleluia: rationabiles, sine dolo lac concupiscite" (Like newborn infants, long for the pure, spiritual milk [1 Peter 2:2]). It was first identified by Mirella Levi D'Ancona in 1978 as part of the missing folio 31 from Cod. Cor. 3 at the Biblioteca Laurenziana, Florence, one of four volumes of the gradual *Diurno Domenicale* written for the Camaldolese monastery of Santa Maria degli Angeli in 1409.[1] Folio 30v concludes with a rubric introducing the communion hymn from the Mass for Saturday within the octave of Easter, while folio 32r begins with the psalm "Exultate deo adjutori nostro:

jubilate deo Jacob," which continues the introit for Low Sunday. In all likelihood, the Woodner initial *Q* appeared at the top of folio 31v, followed by two partial and three full lines of music and text. Of two other illuminations missing from Cor. 3, only one has thus far been successfully identified, an *Initial V with the Ascension of Christ* in the Bernard H. Breslauer collection, New York.[2]

Cor. 3 at the Biblioteca Laurenziana, one of the most sumptuous manuscripts painted in Italy in the first half of the fifteenth century, retains seventeen illuminated initials in addition to the three that have been removed. Painted by at least two and perhaps three or more artists, these have been the subject of a wide range of disputed attributions. Decoration of the manuscript was clearly begun by Lorenzo Monaco, who was responsible for eight half-length figures of prophets in initial letters, probably painted shortly after 1409, the date recorded in the manuscript's colophon.[3] As these initials are not clustered in a group of quires but are dispersed throughout the manuscript, it may be presumed that Lorenzo left several other initials incomplete as drawings, as he did in volumes 1 and 2 from the *Diurno Domenicale*.[4] A design by Lorenzo Monaco has frequently been recognized as underlying the scene of the Resurrection on folio 1v, the Ascension in the Breslauer collection, and the Pentecost on folio 80v, but the extent of his participation in the other eight known scenes is unclear. The author of these scenes was tentatively identified with the young

Fra Angelico by A. M. Ciaranfi and Mario Salmi, with an unknown follower of Fra Angelico (perhaps Battista di Biagio Sanguigni) by Roberto Longhi and the present writer, with Andrea di Giusto by Bernard Berenson, and with Zanobi Strozzi by Mirella Levi D'Ancona and Miklòs Boskovits.[5] More recently Levi D'Ancona has attempted to associate a document of payment to Niccolò Rosselli at Santa Maria degli Angeli in 1454 with work on this manuscript,[6] but her arguments for supporting this hypothesis on stylistic grounds are unconvincing.

The decoration of the initial letter in the Woodner cutting and the technique of its painted foliage (some of which has been scraped away where it passes beyond the confines of the gilded block of the letter) are typical of Lorenzo Monaco's studio in the second decade of the fifteenth century, and it is reasonable to assume that the illumination was planned and partially executed under Lorenzo's supervision. It is difficult to see any influence of Lorenzo's style on the painted scene in the center of the initial, however, and if any drawing by the Camaldolese master underlay that image, it must have been ignored or obliterated by the artist who completed the illumination. None of the pigments used in painting the initial corresponds exactly to those used in the central scene, nor does the initial or its foliate decoration overlap the scene at any point, so there is no reason to regard the latter as anything but a fully independent creation of a later artist.

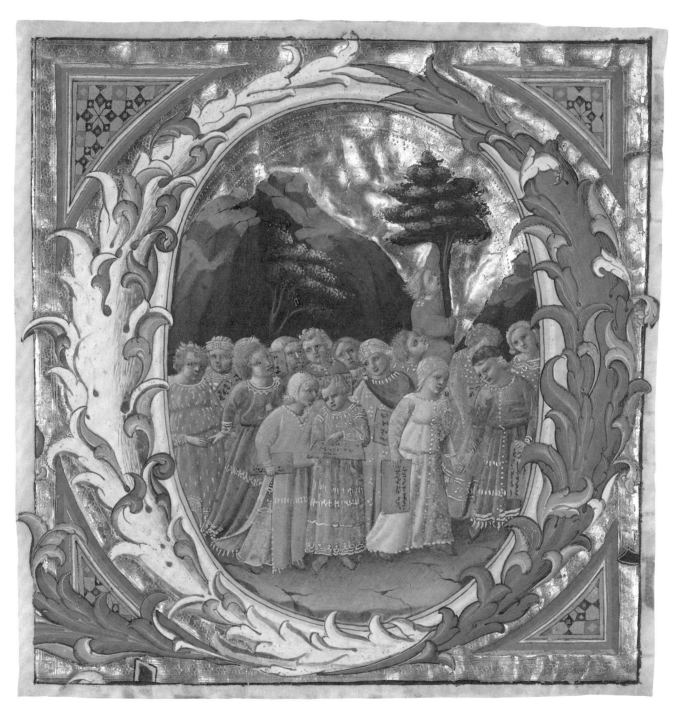

3

The attribution of this scene to Zanobi Strozzi by Boskovits and Levi D'Ancona was based on its resemblance to the early work of Fra Angelico, to whom many of the illuminations in Cod. Cor. 3 as well as the Breslauer and Woodner fragments have been directly ascribed in the past. Zanobi Strozzi's character as an artist, however, remains poorly understood beyond the general recognition of his debt to Fra Angelico, and this impression of him is entirely based upon his mature production, that is, subsequent to the illuminations of 1445 in two psalters painted for Florence Cathedral (Museo dell'Opera del Duomo, Cod. N, inv. 3; and Cod. D, inv. 4), Strozzi's earliest documented works. At that stage of his career, Strozzi evinces none of the influence of Lorenzo Monaco so apparent throughout the illuminations in Cod. Cor. 3, and none of these illuminations can be attributed to any other artist at such a late date.

The first decade and a half of Zanobi Strozzi's career was passed in close association with the little-known illuminator Battista di Biagio Sanguigni, whose work from this period has yet to be clearly defined. An earlier proposal to assign the illuminations in Cod. Cor. 3 directly to Sanguigni recognized among them not only the influence of Lorenzo Monaco and their necessarily precocious date but also their strong dependence on the illuminations in an antiphonary painted in 1432 for the monastery of San Gaggio, now in the Corsini collection, Florence, Sanguigni's only documented works.[7] It is now clear, however,

that notwithstanding their evident stylistic dependence on Sanguigni, most of the illuminations in Cod. Cor. 3 conform in morphological and technical detail to paintings by Strozzi, including many produced after Sanguigni's death in 1451, and that though they may have been conceived as a collaboration between the two artists during the period of their association, their execution can only be ascribed to Zanobi Strozzi. The suggestion that a debt registered to Sanguigni from the monastery of Santa Maria degli Angeli in 1431 may relate to his involvement on the illuminations in Cod. Cor. 3 is indeed plausible[8] and may imply that Zanobi Strozzi's work on these initials within Sanguigni's studio represents his earliest known activity as an illuminator and the key to identifying further paintings from this otherwise unknown period of his career. • *Laurence B. Kanter* •

**NOTES**

1. Cor. 3, containing texts for the Mass from Easter through the octave of Pentecost, is inscribed on folio 1r, "Incipit iii.a pars diurni dominicalis Monasterij Sancte Marie de Angelis," and in a colophon on folio 3r, "Anno Domini M.CCCC.IX completum est hoc opus," referring to completion of the text, music, and pen work initials only.

2. Eisenberg 1989, 110; Voelkle and Wieck 1992, 194; exh. cat. New York 1994–1995, 283–287. The missing folio 19 was misidentified in Levi D'Ancona 1978, 225, and in Levi D'Ancona 1994, 92, as a stylistically unrelated *Initial I with Christ Blessing* in the Fitzwilliam Museum, Cambridge. Folio 19 contained the introit to the Mass for Thursday within the octave of Easter, beginning "Victricem manum tuam, Domine," and the missing illumination therefore included an initial *V*, not an *I*.

3. Lorenzo Monaco's illuminations appear on folios

35r, 38v, 46v, 65v, 86v, 89v, 93r, and 96v. These have been dated about or shortly after 1409 in Ciaranfi 1932, 302; Boskovits 1975, 341–342; and Kanter in exh. cat. New York 1994–1995, 283–284. Eisenberg 1989, 110, assigned them to two different campaigns, c. 1410 and c. 1414, while Levi D'Ancona 1958, 180, dated them to the end of the artist's career, c. 1422–1423.

4. See Kanter in exh. cat. New York 1994–1995, 272–283.

5. See Pope-Hennessy 1974, 223–224; and exh. cat. New York 1994–1995, 286, for a review of the attributional history and bibliography of these illuminations.

6. Levi D'Ancona 1994, 65–69.

7. Kanter in exh. cat. New York 1994–1995, 287 n. 3. See also Levi D'Ancona 1962, 54–58, 261–268, where, however, the documented contribution of Zanobi Strozzi to this manuscript in 1447 is misidentified.

8. Kanter in exh. cat. New York 1994–1995, 287.

**PROVENANCE**

Samuel Woodburn, London [1786–1853] (sale, London, Christie's, 25 May 1854, lot 982); H. G. Bohn (sale, London, Christie's, 23 March 1885, lot 535); Sir Herbert Jekyll (sale, London, Sotheby's, 7 September 1973, lot 14); Woodner Collections (Shipley Corporation).

**EXHIBITIONS**

Woodner, Malibu 1983–1985, no. 2; Woodner, Munich and Vienna 1986, no. 2 (as Fra Angelico or workshop); Woodner, Madrid 1986–1987, no. 3 (here and subsequently as Fra Angelico[?]); Woodner, London 1987, no. 2; Woodner, New York 1990, no. 3 (not exhibited).

**LITERATURE**

Levi D'Ancona 1978, 226; Garzelli 1985, 1:17, and 2:29; Eisenberg 1989, 110; Voelkle and Wieck 1992, 194; exh. cat. New York 1994–1995, 283–284 (as Battista di Biagio Sanguigni); Levi D'Ancona 1994, 67–68, 71.

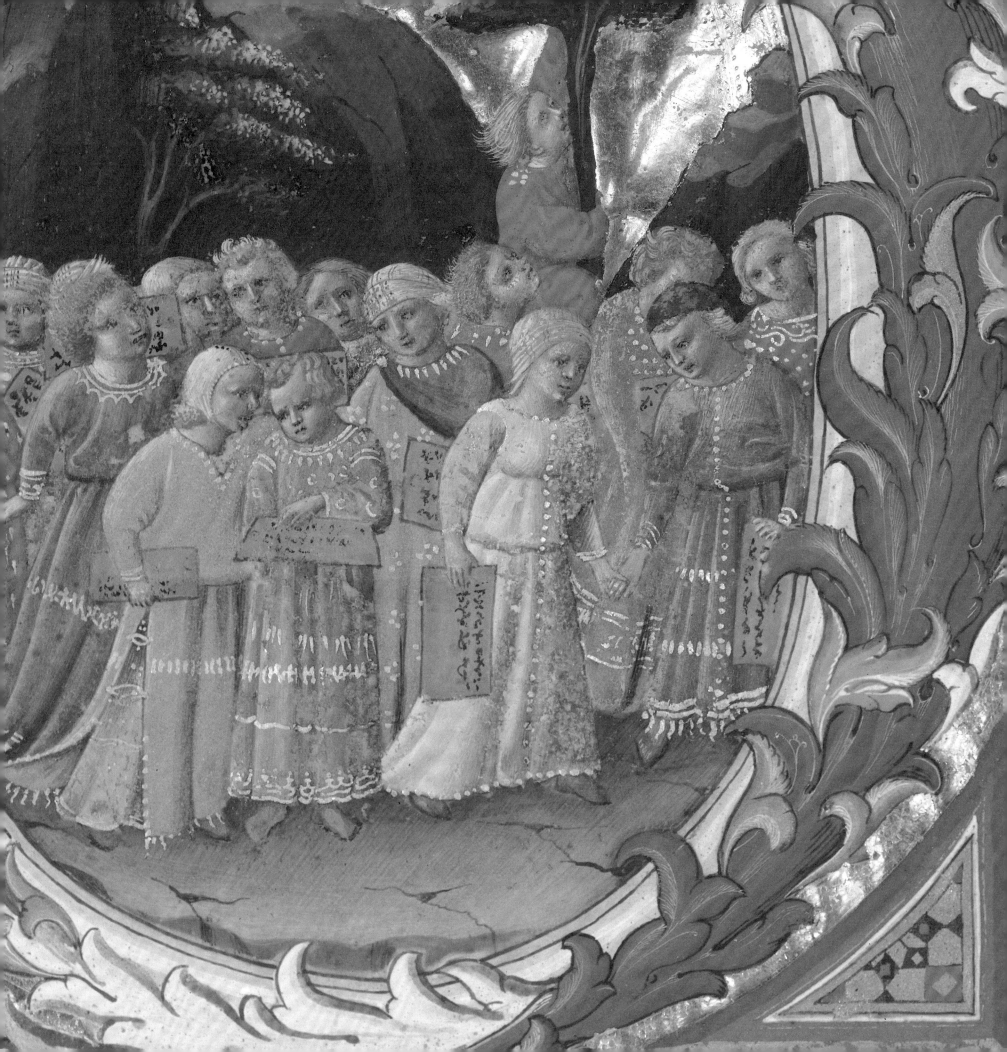

# 4  Page from the Cockerell Chronicle

*Thought to have been born in the eastern Netherlands and perhaps a relative of Jan and Hubert van Eyck, Barthélemy was both a painter and an illuminator. Though only documented at the court of René I in Provence between 1447 and 1470 (records for one fifteen-year period therein are lost), there is good reason to believe he was already in René's service in Naples by 1438/1440. He may have been one of the artists responsible for introducing both the distinctive Netherlandish style and the new oil painting technique to Neapolitan painters at that time. His most important painting is the altarpiece of the* Annunciation *in Aix-en-Provence. Several manuscripts are also accepted as his work, foremost among them the* Coeur d'Amour épris *(Vienna).*

**c. 1442, pen and brown ink with watercolor, heightened with white, on vellum, 314 x 201 (12 3/8 x 7 15/16)**

**Inscribed in pen and brown ink with identifications of the figures in Latin, repeated in French in a 16th-century hand**

**Woodner Collections**

Once consisting of at least thirty-four pages depicting more than three hundred personages of ancient, biblical, and medieval history, the Cockerell Chronicle is known now through only nine of its original pages, including this one in the Woodner collection.[1] Named for Sir Sydney Cockerell who once owned eight of the pages, this manuscript was copied from another known as the Crespi Chronicle, which was executed and signed by the painter and miniaturist Leonardo da Besozzo (fl. 1421–1488) in the 1430s (Crespi Collection, Milan). Besozzo's figures, in turn, had been copied after a series of frescoes painted between 1430 and 1432 by Masolino (c. 1383/1384–1447?) in the Roman palace of Cardinal Giordano Orsini (destroyed c. 1485).[2] The Woodner page corresponds to folio 8v of the Crespi Chronicle. While the artist of the Cockerell Chronicle remained faithful to the organization of the figures on the individual pages of the Crespi manuscript and maintained their same general poses, he did make changes to the draperies and some details of pose.

The Woodner page represents seven figures from the sixth century BC. The two figures in the top row are Brutus Lucius Junius, a founder of the Roman Republic and consul in 509 BC, and Peisistratus (d. 527 BC), a "tyrant" (ruler) of ancient Athens. Next, Cambyses, an Achaemenid king of Persia (r. 529–522 BC), stands before the city of Babylon, which, according to the legend below it ("babilonia d'Egipto condidit"), he saved from Egypt (Cambyses conquered Egypt in 525 BC). He is paired with the apocryphal Hebrew heroine Judith, who carries the severed head of Holofernes, a Babylonian general. They are followed by the Greek philosopher and mathematician Pythagoras (580–500 BC); Cambyses' successor to the Persian throne, Darius the Great (r. 522–486 BC); and the Old Testament prophet Haggai, who was one of the first Jews to be repatriated from the Babylonian exile in about 537 BC.[3]

Illustrated chronicles such as the Cockerell manuscript—often referred to as "Uomini Famosi," or Famous Men, because of their emphasis on historical personages—were based on such works as the *Chronicon* by Eusebius of Caesarea (c. 260–340), the *Chronica majora* by Saint Isidore of Seville (c. 560–636), and *De viris illustribus* by Petrarch (1304–1374). In such chronicles, important men and women, whether biblical, historical, or legendary, were considered in quasi-chronological sequence from the creation of Adam. The years were counted consecutively from the beginning of the world (instead of forward and backward from Christ's birth) and were divided into six ages or periods.[4]

The Crespi and Cockerell Chronicles follow the division established by Eusebius, Saint Augustine, Bede, and others, in which the dividing point between the fourth and fifth ages was the Babylonian Captivity. In both the Crespi and the Cockerell Chronicles the end of the fourth age falls specifically after Peisistratus and the fifth begins with Cambyses. And indeed, in the smudged area to the right of Peisistratus in the Woodner drawing, almost unreadable, is written *Finitur quarta etas* (Here ends the fourth age). Like the Crespi Chronicle, the Cockerell Chronicle presumably continued on to 1400, ending with the Turko-Mongol conqueror, Tamerlane (c. 1336–1405).

The attribution of the Cockerell Chronicle pages has been the subject of considerable discussion and conjecture over the years. In the Fairfax Murray sale of 1919 the drawings were described as "apparently of Italian execution and dated to c. 1500," and in 1938 Bernard Berenson listed them under the school of Fra Angelico.[5] In 1952, however, Ilaria Toesca noted that the spellings of some of the Latin inscriptions suggested a French origin and considered that the artist might have been the young Jean Fouquet, who was in Rome in 1446/1447.[6] After garnering considerable support for that idea in the following years, Toesca revised her opinion in 1970 and suggested a connection with someone in the entourage of René I, the Angevin king of Naples and Sicily, who was in Naples from 1438 to 1442.[7] The name of Barthélemy van Eyck, a painter at René's court, was first attached

FIGURE 1

Barthélemy van Eyck, *The Annunciation,* Church of the Madeleine, Aix-en-Provence

to a page from the Cockerell Chronicle in 1986 by Fiorella Sricchia Santoro.[8] That attribution was explored further by Nicole Reynaud in 1989, who pointed out distinct stylistic similarities between the Cockerell Chronicle pages and paintings and miniatures identified in the 1970s as the work of Barthélemy van Eyck.[9] In particular, she noted that the draperies of the figures in his *Annunciation* altarpiece in Aix-en-Provence (fig. 1), in its wing panels in Brussels and Rotterdam, and in manuscript illuminations in a Book of Hours in the Pierpont Morgan Library (fig. 2) were constructed with a similar combination of long tubular vertical folds, smooth curving loops of draped materials, and intricate, angular folds that suggest the influence of Conrad Witz.[10] From the Woodner page, in particular, she compared the figure of Judith to the *Virgin and Child in a Garden* from the Morgan Library's Book of Hours and to some of the *drôleries* (humorous figures) contained in the margins.[11] She also noted technical similarities between the execution of the Cockerell Chronicle and other miniatures by Van Eyck, especially in the use of reserved areas of untouched vellum to serve as white highlights and in the tiny, closely spaced touches of the brush with which he shaped his forms.[12]

Reynaud proposed, moreover, a clever and plausible reason for René's interest in having a copy of the Crespi Chronicle: the figure at the upper right on the last page of the manuscript was none other than René's ancestor, Charles d'Anjou (1226–1285).[13]

Charles was the brother of Saint Louis (King Louis IX of France) and founder of the Angevin dynasty of the kings of Sicily. He was therefore the basis for René's claim to the throne of Naples and Sicily. At a time when René was in Naples, struggling to hold onto his kingdom, this historical support of his claim would have seemed a godsend. He was forced out of Naples in 1442 by Alphonso of Aragon, however, and retreated to Provence, perhaps taking the copy of the Crespi Chronicle with him.

The only weak link in the chain that connects Barthélemy van Eyck to the Cockerell Chronicle is the lack of direct evidence that he was actually with René in Naples. Leonardo da Besozzo was there; René was there; Barthélemy's stepfather, the embroiderer Pierre Dubillant, was there; Barthélemy was at René's court *after* Naples, in Aix-en-Provence. But was he also in Naples?

The circumstantial evidence is beginning to mount in favor of his presence there, but the proof is still somewhat circular. True, there is incontrovertible evidence in the paintings of Colantonio and his pupil Antonello da Messina that Northern artists were in Naples and brought with them the new techniques and styles of the Netherlandish school, Conrad Witz, and Jan and Hubert van Eyck.[14] Barthélemy's background and the particular characteristics of his style suggest that he could have been one of these northerners; the stylistic evidence of the pages of the Cockerell Chronicle makes it even more probable that he was indeed in Naples.

A faithful sixteenth-century copy of twenty-five pages of the Cockerell Chronicle is in the Bibliothèque nationale, Paris (Lat. 9673), of which folio 16 corresponds to the Woodner page. • *Margaret Morgan Grasselli* •

## NOTES

1. Other pages from this chronicle are in the collections of the Metropolitan Museum of Art, New York (2 folios); National Gallery of Canada, Ottawa; Rijksmuseum, Amsterdam; National Gallery of Victoria, Melbourne, Australia. A folio in the Kupferstichkabinett, Berlin, had been separated from the others before Cockerell bought them. For reproductions of all these drawings see Reynaud 1989, 22–43.

2. Although the connection with the Crespi Chronicle had already been recognized, R. W. Scheller was the first to prove that the Cockerell Chronicle folios were adapted from the Crespi Chronicle rather than copied directly from the Masolino frescoes; see Scheller 1962, 56–67.

3. Brockhaus 1885, 52–58, described all the figures in the Crespi Chronicle, and his readings of the inscriptions in that manuscript help in deciphering the inscriptions on the Woodner folio.

4. The years scrawled after the identification of Babylon and under Pythagoras and Darius are 3410, 3442, and 3442, all referring to the number of years since the world began; see Brockhaus 1885, 55.

5. Berenson 1938, 2:17, no. 164c: "By a finer artist than Domenico di Mechelino or Strozzi, and more delicate than Benozzo and on a level with Pesellino, whom these miniatures most resemble, although almost certainly not by him. There are reminders as well of Domenico Veneziano."

6. Toesca 1952, 16–20.

7. Toesca 1970, 64–65.

8. See Sricchia Santoro 1986b, 83, fig. 5.

9. Reynaud 1989, 25–32.

10. For the specific comparisons, see Reynaud 1989, 27–31.

11. Reynaud 1989, 29.

12. Reynaud 1989, 29; Avril and Reynaud 1993, 225.

13. Reynaud 1989, 27.

14. See Sricchia Santoro 1986a, 28–34; exh. cat. Paris 1993a, 28–38.

## PROVENANCE

Presumably, because of the French inscriptions, in an early 16th-century French collection; (Bernard Quaritch Ltd., London); sold to William Morris, Kelmscott House, 20 December 1894; Charles Fairfax Murray, 1895 (sale, London, Sotheby's, 18 July 1919, lot 50); purchased by Bernard Quaritch Ltd., London, for Sir Sydney Cockerell (sale, London, Sotheby's, 2 July 1958, lot 22); Rudolf Drey (sale, London, Sotheby's, 4 July 1977, lot 152); Woodner Collections (Shipley Corporation).

## EXHIBITIONS

London 1896; Northampton 1978, no. 101 (as Florentine School); Woodner, Malibu 1983–1985, no. 3 (as Florentine School); Woodner, Munich and Vienna 1986, no. 73 (here and subsequently as Italian or French [Jean Fouquet?]); Woodner, Madrid 1986–1987, no. 86; Woodner, London 1987, no. 72; Woodner, New York 1990, no. 89.

## LITERATURE

(On the Cockerell Chronicle in general) Berenson 1938, 2: no. 164c; Toesca 1952, 16–20; Longhi 1952, 56–57; Saxl and Meier 1953, 1:279–280; Grassi 1956, 86; exh. cat. Milan 1958, under no. 202; Van Regteren Altena 1959, 82–83; Berenson 1961, no. 164c; Scheller 1962, 56–57, 60, 62, 66 n. 4; exh. cat. New York 1962, under no. 1; Popham and Fenwick 1965, under no. 1; Simpson 1966, 137 n. 10; Laclotte 1967, 35; exh. cat. London 1969, under no. 1 (same text in Italian in exh. cat. Florence 1969, under no. 1); Toesca 1970, 62–66; Mode 1972, 370; Bologna 1977, 64–69, 73–75; Degenhart and Schmitt 1980, 2: pt. 2, pp. 381, 382 n. 9, under no. 714; Lombardi 1983, 71, 79, 81; Sricchia Santoro 1986a, 31; Sricchia Santoro 1986b, 83; exh. cat. Milan 1988, 216–219; Reynaud 1989, 29, 31, fig. 30 (detail of Judith from the Woodner folio); exh. cat. Paris 1993a, 31–32; Avril and Reynaud 1993, 225–226, under no. 121; Joannides 1993, 453, pl. 153 (Woodner folio).

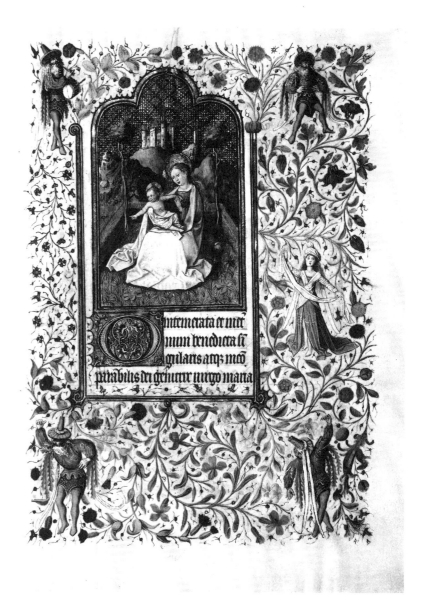

**FIGURE 2**

Barthélemy van Eyck, *Virgin and Child in a Garden,* folio 25 from a Book of Hours, The Pierpont Morgan Library, New York

# 5  Portrait of a Boy in Profile

*Giovanni Badile was one of a large family of painters spanning eight generations from the fourteenth to the early eighteenth century. He probably trained with his father, Antonio, and was influenced by the work of Stefano da Verona (1374–1451). He appears to have worked almost exclusively in his native Verona, where his most important works were a series of frescoes in the church of Santa Maria della Scala and a seven-part polyptych made for the church of San Pietro Martire (now in the Verona Castelvecchio). The polyptych bears a possible signature,* iohes baili, *which is not universally regarded as authentic. Three of his sons also became painters.*

**c. 1448, brush and pen and brown ink over leadpoint on prepared laid paper, laid down, 208 x 153 (8 ⅛ x 6)**

**Inscribed by Antonio Badile II at upper center in pen and brown ink: *2 / joane badille qual fu prete***

**Woodner Collections**

Three points concerning this drawing are beyond doubt. The first is that it is beautiful. The second and third concern the inscription and the provenance, both of which have a bearing on the attribution. The drawing is known to have come from the so-called Moscardo Album,[1] a small sixteenth-century album, which, although the drawings in it were dispersed on the London art market in the 1950s, is preserved in the Lugt Collection (Institut néerlandais, Paris). This is crucial, for the inscription still on the cover of the album indicates, as James Byam Shaw recognized,[2] that the album was put together by Antonio Badile II (1424–1507/1512), son of Giovanni, and a member of one of the most celebrated families of artists in Verona. Such a provenance is indispensable for an understanding of what the inscription on the drawing reveals.

First, there is no reason to question the authenticity of either the drawing or the inscription.[3] The quality of the drawing is manifest, while the inscription is not only entirely acceptable as being of the fifteenth century but is also certainly by the same hand as the inscriptions on other drawings from the Moscardo Album.[4] Important too is the fact that many of the attributions given in these inscriptions have been vindicated by recent scholarship.

Second, the inscription clearly reads *2 / joane badille qual fu prete* (2 / Giovanni Badile who was a priest). The Badile family tree has been worked out in detail and bears several members named Giovanni.[5] Only two are relevant here. One was a priest, and it might be tempting to attribute the Woodner drawing to him in view of the inscription. But he was born in 1449 and died in 1514, whereas the lettering on the cover of the Moscardo Album dates it to 1500, and the inscription on the drawing indicates that the artist was dead by then ("fu prete"). Even more cogent is the stylistic argument that makes it hard to assign the Woodner drawing to an artist born as late as 1449. Another possibility gains credence from a second drawing from the Moscardo Album with an inscription that attributes it to a Giovanni Badile.[6] This is the *Bust of a Young Man in Profile* now in the Art Institute of Chicago (fig. 1), which is not only of high quality, like the Woodner drawing, but is, I believe, by the same hand. It is inscribed *2 / joane badille prete* in the same script appearing on so many of the Moscardo drawings.

Harold Joachim and Suzanne Folds McCullagh, cataloguing the Italian drawings at Chicago, assumed that "prete" referred to the sitter.[7] This is possible, but it certainly does not apply to the boy in the Woodner drawing. And in fact most inscriptions in the Moscardo Album are attributions and do not relate to the subjects of the drawings. I am therefore inclined to agree with Konrad Oberhuber's dissent from the assumption in the Chicago catalogue.[8]

Antonio Badile II could possibly have been in error when he inscribed the Woodner drawing *fu prete*. I think this was probably the case. The crucial point is that the parallels between this drawing and paintings by Antonio's father, Giovanni Badile,[9] are so close that I believe we may attribute the drawing to him. His key work is the *Polittico dell'Aquila (The Eagle Polyptych)* in the Castelvecchio, Verona, which is signed *iohes baili*.[10] The donor appearing in the central panel of the altarpiece (fig. 2) is strikingly similar to the boy in the Woodner drawing. Both heads—and it is true of others in the polyptych and of the Chicago drawing—display the same delicate sensitivity and psychological penetration. There are also parallels in the rendering of the eyes, mouth, and neck.[11]

The Woodner drawing may be dated to c. 1448, while the shorter hair in the Chicago drawing suggests a slightly earlier date c. 1430–1440. Both drawings bear witness to the flowering of draftsmanship that found its purest expression in Pisanello.
• *Terence Mullaly* •

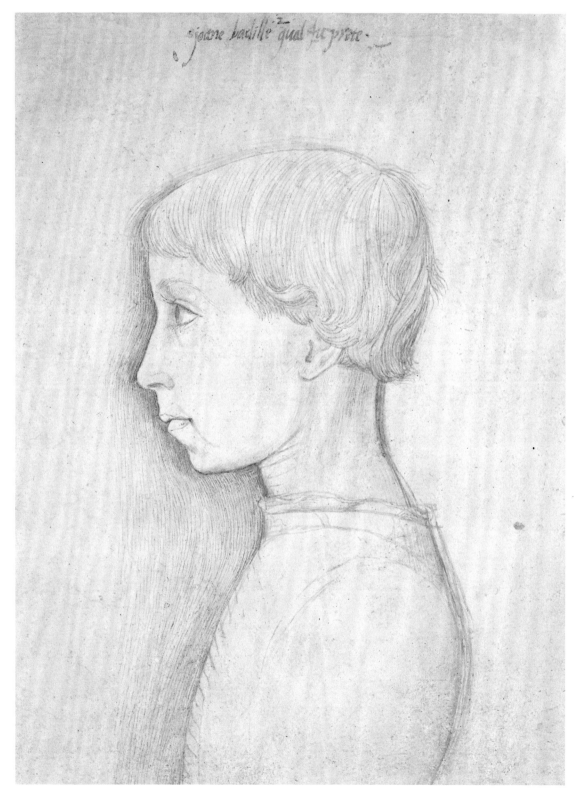

5

## NOTES

1. The provenance from the Moscardo Album was recorded when the drawing was sold by Christie's, London, 6 July 1982, lot 20.

2. The definitive treatment of this album is in Byam Shaw 1983, 1:214 n. 1.

3. Goldner in Woodner exh. cat., Malibu 1983–1985, no. 4, refers to such doubts.

4. Today they are widely scattered in public and private collections.

5. Cavazzocca Mazzanti 1912, 11–28, 65–84.

6. Comparisons with other drawings from the Moscardo Album bearing the name Giovanni Badile are not relevant, for they are in different techniques and are not portraits.

7. Joachim and McCullagh 1979, no. 1.

8. Quoted by Goldner in Woodner exh. cat., Malibu 1983–1985, no. 4, n. 3.

9. The best treatment of the work of Giovanni Badile is Margherita Azzi Visentini's study in Brugnoli 1974, 75–82.

10. See Visentini in Brugnoli 1974, fig. 52. In the past doubts have been expressed concerning the authenticity of the signature, but Visentini is surely correct in discounting them.

11. Further interesting comparisons may be made with the donor in the fresco by Giovanni Badile in the Cappella Salerni of the Church of Sant' Anastasia in Verona (Gazzola and Cuppini 1970, fig. 60).

## PROVENANCE

Probably Antonio Badile II, Verona [1424–1507/1512]; Moscardo family, Verona (in the so-called Moscardo Album) (Lugt 2990b); album dispersed on the London art market in the 1950s; private collection (sale, London, Christie's, 6 July 1982, lot 20); Woodner Collections (Shipley Corporation).

## EXHIBITIONS

Woodner, Malibu 1983–1985, no. 4; Woodner, Munich and Vienna 1986, no. 4; Woodner, Madrid 1986–1987, no. 5; Woodner, London 1987, no. 3; Woodner, New York 1990, no. 4.

## LITERATURE

Byam Shaw 1983, 1:214 n. 1.

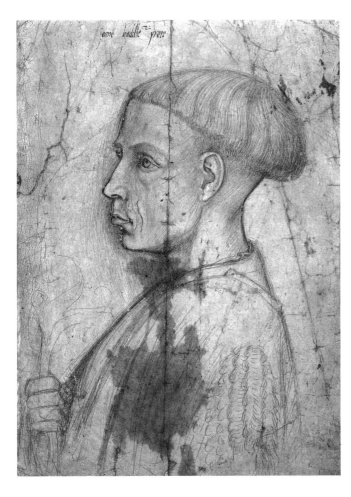

# 6 A Hound Chasing a Hare

*Gozzoli was apprenticed to
Fra Angelico (c. 1400–1455) in
his native Florence, where from
1444 to 1447 he collaborated
with Lorenzo Ghiberti (1378–
1455) on the second door of the
Baptistry. He then worked with
Fra Angelico in Orvieto and
Rome, and from 1450 to 1452
worked in the church of San
Fortunato e San Francesco in
Montefalco. Between 1454 and
1458 Gozzoli worked in Rome
and Lazio, before returning to
Florence in 1459 to execute his
most famous work, the decora-
tion of the chapel of the Palazzo
Medici-Riccardi. Four years in
Valdelsa and San Gimignano
(1463–1467) were followed by
sixteen in Pisa, during which
time he painted important fres-
coes there as well as in Castel-
nuovo and Castelfiorentino.*

**c. 1455/1459, pen and brown ink with traces of
red chalk, heightened with white on pink prepared
paper, 67 x 111 (2⁵⁄₈ x 4³⁄₈)**

**Inscribed at top center in purple-red ink:** *No: 2 =*
**(or** *Ao: 2 =***)**

**Woodner Collections**

This recently identified drawing, which was
unknown either to Bernard Berenson or to
Bernhard Degenhart and Annegrit Schmitt,
was correctly attributed to Benozzo Gozzoli
by Michael Miller,[1] who associated it with a
detail in the background of Gozzoli's fres-
coes of the *Retinue of the Magi* on the west
wall of the Cappella dei Magi at the Palazzo
Medici-Riccardi, Florence (fig. 1). Though
genre details drawn from scenes of the hunt,
especially two-figure groups of a predator
attacking or chasing another animal, are
not uncommon in quattrocento painting,
in this case the fresco and the drawing cor-
respond closely in most significant details,
and it is reasonable to conclude that one
was based upon the other. That the drawing
was in fact preparatory to the fresco and not
copied from it may be argued 1) from the
slight variations of pose, such as the turn of
the hare's head and the angle of its ears and
tail, from one to the other; 2) from the over-
sized prominence of the detail within the
fresco, implying that it was developed from
an independent, carefully finished study
such as this one; 3) from the correspon-
dence of the drawing's technique to that
apparent in a large group of drawings

reasonably attributed to Benozzo Gozzoli
but distinct from those of his known copy-
ists, imitators, and followers; and 4) from
the characterization of the animals' heads,
especially of their eyes, which is typical of
the benign, almost childish expressions used
by Gozzoli for all his figures—animal,
human, or divine—through the first half
of his career.

Among the drawings by Gozzoli most
closely related in technique to the Woodner
fragment, specifically in their use of white
highlighting for modeling effects similar to
those later achieved in chiaroscuro wood-
cuts, are two groups of sheets distinguished
from each other primarily by the color of
their prepared grounds, greenish brown in
one case and pink in the other, and by the
predominance of silverpoint in the former
and of ink and wash in the latter. For De-
genhart and Schmitt the first of these groups
corresponds roughly with Gozzoli's earliest
career, while he was working in Fra Angel-
ico's studio in Rome, Orvieto, and Perugia,
and during his first independent campaign
at Montefalco around 1450. These include
*Male Nude with a Lion* in Dresden (Kupfer-
stichkabinett, inv. c. 6v), *Bust of a Youth*
in the Royal Collection at Windsor Castle
(Royal Library, inv. 12811), a *Horse* in the
Uffizi, Florence (inv. 107 E verso), and a
large drawing, remarkable in its complexity
but poorly preserved, of *Totila Laying Siege
to Perugia* also in the Uffizi (inv. 333 E).[2]
The second group, among which are to be
found slightly stronger affinities to the
Woodner drawing, is associated by Degen-

hart and Schmitt with the period of Goz-
zoli's commission for the frescoes in the
Camposanto at Pisa in the late 1460s and
early 1470s and includes drawings in the
Louvre, Paris (Rothschild 772), and the
Uffizi (inv. 20 F, 28 F, 47 E).[3]

Closest of all to the Woodner drawing,
however, are two sheets in the Uffizi repre-
senting *Philemon and the Ass* (inv. 70 E) and
*Two Nudes with Two Sleeping Dogs in a
Landscape* (fig. 2). Both drawings, executed
in ink and wash with white heightening on
pink paper, had been attributed by Beren-
son to the Alunno di Benozzo and by De-
genhart and Schmitt to the following of
Benozzo Gozzoli.[4] They were correctly re-
stored to Gozzoli himself and plausibly
dated to the mid-1450s by Alessandro An-
gelini,[5] who saw in them a stylistic middle
term between Gozzoli's work at Monte-
falco (1450) and his frescoes in the Palazzo
Medici-Riccardi (1459–1460). The second
of these two drawings is particularly close
to the Woodner sheet in its handling and
use of landscape elements. Conceived as
cells of light and dark that isolate and em-
phasize the figures in the composition, the
facets of rock are rendered in quick parallel
hatches of white, which generally indicate
angles of incidence to the picture plane
but which also curve slightly around drawn
profiles. Assuming the Woodner drawing in
fact to have been prepared as a study for the
Palazzo Medici frescoes, or at the least to
have been executed shortly before as studio
property and subsequently employed in
the design of those frescoes, a date in the

6

**FIGURE 1**

Benozzo Gozzoli, *Retinue of the Magi,* detail of the west wall of the Cappella dei Magi in the Palazzo Medici-Riccardi, Florence

second half of the 1450s for all three of these sheets seems probable.

The inscription at the top center of the Woodner sheet, *No: 2=* (or *Ao: 2=*), corresponds to an album marking that appears on a number of other early Florentine drawings, including two head studies by Domenico Beccafumi inscribed *No: 71=* and *No: 74=*,[6] a chalk drawing of the *Holy Family* by Fra Bartolommeo inscribed *No: m 3=*,[7] and a reclining nude by Pontormo in the British Museum inscribed *No: 24=*.[8] The last formed part of the collection of Italian drawings belonging to William Young Ottley, which was acquired *en bloc* by Sir Thomas Lawrence.[9] As the Woodner

sheet can also be traced to Lawrence's collection, it is possible that it too was acquired from Ottley and ultimately from one of the distinguished collections—Cavaceppi, Martelli, or Lamberto Gori—bought by Ottley in Florence at the end of the eighteenth century. • *Laurence B. Kanter* •

**NOTES**

1. Woodner exh. cat., Munich and Vienna 1986, no. 3.
2. Degenhart and Schmitt 1968, 1: pt. 4, nos. 399, 401, 406, 416.
3. Degenhart and Schmitt 1968, 1: pt. 4, nos. 427–430.
4. Berenson 1938, 2: nos. 1866B, 1868C; and Degenhart and Schmitt 1968, 1: pt. 3, nos. 470, 471.
5. Exh. cat. Florence 1986a, 22–25, nos. 8, 9.
6. Sale, London, Christie's, 16 April 1991, lots 109 and 110. The inscriptions are tentatively identified in this catalogue as the mark of the Florentine painter Lamberto Gori (c. 1731–1801), but no evidence is adduced for this identification.
7. Sale, New York, Sotheby's, 8 January 1991, lot 15.
8. Inv. 1946.7.13.380; see Cox-Rearick 1981, 1:237–238, no. 232.
9. Sale, London, Sotheby's, 14 June 1814, lot 874 (Lugt 455, 501).

**PROVENANCE**

Possibly William Young Ottley; Sir Thomas Lawrence, London [1769–1830] (Lugt 2445); (Bruno de Bayser, Paris); Woodner Collections (Dian and Andrea Woodner).

**EXHIBITIONS**

Woodner, Munich and Vienna 1986, no. 3; Woodner, Madrid 1986–1987, no. 4.

**FIGURE 2**

Benozzo Gozzoli, *Two Nudes with Two Sleeping Dogs in a Landscape*, Gabinetto disegni e stampe degli Uffizi, Florence

# 7 Six Standing Men and Ten Battling Nudes

**1470s, pen and brown ink on gray-blue prepared paper, laid down, 278 x 201 (10 ¹⁵/₁₆ x 7 ¹⁵/₁₆)**

**Inscribed at lower right in pen and brown ink:**
***Polidoro;* and numbered at upper right: *xiiij.***

**Woodner Collections**

The large *Six Standing Men and Ten Battling Nudes* is imposing not only because of its size but also for the distinct contrasts between the two groups of male figures. In the upper half of the drawing six standing men are posed in a frieze. The figure on the extreme left is awkwardly taller than the other five, but his head appears at roughly the same height as the others because his feet are placed below the rocky ledge on which they stand. The group divides into two parts, each with a man facing away from the viewer and two posed frontally. The three at the left seem engaged in conversation, while the next two to the right look upward, as if witnessing some event. Markedly similar poses and drapery arrangements are employed for the two men whose backs are to the viewer: the "wet" drapery appears plastered to their legs and buttocks, revealing the weight-bearing leg on the left and a bent leg on the right; both men point to the right with their right hands. The tunics and togalike robes worn by all the figures are generally classical or biblical in type.

The lower half of the sheet, on the other hand, is filled with ten nude male figures engaged in active combat; they are slightly smaller in scale than the draped figures in the upper half. Of the eight in the principal area of encounter, the body of the man at the extreme left is cropped drastically, suggesting some trimming of the sheet.

All of the figures are drawn in pen with clear contour lines that are occasionally reinforced by an overlay of additional strokes creating a ragged effect. The figures are slightly stiff and lack spontaneity, as if the artist were carefully studying other two-dimensional images. The same type of short curved lines define not only the curly hair but also facial features. No hatching is used, and no shadows are shown on the ground. Drawings of this kind in pen on prepared paper were commonly made in the last third of the quattrocento in northern Italy, the likely place of origin for the Woodner sheet.[1]

The style and subject matter of the Woodner drawing, meanwhile, localize it to late fifteenth-century Padua. A. E. Popham, who was the first to study the drawing,[2] based his attribution to the School of Francesco Squarcione (1397–1468) on similarities to figures in the Ovetari Chapel frescoes in Padua by Andrea Mantegna (1431–1506) and to drawings by Marco Zoppo of Bologna (1433–1478), who also worked in Padua and Venice. Both Mantegna and Zoppo are documented as adoptive sons of Francesco Squarcione, an elusive figure with very few surviving works of his own.[3] Subsequently, Annegrit Schmitt, in attributing the Woodner drawing to Squarcione himself, drew attention to the relationship between it and the famous engraving of *Battle of the Nudes* by the Florentine artist Antonio del Pollaiuolo (fig. 1).[4] Michael Miller widened the discussion of sources by mentioning the probable importance of an engraving of *Hercules and the Giants* by an anonymous North Italian artist, based on a design by Pollaiuolo (fig. 2).[5]

The poses of the nudes in the lower half of the Woodner drawing correspond even more closely to those in the *Hercules and the Giants* than has previously been noted. The central warrior of the Woodner drawing follows the vigorous pose of the figure who thrusts a short straight sword downward in the back row of the *Hercules* print. The next warrior to the right in the print raises an ax in both hands, making more comprehensible the puzzling gesture of his counterpart in the Woodner drawing. Shields are carried by several of the nude warriors in the Woodner drawing, as they are in the *Hercules* engraving, but no shields are actually carried in Pollaiuolo's *Battle of the Nudes*. The artist of the Woodner drawing may also have known the Pollaiuolo, however, since his pair of men at the extreme right awkwardly pull each other's hair, a motif found in the left foreground of the Pollaiuolo. The dating of both *Battle of the Nudes* and *Hercules and the Giants* to the end of the 1460s at the very earliest suggests a date in the 1470s for the Woodner drawing.

Some relationships of style and function with the Woodner drawing are evident in a number of drawings made in the early 1470s by the Squarcionesque artist Marco

7

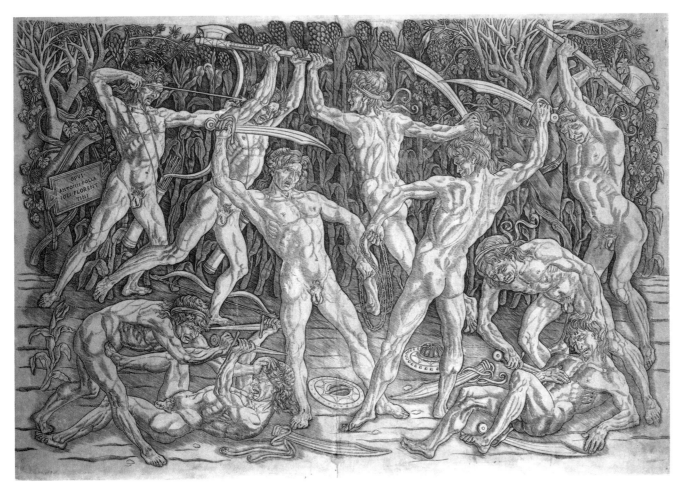

**FIGURE 1**

Antonio del Pollaiuolo, *Battle of the Nudes,* National Gallery of Art, Washington, Gift of W.G. Russell Allen

Zoppo and contained in an album known as the British Museum *Book of Drawings.*[6] Like the Woodner *Six Standing Men,* for example, Zoppo's studies present many groups of conversing men standing on rocky ledges (fig. 3); some are clothed in contemporary dress, some in classical armor, and some in orientalizing robes and turbans. His figures sometimes form coherent groups, and in other instances the fig-

ures are detached from one another either by scale or by pose. In this they also resemble the Woodner *Six Standing Men.*

The Woodner sheet is one of twelve drawings of similar dimensions on prepared paper—gray-blue, green, pink, and brown—executed in pen and ink, which were earlier in the collection of John Skippe. Skippe, who was himself an accomplished draftsman, probably acquired them in

Padua or Venice in 1772–1773 or 1775.[7] Nine of those drawings include nude male figures in active poses, two include draped male figures in conversation, one shows multiple images of centaurs and satyrs, and two include studies of heads. Seven drawings were executed in pen and ink alone, while the others also have brown wash and white heightening. Popham argued that two artists probably executed the drawings, despite the general homogeneity of technique and style.[8] Although there are distinct differences in quality, the similarities of figure types and pen handling leave open the possibility that the drawings may have been executed by one hand.

It has been suggested that the Woodner drawing together with the other eleven Skippe drawings may have formed part of a model book,[9] from which its owner could take draped and nude figures, active and passive, for use in a wide variety of commissions. No exact source is copied, but inspiration is drawn from paintings and prints of famous contemporary artists, with figures often recombined in new constellations. The six standing men on the Woodner sheet, for example, would have been useful for an Ascension of Christ or an Assumption of the Virgin, while the fighting nudes, as both individuals and groups, could have been tapped for use in appropriate battle scenes. • *Lilian Armstrong* •

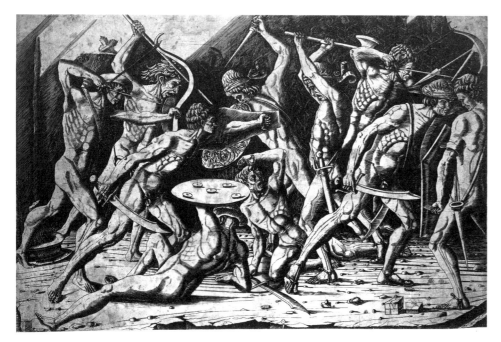

**FIGURE 2**

North Italian, *Hercules and the Giants*, after Antonio del Pollaiuolo, Courtesy of the Trustees of the British Museum, London

**FIGURE 3**

Marco Zoppo, *Standing Figures*, folio 12 from *Book of Drawings*, Courtesy of the Trustees of the British Museum, London

### NOTES

1. Many drawings in this technique are illustrated in the catalogue of the Mantegna exhibition, London 1992.
2. In sale cat., London, Christie's, 20–21 November 1958, lot 207.
3. On Squarcione see Lipton 1974, and Boskovits 1977, 40–70. For Mantegna see Lightbown 1986, exh. cat. London 1992, and De Nicolò Salmazo 1993. For Zoppo see Ruhmer 1966, Armstrong 1976, and Giovannucci Vigi 1993.
4. Schmitt 1974, 211, fig. 8. Pollaiuolo's engraving is extensively treated by Laurie S. Fusco in Levenson et al. 1973, 63–80, and in Fusco 1982, 176–194.
5. Woodner exh. cat., Munich and Vienna 1986, 242–243. On the Pollaiuolo print see Anderson 1968, 155–167.
6. Inv. 1920-2-14-1 (1–26), reproduced in facsimile in Dodgson 1923. The fifty drawings are also reproduced in Ruhmer 1966, figs. 88–138, and Armstrong 1976, pls. I–XXVI.
7. Eleven of the drawings were sold in London at Christie's, 20–21 November 1958, lots 198–208 (catalogued by Popham). The twelfth was separated from the others by the early nineteenth century and is in the Museum Boymans-van Beuningen, Rotterdam. See Schmitt 1974, 205–213, esp. 205, 211 n. 3, fig. 4. On Skippe as a draftsman see Fleming-Williams 1965, 268–275.
8. In sale cat., London, Christie's, 20–21 November 1958, 141.
9. Matthias Winner in exh. cat. Berlin 1973, no. 29; Michael Miller in Woodner exh. cat., Munich and Vienna 1986, 242–243, no. 1. Winner noted similarities in the handling of the male nude between the Woodner

drawing and a *Hercules and Antaeus* in the Kupferstich-kabinett, Berlin, and argued that the two drawings were by the same hand. He also pointed out that the artist's habit of showing figures in reversed poses was typical of drawings associated with model books.

### PROVENANCE

Unidentified collector's mark; John Skippe [1742–1812] (Lugt 2798); James Martin, Worcestershire [b. 1738]; by descent to Edward Holland [d. 1916]; by descent to his nephew, Edward Holland Martin (sale, London, Christie's, 20–21 November 1958, lot 207, as School of Francesco Squarcione); Woodner Collections (Dian and Andrea Woodner).

### EXHIBITIONS

Woodner, New York 1971–1972, no. 1 (as School of Francesco Squarcione); Woodner, Munich 1986, 242–243, no. 1, repro. p. XIII (as School of Squarcione); Woodner, Madrid 1986–1987, no. 2 (as Workshop of Squarcione).

### LITERATURE

Lipton 1974, 238–240, 295–297, no. 47 (10), pl. CXXXIX; Schmitt 1974, 205, 211, 212 n. 2, pl. 9 (as Squarcione).

# 8 Sibyl

**c. 1470, pen and black and gray ink with gray wash on laid paper, 201 x 142 (7 15/16 x 5 9/16)**

**Inscribed on the recto at lower left in pen and brown ink: *MW* (in monogram); on the verso at center in pen and black ink: a few pen marks and *Jos v Camesinaj / Pomal 1825.*; across the bottom in pen and brown ink (by Ploos van Amstel?): *Wolgemuth f. 1459.* [the date struck out] / *geb: Nueremburg 1454 1524,* and on the left, below it: *5, 7 1/2 d / 6, 5 d;* and in the lower left corner: *L;* numbered on the lower right in graphite: *5***

**Watermark: Balance in circle (lower fragment) (cf. Briquet 2562–2564, 2568)**

**Woodner Collections**

Friedrich Winkler recognized in 1913 that this half-length portrayal of a fashionably dressed young woman, with a richly worked, circular bonnet over her headcloth and a careworn, introspective gaze, is a reflection of the Magdalene in Rogier van der Weyden's Bracque Triptych.[1] Although the image is reversed and the figure, without attributes, is somewhat altered in pose and costume, the connection seemed close enough to identify the subject as another Magdalene. Barbara Baxter was the first to read the deviations from Rogier's model— the absence of an ointment vessel and the pseudo-Greek letters sketched on the border of the wheel-shaped hat—as signaling a change in content.[2] She noted that these suggested an antique meaning and proposed that the drawing represented a sibyl.

The drawing is executed in pen and black ink, with the contours rendered in long, thin, loose, somewhat clumsy, occasionally scratchy or broken outlines and the shadows in some places worked with distinct cross-hatching. The rich effect results not least from the use of a soft wash on the face and throat. The draftsman here models with a painter's method, creating fine strokes and sometimes dots with a brush and gray ink that organically follow the roundness of cheeks, throat, or shoulders, even suggesting the ear under the veil. In this way he contrasts the facial features, gently defined by light, with the more linear, draftsmanly formation of the headdress, and he sets the sharp contours of the cheek against the darkness of the pulled-back hair and descending veil. Thus he achieves a remarkable differentiation of materials and a painterly-sculptural effect for the clear, simple forms.

For all that, the manner of drawing is somewhat empty in expression—with trembling, short lines, massed together and sometimes retraced as if produced by tracing over or copying another drawing. The strokes are no longer searching out the forms but are merely rendering them, or transcribing, as is the case with the balustrade supporting the hands in the lower section, indicated with just a stroke of the pen. All this suggests that the drawing is probably a copy.

The drawing has traditionally been considered to be the work of a Nuremberg draftsman. The monogram *MW* on the recto added by one former owner and the *Wolgemuth* inscription on the verso in an eighteenth-century hand both refer to Michael Wolgemut. Since the drawing style is not comparable to Wolgemut's secure drawings,[3] however, Baxter suggested a draftsman from the circle of Hans Pleydenwurff and noted similarities with the latter's great *Crucifixion* in the Alte Pinakothek in Munich.

Daniela von Pfeil was the first to challenge this generally accepted opinion.[4] Pointing out the discrepancy between the draftsmanship in the Woodner *Sibyl* and the general graphic-linear character of Franconian drawings from the circle of Pleydenwurff/Wolgemut, she placed this sheet, primarily because of its painterly use of wash, in the artistic milieu of Augsburg-Upper Swabia. A tradition of drawing in this manner can be observed there up to the time of Hans Holbein the Elder and beyond.

Von Pfeil's conclusion that the drawing came not from Franconia but from the neighboring artistic milieu of Swabia is supported by parallels in the art of Ulm. Among the busts of prophets and sibyls in the Ulm choir stalls carved by Jörg Syrlin the Elder, the *Delphic Sibyl* (fig. 1), despite its very different, genial expression, shows the closest formal similarities. Referring again to Rogier van der Weyden's Bracque Magdalene, the *Delphic Sibyl* shares with the Woodner drawing precisely the same details that differ from the model by Rogier: both have a veil bound under the hat,

8

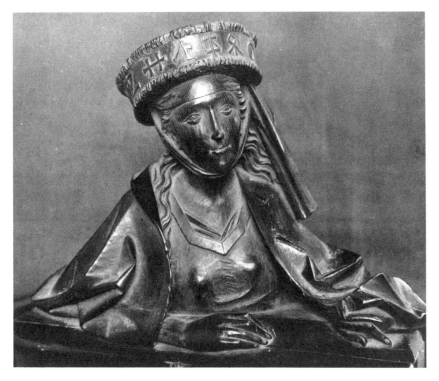

**FIGURE 2**

German School, fifteenth century,
*Bust of a Sibyl*, Kupferstichkabinett
der Staatlichen Kunstsammlungen,
Dresden

with the end falling to the left; both have
hair falling back over the left shoulder and
forward on the right between the neck
and the hanging section of cloth. Both also
have a pseudo-Greek inscription on a flat-
rimmed, wheel-shaped hat. Moreover, Wil-
helm Vöge's research on Syrlin's sculpture
and on images of prophets and sibyls in the
late middle ages calls attention to the paint-
ing cycles by Ludiger tom Ring the Elder
and his son Hermann.[5] There also the
prophesying men and women of antiquity
rest their hands on stone balustrades bear-
ing inscribed commentary. Thus, for the
supporting ledge under the folded hands of
the sibyl in the drawing, an equally applic-
able explanation may be discovered in the
genesis of the closely related busts of sibyls
by Jörg Syrlin.

At the same time, it is unlikely that
both Syrlin and the Woodner draftsman
changed Rogier's model in the same way.
The noted connections tend to support the
conclusion that both derive from a com-
mon model, now lost, in which the associa-
tion of Rogier's Magdalene with the image
of the sibyl was already established. Among
the few known German drawings of the
third quarter of the fifteenth century, one
that has similarities in motif and drawing
style to the Woodner *Sibyl* is a sheet in
Dresden with the image of a female saint
or sibyl and the inscription *Sancta Martha
bzw. Tib[urtina]* on the garment borders
and headband (fig. 2).[6] Although executed
without wash, it is closely comparable to
the Woodner drawing in the handling of
pen strokes. It is itself also a copy after a
lost model, of which another copy is pre-
served on a sheet in the Albertina.[7] Both
resemble the Woodner drawing also in the
form of the letters derived from uncial
script, especially the *A* and *R,* in the in-
scription on the border of the sibyl's head-
dress. In the small, fine, parallel strokes of
the modeling, the Vienna image shows a
drawing style that directly foreshadows that
of the Woodner sheet. The closest compar-
isons are the engravings of Master E. S.
and those of the Master of the Nuremberg
Passion, which help to establish a date in
the 1460s.

Beyond this, in the type of broad, clearly
formed face with large, almond-shaped
eyes in deeply hollowed sockets, the drawing
invites comparison with the portraits of
women in Hans Schüchlin's Tiefenbronner
altarpiece of 1469.[8] Together the evidence of
drawing technique and figure style point to
the work of an artist active around 1470 in
the Augsburg/Ulm region. • *Fritz Koreny* •

**NOTES**

1.  Winkler 1913, 118. Two exact copy drawings of Saint
Mary Magdalene, executed in silverpoint on similar
sheets by fifteenth-century Netherlandish masters,
are in the British Museum, London; see Sonkes 1969,
78–83, B.23, B.24.
2.  In Woodner exh. cat., Malibu 1983–1985, 98, no. 38.
3.  For instance see Wolgemut's drawing for the title
page of Hartmann Schedel's Nuremburg Chronicle;
see Rowlands 1993, 16, no. 27.
4.  Von Pfeil 1995, 147–150, 280, no. 11.
5.  Vöge 1950, esp. 138–140.
6.  Kupferstichkabinett, Dresden, inv. C 1937/190; see
Schilling 1922, no. 1, pl. 1.
7.  Tietze et al. 1933, no. 13; Hartmut Scholz recently
first proposed the connection with Strasbourg stained
glass; see exh. cat. Ulm 1995, no. 23. For a further copy
of that obviously widespread model see Starcky 1988,
61, 62, no. 60.
8.  See exh. cat. Stuttgart 1993, 161–167, pl. 212; see also
Von Pfeil 1995, 59–61.

**PROVENANCE**

C. Ploos van Amstel, Leyden [1726–1798] (Lugt
3002–3004); Josef Camesina de Pomal, Vienna
[1765–1827] (Lugt 429); Robert von Hirsch (sale,
Sotheby's, London, 20 June 1978, lot 9); Woodner
Collections (Shipley Corporation).

**EXHIBITIONS**

Woodner, Malibu 1983–1985, no. 38; New York 1986,
no. 39; Woodner, Madrid 1986–1987, no. 50.

**LITERATURE**

Oberhuber 1983, 80 (repro.).

# 9 Page from "Libro de' Disegni"

*First trained in Arezzo by the French glass painter Guillaume de Marcillat (1475—1529 or 1537), Vasari moved to Florence in 1524 and studied with Baccio Bandinelli (1493—1560) and Rosso Fiorentino (1494—1540). From 1527 he worked in Arezzo and Florence, moving in 1531 to Rome, where he was influenced by Michelangelo (1475—1564) and by Raphael (q.v.) and his followers. Though based in Rome, Vasari worked widely and used his various journeys to compile notes for his* Vite de' piu eccellenti pittori.... *From 1554 he was back in Florence in the service of Cosimo de' Medici, for whom he executed the decoration of the Palazzo Vecchio. In the last five years of his life he worked on the decoration of the cupola of the Cathedral in Florence and on various commissions in the Vatican. His fame as the author of the* Vite, *an indispensable source for the history of Italian painting, has tended to overshadow his career as a painter.*

**Assembled after 1524, album page with ten drawings on recto and verso in various media [see individual descriptions following] and decoration in pen and brown ink, brown and gray wash, on light buff paper, 567 x 457 (22 5/16 x 18)**

**Inscribed in cartouche at lower center of both recto and verso in brown ink: *Filippo Lippi Pitt: Fior:***

**National Gallery of Art, Woodner Collection, Patrons' Permanent Fund 1991.190.1.a–j**

Vasari was not the first to value drawings of past generations and to preserve them, but he was the earliest systematic collector who considered issues of quality and historical significance in creating a collection that spanned the development of Italian draftsmanship from Cimabue to his own time. His drawings were concrete companions to his written *Vite*, exemplifying the work of his predecessors and contemporaries while at the same time providing a view of their creative processes. Vasari anticipated not only the activities and outlook of the many great collectors in successive centuries but the historical and didactic approach taken by museums in our era.

The drawings Vasari collected were mounted on large pages, with frames and other decorations that he drew himself as well as cartouches with his own attributions at the bottoms of the pages. Of the original pages that have survived, this is the most beautifully composed, a work of art made up of other works of art, more impressive even than the sum of its parts.

Vasari approached the design of both recto and verso as an architect and decorator of great palace walls. The recto is thinly framed with a broad, altarlike structure emerging from the flat "wall" of the page. The supporting side consoles rest on steps and are set between decorative swags of fruit. The cartouche with inscribed attribution sits on the lower step, while the most important of the drawings on the recto is seen imbedded in this structure. Vasari intends the viewer to understand the white of the page as a lighted wall, with the light source at his left, suggested by the shadow on the inside of the console at the left. The upper part of the page is dominated by the large drawing that rests on the lower entablature, surrounded on either side by smaller studies in octagons, all set forward illusionistically from the page. The interplay of "real" drawings and drawn architecture is reminiscent of elaborate mannerist wall decorations.

The design of the verso is no less elaborate. It is dominated by the colored drawing of three saints below, set within a marble frame that Vasari has extended by the addition of a pediment. Emerging from behind the pediment is a superstructure that frames the drawing with a dancing putto. On either side of this miniature "altarpiece" Vasari has created niches to contain figure drawings. All around it he has broadly washed shadow. Lastly, he has put the two fragments of torch-bearing angels in the upper lateral spaces, tonally and through the addition of lightly sketched

clouds suggesting that they are set in limitless heavenly space. The design of the verso is less rationally ordered and even more original than that of the recto.

The inscription in the cartouches on both recto and verso indicate that Vasari considered all of the drawings mounted on this sheet as the work of Filippino, whom he referred to as "Filippo" here as elsewhere. • *George Goldner* •

**PROVENANCE**

Giorgio Vasari [1511—1574]; Niccolò Gaddi [d. 1591]; possibly Thomas Howard, Earl of Arundel; probably William Cavendish, 2nd Duke of Devonshire [1672—1729]; by descent at Devonshire House and Chatsworth (inv. 960) (sale, Christie's, London, 3 July 1984, lot 46); Woodner Collections (Shipley Corporation); purchased by NGA, 1991.

**EXHIBITIONS**

London 1930, no. 652 (recto only); London 1949, no. 10; Washington 1962—1963, no. 36 (recto only, with 1991.190.1.a attributed to Raffaellino del Garbo); London 1969, no. 36 (recto only, same cat. entry as for 1962—1963 exh.); London 1973—1974, no. 36 (recto only, same cat. entry as for 1962—1963 exh.); Woodner, Cambridge 1985, no. 76; Woodner, Munich and Vienna 1986, no. 24; Woodner, Madrid 1986—1987, no. 29; Woodner, London 1987, no. 22; Woodner, New York 1990, no. 29.

**LITERATURE**

Kurz 1937, 14; Ragghianti Collobi 1974, 1:85, and 2: pls. 233—234; Shoemaker 1975, 370—374, no. 113; NGA Guide 1992, 312—313 (repro.); exh. cat. New Haven 1994, fig. 52 (facsimile exhibited); Jaffé 1994, 1: no. 36.

Filippo Lippi Pitt: Fior:

9 RECTO

9 VERSO

# 9a  Head of a Youth Wearing a Cap; a Right Forearm with the Hand Clutching a Stone; and a Left Hand Holding a Drapery

*Filippino Lippi was trained by his father, the painter Fra Filippo Lippi (c. 1406?–1469) and from 1472 is mentioned in the workshop of Botticelli (1444/1445–1510) and as a member of the Compagnia di San Luca. He lived in Rome from 1488 to c. 1493 but continued to work in Florence. His principal works were the frescoes of the Life of Saint Peter in the Brancacci Chapel of Santa Maria del Carmine, Florence, where he completed the cycle begun by Masolino (c. 1383–after 1432) and Masaccio (1401–1427/1429); frescoes in the Carafa Chapel in Santa Maria sopra Minerva, Rome, 1488–1493; and frescoes in the Strozzi Chapel in Santa Maria Novella, Florence, 1487–1502.*

**1480/1485, metalpoint heightened with white gouache on mauve prepared paper, 287 x 201 (11 ⁵/₁₆ x 7 ¹⁵/₁₆)**

This fine drawing has been alternately attributed to Filippino Lippi and to Raffaellino del Garbo (1466–1524) over the last several decades. Bernard Berenson, A. E. Popham, and Innis Howe Shoemaker considered it by Raffaellino, whereas Alfred Scharf, Michael Miller, and Nicholas Turner have returned to Vasari's attribution to Filippino. There are good reasons for preferring Filippino's authorship, well elucidated by Miller and Turner.[1] Similar heads of young men appear in Filippino's painting of *Tobias and the Angel* (Galleria Sabauda, Turin), in his altarpiece in San Michele, Lucca (fig. 1), as well as in the Brancacci Chapel frescoes, all dating between 1480 and 1485. In addition, the fineness of modeling and subtle use of white highlights are hallmarks of Filippino's draftsmanship.

One should retain some small measure of doubt on behalf of Raffaellino on account of the hardness of the outline of the face and the uncharacteristic *mise-en-page*. Equally, though the head of the young man fits well among the painted heads of the early 1480s by Filippino, it is more difficult to see it alongside the fragmentary study

of two heads of young boys in the Louvre for the Corsini tondo (inv. 1257 R) or the head of a boy with a beret in the Musée Condé, Chantilly (inv. 23). It is still further removed from the two very early studies of women in the Uffizi (inv. 1156 E and 1153 E).

In spite of these difficulties, the argument still favors Filippino. The closest comparison in Raffaellino's certain work is the sheet of the mid-1490s showing the *Resurrected Christ* (British Museum, London, inv. Pp. 1-32), which also belonged to Vasari, in which both the character of the line and the modeling are more prosaic. If by Raffaellino, it would have to represent an early stage in his career when his style more closely reflected that of Filippino than even the British Museum sheet. Since no drawing fitting this description is known, Vasari's attribution to Filippino should be maintained. • *George Goldner* •

**NOTE**

1. In Woodner exh. cats., Munich and Vienna 1986, no. 24 recto A (Miller), and London 1987, no. 22A (Turner).

**LITERATURE**

Strong 1902, no. 34; Berenson 1903, 2:760 (as Raffaellino del Garbo); Scharf 1935, 129, no. 292; Berenson 1938, 2: no. 760 (here and subsequently as Raffaellino del Garbo); Berenson 1961, 2: no. 760; Ragghianti Collobi 1974, 1:85, 2: pls. 233–234; Shoemaker 1975, 370–371, no. 113B; Jaffé 1994, 1: no. 36A.

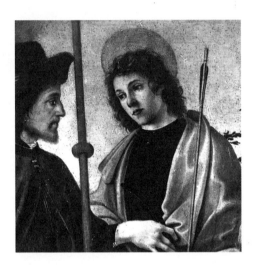

**FIGURE 1**

Filippino Lippi, detail from *Saints Jerome, Sebastian, Roch and Elena*, San Michele, Lucca

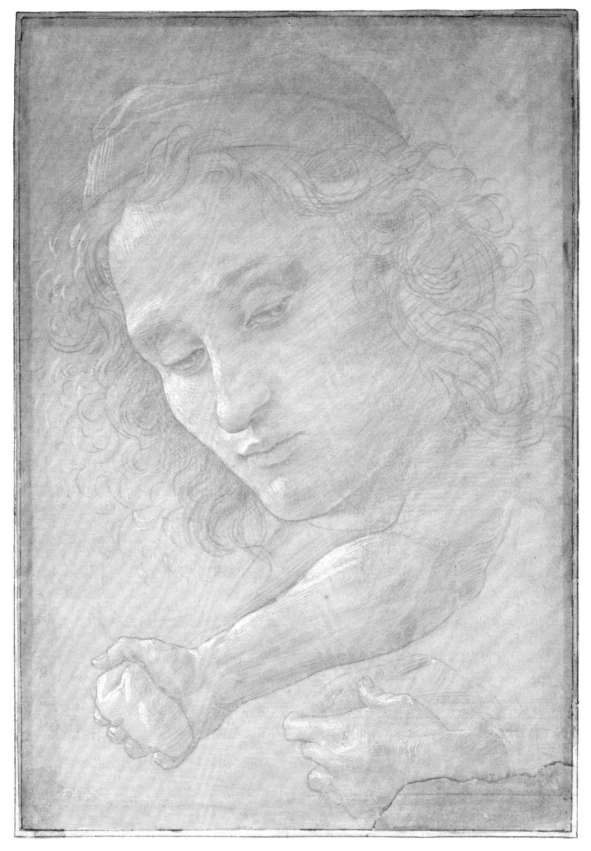

9a

# 9b  Standing Nude Youth

**c. 1496, metalpoint heightened with white on gray
prepared paper, trimmed at corners, 195 x 104
(7 $^{11}/_{16}$ x 4 $^{1}/_{8}$)**

The attribution of this rather pale study
from a studio model to Filippino is correct,
despite the hesitation that understandably
recurs in the scholarly literature about it.
Miller has attempted to link it with a stand-
ing man at the left side of the *Adoration of
the Magi* (National Gallery, London),[1] but
it is much closer to the standing figure of
an older man gesturing toward the Virgin
and Child at the right side of the *Adoration
of the Magi,* dated 1496 (Uffizi, Florence),
where only the tilt of the head is different.
Given the drawing's stylistic and histori-
cal association with the *Man with a Stick*
(cat. 9c), a date of 1496 is preferable.
• *George Goldner* •

**NOTE**

1. In Woodner exh. cat., Munich and Vienna 1986,
no. 24 recto B.

**LITERATURE**

Strong 1902, no. 34; Berenson 1938, no. 1276B; Beren-
son 1961, no. 1276B; Shoemaker 1975, 370, no. 113A (as
follower of Filippino Lippi; Jaffé 1994, 1: no. 36B.

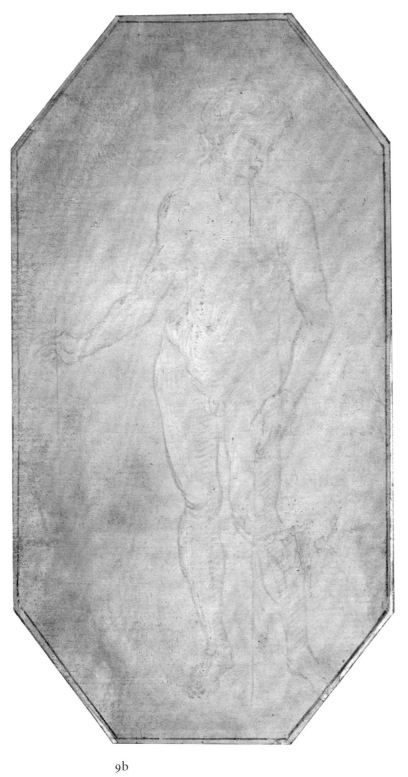

9b

# 9c Man with a Stick

**c. 1500, metalpoint heightened with white on gray prepared paper, trimmed at corners, 196 x 107 (7 $^{11}$/$_{16}$ x 4 $^{3}$/$_{16}$)**

This sketch has had the same critical history as the *Standing Nude Youth* (cat. 9b) and is certainly by the same hand. It is more clearly linked to other works by Filippino, though, with connections suggested by Miller to figures of a cowherd in the *Meeting of Joachim and Anna* from 1497 (Statens Museum for Kunst, Copenhagen) and with the *Saint John the Baptist* of similar date (Accademia, Florence).[1] A still more similar version of the same figure type appears in miniature in the background scene of the Visitation in a drawing in the Pierpont Morgan Library (inv. IV, 3), which has the story of Jonah visited by three friends as its foreground narrative. That too dates from late in the artist's career, around 1500. These relationships would suggest a late date for the drawing, as does the relationship to the *Standing Nude Youth*. • *George Goldner* •

**NOTE**

1. In Woodner exh. cat., Munich and Vienna 1986, no. 24 recto C.

**LITERATURE**

Strong 1902, no. 34; Berenson 1938, 2: no. 571, 1276A; Berenson 1961, 2: no. 571, 1276A; Shoemaker 1975, 371, no. 113C (as Follower of Lippi); Jaffé 1994, 1: no. 36C.

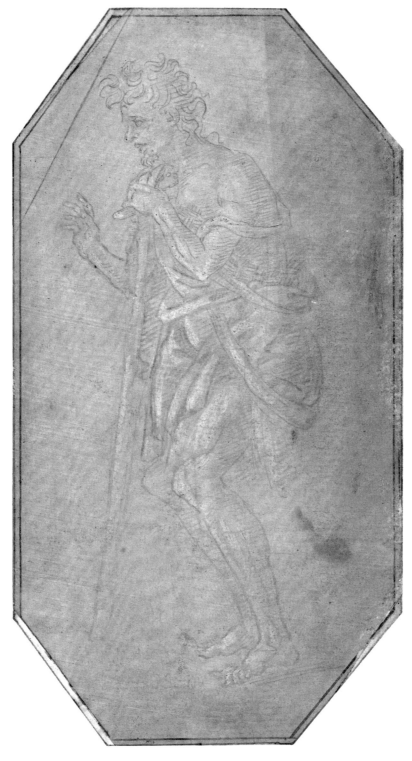

9c

# 9d Various Figure Studies

c. 1493/1495, metalpoint heightened with white on ocher prepared paper with border by Vasari in brown ink, 220 x 329 (8 $^{11}/_{16}$ x 12 $^{15}/_{16}$)

This fine sheet includes the figure of a seated man with an orb in one hand and a staff in the other at the right, a man bending forward and a further study of his leg at the center, and a wildly gesticulating young man with another study of his left arm and a separate study of a leg above at the left. Miller related the style of the drawing to three studies of the *Raising of Drusiana* for the fresco in the Strozzi Chapel of Santa Maria Novella, Florence.[1] Two are in the Uffizi (inv. 185 E and 186 E) and the third at Christ Church, Oxford (inv. A.12). Shoemaker has also compared the highly animated figure at the left with a study of the dead Meleager in the Louvre (inv. 9862). These connections all point to a date in the period following Filippino's return from Rome in 1493. The liveliness of gesture in the figure at the left is typical of the late Filippino, as can be seen in paintings such as the two Moses scenes in the National Gallery, London. Lastly, Federico Zeri has proposed a connection between the seated man at the right and a similarly posed figure in a painting in the Cini Collection, Venice.[2] They are quite different in details such as the direction they face, the placement of their legs, and the attributes they hold, suggesting that the relationship is generic. Perhaps, as Zeri proposes, both figures derive from a common, now lost, Botticellian source. • *George Goldner* •

### NOTES

1. In Woodner exh. cat., Munich and Vienna 1986, no. 24 recto D.
2. Zeri et al. 1984, 28.

### LITERATURE

Scharf 1935, no. 207; Berenson 1938, 2: no. 1276; Berenson 1961, 2: no. 1276; Shoemaker 1975, 371–372, no. 113D; Zeri et al. 1984, 28; Jaffé 1994, 1: no. 36D.

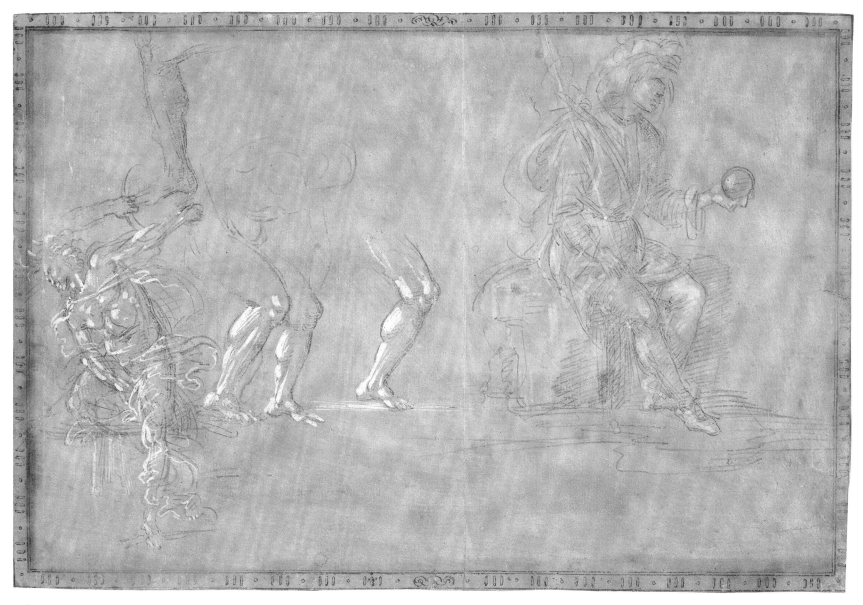

9d

# 9e  Dancing Putto Holding a Drapery

**c. 1493/1497, pen and brown ink on dark buff paper, 203 x 128 (8 x 5 ¹/₁₆)**

The attribution of this spirited study has alternated between Filippino and Raffaellino, but there is clear evidence to support Lippi's authorship. The highly charged manner of drawing and free modeling are qualities that are found in Filippino's ornamental drawings of his Roman years (1488–1493), specifically two splendid sheets in the Uffizi (inv. 1633 E and 1634 E). In addition, as noted by Turner, Filippino sometimes bisected the front of the face with a curved line in sketches of this kind,[1] a usage also seen in the drawing of *An Angel Carrying a Torch* (cat. 9f), in his *Virgin and Child Attended by Angels* (Metropolitan Museum of Art, New York, inv. 68.204), and in other pen drawings. Part of the confusion concerning attribution stems from the mistaken idea that the Metropolitan Museum drawing is by Raffaellino

and the clear stylistic association of the two, first made in a dealer catalogue.[2] In fact, both are certainly by Filippino and date from the period after his return from Rome to Florence in 1493. Not only are the connections to his work strong, but there are none of any consequence to surviving works by Raffaellino.

A relationship has been noticed by C. Douglas Lewis between the lower portion of the putto and a terra cotta attributed to Verrocchio (fig. 1). It seems likely that the drawing was inspired by it or some similar sculptural prototype. • *George Goldner* •

**NOTES**

1. In Woodner exh. cat., London 1987, no. 22E, n. 1.
2. Exh. cat. London 1969a, no. 2.

**LITERATURE**

Berenson 1938, 2: no. 1275; Berenson 1961, 2: no. 1275; exh. cat. London 1969a, under no. 2; Shoemaker 1975, 372–373, no. 113F (as Raffaellino del Garbo?); Jaffé 1994, 1: no. 36E.

**FIGURE 1**

Andrea del Verrocchio, *Putto Poised on a Globe*, National Gallery of Art, Washington, Andrew W. Mellon Collection

9e

# 9f   An Angel Carrying a Torch
# 9g   Two Angels Carrying Torches

*cat. 9f*

**c. 1500/1504, pen and brown ink with gray wash on laid paper irregularly trimmed, partly silhouetting the figure, maximum measurement: 206 x 130 (8 ¹/₈ x 5 ¹/₈)**

*cat. 9g*

**c. 1501, pen and brown ink with brown wash on laid paper, pricked for transfer, irregularly trimmed, partly silhouetting the figures, maximum measurement: 175 x 126 (6 ⁷/₈ x 4 ¹⁵/₁₆)**

These two fragments possibly came from the same sheet, though the single figure is drawn in a sketchier, more exploratory manner, while the pair of angels are more economically and definitively drawn. The latter fragment is also pricked for transfer. It has rightly been noticed by Miller that the drawing with two angels is a study for figures at the top right section of the altarpiece with the *Mystic Marriage of Saint Catherine, with Four Saints,* dated 1501 (fig. 1).[1] The draftsmanship here is close to that of a study of a standing female figure by Filippino in the Uffizi (inv. 173 F). The single angel is more elaborately drawn, suggesting that Filippino was trying out variations. It is stylistically comparable to the *Dancing Putto* (cat. 9e) and to other late pen drawings by Filippino. Turner has related it to the angels at the top left of the Bologna altarpiece,[2] and this may well be

true, but were it not for its historical association with the other fragment, one might as easily relate it to other late projects by the artist. • *George Goldner* •

**NOTES**

1.  In Woodner exh. cat., Munich and Vienna 1986, no. 24 verso B/C.
2.  In Woodner exh. cat., London 1987, nos. 22 F and G.

**LITERATURE**

Berenson 1938, 2: no. 1275; Berenson 1961, 2: no. 1275; Shoemaker 1975, 372, 373, nos. 113E, 113G; Jaffé 1994, 1: nos. 36F, 36G.

**FIGURE 1**

Filippino Lippi, *Mystic Marriage of Saint Catherine, with Four Saints* (detail), San Domenico, Bologna

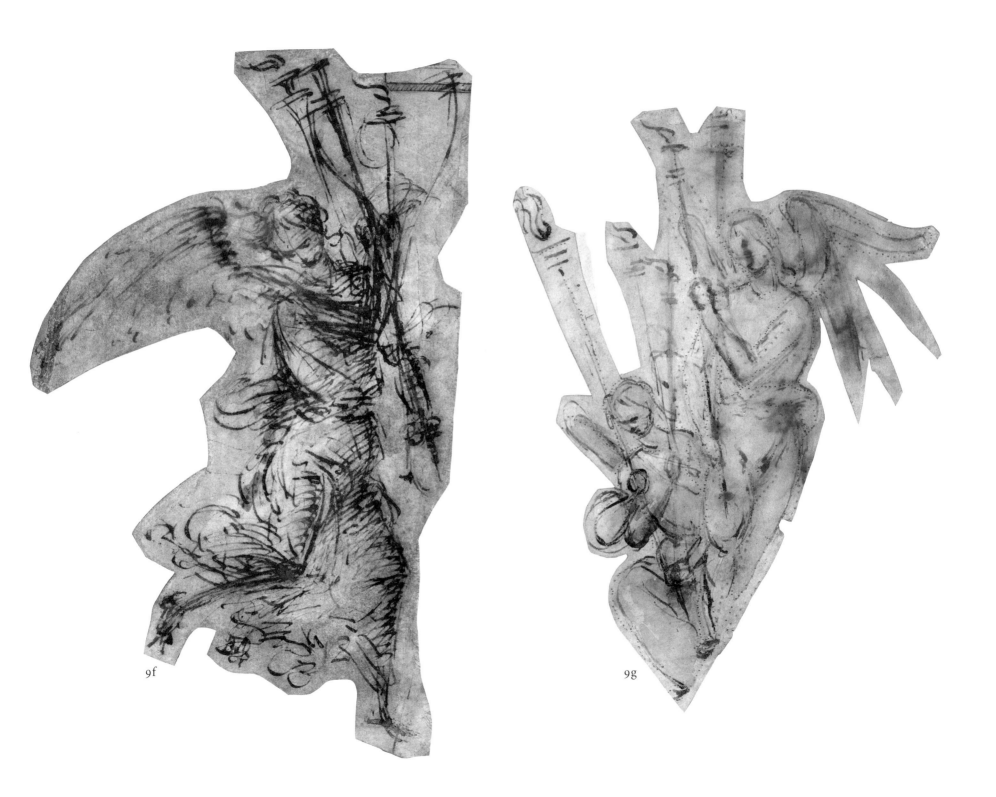

9f

9g

# 9h Saint Roch between Saints Anthony Abbot and Catherine of Alexandria

**FIGURE 1**

Botticelli, *Saints Anthony Abbot,*
*Roch, and Catherine of Alexan-*
*dria,* San Felice, Florence

**c. 1485/1495, gouache with brown wash and
brown-gray wash heightened with white on laid
paper, image: 153 x 156 (6 x 6⅛)**

This exceptional drawing is related to the
altarpiece with the same saints in San Felice,
Florence (fig. 1). In the altarpiece, however,
each saint is shown in an arched panel of
its own and set farther back from the fore-
ground than in the miniature. There are
also innumerable differences in pose, ges-
ture, and other details, and the saints in the
altarpiece appear more introverted and
placid. The palette is completely different
both in choice and sensibility, and such
decorative details as the clouds in the
miniature are not present in the altarpiece.

The nature of the relationship between
the drawing and the altarpiece is difficult
to ascertain, given the rarity of miniatures
of this kind in the late fifteenth century.
Neither the draftsmanship nor the format
of the drawing indicates that it was a pre-
paratory *modello.* Indeed, it differs from the
altarpiece architecturally in the absence of
divisions between panels and in the lack of
provision for the (existing) predella.

The authorship of both altarpiece and
miniature has been much disputed, result-
ing, understandably, in quite divergent
findings. The altarpiece has been attributed
to Piero di Cosimo, Cosimo Rosselli, the
School of Filippino, and the School of Bot-
ticelli. Everett Fahy has recently concluded
that it is by Botticelli himself and dates

from the 1490s.[1] There is much to recom-
mend this view, in particular the relation-
ship it has to the San Marco altarpiece of
the same moment (Uffizi, Florence). At
the very least, it seems surely to have been
designed by Botticelli and executed in his
workshop. Yet it is difficult to see the mini-
ature as the product of the same hand, even
accounting for the obvious disparity of
scale and medium. Where the altarpiece
exudes grandeur and relative simplicity, the
miniature suggests delicacy. Furthermore,
details such as the drapery folds and hands
lack the crispness and brilliant clarity one
finds throughout Botticelli's work of the
period, as in the drawing of *Saint John the*
*Baptist* in the Uffizi (inv. 188 E). The mini-
ature also lacks the breadth of form and
execution visible in the three fragments of
an Adoration of the Magi now divided be-
tween the Fitzwilliam Museum, Cambridge
(inv. 910 and 2888), and the Pierpont Mor-
gan Library, New York (inv. I,5). Finally,
the use of color is quite different from that
in Botticelli's paintings and also in his illus-
trations of the *Divine Comedy* in the Kup-
ferstichkabinett, Berlin, and the Biblioteca
Apostolica, Vatican City.[2]

Therefore, despite the support that the
attribution of the miniature to Botticelli
has received in recent years from Miller,
Turner, and Fahy, it seems much more
probable that it is the work of a follower,
made after the altarpiece, as an indepen-
dent work. It is not to be entirely excluded

that Berenson's attribution to Raffaellino
may be correct. It is worth noting that
Vasari mentions that Raffaellino was skilled
at producing drawings executed in "aque-
rello" in his youth.[3] Unfortunately no com-
parable work by Raffaellino is known, and
comparisons with his paintings and draw-
ings offer little support for an attribution
of the miniature to him.

This drawing is thus likely to be the
work of a Florentine miniaturist who had
seen either the altarpiece or a (now lost)
preparatory drawing for it. A small hint
that would favor the latter possibility is
offered by the decorative marbleized arch
around the figure of Saint Roch. It has no
perceptibly logical connection to the trip-
tych and no functional purpose but might
well reflect either the distant reminiscence
of the altarpiece or of a preparatory design
in which only the central arch was indi-
cated by Botticelli. • *George Goldner* •

**NOTES**

1. Fahy 1993, 169–171.
2. See Dreyer 1988.
3. Vasari 1906 ed., 3:506.

**LITERATURE**

Berenson 1903, 2: no. 571 (as School of Botticelli);
Van Marle 1923–1938, 12:274; Berenson 1938, 2:760
(as Raffaellino); Berenson 1961, 2:760 (as Raffaellino);
Fahy 1968, 32, 37–38; Ragghianti Collobi 1974, 1:85,
2: pls. 233–234 (as Raffaellino); Shoemaker 1975,
373–374, no. 1131 (as Raffaellino); Fahy 1976, 20, 78, 107
(as Workshop of Botticelli); Jaffé 1994, 1: nos. 22, 36H
(as Botticelli).

9h

# 9i Standing Woman with Her Hands Clasped in Prayer

**c. 1488, metalpoint heightened with white on gray prepared paper, the lines of part of the niche drawn by Vasari in pen and brown ink, 194 x 80 (7 ⁵/₈ x 3 ¹/₈)**

Miller has proposed that this may be a study for the figure of the Virgin in the *Assumption* fresco painted above the altar in the Caraffa Chapel, Santa Maria sopra Minerva, Rome (fig. 1).[1] The poses are similar, but not so much as to make the association definitive. Equally, the poor state of the drawing, with considerable additions of white heightening by Vasari not only adjacent to, but on the figure, make it difficult to judge. Nevertheless, the visible metalpoint strokes are of sufficiently high quality to justify the attribution to Filippino.

• *George Goldner* •

**FIGURE 1**

Filippino Lippi, *The Assumption of the Virgin* (detail), Caraffa Chapel, Santa Maria sopra Minerva, Rome

**NOTE**

1. In Woodner exh. cat., Munich and Vienna 1986, no. 24 verso E.

**LITERATURE**

Berenson 1903, 2: no. 1275; Berenson 1938, 2: no. 1275; Berenson 1961, 2: no. 1275; Shoemaker 1975, 373, no. 113H (as Florentine, late 15th/early 16th century); Jaffé 1994, 1: no. 361.

91

# 9j Two Draped Women Standing on Either Side of a Herm

**1488/1493, metalpoint heightened with white on light green prepared paper, the lines of part of the niche drawn by Vasari in pen and brown ink, 190 x 102 (7 ½ x 4)**

The woman at the left was based on figures on the *Sarcophagus of the Muses* (fig. 1), as was first noticed by Miller.[1] As one might expect, Filippino created his own figure out of the first and perhaps third Muses on the sarcophagus, adding the herm and the woman seen from the back from other sources. This kind of free interpretation of Roman sources can be found on a similar metalpoint drawing after a scene in the Domus Aurea, in the Uffizi (inv. 1255 E verso). Both drawings were made during Filippino's stay in Rome from 1488 to 1493.
• *George Goldner* •

### NOTE

1. In Woodner exh. cat., Munich and Vienna 1986, no. 24 verso F. For the sarcophagus, see Bober and Rubinstein 1986, no. 38. It should be noted that since Filippino evidently used this sarcophagus as a source elsewhere it is even more likely that it, rather than an intermediary, was employed in this drawing. Bober and Rubinstein provide a list of other quotations from it by Lippi.

### LITERATURE

Berenson 1903, 2: no. 1276; Scharf 1935, 122, no. 207; Berenson 1938, 2: no. 1276; Berenson 1961, 2: no. 1276; Shoemaker 1975, 374, no. 113J (as Florentine, late 15th/early 16th century); Jaffé 1994, 1: no. 36J.

**FIGURE 1**

Roman, *Sarcophagus of the Muses* (detail), Kunsthistoriches Museum, Vienna

9j

# 10 Design for a Triumphal Chariot

**1490/1495, pen and brown ink on laid paper, 166 x 250 (6⅝ x 9¹³⁄₁₆)**

**Inscribed on the verso at lower center in pen and brown ink: *No 787***

**Woodner Collections**

After a sojourn in Rome between 1488 and c. 1493, Filippino Lippi began to create more extravagant and fanciful architectural settings than those conceived by any of his predecessors or followers. The decorated structures in his frescoes in the Strozzi Chapel in Santa Maria Novella (1494–1502), in particular, could exist only on the surface of a painting or in some ephemeral form such as a theatrical design, for they overflow with ornament and are covered with vividly animated figures and decorative creatures. By contrast, the architectural settings in Filippino's compositional drawings are relatively simplified and unembellished, and it is only in a few of his drawings of antique ornament—and hardly even there—that the wild decorative profusion seen in his paintings can be imagined. Peter Halm long ago acutely observed the major changes that took place between Filippino's relatively austere compositional drawings and his excessively ornate architectural paintings,[1] and it is in this light that the present drawing should be considered.

Bernard Berenson's attribution of this drawing to Filippino has been questioned, but only once seriously doubted.[2] Examination of details seems to confirm Filippino's authorship, even though no other drawings by him so clearly address the decoration of a monumental architectural structure. The large, multi-tiered design is more richly ornamented than any of the buildings in Filippino's compositional drawings of architecture; rather it resembles his drawings of antique ornament or the architectural structures in his paintings. The open, sketchy handling of the minute features and extremities of his figures and the experimental approach to the placement and perspective of his architectural forms correspond to those in his drawing for *The Raising of Drusiana* fresco in the Strozzi Chapel (fig. 1), with its small, spiky figures with dotted features and long, broken lines used to draw and redraw the ornamental and architectural elements. Similar too is the artist's repetition of details and his exploration of different decorative schemes for the architecture. The form and treatment of the ornament also compare favorably with Filippino's *Decorative Designs with a Putto and a Dolphin* (fig. 2), which has several of the same motifs, or the *Sheet of Arabesques* (fig. 3), which shows the same manner of striking through figures and decorative forms with repeated parallel diagonal lines.

The purpose of the Woodner drawing is still uncertain. Berenson's suggestion that it might be a discarded design for the top of the architectural structure in Filippino's *Saint Philip Exorcising a Demon* (Strozzi Chapel) was reasonable, given the obvious similarities to that fresco and other decorative elements in the chapel.[3] Charles Loeser's earlier idea that it was a design for a processional chariot[4] may gain additional support, however, from documents that describe a chariot of the *Triumph of Peace* created by Filippino in 1494 for the entry of Charles VIII into Florence. The high, concave structure rising from a long horizontal base, with lively freestanding figures and decorative motifs, resembles the processional chariots depicted in many quattrocento Triumphs.[5] Unfortunately, the decorative details in the present drawing do not connect it directly with Filippino's chariot for Charles VIII: "…it was large enough to accommodate an orchestra of eighteen musicians and singers.… Descriptions refer to the 'Trionfo' as a 'carro,' or large wagon, made of wood and canvas, at least partly covered with cloth of gold. On it were nymphs, perhaps representing muses or allegorical figures.…There was also a large golden lily, an allusion to the King's crest, and a silvered crown of palms and olive boughs symbolic of peace."[6]

The possibility that this drawing was for the chariot for Charles VIII makes sense both because of the shape of the structure and its secular decorations and because of Filippino's known practice of making highly experimental preliminary sketches that went through major changes before he reached his final solution. If this drawing was not for the chariot of 1494, it must surely relate to some other triumphal chariot designed by Filippino at a date not too distant from it. • *Innis Howe Shoemaker* •

10

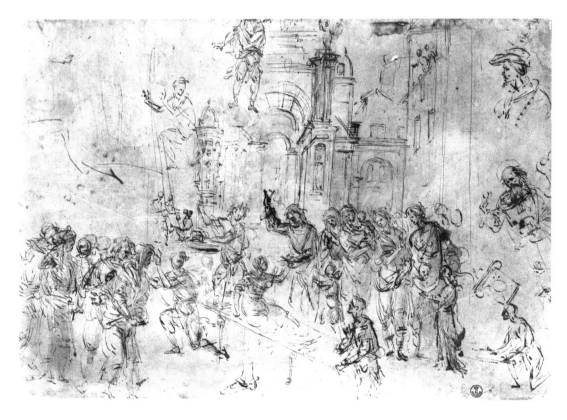

**FIGURE 1**

Filippino Lippi, *The Raising
of Drusiana,* Gabinetto disegni e
stampe degli Uffizi, Florence

**NOTES**

1. Halm 1931, 418.

2. In Woodner exh. cat., Madrid 1986–1987, 12, it was
proposed by Manuela Mena Marqués that the attri-
bution to Filippino should be reconsidered for tech-
nical and stylistic reasons. She suggested that the
more "pictorial" style of drawing recalled a Paduan or
Venetian artist and cited drawings attributed to both
Andrea Mantegna and Giovanni Bellini. She also
compared the formal repertory and style, especially
of the figures, to the work of the sculptor Andrea
Riccio (c. 1470–1532). And she claimed that the draw-
ing resembles some of the work of the anonymous
Lombard Master of 1515, particularly the Berlin Note-
book attributed to him.

3. Berenson 1961, 2: no. 1353A.

4. From a letter, presumably to the Honorable Alfred
Gathorne-Hardy, dated 19 November 1898, cited
by Nicholas Turner in Woodner exh. cat., London
1987, 36.

5. See, for example, the anonymous Florentine en-
gravings of the *Triumph of Petrarch,* c. 1460–1470,
in Hind 1938, 2: pls. 18–24.

6. Borsook 1961, 112–113.

**PROVENANCE**

John Malcolm, London [1805–1893]; Sir John Charles
Robinson, London [1824–1913]; Alfred E. Gathorne-
Hardy, London [d. 1918]; Geoffrey Gathorne-Hardy,
London [1878–1972]; Robert Gathorne-Hardy, London
[1902–1973] (sale, London, Sotheby's, 28 April 1976,
lot 10); Woodner Collections (Shipley Corporation).

**EXHIBITIONS**

London 1971–1972, no. 22; Woodner, Malibu 1983–
1985, no. 5; Woodner, Munich and Vienna 1986, no. 9;
Woodner, Madrid 1986–1987, no. 12; Woodner,
London 1987, no. 9; Woodner, New York 1990, no. 11.

**LITERATURE**

Robinson 1869, no. 399; Gathorne-Hardy 1902, no. 41;
Berenson 1903, 2: no. 1348; Scharf 1935, 131, 147, no. 325;
Berenson 1938, 2: no. 1353a; Berenson 1961, 2: no. 1353a;
exh. cat. London 1973, under no. 36; Shoemaker 1975,
1:375, no. 114.

**FIGURE 2**

Filippino Lippi, *Decorative Designs with a Putto and a Dolphin,* location unknown

**FIGURE 3**

Filippino Lippi, *Sheet of Arabesques,* Gabinetto disegni e stampe degli Uffizi, Florence

# 11  Grotesque Head of an Old Woman

**1489/1490, pen and brown ink on laid paper, laid down, 64 x 51 (2 ½ x 2)**

**Woodner Collections**

*Leonardo was a pupil of Andrea del Verrocchio (1433–1488) in Florence and worked for most of his career in Florence and Milan. He finished very few paintings, but works like the* Last Supper *(refectory of the monastery of Santa Maria delle Grazie, Milan) and* Mona Lisa *(Louvre, Paris) are legendary. Endowed with an inordinately inventive and inquiring mind, Leonardo was also active as a civil and mechanical engineer, a scientist, and a theoretician. Around 1516 he accepted an invitation from François I to settle in France, where he was given the Château of Cloux near Amboise. Because Leonardo was given to jotting down his ideas and observations in notes and sketches—no matter what the purpose or subject—more drawings by him have survived than by any other artist of the Italian Renaissance.*

This drawing depicts the head and bust of an old woman with an elaborate coiffure that is gathered at the back and has a small tiara at the front. A veil emerges from the coiffure at the nape of the neck (perhaps the end of the same fabric into which the hair is gathered). The style of the coiffure was already outmoded when this drawing was made, having been in vogue in Italian court circles toward the middle of the fifteenth century. The woman's low, receding forehead and the small aquiline nose are counterbalanced by the high and fleshy form of the upper lip, while the lower lip, by a rule of opposites dear to Leonardo, is almost nonexistent, as is the chin. Nearly imperceptible are the lines that describe the small folds in the upper lip, indicating the lack of teeth. A few strokes of the pen suggest the shriveled skin, tight under the cheek bones and toward the temples. The curved but wavering lines that delineate the woman's empty, flabby bosom are echoed by the opposing curve of her back, practically a small hump. Hence it is, as a whole, an almost animal-like image—and completing, perhaps mocking, the old woman's physical decay and dull-witted expression is the pretty detail of a carnation inserted between the breasts in the laced-up bodice of the dress, the only agreeable element of the "portrait."

This and several grotesque heads at Chatsworth have given rise to a critical controversy. Kenneth Clark first considered their style to be too finished and descriptive, a sign of a certain disagreeableness, so much so that he cast doubt on the attribution of the drawings as a whole. A. E. Popham also expressed reservations about the group's authenticity but later considered it autograph. Bernard Berenson included a Chatsworth drawing depicting a *Kneeling Leda* in the enlarged edition of his inventories of Leonardo's drawings but did not include the series of twenty-five grotesque heads from the same collection.[1] In 1939, however, in the series on drawings presented by the Reale Commissione Vinciana, Adolfo Venturi published the entire Chatsworth group, including the present grotesque, as autograph works of Leonardo. In 1954 Ernst Gombrich also reevaluated the complete Chatsworth series and especially the drawing under discussion, perhaps also for reasons of polemics with Berenson and Clark. As a result, all successive criticism hinges on Venturi and Gombrich.[2] In the second edition of his catalogue of Leonardo drawings at Windsor, Clark reaffirmed his opinion on the weakness of the style of the Chatsworth series, but while not sharing Gombrich's psychological reading of the series—and, in general, of Leonardo's grotesques—he was in fact compelled to acknowledge the group's authenticity.[3] Incredibly, a few years later, in 1976, it was Gombrich himself who added a question mark to the attribution to Leonardo in the caption of the Woodner drawing, a question mark that has remained even in the most recent Italian translation of his volume of essays.[4]

The suspicion that this drawing might be a copy by Francesco Melzi that was substituted for a lost autograph work by Leonardo (as are certain sheets at Windsor) must be dismissed. Other drawings still at Chatsworth, very weak in quality and drawing style, are in fact certainly workshop copies,[5] but they must not drag with them the grotesques of greater quality that are secure Leonardo autographs. For the *Grotesque Head of an Old Woman* in the Woodner Collections the absurd but clever detail of the small carnation inserted in the woman's bosom should suffice to speak for the hand and genius of Leonardo. It is a humorous detail that would have been almost incomprehensible for another artist or a copyist, even for Francesco Melzi. (One may see in the copy of this head now in the British Museum [fig. 1] how the carnation becomes dried up, almost a piece of wood, compared to the slender vegetal vibration that Leonardo manages to communicate even at a minute scale in the Woodner drawing.) The draftsmanship of this sheet, furthermore, even though insistent, is, as Clark observed in 1968, identical to that found in the anatomical drawings of 1489 now in the Royal Library at Windsor. This is the date around which the little Woodner drawing is to be placed, 1489/1490, during the artist's overly long Lombard period in which his drawing style evolved considerably.

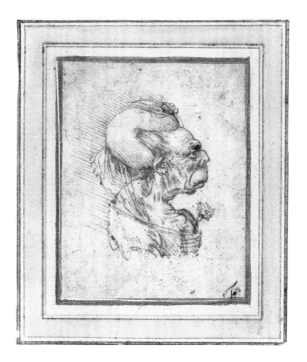

11

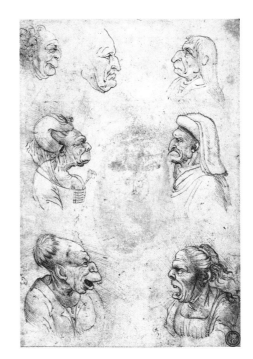

From that setting also derives the work's limited purpose: drawings of this type must have been hurriedly sketched by Leonardo more to satisfy the wishes of the Sforza court than for any psychological reasons. This is in keeping with the taste for Leonardo's "jests" and "puzzles" from the same period, which in turn were lowered to the level of the burlesque and fatuous atmosphere of the court—a graphic and popularized equivalent of the pretentious sonnets of Bellincioni published in 1493. The persistence with which Leonardo drew grotesque heads (different in spirit and function from caricatures, according to the subtle distinction made by Clark) must, however, find its motivation in a type of research into the monstrous, the astounding, and the unusual—parallel with (and not always in opposition to) the pursuit of and research into the beautiful and the sublime. These two contrasting aspects always coexist in the mind and work of Leonardo and constitute two of the major spheres around which his studies turned.

The caricatures and grotesque heads by Leonardo enjoyed great success among his contemporaries and later among European collectors. Artists took possession of them as sources for themes and models for an art that, in a climate of mannerism, especially in Northern and Flemish circles, must have furnished "genres" that were alternatives to sacred painting (a female figure in a painting derived from Quentin Massys [National Gallery, London] seems to be descended from the Woodner grotesque).[6] For collec-tors the drawings were objects of easy acquisition and consumption.[7] A large number of caricatures and grotesques by Leonardo were also engraved: by Wenzel Hollar (1607–1677) during his residence in England; and later by the Comte de Caylus in Paris. Caylus published the Woodner grotesque head (fig. 2) in his *Recueil de testes de caractère et de charges dessinées par Léonard de Vinci florentin et gravées par le C. de C.* (Paris, 1730) (most of the Leonardo drawings used by Caylus were then owned by P. J. Mariette). The present drawing was also copied very early: there is a copy of it in Washington (fig. 3) and the one in the British Museum in London (fig. 1), where six other grotesque heads are added, some of which were taken from the drawings at Chatsworth.[8] The engravings that were made after drawings by Leonardo and the copies made after the drawings themselves gave rise, during the eighteenth century, to a further production of the genres. Two such paintings of Lombard origin depicting the head of a moustached woman and a head of a man with aquiline nose and conical headgear (figs. 4 and 5) reveal their distant prototypes in the drawings of the series that remained at Chatsworth,[9] an indication of the fortunes of Leonardo's grotesques, which, almost uninterruptedly, continued from the sixteenth century to the end of the eighteenth. • *Pietro C. Marani* •

**FIGURE 3**

Francesco Melzi, *Two Grotesque Heads,* after Leonardo da Vinci, National Gallery of Art, Washington, Gift of Mrs. Edward Fowles

**NOTES**

1. See Clark 1935; Popham 1946; Popham and Pouncey 1950, 72–73; and Berenson 1938, 110, no. 1013A.
2. See Venturi 1939, fasc. 5, pl. 7, no. 212; and Gombrich 1954, 197–219.
3. Clark and Pedretti 1968–1969, 1: XLIV.
4. See the reprinting of his 1954 essay in Gombrich 1976, 67, fig. 152; and also Gombrich 1986, fig. 157.
5. See, for example, the drawings in Caroli 1991, 160, 161, and 162, nos. 17, 20, 24, and 25.
6. Compare Paliaga 1995. See also Kwakkelstein 1993, 39–62.
7. On the collecting of Leonardo drawings see Roberts in Nepi Sciré and Marani 1992, 155–178; and Bora in Fiorio and Marani 1991, 206–217.
8. Popham and Pouncey 1950, 72–73, cat. 119, pl. 119.
9. These two paintings seem to derive from a compilation of different grotesque heads by Leonardo. See, in addition to the Woodner drawing with its very similar breasts and bodice, the two drawings at Chatsworth reproduced in Caroli 1991, nos. 10, 14 (sold in London, Christie's, 3 July 1984), and 25.

**FIGURE 4**

Lombard School, eighteenth century, *Grotesque Head of a Woman,* private collection, Lugano, Switzerland

**FIGURE 5**

Lombard School, eighteenth century, *Grotesque Head of a Man,* private collection, Lugano, Switzerland

**PROVENANCE**

Thomas Howard, Earl of Arundel [1586–1646]; Nicolaes Anthoni Flinck, Rotterdam [1646–1723] (Lugt 959); William Cavendish, 2nd Duke of Devonshire [1672–1739]; then by descent at Devonshire House and Chatsworth (inv. 820b) (sale, London, Christie's, 3 July 1984, lot 23); Woodner Collections (Shipley Corporation).

**EXHIBITIONS**

Woodner, Cambridge 1985, no. 77; Woodner, Munich and Vienna 1986, no. 6; Woodner, Madrid 1986–1987, no. 7; Woodner, London 1987, no. 6; Austin 1988–1989; Woodner, New York 1990, no. 8.

**LITERATURE**

Venturi 1939, 7, no. 212; Popham and Pouncey 1950, 72–73, pl. 119; Gombrich 1954, 208, 210, pl. CX, fig. 6; Gombrich 1976, 67, fig. 152; Gombrich 1986, fig. 157; Caroli 1991, 159, fig. 16; Jaffé 1994, 4:883.

# 12  Portrait of a Youth

*Trained in Perugia possibly under Fiorenzo di Lorenzo (c. 1445–1525) and Bartolomeo Caporali (1420–c. 1505), Pintoricchio collaborated with Perugino (c. 1448–1524) on the panels of San Bernardino in Perugia, dated 1473. In 1481/1482 he assisted Perugino on the decoration of the Sistine Chapel in Rome. Pintoricchio developed a highly personal, bright and colorful style, in which he merged decorative elements from a wide variety of sources, including ancient grotesques, German and Netherlandish painting, and the paintings of Perugino, Caporali, and other Umbrians. He painted not only altarpieces and devotional pictures but also stories from ancient history, mythology, and legends of the saints. His most delightful ensembles are the Bufalini Chapel in Santa Maria in Aracoeli, the Appartamento Borgia in the Vatican, the Chapels in Santa Maria del Popolo in Rome, the Capella Baglione in Santa Maria Maggiore at Spello, and the decoration of the Piccolomini Library in Siena.*

**c. 1485/1490, leadpoint and brown wash, heightened with white on gray prepared paper, laid down, 255 x 195 (10 1/16 x 7 11/16)**

**Inscribed on the back of the old mount, probably by Anton Maria Zanetti, in pen and brown ink:** *Ritratto di Raffaèle d'Urbino / Giovine. / fatto di sua propria / mano, / quando era in / Scola di Pietro Perugino / suo Maèstro.*

**Woodner Collections**

This exceptionally well preserved drawing has a fascinating history in terms of both its ownership and its attribution. In the collection of Anton Maria Zanetti, the famous eighteenth-century Venetian collector, it was considered to be a self-portrait by the young Raphael.[1] From there it passed into the Kupferstichkabinett in Darmstadt where it was held to be the work of Pintoricchio.[2] It was still considered a work by Pintoricchio when it entered the collection of Robert von Hirsch and also when it was sold at auction in 1978 and acquired by Ian Woodner.[3] Only within the last fifteen years, during which scholars have concentrated again more intensively on the Umbrian school of painting and particularly on its graphic production, has the attribution to Pintoricchio been dropped. First it was presented as the product of an anonymous Umbrian working around 1490, and more recently it has been attributed to Perugino.[4]

If one tries to understand the motivations for changes of attribution, one finds that they are all based on some grain of truth, even if the assumptions are no longer held as valid. The attribution of the Woodner drawing to the young Raphael and the identification of the subject as a youthful self-portrait both perpetuate the image fostered in preceding centuries of the genius painter as a child prodigy. On the basis of a more profound historical understanding of period characteristics, early twentieth-century scholars recognized the realistic qualities in the portrayal and draftsmanship as more typical of the 1480s and 1490s. Oskar Fischel was particularly reminded of the portraits in the Appartamento Borgia in the Vatican Palace carried out by Pintoricchio between 1492 and 1496.[5] Pintoricchio, who had profited stylistically from his collaborations with Perugino, differs from his more famous master in his more pronounced decorative tendencies and in the lack of Florentine schooling. Whereas Perugino had picked up the exquisite qualities of Florentine *disegno* in Verrocchio's shop in Florence, Pintoricchio only had a secondhand knowledge. Thus Pintoricchio's figure canon lacks the ease, poise, and idealism of Perugino's figural repertoire. A certain dryness in the graphic representation of this youth and his rather pointed features correspond very closely to some of Pintoricchio's painted creations. This artist's graphic oeuvre, however, which had been brought together based on some of the criteria indicated above—that is, on the notion of a general similarity to Perugino's style without the idealized figure canon and the "suave" outlines[6]—has

recently been dismantled by new discoveries. A group of drawings previously considered to be his had to be reassigned to Perugino because of connections to his paintings.[7] For this reason the authorship of all of the remaining drawings attributed to Pintoricchio has been cast into doubt.[8]

Labeling the drawing as "Anonymous Umbrian around 1490" is safe but not satisfying since so few drawings survive by Perugino, Pintoricchio, or their contemporaries and assistants such as Andrea d'Assisi called l'Ingegno, (particularly praised by Vasari),[9] Rocco Zoppo, and Antonio da Viterbo called Pastura. Individual works by these collaborators are not generally recognized and nothing is known about their drawing styles or the level of quality they reached, far less even than is known about Pintoricchio. For these reasons Perugino—the master of Umbrian painting, the link with the artistic capital Florence, the teacher of Raphael, and the most renowned draftsman of the group—was put forward as the most probable author.

In technique the drawing is indeed comparable to a number of Perugino's accepted studies published by Fischel in 1917, most notably perhaps to the head study for a Madonna in Windsor and *Head of a Bearded Man* in the British Museum (figs. 1, 2).[10] In these the whites are applied in fine, mostly vertical lines with some following the curves of the surfaces. In addition, Perugino often used dark wash over metalpoint to emphasize the shaded parts,[11] as we see here in the hair. It is quite logical,

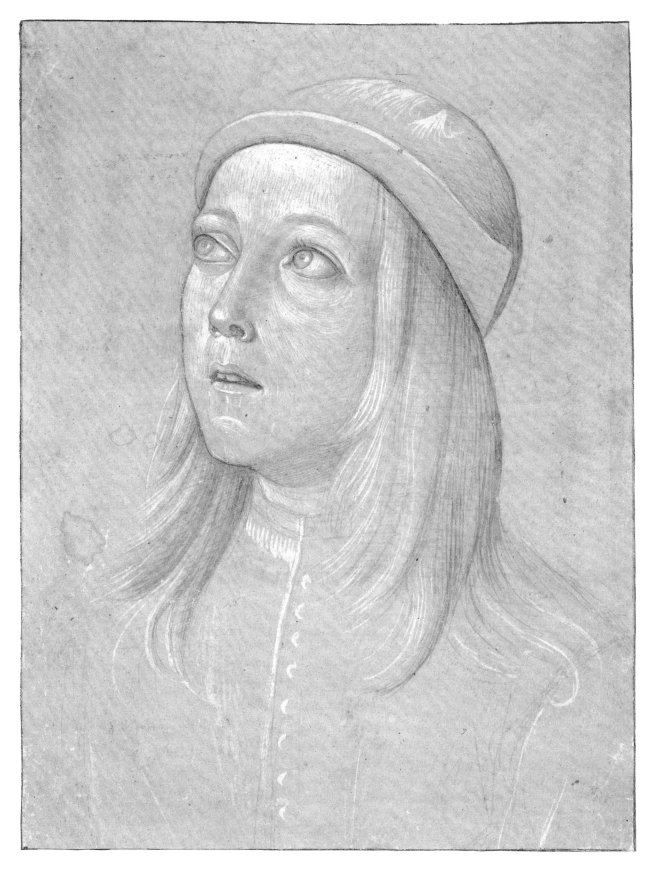

12

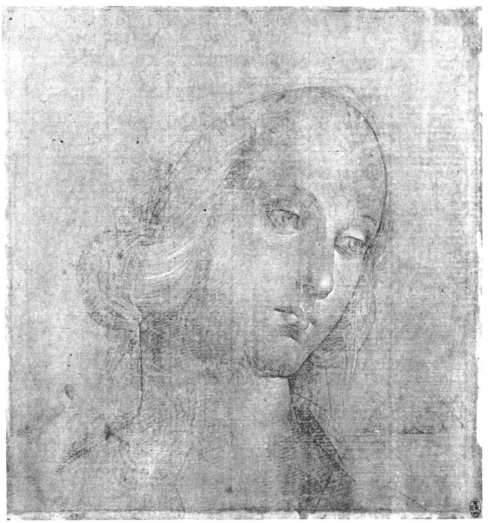

**FIGURE 1**

Perugino, *Head of the Virgin,*
The Royal Collection © Her
Majesty Queen Elizabeth II

however, that Perugino, who had picked up this technique in Florence, would have passed it on to his pupils and shop members. Possible physiognomic comparisons may be made with the portrait heads in the Sistine frescoes, which Pintoricchio had a hand in executing, but also with those in the frescoes of the Appartamento Borgia already mentioned by Fischel. The often-quoted relationship with the portrait painting of a youth in Dresden,[12] once attributed to Pintoricchio and now in my view rightly assigned to Perugino, is too generic in both physiognomic terms and in formal conception for a discussion of the attribution of the Woodner drawing. In any case, the Woodner head seems not to have been done to memorialize the individual traits of the sitter but rather to render the expression of admiration or adoration needed within the larger context of a painting. The boy could have been intended for use as an adoring angel in an Ascension or as little Tobias looking up at the Archangel Raphael.

There are indeed traits in the Woodner drawing that are found nowhere else in Perugino's graphic work, most notably the nearly mechanical insistence—particularly disturbing in the sharpness and precision of the strokes—with which the features are rendered. This painstaking realism seems to contradict Perugino's lofty idealism, which permeates all of the head studies attributed to him so far, even the most realistic and functional ones.[13] But if the execution of the drawing is placed earlier, in the late 1470s, the head type is incompatible with

the Peruginesque idiom. All these traits, which do not correspond with Perugino's draftsmanship, actually characterize Pinto-ricchio's artistic language, from the physiognomy and formal concept to the decorative graphic handling, as was pointed out earlier. I therefore think it better to reattribute the drawing to Pintoricchio, even if we have no certain proof of his graphic capacities. This drawing could serve as a basis on which to try to reconstruct Pintoricchio's graphic oeuvre. • *Sylvia Ferino-Pagden* •

**NOTES**

1. See Woodner exh. cats., London 1987, no. 5, and New York 1990, no. 6.
2. See Schönbrunner and Meder 1896–1908, 5: no. 552; and Fischel 1917, pt. 2, no. 111.
3. Sale cat., London, Sotheby-Parke Bernet, 20 June 1978, 1: no. 22.
4. Goldner in Woodner exh. cat., Malibu 1983–1985, no. 6; then Woodner exh. cats., Madrid 1986–1987, no. 6, London 1987, no. 5, and New York 1990, no. 6.
5. Fischel 1917, pt. 2, no. 111.
6. Fischel 1917, pt. 2, pp. 118–136.
7. Ferino-Pagden in exh. cat. Florence 1982, nos. 47–51.
8. See Fischel 1917, pt. 2, nos. 97, 105, 113, pls. 266, 273, 280. Compare the hatching in nos. 105 and 113 with the shaded drapery in one of the sibyls in the vault of the Baglione Chapel at Santa Maria Maggiore, Spello (see Carli 1960, pl. 116).
9. Ferino-Pagden 1981, 68; Miller 1991, 345; Todini and Zanardi 1980, 90. See also Vasari 1966 ed. 3:613.
10. Fischel 1917, pt. 2, nos. 44, 45.
11. Fischel 1917, pt. 1, colorplate IV (Düsseldorf, Akademie).
12. Carli 1960, pl. 16; Woodner exh. cat., Madrid 1986–1987, 28, no. 6.
13. Fischel 1917, pt. 1, pls. 16, 18; pt. 2, pls. 102, 113, 114.

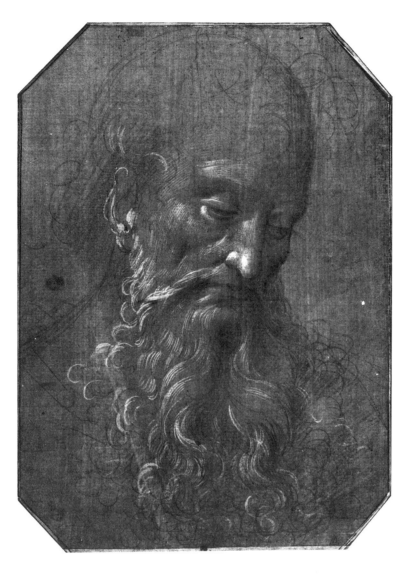

**PROVENANCE**

Anton Maria Zanetti, Venice [1679 / 1680–1767] (Lugt 2992f); Kupferstichkabinett, Darmstadt; Robert von Hirsch, Basel [1883–1977] (sale, London, Sotheby-Parke Bernet, 20 June 1978, lot 22); Woodner Collections (Shipley Corporation).

**EXHIBITIONS**

Woodner, Malibu 1983–1985, no. 6 (as Umbrian School); Woodner, Munich and Vienna 1986, no. 5 (here and subsequently as Perugino); Woodner, Madrid 1986–1987, no. 6; Woodner, London 1987, no. 5; Woodner, New York 1990, no. 6.

**LITERATURE**

Schönbrunner and Meder 1896–1908, 5:552; Fischel 1917, pt. 2, no. 111, fig. 278; *Stift und Feder* 1928, no. 12.

# 13 Christ on the Cross *(recto)*
# Female Figure Kneeling in Prayer *(verso)*

**c. 1490, pen and black ink with gray wash on laid paper (recto) (extensive repair at left); pen and black ink (verso), 211 x 177 (8 5/16 x 6 15/16)**

**Woodner Collections**

Contrary to recent opinion, the figure and drapery studies on both sides of this sheet are quite characteristic of the Strasbourg painter known as the Master of the Coburg Roundels.[1] Uncertainty regarding the attribution has arisen presumably because the artist's drawings are poorly known, are scattered among many collections, and were executed in a great variety of styles and techniques. His oeuvre of more than 150 drawings, the largest preserved by any German artist before 1500, consists primarily of sketches like the Woodner work, in which the artist records individual figures or entire compositions by other artists. Following a typical late Gothic workshop practice, he thus assembled a vast storehouse of images to serve as inspiration or as models for his own future work. A few drawings with compositions of his own invention have come down to us, but the Woodner sheet of studies is not one of these.

The disparate nature of the many paintings, sculpture, and engravings the master copied accounts for the enormous stylistic variety in his drawings and hence for the difficulties of attribution. The range of media he copied, the purpose of a given drawing, and the type of access he had to

his model introduced additional variables into the work. The master's style also varied somewhat as a result of the techniques he used. All of his drawings were executed in pen and ink, but he changed the thickness of the pen, the color of the ground on the paper and of the wash, and the use of heightening.

Uncertainty about whether the sketches on both sides of this sheet were drawn by the same hand was probably due to the dif-

**FIGURE 1**

Master of the Coburg Roundels, *Throne of Mercy with the Virgin and Saint John as Intercessors,* Musée des Beaux-Arts, Lyons

ferent techniques, models, and purposes for which the master recorded these motifs.[2] In *Christ on the Cross* he evidently wanted to capture the forms and proportions of the almost-nude body, especially its modeling. Thus he used no cross-hatching, but rather a light gray wash to emphasize round forms rather than linear ones. The application of wash to enhance the three-dimensionality of figures or backgrounds is common in this master's work.[3] The attractive contrast between the plasticity of Christ's body and the flat linearity of the loincloth, with almost no wash, shows how the artist selectively copied only what interested him in a given model.[4]

The haltingly executed pen contours around the body of Christ have the somewhat belabored appearance of forms painstakingly copied, not spontaneously invented. The master's typically dry, scratchy pen work sometimes produced a discontinous line where the pen skipped over slight irregularities in the laid paper. Thus, even when copying another artist's work, the master's stylistic idiosyncracies betrayed his hand: the dry application of ink with the pen, the heavy contours of Christ's eyelids, the rather wooden, summarily drawn toes, the flatness of the loincloth drapery are found in many of his drawings. Indicative of a copy are the omissions of details due to carelessness or lack of interest: the wound in Christ's side, the right edge of the Cross at Christ's waist,

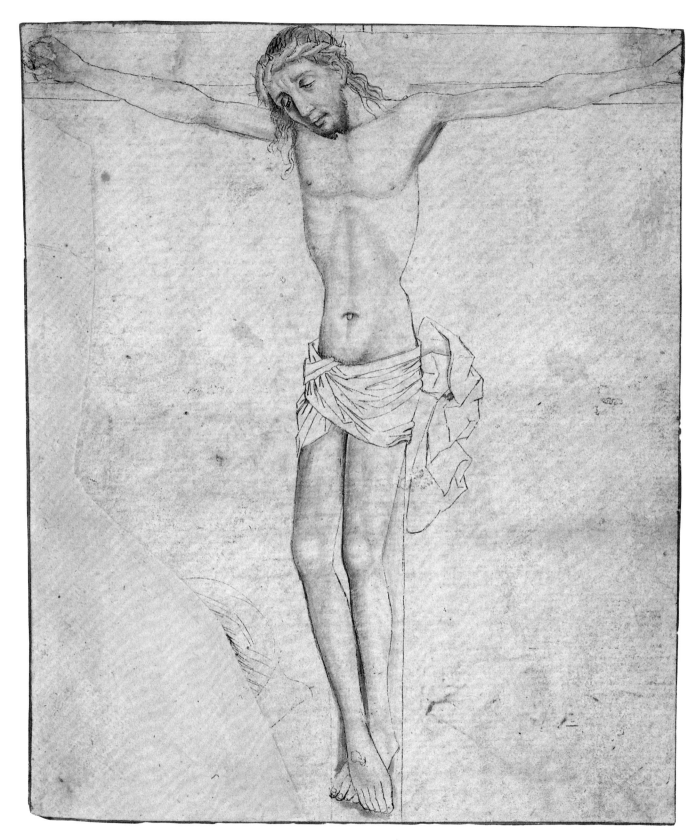

13 RECTO

13 VERSO

the outline and wash on the left underside of the crossbar have all been left out.

The model for this figure presumably derived from Dirk Bouts or his school.[5] The elongated and emaciated proportions of the body, the extremely narrow rib cage, and the handling of the shadow at the abdomen just above the loincloth are typical ways in which Bouts emphasized Christ's suffering; see his *Crucifixion* and *Deposition from the Cross* (Capilla Real, Granada), for instance.[6] Unfortunately, Christ's fingers, so expressive in the Boutsian painting, have been damaged at the left of this drawing and cut off at the right. Another closely similar drawing of *Christ on the Cross* by the Master of the Coburg Roundels, executed in the same technique but including the mourners under the Cross, is preserved in Coburg.[7] The extremely elongated Boutsian proportions of the dead Christ as shown in the Woodner sheet were those the master consistently used in his own paintings: for example, in his *Throne of Mercy with the Virgin and Saint John as Intercessors* (fig. 1),[8] a panel not previously recognized as the master's work, or in the *Crucifixion* panel of the altarpiece shown in the background of his *Last Communion of Saint Mary Magdalene* (M. H. de Young Memorial Museum, San Francisco).[9] • *Christiane Andersson* •

**NOTES**

1. The artist takes his name from two round designs for stained glass preserved in the Kunstsammlungen der Veste Coburg, Franconia. He was formerly also known as the Master of the Drapery Studies after a frequent motif in his work, visible on the verso of the Woodner drawing. For a summary of the literature and his achievement as a draftsman see exh. cat. Detroit 1983, 388–393.

2. Uncertainty was expressed in Woodner exh. cat., Munich 1986, 104, no. 42.

3. Most of the master's drawings included in exh. cat. Detroit 1983 are washed drawings; see nos. 33–37, 40, 43.

4. When the loincloth, which here plays a subsidiary role, was the object of his study, the master filled entire sheets with the motif; see the drawings formerly in the Rodrigues collection, today in Strasbourg (Anzelewsky 1964, 50, fig. 6) and in an Austrian private collection (Buchner 1927, 293, fig. 58).

5. The master copied other works by Bouts, including his *Saint Jerome in the Wilderness* in Berlin (Winkler 1930b, 137, fig. 133). Ian Woodner considered the similarity of the *Christ on the Cross* to the work of Bouts to be so great that he attributed the drawing to the Netherlandish master himself (Woodner exh. cat., London 1987, no. 82).

6. Schöne 1938, pls. 9a, 12.

7. *The Crucifixion,* pen and black ink with gray wash, 276 x 234 mm, Kunstsammlungen der Veste Coburg, inv. z 239; Roth 1992, no. 19.

8. Vincent 1962–1966, 375–382, fig. 2. Stange 1967–1970, 2: no. 126, attributed the painting to the "Master of the Breisach Evangelists."

9. Stange 1955, 7, fig. 66.

**PROVENANCE**

Baron Adalbert von Lanna, Prague [1836–1909] (Lugt 2773) (sale, Stuttgart, Gutekunst, 6–11 May 1910, lot 23); Joseph Meder; (L'Art ancien, Zurich); Woodner Collections (Dian and Andrea Woodner).

**EXHIBITIONS**

Woodner, Munich and Vienna 1986, no. 42; Woodner, Madrid 1986–1987, no. 77 (here and subsequently as Dirk Bouts); Woodner, London 1987, no. 67; Woodner, New York 1990, no. 82.

**LITERATURE**

Schönbrunner and Meder 1896–1908, 12: no. 1351; Winkler 1926–1927, 128; Winkler 1930a, 111; Winkler 1930b, 128, 152; Roth 1992, cat. 18.

# 14  Two Pages from the Strasbourg Chronicle

*14a: Maximilian, Duke of Austria, on Horseback*

**c. 1492/1493, pen and black ink over traces of black chalk on laid paper ruled in leadpoint, 387 x 261 (15 ¼ x 10 ¼)**

**Inscribed with various notations overall; dated at lower right in pen and black ink: *1492***

**Watermark: Bull's head with star (cf. Briquet 14917 – 14941)**

*14b: The Crucifixion with the Virgin, Saints, and the Hungerstein Family*

**c. 1492/1493, pen and black ink over traces of black chalk and leadpoint on laid paper in bound volume, page size: 387 x 282 (15 ¼ x 11 ⅛)**

**Woodner Collections**

These two drawings are illustrations from the large, bound manuscript volume known as the Strasbourg Chronicle. The volume consists of 297 double-columned folios inscribed with extensive German texts written in various shades of brown ink and in several different hands. Fifty-nine of the original folios, some of which bear a watermark that can be dated approximately to the end of the fourteenth century, remained unused.[1] Seventy-four additional blank sheets, some bearing a different watermark, were apparently added when the book was bound in the seventeenth century.[2] The binding is seventeenth-century pigskin over wooden boards, blind-stamped with panels of Justice and Fortune in multiple

borders on the front and back covers (fig. 1), with brass mounts and catches. Folios 3, 4, 54, and 55 were removed at an unknown date; folio 62, which bears an illustration of *Maximilian, Duke of Austria, on Horseback* on the verso, has remained with the volume and is exhibited here.[3]

Some of the paper used for the Strasbourg Chronicle suggests that it was begun shortly before 1400. The earliest manuscript was then expanded in 1492 at the order of Johann von Hungerstein and illustrated with pen drawings, which in some cases cover entire sheets. The manuscript is dated 14 May 1493 in the colophon, but additions to the text continued to be made through the beginning of the seventeenth century. The essential sections of the text were based on the world chronicle of Jakob Twinger von Königshofen (1346–1400), whose work was printed by Bämler in Augsburg in 1476, but transcriptions from other chronicles printed in Strasbourg around 1480 are also assembled in it,[4] and the whole was expanded with events involving the Habsburgs and the Hungerstein family, which rose to prominence in the second half of the fifteenth century in Alsace.

Besides a few illuminated initials drawn in brown and red inks by a none-too-ambitious miniaturist (the scribe?) on the earliest portions of the text, the manuscript still contains four full-page illustrations, which were added during the expansion of the text in 1492/1493; a fifth, which has remained with the volume, was excised at an unknown date. These are on folio 5r: *Tree of*

*Jesse* (fig. 2); folio 15r: *Siege of Troy* (fig. 3); folio 61v: *Arms of Maximilian as Roman Emperor* (fig. 4); folio 62v: *Maximilian, Duke of Austria, on Horseback,* dated 1492 (colorplate); and folio 118v: *The Crucifixion with the Virgin, Saints, and the Hungerstein Family* (colorplate). Four of the pen drawings have been attributed to an unknown Alsatian draftsman of some importance, whereas the *Siege of Troy* has been considered the work of another, less able artist.[5]

The illustrations correspond to the contents of the chronicle, which are divided into six chapters. The first presents the story of the Creation (beginning on folio 1). The next treats the emperors and Roman kings (folio 15). The third deals with all of the popes from the birth of Christ to Urban the Sixth and their accomplishments (folio 119). The fourth records all the bishops of Strasbourg (folio 162). And the fifth is concerned with the founders of the city of Strasbourg and the land along the Rhine (folio ccvii). The sixth chapter is an index with page references and dates for historical and biblical events (unpaginated).

Concerning the patrons of the Strasbourg Chronicle, Fedja Anzelewsky called attention to a double-sided drawing in Berlin (figs. 5, 6).[6] On the recto a nude beauty serves as a shieldbearer for the arms—as sixteenth-century annotations reveal—of Johann von Hungerstein (a leaping hound) and Agatha Reiff (a silver brook on a diagonally partitioned field). Above are the initials of their first names, *H+A*, crowned and bound together with a love knot and

14a

14b

two *l*s to either side, which is apparently a hitherto unknown device. The verso shows God as creator of heaven and earth, blessing Adam and Eve in the Garden of Eden. According to Anzelewsky, this drawing is also by the principal master of the chronicle, may have served as a design for a stained-glass roundel for the center of a window, and was presumably produced for the couple's wedding or shortly thereafter. The Hungersteins were burghers of Gebweiler, while the Reiffs were Strasbourg patricians. The wedding took place in 1489; Agatha died in 1498, Johann in 1503.[7]

For the artistic origins of the chronicle's drawings, especially the *Crucifixion,* scholars have emphasized the influence of the prints of Martin Schongauer (Bartsch 22, 24, and 25) and of Master E.S., while perceiving a connection between the composition of the donor group and contemporary Strasbourg stained glass, especially that of Peter Hemmel von Andlau.[8] Thus the illustrations of the Strasbourg Chronicle, though made around 1492/1493, are drawn in a style that was in vogue as much as twenty years earlier.

Anzelewsky has already tried to link the drawings with Peter Hemmel or the Master of the Coburg Roundels (cat. 13), both of the Strasbourg School, without finding a direct attribution to either of these masters possible. In the meantime, more concentrated study of stained-glass painting in Strasbourg has produced considerable new knowledge and provided access to new material that now permits a

reconsideration of the style and attribution of the chronicle illustrations.[9] The draftsman must in fact have been more closely connected with the Strasbourg "workshop partnership" *(Werkstattgemeinschaft)* than was previously believed. It appears, for instance, that the derivation of the *Crucifixion* owes less to the direct influence of the prints of Master E.S. and Schongauer than to their transposition into models, such as those used also by the Master of the Coburg Roundels for the Lyons *Throne of Mercy* (see fig. 1 under cat. 13).[10] There one encounters the closest parallels for the type of John the Evangelist and the angels, especially for the form of the wings of the musical angel on the left near the dove of the Holy Spirit in Lyons and the angel at the feet of Christ in the *Crucifixion.* The chief master of the Strasbourg Chronicle nevertheless differs from the "nervous" drawing style of the Master of the Coburg Roundels in his clearly articulated drawing of hands and contours, in the clear arrangement of broken folds in his drapery forms, and likewise in the serene fields of hatching with which he covers the half-tones and dark areas. His handling of the drawing medium appears to be most closely related to the repertory of the Strasbourg workshops around 1480, at the time of the great commissions of Tübingen and Ulm. The formal predecessors of the grieving Virgin under the Cross, for instance, may be found there, along with a wholly similar language of expression in the hands, with each finger clearly drawn.[11]

**FIGURE 1**

Binding of the Strasbourg Chronicle, Woodner Collections

**FIGURE 2**

*Tree of Jesse,* folio 5r from
the Strasbourg Chronicle,
Woodner Collections

The decisive, orderly, systematic style of drawing that characterizes the *Crucifixion,* the equestrian portrait of Maximilian, and the *Arms of Maximilian* in the manuscript nevertheless stands in clear contrast to the Berlin drawing (figs. 5, 6), which was executed by a draftsman of decidedly different gifts. He was much less careful and systematic in his handling of line, as for example in the helmet crest of the arms, in the treatment of the terrain behind God in the depiction of the Creation on the verso, and in the band of clouds and stars framing the scene. Otherwise one finds here the expression of a different temperament, which appears to handle the pen carelessly but is in no way inferior to the presumably earlier draftsman of the *Crucifixion* in his ability to achieve his aims through the spontaneous and expressive use of line.

On the other hand, the characteristic form of the hatching in the terrain, grass, and flowers, the little fish in the water, and the stars of the *Creation* show points of stylistic connection with the draftsmanship of the *Siege of Troy* (fig. 3). The relationship is even clearer in the image of the *Tree of Jesse* (fig. 2), in which Jesse, sleeping with one hand propped up in the lower margin of the page, is rendered with clear lines and a rational, transparent application of hatching. The tree rises from his breast in evenly weighted, sure lines up to the first bifurcation. Then the style of drawing changes: from the horizon line upward, the vines appear to be grafted on by the hand of another draftsman, who also drew the

small busts as well as the Madonna, the Crucifixion, and the tendrils spreading out to the sides. While the stylistic features of the sleeping Jesse correspond closely to those of the equestrian portrait of Maximilian, the above-mentioned "handwriting" of the Berlin draftsman is evident in the scrolling vines above and in the portrait medallions contained within these. The Virgin on the upper margin of the illustration, for instance, corresponds closely with Adam and Eve in the *Creation;* the elongated body and crude, short hatching of the Crucifixion at upper left relate to the figure of God in the *Creation;* while the shrieking birds in the vine scrolls on the left margin match those below the herons in the *Creation.* Thus two different, clearly distinguishable hands shared the decoration of the folio with the *Tree of Jesse.* This differentiation of drawing styles confirms that the draftsman of the Berlin sheet—even if he was not, as Anzelewsky believed, identical with the artist responsible for the *Crucifixion, Maximilian,* and the *Arms of Maximilian*—worked on the Strasbourg Chronicle.

These close stylistic connections suggest that the Berlin page was once actually part of the chronicle. Its dimensions, 366 x 262 mm (but evidently cut down all around), also accord with the format of 384 x 282 mm occurring, for instance, in the *Tree of Jesse.* And the images on the Berlin page would make sense within the context of the book. Two folios that were once bound into the manuscript, numbered *3* and *4* in arabic numerals at the upper right,

**FIGURE 3**

*Seige of Troy,* folio 15r from the
Strasbourg Chronicle, Woodner
Collections

**FIGURE 4**

*Arms of Maximilian as Roman
Emperor,* folio 61v from the
Strasbourg Chronicle, Woodner
Collections

**FIGURE 5**

*The Arms of Johann von Hungerstein and Agatha Reiff*, folio from the Strasbourg Chronicle, Kupferstich-kabinett, Staatliche Museen zu Berlin

**FIGURE 6**

*The Creation: God Blessing Adam and Eve* (verso of fig. 5)

are missing. The actual text begins only on folio 5, which illustrates the *Tree of Jesse*; this sheet also bears an apparently older number, roman numeral *1*, at the top center to the left of the Virgin, which was covered by the drawing. Similarly, the large, red initials of the right-hand column of script occasionally invade the portrait medallions in an awkward manner. All of this suggests that the page was not originally intended for decoration, and it also indicates that the original collation of the manuscript was altered. Since this page, moreover, begins, along with a brief outline of the written sources used, with the information concerning the contents of the chronicle, "Das Erste Capittel seit wie got die welt anfieng und Hymel un erde und alle Creaturen" (The first chapter concerns how God created the world, heaven and earth and all the creatures…), a rendition of the Creation on the adjacent left page would also be a logical opening illustration. The family arms on the other side of the sheet, the recto, would be equally appropriate as the frontispiece of the manuscript. Thus the unusual association of the nude female armsbearer on one side and the story of the Creation on the other would become easily explicable.[12]

Two additional folios, both sold at auction in 1993, can also be joined with certainty to the Strasbourg Chronicle. Bearing illustrations of the *Neuf preux*, or Nine Worthies, on three of their sides, these are folios 54 and 55 (fig. 7) from the second chapter on the Roman emperors and

kings.[13] The figures of Joshua, King David, and Judah Maccabee (recto), King Arthur, Emperor Charlemagne, and Gottfried von Bouillon (verso) on folio 54, and Hector of Troy, Alexander the Great, and Julius Caesar on folio 55, accord perfectly with the style of the equestrian portrait of Maximilian. Moreover, the image of the three pagans is dated *1492* below Alexander.

As the connections adduced here indicate, the Strasbourg Chronicle evidently has not survived in its original collation. Worked on by a number of scribes over a period of more than two centuries, and complicated by late additions of new paper and the removal of an unknown number of folios, it is difficult to reconstruct the complete, original organization of the book. A careful, codicological study of the chronicle, which has not yet been undertaken, would undoubtedly yield highly informative and interesting results. • *Fritz Koreny* •

## NOTES

1. The watermark on the page with *Maximilian, Duke of Austria,* is most similar to one appearing on a document in Würzburg dated 1394 (Briquet 14923).

2. The crossed arrows with a star watermark dates the paper to the third quarter of the sixteenth century. See Briquet 6291, 6298–6300.

3. Both roman and arabic numerals are written on many of the pages, but unfortunately the numbering diverges from the very beginning of the book. Folio I (roman numeral), for example, is also numbered 5 (arabic). To avoid confusion, the pages will be referred to here by the arabic numerals written on the recto in the upper right corners, except in cases where only a roman numeral exists.

4. This is partly referred to in the text of the chronicle itself (folio 5); see the extensive description by Schab in Woodner exh. cat., New York 1973–1974, no. 1.

5. Already noted by Schab in Woodner exh. cat., New York 1973–1974, and accepted by all scholars thereafter.

6. In exh. cat. Berlin 1973, no. 10.

7. On the Hungerstein family see Knobloch 1882, 41, and *Oberbadisches Geschlechterbuch* (Heidelberg, 1905), 2:176, 177. Interestingly, the Hungerstein arms, as Anzelewsky observed in exh. cat. Berlin 1973, also appear on a drawing, now in Karlsruhe, for a stained-glass roundel. The actual glass roundel has also survived in a private collection, and an article on this is being prepared by E. Pokorny, Vienna. Schab also recognized Schongauer's print of a wild man with a springing hound (Bartsch 103) as a Hungerstein cypher, and Falk 1979, no. 80, noted a connection between the sheets in both Berlin and Karlsruhe and a pen drawing with a greyhound coat of arms and a lion helmet crest in the Kupferstichkabinett, Basel.

8. Schab in Woodner exh. cat., New York 1973–1974, no. 1; Anzelewsky in exh. cat. Berlin 1973, no. 10.

9. See exh. cat. Ulm 1995, with further references.

10. Roth 1992a, 169, fig. 19.

11. See exh. cat. Ulm 1995, nos. 22, 31.

12. It is not known when the Berlin page was excised from the Strasbourg Chronicle, but its history can be traced back through various collections for about a hundred years. See exh. cat. Berlin 1973, no. 10.

13. Sale cat., London, Christie's, 7 December 1993, lot 121A, as South German School. The roman numeral on folio LIIII was probably wrongly transcribed as LIII in the catalogue.

## PROVENANCE

Hungerstein family; Biblioteca Künastiana, Denmark, 1667 (inscription on the inside of the cover) (sale, London, Christie's, 28 June 1972, lot 31); Woodner Collection (Shipley Corporation).

## EXHIBITIONS

Woodner, New York 1973–1974, no. 1; Woodner, Malibu 1983–1985, no. 39; Woodner, Munich and Vienna 1986, nos. 44, 45; Woodner, Madrid 1986–1987, nos. 53, 54; Woodner, London 1987, nos. 41, 42; Woodner, New York 1990, nos. 51, 52.

## LITERATURE

Exh. cat. Berlin 1973, under no. 10.

**FIGURE 7**

*Hector of Troy, Alexander the Great, and Julius Caesar,* folio 55 from the Strasbourg Chronicle, location unknown

# 15 Study of a Knight in Armor, Holding a Halberd

**c. 1500, pen and brown and black ink, point of the brush and black ink, gray wash, heightened with white, on brown prepared paper (upper corners made up), 288 x 122 (11 5/16 x 4 13/16)**

**Watermark: Bull's head with snake (cf. Briquet 15367–15373)**

**Woodner Collections**

This very skillfully done rendering of a standing knight in armor is a characteristic example of the studies from life that late Gothic artists made for later use in paintings. Realistically drawn and precise in the technical details, such studies served as models for the staffage figures that populated religious pictures such as Crucifixions and martyrdoms of saints. This type of drawing was routinely produced by late fifteenth- and sixteenth-century artists, who valued them as tools for their work and often handed them down from one generation to the next. The technique of chiaroscuro drawing was customarily used to give such figures greater plasticity, anticipating their appearance in paintings: over the dark ground, the tones range from black and brown ink lines, with gray wash as a middle value, to the white heightening added last with the fine point of the brush. The standing knight was obviously drawn from a model in the workshop. The realistic highlights added in white at several points along the left side of the helmet and armor show that the light was coming from the left through double Gothic windows. The model's slightly mannered, almost dance-like pose is typical of the elegant refinement of late Gothic art.[1] The rear view, an artistic device borrowed from Italian art, had become popular during the fifteenth century among Northern artists, who used it to demonstrate their skill in figure drawing and to enliven their compositions.

The armor depicted is of superior quality and would have been very expensive in its day, indicating that it must have been made for a member of the wealthy upper class, presumably a knight.[2] The halberd he holds is somewhat puzzling, however, since it is the weapon of an infantryman, *Landsknecht,* or civic guard. Knights generally did not use infantry weapons except during foot combat, usually in tournaments. Emperor Maximilian (1459–1519) actively fostered a revival of the medieval tradition of jousts and tournaments, and perhaps such a sporting contest would explain the unusual combination of the knightly armor and the foot soldier's weapon in the drawing. In *Der Weiss Kunig* (The White King), a novel-like biography of Emperor Maximilian written by Marx Treitzsaurwein (d. 1527) and illustrated with woodcuts by Hans Burgkmair, Leonhard Beck, Hans Schäufelein, and Hans Springinklee,[3] the young White King (Maximilian) learns to fight on foot, using a halberd (fig. 1). The adversaries are shown in an enclosure typical of foot combat at court.

The steel armor shown here is essentially late Gothic but demonstrates a traditional style. The backplate, somewhat rounded below the shoulder to imitate the anatomy below, shows an older style, while the rounded and scallop-edged pauldrons, or shoulder defenses, are more modern features that became widespread by c. 1500. The combination of styles suggests an origin in southern Germany—in Augsburg, Nuremberg, Landshut, or Innsbruck.

The half-length armor clearly shows its purpose for combat on foot, since it leaves the legs free for maximum mobility. Its design reflects contemporary fashion: the shape imitates that of a tunic, for instance, in the V-neck, the pinched waist, the tapering tailplate, and its flared fluting, analogous to fabric folds. Similar late Gothic suits of armor with the same elegant, wasp-waisted forms and pierced decoration are preserved in Vienna.[4] The armor was worn over a shirt of mail, visible at the neck, the left forearm, and the hindquarters, with separate mail breeches protecting the groin and buttocks. While the backplate, shoulders, and upper arm were constructed in one piece, the elbow covers were attached separately, held in place by leather laces attached to the doublet sleeve and visible in the drawing. The two horizontal plates above the waist were loosely interconnected by rivets, or screws, to allow mobility.

The closely fitting and confining helmet derives from Italian types. It is a visored armet, with hinged cheek pieces closing in front of the chin. The raised visor pivots on rivets at the sides. The knight would have had only minimal vision through the space between the lowered visor and the brow of

15

the helmet. The pierced decoration at the top of the snout visor served as ventilation.

In contrast to the armor, the halberd appears to have been of little interest to the artist; it is less carefully observed and summarily drawn. The wooden shaft, the outline of which is executed with a ruler, does not taper toward the top as it would in reality, and its placement, seemingly on the knight's foot rather than next to it, is awkwardly handled.

A number of other studies of soldiers in armor from this period are known. One such drawing in the Albertina, Vienna, shows a soldier in rear view seated at a table, comparable in technique to the Woodner drawing but executed by a less skillful hand (fig. 2).[5] It appears to depict the same armor. Minor differences, such as the number of rivets on the pauldrons, may be attributed to carelessness on the part of the artist. Another Swabian drawing in Coburg, of slightly earlier date, shows a standing knight in frontal view.[6] Rather than a halberd, he holds a pole ax, the weapon knights customarily used in foot combat on the battlefield. The Coburg study is executed in the same chiaroscuro technique as the Woodner sheet—on a colored ground (in this case gray) with gray wash, and using both a pen and the point of a brush, which give such studies their beauty, refinement, and lifelike realism. • *Christiane Andersson* •

**FIGURE 1**

Leonhard Beck, *Maximilian Learning Foot Combat with a Halberd,* from *Der Weiss Kunig,* Sächsische Landesbibliothek, Leipzig

**NOTES**

1. A similar example is the dancelike pose of Saint George wearing partial armor in a Swabian drawing executed at about the same time and in a similar technique; see Falk 1979, no. 135, pl. 40; and Landolt 1972, colorplate 7.

2. I am indebted to Stuart W. Pyhrr, department of arms and armor at the Metropolitan Museum of Art, New York, for sharing his expertise on German armor.

3. The book was in production c. 1506–1516 but remained unfinished at Maximilian's death in 1519. The complete book with text and 251 woodcut illustrations did not appear until 1775: *Der Weiss Kunig: Eine Erzehlung von den Thaten Kaiser Maximilian des Ersten* (Vienna, 1775). See Kaulbach in exh. cat. Stuttgart 1994.

4. Hofjagd- und Rüstkammer (formerly Waffensammlung), Kunsthistorisches Museum, Vienna, inv. A60, and backplate of inv. A62, c. 1485.

5. Tietze et al. 1933, no. 14, inv. 1446; and Schönbrunner and Meder 1896–1908, 8: pl. 874.

6. Exh. cat. Detroit 1983, no. 47, colorplate III.

**LITERATURE**

Exh. cat. Detroit 1983, under no. 47.

# 16  The Virgin Annunciate

*The leading figure of German Renaissance art, Dürer initially trained as a goldsmith with his father, then was apprenticed to the painter Michael Wolgemut (1434–1519). Although closely associated with Nuremberg throughout his life, Dürer traveled to Italy twice (in 1494 and 1505–1507) and to the Netherlands once (in 1520–1521). Apart from his numerous important painted altarpieces and portraits, he was also a prolific draftsman and printmaker. It was primarily through his engravings and woodcuts that his influence became widespread in Europe. He showed an interest in the theoretical aspects of art, writing treatises on geometry, proportions, and fortifications. His patrons included Emperor Maximilian 1, who paid him an annuity from 1515, and humanist scholars, such as Willibald Pirckheimer, with whom he traveled to Switzerland in 1519.*

**c. 1495/1499, pen and brown ink on laid paper, 164 x 143 (6 ⁷⁄₁₆ x 5 ⁵⁄₈)**

**Inscribed at lower center in gray ink: *AD* (in monogram)**

**Watermark: Tall crown with Latin cross (cf. Briquet 4890–4902)**

**National Gallery of Art, Woodner Collection 1993.51.1**

Since its first mention, this drawing has remained in private hands and has thus been little known and received correspondingly little scholarly attention. Most experts, including Friedrich Winkler, were unable to examine it in the original. The sheet was first presented to scholars, and at the same time to a wider public, in the 1971 exhibition in Nuremberg commemorating Albrecht Dürer's 500th birthday.

The drawing apparently presents a design for a Virgin of the Annunciation, although the Virgin usually receives the angel's message kneeling or standing, not sitting as here. The artist may therefore have had another scene in mind. The open book and the movement of the left hand are nevertheless most consonant with the Annunciation. Surprisingly, the unusual iconography has thus far received no comment.

The repeatedly observed relationship of the drawing to Martin Schongauer's *Saint Dorothy* in Berlin (Winzinger 37) consists primarily—although this has not been explicitly stated—in the sitting motif. The

inclination of the head, the attitude of the forward arm, and the drapery treatment, on the other hand, recall Schongauer's *Virgin with the Carnation*, also in Berlin (Winzinger 33). The careful analyses of the draftsmanship of the Dürer sheet in both the Nuremberg anniversary catalogue and the catalogue of the New York exhibition of the Woodner collection in 1990 underline the connection of Dürer's drawing with the work of Schongauer.

Dating of the Woodner sheet has ranged between 1491 and 1495/1496. The

**FIGURE 1**

Albrecht Dürer, *Madonna with the Monkey*, National Gallery of Art, Washington, Gift of R. Horace Gallatin

Dürer drawings usually cited in comparison with this one—numbers 22/23, 30, and 35 in Winkler's catalogue of the artist's work—are all earlier, however. Mary's head here no longer has the childlike character of the drawings of the early 1490s, which derived from Schongauer's example. It is smaller, no longer as round, and already shows Italian influence. The closest stylistic parallels in Dürer's works are the prints of the *Madonna with the Monkey* of around 1498 (fig. 1) and the *Madonna on a Grassy Bank* of 1503 (Bartsch 34). An origin for the Woodner drawing in the second half of the 1490s is thus more likely.
• *Fedja Anzelewsky* •

**PROVENANCE**

E. Desperet, Paris [1804–1864] (Lugt 721) (sale, Paris, Clément, 7–13 June 1865, lot 215); C. Paravey (sale, Paris, Féral, 13 April 1878, lot 110); Baron E. de Beurnonville (sale, Paris, Hôtel Drouot, 16–19 February 1885, lot 147); Martin Le Roy; Marquet de Vasselot (sale, Paris, Palais Galliera, 7 March 1967, lot 57); private collection, Bavaria; (Rolf Kistner, Nuremberg, November 1985); Woodner Collections (The Ian Woodner Family Collection, Inc.); given to NGA, 1993.

**EXHIBITIONS**

Nuremberg 1971, no. 134; Woodner, London 1987, no. 44; Woodner, New York 1990, no. 54; Woodner, Washington 1993.

**LITERATURE**

Leprieure et al. 1909, 177–178, no. 36; Lippmann and Winkler 1883–1929, 6: no. 617; Beenken 1928, 113; Tietze and Tietze-Conrat 1928–1938, 1: no. 26; Flechsig 1928–1931, 2:399, no. 203; Winkler 1936–1939, 1: no. 36; Panofsky 1943, 2: no. 708; Winkler 1957, 35; Schadendorf 1969; Strauss 1974, 1: no. 1491/7.

16

# 17  Nude Seen from Back with Hands Clasped in Prayer

**c. 1497/1500, pen and brown ink on laid paper,
215 x 136 (8 ⁷⁄₁₆ x 5 ⅜)**

**Woodner Collections**

This drawing was dated around 1505 by Engelbert Baumeister, who discovered it in the print cabinet of the Fürstenberg collection in Donaueschingen and published it in 1914 as a work of Dürer. Gustav Pauli corrected this dating based on the comparative examples Baumeister had cited, placing the sheet between 1497 and 1500, which has been generally accepted. Only Hans and Erika Tietze and Eduard Flechsig still considered possible an origin as late as the second decade of the sixteenth century. And only H. Beenken considered the study a copy after Dürer.

The Woodner drawing must be seen in relation to Dürer's early proportion studies. Among these, as has been repeatedly pointed out, the nude seen from the back in the Dresden sketchbook (fol. 164r) corresponds not only in proportions but above all in the way the artist modeled the bodies with loose pen strokes.[1] As Flechsig has rightly noted, however, the present drawing is not a pure study of proportions in the narrow sense. Friedrich Winkler elaborated on Flechsig's view, holding the work to be a life drawing.[2] The apparently rapid sketching of the woman's plump form supports this view, as do the corrections in various places, particularly evident on the raised right arm. The headcloth, with the very precise rendition of its complicated folds, also points to a drawing from life.

The efforts of various authors to find a meaning in this work are sometimes rather remarkable. Baumeister believed it was a study for a Virgin beneath the Cross. The Tietzes saw the figure as an Eve for an image of Christ in Limbo. Winkler believed Dürer had changed what was originally a nature study into a sketch for an intercessor by adding the raised arms with folded hands; he observed that in other cases Dürer had given meaning to studies of drapery folds by making subsequent additions.

Of all the interpretations, Flechsig's is the most convincing: he sees this as a study for a resurrected woman in a treatment of the Last Judgment. Only in this context is there an iconographic tradition for the unclothed forms of both sexes in prayerful attitudes. Flechsig did note, however, that the headcloth would be very unusual in this connection. In Last Judgment scenes women with headdresses generally appear among those damned for their love of finery. But the figure in the present drawing would belong among the blessed entering Paradise on account of her folded hands. Were it not for the hands raised in prayer, one might also consider this a study for a woman's bath. • *Fedja Anzelewsky* •

**NOTES**

1. Strauss 1972, pl. 2.
2. Winkler 1936–1939, 1: no. 159.

**PROVENANCE**

Fürstenberg collection, Donaueschingen; Woodner Collections (The Ian Woodner Family Collection, Inc.).

**EXHIBITIONS**

Nuremberg 1971, no. 468; Woodner, New York 1990, no. 56.

**LITERATURE**

Baumeister 1914, 224 (repro.); Pauli 1919, 27; Lippmann and Winkler 1883–1929, 6:673; Beenken 1928, 114; Tietze and Tietze-Conrat 1928–1938, 2: pt. 1, no. 561; Flechsig 1928–1931, 2:421, 569, no. 673; Winkler 1936–1939, 1: no. 159; Panofsky 1943, 2: no. 1184; Musper 1952, 114, 332; Winkler 1957, 95; Oettinger and Knappe 1963, 93, 95; Strauss 1974, 2: no. 1500/12.

17

# 18 Male Nude Holding a Mirror *(recto)*
# Male Nude with a Lion *(verso)*

**c. 1500, pen and brown ink on laid paper, pricked in several places with the point of a pair of compasses and indented lightly with a stylus, 267 x 141 (10 ⁹/₁₆ x 5 ⁹/₁₆)**

**Inscribed on the verso at lower left in pen and brown ink: *AD* (in monogram)**

**National Gallery of Art, Woodner Collection 1991.182.11.a,b**

This drawing, discovered by H. S. Reitlinger in 1927 in the Lubomirski collection in Lemberg (present-day Lvov), has received a good deal of attention. The drawing was laid down at the time, showing only the standing male nude holding a barely distinguishable object in his left hand. As A. M. Friend Jr. pointed out in 1943, the drawing is based on an antique sculpture of the resting Hercules. Since the only such work excavated before 1500 was the so-called Hercules Borghese in Rome at the foot of the Quirinal, it must be this sculpture, a copy after a statue by Lysippus, that influenced Dürer's drawing. But Friend also recognized that Dürer had been inspired not by the statue itself, but more probably by a drawing after it, comparable to the ones handed down in the Codex Escurialensis.[1] Dürer's drawing of *Apollo* in London (Winkler 261), based on the marble figure of the Apollo Belvedere, presents a similar case. Matthias Winner has shown that a multitude of drawings were made after the

Apollo sculpture, already installed in the Vatican in 1503.[2] Friend's suggestion that a lost drawing after the resting Hercules served as a model for Dürer is thus abundantly corroborated.[3]

The present sheet, however, is no mere copy after a lost model. It must have been a free interpretation of the prototype, for the drawing shows differences from both the sculptural copy after a Greek original and the drawing reproducing it in the Codex Escurialensis. In Dürer's work the figure's right shoulder is raised, instead of lowered as in all the other, anatomically correct versions. The position of the free leg, drawn and then altered, also suggests this is no copy. The two arms provide further evidence: the right one, resting against the back in the original, remains incomplete here, as if Dürer had used a fragmentary figure as a model; the left arm deviates completely from that of the Hercules model, which leaned on a club covered with a lion skin.

From the beginning Dürer intended his drawing as a study of human proportions. This is shown by the vertical lines, scratched in with a stylus (imperceptible in illustrations), touching the inner anklebone and the calf of the right leg as well as the depression at the throat, initially only lightly sketched.[4] From these lines Dürer then derived the standards for the proportions of his figure and fixed the outlines with strokes of the compass, as the puncture marks prove. Finally he corrected the contours

and changed the position of the left leg.

In the next stage of his work the artist traced the proportional figure from the recto of the sheet onto the back, making use of a lighted glass panel. This procedure can be recognized often in Dürer's work, as in the Berlin proportional study of a nude woman with a shield (Winkler 413/414) and the drawings for the Green Passion.[5] Dürer pictorially completed the traced figure with a lion, and accordingly changed the arm positions. Three possible meanings have been proposed for the man with the lion: 1) Hercules with the Nemean Lion; 2) Samson; and 3) the constellation Leo, in whose house Apollo the Sun rests. If, as can be presumed, Dürer was familiar with the Neoplatonic thought of Marsilio Ficino, all three proposed solutions would be defensible. The analogy of Hercules and Samson was certainly known to him, as shown by words he wrote in 1512/1513, "and from Hercules we will make Samson."[6] The third suggestion, first made by Panofsky, would make sense only if the recto had the relevant meaning as Apollo.[7]

A question remains as to whether Dürer intended an iconographic significance for his proportional study on the recto. Nothing of the sort can be recognized in his contemporary constructed figures of women. Probably the interpretation of the object in the figure's hand as a mirror, a sun disk, or a scepter is best viewed as pure speculation.

18 RECTO

18 VERSO

Friend proposed that the sheet is the earliest surviving study of male proportions by Dürer. The proximity to the London *Apollo* and the above-mentioned studies of female proportions (Winkler 161, 413/414) establishes an approximate date. Moreover, the original monogram on the verso has a form related to the one used in the Apocalypse woodcuts, which suffices to show the high value Dürer placed on this work. • *Fedja Anzelewsky* •

### NOTES
1. Egger 1905, 106.
2. Winner 1968b, 181–199.
3. Friend 1943, 47.
4. See the reconstruction drawing in Friend 1943, fig. 8.
5. See Anzelewsky and Mielke 1984, no. 30 (recto and verso); also Schilling 1954, 14–24; White 1973, 369–372.
6. Rupprich 1966, 2:104.
7. Panofsky 1943, 2:149, no. 1597.

### PROVENANCE
Prince Heinrich Lubomirski [1770–1850]; Lubomirski Museum, Lemberg (now Lvov, Ukraine); Dr. and Mrs. Vitale Bloch (sale, London, Sotheby's, 28 June 1962, lot 87); private collection, Nuremberg; (Rolf Kistner, Nuremberg); Woodner Collections (Dian and Andrea Woodner); given to NGA, 1991.

### EXHIBITIONS
Nuremberg 1928, no. 359; London 1957, no. 27; Manchester 1961a, no. 113; Nuremberg 1971, no. 480; Woodner, Munich 1986, no. 3; Woodner, Madrid 1986–1987, no. 61; Woodner, London 1987, no. 46; Woodner, New York 1990, no. 57; Washington 1992, no. 2.

### LITERATURE
Lippmann and Winkler 1883–1929, 6: nos. 739, 740; Winkler 1927, 16; Reitlinger 1927, 159; Tietze and Tietze-Conrat 1928–1938, 1: nos. 169, 170; Beenken 1928, 116; Gebarowicz and Tietze 1929, 11, 12, 16, 17, no. 5; Flechsig 1928–1931, 2:145, 195, 196, 568, no. 493; Winkler 1936–1939, 2: no. 419; Winkler 1942, under no. 8; Friend 1943, 43–49, fig. 6; Panofsky 1943, 1:86, 262, 266, 2: nos. 1596 (recto), 1597 (verso), and under no. 1627 (6); Musper 1952, 112, 332; Fröhlich-Bum 1956, 10; Winkler 1957, 146; Rupprich 1966, 2:37; Strauss 1974, 2, nos. 1500/36 (recto), 1500/37 (verso).

# 19  Pastoral Scene with the Arms of Willibald Pirckheimer and His Wife Crescentia Rieter

**1502/1504, gouache heightened with gold on laid paper, irregularly cut from and pasted back onto page 1 of Aldus Manutius' first edition of Theocritus' *Idylls* and other texts (Venice, February 1496), page size: 310 x 203 (12 ³⁄₁₆ x 8)**

**Woodner Collections**

The present copy of this book, published in Greek by Aldus Manutius, the most famous printer in Venice, can be traced in an almost unbroken chain back to its first owner, the Nuremberg patrician and humanist Willibald Pirckheimer (1470–1530). Pirckheimer studied law from 1488 to 1491 in Padua, and until 1495 in Pavia, and during the same period pursued humanist learning. On 13 October of the year of his return from Italy he married Crescentia Ricter, who died on 17 May 1504. Dürer must have executed the miniature between these two dates.

Since the Venetian year at that time began on 1 March, the printing date of February 1495 means the book was actually printed in February 1496 by modern reckoning. Pirckheimer probably acquired the Theocritus volume after his return from Italy. If Niklas Holzberg's assertions are accurate that Pirckheimer did not resume his Greek studies until 1501 and only in that year began a close acquaintance with Dürer,[1] the book must have been acquired in 1501/1502. In 1504 Pirckheimer could already boast in a letter to Konrad Celtis that

he owned all the books thus far printed in Greek.[2] The Dürer colophon would thus have been painted between 1502 and 1504.

Pirckheimer's book collection had been begun by his great-grandfather and was steadily augmented by his descendants.[3] After Pirckheimer's death in 1530, his library was divided between his daughter Felicitas, who was married to Hans Imhoff, and his sister Barbara Straube. Felicitas' son Willibald Imhoff later reunited the book collection. His descendants, because of the general economic depression during the Thirty Years' War, were forced to sell some of their possessions, above all the works by Dürer and part of the library. The Theocritus went, together with other books, to the Leyden art dealer Matthäus van Overbeck. After passing through several English collections, the volume came in 1966 to the Frankish entrepreneur Schickedanz, from whose holdings Ian Woodner acquired it.

Holzberg's assertion regarding the friendship between the humanist and the painter is corroborated also by the proliferation of works by Dürer for Pirckheimer beginning in 1503, including two portrait drawings in Berlin and the design for the Pirckheimer-Rieter bookplate in Warsaw (Winkler 268, 270, 329). The miniature with the pastoral scene must also have originated during this period. Stylistically it is closely related to Dürer's woodcut *Annunciation to Joachim* from his Life of the Virgin series (fig. 1). The motif of the shepherd

leaning against a tree, with a clublike staff under his arm and the nearly identical positioning of the legs, appears there as well. In both compositions Dürer also used the group of fighting goats or rams, derived from antique sources.

The miniature with the arms of the Pirckheimer couple must have been among Dürer's earliest works for the humanist. It presumably originated as an individual sign of ownership, even before Dürer produced the above-mentioned design for a bookplate for more general use and before the woodcut with Pirckheimer's motto in three languages from 1502 or 1503 (Bartsch app. 52). Another argument for such a dating of this wonderful work is that none of the other bookplates Dürer executed for Pirckheimer is as lavish and pictorial as this one, which was made on a piece of the Theocritus page and then reattached. In the three other books with the arms of Pirckheimer and Rieter, Dürer limited himself to ornamentally elaborated arms painted directly on the lower margins of the respective initial pages.

Pirckheimer had probably become familiar with printed books with hand-painted illumination—to be distinguished from those with colored woodcuts—in Padua, where this artistic genre was particularly cultivated.[4] As Walter Strauss recognized, the iconography of the two seated shepherds probably derives from a prototype from the Circle of Lorenzo de' Medici.[5]

ΘΕΟΚΡΙΤΟΥ ΘΥΡΣΙΣ Η ΩΔΗ
ΕΙΔΥΛΛΙΟΝ ΠΡΩΤΟΝ.
ΘΥΡΣΙΣ Η ΩΔΗ.

Αδύ τι τὸ ψιθύρισμα καὶ ἁ πί
τυς αἰπόλε τήνα,
Ἃ ποτὶ ταῖς παγαῖσι μελίσ-
δεται·ἁδὺ δὲ καὶ τὺ
Συρίσδες·μετὰ Πᾶνα τὸ δεύ
τερον ἆθλον ἀποισῆ.
Αἴ κα τῆνος ἕλῃ κεραὸν τρά
γον·αἶγα τὺ λαψῆ.

Αἴκα δ᾽ αἶγα λάβῃ τῆνος γέρας·ἐς τὲ καταρρεῖ
Ἁ χίμαρος, χιμάρῳ δὲ καλὸν κρῆς ἔςτε κἀμέλξῃ.
ΑΙ. Ἄδιον ὦ ποιμὰν τὸ τεὸν μέλος ἢ τὸ καταχὲς
Τῆν᾽ ἀπὸ τᾶς πέτρας καταλείβεται ὑψόθεν ὕδωρ.
Αἴ κα ταὶ μῶσαι τὰν οἴιδα δῶρον ἄγωνται·
Ἄρνα τὺ σακίταν λαψῆ γέρας·αἰ δὲ κ᾽ ἀρέσκῃ
Τήναις ἄρνα λαβεῖν·τὺ δὲ τὰν ὄιν ὕστερον ἀξεῖς.
ΘΥ. Λῆς ποτὶ τᾶν νυμφᾶν λῆς αἰπόλε τῇδε καθίξας
Ὡς τὸ κάταντες τοῦτο γεώλοφον ἆ τι μυρῖκαι,
Συρίσδεν·τὰς δ᾽ αἶγας ἐγὼν ἐν τῶδε νομευσῶ·
ΑΙ. Οὐ θέμις ὦ ποιμὰν τὸ μεσαμβρινὸν,οὐ θέμις ἄμμι
Συρίσδεν·τὸν Πᾶνα δεδοίκαμες·ἦ γὰρ ἀπ᾽ ἄγρας
Τὰ νίκα κεκμακὼς ἀμπαύεται·ἐντὶ δὲ πικρὸς
Καί οἱ ἀεὶ δριμεῖα χολὰ ποτὶ ξινὶ κάθηται.
Ἀλλὰ τὺ γὰρ δὴ θύρσι τὰ δάφνιδος ἄλγε᾽ ἀείδες
Καὶ τᾶς βωκολικᾶς ἐπὶ τὸ πλέον ἵκεο μώσης.

A. A ii

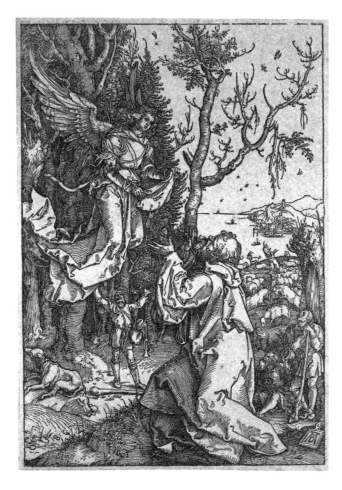

**FIGURE 1**

Albrecht Dürer, *Annunciation to Joachim*, National Gallery of Art, Washington, Ailsa Mellon Bruce Fund

A similarly composed marginal drawing there represents the contest between Apollo and Marsyas. A connection between that manuscript and the Dürer miniature may be found in a drawing of a fiddling Apollo, regarded as a copy after Dürer, in the Sloane collection of the British Museum (inv. 5128-171). • *Fedja Anzelewsky* •

**NOTES**

1. Holzberg 1987, 56, 66.
2. Offenbacher 1938, 241.
3. Riemann 1944, 197–230.
4. See exh. cat. London 1994–1995a, 103–208.
5. Strauss 1982, no. 1502/26. Biblioteca Laurenziana, Florence, Ms Plut.41.33.

**PROVENANCE**

Willibald Pirckheimer [1470–1530]; possibly Barbara Straube [d. 1560] or Felicitas Imhoff; Willibald Imhoff; Hans Hieronymous Imhoff; Matthäus van Overbeck [d. 1638], 1634; Earl of Sunderland (library shelfmark, B4:36, inside front cover) (sale, London, Puttick and Simpson, 16 March 1883, lot 12, 345, to Quaritch); Howell Wills (sale, London, Sotheby's, 11 July 1894, lot 831, to Quaritch); Henry Yates Thompson, 1897 (sale, London, Sotheby's, 3 June 1919, lot 29, bought in); presented by Yates Thompson to the London Library (sale, London, Sotheby's, 14 June 1966, lot 66); purchased by Edelmann; Schickedanz collection; (Rolf Kistner, Nuremberg); Woodner Collections (Dian and Andrea Woodner).

**EXHIBITIONS**

London 1897, no. 307; London 1906, no. 23 (as attributed to Dürer); Nuremberg 1971, no. 296; Woodner, Munich and Vienna 1986, no. 48; Woodner, Madrid 1986–1987, no. 57; Woodner, London 1987, no. 47; Woodner, New York 1990, no. 58.

**LITERATURE**

Rosenthal 1929, 4–14, fig. 1; Tietze and Tietze-Conrat 1928–1938, 2: pt. 1, no. 260a; Rosenthal 1930, 176; Offenbacher 1938, 245, 254; Panofsky 1943, 1:7, 2:161, pl. 1714; Hofer 1947, 73; Magnussen 1958–1959, 118; Pilz 1970, 96, 109 (frontispiece); Eckert and Imhoff 1971, 85–86, p. VIII; Strauss 1974, 2: no. 1502/26; Lowry 1979, 275; Strauss 1982, 10, no. 642; Strieder 1982, 180–181, fig. 212.

SIXTEENTH CENTURY

# 20 Bust of a Youth Looking Upward *(recto)*
# Two Nude Figures *(verso)*

A pupil of Piero della Francesca (c. 1416–1492), with whom he probably worked in Arezzo, Signorelli in 1482 collaborated with a team of Florentine artists on the walls of the Sistine Chapel, where he was responsible for two scenes from the Life of Moses. He was thereafter active throughout central Italy, including Loreto, Città di Castello, Volterra, and Siena. In 1499 his work frescoing a cloister in the monastery of Monte Oliveto was interrupted when he agreed to complete the decoration of the Cappella Nuova, now called the Cappella di San Brizio, in the Orvieto Cathedral. These frescoes are Signorelli's most famous works and later influenced Michelangelo's decoration of the Sistine Chapel. After Signorelli finished the Orvieto chapel in 1504, he continued to the end of his long life to paint altarpieces and frescoes in central Italy, especially in Arezzo and his hometown Cortona.

**c. 1500, black chalk on tan laid paper, partially indented with a stylus (recto); black chalk (verso), 225 x 177 (8 ⅞ x 7)**

**Watermark: Balance**

**National Gallery of Art, Woodner Collection, Gift in Honor of the 50th Anniversary of the National Gallery of Art 1991.8.1.a,b**

This sheet is generally recognized as a study for Signorelli's fresco cycle in the Cathedral at Orvieto, 1499–1504, but there is confusion about which figures it was intended to describe. The discrepancy between the drawing and the finished frescoes may be better understood by examining Signorelli's working method as he set out to design and paint the chapel.

In 1500 Signorelli was commissioned to paint the walls of the Cappella Nuova in the Orvieto Cathedral. He had proven his abilities the previous year by completing the ceiling of the chapel, which had been abandoned by Fra Angelico fifty years earlier. To win the commission to continue the project, Signorelli presented the committee controlling the decoration of the cathedral with a design for the three main walls of the chapel, and he agreed to include at least as many figures in the final painting as depicted in the contract drawing.[1] This documentary evidence is important to all drawings associated with the chapel because it demonstrates that Signorelli had a definite plan for the decoration before he began to refine its details.

Considering that the artist must have been loosely following his contract drawing, it is surprising that so few of the surviving studies for the project appear verbatim in the completed paintings. The present sheet is no exception. Although the upturned head is close to various heads in the frescoes, it cannot be firmly associated with any one example. Bernard Berenson considered it a study for a youth in a group of three figures beneath the trumpeting angel on the left of the scene depicting the *Resurrection of the Flesh*.[2] There are obvious connections with that head, but there are also similarities to other heads in the same scene, such as that of the man pulling himself up in the right foreground. The pointed ears in the drawing present further complications, for they are not appropriate to any figure in the *Resurrection*, but rather suggest the demonic ears and horns given to the devils in the *Damned*, the scene immediately to the left. The fragmentary nudes on the verso of the Woodner sheet are also difficult to connect with the frescoes. Although there are affinities with the *Damned* and the *Antichrist*, where figures fall down or are being chased, the group does not appear in the finished work.

Recent restoration in the chapel has shown that Signorelli continued to refine his designs as he painted. It is possible that the upturned head was drawn and partly incised with a specific figure in mind, but when the artist had a paintbrush in hand, he altered the design so that it no longer followed the drawing. He may also have drawn the head intending to use it in the *Damned* but later adapted it for another scene without including the pointed ears.

While this sheet is typical of Signorelli's working method, it is also characteristic of his style and technique. It shares with a drawing of the same date, *Four Demons Reading a Book* (fig. 1), a similar definition of human anatomy—pronounced muscles sketched with emphatic outlines and cross-hatched shading—and even fantastic horns and ears. The position of the head in the Woodner drawing is also familiar from other works, especially a cartoon of the *Head of Saint John the Baptist*, which was drawn in the same pose nearly twenty years earlier (fig. 2). Most of Signorelli's forty-odd surviving studies were made with natural black chalk, a medium that had traditionally been used for very specific purposes but was becoming popular for all types of studies. The broad line and depth of tone achievable with black chalk suited Signorelli's style. His drawings, normally vigorous studies of the nude, have an immediacy that gives insight to the artist's mind at work as he explored different ways of representing the human body. In comparison, the paintings are polished, more static, and do not convey the liveliness of the drawings. • *Claire Van Cleave* •

20 RECTO

20 VERSO

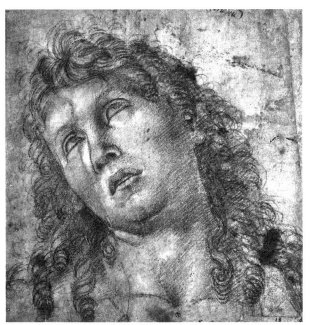

**FIGURE 2**
Luca Signorelli, *Head of Saint John the Baptist,* Nationalmuseum, Stockholm

**FIGURE 1**
Luca Signorelli, *Four Demons Reading a Book,* The Pierpont Morgan Library, New York, Purchased as the Gift of the Fellows

**NOTES**

1. The contract is in the Archivio dell'Opera del Duomo, Orvieto, *Riformanze,* 1484–1526, 372v, and is transcribed in McLellan 1992, 2:168.
2. Berenson 1938, 2:334.

**PROVENANCE**

Archibald George Blomefield Russell, London [b. 1879] (sale, London, Sotheby's, 22 May 1928, lot 89); De Clementi; John Nicholas Brown, Providence [1900–1979]; (David Tunick Inc., New York); Woodner Collections (The Ian Woodner Family Collection, Inc.); given to NGA, 1991.

**EXHIBITIONS**

Philadelphia 1950–1951, no. 19; Cambridge 1962, no. 32; Hartford 1973–1974, no. 1; Woodner, London 1987, no. 4; Woodner, New York 1990, no. 5; Washington 1991, supplement.

**LITERATURE**

Berenson 1938, 3: fig. 94; Tietze 1947, no. 22; Berenson 1961, 2: 564, no. 2509F, 3: fig. 99; Bambach Cappel 1994, 42, fig. 21.

# 21 Two Angels: One Blowing a Trumpet, the Other Holding a Staff

*From 1485 Fra Bartolommeo was a pupil of Cosimo Rosselli (1439–1507), as were Piero di Cosimo (1462–1521) and Mariotto Albertinelli (1474–1515). In 1497, under the influence of the teachings of Savonarola, Fra Bartolommeo burned all his pictures and drawings of profane subjects. He abandoned painting in 1500 and entered the convent of San Domenico in Prato as a novice, taking up painting again in 1504 and traveling to Venice (1508) and Rome (1524). He was influenced by Perugino (c. 1448–1524), Leonardo da Vinci (q.v.), Raphael (q.v.), and Michelangelo (1475–1564), with whom he formed the High Renaissance style. His membership in the Dominican Order also greatly affected his paintings, and his political engagement with the followers of Savonarola made him the preferred painter of Florence during the Republic.*

**c. 1500, pen and brown ink, squared for transfer in red chalk, on laid paper, laid down, 169 x 130 (6⅝ x 5⅒)**

**Woodner Collections**

Few artists have shown more ability than Fra Bartolommeo in expressing energy, rhythmic flow, and geometric clarity by means of swift pen strokes. He preferred the flexible goose quill as long as his main interest was the rendering of pattern and movement, for which this strongly linear medium is so well adapted. Around 1505, however, the artist changed to black chalk in response to his growing interest in describing plasticity and atmosphere, for which the tonal chalk medium is better suited.

Although the figures in the present drawing have no wings, there can hardly be any doubt that they are representations of angels. Wingless angels appear frequently in Fra Bartolommeo's oeuvre, as in works by many of his contemporaries. The angel blowing the trumpet, which is very carefully rendered, was apparently executed in two stages: first, in a linear and relieflike definition of form, as seen in the lower part of the figure; and second, with delicate hatching that created a refined modulation of light and shadow and added a sense of plasticity. The artist carried out this second stage only in the upper part of the figure. The other angel is more spontaneously and sketchily drawn. Its loosely drawn lines and billowing draperies give the impression of

swift movement. The staff in this figure's left hand was probably not part of the original design, as it is held in an awkward way. It seems to support a flag or a banner, although this could also be part of a drapery from a figure cut off at the right. Many of Fra Bartolommeo's drawings have been cut into pieces by later hands. It is not known whether the two angels were intended to appear together; but they do not correspond to any figures in preserved paintings, and the diversity of their execution and the final squaring of only the more finished figure suggest that they were meant to be seen separately.

The attribution to Fra Bartolommeo has been accepted by all scholars, who have dated the sheet around 1505–1506. In 1986 I pointed out a possible connection with a group of drawings in which the Virgin and Child are enthroned with a kneeling saint and two angels to the left and a third angel lifting up the infant Baptist on the right so that he can embrace Jesus, while two angels make music in the background.[1] These drawings were used for a painting by Mariotto Albertinelli (on loan from the Kress Collection to the Columbia Museum of Art, South Carolina), who inherited Fra Bartolommeo's drawings when the latter entered the Dominican Order in 1500. Thus the drawings might well date from shortly before this time.[2] Although the angels in the Woodner drawing bear some resemblance to the musical angels on these

sheets, there is no actual correspondence. In two of the drawings the angels are seen playing the lyre and the pipes, and Nicholas Turner has rightly pointed out that the sounding of a large trumpet would be out of keeping with the intimate and pious event rendered in these drawings.[3]

Trumpet-playing angels normally appear in depictions of the Last Judgment and in scenes of heavenly glory such as the Assumption or Coronation of the Virgin. None of the many preparatory drawings for Fra Bartolommeo's fresco of the *Last Judgment*, left to be finished by Albertinelli when Fra Bartolommeo took vows in 1500, suggests that angels like the ones on this sheet were ever planned for the composition.[4]

Bernard Berenson, Hans von der Gabelentz, Philip Pouncey, and Nicholas Turner have all proposed a connection between the Woodner sheet and a drawing in the Uffizi of angels dancing to music in the sky (fig. 1). Although there is no direct correspondence, the idea seems plausible. The Uffizi drawing belongs to a group of drawings preparatory for a Coronation of the Virgin and an Assumption.[5] It is likely that they were preparatory for the same commission and that the commissioners were the brotherhood of the Contemplanti in Florence who in 1508 received a large altarpiece of the Assumption (formerly in the Kaiser Friedrich Museum, Berlin, and now destroyed). To judge from the style of the drawings and the relation of drawings on

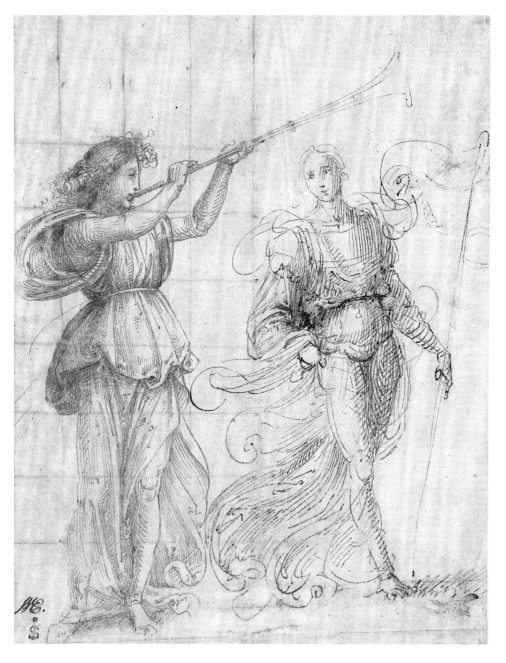

21

the same sheets to dated paintings, Fra Bartolommeo began preparations for this altarpiece as early as c. 1500.[6] Before he took vows he seems to have planned to depict a Coronation. Four years later, when he took up his profession as a painter again, he appears to have changed the subject to an Assumption. If the Woodner drawing is connected with this commission, it should be dated to c. 1500, just like a drawing of the *Coronation of the Virgin* with two trumpet-playing angels in the Louvre (fig. 2).[7]

• *Chris Fischer* •

**NOTES**

1. Fischer in exh. cat. Florence 1986, 71; British Museum, London, inv. 1875-6-12-1; formerly Gaines Collection (sale, New York, Sotheby's, 17 November 1986, lot 6, recto); Uffizi, Florence, inv. 479 E, 6795 F; Kupferstichkabinett, Berlin, inv. KDZ 1548; Museum Boymans-van Beuningen, Rotterdam, inv. N 97.

2. See exh. cat. Rotterdam 1990–1992, 93–95.

3. Woodner exh. cat., London 1987, 38.

4. Holst 1974, 273–318; exh. cat. Rotterdam 1990–1992, 43–77; Fischer 1990, 59–75.

5. Uffizi, Florence, inv. 1235 E verso and 464 E; Lugt Collection, Institut néerlandais, Paris, inv. 2160 verso; British Museum, London, inv. Pp. 1–54; Louvre, Paris, inv. 204 and 223; Museum Boymans-van Beuningen, Rotterdam, inv. M 199 recto and verso, and N 106 recto and verso.

6. Exh. cat. Rotterdam 1990–1992, 145–152; exh. cat. Paris 1994, 56–59.

7. Exh. cat. Paris 1994, 58–59, no. 30.

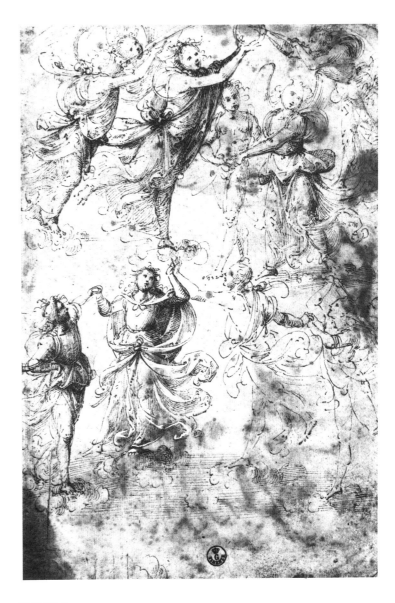

**FIGURE 1**

Fra Bartolommeo, *Angels Dancing to Music,* Gabinetto disegni e stampe degli Uffizi, Florence

**PROVENANCE**

Jonathan Richardson Sr., London [1665–1745] (Lugt 2183); John Barnard, London [d. 1784]; John Thane, London [1748–1818]; George John, 2nd Earl Spencer, Althorp [1758–1834] (Lugt 1532); William Esdaile, London [1758–1837] (Lugt 2617); Charles Sackville Bale, London [1791–1880]; John Postle Heseltine, London [1843–1929]; Henry Oppenheimer, London [1859–1935/1936] (sale, London, Christie's, 10–14 July 1936, lot 29); Robert von Hirsch, Basel [1883–1977] (sale, London, Sotheby's, 10 June 1978, lot 11); Woodner Collections (Shipley Corporation).

**EXHIBITIONS**

London 1930, no. 793; Woodner, Malibu 1983–1985, no. 9; Woodner, Munich and Vienna 1986, no. 11; Woodner, Madrid 1986–1987, no. 14; Woodner, London 1987, no. 10; Woodner, New York 1990, no. 12.

**LITERATURE**

Gruyer 1886, 101, no. 4; Knapp 1903, 314, no. 1; Berenson 1903, 2: no. 433; Gabelentz 1922, 2:131, no. 303; Berenson 1938, 2:39, no. 433; Berenson 1961, 2: no. 203 L-1, and 3: fig. 372; exh. cat. Florence 1986, under nos. 19 and 30.

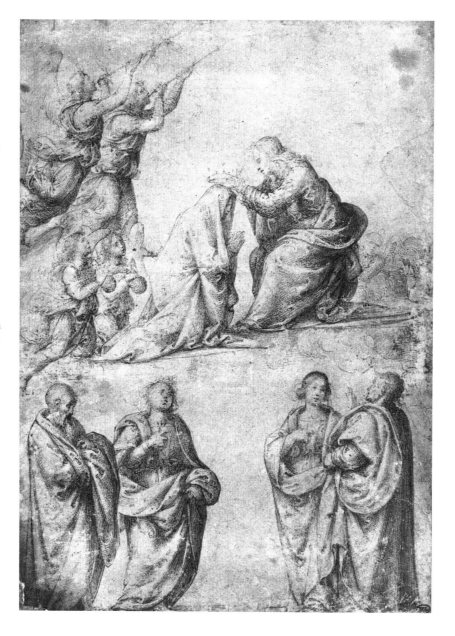

**FIGURE 2**

Fra Bartolommeo, *Coronation of the Virgin*, Département des arts graphiques, Musée du Louvre, Paris

# 22 Archer Drawing a Bow

**c. 1505, black chalk and brown wash, heightened
with white and squared for transfer, on laid paper,
262 x 167 (10 5/16 x 6 5/8)**

**Inscribed on the verso at lower center in pen
and ink: *Perugino Meister von Raphael d'Urbino***

**National Gallery of Art, Woodner Collection
1991.182.13**

In the past this sheet was thought to be an
autograph work by Perugino.[1] The pose,
upturned eyes, and costume of the archer
are unmistakably Umbrian and typical
of Perugino's style, yet the handling of
the drawing suggests that it was not made
by the master himself, but by one of his
followers.

The artist began this drawing with a
black chalk outline of the figure's basic
form. This underdrawing is now difficult
to decipher, except where the chalk is still
visible under the ink, such as on the archer's
right thigh just above the knee. A brown
ink wash was then applied to define the
figure fully, and white lead highlights were
used to pick out the areas of brightest light.
Finally, the drawing was squared for trans-
fer with black chalk. The handling of the
ink is very precise, brushed on with tiny,
closely spaced strokes to create soft tones
of modeling. The refined draftsmanship is
in keeping with the attention given to the
archer's costume: his distinctive hat, billow-
ing sleeves, belt, and quiver, all reproduced
in exquisite detail, further contribute to
the delicate nature of the sheet.

The Woodner figure is nearly identical
to the archer at the far left in the fresco of
the *Martyrdom of Saint Sebastian* (fig. 1)
painted by Perugino in 1505.[2] The pose and
details of the costume are the same, down
to the folds in the sleeves, except that the
archer in the drawing does not have the
extra billowing strips of fabric seen flowing
to the right of the archer in the fresco. The
similarity between the two figures and the
lack of any pentimenti or refinements to
the drawing suggest that this sheet is a copy
after the painting rather than a study made
while the work was in progress. Another
drawing of the archer (Musée Bonnat, Bay-
onne) is certainly a preliminary design by
Perugino,[3] establishing the pose of the fig-
ure while exhibiting a spontaneity of han-
dling not seen in the Woodner sheet. The
head and hair, for example, are not fully de-
fined but sketched with a few economical
strokes. The quick strokes of chalk suggest
that the figure was drawn as the artist ob-
served a studio model. In comparison, the
carefully considered and detailed figure on
the Woodner sheet is more typical of a copy
after a completed painting.

The Woodner *Archer* is not the only
copy after Perugino's Panicale fresco. Each
of the archers in the painting is reproduced
in other copies, apparently drawn by mem-
bers of Perugino's workshop or by his
followers.[4] Notable among these are two
sheets of the same archer seen in the Wood-
ner drawing, one in the Louvre and one in
the Musée Condé at Chantilly.[5] Curiously,
both of these copies omit the billowing fab-

ric that was also absent from the Woodner
*Archer*. Neither of the other two drawings
is as completely drawn as the present sheet,
suggesting that the Woodner drawing
served as the model for these copies. The
existence of so many copies of a single
fresco demonstrates an important practice
of Renaissance draftmanship in which ap-
prentices copied both paintings and draw-
ings by their masters as they learned their
craft. • *Claire Van Cleave* •

## NOTES

1. Attribution first published in Weigel 1854.
2. Repro. in Scarpellini 1984, no. 134, fig. 227.
3. Inv. 149; repro. in Bean 1960, no. 97.
4. The standing archer on the far right is found in two
copies, one in the Louvre (inv. 4372) and one in Christ
Church, Oxford (inv. JBS 11). The archer stringing his
bow on the right appears in a drawing at Chatsworth
(inv. 887A). The crossbowman on the left is reproduced
in a sheet in the Uffizi (inv. 13221) and in a drawing at
the Musée Condé, Chantilly (inv. 40[33]). These copies
are fully discussed in Woodner exh. cat., New York
1990, no. 7.
5. Inv. 4373 and inv. 40[33], the latter also including
the crossbowman to the right of the archer.

## PROVENANCE

Rudolph Weigel, Leipzig (as Perugino); private collec-
tion (sale, Christie's, 8 December 1987, lot 91, as Work-
shop of Perugino); (Succi Ltd., London, as Workshop
of Perugino); (Visual Art Company, Mies, Switzer-
land); Woodner Collections (The Ian Woodner Family
Collection, Inc.); given to NGA, 1991.

## EXHIBITIONS

Woodner, New York 1990, no. 7.

## LITERATURE

Weigel 1854, no. 9 (as Perugino).

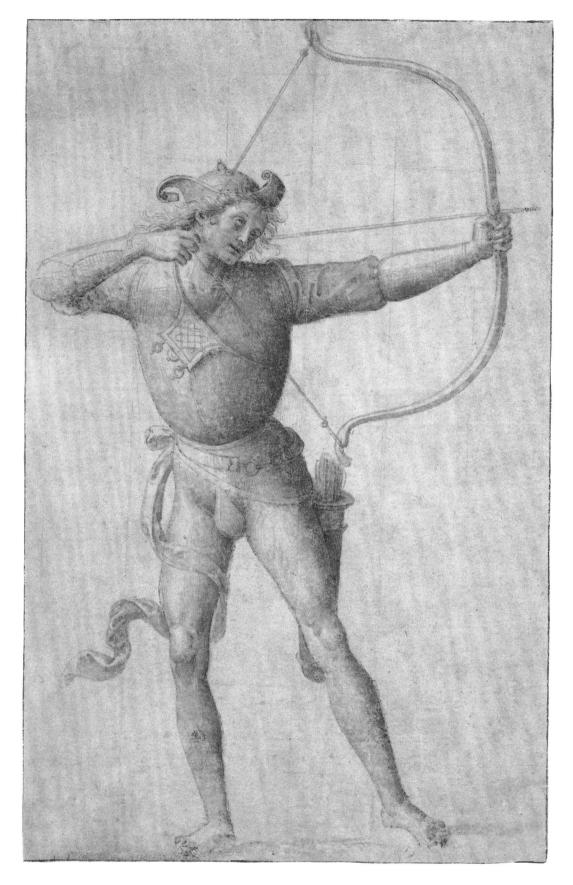

22

# 23 Portrait of a Woman *(recto)*
# Study of a Bearded Man *(verso)*

*Painter and designer of stained glass, sculpture, goldsmiths' work, and woodcuts, Holbein the Elder was probably trained in the Upper Rhineland and perhaps at Ulm. Active mainly there and in Augsburg from the 1490s, he carried out commissions over a much wider geographical area, including Frankfurt, Alsace, and Switzerland. Holbein was one of the foremost artists of his generation north of the Alps, tracing in his own development the transition from the late Gothic to the Renaissance in German painting. His most important works were the large altarpieces so in demand in the last quarter of the fifteenth century. These often incorporated carved elements, which were sometimes contributed by leading sculptors such as Michel (active 1469–1518) and Gregor Erhart (d. 1540). Today Holbein is best remembered for his many brilliantly executed silverpoint portrait drawings, a field in which even his famous namesake son could barely surpass him.*

c. 1508/1510, silverpoint, brush with black and brown ink, and black chalk heightened with white on white prepared paper (recto); silverpoint and black chalk heightened with white on white prepared paper (verso), 144 x 103 (5⅝ x 4)

Inscribed at lower right in pen and ink: *.H.H*

National Gallery of Art, Woodner Collection 1991.182.18.a,b

Although these portrait drawings have suffered from retouching and the sheet from being cut down, the character of the execution does suggest the hand of Hans Holbein the Elder. A large body of Holbein's silverpoint portrait drawings survive, principally divided among the print rooms at Berlin, Copenhagen, and Basel;[1] most of the rest are to be found in the other major museums of western Europe. Compared with his son's drawings, these works suggest that the father often enjoyed an easier relationship with his sitters. Many were friends or acquaintances of long standing in Augsburg, where Holbein ran a busy workshop for the production of altarpieces as well as portraits. He also drew the members of the leading patrician families, including the Fuggers of banking fame. Some of his most sensitive studies depicted members of various religious communities in the city. Among all these portraits, only a few are of women and girls, but these certainly include some of his finest drawings.

The drawing on the recto of the Woodner sheet depicts a sitter who appears elsewhere in the artist's paintings. A portrait in Berlin of a woman with the same kind of headdress bears some similarity to the present drawing,[2] but a closer kinship both in pose and to some extent in facial features is to be found in the portrait of a woman formerly in the Lanckoronski collection at Vienna (now in the Musée d'Unterlinden, Colmar).[3] The sitter in that painting seems to be older than the woman in the Woodner drawing, but might be a relation. More significantly, the sitter in the present drawing may also have served as a model for Holbein's *Saint Catherine* (fig. 1).[4] There is no question that the sitter for that painting is the same as the kneeling woman named "Katherina" in the right foreground of the *Votive Picture for Ulrich Schwarz* (figs. 2, 4),[5] the oldest of Schwarz' fourteen daughters. Her hair is held in a band as a sign that she was engaged to be married, whereas the sitter in the Woodner drawing has her hair hidden by her headdress, which means that she was married. If they are both the same person, the drawing would clearly have been done later than the painting. According to an early documentary source, the painting was commissioned for the church of Saints Ulrich and Afra, Augsburg, and was produced in 1508. Thus the drawing on the recto could be dated c. 1508/1510.

The full-faced portrait of an old bearded man on the verso has been associated with Holbein's portrait of a similarly bearded man at Bamberg.[6] But the features, insofar as one can make them out given the surface damage and retouching, suggest that the sitter is the same seen in two drawings, one in Berlin and the other in Milan.[7] The man's identity is unknown, but he was the model for God the Father in the picture for Ulrich Schwarz just mentioned (fig. 3) and an onlooker in the *Martyrdom of Saint Sebastian,* the central panel of the altarpiece in the Alte Pinakothek, Munich, signed and dated 1516.[8] • *John Rowlands* •

**NOTES**

1. The Kupferstichkabinett, Basel, possesses the most substantial collection.
2. Kupferstichkabinett, Berlin; see Lieb and Stange 1960, 106, no. 252, pl. 329.
3. Exh. cat. Basel 1960, 66, no. 7.
4. Exh. cat. Basel 1960, 67, no. 9 (repro.).
5. Exh. cat. Basel 1960, 66, no. 8. (repro.); exh. cat. Augsburg 1965, 89–90, no. 44 (repro.).
6. See Woodner exh. cat., New York 1990, 172, under no. 62 (repro.).
7. Lieb and Stange 1960, 111, nos. 281–282, pls. 366–367.
8. Lieb and Stange 1960, 71–72, no. 40, pls. 111–116.

**PROVENANCE**

Fürstenberg collection, Donaueschingen; Woodner Collections (The Ian Woodner Family Collection, Inc.); given to NGA, 1991.

**EXHIBITIONS**

Woodner, New York 1990, no. 62 (recto and verso); Washington 1992, no. 3.

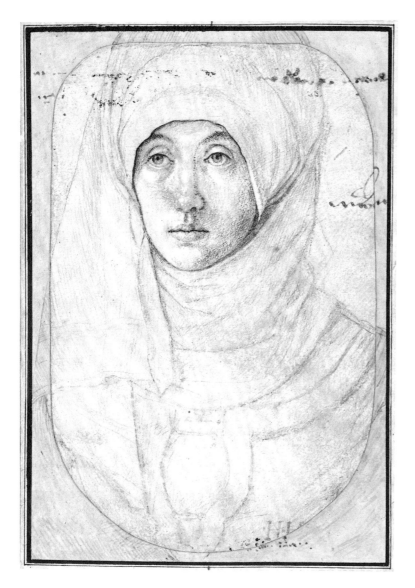

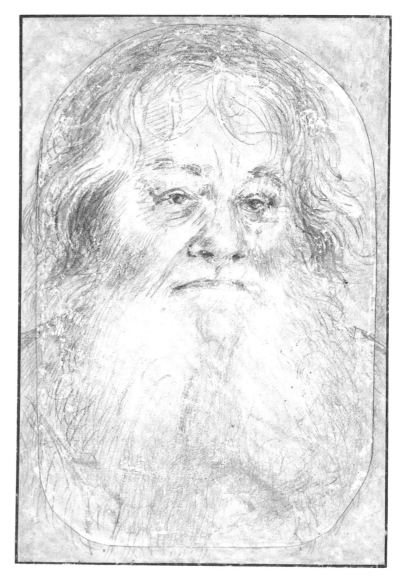

23 RECTO                                    23 VERSO

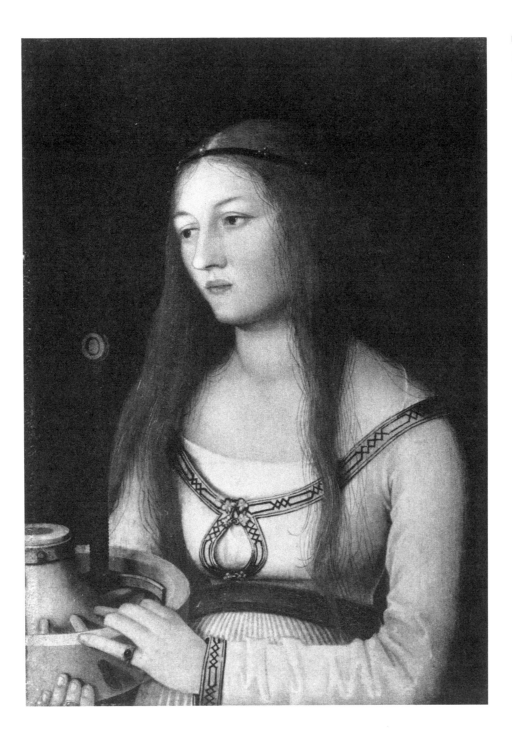

**FIGURE 1**

Hans Holbein the Elder, *Saint Catherine*, Schlossmuseum, Gotha

**FIGURE 2**

Hans Holbein the Elder, *Votive
Picture for Ulrich Schwarz,*
Städtische Kunstsammlung,
Augsburg

**FIGURE 3**

Detail of fig. 2

**FIGURE 4**

Detail of fig. 2

# 24  The Four Latin Church Fathers

**c. 1510/1515, pen and brown ink over black chalk on vellum, 160 x 216 (6⁵⁄₁₆ x 8½)**

**Inscribed at lower left in pen and brown ink:** *raph / URBINA(?)*; **and at lower right in pen and brown ink:** *1511 [1512?] / ROMA*

**Woodner Collections**

This drawing shows the four Latin Fathers of the Church seated in a space that is not clearly defined architecturally.[1] They are easily recognizable in spite of their sparse attributes. As is frequently the case, Saint Augustine holds in his right hand the heart about which he writes in the ninth book of his *Confessions* ("Sagittaveras tu cor meum charitate tua"); he is shown as a bishop with miter and crosier. Saint Gregory wears his papal tiara with its three tiers, while Saint Jerome is recognizable by his cardinal's hat, book, and lion. Saint Ambrose, the fourth Father, also wears a bishop's miter and holds a staff but is not identified otherwise. Their liturgical dress is equally simple: Jerome wears a *cappa clausa* with long slits for the arms; the other three Fathers, simple copes fastened in front with morses. Gregory the Great and Jerome, as pope and cardinal, are distinguished from the two bishops by their central position, frontality, and the canopy. Except for Jerome, they are marked as saints by their aureoles.

The four Latin Fathers had a long tradition in art by the time this drawing was made.[2] Already in the eighth and ninth centuries they appeared on the introductory pages of Bibles, and after that they were represented regularly in various media, usually individually and not bound by common action—for instance, as decorations of pulpits. Of all such serial representations, the monumental *Altar of the Church Fathers* painted by Michael Pacher c. 1480 (Alte Pinakothek, Munich) is certainly the most memorable one.[3] Less frequently the Fathers are represented disputing an issue. Close in time to the present drawing is Jean Bellegambe's painting of *Sixtus iv Proclaiming the Dogma of the Immaculate Conception* of 1526 (Musée de Douai),[4] in which the Fathers are debating the dogma that engaged the leading minds of the time. The figures in this drawing participate in a dialogue, as is apparent from the open mouth of Saint Augustine and the "speaking" hands of Saints Gregory and Ambrose, but it is not clear what the Fathers are discussing.

The artist responsible for this drawing has to be sought among the members of a shop active in Brussels between c. 1510 and 1540 and known under the name of Aert Ortkens, or more recently, Pseudo-Ortkens.[5] Since Max Friedländer considered Aert Ortkens (died c. 1540)—a designer of stained glass who was born in Nijmegen and active from 1503 in Tournai, Antwerp, Rouen, and elsewhere—as the author of a group of drawings,[6] two developments have invalidated his welcome resurrection of an artist known only from sources. It now is obvious that Ortkens was not the designer of all or even part of the more than fifty drawings

brought together under his name, many of them designs for stained-glass roundels, others for tapestries; that the group extends over two generations; that it is far from homogeneous and includes at least five hands; that many drawings are known in more than one version; and that this shop was active in Brussels in the proximity of Bernard van Orley.[7]

These conclusions, based on the drawings themselves, have recently led scholars to try to identify artists whose biographical data and known works would accommodate such characteristics. In 1967–1969 Hilary Wayment proposed that Pseudo-Ortkens in fact was a group of artists spanning two generations active in Malines and Brussels.[8] Herman van den Houte, active in Malines c. 1477–1507, whom Wayment considers to have been the teacher of Bernard van Orley, would be the author of some of the earliest drawings. In Wayment's reconstruction, Van den Houte's son Adrian (Malines and Brussels, c. 1459–1521) was the main artist (Pseudo-Ortkens C) and as such responsible for the core of the drawings, while Van Orley himself and other pupils and collaborators of Van den Houte (Pseudo-Ortkens D and E) produced a certain number of sheets. The evidence to prove these theories is unfortunately still lacking.

Linda Evers has offered a more convincing reconstruction of the shop. Applying the same method as Wayment, she has recently found parallels between the drawings and the work of various members of

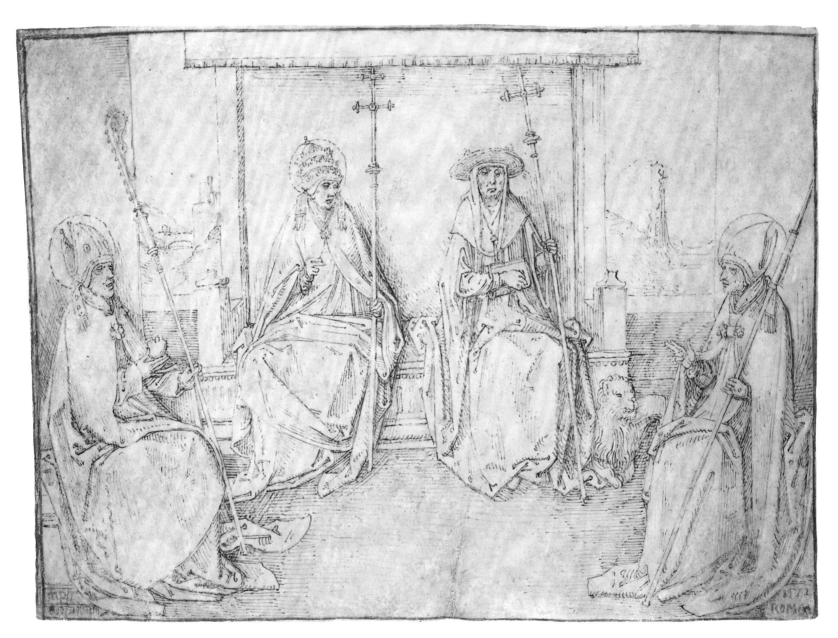

24

the Van Orley family. She proposes that Bernard van Orley's father, Valentijn van Orley (1466–1532), active mainly in Brussels, was the oldest artist in the shop, that his son Bernard soon established himself with his own style, but that two of his younger sons, Everaert (born c. 1489) and Philippe (c. 1492–c. 1555), and their collaborators maintained a remarkably active and tight-knit shop, producing designs and cartoons for tapestries and designs for roundels in great quantities—about 35 designs for roundels and more than 135 roundels are known to exist. The family was related to other artistic dynasties like those of Coninxloo and Tons. The evidence seems impressive, and although mainly circumstantial, stylistic links between works in different media and further data seem to support this reconstruction.[9]

The drawings of the shop, many of them roundels, are all in pen, usually without washes and almost always on paper. They are characterized by idiosyncratic crosshatching, deep folds and heavy draperies, and especially by a peculiar definition of the eyes that makes them seem closed. Frequently the fingers are spread, and architectural elements unstructurally arranged. The pen work is historically situated between Hugo van der Goes and Pieter Bruegel the Elder.

The present drawing shares most of these characteristics. Other details, like the specific formulation of the folds, are found in other drawings of the shop and indicate a particular hand. *Samuel Anointing David*

(Lugt Collection, Institut néerlandais, Paris) seems to be by the same hand, as do two roundels in Oxford, *Shepherd with a Nymph* and *Virgil's Second Eclogue*.[10] *Christ's Entry into Jerusalem* (Albertina, Vienna) and *Scenes from the Life of Saint Benedict* (Kupferstichkabinett, Berlin) may also be by the same hand.[11] It is likely that this artist was a rather early participant in the shop and may have been active c. 1510–1515. A thorough study of all the drawings would yield a wider grouping that includes the Woodner sheet. • *Egbert Haverkamp-Begemann* •

**NOTES**

For assistance in writing this text I want to thank particularly Linda E. Evers, Ellen Konowitz, Zsuzsanna van Ruyven-Zeman, Maria Saffiotti, and Rebecca Tucker.

1. A previous owner was reminded of Raphael's *Disputa,* where the four Fathers are seated prominently on either side of the altar, and this prompted an attribution to Raphael. The annotation makes the impression of not being very recent, but when it was added remains a question. Raphael, according to present scholarship, painted the *Disputa* c. 1509.

2. The most useful bibliography for the iconography of the four Fathers (or Doctors) of the Church is found in Van de Waal 1983, 158, under no. 11 I 5. I have used Kirschbaum 1968–1976, 2:529–533, and Réau 1958, 3:388–390.

3. Munich *Erläuterungen* 1983, 376–380, with bibliography.

4. Friedländer 1967–1976, 12:102, no. 124, pl. 62.

5. The attribution of the drawing to Albert Bouts, first printed in Woodner exh. cat., New York 1973–1974, was based on similarities with *Christ's Entry into Jerusalem* (Albertina, Vienna), probably indeed by the same hand, which Benesch 1926–1941, 2: no. 27, considered to be by Bouts. Ironically, Benesch recognized a relationship with drawings from the Ortkens group, but without questioning the Bouts attribution. (It should

be noted that Wayment 1969, 264, links Adrian van den Houte to Albert Bouts.)

6. Friedländer 1916–1917, 161–167.

7. The complex issue of the reconstruction of this shop and the identification of its leading artists has been reviewed in Boon 1978, 137, 138, and Boon 1992, 1:292–296.

8. Wayment 1967, 172–202, Wayment 1968, 71–94, Wayment 1969, 257–269. This reconstruction is not persuasive mainly because of the Malines connection and the dismissal of Aert Ortkens while his influence on Herman van den Houte is maintained. Wayment correctly established that at least five artists were involved (Pseudo-Ortkens A through E), but he did not work out the categories.

9. Evers proposed her ideas in her unpublished "doctoraalscriptie," Leiden University, 1986. She kindly discussed the contents of the study with me, but I have not seen the text. Evers' ideas will also be reflected in the forthcoming exhibition on painted glass roundels (New York, 1995). At the time of writing, the catalogue is also unknown to me.

10. Wayment 1967, figs. 9, 11, 17.

11. For the drawing in Vienna see above, note 5. The artist who thus would emerge seems identical with the one named "Pseudo-Ortkens D" in Wayment 1967, 180.

**PROVENANCE**

Private collection (sale, London, Sotheby's, 13 July 1972, lot 1, as Flemish School, c. 1500); Woodner Collections (Shipley Corporation).

**EXHIBITIONS**

Woodner, New York 1973–1974, no. 76 (as attributed to Albert Bouts); Woodner, Malibu 1983–1985, no. 44 (as attributed to Albert Bouts); Woodner, Munich and Vienna 1986, no. 65 (as Albert Bouts[?]); Woodner, Madrid 1986–1987, no. 78 (as Bouts[?]).

**LITERATURE**

Sale cat., Amsterdam, Sotheby Mak van Waay, 6 June 1977, under lot 7 (listed among drawings under the name of Aert Ortkens); Boon 1978: 2:138.

# 25  Two Pages from a Manuscript

*25a: Illustration of the Pythagorean Precept* "Quae uncis sunt unguibus ne nutrias" *(Feed not things that have sharp claws)* (folio 38r)
**c. 1512/1514, pen and brown ink with watercolor on laid paper, 163 x 109 (6⁷/₁₆ x 4⁵/₁₆)**

*25b: Illustration of the Pythagorean Precept* "Hirundinem sub eodem tecto ne habeas" *(Do not have swallows under the same roof)* (folio 40r)
**c. 1512/1514, pen and brown ink with watercolor on laid paper, 163 x 109 (6⁷/₁₆ x 4⁵/₁₆)**

**Inscribed at center left in pen and brown ink:**
**pythagoras**

**Watermark: Crown (top fragment of unidentified mark)**

**Woodner Collections**

These two sheets from a group of thirty-five drawings today in the Woodner Collections originally formed part of a didactic manuscript made for François d'Angoulême, later François I, king of France (see also figs. 1-6 for other sheets from this manuscript). The illustrations were accompanied by inscriptions and other texts and were bound in with an edition of Jodocus Clichtoveus' *Dogma moralium philosophorum* (Paris, 1511), a medieval treatise on the virtues. The volume was sold in London in 1941 still intact. By the time Ian Woodner acquired the drawings from the William H. Schab Gallery in New York, which had obtained them through the agency of Paul Graupe, the manuscript had been dismantled, so that a moralizing book for princely instruction could be turned into a saleable collection of drawings. The binding was discarded and is now recorded only in photographs. In fact it belonged to a group of ten bindings, some of which can be associated with the library of the young François d'Angoulême when he was resident in Amboise and Blois. The pages devoted only to texts and an illustration of the Greek letter Upsilon—the symbolic *Y* of Pythagoras—were also discarded. Even the inscriptions on the illustrated pages were often erased. Fortunately Fritz Saxl, former director of the Warburg Institute, saw the manuscript when it was in London and had it photographed; his filmstrip is today the only testimony to the original condition and context of the drawings.

The manuscript's author was François Demoulins, who is recorded as the tutor of François d'Angoulême in the accounts of the prince's mother, Louise de Savoie, from 1501 and 1508. The prince himself is portrayed in the book, as is Louise in the guise of Prudence. This kind of symbolic reference can be paralleled in a whole group of manuscripts made for François and his mother. When the young prince left Amboise for the royal court at Blois in 1508, he was accompanied by Demoulins, who served as chaplain. Much of the information we have about Demoulins is gathered from the manuscripts he wrote for Louise and her two children, François and Marguerite. These works show how the tutor's moral and didactic aims were adapted, in both style and subject, to the changing age and preoccupations of the prince. Yet it is only in the present work—a kind of *Speculum principis (Mirror of a Prince)*—that the full impact of Northern humanism appears.

Since the rediscovery of the manuscript in 1937, the drawings have been attributed successively to the Circle of Holbein, to a French contemporary and imitator of Holbein, to the so-called Master of the Clubfeet (Maître aux Pieds-Bots)—an artist active in Lyons in the early sixteenth century—and to Jean Perréal. None of these attributions is convincing. The traditional dating (fifteenth century or 1500) cannot be accepted either, since internal evidence shows that it was written between 24 May 1512 and the death of Louis XII on 1 January 1515. The illustrations were probably done by an artist from the valley of the Loire who had a lively and distinctive style but remains anonymous.

At first view the Woodner drawings present a curious assortment of subjects. These fall, however, into three distinct groups. One consists of reconstructions of antique works of art known through rhetorical descriptions *(ekphraseis)* and classical epigrams (see fig. 3)—a category to which may be added illustrations of epigrams in Renaissance Latin, such as Bernardino Dardano's *Dialogus in spem* and *Favor humanus in dialogo*. A second group includes illustrations of the classical proverbs collected by Erasmus of Rotterdam in his *Adagiorum chiliades* (either in the 1508 or in a slightly later edition; see fig. 2). The

25a                                    25b

remainder illustrates the Pythagorean *Symbola,* the mysterious and ambiguous sayings attributed to the early Greek philosopher, also included by Erasmus among his adages (see figs. 1, 5, 6). The precepts seem to have reflected primitive taboos, but their supposed moral implications and double meanings intrigued Renaissance commentators, especially Erasmus.

The illustration on folio 38r (cat. 25a) shows a fool entering a lion pit and offering pieces of meat to the wild animals. Erasmus' explanation of the saying *Quae uncis sunt unguibus ne nutrias* is behind this imagery: "Feed not things that have sharp claws. Shun rapacity, explains Tryphon. For my part I think it agrees with the saying of Aeschylus, which I shall give in its due place, 'The lion's cub must not be fostered in the state,' that is, no admittance for 'people-devouring kings,' as Homer has it." Demoulins may have thought this Homeric reference with its implicit warning to kings particularly appropriate for François.

Pythagoras himself is shown twice in the manuscript, on folios 25r (fig. 1) and 40r (cat. 25b). In the first case he is clad in a heavy cloak and turns, with a gesture of rejection, away from a clump of beans. Both philosopher and beans are identified by inscription. *A fabis abstineto (Do not eat beans)* is perhaps the philosopher's best-known injunction, and the accompanying text is based on Plutarch's interpretation (as recorded by Erasmus) that it is advice either to keep out of politics (beans having served in Greece as voting tokens) or to

abstain from lust (beans having a testicular shape). In his second appearance, on folio 40r, Pythagoras, again identified by an inscription, feeds storks but chases flies and swallows from his house. A scroll on the previous page attached to him like a speech bubble explained his actions: "The swallow is a symbol of unfaithful friendship, the fly of an ungrateful and infirm friend, the stork of a grateful and conscientious man." This text derives from Plutarch *(Quaestiones conviviales,* 8.7: *Moralia* 727–728) as taken over by Erasmus in the interpretation of the Pythagorean saying *Hirundinem sub eodem tecto ne habeas (Do not have swallows under the same roof),* also found in the *Adagiorum chiliades.* Erasmus quotes Jerome, who in his *Apologia adversus libros Rufini* compares swallows to idle chatterers. He then discusses them further in comparison with the fly and the stork. Swallows are flesh-eaters who kill cicadas, which are melodious and blessed insects. Alone among the birds who live under a man's roof, they serve no useful purpose and leave as soon as they have raised their young. This makes them a symbol of false friendship. The stork, however (called *ciconia* by Erasmus but *pelargus* in the manuscript), stands for gratitude in that it does not even expect to live under the roof yet destroys toads and serpents, which are dangerous to man. Like the swallow, the fly cannot be domesticated. Both are therefore represented as unpleasant companions.

This manuscript is an exceptional Renaissance document. Made for the future

**FIGURE 1**

*Illustration of the Pythagorean Precept "A fabis abstineto" (Do not eat beans),* folio 25r, pen and brown ink with watercolor, Woodner Collections

French king François I by his tutor, it is a very rare and early example of the influence of Erasmus' writings on the visual arts. The only other comparable project, Holbein's illustration of Myconius' copy of Erasmus' *Praise of Folly* (1515), was done later, and for a very different context. • *Jean Michel Massing* •

**PROVENANCE**

François d'Angoulême, later François I of France; private collection (sale, London, Sotheby's, 13 July 1937, lot 64); private collection (sale, London, Sotheby's, 15–17 November 1937, lot 546); (Maggs Bros. Ltd., London, by 1941); (William H. Schab Gallery); Woodner Collections (Dian and Andrea Woodner).

**EXHIBITIONS**

Woodner, New York 1973–1974, nos. 26 and 17 (as Studio of Jean Perréal).

**LITERATURE**

(On the manuscript as a whole) Maggs Brothers 1941, no. 30; Saxl 1942, 82–134; Massing 1983, 75–82, figs. 33–36, 38; Massing 1987, 215–216, pl. 61; Massing 1990, 48, 67, 81, 93, 284–285, pl. 8A; Massing 1995.

**FIGURE 2**

*Illustration of Erasmus' Adage "In coelum iacularis" (You are shooting at heaven),* folio 9r, pen and brown ink, Woodner Collections

**FIGURE 3**

*The Calumny of Apelles,* folio 6r, pen and brown ink with watercolor, Woodner Collections

**FIGURE 4**

*Illustration of One of Baude's "Dicts moraux": Feeding Flowers to Swine,* folio 42r, pen and brown ink with watercolor, Woodner Collections

**FIGURE 5**

*Illustration of Erasmus' Commentary on the Pythagorean Precept "Ollae vestigium in cinere turbato" (Obliterate the trace of the pot in the ashes),* folios 32v–33r, pen and brown ink with watercolor, heightened with gold, Woodner Collections

**FIGURE 6**

*Illustration of the Pythagorean Saying "Ad finem ubi perveneris, ne velis reverti" (Do not turn back when you arrive at the end),* folios 26v–27r, pen and brown ink with watercolor, Woodner Collections

137

# 26  The Virgin and Four Other Women

*Carpaccio's early training was probably in the workshop of Gentile Bellini (1429–1507), and he worked with Giovanni Bellini (c. 1427–1516) on the decoration of the doge's palace in Venice in 1507. The series of paintings on the Legend of Saint Ursula, 1490–1495 (Accademia, Venice), is his early masterpiece, but his principal work is the cycle of paintings for the Scuola di San Giorgio degli Schiavoni, carried out in 1501–1511, which includes* Saint Jerome in His Study *and* Saint George Slaying the Dragon. *In 1504 Carpaccio began the paintings for the Scuola degli Albanesi: six scenes from the Life of the Virgin. After 1511 he worked on one last series for the Scuola di San Stefano, which includes* The Dispute between Saint Stephen and the Doctors *(Brera, Milan), and one of his major altarpieces, the* Martyrdom of the Ten Thousand, *1515 (Accademia, Venice).*

**1505/1510, pen and brown ink with gray wash over charcoal on laid paper, 141 x 163 (5 9/16 x 6 7/16)**

**Woodner Collections**

The bold strokes and simple geometry typical of Vittore Carpaccio's draftsmanship can be seen in this tender drawing, which contains two separate sketches. The principal composition depicts the Virgin, walking devoutly, followed by four other women. An almost nude, bearded male figure, apparently drawn from a studio model, was added on a smaller scale at the upper right.

This sheet reveals Carpaccio's roots in the draftsmanship of Andrea Mantegna (c. 1431–1506), whose linear rigor is translated in Carpaccio's pen drawings into blunt, angular lines. The strong, serene features of the Virgin and her entourage hark back to the precedents of Giovanni and Gentile Bellini,[1] while the figure of the old man is suggestive of the type that would later animate landscapes by Giorgione, Titian, and Domenico Campagnola.

The Woodner drawing has been related to a more complete compositional sketch of the *Circumcision* in the Uffizi (inv. 1691 F),[2] where the Virgin leans over the altar table, her hands joined in prayer, with three women behind her and another kneeling by her side. The bearded man may relate to the figure of the priest who reaches out from the right side of the altar to hold the infant Christ. The Uffizi drawing has been linked by some scholars to Carpaccio's painting of the *Presentation of Christ in the Temple* from 1510 (Accademia, Venice), but the painting bears greater resemblance to the Woodner sheet.[3] The much simplified painting repeats the stance of the woman at the far left and the bowed head of the woman to the immediate left among the Virgin's attendants, while aspects of the bearded studio model can be seen in both the elderly priest and the bearded man immediately behind him.[4] This is not to say that the Woodner drawing should be regarded as a study for the painting of the *Presentation.* The light source in the drawing, as Michelangelo Muraro has noted, falls from upper left, while that in the painting shines from upper right. The Uffizi sketch is lit from the front.[5] Although related through some of the poses to those other works, the Woodner drawing might have been made in connection with another composition that is now lost or was never realized.[6]

Muraro dated the Uffizi sheet c. 1505,[7] and placed the Woodner sheet in the middle of the first decade of the century, noting that it "perhaps" merits inclusion in the corpus of autograph drawings by Carpaccio.[8] It is difficult to know what specific reservations he had, for the drawing is a fine example of Carpaccio's draftsmanship.
• *Suzanne Folds McCullagh* •

**NOTES**

1. Noted by Goldner and Turner in Woodner exh. cats., London 1987 and New York 1990.
2. Proposed in Woodner exh. cat., New York 1971–1972, and considered justifiable in Muraro 1977, 85.
3. For the painting see Lauts 1962, no. 79, pls. 151–153. Ludwig and Molmenti 1906, 199, proposed the connection with the Uffizi drawing, supported by Tietze and Tietze-Conrat 1944, 151, no. 605, but not accepted by Van Marle 1923–1938, 18:348, Fiocco 1930, 71, or Lauts 1962, 269, no. 17. Goldner suggested the connection with the Woodner drawing in Woodner exh. cat., Malibu 1983–1985, strongly seconded by Turner in Woodner exh. cats., London 1987 and New York 1990. Muraro 1977, 44, while doubting the connection, notes that a change from a horizontal to a vertical format is not sufficient reason to dismiss the possibility, recalling the case of the *Martyrdom of the Ten Thousand* (see cat. 27).
4. Lauts 1962, under no. 79, shows that the artist did lift motifs from his drawings at points in his career.
5. Muraro 1977, 44.
6. Goldner in Woodner exh. cat., Malibu 1983–1985, no. 8.
7. Muraro 1977, 44–45, observes that the Uffizi drawing is dated c. 1510 by Fiocco and Arslan, c. 1507–1508 by Lauts and Zampetti, after 1510 by Hadeln, and as late as 1518 by Van Marle.
8. Muraro 1977, 85.

**PROVENANCE**

Woodner Collections (Shipley Corporation).

**EXHIBITIONS**

Woodner, New York 1971–1972, no. 26; Woodner, Malibu 1983–1985, no. 8; Woodner, London 1987, no. 7; Woodner, New York 1990, no. 9.

**LITERATURE**

Muraro 1977, 85, fig. 42A.

26

# 27 Groups of Figures *(recto)*
# Martyrdom of the Ten Thousand *(verso)*

**c. 1513/1514, red chalk on laid paper (recto); red chalk with pen and brown ink (verso), 211 x 296 (8¼ x 11⅝)**

**Watermark: Balance in circle with star (cf. Briquet 2578, 2584, 2587)**

**National Gallery of Art, Woodner Collection 1991.182.15.a,b**

Few drawings by Vittore Carpaccio have elicited such interest and controversy as this beautiful, relatively rare, red chalk double-sided sheet. Known in the literature since the late nineteenth century and passing through many distinguished collections, this drawing has intrigued scholars and collectors alike for the diversity between its two sides and the unusual handling of each. Indeed, to add to the confusion, the "recto" of the sheet has been determined differently by virtually every author who has addressed the work, each favoring one side over the other. The history of the interpretations of this drawing provides a glimpse into the evolution of insight that successive generations have offered into the mind and habits of an artist.

Already in the collection of Henry Oppenheimer when it was published by the Vasari Society in 1913–1914, both sides of the sheet were identified there as studies for the same picture, *Martyrdom of the Ten Thousand* of 1515 (Accademia, Venice). The drawing was thought to date from "the master's later time" because of the use of

red chalk. The recto was described as "groups of spectators," although only one figure at upper right, leaning on a lance, could be related to the final painting.[1] The verso of the sheet, a lightly sketched, horizontal composition, was identified as a "sketch for the upper part of the same picture" and an early *primo pensiero* vastly changed in the final work.

Detlev Freiherr von Hadeln credited Gustavo Ludwig and Pompeo Molmenti with the identification of the sheet as a "first, vague idea" for the painting of the *Martyrdom* but criticized them for dating the drawing as well as a painting fragment of the *Crucifixion* (Uffizi, Florence) to the same time. Placing the *Crucifixion* twenty years earlier, at the time of the Saint Ursula cycle, Hadeln related the recto to the contemporary work by Michelangelo on the *Battle of Cascina* cartoon.

In the 1936 catalogue of the Oppenheimer sale Karl T. Parker declared Ludwig and Molmenti's connection of the drawing to the Uffizi *Crucifixion* fragment to be erroneous, stating that both sides were almost certainly studies for the *Martyrdom of the Ten Thousand*. That same year, however, Raimond van Marle said that while it might have been Carpaccio's intention to use the sketches of various groups on the recto of the sheet for that painting, "for which they are well suited,...he must have changed his mind because there is nothing resembling them in the composition."

Hans Tietze and Erica Tietze-Conrat were the first to express any doubts about the authenticity of this sheet, calling Carpaccio's work on the verso "wavering and indecisive." They also believed that the connection of the landscape sketch to the painting was too slight, the wrong orientation, and the wrong shape to be a first thought for the Accademia painting. Noting that it "abounds with crosses," they hypothesized the existence of an earlier painted version (subsequently lost) that Albrecht Dürer might have adapted in his painting of the same subject, started in the spring of 1507, possibly even in Venice. They therefore dated the drawing to the beginning of the century. At the same time, they believed that the figure studies on the recto were not only unrelated to the painting but were "so typical of Carpaccio's shop that an assistant may have drawn them on a discarded sheet."

Jan Lauts gave new thought to the sheet in his 1962 monograph, pointing out that the groups of figures on the recto were related to neither the *Crucifixion* fragment in the Uffizi nor the painted *Martyrdom of the Ten Thousand* but constituted ad hoc studies for the audience of listeners in the *Sermon of Saint Stephen* (Louvre, Paris) from the cycle for the Scuola di San Stefano of around 1513–1514, a date consistent with the style of the sheet and not contradictory to the relatively concurrent study for the *Martyrdom* on the other side.

27 RECTO

27 VERSO

Terisio Pignatti, in his review of Lauts' book, reiterated the Tietzes' hesitation about the group of listeners, calling it "a puzzling drawing whose connection with Carpaccio appears slight but not irrelevant."[2] By contrast, Michelangelo Muraro, writing in 1966, called the sheet a "stupendo disegno," a "capolavoro grafico." Manlio Cancogni and Guido Perocco reaffirmed Lauts' identification of the two sides, reproducing the recto as a certain preparatory study for the *Sermon of Saint Stephen* in the Louvre, while listing the verso as a sketch that some scholars consider preparatory for the *Martyrdom.*

Muraro summarized all previous opinions in his 1977 monograph. He supported Lauts' identification of the recto with the *Sermon of Saint Stephen* in the Louvre, dating it 1513–1514, and noting that the Louvre figures are dressed in antique garb, while those in the Woodner drawing are in contemporary fashion. This discrepancy caused Muraro to question whether the work was drawn from studio models or after the painting, and led him to posit that, although the sheet must be among the latest graphic works of Carpaccio, the verso is among the most free and open of his career,[3] while the recto here is so circumscribed and defined that he must consider it to be indirect and after the painting.

None of these hesitations about the authorship of the recto has surfaced in any entries on this sheet since 1977. Nicholas

Turner accepted Lauts' identification of the recto with the *Sermon of Saint Stephen,* a cycle that he called among Carpaccio's most important later works. In discussing the study on the verso, he noted the vastly different function and handling than the recto and many divergences from the final painting, where the Christian martyrs are tied to trees instead of crosses and the figurative groups on either side include corpses of the martyrs and horsemen.

Although this sheet has become inscribed in the consciousness of all scholars of Italian drawing as an unusual late example of Carpaccio's graphic art, perhaps some caution is warranted in the complete acceptance of the figure studies as an autograph work by the master. The very fame of Carpaccio's painting in the artist's era and ever since—thus the likelihood that it would be copied—might justify the hesitation expressed by some of the greatest connoisseurs of early Venetian draftsmanship, until other examples of secure drawings of similar late handling can substantiate the work. • *Suzanne Folds McCullagh* •

**NOTES**

1. It was noted that the same figure was used for an exotically garbed figure at lower right of the *Crucifixion* painting fragment in the Uffizi and that this drawing was incorrectly described as *aquarellato* in Ludwig and Molmenti 1906, 284–285, which also failed to mention that the two images on this sheet are on the recto and verso of a single page and not on two separate pages. For a detail of the figure in the painting see Fiocco 1958, pl. CLXIX.

2. One wonders if Pignatti in exh. cat. Venice 1963, 53, confused the Saint Stephen compositions within the cycle that dates from 1511–1520 when he continued "especially if we consider the possibility of a date towards 1520, in the style of the *Stoning of St. Stephen* at Stuttgart or the Capodistria organ shutters of 1523."
3. Muraro 1977, 107, concurred with Lauts' dating of the verso to c. 1515.

**PROVENANCE**
Earl of Sunderland; John Postle Heseltine, London [1843–1929] (Lugt 1507); Henry Oppenheimer, London [1859–1935/1936] (sale, London, Christie's, 10–14 July 1936, lot 52); Robert von Hirsch, Basel [1883–1977] (sale, London, Sotheby's, 20 June 1978, lot 19); John R. Gaines, Lexington, KY (sale, New York, Sotheby's, 17 November 1986, lot 7); Woodner Collections (The Ian Woodner Family Collection, Inc.); given to NGA, 1991.

**EXHIBITIONS**
Woodner, London 1987, no. 8; Woodner, New York 1990, no. 10.

**LITERATURE**
Colvin 1897, 194; Ludwig and Molmenti 1906, 286; Vasari Society 1913–1914, no. 6; Meder 1919, 288–289, pl. 97 (verso); Hadeln 1925, 58–59, pl. 37–38; Fiocco 1930, 70, pl. 160a (2nd ed. 1931, pl. 170); Van Marle 1923–1938, 18:345; Tietze and Tietze-Conrat 1944, 147, no. 623 (verso); Fiocco 1958, 33; Lauts 1962, 265, pl. 163; exh. cat. Venice 1963, under no. 54; Pignatti 1963, 53; Muraro 1966, 107, pl. 202; Cancogni and Perocco 1967, under no. 56; Muraro 1977, 27–28, figs. 52 (recto), 61 (verso).

# 28  Profile of a Man

**1500/1520, black chalk with stumping and touches of red chalk, heightened with white on laid paper, laid down, 422 x 272 (16⅝ x 10¹¹⁄₁₆)**

**Woodner Collections**

This life-sized bust of a man in a left-facing profile is one of the finest in a series of such portrait drawings by artists working in late fifteenth- and early sixteenth-century Milan. Most of these drawings, including the Woodner sheet, have been attributed to two leading portraitists—Ambrogio de Predis and his younger contemporary Bernardino dei Conti—both of whom specialized in profile likenesses of the Sforza court and their French successors. The names of Predis and Conti have alternated in the literature on the Woodner drawing, but more on the basis of their reputations than of their drafting styles, which are difficult to establish.[1] Most of the drawings associated with the two artists are in metalpoint, a medium well suited to the rigidity of their work. The Woodner profile, however, is in black chalk with white heightening and with touches of red chalk to enliven the features (the more heavily applied whites of the bust may be a later addition). This newer technique suggests a date of between 1500 and 1520. The major master active in Lombardy during this period was Andrea Solario, to whom the *Profile of a Man* has, in fact, recently been given.[2] This proposal also raises difficulties. Although Solario, unlike Predis and Conti, favored black and colored chalks for drawing, he consistently used the three-quarter view, rather than the profile, for independent portraits.[3] The three-quarter type, invented by the early Flemish masters, was adopted in Italy by Antonello da Messina, by whom Solario was strongly influenced. Solario's rejection of the profile (except for donor portraits in devotional works) would seem to disqualify him as author of the Woodner study, as does his drawing style, with its distinctive stippled method of rendering shadows.

A clue to the true authorship of the drawing may lie in the "slight sketch of a monument on a fragment of MS," which, according to the 1936 sale catalogue, was once attached to the back of the sheet and which is now, after several changes of ownership, unfortunately missing.[4] The monument described in the note presumably represented a work of sculpture, and perhaps not coincidentally, the style of the Woodner sheet closely resembles that found in drawings by sculptors working in and around Milan in the early sixteenth century, like Cristoforo Solari (Andrea's brother) or Bambaia.[5] In these drawings, as in the Woodner profile, forms are modeled in broad, smoothly applied areas of shadow in an attempt to translate Leonardo's pictorial devices of chiaroscuro and sfumato into sculpture. The large scale of the Woodner bust as well as its fused shading (done by stumping, or smudging, the chalk) and marblelike smoothness suggest that it might have been intended for a sculptural relief or monument.[6] The character of the portly sitter comes through in his firmly drawn features and benign expression, but his identity is unknown. • *David Alan Brown* •

**NOTES**
1. Bora 1987, 139–182.
2. Woodner exh. cat., Munich and Vienna 1986, and exh. cat. Austin 1988–1989.
3. See Brown 1987 for examples.
4. London, Christie's, 13 July 1936, lot 153. The attached sheet, though "included in the lot," is not mentioned elsewhere in the literature.
5. Valeri 1922, 107 and fig. 90; and Fiorio 1990, 31.
6. Compare Bambaia's monument to Canon Vimercati in the Cathedral of Milan (repro. in Fiorio 1990, 117–118, no. 10).

**PROVENANCE**
(P. & D. Colnaghi, before 1912); Henry Oppenheimer, London [1859–1935/1936] (sale, London, Christie's, 13 July 1936, no. 153, as Ambrogio de Predis); (Bacri, Paris); Benjamin Sonnenberg [1901–1978] (sale, New York, Sotheby-Parke Bernet, 5–9 June 1979, lot 110, as Bernardino dei Conti); (Stuart Denenberg, San Francisco); (Mia Weiner, New York); (Yvonne tan Bunzl, London); (P. & D. Colnaghi, London); Woodner Collections (Dian and Andrea Woodner).

**EXHIBITIONS**
London 1930, no. 625 (as Bernardino dei Conti[?]); New York 1959, 14, pl. XVII (as Conti); New York 1965–1966, no. 13 (as Conti); London 1985, no. 1 (as Ambrogio de Predis or Bernardino dei Conti); Woodner, Munich and Vienna 1986, no. 10 (as Andrea Solario[?]); Woodner, Madrid 1986–1987, no. 13 (as Solario[?]); Austin 1988–1989, no. 24 (as Solario).

**LITERATURE**
Parker 1927, no. 68 (as Bernardino dei Conti); Suida 1929, 173 (as Ambrogio de Predis); Ragghianti 1946, 225–226, pl. 6 (as Pordenone); Young 1967, 178, pl. 6 (as Conti); Shell 1989, 318 (not by Solario); exh. cat. Bergamo 1982, 9–14.

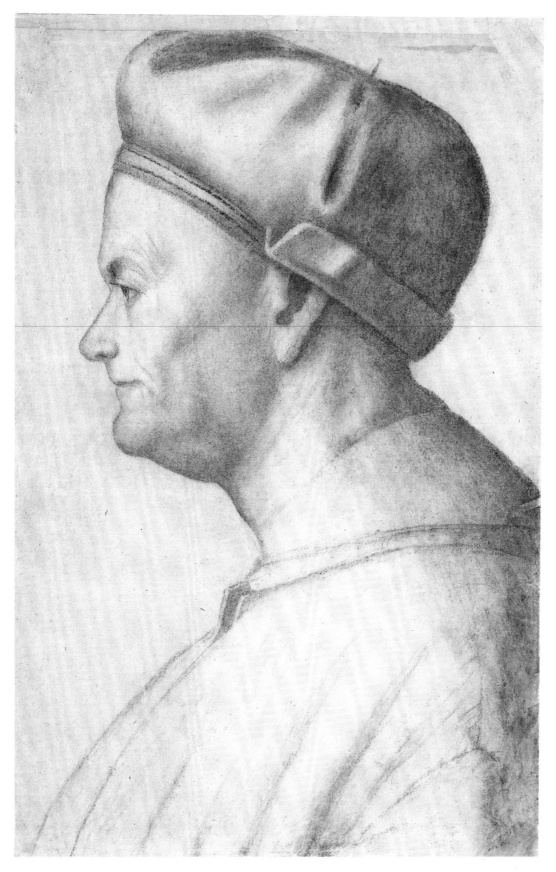

28

# 29  A Farmstead in a Wood

**c. 1500/1510, pen and brown ink and watercolor with white gouache on four joined pieces of parchment, 454 x 558 (17 7/8 x 21 15/16)**

**Traces of illegible writing at the upper left**

**Woodner Collections**

This landscape from the Nuremberg region, composed on four sections of parchment, is an image of unique charm. The pronounced Franconian character of the farmhouses in the clearing is the essential evidence for the localization. These houses are similar to the ones Albrecht Dürer drew in his famous watercolor in the Bremen Kunsthalle, with the autograph inscription *Kalkrewt* (Winkler 118). The suggestion of a hill in the foreground of the Woodner drawing, the houses with very high roofs set among trees, and the wattle fence partly surrounding the hamlet are all similar to Dürer's image. Yet this is not an abbreviated rendition of the same place.

Previous discussions of the Woodner drawing have made reference to the work of Nuremberg mapmaker Erhard Etzlaub (1455–1532) in whose circle similar images originated.[1] Yet the drawing style, primitive at first glance, should not be dated as early as has thus far been done. It is distinguished by the firmly outlined form of the treetops, which are treated as a compact mass of leaves, comparable to the trees that appear, for instance, in the woodcuts of Hartmann Schedel's Nuremberg Chronicle of 1493. In addition, the draftsman was certainly familiar with works by Dürer, such as *Three Lindens* (Kunsthalle, Bremen) or *Houses and Mill on a River* (Musée Bonnat, Bayonne) (Winkler 64, 199). Thus the sheet cannot have been produced as early as 1480, as suggested in previous Woodner catalogues, and certainly dates after 1500.

Four woodcuts from the circle of Dürer combine cartographic elements with topographical views in a very similar manner: the four quarters of Germany in the *Quattuor libri amorum secundum quattuor latera Germaniae* by Konrad Celtis, printed in Nuremberg in 1502. The relationship to Etzlaub is clear here also, since the real distances are indicated in ten-mile intervals in the side and lower margins.[2] These pictorial treatments of whole provinces must have been predecessors to the "meadow-map" of the Woodner collection, which already signals an advance in the development of mapmaking.

The "beautiful maps and pictures" that decorated the district office of the Nuremberg town hall, described by Johann Neudörfer,[3] must have looked similar to the present watercolor. The painstaking execution on parchment and the imposing dimensions raise the possibility that the Woodner drawing is in fact a surviving fragment of that decoration.  • *Fedja Anzelewsky* •

**NOTES**

1. Erhard Etzlaub, who came from Erfurt, settled in Nuremburg in 1482 as a compass maker but beginning in 1513 was also active as a physician. See Schnelbögl 1966, 11–26.
2. See Christoph Scheurl's 1517 report in Schnelbögl 1966, 14.
3. Schnelbögl 1966, 18.

**PROVENANCE**

Archduke Ferdinand, Vienna; then by descent to Archduke Friedrich, until 1918 at the Albertina (divided vertically into two halves; inv. 19790 and 19791); Dr. E. Czeczowiczka, Vienna (sale, Berlin, Boerner und Graupe, 12 May 1930, lot 6); Woodner Collections (Dian and Andrea Woodner).

**EXHIBITIONS**

Woodner, Cambridge 1985, no. 93; Woodner, Munich and Vienna 1986, no. 47; Woodner, Madrid 1986–1987, no. 56; Woodner, London 1987, no. 43; Woodner, New York 1990, no. 53.

**LITERATURE**

Rave 1938, 84 (detail from left part reproduced in reverse), 186.

29

# 30  Landscape with Buildings

c. 1510/1513, pen and brown ink on laid paper, laid down, 177 x 266 (6 $^{15}$/16 x 10 ½)

Inscribed at lower left in pen and brown ink: *Titiano*; numbered at lower right in pen and brown ink: *1606 No.69*

Watermark: Pascal lamb in circle

Woodner Collections

The complex but charming ensemble of buildings among wooded hills presented in this beautiful drawing is typical of the mountain landscapes portrayed in Venetian paintings, drawings, and prints from the first and second decades of the sixteenth century, from Giorgione and Titian to Giulio and Domenico Campagnola.

Although the compositional format of the Woodner drawing—with the close-up view of buildings filling nearly the entire sheet—is rather unusual, the atmosphere and style are very much in the taste of Giorgione. The morphology of the various elements, the decorative makeup of the sheet, and the artist's tendency to render delicate tonal passages with a pictorial touch are similar to Arcadian landscapes produced at the beginning of the second decade in prints and drawings by Giulio Campagnola and in paintings by Jacopo Palma il Vecchio. The charming motif here of water lapping at the houses and trickling under the arch,

calls to mind the drawing of *Rustic Buildings on a Riverbank* at Windsor Castle (Royal Library, inv. 5726)[1] and paintings like the *Concert in a Landscape* (Ardencraig, Scotland).[2] So too does the complex and fanciful assemblage of the rustic buildings.

The Woodner sheet, however, was executed in a free and open drawing style —especially in such details as the trees and the undulations of the terrain in the foreground—which has no comparison in the graphic work of Giulio. The delicate and mellow hatching in the chiaroscuro effects of the Woodner landscape is unlike Giulio's precision and brilliance in the clear optic definition of forms, nor does the drawing share the sense of a space full of air and light that is typical of the landscapes drawn by Titian in the same period.[3] It is not possible at this time to place it more precisely than in the general circle of Giorgione and to date it toward the beginning of the sixteenth century. • *Elisabetta Saccomani* •

## NOTES

1. Popham and Wilde 1949, 202 (as a copy or from the Workshop of Domenico Campagnola); attributed to Giulio Campagnola in Saccomani 1982, 83.
2. Collection of Lady Colum Crichton Stuart. See Rylands 1988, 278 (attributed to the Master of the Lansdowne Concert).
3. One may compare, for example, *Landscape with a Goat* (Louvre, Paris, inv. 5539) or *Landscape with a Castle* (British Museum, London, inv. 1895-9-15-832); see Wethey 1987, 151, 154 (with a proposed date for the London drawing of c. 1535, which is too late).

## PROVENANCE

Private collection (sale, London, Sotheby's, 4 July 1975, lot 21); Woodner Collections (Dian and Andrea Woodner).

## EXHIBITIONS

Woodner, Munich and Vienna 1986, no. 14 (here and subsequently as Venetian School); Woodner, Madrid 1986–1987, no. 18; Woodner, London 1987, no. 14; Woodner, New York 1990, no. 18.

30

# 31 A Town on a Hill

*The son of an obscure Paduan artist, Geralomo Campagnola, Giulio was very precocious and was already famous for his unusual talent for ancient languages, music, and art by the age of ten. The details of his artistic education are unknown, but he was at the court of Ferrara in 1498 and in Venice in 1507. According to Vasari (q.v.), Giulio was active as a painter and miniaturist, but now his reputation rests almost entirely on his engravings. He was influenced by the prints of both Andrea Mantegna (1431–1506) and Albrecht Dürer (q.v.), and he invented a pointillist technique that yielded finely modulated tonal effects. His art as a whole was most strongly influenced by Giorgione (1477 or 1478–1510), and he is regarded as the one who introduced Giorgionesque style and aesthetic to Paduan art.*

**c. 1513, pen and brown ink on laid paper, 187 x 219 (7⅜ x 8⅝)**

**Inscribed at lower right in pen and brown ink: *di Tizian***

**Watermark: Arrow (fragment)**

**Woodner Collections**

The remarkable qualities of this landscape drawing must be grasped first in the ornamental way the artist unified the composition, which is focused on a hill at the center of a broad space. He has indicated a sense of atmosphere, spatial recession, and the forms of rocks, trees, buildings with a touch that is entirely in the manner of Giorgione. Surface values and tonal variations are all achieved by means of extremely fine pen strokes and delicate, measured use of hatched shadows against the white ground of the paper. This decorative sensibility and refined toning of the surfaces, which suggest that the artist wanted to translate into graphic terms the fundamental values of the new depiction of landscape in Giorgione's painting, underscore the Woodner drawing's special harmony with the stylistic attitudes of Giulio Campagnola.[1]

The profound influence of Giorgione on Giulio is well documented in known engravings by the latter from the first decade of the sixteenth century (*Saint John the Baptist in a Landscape*; *Reclining Venus*; *Seated Young Shepherd*; *Old Shepherd Reclining with Flute*; *Astrologer*). Less tidy from the viewpoint of criticism and attribution is the definition of Giulio's work as a draftsman and the establishment of a clear line of separation between his landscape drawings and the early ones by his disciple Domenico Campagnola.[2]

Some notable landscape drawings date from precisely that moment of transition, toward the middle of the second decade, when Giulio's activity comes to an end and Domenico's begins. Among these are *Mountain Landscape with Village and Lake* (Museum Boymans-van Beuningen, Rotterdam, inv. I 339), the very similar *Landscape with Village on a Riverbank* (private collection, Paris), and *Rocky Landscape with Buildings* (fig. 1). Although these have recently been attributed to the young Domenico,[3] mention has also been made of the strongly Giorgionesque quality of the conceptions and the close dependence on the delicate and meticulous graphic manner of Giulio.

I had previously considered these drawings to be early works by Domenico (preceding his more expressionistic and Germanic prints of 1517),[4] but I am now in agreement with Alessandro Ballarin's attribution of the drawings to Giulio.[5] In reconsidering all the artist's activity, Ballarin has distinguished in these works characteristics such as attention to tonal values, extreme fineness of line, and great optical clarity that can properly belong only to someone whose artistic sensibility was formed under the influence of Giorgione and not to someone like Domenico, who began working during a time already dominated by Titian.

The Woodner drawing has strong and strict stylistic analogies with these transitional works. Even recognizing that the drawing includes some motifs and spatial solutions that occur in the drawings of Domenico—for example, the structure of the foreground or the very Düreresque distant view of the landscape on the right—the present drawing and the others mentioned above lack the dynamic pen strokes and the chiaroscuro description of forms in the manner of Titian that are Domenico's most typical traits.

A final reason for excluding the attribution to Domenico is offered by the faintly drawn head of a young man at the lower left on the verso of the sheet (fig. 2), which, in contrast to the other studies in black chalk, is from the same hand as the recto and is executed with a lightness and delicacy absolutely foreign to the incisive and mechanical drawing style of the younger of the two Campagnolas.

As for the black chalk *Nude Studies* on the verso, I maintain the validity of the earlier proposal that the artist is Jacopo Tintoretto (1518–1594), who somehow came into possession of this older drawing.[6] As proof, compare, for example, Tintoretto's *Study of a Man on Horseback* (Pierpont Morgan Library, New York) or *Figure Studies* (Uffizi, Florence, inv. 12969 F and 12931 F), all belonging to the late activity of the artist (late 1570s).[7] • Elisabetta Saccomani •

31

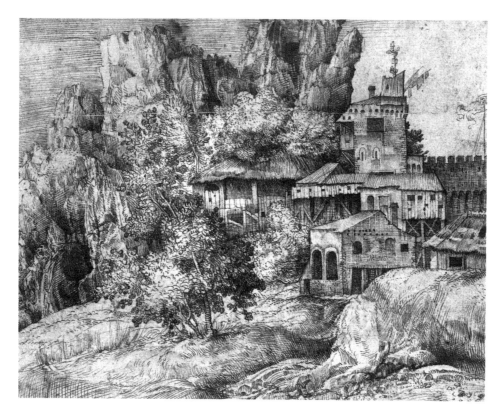

**FIGURE 1**

Giulio Campagnola, *Rocky Land-scape with Buildings,* The Pierpont Morgan Library, New York

**NOTES**

1. See Exhibitions below for different attributions.
2. The most recent study of the work of Giulio Campagnola is Oberhuber in exh. cat. Paris 1993, 483–502, where he attributes to Giorgione all the drawings earlier given to Giulio. Oberhuber based his conclusions on the very high quality of these drawings, which he believed was not found in the engravings securely attributed to Giulio. On the relationship between the two Campagnolas and on the youth of Domenico, see Rearick in exh. cat. Florence 1976; Oberhuber in exh. cat. Venice 1976; and Saccomani 1982, 81–99.
3. See exh. cats. Venice 1976, 116–117, and Venice 1985, 37–38; Saccomani 1982, 84; and exh. cat. Paris 1993, 513.
4. Saccomani 1982, 84–85.
5. This argument was the subject of a course of lectures Alessandro Ballarin gave at the Università degli Studi di Padova in 1990–1991, "Painting of the Renaissance in Northern Italy (1480–1540): Venice 1511–1518, Titian from the Frescoes of the Scuola del Santo to the *Assumption.*" For the reconstruction of the work of Giorgione and of the young Titian, on which the new perspective on the graphic production of Giulio and Domenico Campagnola directly depends, see the contributions of Ballarin in exh. cat. Paris 1993.
6. See Woodner exh. cat., New York 1971–1972, no. 29b.
7. Rossi 1975, 48, 29, 21.

**PROVENANCE**

Jacopo Tintoretto [1518–1594]; Maurice Marignane, Paris [b. 1879] (Lugt 1872); Hubert de Marignane, Paris; Woodner Collections (Dian and Andrea Woodner).

**EXHIBITIONS**

Woodner, New York 1971–1972, no. 29a (as Domenico Campagnola), 29b; Woodner, Munich and Vienna 1986, no. 15 (recto as Circle of Titian); Woodner, Madrid 1986–1987, no. 19 (recto as Circle of Titian or Giulio Campagnola); Woodner, London 1987, no. 15 (recto and verso as Circle of Titian); Woodner, New York 1990, no. 19 (recto and verso as Circle of Titian).

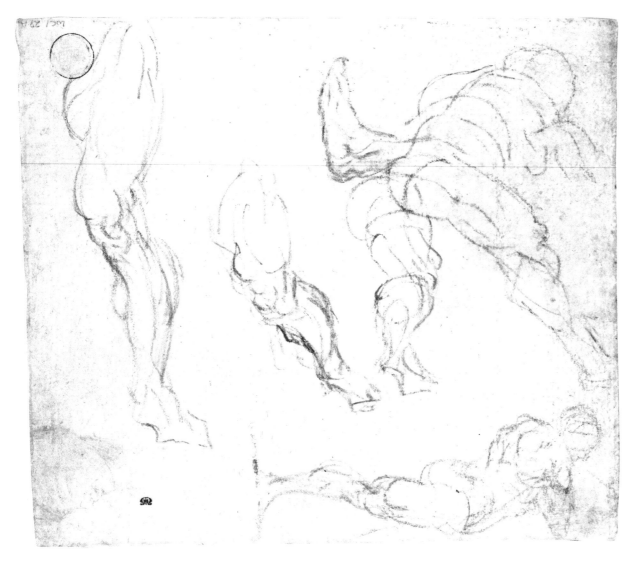

**FIGURE 2**

Verso of cat. 31: Giulio Campagnola (head at lower left), pen and brown ink; and Jacopo Tintoretto (figure and leg studies), black chalk

# 32  Head of a Horse

*An architect as well as a painter, Raphael was first trained by his father, Giovanni Santi (c. 1435–1494), and was probably already in the workshop of Perugino (c. 1448–1524) by 1495. From 1505 he worked in Florence, where he was much influenced by the work of Leonardo da Vinci (q.v.) and Michelangelo (1475–1564). He was summoned to Rome by Pope Julius II in late 1508 or early 1509, and soon after began work on the decoration of the Stanza della Segnatura in the Vatican (1509–1511). He also decorated the Stanza d'Eliodoro (1511–1514) and the Stanza dell'Incendio (1514–1517). Other works of Raphael's Roman period include the* Galatea *in the Farnesina (1511) and the cartoons of the Acts of the Apostles for the Sistine Chapel tapestries (1514–1516). In many of his late works he was helped by assistants. During his Roman period he painted a succession of altarpieces, among the most important being the* Transfiguration, *completed in 1520, now in the Vatican.*

**c. 1512, silverpoint with incised lines heightened with white, reworked with black chalk, on gray prepared paper, 144 x 107 (5 ¹¹⁄₁₆ x 4 ³⁄₁₆)**

**Inscribed on the verso across the top in pen and brown ink:** *mano del Gioseppino m. c. 67.*

**Woodner Collections**

This highly interesting study of the head of a horse was formerly attributed to Giuseppe Cesari (1568–1640), the late mannerist artist whose frescoes in the Palazzo dei Conservatori on the Capitoline Hill in Rome abound with horses. Nicholas Turner and Noël Annesley, however, recognized the similarity to Raphael, and Paul Joannides confirmed the attribution by establishing the relationship of the sheet to the frescoes in the Stanza d'Eliodoro (1511–1514) in the Vatican. The horse is extremely close in general features to the grand, prominent animal in Raphael's *Expulsion of Heliodorus,*

**FIGURE 1**
Giovanni Francesco Penni (?), *Repulse of Attila* (detail), Ashmolean Museum, Oxford

for which the fragment of a cartoon is preserved in Oxford.[1] It is also in the same technique as the silverpoint study on gray prepared paper in Frankfurt of a rider on horseback seen from behind.[2] Both this and the Woodner drawing are detail studies for a composition preserved in an old copy in Oxford (fig. 1),[3] which is clearly Raphael's first design for the *Repulse of Attila.* The Woodner drawing is a study for the horse's head in the right background of this design.

The painting was executed only after the accession of Leo X in 1513 but was originally conceived together with the *Expulsion of Heliodorus* around 1512.[4] It was then that Raphael also executed a number of other drawings in silverpoint on grayish prepared paper, some of which were landscapes or studies after the antique.[5] The free, rapid execution of the Woodner sheet might suggest that it was studied from nature, albeit with the commission in mind. Similar studies must have existed for the horse in *Heliodorus* and for the other horses in the *Repulse of Attila.* When Raphael modified the first design for *Attila* somewhat later into the much more elaborate version now preserved in a rare presentation drawing on parchment in the Louvre,[6] he used this study again, though with some modifications, for one of the two horses to the left of Attila. In the fresco this head is partially covered by two soldiers.

The *Repulse of Attila* was of particular importance in the development of Raphael's oeuvre. It was his first public reaction to Leonardo's great cartoon for the *Battle of*

*Anghiari,* which he had studied shortly after his arrival in Florence in 1505.[7] It allowed him to tap his archeological knowledge of antique battle scenes, including those on Trajan's column, which he had gained through intensive study since coming to Rome. And it led to his great *Battle of Constantine,* executed by his pupils after his death. • *Konrad Oberhuber* •

**NOTES**

1. Knab et al. 1983, no. 433; Joannides 1983, no. 336.
2. Knab et al. 1983, no. 457; Joannides 1983, no. 339.
3. Knab et al. 1983, fig. 111.
4. Shearman 1965, 170–172.
5. Knab et al. 1983, nos. 450, 453–455; see also nos. 319–322, where the same prepared paper was also used for studies of the Madonna and Child with strongly realistic tendencies.
6. Knab et al. 1983, no. 449; Joannides 1983, no. 341.
7. Knab et al. 1983, no. 112; Joannides 1983, no. 99.

**PROVENANCE**

Edward Bouverie, Delapré Abbey, Northamptonshire [1767–1858] (Lugt 325); private collection (sale, London, Christie's, 6 July 1982, lot 21); Woodner Collections (Shipley Corporation).

**EXHIBITIONS**

Woodner, Malibu 1983–1985, no. 11; Woodner, Munich and Vienna 1986, no. 13; Woodner, Madrid 1986–1987, no. 16; Woodner, London 1987, no. 11; Woodner, New York 1990, no. 14.

**LITERATURE**

Knab et al. 1983, no. 456; Joannides 1983, no. 340.

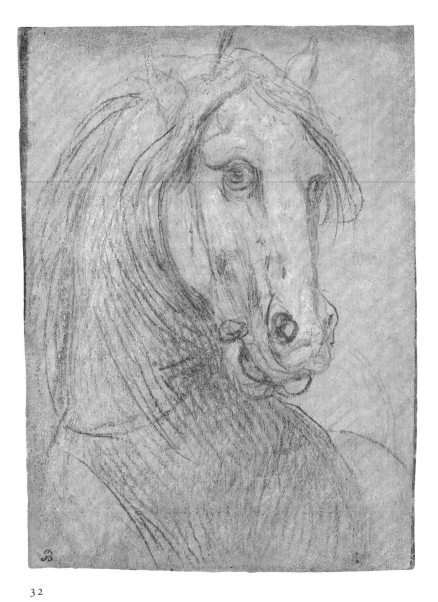

32

# 33 A Marble Horse on the Quirinal Hill

**c. 1513/1514, red chalk, with stylus underdrawing and traces of leadpoint on laid paper, 219 x 274 (8 ⅝ x 10 ¹³/₁₆)**

**Inscribed on the recto with numerical notations overall in pen and brown ink. Inscribed on the verso at lower right in red chalk: *desegno fato a Roma*; at lower center in red chalk: *D-1-*; at lower right in brown ink: *Perino 2 8,* and other numerical notations overall**

**National Gallery of Art, Woodner Collection 1993.51.3.a,b**

This drawing, representing the great horse on the Quirinal erroneously attributed to Praxiteles by an old inscription (fig. 1), once belonged to Sir Peter Lely and then to the dukes of Devonshire. It was always thought to be by Raphael, but only when John Gere, John Shearman, and James Byam Shaw studied it again in the late 1960s was it published as his work. It may have seemed to earlier authors too archeological for Raphael, a conception that, by contrast, fit in perfectly with studies in the 1970s and 1980s by Tilmann Buddensieg and Arnold Nesselrath in which this side of Raphael's work figured prominently. The latter recognized the Woodner sheet as Raphael's first known measured drawing of an antique sculpture, in keeping with a practice used before in the study of antique architecture. Roger Jones and Nicholas Penny further elaborated this reading and associated the sheet with Raphael's effort to reconstruct antique Rome at the end of his life. Nesselrath noted that the measurements marked in pen over the great transparent red chalk drawing are not in Raphael's hand, but he surmised that the drawing was made with the horse's measurements in mind and done in the context of a planned restoration executed by the Mantuan sculptor Jacopo Alari-Bonacolsi, called Antico, who signed his name at the supporting base of the sculpture. Antico is documented in Rome in 1495 and 1497, but Nesselrath assumed he could have come back later to do the work.

The connection with Antico's restoration is less likely now that the verso has been uncovered (fig. 2). Executed in pen, it shows another measured drawing of an antique sculpture—a round altar with its base drawn separately—to which are applied the same lines and inscriptions as appear on the horse on the recto. The end of a sarcophagus with three standing figures in a niche is not measured here, however, nor is the sketch of a helmeted warrior. This verso, later inscribed in red chalk *desegno fato a Roma,* has an old attribution to Raphael's pupil Perino del Vaga, and as Nicholas Turner pointed out in 1990 after discovery of the verso, the drawing and handwriting correspond well with similar works attributed to Perino who worked with Raphael in the Logge from about 1517/1518 on. This kind of measured drawing is more in keeping with the sketches of architects after Roman antiquities, which were common in the Renaissance. Indeed, the way the base of the altar is drawn fully fits into that tradition. The horse may therefore have first been drawn by Raphael without measurements, then measured by the draftsman of the verso in a campaign of studying antique sculpture in Rome.

The alternative that the artist of the verso helped Raphael in a study of antiquities in Rome must also be considered. Drawings made after the antique in Raphael's workshop have not yet been systematically studied, though Arnold Nesselrath has made much progress in that direction.[1] Nesselrath has suggested to this author, in fact, that the verso drawing may be by Giovanni da Udine, who is known to have studied antiquities with Raphael. His drawings are very similar to those attributed to Perino, thus Nesselrath's idea is very persuasive. He will publish his findings in the future.

This monumental red chalk study of the famous horse on the Quirinal certainly remains rather isolated. It is difficult to date but seems earlier in style than the drawings for the Loggia di Psiche of around 1517 to 1518. It could have been made as early as 1513/1514. The group of two horses and horse tamers on the Quirinal, standing there since antiquity, have been restored several times since the Renaissance. They have old inscriptions attributing them to Phidias and Praxiteles and have been named the Dioscuri—that is, Castor and Pollux, the twin gods—but each has also been identified with Alexander and his horse Bucephalus. They are now thought to be Roman replicas of Greek fifth-century statues not far in style from that of Phidias.
• *Konrad Oberhuber* •

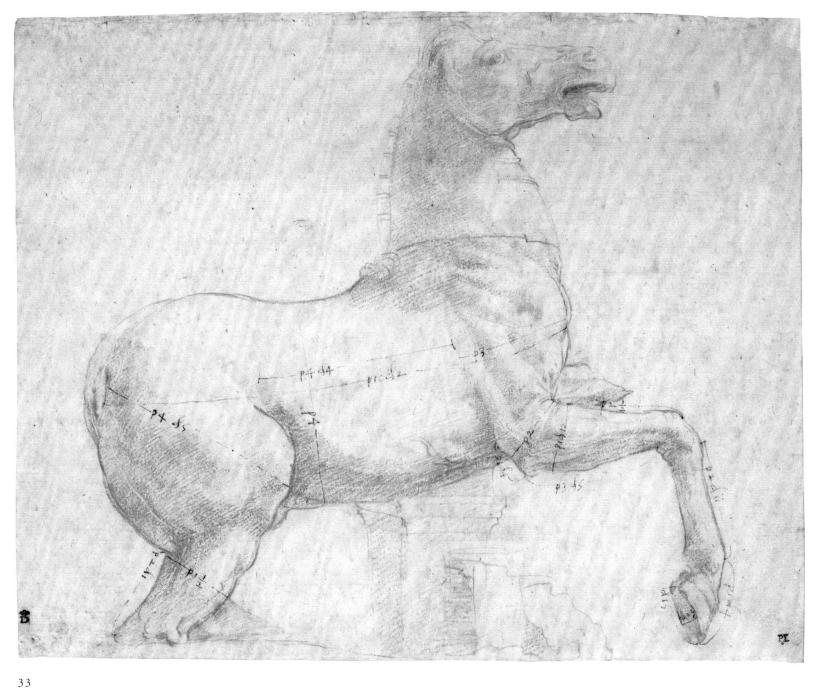

33

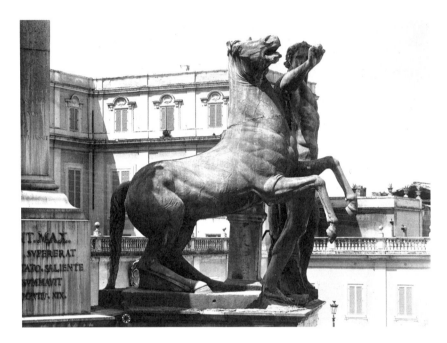

**FIGURE 1**

Roman, *Horse and Horse Tamer,*
Piazza del Quirinale, Rome

### NOTE

1. See Nesselrath in exh. cat. Rome 1984, 397–421.

### PROVENANCE

Unknown Italian collection (armorial blind stamp at
upper left); Sir Peter Lely, London [1618–1680] (Lugt
2092); presumably William Cavendish, 2nd Duke of
Devonshire [1672–1729]; then by descent at Devon-
shire House and Chatsworth (inv. 657) (sale, London,
Christie's 6 July 1987, lot 10); (P. & D. Colnaghi, Lon-
don, 1987); Woodner Collections (The Ian Woodner
Family Collection, Inc.); given to NGA, 1993.

### EXHIBITIONS

Washington 1969–1970, no. 56; London 1973–1974, no.
56; Tokyo 1975, no. 18; Jerusalem, 1977, no. 25; Washing-
ton 1983, no. 127; Rome 1984, 408, no. 3.2.10; Woodner,
London 1987 (*hors catalogue*); Woodner, New York
1990, no. 16; Woodner, Washington 1993–1994.

### LITERATURE

Buddensieg 1976, 3; Nesselrath 1982, 353–356, fig. 37;
Knab et al. 1983, fig. 531; Jones and Penny 1983, 203–205,
fig. 219; Joannides 1983, no. 398; Gere and Turner 1983,
no. 127; Bober and Rubinstein 1986, 125, 160, fig. 125a;
exh. cat. New York 1987, no. 20 (not exhibited); exh.
cat. New York 1987a, no. 20 (not exhibited); Jaffé 1994,
2: no. 315.

# 34 Eight Apostles

**c. 1514, red chalk over stylus underdrawing and traces of leadpoint on laid paper, cut in two pieces and rejoined, laid down, 81 x 232 (3 ³/₁₆ x 9 ¹/₈)**

**National Gallery of Art, Woodner Collection 1993.51.2**

*Eight Apostles* is a fragment of a much larger drawing, the original appearance of which can still be reconstructed on the basis of an old contemporary counterproof in Windsor Castle (fig. 1).[1] This fragment is itself composed of two smaller parts, which were only recently rejoined in their original positions. A third fragment in the Louvre shows the single standing figure of Christ.[2] It is not known when the original sheet was dismembered, but such a fragmentation usually took place when the whole page was damaged through some accident and a dealer or collector strove to salvage some of the well-preserved parts.

The three fragments of the original drawing and the counterproof of the whole form an extremely precious record of Raphael's preparatory work for the cartoon of *Christ's Charge to Saint Peter,* part of a series of ten cartoons commissioned by Pope Leo x as preparation for tapestries to be woven by Peter van Aelst in Brussels and hung in the lower part of the walls of the Sistine Chapel.[3] A first payment of 300 ducats for the series was received by Raphael on 15 June 1515; a second, possibly final payment of another 300 ducats was made on 20 December 1516. For reasons of style, it is believed that Raphael had already started

the series in 1514, and *Christ's Charge to Saint Peter* was certainly one of the first, if not the very first cartoon created in this project.

Numerous sketches must have preceded the now-fragmented drawing, for it belonged to a stage in the working process in which the general composition was fully established and the artist drew each figure from models placed in the positions foreseen in the design. Raphael did not have a group of models pose like a staged scene in the configuration of the complete picture, but rather studied the models either one at a time or in small groups of about three, inserting the studies into the spaces provided in the composition and over the nearly invisible preparatory sketch made on the paper with a stylus, indentations from which are still visible under the red chalk. Careful study indicates that the third and the fifth Apostles on the Woodner sheet were drawn from the same model, as were the second and sixth. These models were stripped to undergarments when Raphael needed to study the positions of their legs; others were draped in clothes already close to the garments used in the final composition, when this was more important for the artist's understanding of the whole. At this stage of the development Raphael left out two figures who would appear in the final composition. One was later placed at the beginning of the group behind the young Saint John (in the prayerful pose at the left); the other was added at the back of the group where Raphael seems to have been restricted by the size of his paper.

The finished composition study from which the Woodner *Eight Apostles* was cut was used for the preparation of the so-called *modello,* a well-developed drawing containing all the essential elements of the final work; this *modello* is still preserved in the Louvre (fig. 2).[4] In it all the poses studied here are retained, along with many of the facial expressions and hairstyles. Even in the cartoon, where Raphael gave each Apostle more individualized features, the artist kept much of what he studied here in the attentive expressions of his studio models. The movement of the heads, drawn with utmost economy and clarity in the red chalk, is one of the most classical formulations of a Renaissance concern for variety in psychology and pose in a group of people, which found a first culmination in Leonardo's *Last Supper.* There the Apostles react to Christ's announcement of his betrayal by Judas. Here they are moved and astonished by his giving the keys of the Church to Saint Peter and his charge to the Apostle to "feed my lambs," a combination of two different passages from the Gospels, one taking place before and the other after the Resurrection of Christ.[5] For the Church these were both essential confirmations of the primacy of Peter and of his successors, the popes. • *Konrad Oberhuber* •

34

## NOTES

1. Knab et al. 1983, no. 513; Joannides 1983, no. 359.
2. Knab et al. 1983, no. 512; Joannides 1983, no. 358.
3. Shearman 1972, 96–97.
4. Knab et al. 1983, no. 517; Joannides 1983, no. 360.
5. John 21:15–17 and Matthew 26:17–19. See also Shearman 1972, 55.

## PROVENANCE

Possibly Pierre Crozat, Paris [1665–1740]; private collection (sale, London, Christie's, 29 November 1977, lots 33 and 34); John R. Gaines, Lexington, KY (sale, New York, Sotheby's, 17 November 1986, lot 8); Woodner Collections (The Ian Woodner Family Collection, Inc.); given to NGA, 1993.

## EXHIBITIONS

Woodner, London 1987, no. 12; Woodner, New York 1990, no. 15; Woodner, Washington 1993–1994.

## LITERATURE

Popham and Wilde 1949, no. 802; Shearman 1972, 96–97, figs. 48, 49; Fischel and Oberhuber 1972, no. 443–444, pl. 45; Annesley 1978, 96; Knab et al. 1983, 125, figs. 514, 515; Joannides 1983, no. 2; exh. cat. Paris 1983–1984, under no. 99; Ames-Lewis 1986, 131–132, figs. 141–142; exh. cat. New York 1987, under no. 26.

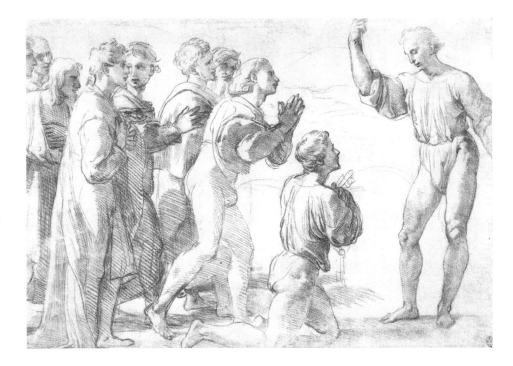

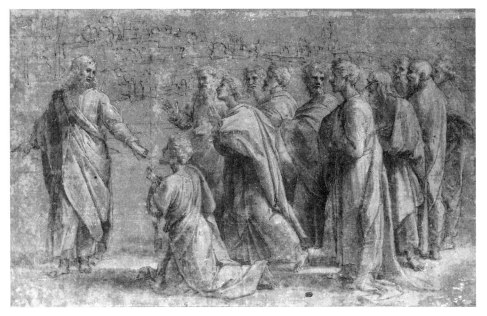

**FIGURE 1**

Raphael, *Christ's Charge to Saint Peter*, counterproof, The Royal Collection © Her Majesty Queen Elizabeth II

**FIGURE 2**

Raphael, *Modello for Christ's Charge to Saint Peter*, Département des arts graphiques, Musée du Louvre, Paris

# 35  Mary and John before the Man of Sorrows

*Kulmbach trained with the Italian printmaker and painter Jacopo de' Barbari (c. 1460/1470–1516 or before), who worked in Germany for several years beginning in 1500, and also with Albrecht Dürer (q.v.). Upon the departure of Hans Schäufelein (c. 1480/1485–1538/1540) and Hans Baldung (q.v.) from Nuremberg by 1509, Kulmbach became the foremost interpreter of Dürer's art there, and by 1510 he had succeeded Michael Wolgemut (1434–1519) as the most important designer of elaborate altarpieces combining sculpted shrines and painted wings. His masterpiece was the Memorial Picture for Lorenz Tucher (1513), in Saint Sebald's Church, Nuremberg. Between 1514 and 1516 Kulmbach worked extensively for patrons in Kraków. He was also a leading designer of stained-glass windows in Nuremberg and may have designed woodcuts for book illustrations, though none can be securely attributed to him. Numerous drawings by Kulmbach survive.*

**c. 1514, pen and brown ink with watercolor on laid paper, 147 x 176 (5 13/16 x 6 15/16)**

**Watermark: Orb with cross and star (cf. Briquet 3061)**

**Woodner Collections**

In this drawing the Virgin Mary and John the Evangelist act as intercessors for a kneeling donor, who is presented to the risen Christ by an angel. Choirs of cherubim fly above. Christ, depicted as the Man of Sorrows, stands on the large stone that had been placed against the entrance of his tomb and displays the bleeding wounds of his Crucifixion. He holds under one arm the scourges with which he was beaten and wears the crown of thorns as further reminders of his Passion.

Christ as Man of Sorrows was a popular image from the first century until 1530, in part because of widespread cults devoted to his wounds and blood. In a drawing of c. 1511 Kulmbach represented Christ in this guise, seated on the stone that had sealed his tomb.[1] The idea of the Perpetual Passion seems to have informed contemporary interpretations of the theme. In 1511 Albrecht Dürer depicted the Man of Sorrows on the frontispiece of his Small Passion, with accompanying verses by Benedictus Chelidonius that refer to the widely accepted idea that Christ, having completed his suffering on earth, continues to be tortured by the sins of mankind.[2] In the present drawing the blood that freely flows from Christ's wounds implies his continued suffering.

It also symbolizes his body and blood in the bread and wine of the Eucharist. According to an apocryphal story, Christ appeared to the sainted Pope Gregory the Great during a celebration of the Eucharist, bearing the instruments of his Passion. Thus images of Christ above the altar served as visual confirmation of the doctrine of transubstantiation, which asserts that the bread and wine of the Mass actually become the body and blood of Christ. Indeed, in the Woodner drawing the stone on which Christ stands suggests an altar.

Particularly in Italian images of the late middle ages and Renaissance, Christ as the Man of Sorrows is mourned by the Virgin, John the Evangelist, and angels. Kulmbach relies on this tradition but introduces a variation that seems to be unique to the Woodner drawing when he includes an angel presenting a kneeling donor.

This drawing was once affixed in an album along with important drawings by both the elder and younger Lucas Cranach. Its original purpose is uncertain, but it may have been a study for a devotional painting or painted epitaph or it may have been intended for a private prayer book. The horizontal format, the placement of the figures against an extensive landscape, and the execution in pen and watercolor call to mind Dürer's preliminary drawing of 1511 for the *Memorial Picture for Lorenz Tucher* in Saint Sebald's Church, Nuremberg,[3] which Kulmbach completed in 1513.[4] The swift, sure pen work, attenuated figures, and soft, full drapery in the Woodner drawing sug-

gest a slightly later date, contemporary with Kulmbach's designs of 1514 for the Emperor's Window in Saint Sebald's.[5]

The donor in Kulmbach's drawing is unidentified. If the sheet were a study for a memorial picture, a coat-of-arms would most likely have been added in the final work. The Italian derivation of the iconography suggests that the donor might have been one of many German scholars and merchants educated or working in Italy in the late fifteenth and early sixteenth centuries. • *Barbara Rosalyn Butts* •

**NOTES**

1. Graphische Sammlung der Universität, Erlangen; Winkler 1942, no. 34.
2. Hebrews 6:4–6. See Bartsch 16; and Strauss 1980, 445–558, no. 155.
3. Kupferstichkabinett, Berlin; Winkler 1936–1939, 508.
4. Stadler 1936, no. 74.
5. Winkler 1942, nos. 77–80.

**PROVENANCE**

A noble Saxon family; (art market, Berlin); (Galerie Dr. W. Raeber, Basel); Tobias Christ (sale, London, Sotheby's, 9 April 1981, lot 10); (Richard Day, Ltd., London, 1981); Woodner Collections (Dian and Andrea Woodner).

**EXHIBITIONS**

Zurich 1973, no. 186; Woodner, Cambridge 1985, no. 94; Woodner, Vienna 1986, no. 51; New York 1986, no. 165; Woodner, Madrid 1986–1987, no. 62.

**LITERATURE**

Winkler 1942, 22, 60, no. 42, pl. 42; Winkler 1959, 85; Winzinger 1970, 67; Butts 1985, 124.

35

# 36 The Lamentation

*From 1500 Baldung trained in the tradition of Martin Schongauer (c. 1450–1491) in a workshop in Strasbourg. Between 1503 and 1507 he worked in Nuremberg, where he apprenticed with Albrecht Dürer (q.v.). Except for a period in Freiburg-im-Breisgau from 1512 to 1517, Baldung lived and worked for the rest of his life in Strasbourg, where he became a master in 1510. He was a supporter of the Reformation and a close colleague of the Strasbourg humanists. He was active as a painter, printmaker, book illustrator, and designer of stained glass. Many of his works are characterized by disquiet and sensuality; he often provided a violent or highly personal interpretation of traditional themes.*

**c. 1515, brush and black ink heightened with white on dark brown prepared paper, the surface varnished, 272 x 183 (10³⁄₄ x 7 ¹⁄₄)**

**Dated at upper left in black chalk: *1515 [?]*; illegibly inscribed at upper right in brown ink; inscribed on the verso at upper center in brown ink: *Tie hat Jost von kreissen [?] gewerckt u tan / Tie hat / Jost von;* inscribed on the verso at lower right in brown ink: *Mein freudlich grü... / zu vor herz lieben in / ich loss dich wissen das ich / fugl[i]ch und noch gesund- / Mein f.;* also on the verso a graphite tracing of the watermark**

**Watermark: Octopus in shield (cf. Briquet 2208–2211)**

**National Gallery of Art, Woodner Collection 1991.182.3**

Hans Baldung Grien was the most precocious and idiosyncratic artist in Albrecht Dürer's circle. An apprentice in Dürer's Nuremberg workshop from 1503 to 1507, he revealed in his early work a profound debt to Dürer's compositions and graphic vocabulary. The compositional arrangement of the present drawing can be traced to Dürer's *Lamentation* engraving of 1507 from the Small Passion. Baldung has borrowed from Dürer not only the dense pyramidal arrangement of the characters (though reduced from Dürer's larger groupings to the four essential figures) but also such details as the Cross and ladder behind the mourners and the gestures of the crouching Saint John and Mary Magdalene wringing her hands above her head in grief.

But whereas Dürer still exercises a certain restraint and retains a sense of decorum, Baldung heightens the pathos to appeal more directly to the viewer's emotions. He does this by transforming the Christ into an inert, broken figure, with drooping arms and head sunk onto his bony shoulder. The expression on Christ's emaciated face resonates in the facial expressions of the women, who are overcome by his death.

The moonlit, nighttime effect achieved in this chiaroscuro drawing—using black and white ink on dark brown prepared paper—contributes to the poignancy of the scene and further underlines the highly charged mood and emotional impact of this image.

It is likely that the impassioned grief expressed in this drawing and the unrestrained emotionalism of Baldung's work after 1512 in general are due to his contact with Matthias Grünewald, who was at work at the time on the Isenheim altarpiece. News of Grünewald's masterpiece must have lured Baldung to Alsace to see the great work firsthand, and Grünewald's style must have greatly appealed to Baldung, who was predisposed to express traditional religious subjects in uncommon and profoundly expressive ways. The Isenheim altarpiece was completed in 1515, the very year in which Baldung likely made this drawing.

Although some of Baldung's chiaroscuro drawings are clearly preparatory studies for paintings, this *Lamentation* seems to be a complete, finished work in its own right, only generally related to Baldung's other renditions of the subject.

One such *Lamentation,* the panel painting dated 1513 in the Tiroler Landesmuseum Ferdinandeum, Innsbruck, comes closest to the Woodner drawing in the depiction of the Christ figure, with elongated torso and legs. The panel predates this drawing, however, and represents an earlier and less well-resolved composition. • *Alan Shestack* •

**PROVENANCE**

Gottfried Winkler, Leipzig; W. Hauth, Frankfurt am Main, 1924; purchased by A. Strölin, Lausanne, 1926; Woodner Collections (Dian and Andrea Woodner); given to NGA, 1991.

**EXHIBITIONS**

Karlsruhe 1959, no. 145; Woodner, Malibu 1983–1985, no. 89 (Washington and Cambridge only); Woodner, Munich and Vienna 1986, no. 53; Woodner, Madrid 1986–1987, no. 65; Woodner, London 1987, no. 52; Woodner, New York 1990, no. 64.

**LITERATURE**

Swarzenski and Schilling 1924, x, no. 5; Koch 1941, 37; Möhle 1942, 215, 218; Möhle 1959, 125; Bernhard 1978, 179; Osten 1983, 138, under no. 40.

36

# 37  The Madonna and Child with Saint Francis, Saint Anthony Abbot, and a Donor

**c. 1517, red chalk (wetted for counterproofing) on laid paper, laid down, 202 x 186 (7 15/16 x 7 5/16)**

**Inscribed at upper left in red chalk:** *Hieronimo romani / da bressa*

**Woodner Collections**

*Romanino's early oeuvre reveals that he studied the Milanese works of Bramante and Bramantino as well as the paintings of Giorgione (1477 or 1478–1510). During the second decade of the sixteenth century he was one of the most successful followers of Titian (c. 1488–1576) and produced his greatest work, the San Francesco altarpiece in Brescia. In 1519 he frescoed four stories of the Passion of Christ in the nave of the Cremona Cathedral, stimulated by the daring heterodox style of his former pupil, the Cremonese Altobello Melone (active 1497–1530). His anticlassical phase continued well into the 1530s, when he frescoed the palace of Cardinal Clesio in Trent as well as many churches in the Valcamonica. In the last period of his career Romanino returned to a more conventional style, influenced by the works of his partner and son-in-law Lattanzio Gambara (c. 1530–1574), who imported into Brescia the language of mannerism.*

This drawing became known to modern scholars in 1939 when it was exhibited in Brescia. It belonged then to Conte Rasini (Milan), who had bought it from an unidentified Parisian dealer on the advice of Antonio Morassi. The attribution has never been disputed, in part because of the inscription at the top left,[1] but the dating has varied widely. This is explained by several factors. The artist was active for approximately fifty-five years, yet he signed and dated only three paintings. A few more are either datable or well documented, but for the most part connoisseurship provides the sole insight into Romanino's different stylistic phases. Furthermore, his drawings were seldom made as preparatory studies for his paintings. The artist enjoyed improvising on the canvas or on wet plaster, with gouache and fresco being his favorite media and his drawings serving only as informal guidelines. Vasari tells us that Romanino was a great draftsman,[2] but it is very difficult to date his surviving graphic oeuvre, which has been critically discussed and partly reconstructed only in the last four decades.[3]

Antonio Morassi was the first to offer a thorough analysis of the Woodner sheet, noticing certain affinities with the work of Palma il Vecchio (1480–1528) and dating the drawing c. 1515. Maria Luisa Ferrari then connected it stylistically with the lost altarpiece of the *Madonna and Child Enthroned between Saint Louis of Toulouse and Saint Roch* (formerly Kaiser-Friedrich Museum, Berlin) and dated the sheet between 1516/1517 and 1519/1520.

The drawing was discussed often in 1965, when it was exhibited again in Brescia. F. Kossoff emphasized its Giorgionesque flavor, dating it c. 1515; she noted how Romanino reused the same composition for a later altarpiece (fig. 1) and observed that a later red chalk drawing of a kneeling worshiper (Uffizi, Florence) was based on the figure of the donor in the Woodner sketch.[4] Ivan Fenyö connected the Woodner sheet stylistically with a red chalk drawing of the *Adoration of the Shepherds* (Szépmüvészeti Múzeum, Budapest), dating them both c. 1530 or later. H. A. Peters detected a similarity between the Woodner and Budapest drawings but dated them much earlier, c. 1512, seeing a connection between the saints on the Woodner sheet and those on two panels in the Cunietti collection (Milan) as well as the *Saint Peter* and *Saint Paul* panels in the Schloss Wilhelmshöhe (Kassel).[5]

Recent exhibition catalogues of the Woodner collection have continued to propose varying dates for this drawing: in 1986 it was dated between 1517 and 1519; in 1987, shortly before 1520 "when the artist was working on the frescoes in the Cathedral at Cremona, begun in 1519." Finally, Anna Forlani Tempesti noted affinities with the *Concert champêtre* in the Lehman Collection (Metropolitan Museum, New York) probably drawn in 1531/1532, and dated the Woodner drawing between 1520 and 1530.

Opinions thus range from c. 1512 to 1530 or later, which is typical for scholarship on Romanino's oeuvre. In 1986 I listed the Woodner drawing in the context of Romanino's Franciscan patrons. It is akin in its almost square format and in the theme of the Madonna seated in front of a tree in the middle of a landscape to the *Madonna and Child between Saint Bonaventure and Saint Sebastian* painted by Romanino for the church of San Bernardino in Salò (fig. 2).[6] The church belonged to the Franciscan Observants, and the altarpiece has been plausibly dated c. 1517. In my opinion, the same date should be assigned to the drawing, which is profoundly influenced by Giorgionesque models revisited by the young Titian. The extremely elegant use of the smoldered red chalk, the few bravura touches used to render the crucifix held by Saint Francis or the hands of the donor, the face of the Virgin, and the right background are all elements derived from works produced by Titian during the second decade of the sixteenth century.

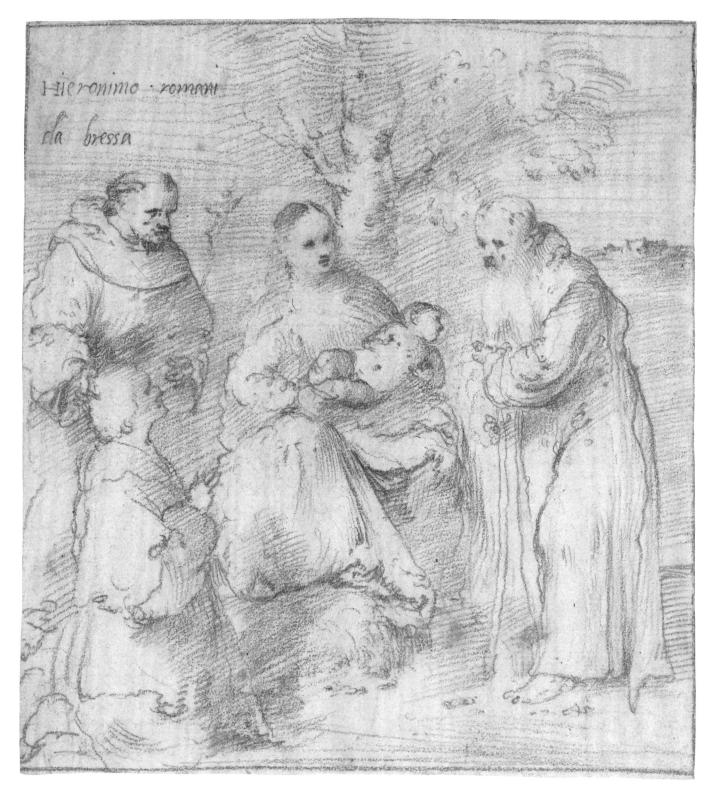

37

**FIGURE 1**

Girolamo Romanino, *Madonna
and Child with Saint Francis and
Saint Anthony of Padua,* Pinacoteca
del Castello Sforzesco, Milan

The sheet was once wetted for counter-
proofing, and it may have originally served
as a model for an engraving. Romanino's
activity in this area is usually ignored, but
as early as 1948 A. M. Hind published three
engravings designed and perhaps also exe-
cuted by Romanino.[7] If this were the pur-
pose of the Woodner drawing, however, no
trace of such an engraving survives.
• *Alessandro Nova* •

**NOTES**

1. Most critics consider the inscription to be auto-
graph, although no clear evidence currently supports
this. Morassi 1959, 190, claimed that the inscription
was written in the same red chalk used to make the
drawing, but it would have been highly unusual to
"sign" a drawing in this way in the early sixteenth cen-
tury. And although the handwriting may date from the
sixteenth century, as is usually suggested, two other
drawings by Romanino with similar inscriptions cast
doubt on this assumption. A red chalk drawing of
*Two Standing Soldiers* (Pierpont Morgan Library, New
York, inv. 1973.38) is inscribed *Hieronimo Romanino da
Bressa;* and a brush and wash drawing of a *Nude Male
Figure with Upraised Right Arm* (Metropolitan Mu-
seum, New York, inv. 61.123.3) is inscribed *Gerolamo
Romanio Prattico / Pittore Bresciano.* The latter was
certainly added in the eighteenth century, and both
were probably written by collectors. It is possible that
the inscription on the Woodner drawing was also
added by a collector, perhaps in the sixteenth century.
It is also possible that the artist or his engraver (if
there was one) added the inscription after the red
chalk was wetted for counterproofing.

The Woodner and Morgan Library drawings were
said to be in the same English private collection either
in the seventeenth century (exh. cat. Woodner, Munich
and Vienna 1986, 36) or in the eighteenth century
(Muraro in exh. cat. Venice 1957, 22). The confusion
may have been created unintentionally by oral infor-
mation given by Janos Scholz to the Pierpont Morgan
Library, clarified somewhat in Scholz 1958, 416.

2. Vasari 1966 ed., 3:626.

3. For a discussion of Romanino's surviving prepara-
tory drawings, see Nova 1995, 159–168.

4. Rearick in exh. cat. Florence 1976, 126, tentatively
seconded the connection with the Uffizi drawing but
dated both sheets c. 1518–1519.

5. According to the most recent studies, the two panels
in Milan and the two in Kassel were part of the same
polyptych; see Nova 1994, 213–215.

6. Ruggieri 1976, 25, also pointed out the affinities of
the present drawing to the painting in Salò and dated
the sheet slightly earlier than 1519.

7. Hind 1948, 5:229, and 7: pls. 898–899.

**PROVENANCE**

Unidentified seventeenth- or eighteenth-century Eng-
lish collection; (unidentified Parisian dealer, around
the 1930s); Conte Rasini, Milan, 1939; (P. & D. Colnaghi,
London); Woodner Collections (Dian and Andrea
Woodner).

**EXHIBITIONS**

Brescia 1939, no. 9; Brescia 1965, no. 122; Woodner,
Cambridge 1985, no. 81; Woodner, Munich and Vienna
1986, no. 17; Woodner, Madrid 1986–1987, no. 21;
Woodner, London 1987, no. 16; Woodner, New York
1990, no. 20.

**LITERATURE**

Muraro in exh. cat. Venice 1957, under no. 14; Scholz
1958, 415–416; Morassi 1959, 190, fig. 38; Ferrari 1961,
under no. 25; Kossoff 1965, 514–521; Fenyö 1965, 48;
Peters 1965, 151–152; exh. cat. Florence 1976, 126; Rug-
gieri 1976, 25; Nova 1986, 114; Forlani Tempesti 1991, 91.

**FIGURE 2**

Girolamo Romanino, *Madonna
and Child between Saint Bona-
venture and Saint Sebastian*, San
Bernardino, Salò

# 38  The Adoration of the Magi

**Mid-1520s, tempera heightened with gold on vellum mounted to wood, 168 x 229  (6⅝ x 9)**

**Woodner Collections**

Listed as a work of Simon Bening in Christie's sale catalogue of 1973 and in the Woodner catalogue of the same year, this jewel-like miniature was attributed to the circle of Simon Bening in subsequent catalogues of the Woodner collection. The work has many characteristics of Simon's personal style, however, and seems securely attributable to his hand.

According to Friedrich Winkler, the origin of the composition is a lost painting by Hugo van der Goes,[1] known only in copies, one in Berlin by an anonymous follower of Hugo, and the other a panel by Gerard David in Munich (fig. 1). The Woodner version is closer to David's panel, and although differing in many details, it appears to have been based directly on David's painting rather than on an intermediate source.[2]

The spatial construction of Bening's composition is more complex than David's and causes the viewer to see the composition from slightly above, rather than from below, as in David's work, with the result that the distant background in Bening's seems deeper and more spacious. Bening's composition also contains a third angel, in an energetic, "diving" pose, in addition to the pair that hovers above the Holy Family in David's painting. All three have the soft, sweet faces and small hands typical of Bening.

The Woodner miniature is also related to various miniatures in extant manuscripts, and several scholars have claimed that replicas of it exist that are now untraced. Variations occur in two manuscripts: the Breviary of Isabella of Castile from the late 1490s (British Library, London, Add. MS 18851, fol. 41v), and the Grimani Breviary of c. 1517 (Biblioteca marciana, Venice, MS Lat. I.99, fol. 74v).[3] As for the possible existence of replicas, Friedländer noted the presence in the Fauconnier collection, Mons, of a miniature that reproduces David's composition.[4] That same miniature eventually turned up in the Young Collection, New York City (fig. 2), but was at first thought to be another variant of the David composition.[5] It is, however, a replica, with some changes, of the Woodner miniature.[6] Finally, Winkler mentioned another miniature of the same composition in the Detroit Institute of Arts.[7]

The dating of the Woodner sheet has never been adequately addressed and has thus far been placed no more precisely than to the period between the late fifteenth century and the middle of the sixteenth.[8] Yet the fine surface detail, the mastery of three-dimensional space seen in the complex construction of the interior of the stable, and the equally accomplished aerial perspective employed to form the transition from middle ground to background indicate that this is a fairly mature work of Bening's, probably from the mid-1520s.

The question of whether the Woodner miniature was excised from or made for insertion into a manuscript, or whether it was intended to serve as an independent image, cannot be answered with certainty.[9] Although both the relatively large size and the horizontal format make it an unlikely candidate for insertion into most manuscripts produced in Bening's shop, the artist occasionally undertook the illumination of large-scale books.[10] He also contributed to the illumination of the Grimani Breviary, a manuscript in which the full-page miniatures are on the same scale as the Woodner work. If the Woodner miniature is actually a fragment of a book that no longer exists, the original must have been of unusual size and richness of decoration, which would lead one to suspect that other illuminations of similar dimensions might have survived. There are, however, no examples among the numerous detached miniatures attributed to Bening that appear related to the Woodner miniature, and no known manuscript by Bening from which the miniature could have been removed.[11] It is more likely that the Woodner *Adoration* was intended to serve as an independent devotional image.[12]  • *Judith Anne Testa* •

38

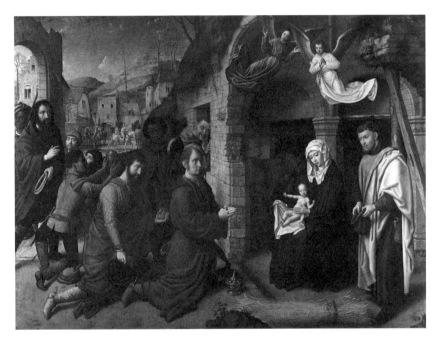

**FIGURE 1**

Gerard David, *Adoration of
the Magi*, Staatsgemäldesamm-
lungen, Munich

**FIGURE 2**

After Simon Bening, *Adoration
of the Magi*, H. Young Collection,
New York

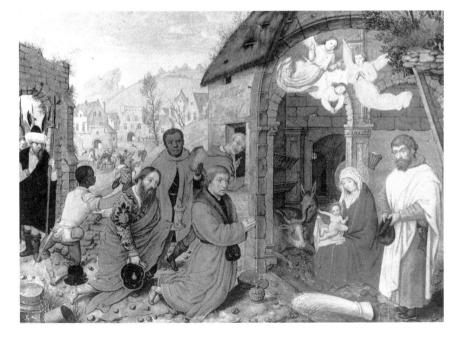

**NOTES**

1. Winkler 1964, 190–195. Van Migroet 1989, 287, notes that there is no documentary evidence that any such lost original by Hugo ever existed.

2. Versions of this composition were already in use among illuminators of the Ghent-Bruges School in the late fifteenth century. Winkler 1964, 195, figs. 152 and 153, illustrates two miniatures (which he attributes to Simon Bening's father, Alexander Bening): one from the Hours of Mary of Burgundy (Kupferstichkabinett, Berlin, no. 78B12), and the other from the Hours of Philip of Cleves (Bibliothèque royale, Brussels, no. IV.40). Neither are as close to David's painting as the Woodner miniature.

3. For discussion of the Isabella Breviary see exh. cat. New York 1983–1984, 40–48, pl. IV. Although Winkler 1964, 189, mentions this Grimani miniature as the work of Simon Bening, it has none of the characteristics of Bening's style.

4. Friedländer 1967–1976, 4:72 and n. 67; pl. 34, no. 20A.

5. First mentioned in sale cat., London, Christie's, 20 March 1973, 43, lot 116. Woodner exh. cat., New York 1973–1974, no. 77, suggests that the Woodner *Adoration* may be identical with the Mons miniature.

6. Two of many tiny variances in detail between the Woodner miniature and the Fauconnier-Young minia-ture concern the figure of Joseph and a dog in the left background in front of a gate. In the Woodner mini-ature Joseph stands securely on feet that are slightly splayed; in the Fauconnier-Young version Joseph's feet point straight ahead, and the right foot is much smaller than the left. In the Woodner miniature the dog is standing on all fours; in the other it appears to be leaping.

7. Winkler 1964, 190 and n. 1, suggested that the Detroit miniature might have formerly been in the Fauconnier collection. But according to Goldner in Woodner exh. cat., Malibu 1983–1985, 116 n. 2, this miniature cannot be traced in the collections of the Detroit Institute of Arts.

8. Friedländer 1967–1976, 4:72, no. 20, and 6b:103, no. 181; Goldner in Woodner exh. cat., Malibu 1983–1985, 116.

9. Goldner in Woodner exh. cat., Malibu 1983–1985, 116; and Van Migroet 1989, 287, repeat the claim that the Woodner *Adoration* was intended for use in a manuscript. Both apparently base their comment on an observation made in Friedländer 1967–1976, 4:72, that the original composition, as interpreted by David, often served as a model for book illuminations.

10. Among the few large-format books by Simon Bening are the documented Genealogy of the House of Portugal (British Library, London, Add. MS 12531), and the Statute-Book of the Order of the Golden Fleece (Instituto de Valencia de Don Juan, Madrid, Codex 26-1-27).

11. The reappearance within the past thirty years of a number of important manuscripts by Bening — including the Passion Prayerbook and the Book of Hours of Cardinal Albrecht of Brandenburg as well as the Beatty Rosarium — suggests that unknown manu-scripts by Bening may still exist in private collections. For the Passion Prayerbook see Winkler 1962, 7–107; for the Book of Hours of Cardinal Albrecht see Hind-man, forthcoming; for the Rosarium see Testa 1986.

12. If the Woodner *Adoration* were used to illustrate a manuscript, the horizontal format would preclude its being a full-page miniature, since manuscripts of Bening's era were vertical. The miniature would therefore have occupied a position on the top half of the page, similar to that of the compositional variant that appears in the Breviary of Isabella of Castile (see above, note 4). It would have had a painted frame, adding another 10 mm to its height and width; and it would have required another 60 or 70 mm of width to provide an adequate border on the vertical sides, resulting in a total page width of at least 290 mm. A book that wide would have had to be at least 400 mm high. These are improbable dimensions for a manuscript from the Bening shop; only the anomalous Genealogy of the House of Portugal (see above, note 11) was designed on such a scale. It is significant that Bening had nothing to do with determining the dimensions of that work, since the leaves were prepared and designed in Portugal by Antonio de Hollanda and subsequently sent to Bening to be painted; see exh. cat. New York, 1983–1984, 69–78; and Aguiar 1962.

### PROVENANCE

Alfred Morrison, London [1821–1897], then by descent to his grandson, Lord Margadale of Islay (sale, London, Christie's, 20 March 1973, lot 116); Woodner Collections (Shipley Corporation).

### EXHIBITIONS

London 1973b, no. 37; Woodner, New York 1973–1974, no. 77; Woodner, Malibu 1983–1985, no. 45 (here and subsequently as Circle of Bening); Woodner, Munich and Vienna 1986, no. 66; Woodner, Madrid 1986–1987, no. 79; Woodner, London 1987, no. 68; Woodner, New York 1990, no. 83.

### LITERATURE

Exh. cat. New York 1983–1984, 48 n. 28.

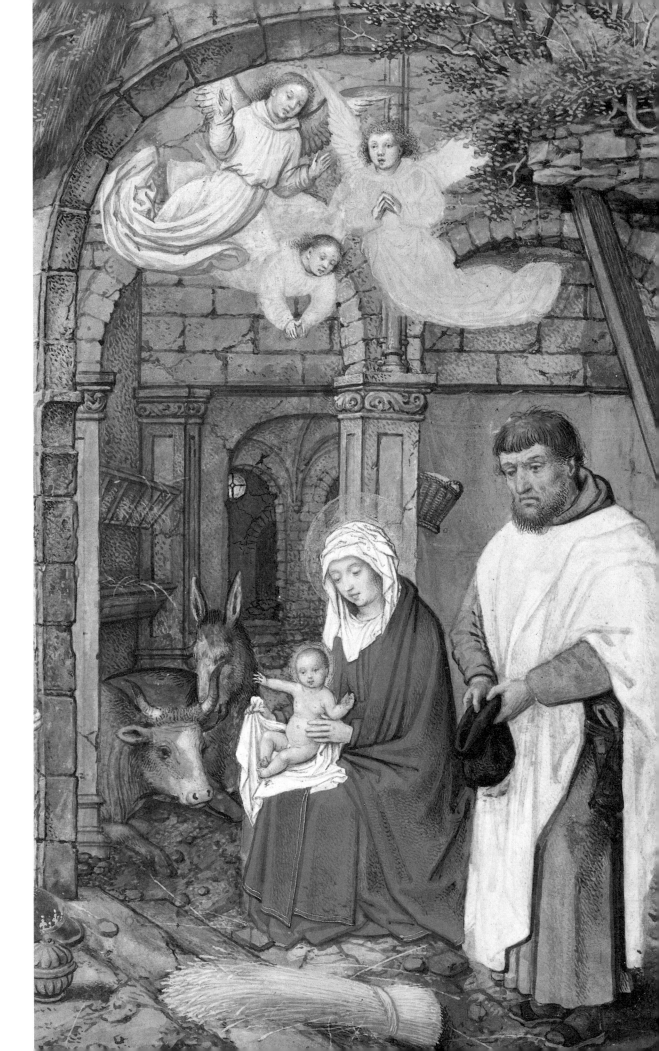

# 39  Woman Carrying a Torch

*The predominant influence upon Correggio's early style seems to have been the work of Andrea Mantegna (1431–1506). He was also inspired by Leonardo da Vinci (q.v.) in Milan, a city he probably visited, and by Giorgione (1477 or 1478–1510) in Venice. Correggio's earliest signed work is the Madonna of Saint Francis (Gemäldegalerie, Dresden), painted in 1514–1515 for the church of San Francesco at Correggio. The date of his journey to Rome is not known, but the impact of Michelangelo (1475–1564) and Raphael (q.v.) was considerable. Correggio is first recorded in Parma in 1520 when he began work on the cupola of San Giovanni Evangelista. He decorated the cupola of Parma Cathedral some time between 1523 and 1530, perhaps not starting until 1524 or 1525. The two allegorical paintings in the Louvre, made for Isabella d'Este of Mantua, are among his last works. Many of the trends of the baroque and the rococo were influenced by Correggio's style.*

**1525/1530, red chalk on laid paper, 79 x 60 (3 ⅛ x 2 ⅜)**

**Woodner Collections**

This small, spirited sketch likely belongs to a group of drawings made in preparation for paintings for the *studiolo* of Isabella d'Este in the Palazzo Ducale in Mantua. Several drawings exist for Correggio's *Allegory of Virtue* and *Allegory of Vice* (Louvre, Paris), which were the last works to complete the room and were recorded in the *studiolo* by 1542.[1] A. E. Popham plausibly suggested that the Woodner drawing is a study for another, unexecuted, painting for the *studiolo* with the subject of the *Battle of Chastity and Lust.* Isabella had not been pleased with Perugino's painting of this subject (Louvre, Paris), completed and delivered in 1505 after numerous delays.[2] Popham supposed that the marchesa some years later would have asked Correggio to replace the unfashionable work by Perugino with a painting in a more up-to-date style. Supporting Popham's theory is a two-sided drawing by Correggio in the Musée Bonnat, Bayonne, with studies on the recto of a running woman carrying a torch, similar to the Woodner sheet, and studies on the verso of a woman with a quiver on her back, grappling with something in her hands.[3] Also on the verso is a kneeling woman in the act of tying something. These must be studies for Venus (attacking with a torch) and for Diana (deflecting the attack), the prime protagonists in Perugino's multi-figured composition. The kneeling woman would then be Athena restraining Cupid. As Isabella had dictated in her contract with Perugino, she desired a battle between Chastity and Lust, that is, Athena and Diana fighting Venus and Cupid.[4] The Woodner drawing, like the Bayonne sheet, would then portray Venus running and thrusting her lighted torch toward an unknown opponent.

The dating of the Woodner drawing remains controversial, though it appears to belong to the second half of the 1520s. The two allegories in the Louvre have been dated c. 1529 by Cecil Gould and c. 1530–1534 by Popham, who believed that the commission for the *Battle of Chastity and Lust* grew out of Correggio's work on the Louvre pictures.[5] The drawing can confidently be dated somewhat earlier than Correggio's last period, however, when he was executing other mythological paintings for Isabella's son, Federigo Gonzaga. Two other drawings in the Woodner collection—with the same provenance and in the same technique as the *Woman Carrying a Torch*, and on similar paper—may have been cut from the same sheet as the present study.[6] These drawings, with half-figures of men shielding their eyes, are almost certainly studies for the Apostles in the cupola of the Parma Cathedral, begun in 1524.[7] Although the cupola may have been finished by 1526, one can be sure only that both the cupola and pendentives were finished by November 1530, when Correggio received final payment for his work in the cathedral.

Correggio was extremely busy in the 1520s, and numerous commissions were completed over a long period; consequently, precise dating of his paintings and drawings is not possible. Stylistically, this red chalk study, with its nervous, repetitious contours, softly applied chalk, and swirling lines, fits well within this broad period of Correggio's maturity in the middle to late 1520s. • *Diane De Grazia* •

**NOTES**

1. Gould 1976, 127–130, 239–242; Popham 1957, 98–101.
2. Popham 1957, 96–97 (fig. 40 for Perugino's painting).
3. Popham 1957, 96, 166, no. 86, pls. CVII–CVIII.
4. Popham 1957, 96, and 96 n. 3.
5. Gould 1976, 128–130; Popham 1957, 96–97.
6. Popham 1957, nos. 64–65, pls. LXXIIIA, b.
7. Gould 1976, 106–107.

**PROVENANCE**

Jonathan Richardson Sr., London [1665–1745]; Edward Bouverie, Northampton, England [1767–1858] (Lugt 325); Dr. Henry Wellesley, Oxford [1791–1866](sale, London, Christie's, 26 June 1866, possibly lot 360A); Richard Johnson, Manchester [died c. 1877]; Henry Oppenheimer, London [1859–1935/1936] (sale, London, Christie's, 10–14 July 1936, lot 74A); François Strölin, Lausanne; Woodner Collections (Shipley Corporation).

**EXHIBITIONS**

Woodner, New York 1973–1974, no. 40; Woodner, Malibu 1983–1985, no. 13; Washington 1984, no. 26; Woodner, Munich and Vienna 1986, no. 18; Woodner, Madrid 1986–1987, no. 22; Woodner, London 1987, no. 17; Woodner, New York 1990, no. 21.

**LITERATURE**

Popham 1957, no. 87.

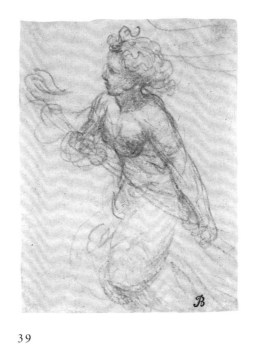

39

# 40  Madonna and Child

*According to Vasari (q.v.), Parmigianino was trained by his uncles Michele and Pier Ilario Mazzola. His decoration of the first two chapels on the left in San Giovanni Evangelista in Parma, begun in 1522 or shortly before, already reveals the influence of Correggio (q.v.), who was at work in the church at the same time. Recently it was shown that Parmigianino contributed a figure to Correggio's cupola in the same church. In c. 1523 he decorated a room in the Rocca Sanvitale at Fontanellato, near Parma, and later went to Rome where he remained until 1527, coming into contact with the school of Raphael (q.v.). After the sack of the city he visited Bologna, and in 1531 he was again in Parma where he contracted to decorate the eastern apse of the Steccata, his most important late work. Parmigianino's work was immensely influential upon the development of the mannerist style in northern Italy and in France.*

**c. 1521/1523, red chalk on laid paper, 176 x 150 (6 ¹⁵⁄₁₆ x 5 ⅞)**

**Inscribed at upper right in black ink: *Parmegiano***

**Woodner Collections**

The representation of the Madonna adoring the Christ Child on the recto of this sheet is unusual in Parmigianino's oeuvre for the tenderness and the obvious emotional connection it portrays between the Mother and Child. Rather than the aloofness of most of his subjects, the artist here emphasizes the maternal bond by the placement of the Virgin's hand on the Child (as if to restrain gently his playful antics) and the exposure of her left breast, as she evidently prepares to feed her baby. The relationship is reinforced by the choice of technique and handling: red chalk tends to downplay contours, and the use of circular strokes and curlicue lines integrates the various forms on the page.

The style of the Woodner sheet suggests a date in Parmigianino's first Parmese period, prior to his departure for Rome in late 1523. The lack of emphasis on contours, the softly applied chalk for shadows, and the lightly indicated trees and shrubbery imply an attachment to Correggio's draftsmanship typical of this period. The ovoid forms that make up the Virgin's body correspond to those in Parmigianino's frescoes at Fontanellato and in his painting of the *Rest on the Flight into Egypt* (Courtauld Institute, London), works datable to c. 1523.[1] It is tempting to think that

the Woodner *Madonna and Child,* with its landscape, relates to the Courtauld painting.

The figure on the verso of the sheet (fig. 1), however, may indicate an entirely different compositional goal for the recto. This standing male figure (which seems to have been cancelled by the artist with slashes of vertical lines) has been likened to a shepherd holding a lamb in a drawing of the *Adoration of the Shepherds* (Metropolitan Museum, New York), a work from Parmigianino's Roman period, c. 1524/1527.[2] Although both drawings on the Woodner sheet may relate to an Adoration of the Shepherds, the standing male figure may also be a study for Saint John the Baptist holding a lamb, or even for Saint Roch. A figure of Saint John wearing a loincloth,

**FIGURE 1**

Verso of cat. 40, *Standing Male Figure,* red chalk

seen in profile rather than from the front, appears in Parmigianino's early *Madonna and Child and Saints* in the church of Santa Maria at Bardi (1521).[3] In fact, the same elongated forms, circular strokes, clawlike hands, and fluffy foliage in the Woodner chalk sketch appear in a pen drawing in the Louvre, Paris, which was preparatory for the Bardi painting.[4] These features appear in many of Parmigianino's drawings between c. 1521 and 1523, supporting a similar dating for the present sheet.

Parmigianino often returned to ideas formed on paper at different points in his career, as demonstrated by the early date for the *Madonna and Child* and *Standing Male Figure* and the later dates for paintings of analogous subjects and compositions. This working method of reinventing ideas in what was less than a linear progression toward his final compositions was typical of Parmigianino's somewhat erratic preparatory process. • *Diane De Grazia* •

**NOTES**
1. Di Giampaolo 1991, nos. 7 and 6, respectively.
2. Popham 1971, 1:119, no. 297; 2: pl. 148.
3. Di Giampaolo 1991, 18–19, no. 2.
4. Popham 1971, 1:139, no. 381; 2: pl. 1.

**PROVENANCE**
Hanley Collection; Woodner Collections (Shipley Corporation).

**EXHIBITIONS**
Woodner, New York 1971–1972, no. 22; Woodner, Malibu 1983–1985, no. 14; Woodner, Munich and Vienna 1986, no. 22; Woodner, Madrid 1986–1987, no. 27; Woodner, New York 1990, no. 27.

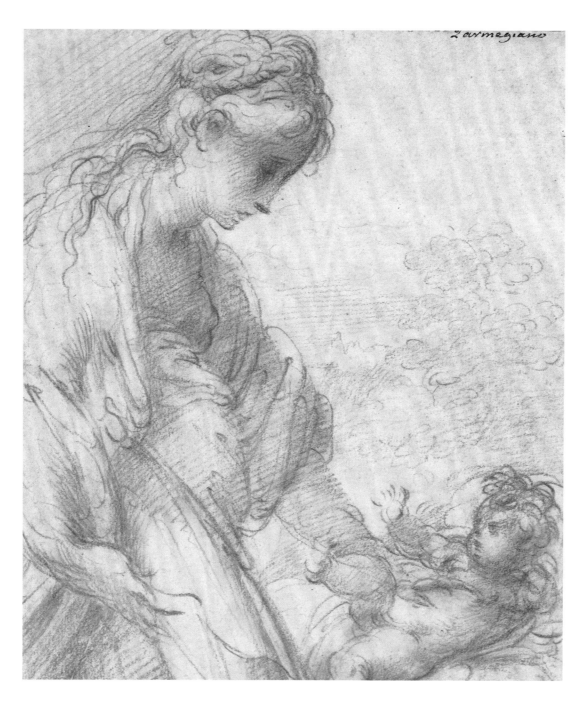

40

# 41 Head of Saint John the Baptist

*Possibly a pupil of Piero di Cosimo (1462–1521) and later an associate of Franciabigio (c. 1482–1525) and Jacopo Sansovino (1486–1570), Andrea del Sarto received his first important commission for the five frescoes of the Life of San Filippo Benizzi in the forecourt of SS. Annunziata, the latest of which is dated 1520. Probably in 1522 he began the series of grisaille frescoes of the Life of Saint John the Baptist in the Chiostro dello Scalzo. In 1518 he journeyed to France, where he was to have been court painter, but he returned to Florence in 1519. One of his most important commissions thereafter was the fresco of the* Last Supper *for San Salvi, finished c. 1526. From the beginning of his career Andrea painted a succession of major altarpieces, including the outstanding* Lamentation *in the Pitti Gallery. After the return of the Medici and the change of the political system in 1512, he succeeded Fra Bartolommeo (q.v.) as the leading painter of Florence.*

**c. 1523, black chalk on paper laid down on panel, 330 x 231 (13 x 9 1/16)**

**National Gallery of Art, Woodner Collection 1991.182.14**

Andrea del Sarto was one of the most accomplished draftsmen of the High Renaissance in Florence. Unlike many of his contemporaries, who relied to a large extent on conceptual images, Andrea was totally dependent on the living model, to which he returned as a touchstone throughout the various stages of the working process. This drawing is characterized on the one hand by acute observation of the model's inner mood and outward expression, and on the other, by the polish and calculation of classical convention.

A deceptively fine but slightly heavy-handed copy of the Woodner drawing[1] was long thought to be an original on account of its distinguished provenance—from Mariette to Paignon-Dijonval, Morel de Vindé, Dimsdale, and Lawrence. The first to recognize it as a copy was Jean Paul Richter in the 1901 catalogue of the Locko Park collection. Bernard Berenson still accepted both versions as authentic even in 1961,[2] although A. E. Popham had compared the two works firsthand as early as 1949 and noted that the present drawing appeared to be the original.[3]

Early scholars were inclined to connect this drawing with the head of Isaac in the *Sacrifice of Isaac,* of which there are versions in Madrid, Dresden, and Cleveland.[4] Beren-son was the first to point out the connection with the painting of *Saint John the Baptist* in the Pitti Gallery (fig. 1),[5] an opinion followed by all later critics. Commissioned by the banker Giovan Maria Benintendi, who later presented it to Duke Cosimo de Medici, the Pitti painting was probably made shortly before the artist fled to the Mugello to escape the plague in Florence in 1523. Shearman has proposed that it was originally part of a series of paintings fitted into the paneling of a room in the Benintendi house.[6]

The correspondence between the Woodner drawing and the Pitti painting is very close, but contrary to most cases, the Baptist in the painting appears to be more sensuous and to have the more lifelike expression, owing to the painting's recent cleaning and to the damage and extensive repair of the drawing. Despite the condition of the sheet, this classically poised head of a youth still possesses the nobility and intimacy so typical of Andrea's best works.
• *Chris Fischer* •

## NOTES

1. British Museum, London, inv. 1860-6-16-92; see Freedberg 1963, 1:168; Shearman 1965a, 2:359; and Turner in Woodner exh. cat., London 1987, 46.
2. Berenson 1903 and Berenson 1938, 2: no. 136, identify the British Museum drawing as "apparently for the Baptist in the Vienna 'Pietà.' Probably Andrea's but not of his best quality." In Berenson 1961, 2: no. 136, it has become "della migliore qualità."
3. Turner in Woodner exh. cat., London 1987, 45.
4. Guinness 1899, 74; Richter 1901, 27.
5. Berenson 1903, no. 130.
6. Shearman 1965a, 2:259. The other artists who delivered paintings for this lavish room were Bachiacca, Pontormo, and Franciabigio, whose contribution, the *Story of Bathsheba* (Gemäldegalerie, Dresden) is dated 1523; see McKillop 1974, 168–169, no. 35.

## PROVENANCE

Guadagni collection, Florence; William Drury-Lowe, Locko Park, England, acquired between 1840 and 1865; by descent to Capt. J.D.B. Drury-Lowe, Prestwold Hall, Loughborough, England, by 1953; private collection (sale, New York, Sotheby's, 14 January 1987, lot 32); Woodner Collections (The Ian Woodner Family Collection, Inc.); given to NGA, 1991.

## EXHIBITIONS

Leeds 1868, no. 243; London 1953, no. 51; Nottingham 1968, no. 10; Edinburgh 1969, no. 1; Woodner, London 1987, no. 13; Woodner, New York 1990 no. 17; Washington 1992, no. 5.

## LITERATURE

Guinness 1899, 74; Richter 1901, no. 68; Berenson 1903, 2: no. 130; Knapp 1907, 135 (2nd ed. 1928, 115); Berenson 1938, 2: no. 130; Berenson 1961, 2: no. 130; Freedberg 1963, 1:168, and 2: fig. 125; Shearman 1965a, 2:359, pl. 124b; Forlani Tempesti 1970, 92, fig. 40.

**FIGURE 1**

Andrea del Sarto, *Saint John the Baptist,* Galleria Palatina, Palazzo Pitti, Florence

41

# 42 Christian II of Denmark and Norway

**c. 1523, pen and brown ink with gouache on vellum, 120 x 95 (4¾ x 3¾)**

**Woodner Collections**

Dubbed the "Nero of the North" by Erasmus because of the ruthlessness of his rule, Christian II (1481–1559) was elected monarch of Denmark and Norway in 1513. He then forced Sweden to accept him as its ruler too and was crowned in Stockholm in 1520. Only four days after his coronation he ordered the deaths of more than eighty leaders of the Swedish opposition, a massacre that incited a war of liberation. Denmark also rose against him, and Christian was deposed and fled to the Netherlands in early 1523. In a bid to regain his kingdom, he attempted to invade Norway in 1531 but failed and was arrested the following year. He spent the rest of his life in prison.

Christian II's bearded countenance, with its long fleshy nose, high cheekbones, thin lips, and deep-set eyes is well known through a number of portraits by artists of no lower stature than Albrecht Dürer, Lucas Cranach the Elder, and Jan Gossaert.[1] Comparisons with these and other portraits of the Scandinavian monarch leave no doubt as to the identity of the sitter in the Woodner miniature.

Though unfinished, the Woodner portrait belongs to a distinct group in which Christian, wearing a large, flat black velvet beret, a wide-collared mantle, and a finely pleated chemise, is presented half-length and in three-quarter view to the left.[2] Closest to the Woodner drawing in pose and many of the details—including the acid-green background—is a gouache portrait in a Swiss private collection. Also included in this group are three other anonymous paintings: one formerly attributed to Joos van Cleve (present location unknown); a miniature on panel in Frederiksborg Castle, Denmark; and a larger panel in which a foliate ornament was added at the top (Statens Museum for Kunst, Copenhagen). The expression and pose are also closely similar in an oil portrait on panel attributed to Quentin Massys in Kroměříž (Czech Republic).[3] Curiously, all except this last version feature the same bunching of the chemise at the sitter's left shoulder as in the Woodner drawing. The remarkable similarities among these versions, none of which is identical to any of the others, suggest that they were variants of a portrait that is now unknown. Else Kai Sass proposed that this group might have been based on a lost oil made by Dürer in 1521, but the appearance of the Dürer drawing in the British Museum, London, presumed to have been made in preparation for the painting, does not seem to support that theory.[4]

A connection with Cranach's workshop, which produced at least four other portraits of Christian II,[5] seems more likely. Indeed, Christian's face in the Woodner drawing is slightly stylized in the manner of the Cranach workshop, while the delicate rendering of hair, beard, eyes, and lips is close to the painting technique of Cranach himself. The adept handling of the brush, the attention to fine detail, and most especially the capturing of Christian's alert, yet slightly distracted expression suggest that this drawing is the work of an accomplished master in Cranach's circle. • *Alan Shestack and Margaret Morgan Grasselli* •

**NOTES**

1. For a survey of the portraits of Christian II see Kai Sass 1976, esp. 165, 167, and 171A. Michael Sittow made the earliest portrait in 1514 (lost; a copy is in the Statens Museum for Kunst, Copenhagen). Then Dürer made both a drawing (British Museum, London) and a painting (now lost) in July 1521, when both artist and monarch were in Antwerp. After Christian was exiled in 1523, he is said to have lived for a time in Cranach's house in Wittenberg. In that year Cranach painted his portrait (Germanischen Nationalmuseum, Nuremberg; Schade 1974, fig. 122), and the artist and his workshop produced three woodcuts (exh. cat. Basel 1974, 1: figs. 114, 191, 192). Finally, a pen and ink drawing by Gossaert, probably made in 1524, is in the Institut néerlandais, Paris.
2. See Kai Sass 1976, 171B, 171C, 175B, 175D.
3. See Kai Sass 1976, 173A, 173B.
4. Kai Sass 1976, 176. The Dürer portrait drawing also shows Christian in three-quarter view to the left, but his hair is longer and his beard is more neatly trimmed. The sharp cheekbone that is such a prominent feature of the king's face in portraits of the Woodner type is far less pronounced in the Dürer drawing. Unless the lost oil differed quite considerably from the British Museum drawing, it could not have served as the model for the portraits in the Woodner group.
5. See note 1, above.

**PROVENANCE**

F. Corman (sale, Paris, Nouveau Drouot, 8 March 1984, lot 80); Woodner Collections (Dian and Andrea Woodner).

**EXHIBITIONS**

Woodner, Munich 1986, 250, no. IX; Woodner, Madrid 1986–1987, no. 63; Woodner, London 1987, no. 50. Woodner, New York 1990, no. 61.

42

# 43 Portrait of a Man Wearing a Hat with a Medallion

**Possibly 1540s or 1550s, black, red, and yellow chalks on laid paper, 204 x 203 (8 ¹/₁₆ x 8)**

**Inscribed at upper left in black chalk:** *HB* (in monogram); inscribed by Cornelis Ploos van Amstel on verso in brown ink: *Hans Holbein / gebooren Basel 1520 / gestorven London 1583. / Discepel van zyn / Vader Hans Holbeen* [illegible]

**Watermark: Anchor in circle with star (cf. Briquet 477–493)**

**National Gallery of Art, Woodner Collection 1991.182.4**

This drawing was evidently unknown to Alfred Woltmann and was given its first proper consideration by Paul Ganz, who thought it was a drawing of c. 1524–1526 by Hans Holbein the Younger. This was largely an act of faith on his part, for he believed it had been thoroughly reworked by a later hand, which he presumed to be that of Cornelis Ploos van Amstel, the earliest known possessor of the drawing. Although this judgment no doubt now appears surprising, it arises in part from a long critical tradition, stretching back to the seventeenth century, primarily concerning the state of the Holbein portrait drawings at Windsor, to the effect that they were so badly defaced and damaged that what survives is largely reworking. Among modern connoisseurs, as Karl T. Parker has pointed out,[1] Ganz took the most extreme position by asserting these drawings originally were largely executed in chalks alone and that "*all* the

line-work which we now see done with the pen and brush is false and of a later date." Without going further into this question, one could have here a partial explanation for Ganz' view of the Woodner drawing.

It has been suggested that the draftsman was strongly influenced by Jean Clouet (c. 1485–1541), to whom a distinctive group of drawings has been attributed on the basis of one related to the *Portrait of Guillaume Budé* (Metropolitan Museum, New York), the painting most firmly attributable to the artist.[2] It is generally accepted that the technique of black and colored chalks on unprimed paper, which Holbein used on his first visit to England (1526–1528), is likely to have been adopted through the influence of Clouet's work, probably first encountered on a visit to France in 1524.[3] But how does this shed light on the present drawing? As Christopher Lloyd has pointed out in a previous catalogue of the Woodner collection, the black chalk is more broadly applied here than in Clouet's portraits.[4] Furthermore, the execution has produced a smudgy effect, especially in the beard and hair, which one does not find in Holbein's drawings, even the most vigorously worked of his portrait drawings, such as that of Sir Nicholas Carew.[5] Crucially, the features are too softly defined for Holbein to be responsible. All the same, it is very probable that the draftsman was left-handed like Holbein, and it might be that this is a copy after a lost drawing by Holbein. The draftsman seems to be of German origin, familiar with the work of Clouet and his followers. His initials

might have been *HB*, as in the monogram at the upper left-hand corner of the sheet,[6] but none of the German artists of the first half of the sixteenth century with such a monogram appears to be a likely candidate: it could not be Hans Brosamer (c. 1500– after 1554), for instance.

A. E. Popham made the interesting, indeed tantalizing, suggestion that the sitter bears a close resemblance to Anne de Montmorency (1492–1567), constable of France, as represented in a portrait of 1525, attributed to Jean Clouet (an oral communication recorded by Ganz). There can be little doubt that Popham was referring to the drawing at Chantilly (fig. 1), which was first described by Louis Dimier as a copy. It has since been accepted as an original by Peter Mellen because of the "close similarity to the miniature" of 1519, when the sitter was twenty-two, in the second volume of *Les commentaires de la guerre gallique.*[7] That portrait drawing is undoubtedly a rather delicately done sketch, quite characteristic of Clouet. Despite Lloyd's rejection of this identification of the sitter, it seems quite conceivable that the Woodner drawing may show de Montmorency when he was somewhat older. Indeed the hat with a medallion of the Virgin and Child is typical of those worn by the French nobility in Clouet's and Holbein's portraits.

The present drawing was done on paper with the watermark found in sheets made in northeast Italy, chiefly in the region around Venice—an anchor within a circle surmounted by a star—which were

43

FIGURE 1

Jean Clouet, *Portrait of Anne de Montmorency,* Musée Condé, Chantilly

widely distributed north as well as south of the Alps. Although there does not seem to be a closely similar example of the watermark recorded by Piccard,[8] nevertheless an interesting tendency can be found in the evolution of the design of the mark. It is noticeable from Piccard's evidence that the flukes of the anchor become more and more wedge-shaped in the 1540s and 1550s, just as they are found in the present sheet.[9] It would not be wise to conclude merely from this that the Woodner drawing must necessarily have been executed in either of these two decades or later, but in view of the earlier discussion, it is a strong indicator of its likely date of execution. • *John Rowlands* •

**NOTES**

1. Parker 1945, 28–29.
2. Mellen 1971, 240–241, no. 145.
3. Holbein's first use of this technique was in the studies of the kneeling figures of Jean, Duc du Berry, and his wife, Jeanne de Boulogne, in the chapel of the ducal palace at Bourges (see Müller 1988, 152–157, no. 46a,b).
4. Woodner exh. cat., London 1987, 158, no. 55.
5. Müller 1988, 216, no. 67.
6. Lloyd's presumption that the monogram could be the initials of the sitter is not at all convincing.
7. Mellen 1971, 219, 234, nos. 41, 131. Indeed there is a photograph of the Chantilly drawing, acquired in 1907 by the British Museum (A.G. 262, as Jean Clouet), dated "vers 1525," which would have been known to Popham.
8. See Piccard 1978, sec. 5, Oberitalien—Raum Venezia.
9. See esp. Piccard 1978, sec. 5: nos. 310 (Ulm, Swabia, 1543) and 341 (Villanch, Kärnten, 1552).

**PROVENANCE**

Cornelis Ploos van Amstel, Amsterdam [1726–1798] (Lugt 3002–3003); (possibly sale, Amsterdam, van der Schley…Roos, 3 March 1800, part of Album BBB, lot 49); Rudolph Weigel, Leipzig, 1838 (inv. 1187); J.A.G. Weigel (sale, Stuttgart, Gutekunst, 8–15 May 1883, lot 445); William Mitchell, London [d. 1908] (Lugt 2638); private collection (sale, Frankfurt am Main, Prestel, 7 May 1890, lot 54); A. W. Thibaudeau, Paris; (A. S. Drey, Munich); (F. A. Drey, London); (A. Strölin, Lausanne); Woodner Collections (Dian and Andrea Woodner); given to NGA, 1991.

**EXHIBITIONS**

Woodner, London 1987, no. 55; Woodner, New York 1990, no. 67.

**LITERATURE**

Ganz 1939, 1: no. 10.

# 44  Portrait of a Young Man

Black chalk and wetted red chalk with brown wash on laid paper, 303 x 196 (11 $^{15}$/$_{16}$ x 7 $^{11}$/$_{16}$)

Inscribed at center left in black chalk: *HH* (in monogram); and by another hand at lower left in pen and brown ink: *H Holbein*

Woodner Collections

This drawing, about which opinion is much divided, appears to be a very presentable copy after a drawing at Chatsworth, which is likely to be an original by Hans Holbein the Younger. Paul Ganz considered the Woodner drawing to be the original and dated it c. 1524–1526, whereas Gustav Friedrich Waagen, the first to mention the sheet, regarded it as an early work.[1] Subsequently Konrad Oberhuber likewise accepted it as by Holbein and dated it on the strength of a comparison with the portrait drawing at Basel, *Man in a Slouch Cap*, c. 1528, made soon after the artist's return to Basel from his first visit to England.[2] The present drawing is not only less spontaneously done than the Chatsworth version, however, but it also contains, as Michael Jaffé has pointed out, certain flaws or signs of revision.[3] In particular Jaffé noted deficiencies in the drawing of the hat and the earlobe and the revised completion in white of the rough sketching of the shoulder on the right in the Chatsworth original.

The drawing at Chatsworth is most probably from the period just before Holbein's visit to England, which he began at the end of August 1526. The portrait drawing of Anna Meyer, done c. 1526 when the artist first began work on the Meyer family altarpiece, is less vigorously executed but contains work in chalk, especially in the details of the sleeves, that is similar in style to much in the drawing at Chatsworth.[4]

Although one cannot dismiss out of hand George Goldner's point that it is not impossible that both versions might be copies after a lost original,[5] it is not the solution that I find credible. Undoubtedly, as he has suggested, if both drawings could be examined side by side together with portrait drawings firmly attributed to Hans Holbein, one could go some way toward establishing a measure of agreement among connoisseurs about their relative merits.

• *John Rowlands* •

**NOTES**

1. Ganz 1939, 139, no. 465; and Waagen 1866–1867, 2:196.
2. Woodner exh. cat., Munich and Vienna 1986, no. 54; and see Müller 1988, 226, no. 70.
3. Exh. cat. London 1993–1994, 186, no. 203.
4. See Müller 1988, 198, no. 61; and Rowlands 1985, 64–66, 131–132, no. 23.
5. Woodner exh. cat., Malibu 1983–1985, 110, no. 43.

**PROVENANCE**

Possibly Everhard Jabach, Paris [1610–1695] (inscription close to Lugt 2991a); Samuel von Festetis, Vienna [1806–1862]; Hofrat Philipp Dräxler von Carin; Joseph Carl von Klinkosch, Vienna [1822–1888], 1874 (sale, Vienna, Wawra, 15 April 1889, lot 474); Baron Alfred Liebig, Vienna (sale, Vienna, Artaria, 22 March 1934, lot 551); Baron Heinrich Thyssen-Bornemisza, Lugano [1875–1947]; Gräfin Margit Battyany; (William H. Schab Gallery, New York); Woodner Collections (Shipley Corporation).

**EXHIBITIONS**

Woodner, New York 1971–1972, no. 53 (as Holbein); Los Angeles 1976, no. 180 (as Holbein); Woodner, Malibu 1983–1985, no. 43 (as attributed to Holbein); Woodner, Munich and Vienna 1986, no. 54 (here and subsequently as Holbein); Woodner, Madrid 1986–1987, no. 66; Woodner, London 1987, no. 54; Woodner, New York 1990, no. 66.

**LITERATURE**

Waagen 1866–1867, 2:196 (here and subsequently as Holbein); Heinemann 1937–1941, 1:73–74, no. 198; Ganz 1937, 97, no. 465; Ganz 1939, 139, no. 465; Ganz 1943, no. 20; exh. cat. London 1950–1951, 64, under no. 133; Oberhuber 1983, 79–80; exh. cat. London 1993–1994, under no. 203 (as copy after Holbein).

44

# 45 The Hermits Saint Paul and Saint Anthony Receiving Bread from a Dove

*Probably born a few years before the 1500 birthdate that has long been ascribed to him, Domenico Campagnola was a pupil of both Giulio Campagnola (q.v.), who may have adopted him, and Titian (c. 1488–1576). He worked mostly in Padua as well as in Venice. His earliest painting is thought to be* The Meeting of Anna and Joachim at the Golden Gate *in the Scuola del Carmine in Padua, made within a few years of Titian's completion of the decoration at the Scuola del Santo there in 1511. Domenico was a skilled printmaker, working in both engraving and woodcut. He also executed elaborate pen drawings, sometimes in preparation for his paintings but often as finished works of art. His expansive landscape drawings, which show the influence of Giorgione (1477 or 1478–1510) and Titian, were particularly admired, and were much studied and copied by young artists well into the eighteenth century.*

**c. 1530, pen and brown ink over traces of metalpoint on laid paper, 393 x 258 (15 ½ x 10 ³⁄₁₆)**

**Inscribed at upper right in graphite: *65*; inscribed on the verso at lower left in graphite: *Mar 2*, and at lower right in graphite: *1399 / H 391 / W 259***

**Woodner Collections**

According to the *Golden Legend* of Jacopo da Voragine, Saint Anthony the Hermit went into the desert toward the end of his life to visit the anchorite Paul, who was by then very old. On that occasion the raven that fed Paul every day brought a double portion of bread, which led to a discussion between the two hermits concerning whose right it was to divide the food into shares.[1] It is this very moment that is depicted in the drawing, in which special emphasis is placed on the eucharistic significance of the bread, brought not by a raven but by a dove enveloped in a halo of divine light, the symbol of the Holy Spirit.[2]

The diffusion in the West of the cult of Saint Anthony the Hermit is linked to his attributes as a healer and to the importance of the monastic order of the Anthonites (founded in the eleventh century and reformed in the thirteenth), which specialized in the treatment of contagious diseases. In fact, Saint Anthony the Hermit is often portrayed together with two other saints, Roch and Sebastian, whose intercession was also considered effective against plague.

In the iconographic tradition relative to the life of Saint Anthony the Hermit, which spread especially in countries north of the Alps, the visit to Saint Paul is almost always linked with the temptation of Saint Anthony (as in Pintoricchio's decoration of the Sala dei Santi in the Vatican, and Matthias Grünewald's Isenheim altarpiece in Colmar). The isolated treatment of the saints' visit seems rather rare, though Albrecht Dürer made a woodcut c. 1502,[3] and, nearer in time and place, Giovanni Girolamo Savoldo executed a painting of the subject (Accademia, Venice) in the second decade of the sixteenth century for a Venetian commission (its possible pendant being the *Prophet Elias Being Fed by a Raven*, National Gallery of Art, Washington).[4]

With regard to these examples, characterized in the attitudes of the two hermits by a dignified but nonetheless intense spirituality, the present drawing is distinguished by the uncommon treatment of the figure of Saint Anthony the Hermit at the left. He looks much younger than he would have been at the time of the event, caught in a dynamic pose that is accentuated by his nudity. The kneeling Saint Paul is similar in appearance to well-codified representations of Saint Jerome; only in the gesture of his hands and in his gaze toward heaven does his depiction respect the traditional iconography for the hermit.

The attribution of this drawing to Domenico Campagnola rests on the typo-logical and formal similarities with some of his drawings: *Saint Jerome in Penitence* (fig. 1), already compared to the figure of Saint Paul by George Goldner; *Allegory* (Art Museum, Princeton University, inv. 4681); and *Contest between Apollo and Marsyas* (Kupferstichkabinett, Berlin, inv. kdz 5163), all datable to the first half of the 1520s.[5]

Yet certain graphic features in the Woodner drawing—the high degree of finish and the restrained, precise, and slightly mechanical draftsmanship—suggest that it belongs to a category of drawings executed expressly for reproduction as prints, in this case for a woodcut, even though one has not survived. In this, it would be comparable to earlier drawings, dated c. 1517: *The Calling of Peter and Andrew* (Teylers Stichting, Haarlem, inv. k. ix. 13), *Saint Jerome in a Landscape* (formerly Woodner collection), and *The Flight into Egypt* (fig. 2).[6]

Other qualities in the present sheet indicate a more advanced phase of the artist's stylistic development, c. 1530: the sense of space, the more decorative placement of the compositional elements on the page, the tendency toward a greater plasticity of the figures (which is achieved, as is typical of Domenico, through hatching of the surfaces).[7] To the same phase belongs a drawing of *Susanna and the Elders* (Uffizi, Florence, inv. 1783 f),[8] which presents an analogous vertical development of the composition, underscored by large trees that stand out against the light ground of the paper.

In the years around 1530 Domenico elaborated compositional and formal solutions that certainly reflect the Titianesque inventions of the 1520s, from the Este *Bacchanalia* to the *Murder of Saint Peter Martyr* (now known only from the engraving by Martino Rota). Within Domenico's work one may find a further point of comparison in a woodcut of *Saint John the Baptist* (fig. 3), signed by Nicolò Boldrini and dating to the 1530s.[9] The landscape is wide-ranging and the relationship between the figures and the space is different, but observing the details of the tree trunks and the foliage or the body of the Baptist, with the musculature rendered in short, parallel strokes, one might easily suppose that the printmaker had before him a drawing by Domenico that was graphically similar to this one.
• *Elisabetta Saccomani* •

**FIGURE 1**
Domenico Campagnola, *Saint Jerome in Penitence*, National Gallery of Art, Washington, Ailsa Mellon Bruce Fund

## NOTES

1. Réau 1958, 3:101–115.

2. Hall 1974, 21–22.

3. Bartsch 7:68, 107. The Dürer print was cited as a precedent by Goldner and Miller in Woodner exh. cats., Malibu 1983–1985, 46, and Vienna and Munich 1986, 34.

4. Frangi 1992, 30–35.

5. Oberhuber in exh. cat. Venice 1976, 129–130, 124–125; and Saccomani 1991, 31–36.

6. Keyes 1976, 167–172; sale cat., London, Christie's, 2 July 1991, lot 75; and Saccomani 1982, 81–99.

7. A group of drawings, largely drawn from the antique or from sculptors' models, that was once attributed to Domenico (for the critical history see Saccomani 1979, 43–49) is now more justly considered the work of his Paduan student Stefano dell'Arzere, dating from the late 1520s (see Ballarin in exh. cat. Padua 1991, 63). In fact, the hatching in these drawings, which involves intense contrasts of light and dark, shapes the forms with a more vigorous plastic sense.

8. Rearick in exh. cat. Florence 1976, 112–113; Saccomani 1982, 92.

9. See Muraro and Rosand in exh. cat. Venice 1976, 106–108.

## PROVENANCE

Maurice and Hubert Marignane, Paris; Woodner Collections (Shipley Corporation).

## EXHIBITIONS

Woodner, New York 1973–1974, no. 48; Woodner, Malibu 1983–1985, no. 15; Woodner, Munich and Vienna 1986, no. 16; Woodner, Madrid 1986–1987, no. 20.

**FIGURE 2**

Domenico Campagnola, *The Flight into Egypt*, The Pierpont Morgan Library, New York

**FIGURE 3**

Nicolò Boldrini, *Saint John the Baptist*, after Domenico Campagnola, Museum of Fine Arts, Boston, Bequest of W.G. Russell Allen

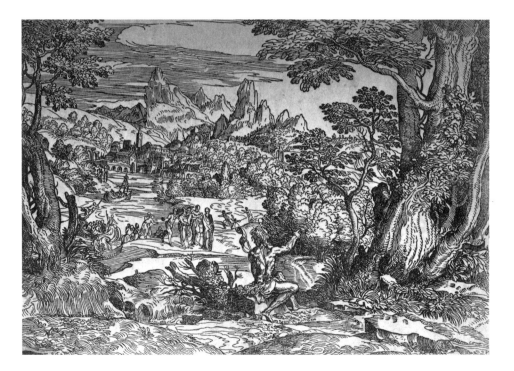

# 46  Cimon and Pero

*Less active as a painter than his younger brother Barthel (1502– 1540), Sebald Beham (formerly known as Hans Sebald Beham) worked primarily as an engraver, etcher, and designer of woodcuts; he also painted miniatures and designed stained glass, fountains, and medals. The small scale of many of the prints of both brothers led to the appellation* Kleinmeister *(Little Masters). In the 1520s Sebald was one of the leading designers of Reformation woodcuts, many with polemical texts by Hans Sachs. His oeuvre was greatly influenced by unpublished studies by Albrecht Dürer (q.v.) for his book on the proportions of horses. Both Sebald and Barthel were based in Nuremberg until 1525, when they were expelled, along with Georg Pencz (c. 1500–1550), for expressing heretical views. Subsequently Sebald worked in Ingolstadt, Munich, and from 1532, Frankfurt am Main. He became a citizen of Frankfurt in 1540, having given up his citizenship of Nuremberg in 1535.*

**1540, pen and black ink and charcoal, heightened with white on heavy laid paper, laid down (repair to Pero's ear), 397 x 241 (15⅝ x 9½)**

**Inscribed at upper right in pen and black ink:** *1540 / HSB* **(in monogram); at upper left in pen and brown ink:** *QVO NON PENETRAT / AVT QVID NON EX: / COGOTAT PIETAS*

**Woodner Collections**

The story of the aged Athenian Cimon and his daughter Pero is recounted by Valerius Maximus.[1] In prison awaiting execution and given no food, Cimon is visited by his daughter Pero, a new mother, who nourishes him by offering her breast. An example of filial piety in the literature of antiquity, the subject became known in humanist circles as "Roman Charity" and was frequently depicted in the sixteenth to eighteenth centuries. Charity could be depicted alone, as one of the Roman Virtues, or visiting prisoners in the cycle of the works of mercy. The subject of Cimon and Pero was at times treated as an allegory of youth and age with a sexual emphasis. By representing Pero as a nude figure in the Woodner drawing, Sebald Beham risked emphasizing the sexual aspect of the story; he reasserted the moralizing content by means of the solemn expression of Pero's powerful features and use of the Latin inscription at the upper left, which translates: "Where does piety not penetrate or what does it not devise."

Herbert Zschelletzschky noted that the subject of Cimon and Pero was first treated by Barthel Beham in an engraving of 1525,[2] the year he, his brother Sebald, and Georg Pencz were imprisoned in Nuremberg and then expelled from the city. The three were accused of disseminating the radical Reformation ideas of Andreas Bodenstein (called Karlstadt), Thomas Müntzer, and others; of seditious activities; and of not recognizing the municipal authorities. Two etchings of Cimon and Pero by Sebald Beham date from 1526/1530 and two engravings from 1544 (Bartsch 72–75). Pencz made two paintings of the subject.[3]

The Woodner drawing was executed in 1540, the year Sebald Beham became a citizen of Frankfurt am Main. The features and posture of the shackled Cimon closely follow the artist's earlier etchings. It is the nude figure of Pero that varies and is the focus of his artistic attention. Seated and clothed in the etchings, Pero is shown here standing and nude, allowing Beham to articulate her figure in clear, uninterrupted contours. Those outlines, the powerful modeling achieved by the combination of charcoal and white heightening, and the overall proportions recall the nude figures in Marcantonio Raimondi's engraving after Raphael's *Judgment of Paris,* 1517/1520 (Bartsch 245). Beham had already borrowed figures from this print for his woodcut *Fountain of Youth and Bathhouse* of 1531 (Bartsch 165).

Old Testament subjects (including Lot and his daughters, Joseph and Potiphar's wife, and Susanna and the Elders), depictions of bathhouses, and mythological subjects all lent themselves to the articulation of the idealized nude figure. The Woodner drawing is one of Beham's most masterful, showing his skill in the representation of the human figure in the "Welsch" or Italian Renaissance style. In one of the engravings of 1544 Beham used this upright figure of Pero again, but clothed. Although it is possible that the Woodner drawing was made as a study for this engraving, the size and finish of the sheet suggest that it was intended as an independent work.

Beham's prints and drawings reflect a growing taste for the collectible object in Renaissance Germany beginning in the 1520s. Humanists, wealthy merchants, and nobles, many of whom had studied or worked in northern Italy, would have displayed such works in private Kunstkabinetten along with paintings, plaquettes, portrait medals, small-scale sculpture, antiquities, and other treasures.  • *Barbara Rosalyn Butts* •

**NOTES**
1. *De factis dictisque memorabilibus libri* IX, 5:4.
2. Zschelletzschky 1975, 132 (Bartsch 11).
3. Zschelletzschky 1975, 133, 134, 425, figs. 91 and 92.

**PROVENANCE**
A. Mouriau, Belgium (Lugt 1853); Jacqueline Strölin, Lausanne, Switzerland; Woodner Collections (Dian and Andrea Woodner).

**EXHIBITIONS**
Woodner, London 1987, no. 56; Woodner, New York 1990, no. 68.

QVO NON PENETRAT
AVT QVID NON EX:
COGOTAT PIETAS.

1540

HSB

46

# 47 Satyr

1544/1545, pen and brown ink with brown wash over black chalk on laid paper, laid down, 416 x 203 (16³⁄₈ x 8)

Inscribed by Cellini at lower right in brown ink: *alla porta di fontana / Bellio di bronzo p[er] piu / di dua volte il vivo b[raccie] 7 / erano dua variati.*

National Gallery of Art, Woodner Collection, Patrons' Permanent Fund 1991.190.2

Cellini was trained as a goldsmith by Michelangelo Bandinelli (1459–1528), the father of sculptor Baccio Bandinelli (1493–1560). He entered the service of Pope Clement VII in 1523 and remained in Rome until 1530. There he studied the works of Michelangelo (1475–1564) and Raphael (q.v.). Between 1529 and 1540 he was principally active as a medalist. In 1540 he was called to France by François I and spent nearly five years working at Fontainebleau. He left in 1545, perhaps because of a quarrel with Francesco Primaticcio (1504–1570), and returned to Florence. His most important commissions there were a bronze bust of Cosimo I Medici (1546, Museo del Bargello, Florence), the statue of Perseus (1554, Loggia dei Lanzi), and the fountain of Neptune (1565, Piazza della Signoria). Cellini's famous Autobiography is both a highly personal record of his extraordinary life and an important document of Italian Renaissance culture.

This magnificent *Satyr* is not only the finest of the few known drawings by Benvenuto Cellini, it is also acknowledged as one of the greatest old master drawings in America.[1] As the autograph inscription indicates, this imposing figure was intended "for the gate of Fontainebleau—of bronze, more than twice life-size: 7 braccie—there were two variants." It was one element in Cellini's complex plan for a new Porte Dorée (Gilded Gate) at the favorite château of François I. Work on the project began in 1542, but it was left incomplete upon the artist's abrupt departure from the French court in 1545.[2]

The original gateway, which is still in place, was built by Gilles de Breton in 1538 and features a slightly flattened semicircular pediment above an opening that is almost perfectly square. Contemptuous of this "vicious French style," Cellini proposed a grander entryway that would be more suited to a royal residence:

"I corrected the proportions of the doorway, and placed above it an exact half circle; at the sides I introduced projections, with socles and cornices properly corresponding: then, instead of the columns demanded by this disposition of parts, I fashioned two satyrs, one upon each side. The first of these was in somewhat more than half-relief, lifting one hand to support the cornice, and holding a thick club in the other; his face was fiery and menacing, instilling fear into the beholders. The other had the same posture of support; but I varied his features and some other details; in his hand, for instance, he held a lash with three balls attached to chains. Though I call them satyrs they showed nothing of the satyr except little horns and a goatish head; all the rest of their form was human."[3]

The Woodner figure corresponds precisely to Cellini's description of the first satyr, except that its expression, though arresting, is not particularly "fiery" or "menacing" in effect. The same satyr is also known through a small-scale bronze model (fig. 1), whose demeanor is considerably more intimidating. The satyr holding a flail, on the other hand, has not survived, though a marble head with small, curling horns and a fierce expression (New York art market) might preserve its appearance.[4]

The full-scale, more than twice life-size satyr with a club was intended to be placed to the left of the portal at Fontainebleau. The figure would thus have been placed with his back to the entrance, his head turned to look over his shoulder at those who dared enter.[5] In keeping with Cellini's note that the satyr would be presented "in somewhat more than half-relief," shadows along the Woodner satyr's right arm, back, buttocks, and right thigh indicate that the sculpture was to be positioned against a wall. This is even more clearly visible in the Getty *modello* (fig. 2), in which the the entire right side of the back has been omitted from the head to the knee and along the back of the upper arm, just where the figure would be attached to the supporting wall.

Scholars have disagreed as to the exact placement of the Woodner drawing within the course of Cellini's work on the sculpture: whether it was a model drawing made in preparation for his huge sculpture, or whether it was drawn after it as a *ricordo*.[6] Clearly Cellini was a gifted draftsman, but the fact that so few drawings by him are known suggests that he may not normally have made elaborate drawings in preparation for his sculpture, but would more likely have made small sculpted models like the Getty figure instead. Furthermore, the extraordinary care and beauty with which the Woodner *Satyr* was drawn suggests that Cellini made it for a special reason. Two possibilities come to mind: either he made the drawing in 1542 to show the king as part of his effort to win royal approval for the Porte Dorée project; or he made it in 1544/1545 as he was on the verge of leaving France, wanting to take with him a detailed, easily portable record of the enormous sculpture he was leaving behind. The latter case seems somewhat more likely, for the strongly sculptural appearance of the satyr's face and hair in the drawing suggests that Cellini had a sculpted figure rather than a live model or a mental image before

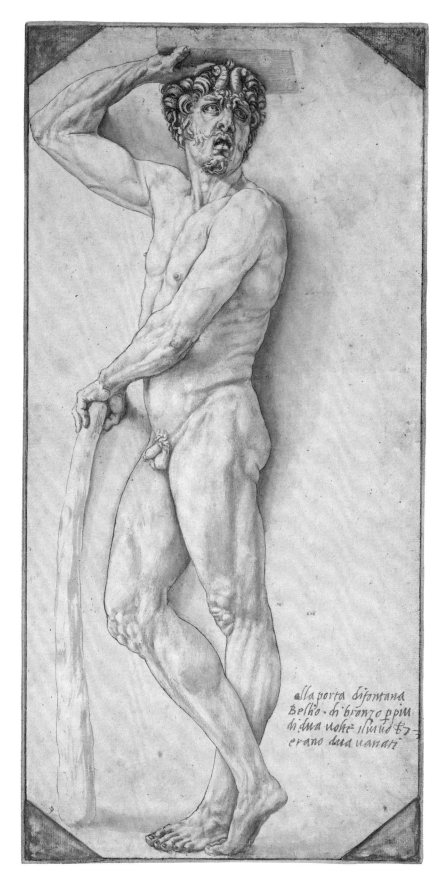

alla porta difontana
Belho · di bronzo ppiu
di dua uohe ilmuo &7
erano dua uanati

47

**FIGURE 1**

Benvenuto Cellini, *Satyr,* Collection
of the J. Paul Getty Museum, Malibu

**FIGURE 2**

Back of fig. 1

him when he made it. Moreover, if the drawing had been made for the king's approval, one might logically expect that Cellini's pride would have led him to include that information in his inscription.[7] In any case, the Woodner drawing was certainly not made after the Getty *modello,* for there are distinct differences between the two, particularly in the proportions, the expression of the face, and the articulation of the musculature.

As Virginia Bush has pointed out, the pose of the Woodner *Satyr* reflects Cellini's knowledge of and admiration for the sculpture of Michelangelo, whose work he would have known in both Florence and Rome. Here he was inspired in particular by the slaves from the tomb of Julius II.[8] The satyr's spiraling pose is almost identical to that of the slave at the right center of the tomb, with changes only to the position of the arms. In turn Cellini's caryatid may have been known in some form to Carlo Marcellini (1644–1713), who used a closely similar figure in his decoration of the Grotta at the Palazzo Corsini in Parione, Florence.[9] • *Diane De Grazia and Margaret Morgan Grasselli* •

**NOTES**

1. On Cellini's drawings see Winner 1968a, 293–304; Pope-Hennessy 1985; and sale cat., Monaco, Christie's, 7 December 1990, lot 202A.
2. Only the well-known *Nymph of Fontainebleau* (Louvre, Paris) and the two Victories (Neuilly) were cast in bronze before Cellini left France (the first by 1543, the second in 1544), and the satyrs were ready for casting. For a recounting of this enterprise see Pope-Hennessy 1982, 406–412 and 1985, 133–146.
3. Cellini 1983 ed., 131–132.
4. See Parronchi 1969, figs. 1–3. Without more detailed descriptions and documentation, it is currently impossible to confirm whether the marble head is connected with Cellini's work on the Porte Dorée.
5. Pope-Hennessy 1982, 411.
6. See, for example, Winner 1968a, 296–297; and Pope-Hennessy 1982, 410.
7. The wording of the inscription, in the past tense, sheds little light on the origins of the drawing, as it was written in a different ink from the drawing and was almost certainly added after the drawing was made. A similar inscription, also couched in the past tense, is found on one other Cellini drawing, a half-length chalk study of *Juno* (Louvre, Paris; see Avery and Barbaglia 1981, no. 31). That, too, was connected with a Fontainebleau project, in this case a set of twelve life-sized silver torchères. The *Juno,* like the *Satyr,* was never cast.
8. See Bush 1976, 265.
9. Repro. in Pratesi 1993, 2: pls. 305–307. This connection was made by Donald Myers.

**PROVENANCE**

John Barnard, London [d. 1784] (Lugt 1419); Sir Thomas Lawrence, London [1769–1830] (Lugt 2445); (Hans M. Calmann, London); (William H. Schab Gallery, New York); Woodner Collections (Shipley Corporation); purchased by NGA, 1991.

**EXHIBITIONS**

Newark 1960, no. 25; New York 1965–1966, no. 82; Notre Dame 1970, no. D7; Woodner, New York 1971–1972, no. 14; Paris 1972–1973, no. 51; Ottawa 1973, no. 51, pl. 67; Los Angeles 1976, no. 26; Woodner, Malibu 1983–1985, no. 18; Woodner, Munich and Vienna 1986, no. 23; Woodner, Madrid 1986–1987, no. 28; Woodner, London 1987, no. 20; Woodner, New York 1990, no. 26.

**LITERATURE**

Heikamp 1966, 53; Vitzthum 1966, 110, fig. 58; Hayward 1967/1968, 264; Winner 1968a, 294; Parronchi 1969, 43, fig. 10; Lyons 1972, 31; Bush 1976, 265–266, fig. 279; Perrig 1977, 81, pl. 56; Avery and Barbaglia 1981, no. 33, pl. 12; Pope-Hennessy 1982, 409, fig. 14; Cellini 1983 ed., 150, pl. 64; Pope-Hennessy 1985, 135–136, pls. 70, 71; NGA Guide 1992, 314, repro. 318.

# 48  Alexander Consecrating the Altars for the Twelve Olympian Gods

**1545/1547, pen and brown ink with gray wash over black chalk on laid paper, laid down, 317 x 210 (12 ½ x 8 ¼)**

**Inscribed at lower left in pen and brown ink: *perin / del vaga***

**Woodner Collections**

A fine example of Perino del Vaga's highly fluid late graphic manner, this drawing is a study for one of the murals in the Sala Paolina in Castel Sant'Angelo in Rome (fig. 1). This commission was awarded by Pope Paul III in 1545, and work was largely completed by the time of the artist's death in 1547. Illustrating scenes from the life of Alexander the Great, the monumental wall frescoes, executed in gold monochrome in imitation of ancient reliefs, allude to the pope's baptismal name, Alessandro Farnese, and celebrate his papacy. The subject here is taken from the ancient ruler's campaign in India, when he erected twelve altars on the banks of the Hydaspes River.

As was typical of Perino's working method in the last decade of his life, the artist provided preparatory studies and compositional drawings for these frescoes but entrusted their execution to assistants, who translated his designs into paint with only minor variations. In this instance, the gesture of Alexander was altered slightly in the fresco, where his left hand is raised to his breast and his right arm extended at his side.

Characteristic of Perino's style is the tight, planar compression of figures, their graceful, rhetorical gestures, and the artificially elongated proportions seen in the Woodner drawing. This stylized ballet, of which Perino was the consummate purveyor, replaced the heroic drama of Michelangelo and Raphael in Roman art of midcentury, culminating in the work of such late *maniera* artists as Taddeo Zuc-

**FIGURE 1**

Perino del Vaga, *Alexander Consecrating the Altars for the Twelve Olympian Gods*, Sala Paolina, Castel Sant'Angelo, Rome

caro, for whom the Sala Paolina frescoes proved highly influential.

In addition to the Woodner sheet, *modelli* by Perino for two other Alexander scenes are preserved in the Metropolitan Museum, New York, and a British private collection.[1] An early copy after the present drawing is in the National Gallery of Scotland, Edinburgh.[2]  • *Linda Wolk-Simon* •

**NOTES**

1. For *Alexander the Great Cutting the Gordian Knot* (inv. 1984.413), see Wolk-Simon in exh. cat. New York 1994a, no. 66; and for *Alexander the Great Preserving the Writings of Homer,* see Gere 1960, 16, fig. 25.
2. Inv. D645; see Andrews 1968, fig. 839 (misidentified as *Alexander Opening the Tomb of Darius*); identified as a close copy after the Woodner drawing in Bean 1969, 57.

**PROVENANCE**

(Jacques Seligmann & Co., New York); Woodner Collections (Shipley Corporation).

**EXHIBITIONS**

New York 1966, no. 29; Notre Dame 1970, no. D24; Woodner, New York 1971–1972, no. 18; Rome 1981–1982, no. 74; Woodner, Malibu 1983–1985, no. 19; Woodner, Munich and Vienna 1986, no. 21; Woodner, Madrid 1986–1987, no. 26; Woodner, London 1987, no. 19; Woodner, New York 1990, no. 25.

**LITERATURE**

Bean 1969, 57, pl. 38; Harprath 1978, 43–46, pl. 74; Parma Armani 1986, 293; exh. cat. New York 1994a, under no. 66.

48

# 49  The Resurrection

*A pupil of Andrea del Sarto (q.v.)
in Florence, Francesco Salviati
entered the service of Cardinal
Giovanni Salviati in Rome and
subsequently took his name.
He was greatly influenced there
by the works of Michelangelo
(1475–1564) and Raphael (q.v.)
as well as Perino del Vaga (q.v.)
and Parmigianino (q.v.). He
worked widely in Italy, executing
commissions for the Medici
family in Florence, the Grimani
family in Venice, and the Farnese
and Sacchetti families in Rome.
He went to France in 1554 to
work at the court of Henri II but
encountered the hostility of his
fellow Italian painter Francesco
Primaticcio (1504–1570). He
then worked for Cardinal de
Lorraine at Dampierre, before
finally returning to Rome in 1555.
A gifted draftsman and painter,
Salviati was one of the foremost
mannerist artists in Italy.*

**1545/1548, pen and brown ink with brown wash
heightened with white on laid paper; indecipherable
sketch in black chalk on verso, oval: 280 x 191
(11 x 7½)**

**Inscribed at lower center in pen and brown ink:**
*Primaticio*

**Woodner Collections**

The oval format that is a particular feature
of this highly refined project is not the re-
sult of cutting down a rectangular original.
Oval compositions had been painted
by Primaticcio in the chamber of Mme
d'Etampes (Château de Fontainebleau, 1541–
1544) and were immediately engraved by
the Master L. D.[1] This was also the form
used around 1567 for the paintings that dec-
orated the panels of the *studiolo* of Fran-
cesco I (Palazzo Vecchio, Florence). In the
work of Salviati the oval format was dic-
tated by the spaces reserved for composi-
tional scenes in decorative projects.

An exceptional testimonial to Salviati's
technical virtuosity as a draftsman, the
Woodner drawing calls to mind chased sil-
ver or engraved crystals, like the ones used
to decorate the Farnese Casket (Museo di
Capodimonte, Naples), for which Salviati
provided designs (Uffizi, Florence).[2] Rela-
tionships between Salviati and Florentine
silversmiths such as Francesco di Girolamo
dal Prato, a friend from youth, and Piero di
Marcone, who campaigned for the painter's
return to Florence in 1543, are attested by
Vasari.[3] This drawing was also engraved by

an anonymous printmaker from either
Italy or Fontainebleau who faithfully repro-
duced the composition, but in a rectangular
format (British Museum, London),[4] sug-
gesting that the drawing was not made
specifically for the print.

The drawing seems to be part of a series
of studies on the theme of the Resurrec-
tion of Christ that culminated in the fresco
painted in the Chapel of the Margraves of
Brandenburg, Santa Maria dell'Anima,
Rome,[5] but it was not preparatory for that
project. Rather, the Woodner drawing con-
stitutes a synthesis between the general
schema of the fresco and the composition
of a tapestry in the Uffizi. The fresco was
begun in 1541 (the figure of Christ), then
interrupted between 1543 and 1548 while the
artist was in Florence. The decoration of
the chapel was entirely finished in 1550. In
my opinion, the original conception for
this painting is a drawing in a private col-
lection in Paris in which the tomb is open.[6]
That iconography was very likely rejected
for theological reasons, because in all other
representations the tomb is closed. The
detail of the ring attached to the tomb's lid
and clearly discernible in both the Wood-
ner drawing and the fresco is emphasized to
heighten the manifestation of the mystery.[7]
The tapestry, on the other hand, is more
closely related to a third drawing (fig. 1,
formerly in the collection of Timothy Clif-
ford), which is square in format and in
which the space is proportionately widened.[8]
The Uffizi tapestry was woven in Florence
around 1545 for Benedetto Accolti, Cardinal

of Ravenna,[9] and the image ultimately
retained for the tapestry shows Christ in
a dancelike pose with his feet crossed.
The Woodner drawing was not necessarily
made after the completion of the fresco
in 1550 but may be dated—somewhat
cautiously—just after the tapestry, during
the second part of the artist's Florentine
sojourn.

Among Salviati's other known draw-
ings, the Woodner *Resurrection* is com-
parable to, but more vibrantly drawn than,
a representation of *Phanès* (fig. 2) that is
related to the fresco of the Sala dell'Udienza
in the Palazzo Vecchio,[10] and to the *Figure
of the Poet from Antiquity* (Uffizi, Florence).[11]
These two drawings share some of the
sophistication and precision that are such
outstanding features of the Woodner
drawing. • *Catherine Monbeig Goguel* •

49

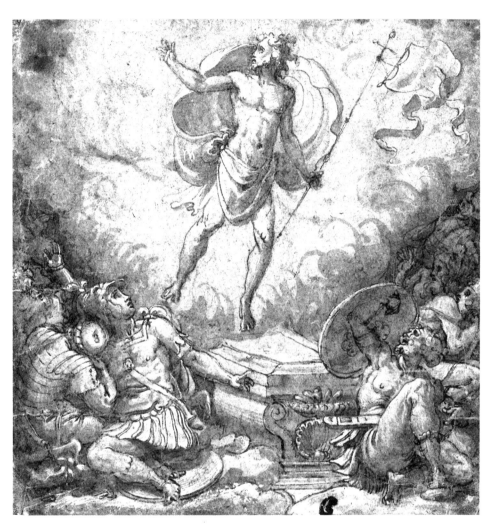

**FIGURE 1**

Francesco Salviati, *The Resurrection,*
Courtesy of Sotheby's, London

**NOTES**

1. Zerner 1969, nos. 50–52 (repro.).
2. For the crystal of the *Resurrection of Christ* engraved by G. dei Bernardi (Statens Museum for Kunst, Copenhagen) see Monbeig Goguel 1978, 20, fig. 18.
3. Vasari 1966 ed., 6:511, 519–520, 534–535.
4. Béguin 1969, 103–104, fig. 1. See also Mortari 1992, 296–297, no. 11 (repro.).
5. Monbeig Goguel 1978, 7–9, fig. 1; Nova 1981, 356–360, 370 n. 11, fig. 1; Mortari 1992, 118, no. 27 (repro.).
6. See Monbeig Goguel 1978, 8, fig. 2. This drawing has been called into question in Mortari 1992, 268, no. 520 (repro.), for reasons that remain unclear.
7. Monbeig Goguel 1978, 9–21.
8. Sale cat., London, Sotheby's, 3 July 1989, lot 12 (repro.); Mortari 1992, 222, no. 307 (repro., and with earlier bibliography).
9. Mortari 1992, 290, 293, nos. 5, 14 (repro.), noting another version in the Museo Correr, Venice.
10. Most recently exh. cat. New York 1992, no. 7 (repro. in color).
11. Mortari 1992, 187, no. 91 (repro.). See also Petrioli Tofani 1991, 253, no. 601 F (repro.). Mortari 1992 (no. 299, repro.) suggests a relationship between the present drawing and a *Baptism of Christ* heightened with gouache (location unknown), but the attribution of that sheet to Salviati should be reconsidered.

**PROVENANCE**

Peter Lely, London [1618–1680] (Lugt 2092); (Hans M. Calmann, London), (Stephen Spector, New York, by 1962); M. H. Valton; Daphné Wilkinson; (William H. Schab Gallery, New York); Woodner Collections (Shipley Corporation).

**EXHIBITIONS**

Washington 1967–1968, no. 17; Woodner, New York 1971–1972, no. 17 (as Niccolò dell'Abate); Paris 1972–1973, no. 220; Ottawa 1973, no. 220; Woodner, Malibu 1983–1985, no. 20; Woodner, New York 1990, no. 28.

**LITERATURE**

Béguin 1969, 103; Bussmann 1969, 81, 151; Monbeig Goguel 1978, 18–20, 22, fig. 15; Nova 1981, 360, 370; Clifford sale cat., London, Sotheby's, 3 July 1989, under lot 12; Mortari 1992, 242, no. 412 (repro.); 220, under no. 299; 296, under no. 11.

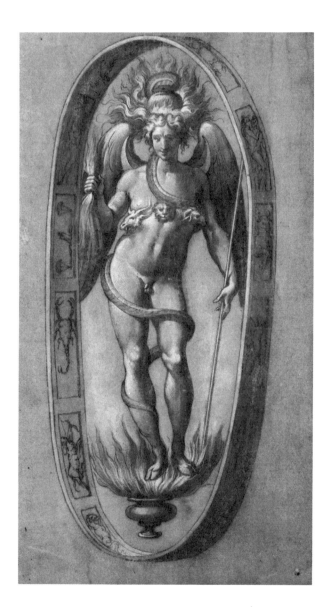

# 50 The Rape of Ganymede

*Niccolò dell'Abate is said to have studied with his father and Antonio Begarelli, both sculptors. His first paintings, such as the Beccherie in Modena (1537), show the influence of Dosso Dossi (active 1512–1542) and suggest that Niccolò traveled to Ferrara or collaborated with Dosso on the Villa Imperiale at Pesaro. The influence of Correggio (q.v.), Parmigianino (q.v.), and Venetian painting is evident in Niccolò's use of color and is seen especially in Bologna in his decoration of the Palazzo Torfanini and Palazzo Poggi (1548). In 1552 Niccolò went to Fontainebleau, where he worked with Francesco Primaticcio (1504–1570) on the Salle de Bal and the Galerie d'Ulysse. He also provided designs for tapestries, enamels, ceremonial entries, and pageants and displayed a special talent for landscape painting. Key elements of his style were his brilliant technique, rich colors, sensuously mannerist figures, and imaginative details.*

**c. 1545, pen and brown ink with brown wash and watercolor over traces of black chalk, heightened with white on laid paper washed light brown, laid down, 389 x 289 (15 5/16 x 11 3/8)**

**Inscribed at upper center in pen and brown ink: *Ganymede;* inscribed by Jonathan Richardson Sr. on the mount at lower center in pen and brown ink: *Perino***

**Woodner Collections**

This dramatic composition once bore an attribution to Perino del Vaga. Its location between 1908 and 1976, when it was purchased by Ian Woodner, is not known, but it cannot be the drawing of the same motif attributed to Paolo Veronese that was in the collection of Abbé Thuèlin in 1927 (location now unknown); judging from the reproduction in the Witt Library, the latter's proportions and octagonal shape distinguish it from the Woodner drawing. The Thuèlin drawing, moreover, appears to lack the inscription *Ganymede,* visible at the upper center on the present drawing, and its quality and technique of execution seem inferior.

Some drawings attributed to Niccolò dell'Abate have been compared with the Woodner sheet, including *Jupiter and Semele* and *Jupiter Embracing a Nymph* (both British Museum, London), *Jupiter and Juno* (Louvre, Paris), and *Jupiter and Juno* (Yvonne tan Bunzl collection, London).[1] They are not all of the same period nor by the same hand, however. In fact, even if they all illustrate the loves of Jupiter,

they clearly do not belong to the same series and certainly not to one that included the present work: the classical draperies in the other drawings differ from the fancy contemporary costume worn by Ganymede in the Woodner drawing (which is a very strange choice of dress for a young shepherd loved by Jupiter and carried off by him to Olympus to become cupbearer to the gods). Could this image be an allegory of the Este family for which the eagle is a part of the family crest, or *not* a Ganymede but rather a hero of a chivalric novel?

The painterly technique of the Woodner sheet is closer to such early drawings by Niccolò as the *Legendary Subject* (Royal Library, Windsor Castle), two *Chivalric Scenes* (Louvre, Paris, and Uffizi, Florence), *Marriage of a Patrician Couple* (Getty Museum, Malibu), and a *Legendary Scene* (Staatliche Graphische Sammlung, Munich).[2] Two other drawings recently attributed to Niccolò, *A Battle* and *Falcon Hunt* (both Uffizi, Florence), also present notable analogies with this group.[3] In *Falcon Hunt* the third young boy on the left wears a costume similar to that worn by Ganymede in the Woodner sketch. Some of these drawings can probably be related to decorations in Sassuolo (Sala detta dell' Orlando) or in Scandiano, inspired by Boiardo or the poems of Ariosto, decorations that are now lost or were never realized.[4]

A drawing of *Ganymede* by Parmigianino (Huntington Library, San Marino), dated c. 1535, may have inspired both Niccolò's version and Girolamo da Carpi's

preparatory drawing for his Dresden picture of the same subject, dating from 1544. The technical qualities of the Woodner drawing, which was probably a highly finished sketch for a ceiling, support that idea and confirm an early date in his career, c. 1545, before the Torfanini frescoes in Bologna. • *Sylvie Béguin* •

**NOTES**

1. In previous Woodner exh. cats.
2. Technical differences are noticeable in these drawings, but their stylistic affinities are striking.
3. Exh. cat. Modena 1989, 158–161, nos. 74 and 75.
4. Béguin in exh. cat. Bologna 1969, 88–89, no. 31; *Getty Journal* 1988, 173, no. 58.

**PROVENANCE**

Unidentified eighteenth-century collector (mount stamped in gold, similar to mounts from the collection of Lord Yarmouth); Jonathan Richardson Sr., London [1665–1745] (Lugt 2184); John Clayton (sale, London, Christie's, 11 May 1908, lot 85, as Pietro Buonaccorsi); private collection (sale, London, Christie's, 6 July 1976, lot 90); Woodner Collections (Shipley Corporation).

**EXHIBITIONS**

Woodner, Malibu 1983  1985, no. 17; Woodner, Munich and Vienna 1986, no. 26; Woodner, Madrid 1986–1987, no. 32; Woodner, London 1987, no. 23; Woodner, New York 1990, no. 30.

**LITERATURE**

Herbert 1976, 97 (repro.).

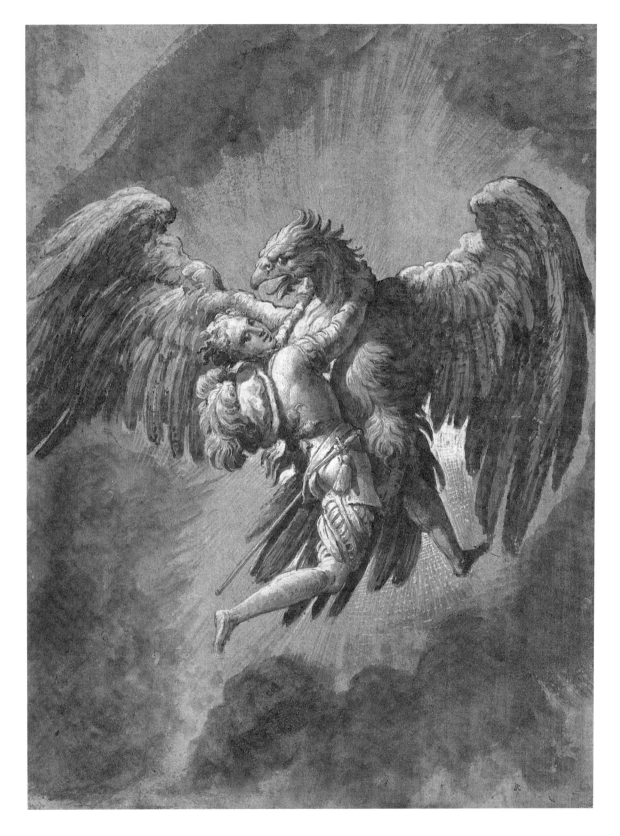

# 51  Design for a Parade Morion

*Cousin was first a geometrician in his native city Sens, but then turned to a variety of artistic pursuits. He designed windows for Sens Cathedral (1530–1542) and painted an altarpiece for the abbey of Vauluisant (1530). Around 1540 he moved to Paris, where he was much influenced by the art of Rosso Fiorentino (1494–1540). Among his most important commissions were designs for two sets of tapestries illustrating the Life of Saint Genevieve (1541) and the Life of Saint Mammès (1543). He was also one of the designers of the elaborate decorations built for the ceremonial entry of Henry II into Paris in 1549. A sculptor, painter, engraver, and designer of objets de luxe, Cousin also wrote two theoretical treatises,* Livre de Perspective *(1560)* and Livre de Portraicture *(1571, published by his son, Jean, also an artist). He was mentioned in the* Vite *by Vasari (q.v.), who referred specifically to his engravings and architectural treatises.*

**c. 1545, pen and gray ink with gray wash over black chalk on laid paper, 349 x 420 (13¾ x 16⁹⁄₁₆)**

**Inscribed at lower right in brown ink: *189***

**Watermark: Small shield with initials PS (cf. Briquet 9666)**

**National Gallery of Art, Woodner Collection 1993.51.4**

Sumptuously decorated parade armor was the prerogative of kings and princes, to be worn on state occasions or at court but never in war. Embossed and chiseled with elaborate designs that covered every piece of the harness, often enriched with gold and other precious metals, these suits of armor were works of art, the combined effort of sculptors, painters, goldsmiths, metalworkers, and armorers. Production of ornate armor for ceremonial use reached a peak in the sixteenth century, with Milan as the most important center. Toward the middle of the century, though, Fontainebleau gained prominence, responding to the growing demand for ceremonial armor from members of the French court; its armor was noted especially for the originality and intricacy of its designs.

The Woodner *Design for a Parade Morion* is one of the earliest known drawings for armor from the Fontainebleau School. The abundant strapwork, with figures, grotesques, scallop shells, and fruits and vegetables intermingled in a complex ornament surrounding three distinct mythological scenes, is characteristic of the style developed at Fontainebleau under the influence of the Florentine expatriate, Rosso Fiorentino. This drawing was, in fact, previously attributed to Rosso,[1] though the execution and conception are closer to those of his French followers in the Fontainebleau School. When the drawing was sold in Paris in 1989, George Wanklyn suggested that it was the work of Jean Cousin the Elder.[2] Comparison with indisputable works by Cousin, such as the drawing of the *Martyrdom of a Saint* (Bibliothèque nationale, Paris)[3] and a print by Master N. H. after an ornamental vessel designed by Cousin (fig. 1), shows that both the linear vocabulary and the ornamental motifs are consistent with Cousin's work. Similarities of form and pose between the nude woman on the earflap of the helmet and painted nude figures by Cousin, most notably his *Eva Prima Pandora* (Louvre, Paris)[4] and his *Charity* (fig. 2), lend further support to the attribution. Indeed, one of the children in *Charity* is nearly identical in pose to the winged child embracing the nude in the Woodner drawing, while the position of the woman's right arm closely echoes that of Eva in the Louvre picture.

The three mythological scenes included in the decoration, though quite different from each other in scale and composition, seem otherwise to be linked loosely through their subjects. On the earflap must be Venus and Cupid; the central medallion with two men working at an anvil probably represents the forge of Vulcan; and on the crest is a battle of sea gods, with a river god at the left and a warrior in ancient armor on the right. If the three scenes are connected, as would seem logical, the warrior must be either Aeneas, whose mother Venus asked Vulcan to make arms and armor for her son when he was about to begin fighting the Greeks in the Trojan War; or Mars, the god of war and lover of Venus, who was married to Vulcan. In any case, the martial elements of the design as a whole are surprisingly subdued considering that it was intended to embellish part of a suit of armor.

A closely related design for a parade morion, identical in shape and size and similar in the organization and character of the decoration is contained in an album of drawings of arms and armor in the collection of the Staatliche Graphische Sammlung, Munich, *Dessins originaux pour armures de luxe destinées à des rois de France.*[5] It appears to be by the same hand as the Woodner sheet and was undoubtedly drawn within a very short time of it. The date c. 1545, suggested by Bruno Thomas for the Munich design on the basis of style,[6] would also be appropriate for the Woodner helmet, placing it toward the end of the reign of François I. • *Sylvie Béguin and Margaret Morgan Grasselli* •

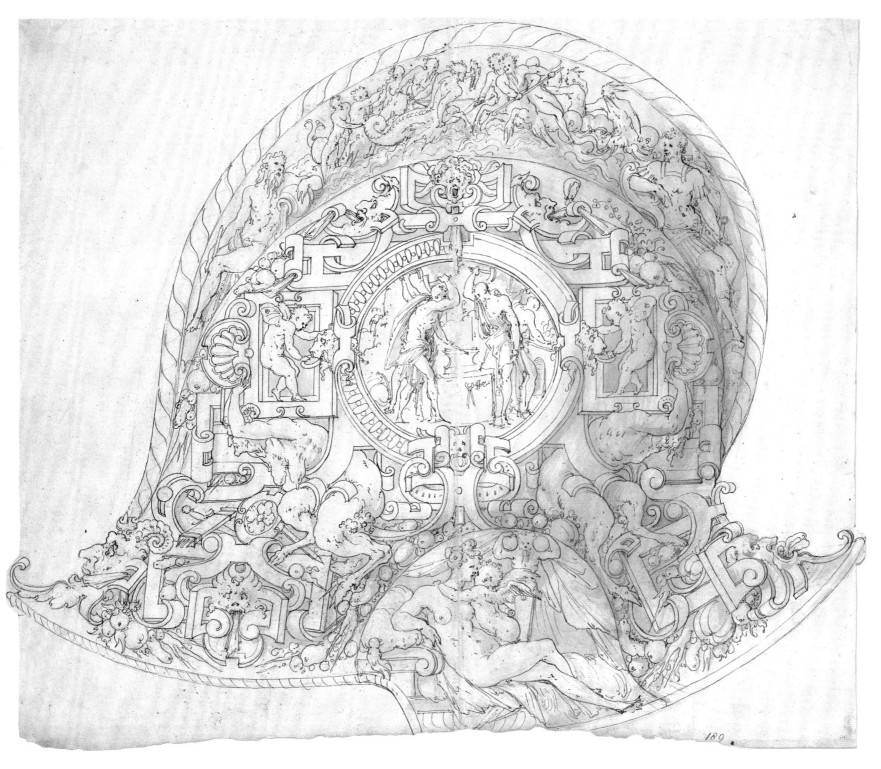

51

189

## NOTES

1.  In Woodner exh. cat., New York 1990, under no. 23.
2.  Conversation between George Wanklyn and Sylvie Béguin, May 1989.
3.  Repro. in exh. cat. Paris 1972–1973, no. 59.
4.  Repro. in exh. cat. Paris 1972–1973, no. 56.
5.  Inv. 34.559. This and other designs for arms and armor were discussed in four articles by Bruno Thomas published between 1959 and 1965. The helmet that is close to the Woodner piece is reproduced in Thomas 1959, 65, fig. 71. Two copies after the Woodner helmet are contained in the same album, plate XII; neither is reproduced in Thomas 1959.
6.  Thomas 1959, 67.

## PROVENANCE

Chevalier de Kirschbaum, sold 1840; Hippolyte-Alexandre-Gabriel-Walter Destailleur, Paris [1822–1893] (Lugt 740) (sale, Paris, Morgaud, 26–27 May 1893, lot 7); to Alfred Beurdeley, Paris [1847–1919] (sale, Paris, Rahir, 31 May 1920, lot 123); H. Grosjean-Maupin (sale, Paris, Hôtel Drouot, 26–27 March 1958, lot 43, as Delaune); private collection (sale, Paris, Hôtel Drouot, 15 March 1989, lot 44, as attributed to Rosso Fiorentino); Woodner Collections (The Ian Woodner Family Collection, Inc.); given to NGA, 1993.

## EXHIBITIONS

Woodner, New York 1990, no. 23 (as attributed to Rosso Fiorentino); Woodner, Washington 1993–1994 (as Fontainebleau School).

**FIGURE 1**

Master N. H., *Design for an Ornamental Vessel*, after Jean Cousin the Elder, Bibliothèque nationale, Paris

**FIGURE 2**

Jean Cousin the Elder, *Charity*, Musée Fabre, Montpellier

## 52  Design for the Backplate of a Suit of Parade Armor

*Apparently born in Milan, Delaune was a compagnon orfèvre (companion goldsmith) in Paris by 1546. Appointed principal medalist to Henri II (1519—1559) in 1552, he held the post for less than five months but continued to work for the king, beginning to provide designs for the king's armor around 1555. Although Delaune is perhaps best known for his book illustrations and detailed engravings after works by Fontainebleau artists, he seems to have turned to print-making relatively late in his career, only after the death of Henri II. Because he was a Protestant, Delaune fled the French court after the Saint Bartholomew's Day massacre in 1572, going first to Strasbourg, then to Ausburg, where he remained from 1576 to 1580. His last engraving is dated 1582. His training as a goldsmith and designer of ornament no doubt accounts for the strong sense of craftsmanship and minia-turist precision in his drawings and prints.*

**1555/1557 pen and black ink with gray wash on laid paper, with faint traces of black chalk along border line, 390 x 308 (15 ⁵⁄₁₆ x 12 ⅛), irregular**

**National Gallery of Art, Woodner Collection 1991.182.20**

Like the *Design for a Parade Morion* by Jean Cousin (cat. 51), this oddly shaped drawing was made for part of a highly decorated suit of armor, in this case for the left half of the backplate. Though made just a little more than a decade after the Cousin design, it reflects a dramatic change in the style of ornament. Instead of Cousin's strongly geometrical strapwork, Delaune traced a more delicate design of foliate rinceaux embracing a variety of fantastic creatures, allegorical figures, warriors and princes, and even a camel readied for war. The inclusion on the Woodner page of some of the details from the right half of the armor—most notably the seated figure at right—shows that the design of the entire backplate would have been symmetrical, with each of the elements of the decoration on the left side balanced by a matching or closely similar element on the right side.

Most of the figures in Delaune's design are engaged in martial activities or refer to military victories, perfectly appropriate for a suit of armor, but the overarching theme remains elusive. Most prominent is the winged figure of Victory holding two swords, which would occupy the exact center of the backplate of the finished armor. Below her, trophies of war are piled up at the feet of two bare-breasted women holding branches of laurel. At the bottom two warriors in ancient armor engage in furious combat, while at left another warrior prepares to mount a camel bearing his shield and arms. Seated on either side of the Victory are two men, one of whom is clearly a king. Since Victory is placed directly between them, they may well be interpreted as the victor (crowned) and the vanquished (uncrowned), though the defeated man still wears a broad, curved sword at his side. The ancient armor worn by all the men in the drawing suggests that they may represent actual historical personnages and that the individual vignettes refer to specific incidents, but there are otherwise no clues to their identities.[1]

In the Munich album of armor designs mentioned in connection with the Cousin *Parade Morion*, two drawings are related to the Woodner *Backplate*: a preliminary drawing in black chalk by Delaune for the right half of the same backplate (fig. 1), with almost all of the figural elements virtually identical to, but in reverse to, those on the Woodner page; and a red chalk copy, not by Delaune, after the Woodner drawing and in the same direction.[2] Also in the Munich album is a small study (93 x 77 mm) of a figure mounting a reclining mule, a motif that would undoubtedly have been used, as Bruno Thomas noted, on the right half of the backplate to balance the man with the camel at lower left in the Woodner design.[3] Thomas identified a black chalk design in the same album that seems to have been made in preparation for the same suit of armor as the Woodner sheet, in this case for the right half of the breastplate.[4]

Delaune's armor designs were intended to serve as actual-size models for the armorers and goldsmiths who would execute the many pieces of the individual harnesses. Since the person for whom the Victory armor was designed was fairly narrow in the chest, about 34 inches at most, Thomas posited that it was intended for a youth of about sixteen or seventeen, and suggested that it was made for the young Charles IX (1550—1574) in about 1567.[5] The character of the Woodner design and the relationships between the figures and the ornamental rinceaux seem to be more closely related to armor designs made by Delaune about ten years before that, how-ever—in particular the *Emperor Harness* made for Henri II in about 1555 (fig. 2) and the *Hercules Harness* made for Emperor Maximilian II in about 1556—1557 (Kunsthistorisches Museum, Vienna).[6] Indeed, it is noteworthy that a drawing for the breast-plate of the *Emperor Harness* (fig. 3) is very similar in organization, conception, and execution to the Woodner design. If the Woodner drawing were made at about the same time, as seems probable, then the armor may well have been intended for Henri's older son, François II (1543—1560), who would have been fourteen in 1557. It is not known whether the harness was ever executed. • *Margaret Morgan Grasselli* •

52

**FIGURE 1**

Étienne Delaune, *Backplate for a Suit of Armor*, Staatliche Graphische Sammlung, Munich

## NOTES

1.  The decoration of other suits of armor designed by Delaune was organized along particular themes, such as the *Hercules Harness* made for Emperor Maximilian II (see Thomas 1965, figs. 92, 96–99).

2.  See Thomas 1965, fig. 105.

3.  Inv. 34.537; see Thomas 1965, fig. 104. In the red chalk copy after the Woodner sheet, the man mounting the mule is included in the design at upper right, instead of in its more logical position at lower right (see Thomas 1965, fig. 105).

4.  Inv. 14.531; see Thomas 1965, 77–79, fig. 101. The central figure in that design is a king in ancient armor, perhaps a Roman emperor or general. Above him is an allegorical figure of Fame sounding two long, curved trumpets. The surrounding design of foliate rinceaux is closely similar in every way to that of the Woodner *Backplate*, not only in its curling structure and inventive use of the vegetal elements, but also in the way the rinceaux contain and interact with the various figures, both real and imaginary. The details of the breastplate design are more easily read in a red chalk copy, also in the Munich album (inv. 14.460; see Thomas 1965, fig. 102).

5.  Thomas 1965, 80.

6.  For the *Hercules Harness* see Thomas 1965, figs. 92, 96–99, as noted above.

## PROVENANCE

Chevalier de Kirschbaum; Hippolyte-Alexandre-Gabriel-Walter Destailleur, Paris [1822–1893] (Lugt 740) (sale, Paris, Morgaud, 26–27 May 1893, lot 7, a volume consisting of 97 folios); to Alfred Beurdeley, Paris [1847–1919] (sale Paris, Rahir, 31 May 1920, lot 123); H. Grosjean-Maupin (sale, Paris, Hôtel Drouot, 26–27 March 1958, lot 43); private collection (sale, Paris, Hôtel Drouot, 15 March 1989, lot 12); Woodner Collections (The Ian Woodner Family Collection, Inc.); given to NGA, 1991.

## EXHIBITIONS

Woodner, New York 1990, no. 91; Woodner, Washington 1993–1994.

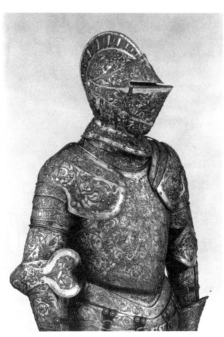

**FIGURE 2**

*Emperor Harness* (detail), The Metropolitan Museum of Art, New York, Harris Brisbane Dick Fund

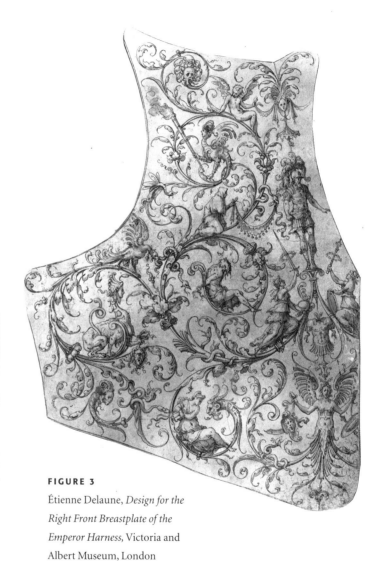

**FIGURE 3**

Étienne Delaune, *Design for the Right Front Breastplate of the Emperor Harness*, Victoria and Albert Museum, London

# 53 Alexander the Great and Bucephalus

*Taddeo Zuccaro arrived in Rome c. 1543 and taught himself to paint by copying from the early masters. He was particularly influenced by the work of Perino del Vaga (q.v.) and Polidoro da Caravaggio (c. 1499–1543[?]). In 1553–1556 Taddeo painted the Mattei Chapel in Santa Maria della Consolazione with scenes of the Passion, and in 1558–1559 he began to paint the Frangipani Chapel in San Marcello al Corso. Both decorations show his highly individual variant of the mannerist style then in vogue. In 1560–1562 he began work on the decoration of the Villa Farnese at Caprarola. He was also employed by Cardinal Ranuccio Farnese to complete the Sala dei Fasti Farnesiani in the Palazzo Farnese, left unfinished at the death of Francesco Salviati (q.v.). He was the leading exponent of the late mannerist style of painting in Rome just after the middle of the sixteenth century.*

**c. 1553, pen and brown ink with brown wash over traces of graphite on laid paper, 194 x 241 (7⅝ x 9½)**

**National Gallery of Art, Woodner Collection 1991.182.1**

This lively drawing illustrates an anecdote reported by Plutarch in which the young Alexander the Great prepared to mount his new horse, Bucephalus. According to this story, the animal would not be ridden, but Alexander took "hold of the bridle, turned him directly towards the sun, having, it seems, observed that he was disturbed and afraid of the motion of his own shadow." He led the horse this way and then quickly mounted him. The artist has added a reclining river god in front of the tree in the left foreground, referring to the Hydaspes River beside which Alexander later founded the town of Bucephala in memory of his horse. The role of the partly nude female figure depicted here cannot be explained.

The artistic career of the brilliant and prolific draftsman Taddeo Zuccaro lasted less than twenty years, with all of his activity confined to Rome and its environs. Thus a traditional division into early, middle, and late phases of development is not a particularly effective method for understanding his art. Nonetheless, one useful point of reference, supported by Vasari's life of the artist, is that Taddeo's career began with commissions to decorate the exteriors of Roman *palazzi* with scenes from classical antiquity in the manner popularized by Polidoro da Caravaggio.

In the early 1550s, according to Vasari, Taddeo decorated the exterior of a house near the church of Santa Lucía della Tinta, "full of histories from the life of Alexander the Great, beginning with his birth and followed by five additional stories of this famous man, well executed and very noteworthy." John Gere thought these frescoes might be, in part, reflected in an engraving by Conrad M. Metz (1755–1827) of a frieze in three sections portraying the *Birth of Alexander, Alexander and Bucephalus,* and *Alexander Cutting the Gordian Knot,* published in the volume *Schediasmata selecta ex archetypis Polidori Caravagiensis* in 1791. The drawings on which the engravings were based are in the Lugt Collection (Institut néerlandais, Paris) and were published by James Byam Shaw with attributions to Cherubino Alberti.[1] Since the Lugt drawing of *Alexander and Bucephalus* is very relief-like and planar and looks nothing like the Woodner drawing, either the former was not copied from a fresco by Taddeo, or the latter was intended for another purpose.

A closely related drawing mistakenly entitled *Alexander and Bucephalus* (Christ Church, Oxford)[2] corresponds with the Woodner sheet in format and every aspect of style, suggesting that the two formed part of an Alexandrian cycle. Judging from the rather deep illusionistic space, the use of landscape, and the lack of Polidoro's influence, however, the two drawings may relate to an indoor rather than an outdoor decorative scheme.

The only other occasions on which

Taddeo took up the Alexander narrative were in his decorations for the Palazzo Caetani, Rome, and the Castello Odescalchi, Bracciano, in 1559–1560. For the Palazzo Caetani he illustrated both *Alexander and Bucephalus* and *Alexander and Timoclea,* the latter also being the possible subject of the Oxford drawing. While neither the Woodner nor the Oxford sheet is a direct study for these frescoes and should remain dated to the early 1550s (likely c. 1553 since the verso of the Oxford drawing contains a possible study for a *basemento* for the Mattei Chapel, commissioned in that year), they both might reasonably have provided first thoughts for the later Palazzo Caetani commission. • *James Mundy* •

**NOTES**

1. Byam Shaw 1983, 1:19–24.

2. The title apparently derives from the inclusion of a horse on the right side of the composition, but the work has nothing to do with any known moment involving Bucephalus. The drawing depicts Alexander enthroned and gesturing to two women. He is surrounded by soldiers and two other female figures. This scene probably portrays Alexander and the matron Timoclea, who was brought before Alexander for killing a Thracian who had raped her. Her eloquence moved the king and he set her free.

**PROVENANCE**

Private collection (sale, London, Christie's, 5 July 1983, lot 62); Woodner Collections (Dian and Andrea Woodner); given to NGA, 1991.

**EXHIBITIONS**

Woodner, Cambridge 1985, no. 80; Woodner, London 1987, no. 24; Milwaukee 1989–1990, no. 7; Woodner, New York 1990, no. 31.

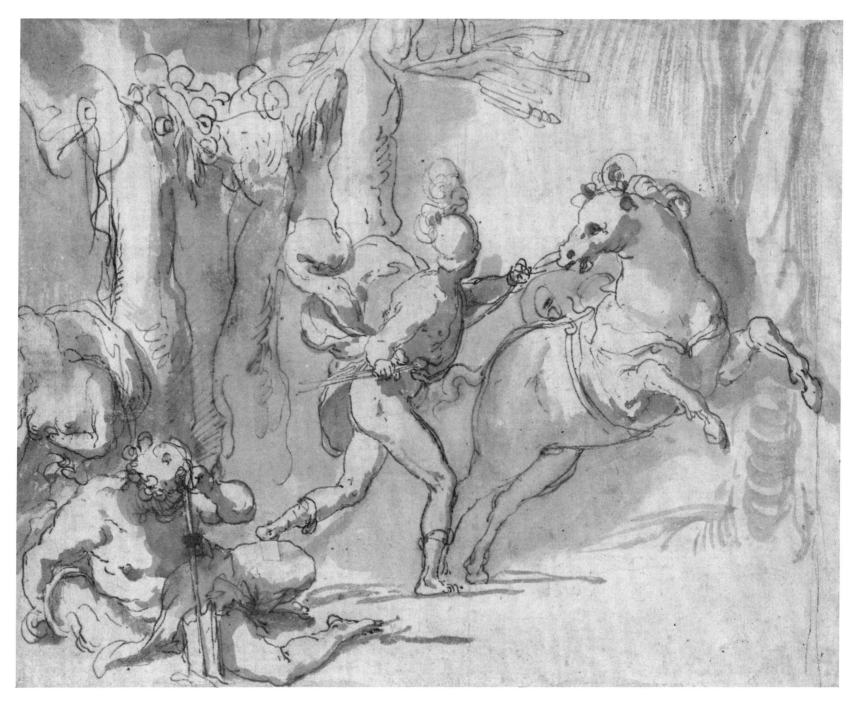

53

# 54 The Fall of Phaeton

Alessandro Allori trained with Agnolo Bronzino (1503–1572) and spent most of his career in his native Florence. Between 1554 and 1559, however, he was in Rome, where he studied and copied ancient art and the works of Michelangelo. Upon his return to Florence, Allori's career flourished with numerous commissions from the ruling house of Medici and other major patrons. In 1574, following the death of Vasari (q.v.), Allori was appointed court painter to the Medici, completing one of their major projects, the decoration of the salone of Leo x in the Medici villa at Poggio a Caiano, in 1582. Throughout a vastly productive career, Allori continued to sign himself as Bronzino's pupil, but in his later years he responded to the "reformed" current in Florentine painting, including the work of his son, Cristofano, and his forms became less stylized, his color schemes richer and denser, and his surfaces more realistically textured.

**c. 1555/1559, black chalk on laid paper, 407 x 272 (16 x 10 11/16)**

**Inscribed by William Esdaile on the verso across the bottom in pen and brown ink: *1814 WE P 15-N 9bx / The Fall of Phaeton by Michael-Angelo*; by J. C. Robinson on the verso at lower right in pen and brown ink: *J. C. Robinson July 2 1887 / Giorno felicissimmo per questa / trovaglia!!!*; by a later hand on the verso at lower left in graphite: *being lot 49 in his Sale***

**Watermark: Crossed arrows with star (cf. Briquet 6291, 6298 – 6300)**

**Woodner Collections**

The present drawing is an exact-size copy in the same medium of Michelangelo's *Fall of Phaeton* in the Royal Collection at Windsor (fig. 1).[1] All internal dimensions, it seems, are identical to the original's, but how this was achieved is unknown: even if this drawing followed an intermediary copy, some procedure for replication of the original must have been employed at some stage.

Michelangelo's *Phaeton* was one of several "presentation drawings" made for the Roman aristocrat Tommaso de' Cavalieri. Cavalieri's birthdate is unknown, but he may have been only twelve or thirteen when Michelangelo met him in 1532.[2] If so, it is likely that Michelangelo's love was more paternal than erotic and the drawings made for him less visual love-poems than educational allegories.

Three autograph versions of the *Fall of Phaeton* survive. The earliest drawing (British Museum, London) was done in Rome probably in June 1533. This bears Michelangelo's autograph message offering either to make a new version of the drawing the next evening if Cavalieri did not like it or to finish it if he did. It may be that Michelangelo next drew the version in the Accademia, Venice, which also carries a message to Cavalieri, although that is generally seen as a variant, datable to 1534–1535.[3] Perhaps Michelangelo offered Cavalieri a choice of designs. The Windsor drawing was made in Florence, whence it was sent to Rome around late August 1533; Cavalieri's acknowledgment is dated 6 September. In a quick pen sketch, also at Windsor, Raffaello da Montelupo, then assisting Michelangelo in the Medici chapel, copied the Windsor *Phaeton*, which he surely saw in Michelangelo's hands.[4]

The arrival in Rome of Michelangelo's *Phaeton* was a public event. Cavalieri was visited by Pope Clement, Cardinal Ippolito de' Medici, and *ognuno* (everyone). Ippolito asked to have several of Michelangelo's drawings engraved in crystal by Giovanni Bernardi di Castel Fiorentino; and Cavalieri provided first the *Tityus* and later, presumably, the *Ganymede* and *Phaeton,* perhaps lending one drawing at a time. Interestingly, the crystal of the *Fall of Phaeton* in the Walters Art Gallery, Baltimore, combines features from the Windsor and London *Phaeton*s; Cavalieri had probably retained the latter, which was also copied and engraved. The Venice version, however, was entirely unknown to contemporaries, and no copies of it have been discovered.

The Windsor *Phaeton* is the most elaborate of the three drawings, but it shows many signs of working and contains numerous, carefully erased, pentimenti. The Heliade at far right once had both arms raised, and the airborne group was first tried lower down, with the hapless Phaeton's arms silhouetted against the sky. These earlier efforts are not reproduced in the Woodner drawing, in which the author tried to follow the definitive statement. It everywhere simplifies the original: it is more linear, its contrast between lights and darks is much diminished, and the lustrous surfaces of Michelangelo's original are detextured. There is also a tendency to graphic formalism: the horses' tails form flowery and flamelike patterns. In contrast, the flowing water at bottom left, which in Michelangelo's original is like marble under a broad-clawed chisel, is here a formless bundle of lines. And certain details are left unexplained: in the present drawing Jupiter does not appear to be holding the thunderbolts; and the far wheel of Phaeton's chariot is undefined.

The watermark in this sheet is like that in paper used in Rome by Michelangelo c. 1560, thus the present drawing was probably made within Michelangelo's lifetime, and in Cavalieri's house. In 1562 Cavalieri commissioned a replica of the *Cleopatra,* which he had been compelled to donate to Cosimo I.[5] The copyist is unknown, but it may have been Giulio Clovio, to whom

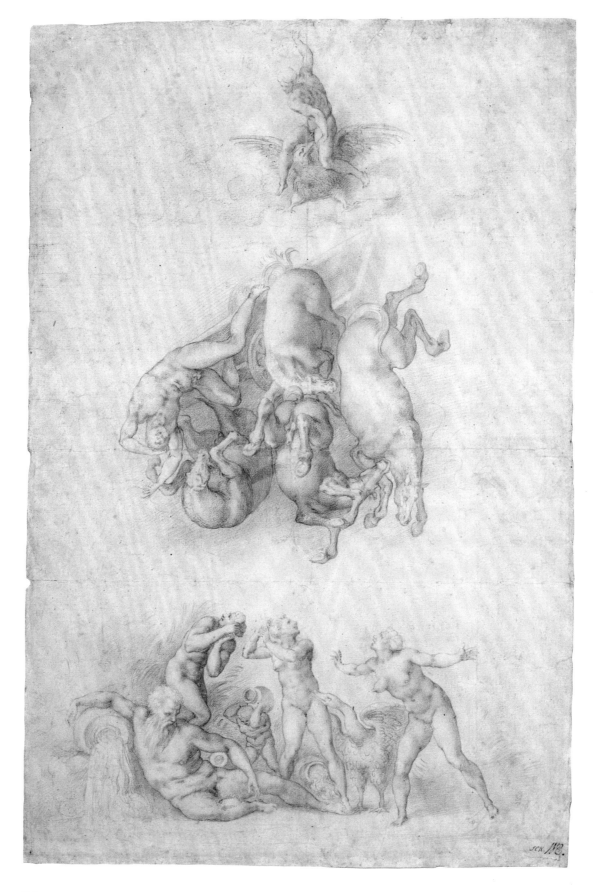

54

**FIGURE 1**

Michelangelo Buonarroti,
*The Fall of Phaeton,* The Royal
Collection © Her Majesty
Queen Elizabeth II

Philip Pouncey has plausibly attributed a *Cleopatra* in the Louvre (inv. 733). Clovio's inventory of 1577 includes "Il phetonte di Mro. Michelangiolo fatta da Don giulio." Although the Woodner drawing may be by Clovio, the present writer doubts this attribution, while acknowledging that the authorship of exact copies is difficult to establish. Yet the technique of the Woodner drawing does not seem consistent with Clovio's method of building forms through a minute groundwork of long thin lines, his dense treatment of shadowed areas, or his flickering, tentative contours. Where details of physiognomy differ from those in Michelangelo's original, as in the heads of the river god and of Phaeton, they conform less to Clovio's types than to those of Bronzino. The drawing is more likely by Bronzino's pupil Alessandro Allori, working in Rome in the second half of the 1550s. Allori was deeply impressed by Michelangelo, copied him avidly, and probably had access to his drawings. A study for Allori's *Cleansing of the Temple* (Musée des Beaux-Arts, Lille), frescoed between 1560–1564 in the Montauto chapel of Santissima Annunziata, is very close in technique to Michelangelo's *Last Judgment* drawings. Another highly finished copy in the Louvre after Michelangelo's *Resurrected Christ* (Royal Collection, Windsor Castle), which Cavalieri may also have owned, carries a traditional attribution to Allori, and the interpretation of Christ's visage is similar to that of the central Heliade in the Woodner drawing. • *Paul Joannides* •

**NOTES**

1. Popham and Wilde 1949, no. 430.
2. Panofsky-Soergel 1984, 399–406.
3. Exh. cat. Washington 1988, 107–112.
4. Popham and Wilde 1949, no. 787 (verso).
5. Perlingieri 1992, 72.

**PROVENANCE**

John Thane, London [1748–1818] (Lugt 1544); William Esdaile, London [1758–1837] (Lugt 2617) (sale, London, Christie's, 18 June 1840, lot 48, as Michelangelo; to "Sheath"); Sir John Charles Robinson, London [1825–1913], 1887 (Lugt 1433), (sale, London, Christie's, 12–14 May 1902, lot 112, as Michelangelo); Sir Brinsley Ford, London (sale, London, Christie's, 11–13 December 1985, lot 228, as Giulio Clovio); Woodner Collections (Dian and Andrea Woodner).

**EXHIBITIONS**

Woodner, New York 1990, no. 24 (as Giulio Clovio).

# 55  The Bagpipe Player

*Possibly a pupil of Pieter Coecke van Aelst (1502–1550), Bruegel entered the Antwerp artists' guild in 1551/1552. He traveled through Switzerland to Italy from 1552 to 1555, a journey that provided inspiration for his landscape paintings, drawings, and prints (many of which were published in Antwerp by Hieronymus Cock). In 1563 Bruegel moved to Brussels, marrying Pieter Coecke's daughter Mayken. Their sons Pieter Bruegel the Younger and Jan Bruegel the Elder also became artists. Bruegel's own work consisted mainly of landscapes and allegorical compositions, the complexity of the latter echoing the fantastic creations of Hieronymus Bosch (c. 1450–1516). His art was highly praised in his day, and collectors of his work included Cardinal Granvelle (Archbishop of Malines and advisor to the regent, Margaret of Parma) and the renowned geographer Abraham Ortelius.*

**c. 1562/1563, pen and brown ink, with some incised lines, on laid paper, laid down, 206 x 146 (8 ⅛ x 5 ¾)**

**Inscribed at lower left in pen and brown ink:**
*P. Bréugel f*

**Woodner Collections**

In spite of the poor condition of the sheet, parts of which have been reworked in a dark brown ink, there seems to be no reason to doubt the autograph status of this drawing as a work by Pieter Bruegel the Elder. Its quality is most apparent in the hair, face, and subtle parallel hatching in the figure's right thigh. Many of the other contours have been redrawn, yet despite all the reworkings the effect is still monumental and sculptural—as if chiseled—as becomes especially clear on comparison with an old copy of the drawing (Metropolitan Museum, New York).[1] The copy also shows that the original has been trimmed, particularly above (removing part of the pipes).

Like Bruegel's drawing of the *Standing Shepherd* (fig. 1),[2] the figure is based on an exact knowledge of reality, although it was drawn from the imagination. The musician, nearly toppling over, is transformed into a considered composition of surpassing mastery. A parallel in Bruegel's work may be found in the print after his design, the *Fat Kitchen*, engraved by Pieter van der Heyden and dated 1563;[3] in it a fat peasant balances his corpulent mass on an identical stool. On the right of the drawing of *Saint James and the Magician Hermogenes* (Rijksmuseum, Amsterdam)[4] similar stools are stacked on each other, with an acrobat performing on top of them; the composition includes several acrobats posed in extreme, precisely calculated movements. The *Bagpipe Player* seems also to have been made in around 1562–1563, and its affinities with Bruegel's preparatory drawings for the engravings of *Spring* and *Summer* (Albertina, Vienna, and Kunsthalle, Hamburg) have been noted.[5] • *Hans Mielke* •

**NOTES**

This is a free translation by Martin Royalton-Kisch of the text prepared by the late Hans Mielke for his forthcoming catalogue of Bruegel's drawings. We are grateful to the author's widow, Ursula Mielke, and to Marc Jordan of Phaidon Press, for permission to use it.

1. Pen and brown ink, 280 x 195 mm, inv. 1975.131.172, inscribed *Bruegel,* from the J. G. van Quandt collection, Leipzig.
2. Münz 1961, no. 90.
3. Van Bastelaer 1908, no. 159.
4. Münz 1961, no. 150.
5. Goldner in Woodner exh. cat., Malibu 1983–1985, 118, no. 46.

**PROVENANCE**

Private collection (sale, Paris, Hôtel Drouot, 20 May 1966, lot 144); Woodner Collections (Shipley Corporation).

**EXHIBITIONS**

Woodner, New York 1971–1972, no. 61; Los Angeles 1976, no. 210; Woodner, Malibu 1983–1985, no. 46; Woodner, Munich and Vienna 1986, no. 68; Woodner, Madrid 1986–1987, no. 81; Woodner, New York 1990, no. 84.

**LITERATURE**

De Tolnay 1969, 62–63; Haverkamp-Begemann 1974, 35, 37, no. 1; exh. cat. Berlin 1975, under no. 103; exh. cat. Washington 1986–1987, under no. 30.

**FIGURE 1**

Pieter Bruegel the Elder, *Standing Shepherd*, Kupferstichkabinett der Staatlichen Kunstsammlungen, Dresden

55

# 56 Head of a Bearded Man

*The son of a university professor, Jost Amman was probably trained initially in Zurich as a designer of stained-glass windows. He may have worked in Basel for a time before settling in Nuremberg. He became a citizen of that city in 1577. Upon the death of Virgil Solis in 1562, Amman became Germany's foremost book illustrator, working mainly for the Frankfurt publisher Sigmund Feyerabend. Among his most important books were* Eygentliche Beschreibung Aller Stände auff Erden *(1568), a book of occupations and professions; and* Kunnst und Lehrbüchlein für die anfahenden Jungen… *(1578), an art instruction book for youngsters that was expanded and published posthumously in 1599 as* Kunstbüchlin. *Though often described as a painter, Amman's main activity centered around drawing, printmaking, and book illustration.*

**1572, brush and black ink with white wash on blue prepared paper, 155 x 115 (6 ⅛ x 4 ⁹/₁₆)**

**Signed (indistinctly and partly cut off) across the bottom of the page: *IA 1572;* inscribed by a later hand on the verso at lower center in graphite: *Nicolas Manuel g* [illegible] *Deutsch / geb. Bern 1484***

**National Gallery of Art, Woodner Collection 1991.182.19**

According to Kurt Pilz, this virtuoso drawing was first recorded in the Zurich collection of H. J. Nüscheler the Younger in the early seventeenth century. It was in the London collection of Victor Koch around 1930, having been purchased from an American private collector in 1928. Pilz recorded that it was formerly attributed to Hans Hoffmann, then to Nikolaus Manuel Deutsch, and now to Jost Amman, asserting that he believed Amman's monogram had been added posthumously by Hans Hoffmann. When the drawing was sold by Sotheby's in Amsterdam in December 1986, the inscription was still indistinctly visible, but it is now barely discernible. With microphotography, however, one can still see the remains of the initials and the partly cut-off date.

Three other drawings with the same date and Amman's signature are known. The first is the *Roundel with Susanna and the Elders* (Kupferstichkabinett, Berlin, inv. 210).[1] The second is the drawing of *Five Helmets* (tree with crowns and lions rampant), pen and brush in gray, white, and gold on grayish blue paper, 215 x 302 mm

(formerly Franz Koenigs Collection, Haarlem; on loan to Rotterdam since 1936 and lost during the war). There is a good photograph of it in the Witt Library, London, and a copy in a Swiss private collection. And the third is a drawing with *Coats of Arms* (Rijksprentenkabinet, Amsterdam, inv. 1918.378).[2] All three of these drawings are in the same technique as the Woodner head: pen and dark ink, heightened with white on colored prepared paper, a technique that was frequently used by Swiss artists of the time. In Amman's work there are many other examples of it: from 1563 (*Three Lions,* Kupferstichkabinett, Berlin, inv. 12254/128–1925) to 1588 (*Saint Nicholas,* Louvre, Paris, inv. 18.498). Closest in style, however, is the undated drawing of a *Lion's Head* from the Devonshire collection (Chatsworth, inv. 88 B),[3] which has always been attributed to Amman and shows the same decisive, flamboyant black pen strokes, echoed by curling white brush lines on colored prepared paper as the Woodner *Head of a Bearded Man.*

Like so many of Amman's drawings, the Woodner study is not related to any known project but appears instead to have been made as a finished work in itself. Whatever the purpose, the artist took special delight in the textures and ornamental potential offered by the hair, whiskers, and cap of his bearded model, creating an extravagant play of swirling lines—both white and black—against the pale blue of the prepared paper. • *Ilse O'Dell* •

**NOTES**

1. Bock 1921, 6, pl. 8.
2. Exh. cat. Rotterdam 1974, no. s 7, pl. s 7.
3. Exh. cat. London 1993–1994, pl. 194.

**PROVENANCE**

H. J. Nüscheler the Younger, Zurich [1583–1645] (Lugt 1345); American private collection; Victor Koch, London, 1928; (sale, Amsterdam, Sotheby's, December 1986); (P. & D. Colnaghi, London and New York); Woodner Collections (The Ian Woodner Family Collection, Inc.); given to NGA, 1991.

**EXHIBITIONS**

London 1987, no. 3; Woodner, New York 1990, no. 73.

**LITERATURE**

Pilz 1930, 330–331; Pilz 1940, pl. 12.

56

# 57  Head of a Boy

**Second half of 16th century, brush and brown ink with touches of graphite, heightened with white on prepared blue-green paper, 269 x 208 (10⁹/₁₆ x 8³/₁₆)**

**Inscribed at lower left in pen and black ink:** *1508,* **and at lower right in pen and black ink:** *AD* **(in monogram); numbered on the verso at upper center in red chalk:** *227*

**Watermark: Initials VA (?)**

**Woodner Collections**

This drawing of the head of a boy has always presented difficulties for scholars. On the one hand, while inspired by a painting by Cima da Conegliano,[1] it is closely related to the work of Albrecht Dürer. Erwin Panofsky pointed out its connection with Dürer's head of Jesus as a boy among the doctors, and Friedrich Winkler had already noted its similarity to the small painting of 1507 of the head of a girl (Staatliche Museen, Berlin).[2] On the other hand, the signature, date, and quality of the line all raise questions.

The draftsmanship has a more mechanical effect than that of a badly preserved second version of the head in Munich (fig. 1), particularly evident at the boy's left shoulder and throat. While the lines in the Munich drawing swell and taper perceptibly, those in the Woodner sheet are of uniform strength.

Campbell Dodgson, who initially considered the present drawing the original by Dürer, later changed his opinion and came to regard the Munich sheet as the original. Hans and Erika Tietze as well as Eduard Flechsig later concurred.[3] Panofsky, in spite of certain reservations, shared Winkler's opinion that the present work was produced by Dürer's hand.

The watermark, difficult to decipher, may be composed of the letters *V* and *A*. Several watermarks combining letters in a similar manner are noted by Briquet, even some that, as in the present case, are arranged parallel to the chain lines.[4] They all date from the years 1550–1600 and have places of origin ranging from central Germany to Prague. The Woodner drawing of the head of a boy must thus be seen as a work of the Dürer renaissance. Whether it is the work of Hans Hoffmann or another of the famous Dürer copyists cannot be determined. • *Fedja Anzelewsky* •

**NOTES**

1. Wölfflin 1905, 137.
2. Panofsky 1943, 1:117; and 2: no. 1063; Winkler 1936–1939, no. 437 (repro. in Anzelewsky 1971, nos. 98, 102).
3. Dodgson 1898–1911, 11:67; Tietze and Tietze-Conrat 1928–1938, 2: no. 381; Flechsig 1928–1931, 2:453.
4. Briquet 1968, under *Lettres combinées.*

**PROVENANCE**

B. Hertz; John Malcolm, London [1805–1893]; Alfred Gathorne-Hardy, London [d. 1918]; Geoffrey Gathorne-Hardy, London [1878–1972]; Robert Gathorne-Hardy, London [1902–1973] (sale, Amsterdam, Sotheby Mak van Waay, 3 May 1979, lot 8); Woodner Collections (Shipley Corporation).

**EXHIBITIONS**

London 1869, no. 147; London 1906, no. 5; Manchester 1961a, no. 116; London 1971–1972, no. 1; Woodner, Malibu 1983–1985, no. 41; Woodner, Munich and Vienna 1986, no. 49; Woodner, Madrid 1986–1987, 58; Woodner, London 1987, no. 48; Woodner, New York 1990, no. 59.

**LITERATURE**

Robinson 1869, no. 520 (2nd ed. 1876, no. 527); Lippmann and Winkler 1883–1929, 7: no. 749; Dodgson 1898–1911, 7:7 and 11:67; Gathorne-Hardy 1902, no. 108; Wölfflin 1905, 137; Flechsig 1928–1931, 2:453, 571; Tietze and Tietze-Conrat 1928–1938, 2: pt. 1, no. 381; Winkler 1936–1939, 2: no. 437; Panofsky 1943, 1:117; 2: no. 1063; Winkler 1957, 191; Anzelewsky 1971, under no. 102; Strauss 1974, 2: no. 1508/1522; Strauss 1982, 12, no. 1058; Oberhuber 1983, 77 (repro.), 80; Humfrey 1983, 53, 124, under no. 88.

**FIGURE 1**

Albrecht Dürer or Studio, *Head of a Boy*, Staatliche Graphische Sammlung, Munich

57

# 58  Red Squirrel

*Hans Hoffmann spent the first part of his life in Nuremberg, where he had access to the Imhoff collection of drawings by Albrecht Dürer (q.v.), of which he made numerous copies and imitations. In addition to his many studies of plants and animals, he also painted portraits. In 1584 Hoffmann worked temporarily in Munich at the court of Duke Wilhelm V of Bavaria, and from 1585 on he was court painter at Prague, where he most probably acted as an adviser to Emperor Rudolf II.*

**1578, watercolor and gouache over traces of graphite on vellum, 250 x 178 (9 ⁷⁄₈ x 7)**

**Inscribed lower center in pen and black ink: *Hh* (in monogram) / *1578***

**National Gallery of Art, Woodner Collection 1991.182.5**

Hans Hoffmann was one of the most talented artists of the "Dürer renaissance" in the second half of the sixteenth century. Although most of his works were either exact or slightly changed copies or free variations of originals by Albrecht Dürer, Hoffmann also made independent portraits and nature studies. His appealing drawing of a squirrel eating a nut is regarded as an exceptionally vivid animal study, mainly for the skilled execution of the animal's fur, in which the artist conveys its softness while also reflecting its diversity of length and texture.

Since its publication in 1929 this drawing has been discussed in conjunction with a related sheet depicting two squirrels (formerly Northbrook collection):[1] one of the animals on that sheet, also eating a nut, is seen from a point of view similar to that of the Woodner squirrel; the other from behind. Pieces of broken nuts and shells scattered around them contribute to a playful sense of intimacy. Because the Northbrook drawing, which closely follows the Woodner squirrel even to the method of execution, is inscribed *AD 1512*, scholars have had to consider whether the *Two Squirrels* was wholly or partly an independent invention

by Hoffmann or a copy of a lost Dürer original. Campbell Dodgson believed the drawing with the two squirrels probably preserved a lost work by Dürer in its entirety, while the present work could be regarded as a partial copy. Friedrich Winkler at first agreed but later suggested that the two squirrels could be a free invention of an artist in Hoffmann's circle. Hans and Erika Tietze, seconded by Erwin Panofsky, thought the lost Dürer probably featured only one squirrel, which was faithfully copied by Hoffmann, and that the second animal was the invention of someone else. Only H. T. Musper considered *Two Squirrels* to be entirely by Dürer's hand, albeit bearing a false signature. Kurt Pilz was the first to assign that drawing also to Hoffmann. Fritz Koreny then convincingly identified Hoffmann's characteristic drawing style on both sheets and rightly stated that the dates and monograms on both were in Hoffmann's hand. He also pointed out that another drawing of a squirrel, previously attributed to Tobias Stimmer (1539–1584) and often regarded as further evidence for the existence of an original by Dürer, was an eighteenth-century work.[2]

The Woodner squirrel, presumably together with the related sheet, was painted during Hoffmann's Nuremberg period, when he copied many of the drawings by Dürer in the collection of Willibald Imhoff. He often made several copies, as well as different versions of the same original, signing perhaps one with his own monogram, another with that of Dürer. No Dürer

original, partial or complete, has yet been found for either the *Red Squirrel* or the *Two Squirrels*. Perhaps Hoffmann himself invented a "Dürer original," then produced a variation of it in the Woodner drawing.
• *Szilvia Bodnár* •

**NOTES**
1. Exh. cat. Vienna 1985, no. 28. The drawing was sold in London, Christie's, 3 July 1990, lot 143.
2. Exh. cat. Vienna 1985, no. 29.

**PROVENANCE**
Mrs. M. A. Parker, Wilmington, Kent (sale, London, Sotheby's, 24 April 1929, lot 287); private collection (sale, London, Christie's, 30 March 1976, lot 147); Dr. G. Rau (sale, London, Christie's, 7 April 1981, lot 147); (purchased by Albrecht Neuhaus, Würzburg); Woodner Collections (Dian and Andrea Woodner); given to NGA, 1991.

**EXHIBITIONS**
Berlin 1983, no. 61/8; Woodner, Cambridge 1985, no. 95; Vienna 1985, no. 27; Woodner, Munich and Vienna 1986, no. 56; Woodner, Madrid 1986–1987, no. 68; Woodner, London 1987, no. 58; Woodner, New York 1990, no. 70; Washington 1992, 13, 22, no. 9.

**LITERATURE**
Tietze and Tietze-Conrat 1928–1938, 2: pt. 1, p. 144, no. w24a; Dodgson 1929, 50–51; Winkler 1932, 86; Schilling 1934, no. 56; Winkler 1936–1939, 3: app. under pl. XII; Panofsky 1943, no. 1356; Musper 1952, 126, 128; Pilz 1962, 254; Strauss 1974, 2: under no. 1502/8; app. 2, no. 3; Davis 1981, 1326; sale cat., London, Christie's, 3 July 1990, under lot 143.

# 59 Left Wing of a Blue Roller

**c. 1580, watercolor and gouache on parchment, 189 x 239 (7 7/16 x 9 7/16)**

**Inscribed at lower right in pen and black ink: *15 AD* (in monogram) *24***

**Woodner Collections**

One of the most admired works by Albrecht Dürer is his painting on parchment of the wing of a European blue roller *(Coracias garrulus L.)* (fig. 1).[1] A coloristic and formal masterpiece of finely detailed painting, it was often copied and imitated for collectors who wanted to own versions of it.[2] One of the few artists who commanded the skill and precision required for such repetitions was Hans Hoffmann, who was active in Prague in the service of Emperor Rudolph II. It was Rudolph in fact who owned the famous *Wing* by the end of the sixteenth century, though Hoffmann may have been able to study it first in his native Nuremberg, where it had resided in the Imhoff collection. Two copies of the Albertina *Wing* have been attributed to Hoffmann (Musée Bonnat, Bayonne, and Staatsbibliothek, Bamberg) along with several further copies and imitations of other bird drawings by Dürer.[3]

The Woodner drawing, which was clearly inspired by the Albertina study, is by no means a copy after it, for the wing is seen from the upper side, is presented in a more closed position, and is placed more horizontally on the page. Nor does it simply present another view of the same wing, for the Woodner wing seems to have come from an older specimen, with a slightly darker coloration and more raggedness in the tips of the primary feathers.[4]

The authorship of the Woodner watercolor, which had virtually disappeared from view for more than a century until it was sold at auction in 1982 as "attributed to Dürer," quickly became the subject of ardent debate. That same year Walter Strauss described Dürer's authorship as "questionable," but in 1983 George Goldner and Konrad Oberhuber repeated the auction house's designation.[5] At the 1985 Dürer exhibition in Vienna, however, Fritz Koreny made a strong case for removing the drawing from Dürer's orbit altogether and giving it instead to Hans Hoffmann.[6] The controversy came to a head at a symposium sponsored by the Albertina at the time of the exhibition, when Oberhuber and Koreny presented their opposing points of view in front of the drawing itself and a host of interested scholars. In the end Koreny prevailed, but the attribution to Dürer was maintained in subsequent Woodner exhibitions.[7]

The attribution of the Woodner *Wing* to Hoffmann has now gained general acceptance for two compelling reasons. First, Hoffmann's style as a draftsman is now better known and understood, and his considerable talents as an imitator of Dürer well recognized. Second, the date and monogram are demonstrably in his hand.

Hoffmann had extraordinary opportunities to study significant numbers of Dürer drawings at first hand and had made copies of many of them. Although he incorporated much of what he had learned into his individual studies, he did allow small vestiges of his individual artistic personality to show in his drawings. For example, whereas each feather in Dürer's drawing is treated with about the same degree of clarity and detail, Hoffmann tended to vary his focus, carefully picking out the details of some feathers while leaving others more generalized, as in some of the bright blue and green-blue scapular feathers. Whereas Dürer enclosed each feather within a fluid, rather decorative contour line, Hoffmann preferred to leave the tips and edges of the feathers in his drawing more open. These and other differences in their artistic visions are perhaps seen most dramatically in the execution of the brown, red, and orange downy feathers massed at the point where the wing would normally join the bird's body — at the right in the Dürer and at the bottom in the Hoffmann. In Dürer's drawing the shapes of the individual feathers stand out prominently, as does the bold patterning of the white and black striations that give the feathers their texture. In Hoffmann's, on the other hand, these feathers are presented in a smooth, colorful mass — rather like skeins of wool twisted together — beautifully articulated with delicate touches of the pen and brush.

Further supporting the attribution to Hoffmann are the date and monogram inscribed at lower right. Though meant to indicate Dürer's authorship and written in a style and a hand that are close to Dürer's,

59

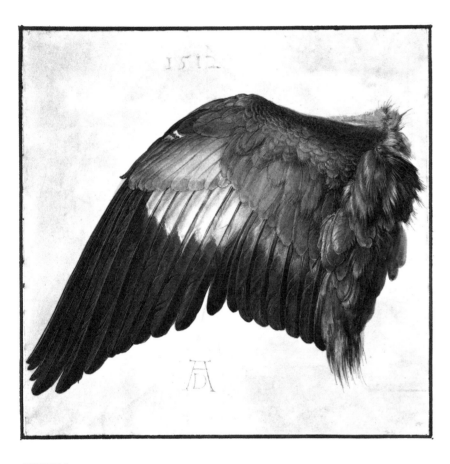

**FIGURE 1**

Albrecht Dürer, *Left Wing of a
Blue Roller*, Graphische Sammlung
Albertina, Vienna

they match quite precisely, number by number and letter by letter, inscriptions that are known to have been written by Hoffmann.[8] Indeed, the *1* and the *5* in the date on the Woodner sheet are virtually identical in shape to those numbers on the *Red Squirrel* (cat. 58), which is unequivocally by Hoffmann.

Among the several other known wing drawings by and after Dürer, no other corresponds exactly to the presentation of the Woodner *Wing*. Although it is possible that it was copied after a Dürer original that is now lost, it seems more likely, given the extraordinary quality of this drawing and the freshness of its conception, that Hoffmann was inspired by Dürer's example to make his own minute study from the actual wing of a bird. • *Fedja Anzelewsky and Margaret Morgan Grasselli* •

**NOTES**

1. Koschatzky and Strobl 1971, no. 33.
2. The most recent copy dates as late as the period around 1900; see exh. cat. Vienna 1985, no. 26.
3. See exh. cat. Vienna 1985, nos. 24, 25, for the Bayonne and Bamberg copies (a third is in the Dürerhaus, Nuremburg, and another was formerly in the Lanna collection, Prague); see also nos. 11, 12, 13 (with Hoffmann's own monogram), and 14, for other bird drawings by Hoffmann.
4. First noted in Strauss 1982, 6: app. 2, no. 7a, and expanded in Woodner exh. cat., London 1987, no. 49.
5. Strauss 1982, 6: app. 2, no. 7a; Goldner in Woodner exh. cat., Malibu 1983–1985, no. 42; Oberhuber 1983, 76–77.
6. In exh. cat. Vienna 1985, no. 25.
7. Koreny and Oberhuber 1986/1987, 17–21.
8. See Koreny and Oberhuber 1986/1987, 19–21, in which several dates and monograms by both Dürer and Hoffmann are reproduced.

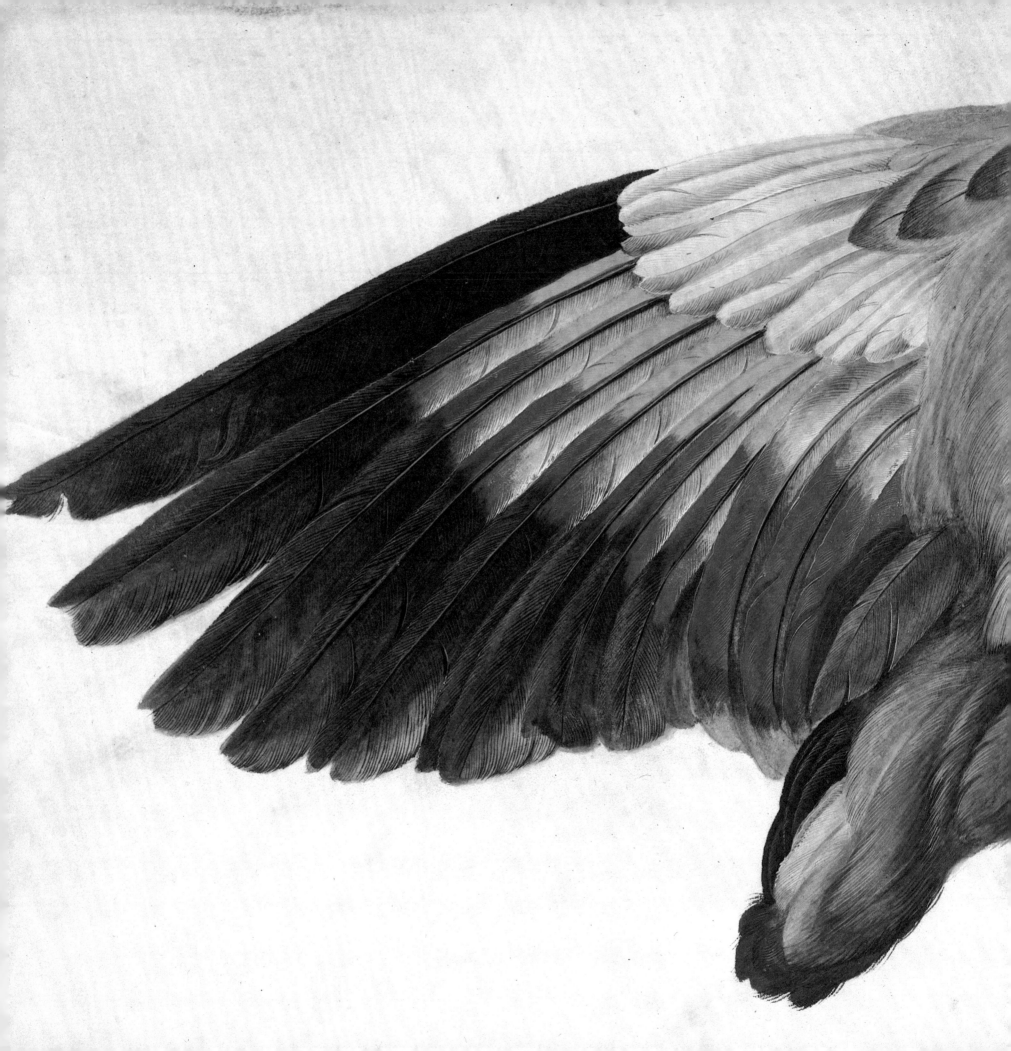

# 60  Portrait of a Lady (Madame de Pellegars?)

*The son of Pierre Quesnel, a French painter at the court of James V of Scotland, François Quesnel probably trained in his father's workshop. In 1572 he moved to France with his brother Nicolas (c. 1545–1632), also an artist, and worked as a portraitist and painter at the courts of Henri III and Henri IV. He is known mainly for his portrait drawings, which follow in the tradition established by Jean Clouet (c. 1485–c. 1541) and his son François (before 1522–1572), but which use a new technique of subtly blended colored chalks that more closely simulates the natural tones of skin and hair. Paintings attributed to him include portraits of important personages and scenes from the lives of both of the kings whom he served. In 1609 he executed a map of Paris that was engraved in twelve parts by Pierre Vallet. At least three of his fourteen children became artists.*

**c. 1590/1595, black and red chalks with stumping, heightened with white, on laid paper, 290 x 232 (11 7/16 x 9 1/8)**

**Inscribed on the verso at lower left in graphite: *ChMc***

**Watermark: Grapes (possible twin mold of Briquet 13196)**

**Woodner Collections**

This handsome likeness belongs to a well-defined tradition of portrait drawing in France, which began with Jean Clouet in the 1520s and only ended with the death of Daniel Dumoustier in 1646. The bust-length presentation of the sitter, turned slightly to her right, is typical of these portraits, as is the heightened focus on the face, with the costume only roughly sketched in. By Quesnel's time these likenesses had become highly refined yet utterly impersonal representations of the appearance of the sitters—"psychologically distancing," as Hilliard Goldfarb has described them.[1] Perhaps it was this masklike impassivity that appealed to Quesnel's patrons, most of whom must have learned through their lives as courtiers not to betray their innermost thoughts. More likely it was the simple elegance and beauty of his renderings, the subtle use of color and the porcelain smoothness of the skin that made Quesnel such a popular portraitist.

A tentative identification of the sitter in the Woodner drawing as Catherine-Charlotte de la Trémoille, princesse de Condé (1565–1629), was first made in 1909 in the catalogue of the sale of the collection of Charles Wickert and was taken up again when the drawing was exhibited in Toledo in 1941. That identification has been accepted in all subsequent publications. But other portraits that are supposed to represent the same sitter differ from this one in small but important respects,[2] most notably in the shape of the nose and in the overall proportions of the face. This raises real questions as to whether the lady depicted on the Woodner sheet is indeed the princesse de Condé.

In fact, the Woodner likeness more closely resembles a different woman, known through a portrait attributed to Quesnel's brother Nicolas in the Bibliothèque nationale, Paris.[3] The nose, the mouth, the shape of the face, and even the hairstyle are virtually identical—so close as to suggest that the drawings must have been made within a short time of each other. The sitter in the Bibliothèque nationale's drawing is identified by an old inscription as "Mad. Pellicart," which might be a misspelling of Pellegars, part of the name of a noble family from Normandy.[4] Even if that identification is accurate—and it should be noted that the vast majority of such inscriptions were added years after the drawings were made—nothing further is known about the lady. On the basis of hairstyle and costume, however, both drawings may be dated to c. 1590/1595.[5] • *Margaret Morgan Grasselli* •

**NOTES**

1. See exh. cat. Cleveland 1989–1990, no. 48.
2. See Adhémar 1973, nos. 112 (illustration wrongly numbered 111), 150, 231, 443. One other portrait drawing identified as that of the princesse de Condé, but bearing no inscription, is Adhémar 1973, no. 460.
3. Adhémar 1973, 154, no. 224.
4. In the sixteenth century names were often spelled differently from the way they are today, and many of the inscriptions identifying the sitters in old French portrait drawings use unusual, sometimes barely identifiable, spellings of the sitters' names. A note about the de Pellegars de Malortie family is included in Sereville and Saint Simon, 782.
5. Miriam Stewart, assistant curator at the Fogg Art Museum, noted that the costume was in vogue between 1585 and 1595 (cited in Woodner exh. cat., Malibu 1983–1985, no. 55, and exh. cat. Cleveland 1989–1990, no. 48). Dimier 1925, 2:244, 261, nos. 136 and 18, proposed dates of c. 1594 for the Woodner drawing and c. 1593 for the version in the Bibliothèque nationale.

**PROVENANCE**

Henri du Bouchet de Bournonville, Paris; his brother Jean-Jacques du Bouchet de Villeflix; Charles Wickert, Paris [d. 1918] (sale, Paris, Galerie Georges Petit, 3 May 1909, no. 43); Edward M. Hodgkins, Paris; (Duveen Brothers, New York, by 1941); (William H. Schab Gallery, New York); Woodner Collections (Shipley Corporation).

**EXHIBITIONS**

Toledo 1941, no. 3; Woodner, New York 1971–1972, no. 55; Woodner, Malibu 1983–1985, no. 55; Woodner, Munich 1986, no. x; Woodner, Madrid 1986–1987, no. 87; Cleveland 1989–1990, no. 48.

**LITERATURE**

Firmin-Didot 1875–1877, 1: no. 982; Delteil 1909, 4, 40, no. 43; Moreau-Nelaton 1924, 2: 99, and 3: 152–153; Dimier 1925, 2: no. 1006; Woodner exh. cat., New York 1973–1974, under "Additions and Corrections to Woodner Collection I," no. 55.

60

# 61 Head of a Bearded Man

*A painter, engraver, and prolific draftsman, Barocci was influenced by Battista Franco (probably 1498–1561) and Bartolomeo Genga (1516–1558). He worked in Urbino, Rome, Perugia, and Genoa, and his models were Raphael (q.v.), the Venetians, and above all Correggio (q.v.). The most important work of his early period is the* Madonna del Popolo *of 1579 in the Uffizi in Florence, in which the figures are almost baroque in pose and there is a great sense of movement. The new pathos of the Counter-Reformation can also be seen in his* Martyrdom of San Vitale *of 1583 in the Brera, Milan. Barocci's work exerted a considerable influence on artists such as the Carracci and Rubens.*

**1579/1582, red, black, white, and ocher chalks on blue laid paper, laid down, 380 x 263 (14 15/16 x 10 3/8)**

**National Gallery of Art, Woodner Collection 1991.182.16**

This sketch of the head of a bearded man is among more than thirty drawings, cartoons, and *bozzetti* for one of Federico Barocci's most complicated and successful compositions, the *Entombment of Christ*, commissioned in 1579 by the Confraternità della Croce e Sagramento for the church of Santa Croce in Senigallia. The painting was to be completed in two years but was finally delivered in May 1582.[1] Bellori's description of Barocci's painstaking preparatory process[2] makes clear the role played by the Woodner drawing in his progress toward completing the altarpiece.

According to Bellori, Barocci began his working process by drawing from life, arranging studio models in natural poses and sketching them. After working out the poses, and after preliminary sketches of the composition, he would make the finished compositional drawing, create figures in clay and wax, and dress the models in drapery to appear natural. After this he would execute the small cartoon (or *modello*) in oil or grisaille and afterward a full-scale pen or charcoal cartoon. Following this the artist would make another small cartoon to balance the colors and tones. While Barocci was painting, he also made colored chalk drawings and oil sketches of individual heads, sometimes incising them on the canvas. It is this stage in the process to which the Woodner drawing belongs.

Barocci worked out the composition for the *Entombment* in several sketches now in Berlin, Florence, and Chicago. From these it is evident that he took Raphael's famous *Entombment* (1507, Villa Borghese, Rome) as his departure.[3] In other sheets in Berlin, Rotterdam, Florence, Amsterdam, and Princeton, the artist studied various positions of figures, arms, hands, feet, and legs. Chiaroscuro drawings in the Rijksmuseum, Amsterdam, and the Getty Museum, Malibu, and a *bozzetto* in Urbino represent the final composition and enabled Barocci to study the tone and color for the painting.[4] Another pen *modello* in the Art Institute of Chicago, not accepted by all scholars, may have preceded the Getty sheet in the creative process.[5] Finally, during the painting of the altarpiece, Barocci made "auxiliary" cartoons to recheck the color and tonal values of the individual heads. The five extant auxiliary heads for the *Entombment* are rendered in colored chalks (Lugt Collection, Institut néerlandais, Paris; and the Woodner drawing) or oil on paper (Metropolitan Museum, New York; National Gallery of Art, Washington; and formerly Jacques Petithory, Paris).[6] The oil *bozzetto* in the National Gallery is a study for Saint John, at the left, who helps lower Christ's legs into the tomb. The Lugt drawing relates to Nicodemus, the turbaned figure whose arms support Christ's body. The *bozzetto* in Paris refines the head and torso of Mary Magdalene, while the Metropolitan oil *bozzetto* and the Woodner drawing analyze the color and light of the bearded man supporting Christ's shoulders.

Differences between the two studies for the bearded man suggest that the Woodner sheet preceded the Metropolitan oil: the red beard and strong features in the drawing suggest a studio model. These were altered somewhat in the oil sketch, which is closer to the finished painting. Apparently, Barocci found this figure difficult to realize and thus needed to study it fully in both colored chalk and paint. • *Diane De Grazia* •

**NOTES**

1. On the commission and execution of the painting for Senigallia see Vecchioni 1926, 497–503 (publishing documents concerning the painting); Olsen 1962, 169–172; and Emiliani 1985, 150–167. See also exh. cat. Cleveland 1978, 63–67; and De Grazia 1985, 31–41. The picture was so popular that copyists almost ruined it by polishing the surface and making incisions (Bellori 1672, 179). Barocci restored and revised the painting between 1606 and 1608 (see Emiliani 1985, 159).
2. Bellori 1672, 194–195 (English translation in exh. cat. Cleveland 1978, 23–24).
3. Barocci saw the *Entombment* in 1569 when he was working on the *Deposition* for the Cathedral in Perugia. Raphael's painting was then in the church of San Francesco, Perugia.
4. For reproductions of the drawings mentioned in this paragraph see Emiliani 1985 and Goldman 1988, 249–252, pl. 13.
5. See exh. cat. Cleveland 1978, 63, cat. 40; and De Grazia 1985, 36.
6. Repro. in Emiliani 1985, figs. 314, 316; Pillsbury, 1978, 171, pl 1; and De Grazia 1985, 37.

**PROVENANCE**

**EXHIBITIONS**

61

# 62  Presentation of the Virgin in the Temple

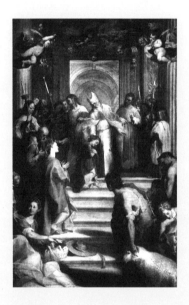

**FIGURE 1**

Federico Barocci, *Presentation of the Virgin in the Temple,* Santa Maria in Vallicella, Rome

**c. 1593/1603, oil over graphite, heightened with white, on laid paper, laid down, 398 x 339 (15 ¹¹/₁₆ x 13 ³/₈)**

Inscribed at lower right in pen and brown ink: *Ba*...

**Woodner Collections**

This chiaroscuro drawing is related to Barocci's *Presentation of the Virgin in the Temple* (fig. 1), a painting commissioned by the Oratorio di San Filippo Neri, Rome, begun in 1593 and completed by 1603.[1] The painting was placed on the altar that year "with incredible applause and satisfaction not only by us [the congregation of the Oratorio] but by all Rome."[2] At least thirty-two chalk sketches exist for this famous composition, but no cartoon or possible *modello* had been known before the discovery of the present sheet. A work in grisaille such as this would have been made to study the fall of light after the artist had completed numerous studies of individual figures and finalized the composition in a cartoon.[3]

Edmund Pillsbury has explained that Barocci left several of his grisaille *modelli* unfinished in order to study those figures more closely in "auxiliary" drawings in colored chalks or oil.[4] A prime example is the chiaroscuro study for the *Entombment* in the Getty Museum, Malibu, with the torso of Mary Magdalene sketched in ink. A corresponding oil study of the bust and head of this figure (English private collection) supplements the *modello*.[5]

In the *Presentation* drawing most of

the lower half of the composition has been left unfinished, with barely visible light black chalk sketches to indicate the remaining figures. Pillsbury believed that the bending shepherd at far right, who looks down in the painting, was looking toward the high priest in the sketched portion of the Woodner drawing, suggesting that Barocci wished to refine this area. But it is almost impossible now to decipher this figure in the drawing, and no other preparatory sketches for him exist.

The grisaille portions of the Woodner sheet, it must be noted, do not correspond stylistically with accepted chiaroscuro *modelli* by Barocci, such as the Getty *Entombment*. In fact, the exact correspondences between the drawing and the completed painting are suspicious, and the harsh drapery folds and mechanical application of the white heightening differ markedly from Barocci's autograph sheets. The present work was possibly executed after Barocci's painting in the Oratorio di San Filippo Neri. It may be the same sheet mentioned in a letter of 1673 to Leopoldo de' Medici as Barocci's "Cartone grande della Presentazione della Madonna" in the collection of Giovanni Lavalas, a collector from Urbino.[6] • *Diane De Grazia* •

**NOTES**
1. For the history of the commission see Emiliani 1985, 2:346–359.
2. Letter from the congregation of the Oratorio to the bishop of Todi, quoted in Italian in Emiliani 1985, 347.
3. See cat. 61 for bibliography on the artist's working methods.
4. Exh. cat. Cleveland 1978.

5. See previous entry (cat. 61), and exh. cat. Cleveland 1978, 64, under no. 41.
6. Exh. cat. Cleveland 1978, 89, under no. 67.

**PROVENANCE**

Possibly Giorgio Lavalas, Urbino; unidentified collector (mark similar to Lugt 2883); (William H. Schab Gallery, New York); Woodner Collections (Shipley Corporation).

**EXHIBITIONS**

New York 1974, no. 1b (here and subsequently as Barocci); Cleveland 1978, no. 67; Woodner, Malibu 1983–1985, no. 24; Woodner, Munich 1986, no. 6; Woodner, Madrid 1986–1987, no. 35; Woodner, London 1987, no. 25; Woodner, New York 1990, no. 33.

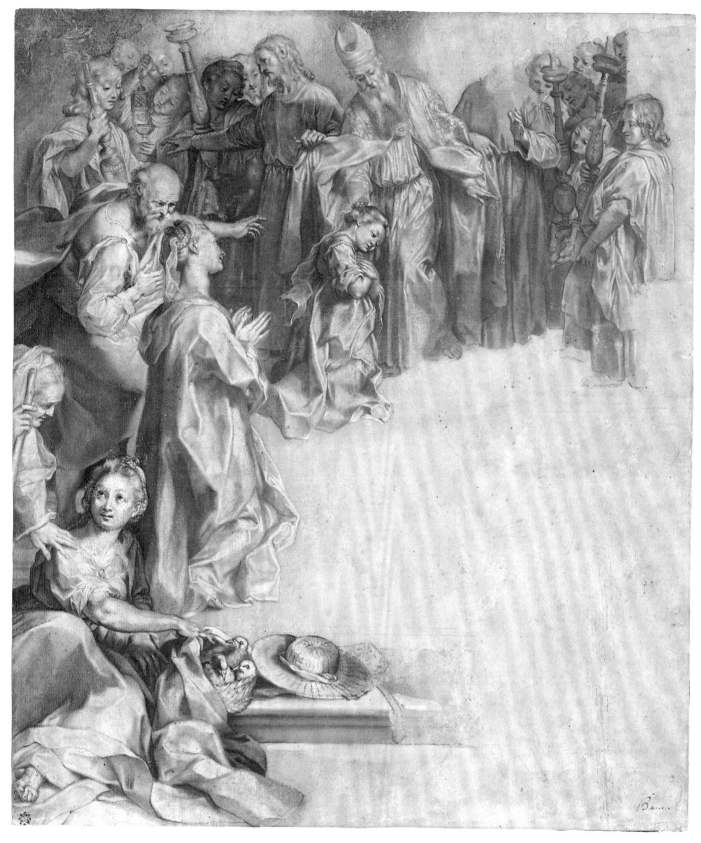

62

# 63  Acis and Galatea

*Having moved early to Utrecht from his native Gorinchem, Abraham Bloemaert was taught first by his father, who was an architect, sculptor, and engineer, and then by a series of ineffective masters, including Joos de Beer (d. before 1595). He received part of his training with three more teachers in Paris, having traveled there when he was about sixteen. He lived in Amsterdam from 1591 to 1593, the period during which his early, best-known works were executed. During those years and on into the next century, Bloemaert worked in the mannerist style of Bartholomeus Spranger (1546–1611), Hendrik Goltzius (1558–1617), and the Haarlem School. In 1593 he settled in Utrecht, where he remained until his death nearly sixty years later. His surviving oeuvre includes about 1,500 drawings, many of which were engraved.*

**1590/1592, pen and brown ink with brown wash and traces of white heightening over black chalk on laid paper, 312 x 301 (12 5/16 x 11 7/8)**

**Inscribed on verso at center in graphite: *Gernt Pieters / cf. Pieters / 130788***

**Watermark: Fleur-de-lis with initials IS in circle with number 4 and initials WR below (cf. Briquet 7124)**

**Woodner Collections**

The story of Acis and Galatea as depicted here is told most amply by Ovid in book 13 of his *Metamorphoses*. Galatea, the daughter of Nereus and Doris, was loved by the youthful Acis, the son of Faunus, god of the forests. She was also loved, however, by Polyphemus, the wild, one-eyed giant Cyclops, who pursued her relentlessly. She gave her heart to the beautiful Acis and hated the ferocious Polyphemus, who was envious of his more successful rival. When Polyphemus spotted Acis and Galatea making love in a cave, Galatea dived into the nearby sea and Polyphemus chased Acis, breaking a piece off the mountainside and hurling it after the fleeing youth. The pieces of rock thrown by the Cyclops buried Acis, and the only way Galatea could help her lover was to cause Acis to assume his latent powers: his blood, trickling from beneath the mass of rock, changed into a clear river, and Acis himself, larger than life and blue as the ocean, stood waist-deep in the water as a river god.

Bloemaert depicted many scenes from the *Metamorphoses*, most of them at the beginning of his career in the last decade of the sixteenth century. During the second half of that century, many illustrated books of Ovid's popular stories had been published,[1] and in 1589–1590 the first two installments appeared of what was meant to be a large print series designed by Hendrik Goltzius with episodes from the *Metamorphoses*.[2] Bloemaert's treatment of these themes usually concentrates on formal problems rather than iconological profundity. In the case of this drawing, no particular attention seems to have been paid to learned interpretations of the story.[3]

In some of the illustrated editions of Ovid's *Metamorphoses* the story of Acis and Galatea was told in two plates;[4] in other editions the two scenes were combined into one, as in Bloemaert's drawing. Bloemaert more or less followed the narrative arrangement used in Jacques de Gheyn's engraving after Cornelis Cornelisz van Haarlem (fig. 1).[5] Acis and Galatea are depicted in this print as a pair of lovers in a cave, with Polyphemus in the distance sitting on the slope of Mount Etna and playing the reed pipe. In the Woodner drawing, too, Acis and Galatea embrace in the foreground, but here Galatea points to the sequel of the story in the background, where Polyphemus stands on a rocky promontory and hurls a rock after the fleeing Acis. Bloemaert thus telescopes the scene in time as well as space.

Formally, Bloemaert created his own cave and landscape. The invention of the embracing figures of Acis and Galatea may have been inspired by the two figures in Goltzius' engraving of 1582, *Honor and Opulence* (fig. 2), the third of a set of four allegorical prints of *The Ways and Means to Fortune*.[6] Such groups of intertwined lovers do not necessarily need to be of Sprangerian origin, however; witness the similarities in the Woodner drawing to Virgil Solis' woodcut of *Mars and Venus* in a 1563 volume of plates illustrating Ovid's *Metamorphoses*, though the positions of the male and female figures have been interchanged.[7]

Another element in the genesis of Bloemaert's invention of the figure of Acis may have been his formal experiments with a seated male nude, seen from the back at an oblique angle; one can find traces of these experiments in an early study in Leiden (University Print Room, inv. PK 6816); in a study with many figures of c. 1590 in London (British Museum, inv. 1946.7.13.1065, as Wtewael) and in a roundel with the *Adoration of the Shepherds* in Weimar (Kupferstichkabinett, Schlossmuseum, inv. KK 4480).
• *Jaap Bolten* •

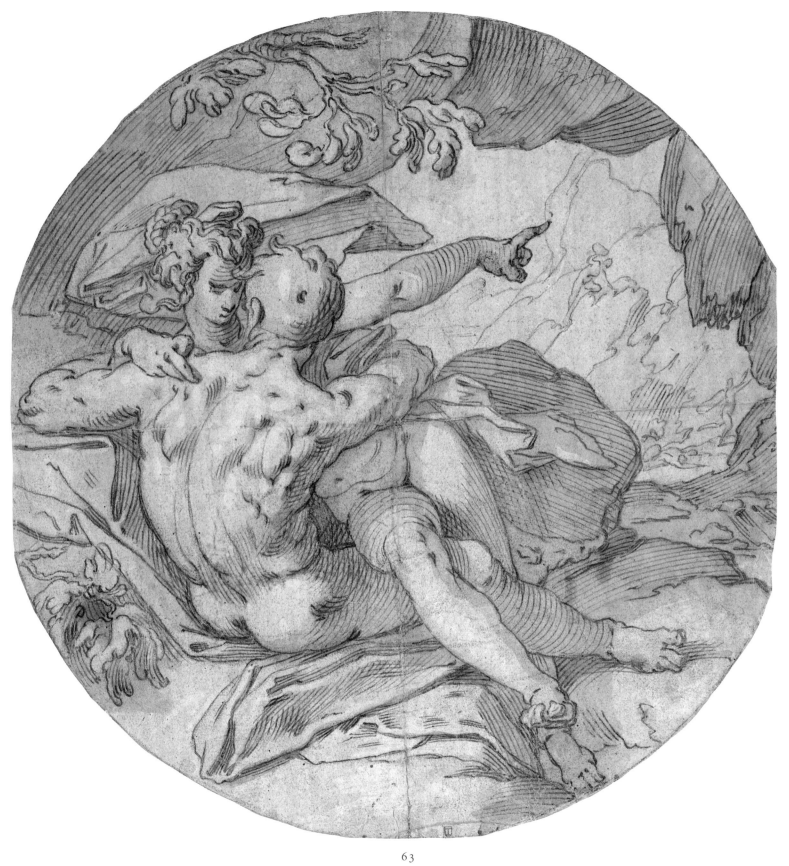

63

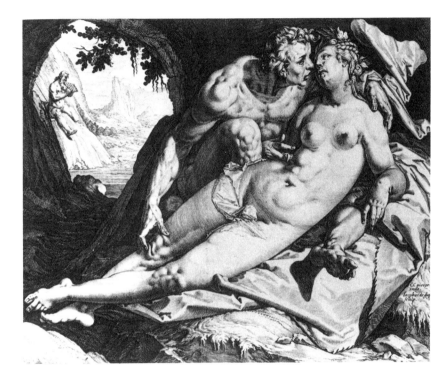

**FIGURE 2**

Hendrik Goltzius, *Honor and Opulence,* The Metropolitan Museum of Art, New York, Harris Brisbane Dick Fund

**FIGURE 1**

Jacques de Gheyn, *Acis and Galatea with Polyphemus,* after Cornelis Cornelisz van Haarlem, Rijksprenten-kabinett, Amsterdam

**NOTES**

1. The first of these was Bernard Salomon's, published in Lyons in 1557. Virgil Solis' woodcuts of 1563 were more influential in the Netherlands. Various Netherlandish copies after these two artists are described in exh. cat. 's-Gravenhage 1980, 25–27. One of these was published in Amsterdam in 1588, three years before Bloemaert's stay in that city.

2. This ambitious project was never finished. Forty prints were published in 1589 and 1590; twelve more plates, probably begun in 1590 in Goltzius' workshop, were finally published by Robert de Baudous in 1615. See Filedt Kok 1993, 159–218, nos. 65, 79, P.6. The story of Acis and Galatea was not represented among the published engravings but would presumably have had a place in the unfinished part.

3. At the time not many explanations were connected with the myth. Ripa 1644, 552, mentioned Ovid's story when discussing Acis but did not give it any special significance. Van Mander 1604, folio 109a, concentrated

on the self-destructiveness resulting from Polyphemus' coarse, sinful behavior.

4. For instance, in Plantijn's 1591 edition, illustrated with 178 etchings by Pieter van der Borcht after Salomon and Solis, two plates are devoted to the story. Two plates also told the story in Antonio Tempesta's set of 150 *Metamorphoses* illustrations (Bartsch 765, 766).

5. Hollstein 5:1, no. 3, and 7:176, no. 347 (repro.). Filedt Kok 1990, pt. 1, pp. 248–281; and pt. 2, pp. 370–396, no. 347 (repro.), as c. 1589.

6. Strauss 1977, 1:256–257, nos. 150–153.

7. Published in Posthius 1563, 49.

**PROVENANCE**

Dr. Matthias Konrad Hubrecht Rech, Bonn [1879–1946] (Lugt 2745b); private collection (sale, London, Sotheby's, 27 June 1974, lot 169); Woodner Collections (Shipley Corporation).

**EXHIBITIONS**

Woodner, Malibu 1983–1985, no. 48; Woodner, Munich and Vienna 1986, no. 58; Woodner, Madrid 1986–1987, no. 70.

SEVENTEENTH CENTURY

# 64  Mountainous Landscape with Castles and Waterfalls

*The Savery family left Flanders in the early 1580s, presumably for religious reasons. Jacob Savery (c. 1565–1603), surely accompanied by his younger brother and pupil Roelandt, was settled in Amsterdam by 1591. After Jacob's death in 1603, Roelandt traveled to Prague, where he entered the service of the Emperor Rudolf II. In 1613, after Rudolf's death and the accession of his brother Mathias as emperor, the artist returned to Amsterdam, though maintaining connections with Mathias' court in Vienna. In 1618 Roelandt settled in Utrecht, becoming a member of the Guild of Saint Luke in 1619, and he remained in that city until his death. Savery's extant drawings are datable to the years around 1603–1618. The majority were made in Prague and depict Bohemian peasants and Jews, animals, and landscape views of Prague and the Alps.*

**c. 1606, black, ocher, red, and blue chalks, with traces of white heightening on gray-green laid paper, 355 x 494 (14 x 19 7/16)**

**Watermark: Unidentified initials in circle**

**Woodner Collections**

Savery's mountain landscape drawings are datable to c. 1603–1609,[1] a very limited period in which his mastery of this genre developed quickly, paralleled by that in his peasant, or so-called *naer het leven* (from life), studies. His earliest pen and ink mountain landscape drawings, which are fantasies and romantic views of the valleys of Bohemia, were inspired by the work of his older brother, Jacob Savery, and indirectly by Pieter Bruegel the Elder. His greatest colored chalk studies, executed in 1606 and 1607, depict high mountain, essentially Alpine, subjects and range from the present work—a tentative experiment in chalk perhaps inspired by the pen and ink *Valley in Bohemia* of 1606—to such magnificent landscapes as the *Falls on the Rhine at Schaffhausen,* both in the Atlas van der Hem.[2] The mountainous chalk landscapes that Savery made back in Prague in late 1607 and 1608 as models for engravings are compositionally more intimate, tame, and consciously picturesque.[3]

According to Joachim von Sandrart in his *Teutsche Academie* (1675), Savery went into the Alps to search for and draw "wonders" of nature to use in paintings for the emperor's Kunst- und Wunderkammer.

His extant drawings record waterfalls, anthropomorphic rocks, and a rainbow.

Savery used combinations of black and colored chalks throughout his Alpine drawings of 1606–1607. At least some passages of the present drawing, such as the broken tree in the foreground, were first sketched in pen and brown ink. Savery then applied red chalk in solution to lend substance to broad areas; introduced ocher where sunlight, emanating from the sky at the left, hits the rocks; used traces of white for accents; and added blue in the rushing water and on roofs of the buildings.

As in so many of his landscapes, the artist's vantage point is included here: a path in the lower right leading into the composition. An otherwise unexplained blank spot in the drawing a little way up the path appears to encompass the faint remains of a sketch of a figure walking away. There are no other figures in the drawing.

Clustered around the four waterfalls issuing from the crest of the mountain are fortifications, the ruins of an aqueduct(?), and a glimpse of a town at the upper right. This combination of structures prompts a comparison with slightly earlier views of the famous falls and ruins at Tivoli outside Rome by Jan Bruegel and Paulus van Vianen, both active in Prague in 1604 and 1603–1613, respectively. The Alpine waterfall was not previously a subject in European art, and allusions to famous motifs (not repeated in other extant Savery drawings) were probably intended to give credibility to the new subject.

These inclusions as well as the general insecurity of the composition and the handling of the chalk point to this as one of Savery's first chalk studies of the Alps and very possibly the first in which he grappled with the excitement of the waterfall as the controlling motif. Goldner's suggestion that this drawing was made later, after Savery's travels in the Alps,[4] does not take into adequate consideration the course of the artist's stylistic development. • *Joaneath Spicer* •

**NOTES**

1. See Spicer Durham 1979, chap. 2.
2. Kartensammlung, Nationalbibliothek, Vienna. For *Valley in Bohemia,* see Spicer Durham 1979, no. 16. The site is identified in the engraving by J. Matham. For the *Falls on the Rhine,* see Spicer Durham 1979, no. 30; and Spicer in exh. cat. Essen 1988–1989, no. 246. The site was identified by the author.
3. See for example, *Mountain Valley in the Tirol,* Nationalmuseum, Stockholm, inv. 3246/1863; Bernt 1980, 5: no. 529.
4. Woodner exh. cats. since 1983.

**PROVENANCE**

Friedrich Quiring, Eberswalde, Germany [b. 1886] (Lugt 1041b); Herbert List; (Hans M. Calmann, London); Woodner Collections (Shipley Corporation).

**EXHIBITIONS**

Hamburg 1965, no. 120; Woodner, New York 1973–1974, no. 80; Los Angeles 1976, no. 215; Princeton 1982–1983, no. 61; Woodner, Malibu 1983–1985, no. 49; Woodner, Munich and Vienna 1986, no. 70; Woodner, Madrid 1986–1987, no. 83; Woodner, London 1987, no. 70; Woodner, New York 1990, no. 86.

**LITERATURE**

Spicer Durham 1979, 64–65, 414, no. 18; Kaufmann 1985, 101.

64

# 65  The Mystic Marriage of Saint Catherine

**c. 1618/1620, pen and brown ink with brown and
gray washes over black chalk on laid paper,
182 x 281 (7 ³/₁₆ x 11 ¹/₁₆)**

**Inscribed by a 17th-century hand with pen and brown
ink at lower center: *NL* or *M*; by Van Dyck(?) on the
verso three times: *Come*; annotated by another
hand(s) in French: *pour la somme de deux ce[nt?]
soixante douze mille / pistolles pour laquelle
somme* [cut off]; and *Dieu donne* with repeated *Ds***

**National Gallery of Art, Woodner Collection
1993.51.7**

This is one of several compositional studies
that the young Anthony van Dyck made in
preparation for his *Mystic Marriage of Saint
Catherine* (fig. 1), one of his most "Venetian"
paintings from the first Antwerp period,
variously dated from c. 1616 to 1621.[1] The
three-quarter-length figures, arranged in a
horizontal format, seem to have been in-
spired by Titian's *Madonna and Child with
Saints Stephen, Jerome, and Maurice* (Louvre,
Paris) of about 1520, as Michael Jaffé was
the first to point out.[2] Jaffé also noted that a
variant of the Louvre painting is found in
the so-called Van Dyck Sketchbook at Chats-
worth.[3] The pose of Saint Catherine here,
standing and facing the Virgin, seems to de-
rive from another painting by Titian and
his workshop, *The Madonna and Child with
Saints John the Baptist, Mary Magdalene,
Paul, and Jerome* (Gemäldegalerie, Dres-
den).[4] Van Dyck's familiarity with paintings
by Titian and his workshop supposes that
such works were to be found in Antwerp

collections at the beginning of the seven-
teenth century.

The Woodner drawing is a more elabo-
rate and somewhat expanded version of a
slightly smaller study in the Pierpont Mor-
gan Library, New York (fig. 2). Van Dyck
began it first in black chalk, then revised it
with pen and brown ink, the point of the
brush, and brown and gray wash. The most
noticeable change is the bearded old man
holding a book at the right, who recalls
Saint Jerome in Titian's *Madonna and Child
with Saints* in the Louvre. Van Dyck also
somewhat reduced in size the head of the
youth with curls (possibly a soldier-saint)
who holds a banner and stands between
the Virgin and Saint Catherine. And at the
saint's right, by sketching in pen the head of
a woman with her eyes lowered, he covered
over a figure in black chalk that held a crosier.
In two fragments of an *Infant Jesus and Saint
Catherine,* drawn exclusively in pen, he fur-
ther developed the main protagonists in the
*Mystic Marriage of Saint Catherine.*[5]

According to Horst Vey, the Woodner
study marks a hiatus in the series that
began with the version of the *Mystic Mar-
riage* in the Lugt Collection, Paris, where
the Virgin is seated in the center facing the
viewer, and continued with a drawing
formerly in Bremen, where the Virgin and
Child are arranged more in accordance
with Van Dyck's study in New York (Pier-
pont Morgan Library).[6] Van Dyck sketched
predominantly with pen on the Morgan
sheet and followed it up with this more
carefully worked study on the Woodner

sheet. Despite the apparent completeness of
the present drawing, Van Dyck continued
to revise the composition. It was developed
further in another study (last seen on the
Berlin art market in 1908), where an angel
carrying the martyr's palm is added next to
the Virgin.[7] Even closer to the final compo-
sition is an abbreviated sketch on the verso
of a sheet in London (Courtauld Institute
Galleries), where the poses of the three
main protagonists are almost identical to
those in the Prado painting.[8]

In contrast to these compositional
drawings, the number of figures in the paint-
ing is greatly reduced and attention is con-
centrated on the Virgin, the Christ Child, and
Saint Catherine, with the Child sliding a ring
on a finger of Catherine's extended right
hand. A large sword hangs from the saint's
waist, alluding to her martyrdom by decapi-
tation. The angel holding the martyr's palm
remains in the background at the left, but
Saint Joseph is replaced by a heavy column,
a detail that Van Dyck summarily indicated
in the Morgan Library drawing. The group
at the right is reduced to the two monks,
who observe the event intently.

The letters or monogram inscribed in a
seventeenth-century hand at the bottom of
the Woodner drawing have proven difficult
to decipher. They were first read as *A.V.D.*
and thus as an original monogram by An-
thony van Dyck. More recently they have
been interpreted as *NL* or *M; NL* has become
the preferred reading.[9] The inscription's
purpose and meaning remain unexplained,
though it may be a collector's mark.

65

**FIGURE 1**

Sir Anthony van Dyck, *The Mystic Marriage of Saint Catherine,* Museo del Prado, Madrid

Vertical folds in the paper indicate that at one point the drawing probably was mailed as a letter. It must have been highly valued since the well-known collector Pierre-Jean Mariette (1694–1774) owned a copy after it that he considered to be an original by Van Dyck, a "savante composition…, pleine de feu & d'expression"; Mariette also published a print after it.[10]

• *Anne-Marie Logan* •

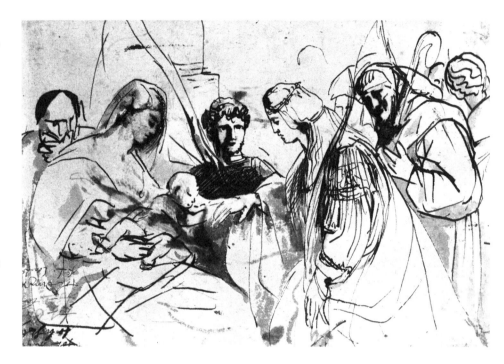

**FIGURE 2**

Sir Anthony van Dyck, *The Mystic Marriage of Saint Catherine,* The Pierpont Morgan Library, New York

**NOTES**

1. Glück 1931, 60; Larsen 1988, 2:94, no. 216 (c. 1616–1618); Nora de Poorter in Balis et al. 1989, 200–201 (c. 1620; repro. in color); exh. cat. New York 1991, no. 18 (c. 1618–1621).

2. Repro. of Titian painting in Wethey 1969, nos. 72, 73, pls. 15, 16 (Titian and Workshop), listing several variants and copies.

3. Jaffé 1966, 1: fol. 63v and 2:242. For the latest discussion on the sketchbook see Brown in exh. cat. New York 1991, no. 1 (Van Dyck, c. 1615–1617) and Müller Hofstede 1994, 49–60 (attributed to a young Flemish artist, c. 1636–1639).

4. Repro. in Wethey 1969, 1: no. 67, pl. 14 (c. 1520); see also *Gemäldegalerie Dresden* 1992, no. 168 (c. 1516).

5. Collection of Michael Jaffé; published as copies in Vey 1962, 1: no. 58 but reinstated as originals in Müller Hofstede 1973, 156, no. 3, pl. 20, and linked to the Woodner drawing as well as to a sheet last recorded on the Berlin art market (see note 7, below).

6. See *Bremen Dokumentation* 1992, 224, no. 1227 (repro.), inv. 1189; and Vey 1962, 1: nos. 44, 52–59, and 2: figs. 60, 70, 72–80. The *Mystic Marriage of Saint Catherine* drawing in Berlin (Kupferstichkabinett, inv. 1338), which recent writers have considered an early compositional study for the Prado painting (see exh. cat. Princeton 1979, 85; McNairn in exh. cat. Ottawa 1980, 71, under no. 23; and Brown in exh. cat. New York 1991, 91), must derive from another work of art, as Vey convincingly pointed out (no. 59): the figures end too evenly and abruptly at the bottom (earmarks of a copy), the composition "floats" on the sheet, the work is uncharacteristically free of pentimenti, and Van Dyck did not usually redraw a figure in the margin.

7. Exh. cat. New York 1991, 93, fig. 6; and Vey 1962, 1: no. 56.

8. Vey 1962, 1: no. 44. Following a practice favored by Rubens, Van Dyck made a specific study in black chalk of the Virgin alone and several sketches of a child, to be incorporated into the rendering of the Christ Child, as a last preparation of the painting. Exh. cat. New York 1991, no. 14 verso (repro. in color); Vey 1962, 1: no. 57 recto, fig. 60.

9. See Delacre 1934, 125, and d'Hulst and Vey in exh. cat. Antwerp 1960, no. 29.

10. Basan 1775, 140, no. 910; also Lugt 1949, under no. 605, pl. LXI (copy after the drawing at Chatsworth); Hollstein 6:120, no. 467 (Mariette exc.).

**PROVENANCE**

Nicolaes Anthoni Flinck, Rotterdam [1646–1723] (Lugt 959); William Cavendish, 2nd Duke of Devonshire [1672–1729]; by descent at Devonshire House and Chatsworth (inv. 989) (sale London, Christie's, 6 July 1987, lot 12, repro. in color); Woodner Collections (The Ian Woodner Family Collection, Inc.); given to NGA, 1993.

**EXHIBITIONS**

London 1938, no. 582; Rotterdam 1948–1949, no. 81; Paris 1949, no. 120, pl. XXVII; Genoa 1955, no. 105; Nottingham 1957, no. 33; Antwerp 1960, no. 29; Nottingham 1960, no. 44; Washington 1969–1970, no. 81; London 1973, no. 81; Tokyo 1975, no. 76; Princeton 1979, no. 20; Richmond 1979–1980, no. 82; Woodner, London 1987 (*hors catalogue*); Woodner, New York 1990, no. 88; New York 1991, no. 18; Woodner, Washington 1993–1994.

**LITERATURE**

Vasari Society 3: no. 16; Pauli 1908, 84; Haberditzl 1909, 66; Oppé 1931, 72; Glück 1931, 525, under s. 60; Delacre 1934, 125–126, fig. 66; Lugt 1949, 1:56, under no. 605; Vey 1958, 83–84, 89–91; Vey 1962, 1:123–124, no. 55, and 2: pl. 75; Müller Hofstede 1973, 156, under no. 3; Tarnove 1976, repro. (unpaginated); exh. cat. Ottawa 1980, 72, under no. 23; Larsen 1988, 2:94, under no. 216.

# 66 Two Studies for the Head of Christ

*Initially a student of the Flemish artist Denys Calvaert (1540– 1619), Guido Reni migrated c. 1595 to the more stimulating atmosphere of the Carracci academy where drawing after nature was the imperative. He transferred to Rome at the turn of the century, and during the Borghese pontificate he became the foremost fresco painter in that city in the wake of Annibale Carracci (1560–1609). Abandoning this role for one in which he enjoyed greater independence, Reni returned to his native soil c. 1614 and painted primarily in oil. For nearly thirty years he dominated the artistic scene in Bologna and the Emilian province. Reni is distinguished from his contemporaries by his exceptional sense of color and his loose handling of paint; yet drawing remained an essential practice for him.*

**c. 1623, black, red, and white chalks on gray-green laid paper, 379 x 280 (14 15/16 x 11)**

**Numbered on the verso at upper left in red chalk: 7; and inscribed at lower center in graphite: S + L / 75 (encircled)**

**Woodner Collections**

When this drawing came to light little more than twenty years ago, its association with Guido Reni's famous painting *The Baptism of Christ* (fig. 1) was already known.[1] According to Carlo Cesare Malvasia, Reni's biographer, that work had been ordered by the Flemish silversmith Giovanni Jacobs (1580– 1650), a longtime resident of Bologna and founder of his nation's college in the famous university city.[2] It can be assumed that the painting, sent north in 1623, was finished shortly beforehand and that Jacobs was acting on behalf of a third party, as it is unlikely that he would have been able to afford a picture of such importance. Since it was recorded in the sale of the duke of Buckingham's collection in Antwerp in 1648, the painting was presumably acquired before Buckingham was assassinated in 1628.[3] Jacobs may have met Reni through his compatriot, the painter Denys Calvaert, who was Reni's first teacher, although Calvaert had died before the *Baptism* was completed.[4]

Traditionally the *Baptism* has been seen as a transition between the artist's early, fully developed style and his late manner, distinguished by a move away from sculptural, strongly colored figures to less plastic ones that blend into a chromatic symphony of softer colors. While it is now recognized that the characteristics of the artist's mature style had made an appearance in paintings of an even earlier date, they are entirely appropriate to the spirit of grave dignity required in a scene of the Baptism, and they contribute to the mood of languid melancholy so typical of the artist.

This shift in emphasis is also evident in Reni's drawings. Trained in the Carracci academy, Reni's graphic style was nevertheless more delicate and less sculptural than that of his masters. He employed chalk vigorously, yet he described form through patterns of parallel hatchings rather than by the Carracci method of strong unbroken outlines and passages of smoothly built up chalk contrasting with untouched paper. Initially Reni used a single color of chalk, either black with a touch of white highlighting or red chalk alone. Following his return from Rome, when he dedicated himself to painting in oil rather than fresco, Reni became increasingly concerned with brush strokes and surface texture. This concern was likewise reflected in his drawings, where the hatchings became bolder and more emphatic or looser and more delicate, depending on the need they served; and they involved a greater use of color. From then on Reni showed a preference for black chalk, adding red chalk to develop the internal form and white chalk for highlights.

By the early 1620s virtually all of Reni's head studies (of which a considerable number from the period survive) combined three colors of chalk as they are used here. The artist had carefully worked out the pose and the direction in which the light would fall before beginning this detailed study. The manner in which Christ's hair falls forward, his eyelids are lowered, and the shadows and highlights are defined makes identification with the *Baptism* certain.[5] Similarly, in the only other known drawing for this composition, a study for the head of an angel (fig. 2), the angle of the head, the shadows on the neck and cheek, and highlights on the eyelids, nose, and chin are all as they would be in the painting.[6]

The sheet bears the mark of the Spencer collection, from which it was sold in 1811.[7] While the compiler of the catalogue did not make the connection, one is curious to know whether the earl, sent to Vienna as ambassador, saw Reni's *Baptism of Christ* in the Stallburg and recognized that he owned a preparatory drawing for it.

• *Catherine Johnston* •

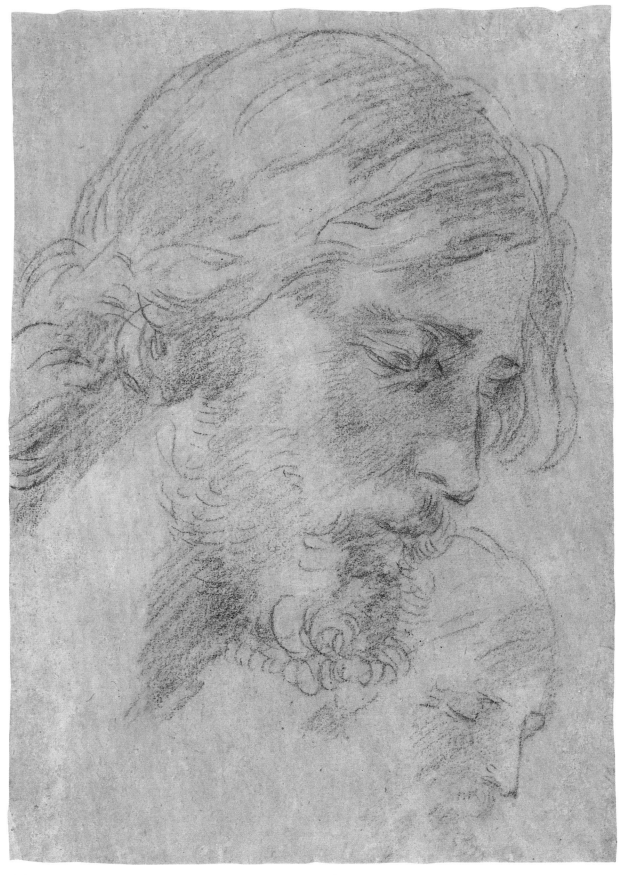

66

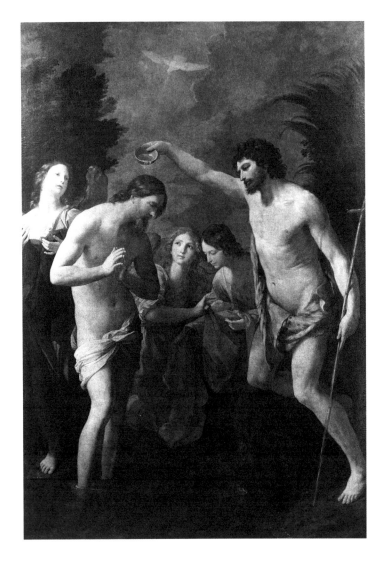

**FIGURE 1**

Guido Reni, *The Baptism of Christ*, Kunsthistorisches Museum, Vienna

**NOTES**

1. Pepper 1984, no. 86.

2. Malvasia 1841 ed.; Enggass 1980, 84. For a portrait of Jacobs attributed to Reni and for Jacobs' activity as a silversmith see Bulgari 1974, 198–199, pl. xx.

3. Although not included in the inventory of York House drawn up in 1635 before Buckingham's widow remarried, there is a suggestion that this listing may not have been complete; see McEvansoneya 1994, 32. According to Betcherman 1970, 250–259, Buckingham sent his agent Gerbier to Flanders in 1625 to evaluate Rubens' collection with the intention of purchase and again in 1627 when he had diplomatic responsibilities in Brussels.

4. Jacobs was a witness in 1610 to drawing up the will of Calvaert, who died in 1619. Malvasia indicates that when Reni's *Assumption of the Virgin* was displayed in Bologna in 1617, before being sent to Genoa, Calvaert was effusive in his praise of his former pupil.

5. Other occasions when the artist portrayed Christ in profile to the right with his head slightly bowed include his *Glory of Saint Dominic* fresco and paintings such as *Jesus and Saint John* (Sacristy of the Gerolamini, Naples; there he is beardless), *Christ in Limbo* (formerly in the Gemäldegalerie, Dresden), and *Christ Consigning Keys to Saint Peter* (Louvre, Paris). See Pepper 1984, nos. 81, 85, and 145.

6. See Kurz 1955, no. 345. A drawing sold at London, Sotheby's, 12 March 1963, lot 40, and listed in Pepper 1984, 245, as related to this composition is not, in my opinion, by Guido Reni.

7. In the sale cat. the drawing is described as "A man's head, *black chalk, heightened, large as life,* CAPITAL—*a sketch for a smaller head under it.*" The reference to a secondary sketch, the rudimentary drawing that occurs in the lower right of this sheet (a rare occurrence among Reni's drawings and unique in his head studies) confirms the identification. The cryptic markings on the verso of the sheet and on the verso of a former mount *(Q/no.20;* see sale cat., London, Sotheby's, 8 December 1972, lot 34*)* presumably refer to shelf numbers either in the Spencer or some other collection or, perhaps, to an unrecorded sale. According to Lugt 1532, the Spencer collection of drawings appears to have been formed by the second earl's grandfather, the Honorable John Spencer (1708–1746), who may possibly have been given them by his maternal grandmother, Sarah, Duchess of Marlborough (1660–1744).

**PROVENANCE**

Probably the Honorable John Spencer [1708–1746]; by descent to George John, 2nd Earl Spencer, Althorp [1758–1834] (Lugt 1532) (sale, London, Philipe, 10 June 1811, lot 294); private collection (sale, London, Sotheby's, 8 December 1972, lot 34); (Lorna Lowe, London); (Adolphe Stein, Paris); Woodner Collections (Shipley Corporation).

**EXHIBITIONS**

London 1973a, no. 68; Vienna 1981, no. 97; Woodner, Malibu 1983–1985, no. 28; Woodner, Munich and Vienna 1986, no. 29; Woodner, Madrid 1986–1987, no. 37; Woodner, London 1987, no. 28; Woodner, New York 1990, no. 36.

**LITERATURE**

Pepper 1984, 245, under no. 86 (drawing no. 2).

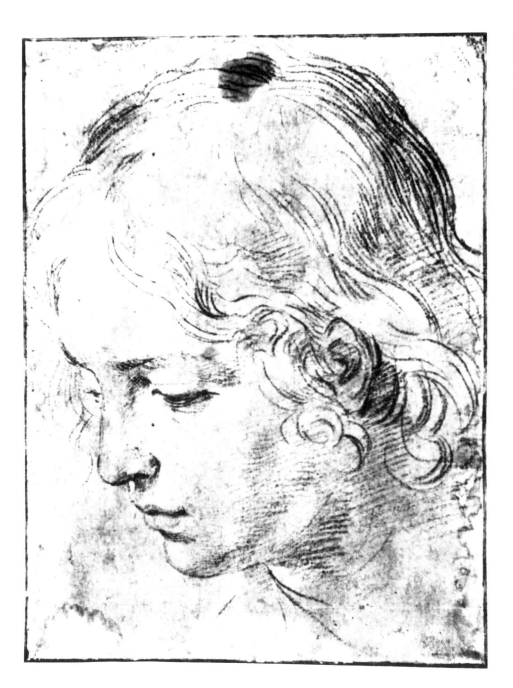

**FIGURE 2**

Guido Reni, *Study for the Baptism of Christ: Head of an Angel,* The Royal Collection © Her Majesty Queen Elizabeth II

# 67 "Colf" on the River IJsel

The son of an apothecary who
moved to Kampen in 1586,
Hendrick Avercamp probably
received his initial training in
Amsterdam from the Flemish
emigré landscape painter Gillis
van Coninxloo (1544–1607)
and then studied with Pieter
Isaacsz (1569–1625). He was
back in Kampen by January 1613
and remained there for the rest
of his life. His nickname "Stomme
van Kampen" (literally, mute
from Kampen) comes from the
fact that he was unable to hear
or speak. He specialized in
winter scenes filled with figures
engaged in a variety of activities.
His drawings with watercolor
and sometimes gouache were
regarded as finished works in
themselves and were often framed
and hung as small paintings.

**c. 1626/1627, pen and black and gray ink with
watercolor, gouache, and graphite on laid paper,
laid down, 199 x 331 (7 ¹³/₁₆ x 13 ¹/₁₆)**

**Inscribed at lower left in gray watercolor: *HA* (in
monogram); and on the verso at lower left in pen
and brown ink: *1823 WE 63+ G. Hibberts colln
Stomme van Campen***

**Watermark: Eagle with wings displayed**

**Woodner Collections**

Hendrick Avercamp must have been a most
industrious draftsman. In the inventory
of the marine painter and collector Jan van
de Cappelle, who probably owned all or a
large part of Avercamp's studio estate, men-
tion is made of hundreds of drawings by
"de Stomme van Campen," as Avercamp
was called in the seventeenth and eigh-
teenth centuries.[1] Most of the drawings in
Van de Cappelle's possession would have
been studies and rapid sketches of the kind
that is now best represented in the Royal
Collection at Windsor Castle.[2] On one of
the walls in his house, however, also hung
"Een teekeningh, winter, met een glaesje,
van de Stomme" (A drawing, a winter scene,
behind glass, by the Mute),[3] which would
have been not unlike the Woodner drawing.
Mounted on panel and framed in ebony—
or a less costly wood painted black to resemble
ebony—these minutely executed drawings
in watercolor and gouache were an attrac-
tive alternative to much more expensive oil
paintings.[4]

Avercamp made his finished drawings
with the aid of numerous figure studies.
In his large winter scenes the same figures
reappear often in ever-varying composi-
tions. Thus the man playing "colf" in the
left foreground of the Woodner drawing
can be seen in exactly the same pose, and
once in reverse, in two drawings in the
Teylers Museum, Haarlem,[5] and in one in
the Lugt Collection, Paris (fig. 1).[6] Likewise
the young couple immediately behind the
colf player also appears in the drawing in
the Lugt Collection and in one in the Rijks-
prentenkabinet, Amsterdam.[7] The man
seen from the back, virtually in the middle
of the Woodner drawing, also appears on
the Amsterdam sheet, although the posi-
tion of his right arm has been altered. The
sweethearts seated at the right are rendered
in almost the same pose as a couple in a
drawing in Dresden.[8] In the Dresden draw-
ing, however, the young people are dressed
in clothes that would have been worn
around 1620; in the Woodner drawing they
are dressed in the fashion of the second half
of the 1620s (Avercamp's patrons evidently
wanted current fashions in the drawings
they ordered from him). Finally, the two
sedate onlookers and the man fastening his
skates recur with small variations time
and time again in Avercamp's paintings.

Although the buildings in the back-
grounds of Avercamp's paintings and draw-
ings are often fairly accurately portrayed,
the artist obviously did not strive for ab-
solute topographical fidelity, as the Wood-
ner drawing clearly demonstrates (fig. 2).

Two of the churches of Kampen have been
rendered: on the left the Church of Saint
Nicholas ("Bovenkerk"), and on the right
the Church of Our Lady ("Buitenkerk").
For reasons unknown, Avercamp has
turned the Bovenkerk around so that it
now seems as if the church were oriented
toward the west. And on top of the still-
spireless tower of the Buitenkerk appears
what must be the beginning of a parapet.
As this ornamental addition was not com-
pleted until 1627, the Woodner drawing
should be dated to that year or slightly ear-
lier.[9] Even without such topographical con-
siderations, a dating of the drawing in the
second half of the 1620s seems appropriate.
• *Marijn Schapelhouman* •

**NOTES**

1. Bredius 1892, 37–39.
2. White and Crawly 1994, nos. 242–247, 251–275.
3. Bredius 1892, 34, no. 73.
4. In the course of more than four and a half centuries
nearly all of these drawings have lost their frames.
Only a *Winter Landscape* in the collection of Maida
and George Abrams has retained what seems to be the
original seventeenth-century frame. Exh. cat. Amster-
dam 1991–1992, no. 25.
5. Scholten 1904, 91–93, nos. o*6, o*7; Welcker/Hens-
broek-van der Poel 1979, 259–260, nos. T 44, T 45. An
ancestor of the modern game of golf, "colf" was an
outdoor game, played by two or four players with two
or four balls. For a history of the game see Van Hengel
et al. 1982.
6. Inv. 5461; Welcker/Hensbroek-van der Poel 1979,
264, no. T 67, and 276, no. T 131.15.
7. Inv. RP-T-1883-A-240; Welcker/Hensbroek-van
der Poel 1979, 254, no. T 11.
8. Welcker/Hensbroek-van der Poel 1979, 270, no.
T 106, pl. XXVI, fig. XLVII.
9. Van Mierlo 1989, 10–11.

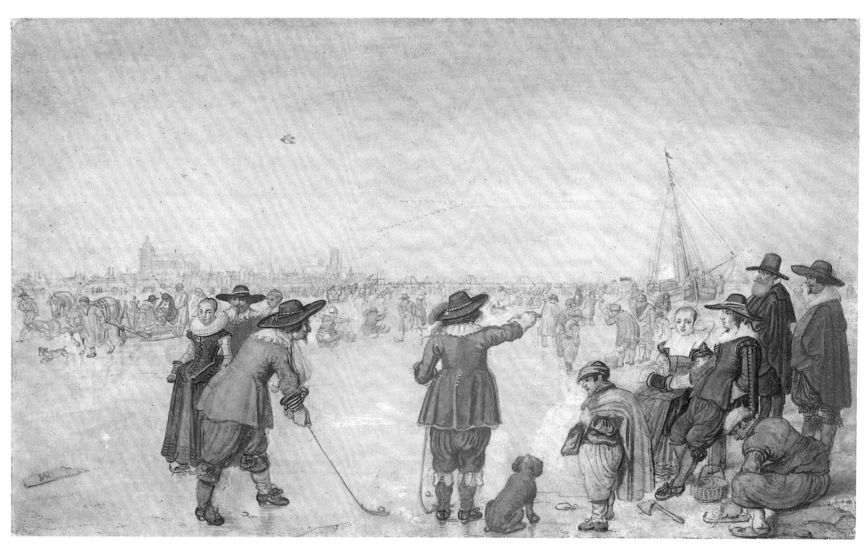

67

### PROVENANCE

George Hibbert, London [1757–1837]; William Esdaile, London [1758–1837] (Lugt 2617) (sale, London, Christie's, 18–25 June 1840, lot 1178); John Postle Heseltine, London [1843–1929] (Lugt 1507); Henry Oppenheimer, London [1859–1935/1936] (Lugt 1351); by descent to Eric Oppenheimer (sale, London, Christie's, 6 July 1976, lot 150); (Martyn Gregory, London); private collection (sale, London, Christie's, 7 July 1981, lot 121); Woodner Collections (Shipley Corporation).

### EXHIBITIONS

London 1929, no. 554; London 1953, no. 329; Woodner, Malibu 1983–1985, no. 50; Woodner, Munich and Vienna 1986, no. 59; Woodner, Madrid 1986–1987, no. 71; Woodner, London 1987, no. 60; Woodner, New York 1990, no. 74.

### LITERATURE

Heseltine 1903, no. 4; Welcker 1933, 253, no. T 129; *Illustrated London News* (Christmas 1956), 20; exh. cat. Rotterdam 1974a, under no. 3; Herbert 1976, 104 (repro.); exh. cat. New York 1977–1978, under no. 1; Welcker/Hensbroek-van der Poel 1979, nos. T 129, T 130.

**FIGURE 1**

Hendrick Avercamp, *Ice-Sport Near Kampen*, Collection Frits Lugt, Institut néerlandais, Paris

**FIGURE 2**

Detail of cat. 67

# 68  Interior of Saint Bavo's Church, Haarlem

mid-1630s, pen and brown ink with gray wash and touches of red chalk over graphite on laid paper, squared in red chalk, laid down, 491 x 358 (19⁵⁄₁₆ x 14⅛)

**Woodner Collections**

*Saenredam was the son of the engraver Jan Pietersz Saenredam (1565–1607). After his father's early death, he and his mother moved to Haarlem, where he spent the rest of his career. He studied painting under Frans Pietersz de Grebber (1573–1649) and in 1623 became a member of the Guild of Saint Luke. Noted for his views of church interiors, which he began to paint in 1628, Saenredam became the foremost architectural painter in the Netherlands in the seventeenth century. Numerous Dutch artists painted similar subjects, but few rivaled the solemn grandeur achieved in Saenredam's works.*

In this large and imposing drawing Saenredam captures the soaring expanse of the interior space of the Grote Kerk (Great Church), or the church of Saint Bavo, situated at the Grote Markt in the center of Haarlem. Saenredam made numerous drawings of this magnificent church during his career, most of them concentrated in two separate campaigns, the first in the late 1620s and the second in the mid-1630s, the period to which this exquisite example belongs.[1]

The Woodner drawing is comparable in technique and function to construction drawings Saenredam made for paintings that he often executed many years later. Uniquely among Dutch artists, Saenredam used construction drawings as an integral part of his creative process. He began by drawing at the site with chalk, often on blue paper.[2] Later in the studio he produced a construction drawing according to the laws of perspective, which he then would transfer to panel before beginning to paint.

Although Saenredam's view down the fifteenth-century nave toward the west end of the church seems complete in the Woodner sheet, it is but a fragment of an enormous construction drawing made for his largest painting, *Interior of Saint Bavo's Church*, completed some twelve years later

(fig. 1). The left section of the original construction drawing, now in Haarlem (fig. 2), depicts the south transept and includes a full inscription by Saenredam that explains the relationship of the drawing to the painting: "Finished this drawing the 15th of December 1635. It is a view in the Great Church in Haarlem. Finished painting the 27th February 1648."[3] Saenredam most likely prepared the design of the vault surmounting the crossing in a similar fashion, joining another sheet along the top edges of the Woodner and Haarlem sheets.[4] Although the artist normally transferred his designs to panel by darkening the back of the sheet and incising the lines from the front, here he created a grid in red chalk, which allowed him to transfer the image at a larger scale.[5] Infrared reflectography reveals a comparable grid pattern on the Edinburgh panel, although with intervals twice as large.[6]

Saenredam executed this construction drawing with the aid of a ruler and compass, refining his initial drawing on blue paper through careful attention to the laws of linear perspective. He began by laying out his elaborate perspective system in graphite, locating the vanishing point on the horizon to the right of the foreground group of figures (the point circled in ink). Traces of the graphite orthogonals reveal how closely the final design followed his initial concept. Saenredam determined the rate of recession with his distance point, which he located on the base of the column to the left of the nave on the portion of the

original construction drawing now in Haarlem. This point is marked with a pin hole and the number "30" (fig. 2).[7] After locating the vanishing and distance points, Saenredam could situate his columns correctly in space and construct the proper arch for the ceiling, which he drew in graphite with the aid of a compass.

After thus establishing his spatial organization, Saenredam, quite remarkably, defined the architecture exclusively with gray washes, capturing the play of light across the forms. At this stage in the process he also drew in his staffage figures with pen and wash. Once he had completed this stage, but before he added the brown pen lines, Saenredam squared the drawing in red chalk. This sequence suggests that the artist only squared the drawing in 1648 when he was preparing the large panel for the painting. He probably added the brown pen lines as an aid in defining the architectural forms in the final painting. Although Saenredam used a ruler for the straight edges, he drew the arches and the elaborate rib system free hand.

Saenredam's earliest church interior is a 1627 drawing of Saint Bavo's made for Samuel Ampzing's 1628 city history of Haarlem.[8] Pieter Wils (active 1621–c. 1647), a surveyor, mathematician, and engineer, compiled for the same publication a list of measurements and elevations of the Grote Kerk. In the caption to his list of measurements, Wils explained that they would be "of use to anyone wishing to draw [the Grote Kerk] in perspective."[9] Indeed,

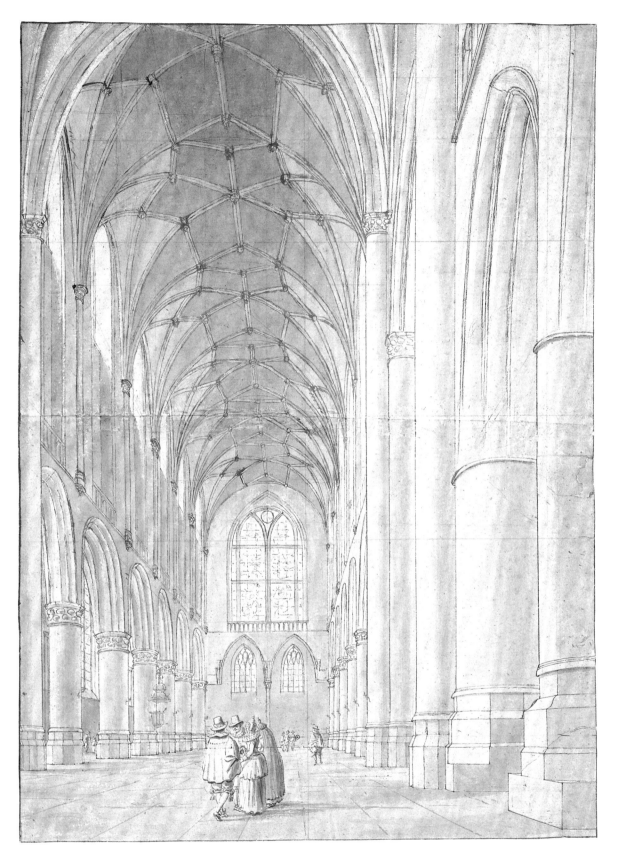

68

Saenredam probably learned the art of perspective from Wils.

Although Saenredam is widely famed as an accurate portrayer of church interiors, he frequently adjusted the proportions of architectural elements to emphasize the grandeur of a space. Comparison of this construction drawing with Saenredam's free-hand preliminary sketch reveals that he not only enlarged the scale and height of the columns and arches of the arcade but also narrowed and heightened the nave.[10] He also introduced foreground figures to emphasize the vastness of the interior. One puzzling aspect of Saenredam's oeuvre is the long time that often passed between a construction drawing and painting. The artist may have kept a stock of drawings on hand in anticipation of future commissions. The circumstances leading to the execution of the Edinburgh painting appear to be different, however. On 21 May 1648, a few months after completing the painting, the artist offered to sell it to Stadholder William II, the prince of Orange.[11] The timing was significant. Indeed Saenredam wrote the letter only six days after the prince had attended the signing of the Treaty of Münster, bringing to a close the long conflict between the Netherlands and Spain. Saenredam's proposal to the prince suggests that he had painted this work prior to the signing of the treaty, as though he had intended his glorious image to serve as a symbol of the national prestige accorded the Dutch Republic at this historic event. Although the prince did not purchase the painting, the powerful burgomaster of Amsterdam, Andries de Graeff, did, suggesting that others responded to its nationalistic appeal. De Graeff sold it soon after to the states of Holland and West Friesland for inclusion in "the Dutch Gift," an important group of paintings and sculpture presented to the king of England in 1660. • *Arthur Wheelock* •

**FIGURE 1**

Pieter Jansz Saenredam, *Interior of Saint Bavo's Church,* National Gallery of Scotland, Edinburgh

**FIGURE 2**

Pieter Jansz Saenredam, *Nave of Saint Bavo's Church,* Gemeentearchief, Haarlem

**NOTES**

1. See Schwartz and Bok 1990, 257–262.
2. Saenredam's free-hand drawing on blue paper is in the Gemeentearchief, Haarlem. Measuring 541 x 388 mm, it is signed and dated *Den 25 augustij/anno 1635/Pieter Saenredam.*
3. Exh. cat. Edinburgh 1984, no. 19. A second inscription gives the size of the final painting.
4. Saenredam used a separate preliminary drawing, now in the Lugt Collection, Institut neérlandais, Paris, for the organ in the Edinburgh painting. See Schwartz and Bok 1990, 117, fig. 127.
5. A comparable red chalk grid is found on the sheet in the Gemeentearchief (see fig. 2).
6. See exh. cat. Edinburgh 1984, 34–35, figs. 9 and 10.
7. Ruurs 1985, 162, and Ruurs 1987, 140, identified the number "30" on the base of the column as the distance point. For an analysis of Saenredam's distance point method, see Ruurs 1982, 105–106, 119 n. 19.
8. Saenredam's design was reproduced in an etching by Jan van de Velde for Ampzing's *Beschryvinge ende lof der stad Haerlem in Hollan* (Haarlem, 1628).
9. Ampzing 1628, 503. For an English translation and analysis of Wils' list, see Ruurs 1987, 87. Ruurs was the first to propose that Wils may have taught Saenredam the art of perspective.
10. Ruurs 1987, 139–142, determined that, contrary to the conclusions reached by Kemp and Saniee in exh. cat. Edinburgh 1984, 24–25, 30, 32–33, 36–37, the relative proportions of the columns to the height of the nave are accurate if one takes as a basis the measurements made by Pieter Wils.
11. The offer appeared in a letter to Constantijn Huygens, secretary to the prince of Orange; see Schwartz and Bok 1990, 206.

**PROVENANCE**

Rudolph Weigel, Leipzig; the bookdealer Vincent van Gogh, Amsterdam (sale, Amsterdam, R.W.P. de Vries, 16–17 July 1930, lot 162); J.M.C. Hoog, Haarlem; private collection, Maastricht; Edward Speelman, London; (Lodewijk Houthakker, Amsterdam); Woodner Collections (Shipley Corporation).

**EXHIBITIONS**

Utrecht 1961, no. 61; Woodner, Malibu 1983–1985, no. 51; Edinburgh 1984, no. 20; Haarlem 1985, no. 52; Woodner, Munich and Vienna 1986, no. 61; Woodner, Madrid 1986–1987, no. 73; Woodner, London 1987, no. 62; Woodner, New York 1990, no. 76.

**LITERATURE**

Swillens 1935, 39, 60–61, 94–95, no. 86; Kemp 1984, 131–132; Alpers 1984, 70–79 (repro.); Ruurs 1985, 161–162; Kemp 1986, 244, 256, fig. 18; Ruurs 1987, 139–142, pl. 21; Schwartz and Bok 1990, 106, 117 (fig. 126), 128, 262, cat. 61.

# 69 Study of Trees

*A landscape painter, draftsman, and etcher, Van Uden probably received his early training from his father, Artus van Uden (1544– 1627/1628), Antwerp's city painter (stadmaler), since he entered the painters' guild in 1626 as "son of a master." In 1641 and 1642 Van Uden registered an apprentice. Around 1644 he traveled along the Rhine and returned to Antwerp two years later; in 1649 he is recorded as living outside the city. Van Uden, whose panoramic landscapes continue the tradition of Joos de Momper (1564–1635), Jan Bruegel the Elder (1568–1625), and Anthony van Dyck (q.v.), was also strongly influenced by Peter Paul Rubens (1577–1640); he made prints after a number of Rubens' compositions, but never collaborated with the older master. David Teniers the Younger (1610–1690) often added the figures in Van Uden's painted landscapes.*

**1640s, pen and brown ink with gray wash, yellow and white chalks over traces of graphite on laid paper, laid down, 346 x 218 (13⅝ x 8⁹⁄₁₆)**

**National Gallery of Art, Woodner Collection 1991.182.6**

Lucas van Uden is best known for his landscape drawings, often enhanced with colored wash or chalk. His many views continue the tradition of the much-admired

**FIGURE 1**

Lucas van Uden, *Three Birch Trees,* Collection Frits Lugt, Institut néerlandais, Paris

landscape watercolors of the 1630s by Anthony van Dyck and his circle.

Most of Van Uden's landscapes are horizontal in format and present views of the rolling countryside with trees and streams. The present *Study of Trees*, however, belongs to a small group of drawings, invariably in a vertical format, in which only two or three trees fill most of the sheet and even extend beyond.[1] Closest to the Woodner drawing in execution are *Three Birch Trees* in the Lugt Collection (fig. 1) and *Three Trees* in a private collection. The latter is a rare example in which the trees actually may be associated with a known painting.[2] Another related example is in the Fitzwilliam Museum, Cambridge.

These majestic trees, silhouetted against an evening sky and enhanced with touches of yellow chalk, are drawn so carefully that the artist must have executed them in his studio, probably basing them on studies from nature that are now lost. No extant painting by Van Uden includes the same clump of trees.

Since a number of Van Uden's drawings are signed and dated, primarily from the 1640s, one may assume that he intended them as finished works for the art market rather than as preliminary studies. The Woodner *Study of Trees,* although not signed, most likely dates from the same time and may well have been drawn for the same purpose, namely to be sold.
• *Anne-Marie Logan* •

**NOTES**
1. For an overview of Van Uden's landscape drawings, see Van Hasselt in exh. cat. London 1972, no. 111.
2. See exh. cat. Wellesley 1993–1994, no. 73 (repro.).

**PROVENANCE**
(Bruno de Bayser, Paris); Woodner Collections (Dian and Andrea Woodner); given to NGA, 1991.

**EXHIBITIONS**
Woodner, Munich and Vienna 1986, no. 72; Woodner, Madrid 1986–1987, no. 85; Woodner, London 1987, no. 71; Woodner, New York 1990, no. 87.

69

# 70 Joseph Recounting His Dreams

*The premier Dutch painter, drafts-man, and etcher, Rembrandt studied first in Leiden under Jacob van Swanenburgh, then in Amsterdam with Pieter Last-man in 1624–1625. He later worked independently in Leiden but settled permanently in Amsterdam in 1630/1631. Much in demand for his portraits, he worked for Hendrick Uylen-burgh, whose cousin Saskia he married in 1634. From 1633 to 1639 he painted six scenes of Christ's Passion for the prince of Orange. He purchased a large house in Amsterdam in 1639, and his son Titus was born in 1641. Rembrandt completed his celebrated* Night Watch *in 1642, the same year Saskia died. By 1656 financial difficulties led him to assign his assets to the courts, and from 1658 he lived more mod-estly. Titus died in 1668, and Rembrandt himself the follow-ing year. Rembrandt's fame rests on his scrutiny of nature and the expression of human emotion, described with an increasingly broad touch and somber palette.*

**Early 1640s, reed pen and brown ink with brown wash, heightened with white, on laid paper, 173 x 224 (6 $^{13}$/₁₆ x 8 $^{13}$/₁₆)**

**National Gallery of Art, Woodner Collection 1991.182.12**

This drawing illustrates a scene from Gene-sis 37:5–11 in which Joseph, on the right, the favorite son of Jacob, who is seated in the center with his youngest son, Benjamin, tells his father and half-brothers about two dreams, which he interprets as signs that they will one day bow down before him. Jacob rebukes him, and his brothers, already jealous of the favored son, decide to do away with him. This Old Testament story preoccupied Rembrandt in the 1630s, when he depicted it in an elaborate grisaille oil sketch thought to have been made c. 1633 (Rijksmuseum, Amsterdam), and in an etching of 1638 that is a smaller-scale variant of the oil.[1] Rembrandt made preparatory studies for the print and also produced another etching c. 1637.[2]

An unusual iconographic feature of the Woodner drawing, as of the grisaille and the 1638 etching, is the presence of Joseph's mother, Rachel, although she had died before the incident represented. She may even appear twice here: in a bed in the background to the right, and again imme-diately behind Jacob. Her presence might be attributable to Rembrandt's having mis-read an engraving of the subject made by Heinrich Aldegrever in 1532 (Bartsch 18) in which a figure in the background is intended

to represent Joseph, lying in bed dreaming. Alternatively, Rembrandt may have wanted to include Jacob's other wife, Leah, but there is no known precedent for this.[3] Yet Jacob and a woman standing behind him reappear in a sketch of just these two fig-ures in the British Museum, London.[4]

The Woodner drawing has been vari-ously dated by previous writers, who have either related it to the 1638 etching or placed it in the early 1640s. Stylistic analo-gies with Rembrandt's drawings support the latter view: the skimpily outlined, seated figure in the left foreground is com-parable to the kneeling saint in a sketch of the *Beheading of Saint John the Baptist* (Rijksmuseum, Amsterdam), which is related to Rembrandt's 1640 etching of the subject.[5] Another study for the etched figure of the Baptist (Musée Bonnat, Bay-onne) has affinities with passages in the present work, in the freely drawn outlines and in the small pockets of hatching.[6]

These studies provide a secure basis for attributing Rembrandt's pen and ink drawings from the beginning of the 1640s. Yet the similarities between them and the Woodner sheet do not inspire confidence in the autograph status of this work. Other drawings of the period that are reliably attributed to Rembrandt, such as the *Two Men in Conversation,* signed and dated 1641 (Courtauld Institute Galleries, London),[7] are yet further removed in style.

Certain features in the Woodner drawing give further cause for doubt. On a Morellian level, the figure of Joseph has

sharply pointed fingers that are impossible to parallel in Rembrandt's authenticated drawings of this period. Moreover, although this figure is crucial to the composition, it is tentatively drawn, with the posture and gestures lacking the decisive originality seen in earlier versions of the subject. The outlines, like those of the other figures, are fussed over and retraced many times, nonetheless often failing to realize a defini-tive form. In Rembrandt's secure drawings of this type, a sense of direction and in-creasing precision is usually generated, with firmer pressure exerted on the pen as work progresses. While the initial indications in his drawings may sometimes be tentative, they are superseded by clearer, more boldly applied outlines—particularly in the chief protagonists of a scene. In some areas of the present work, however, the lines become confused and lack the robustness, clarity, and economy of Rembrandt's autograph style.

The facial expressions also strike an un-convincing note, being somewhat repetitive and not always judicious in the context of the narrative. The brothers, according to the biblical text, "hated" Joseph, yet they do not seem unduly hostile here. Two brothers standing on the far side of the table actually seem to smile benignly at one another, while two more look out at the spectator with ap-parent indifference. Other figures, unusually for a biblical illustration by Rembrandt, also fail to engage with the events depicted.[8]

The Woodner drawing is unquestion-ably a work of high quality, but an illumi-

70

**FIGURE 1**

Rembrandt van Rijn, *Jacob and His Sons,* Rijksprentenkabinet, Rijksmuseum, Amsterdam

**FIGURE 2**

Rembrandt van Rijn, *Christ Preaching: The One Hundred Guilder Print,* National Gallery of Art, Washington, Gift of R. Horace Gallatin

nating comparison may be made with a related work from the same period that has always been accepted as by Rembrandt's own hand: *Jacob and His Sons* in the Rijksmuseum (fig. 1).[9] Although some aspects of the draftmanship seem close—such as the delineation of the faces—the overriding impression is of a more disciplined hand at work, one with a more varied armory of touch. The lines have a more lyrical, unifying quality, with greater economy in the definition of form. The lie of the draperies, although containing some pentimenti, is described with greater precision. Darker lines emphasize particular profiles and folds in the cloth where the initial work had been tentative. The contrast with the more broken pen work in the Woodner sheet is clear,

even in the most finished figures of Jacob and Joseph. As has been written of Rembrandt's drawings of this period, they may sometimes appear messy, "but on closer inspection his pen is always single-minded in its pursuit of the desired form."[10]

The variety of touch in the Amsterdam drawing (fig. 1) is matched by the variety of characterizations: figures are arranged inventively, split into four separate groups, and each attends to the words spoken with individual stances and gestures. This is typical of Rembrandt's work, exemplified among his religious compositions of the 1640s by his etching of *Christ Preaching: The One Hundred Guilder Print* (fig. 2), in which the background group of figures to the left might almost have provided a model for the present work.[11] In all of these compositions Rembrandt's approach to details such as the hands and facial features is more precise, yet achieved with minimal means.

Other drawings traditionally attributed to Rembrandt may be grouped with the Woodner drawing, including a version of this subject in Vienna in which the main figures are repeated freely but in reverse.[12] The pen work has the same imprecise quality, and the forms of the hands and other details are comparable. Also similar is an elaborate composition drawing of the *Beheading of Saint John the Baptist* (private collection).[13] This last drawing also includes broad sweeps of brown wash like those that play such a part in the Woodner drawing as well as in the *Metamorphosis of Io* (Victoria and Albert Museum, London), a sheet

that has been rejected from Rembrandt's oeuvre.[14] Of the drawings that are still generally accepted as by Rembrandt, the most comparable to the Woodner sheet is perhaps *Three Men Being Beheaded* (British Museum, London).[15] But again, whether in the details, in the fluid character of the outlines, or in the arrangement and interaction of the figures, in style it seems distinct.

The possibility that the Woodner drawing might not be by Rembrandt was first suggested by Ludwig Münz, who assigned it to the artist's pupil Govert Flinck (1615–1660).[16] This seems wide of the mark, however. A more likely candidate is probably Ferdinand Bol (1616–1680). Bol's style varies widely, but his specific tasks in Rembrandt's workshop (which he may have joined after receiving training in his native Dordrecht) seem to have included the imitation of his master's style: on the back of a drawing of the later 1630s Rembrandt listed copies by Bol that he apparently intended to sell.[17] Numerous drawings attributed to Bol, not least his *Joseph Telling His Dreams to the Prisoners* (Kunsthalle, Hamburg), betray at least some of the characteristics noted in the Woodner drawing.[18] Similarities include the broad, peripheral lines and the use of wash. Yet in other respects the drawings appear different enough that a secure attribution for the present work remains elusive. For this reason, it is catalogued here under its traditional attribution, but with considerable reservations.
• *Martin Royalton-Kisch* •

## NOTES

I am grateful to Charles Dumas at the Rijksbureau voor Kunsthistorische Documentatie in the Hague for finding the reference to the drawing in the Hoofman sale cat. of 1846. See Provenance below.

1. For the grisaille see *Rembrandt Corpus* 2: no. A66 (repro.). For the etching see White and Boon 1969, no. B37 (repro.).

2. White and Boon 1969, no. B33; Valentiner 1925–1934, 1:467, under no. 87.

3. *Rembrandt Corpus* 2:296, following exh. cat. Berlin 1970, under no. 14 (the idea having been advanced in a paper by Lorenz Seelig).

4. See Royalton-Kisch in exh. cat. London 1992a, 102, no. 38 (attribution to Rembrandt described as "not wholly secure").

5. Benesch 1973, no. 482 verso (see Schatborn 1985, no. 19 verso). The etching is White and Boon 1969, no. B92.

6. Benesch 1973, no. 477.

7. Benesch 1973, no. 500a.

8. Contrast, among other examples, the groups of listeners in the Berlin grisaille sketch showing *Saint John the Baptist Preaching,* c. 1633 (*Rembrandt Corpus* 3: no. A106).

9. Benesch 1973, no. 541, and Schatborn 1985, no. 17 (repro. in color), where dated to c. 1641.

10. Schatborn in exh. cat. Berlin 1991–1992, 19.

11. For the *One Hundred Guilder Print* see White and Boon 1969, no. B74. That these qualities are present *in general* in Rembrandt's work can also be gauged by comparing such drawings as the *Allegory of Art Criticism* (Metropolitan Museum, New York; Benesch 1973, no. A35a), which may date from 1644, or the *Star of the Kings* (British Museum, London), a signed drawing of c. 1645–1647 (Benesch 1973, no. 736; Royalton-Kisch in exh. cat. London 1992a, no. 44, repro. in color).

12. The "signature" on the drawing is not authentic, as pointed out in Benesch 1973, no. 526.

13. Benesch 1973, no. 480, formerly in the Robert von Hirsch and the John R. Gaines collections.

14. Benesch 1973, no. A39, said the drawing might be by Rembrandt but catalogued it as an "attributed" work.

15. Benesch 1973, no. 479; Royalton-Kisch in exh. cat. London 1992a, no. 35 (repro.).

16. Münz 1937, 105.

17. Benesch 1973, no. 448 (Berlin). The inscription, on the verso of a copy by Rembrandt after Pieter Lastman's *Susannah and the Elders,* also lists copies by Leendert van Beyeren. For Bol's training see Blankert 1982; and Sumowski 1983, 1:282.

18. See Sumowski 1979–1992; 1: no. 101 (repro.).

## PROVENANCE

Mlle M. Hoofman (sale, Haarlem, Engesmet, 9 June 1846, lot A. 33: "Eene Historiëele Ordonnantie met 14 beelden, met de pen en O.I. inkt" [a historical composition with 14 figures, in pen and india ink]; bought by Leembruggen); Gérard Leembruggen Jz. (sale, Amsterdam, Roos, Engelberts, Lamma and Roos, 5 March 1866, no. 470, bought by Six); Jan Six (sale, Amsterdam, Muller, 16 October 1928, lot 62); Lady Violet Melchett; (Matthiesen Gallery); purchased by Paul Hatvany, 1947 (sale, London, Christie's, 24 June 1980, lot 74); Henry Hudson; Woodner Collections (Dian and Andrea Woodner); given to NGA, 1991.

## EXHIBITIONS

Amsterdam 1956, no. 88; Woodner, Cambridge 1985, no. 100; Woodner, Munich and Vienna 1986, no. 63; Woodner, Madrid 1986–1987, no. 75; Woodner, London 1987, no. 63; Woodner, New York 1990, no. 77.

## LITERATURE

Vosmaer 1877, 585; Lippmann and Hofstede de Groot 1888–1911, 1: no. 7; Hofstede de Groot 1906, no. 1231; Bredt 1921, 39; Valentiner 1925–1934, 1: no. 87; Kauffmann 1926, 169; Benesch 1935, 37; Münz 1937, 105; Benesch 1954–1957, 3: no. 527, fig. 657; Haverkamp-Begemann 1961, 51–52; Benesch 1964, 123 n. 11; Slive 1965, 1: pl. 224; Benesch 1973, 3: no. 527, fig. 695; Royalton-Kisch in exh. cat. London 1992a, 102, under no. 38, n. 5.

# 71  The Parable of the Publican and the Pharisee

**Late 1640s or after, reed pen and brown ink with
brown wash, heightened with white on laid paper,
laid down, 208 x 187 (8 3/16 x 7 3/8)**

**Woodner Collections**

The story illustrated here is Christ's parable
of the publican and the Pharisee, taken
from Luke 18:10–14: the publican at prayer
in the foreground shows genuine remorse
for his sins, whereas the Pharisee kneeling
behind thanks God that he is "not as other
men are…or even as this publican." Christ
wished to emphasize the humility expected
of true believers.

The style of the drawing resembles
Rembrandt's work of the 1640s, but the
similarities are counterbalanced by differ-
ences that suggest strongly that it was made
by a pupil or follower rather than by Rem-
brandt himself. Whether in the manner of
the hatching, the character of the line, or
the definition of the forms, the Woodner
drawing appears distinct from such works
as the *Star of the Kings* of c. 1645–1647
(British Museum, London)[1] or the so-
called *Expulsion of Hagar* of the same or a
slightly earlier period (Museum Boymans-
van Beuningen, Rotterdam).[2] Of the draw-
ings securely attributable to Rembrandt on
the basis of their connections with other
works, only two reveal any stylistic connec-
tions with the present drawing: the *Study
for the One Hundred Guilder Print* (Kupfer-
stichkabinett, Berlin),[3] and the *Saint Jerome
in a Landscape* (Kunsthalle, Hamburg),
which is related to Rembrandt's etching of

the subject, which has been variously dated
between around 1649 and 1652.[4] But these
drawings are different in character.

The draftsman of the Woodner sheet
cannot be identified, but he may have been
responsible for several other drawings
traditionally attributed to Rembrandt, in
particular the *Presentation in the Temple*
(fig. 1), to which it has been previously
compared.[5] Another drawing in which the
treatment of the main figures and their
drapery seems comparable is the *Suicide
of Thisbe* (Kupferstichkabinett, Berlin), a
work that has raised doubts about its attri-
bution in several scholars' minds.[6] This in
turn has been compared with two other
drawings, of which the attribution to Rem-
brandt has proved contentious and which
could be by the same hand—the *Tobias
with the Angel* and *The Circumcision*, both
also in Berlin.[7]

The composition of the *Parable of the
Publican and the Pharisee* may have been
suggested by several of Rembrandt's own
works, including the 1648 etching of the
*Marriage of Jason and Creusa* (fig. 2),[8] and
perhaps also his drawing of *Daniel in the
Lions' Den* (Rijksmuseum, Amsterdam),
which includes a kneeling figure in the cen-
tral foreground and others looking over a
circular gallery above.[9]

It should engender no surprise that an
identification of the pupil or follower re-
sponsible for the Woodner drawing has not
been possible. The German artist Joachim
von Sandrart, writing in 1675 on the basis of
his memory of Rembrandt's workshop in

Amsterdam in the 1640s, stated that Rem-
brandt had "countless prominent children"
training in his studio.[10] Yet for Rembrandt's
career as a whole fewer than forty pupils
can be identified today. Small wonder, then,
that many of the hundreds of paintings
and drawings traditionally associated with
Rembrandt—some fine works among
them—can be designated no more exactly
than as products of his school. • *Martin
Royalton-Kisch* •

**NOTES**
1. Benesch 1973 no. 736; Royalton-Kisch in exh. cat.
London 1992a, no. 44.
2. Benesch 1973, no. 190. Giltaij 1988, no. 16, dates this
work to around 1642–1643.
3. Benesch 1973, no. 188.
4. Benesch 1973, no. 886. For the earlier dating see
Schatborn 1985, no. 24, and exh. cat. Amsterdam
1991–1992, 94.
5. Benesch 1973, no. 588; also no. 589, which compared
the *Presentation in the Temple*, now in the Louvre; and
no. 593, which discussed *Elijah and the Prophets of
Baal* in the Wessenberg-Gemäldegalerie, Konstanz—
but these two seem less close to the Woodner sheet.
6. Benesch 1973, no. A27, following Karl Lilienfeld and
Frits Lugt, hesitated to give the drawing to Rembrandt.
7. Benesch 1973, nos. 559 and 574. The comparisons
were made in Lugt 1931, 59.
8. Bartsch 112. The comparison was made by several
earlier writers, especially in Benesch 1964, who, how-
ever, mistook the priest with a book at upper right
for a guitar-playing temple musician.
9. Benesch 1973, no. 887; this drawing was dated to the
end of the 1640s in Schatborn 1985, no. 24.
10. Sandrart 1925 ed., 203. For an analysis of the prob-
lems involved in identifying the number of Rem-
brandt's pupils see Broos in exh. cat. Amsterdam 1983,
35–38.

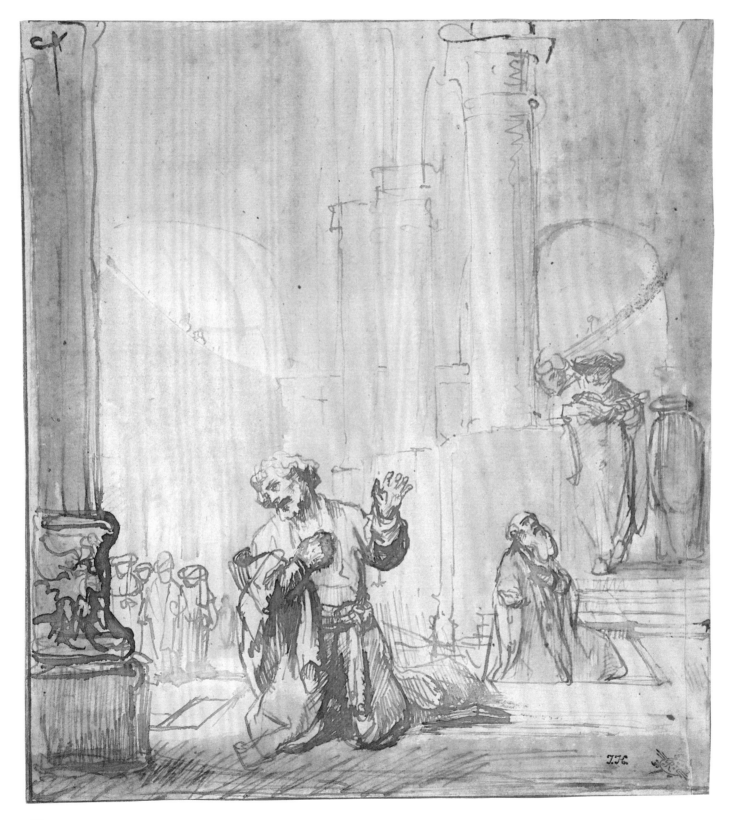

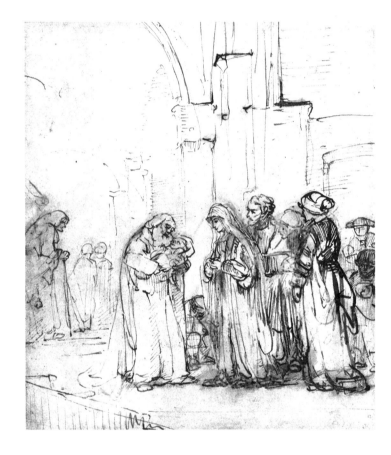

**FIGURE 1**

Rembrandt van Rijn, *Presentation
in the Temple,* Kupferstichkabinett,
Berlin

**FIGURE 2**

Rembrandt van Rijn, *Marriage of
Jason and Creusa,* National Gallery
of Art, Washington, Rosenwald
Collection

**PROVENANCE**

Jonathan Richardson Sr., London [1665–1745] (Lugt
2183); Thomas Hudson, London [1701–1779] (Lugt
2432); Mrs. Symonds (sale, Oxford, 11 April 1951); pri-
vate collection (sale, London, Sotheby's, 12 March 1963,
lot 66); Woodner Collections (Shipley Corporation).

**EXHIBITIONS**

Woodner, New York 1971–1972, no. 64 (here and sub-
sequently as Rembrandt); Los Angeles 1976, 194;
Woodner, Malibu 1983–1985, no. 52; Woodner, Munich
and Vienna 1986, no. 62; Woodner, Madrid 1986–1987,
no. 74; Woodner, London 1987, no. 64; Woodner, New
York 1990, no. 78.

**LITERATURE**

Benesch 1964, 127–130; Benesch 1973, 3: no. 587a, fig.
760; Dethloff 1992, 203, fig. 7.

## 72  View of Houtewael near the Sint Anthoniespoort *(recto)*
## Figures on the Anthoniesdijk Entering Houtewael *(verso)*

**c. 1650, reed pen and brown ink with gray-brown
wash and touches of white and a touch of red chalk
(accidental?) in the sky, center, on laid paper (recto);
reed pen and brown ink on paper washed light
brown (verso), 125 x 183 (4 ¹⁵/₁₆ x 7 ³/₁₆)**

**National Gallery of Art, Woodner Collection
1993.51.6.a,b**

The hamlet of Houtewael was situated
about one mile east of the walls of Amster-
dam. When Rembrandt made this drawing,
which can be dated to c. 1650 on grounds
of style, his house in the Sint Anthoniesbree-
straat was conveniently placed for excur-
sions to the east of the city, which he could
leave by the gate near the end of his own
street, the Sint Anthoniespoort. To reach
Houtewael he would have taken the road
to Diemen, walking for fifteen or twenty
minutes along the so-called Diemerdijk, a
major dike that protected the area from the
waters of the River IJ. In the decades after
this drawing was made, Houtewael was in-
corporated into Amsterdam itself as the
city expanded to the east.[1]

Houtewael was drawn many times by
artists, especially after the spectacular burst-
ing of the dike on 5 March 1651, not far
from the spot where Rembrandt must have
drawn the verso of the Woodner drawing.[2]
This lightly indicated sketch depicts the raised
dike in the center, on and around which the
buildings of the hamlet are perched. Few
comparable thumbnail sketches by Rem-

brandt survive, and it may have served as
a trial for a more elaborate drawing of the
view in Rotterdam.[3]

The landscape on the recto has been
praised by many writers for its expressive
economy of means. The foreground in par-
ticular is indicated with broad, suggestive
lines, drawn both with the pen and a few
sweeps of the brush, leading the viewer to
focus on the more detailed delineation of
the trees and buildings along the horizon.
The hamlet is seen from the northwest,
near the fortifications of Amsterdam by
the so-called Kadijk, a low dike that ran
north of the Sint Anthoniesdijk. The latter
is indicated here by the horizontal line
given restrained emphasis with the brush
in brown wash immediately beneath the
group of buildings.

This drawing belongs to one of the
most significant groups of landscapes by
Rembrandt. It bears the collector's mark of
Nicolaes Anthoni Flinck, the son of Rem-
brandt's own pupil Govert Flinck, whose
collection was acquired *en bloc* by the 2nd
Duke of Devonshire in 1724. This drawing
remained in the Devonshire collection
along with some thirty-one landscape draw-
ings by Rembrandt until this one was sold
in 1984. • *Martin Royalton-Kisch* •

### NOTES

1. Many of the sites drawn by Rembrandt were first
identified in Lugt 1920. For a recent study see exh. cat.
Washington 1990. Rembrandt's drawings of Houte-
wael were discussed in Giltaij 1988, no. 18. Giltaij sug-

gests dating all the drawings to around 1648/1649, as
he believes the newly dug canal, the Nieuwe Vaart,
would have been visible, along with the Zeeburg redoubt
at the end of the Diemerdijk. Rembrandt's landscapes
are not always topographically exact, however.
2. Two drawings of the burst dike at Houtewael, by
Willem Schellincks (engraved by Pieter Nolpe) and
Roelant Roghman, are in the British Museum. Others
by Jan van Goyen and Jan Asselijn are known. *A View
of Houtewael* by Claes Jansz Visscher, taken from a
similar viewpoint to the verso of the Woodner draw-
ing, is in the Maida and George Abrams collection,
Boston, but may date from the first decade of the
seventeenth century. See exh. cat. Amsterdam 1991–
1992, no. 22.
3. Benesch 1973, no. 1262; Giltaij 1988, no. 18.

### PROVENANCE

Possibly Govert Flinck [1615–1660]; Nicolaes Anthoni
Flinck, Rotterdam [1646–1723] (Lugt 959); William
Cavendish, 2nd Duke of Devonshire [1672–1729]; by
descent at Devonshire House and Chatsworth (inv.
1032) (sale, London, Christie's, 3 July 1984, lot 63); John
R. Gaines, Lexington, KY (sale, New York, Sotheby's, 17
November 1986, lot 19); Woodner Collections (The Ian
Woodner Family Collection, Inc.); given to NGA, 1993.

### EXHIBITIONS

London 1929, no. 608; London 1949, no. 36; Stock-
holm 1956, no. 134; Manchester 1961, no. 93; Washing-
ton 1969–1970, no. 93; London, 1973–1974, no. 93;
Woodner, London 1987, no. 65; Woodner, New York
1990, no. 80; Woodner, Washington 1993–1994.

### LITERATURE

Lippmann and Hofstede de Groot 1888–1911, 2: no. 58;
Hofstede de Groot 1906, no. 846; Eisler 1918, 65; Lugt
1920, 107, 133, no. 82 (repro. recto only); Wimmer 1935,
65; Benesch 1935, 48; Benesch 1947, 26, no. 181 (repro.
recto only); Benesch 1954–1957, 6: no. 1261, figs. 1485,
1486; Slive 1965, 1: no. 58 (repro. recto only); Benesch
1970, 48; Giltaij 1988, under no. 18 (verso repro. fig. a);
Royalton-Kisch 1992, 114–115, figs. 1, 2.

72 RECTO

72 VERSO

# 73    The Castle at Culemborg

*Roelant Roghman was evidently named after his great-uncle, the well-known landscape painter Roelandt Savery (q.v.), and he may have first studied with him. A painter, draftsman, and etcher, Roghman concentrated mainly on landscape subjects. He was influenced at first by the work of his great-uncle, especially in his mountain subjects, but his pen and ink drawings often recall the work of Rembrandt (q.v.), whom he knew. His forest landscapes, on the other hand, are very close in style and execution to works by Simon de Vlieger (c. 1600–1653) and Anthonie Waterloo (1609/1610–1690). Roghman's greatest achievement was his large series of views of the castles and country houses of Holland.*

**1646/1647, black chalk with gray wash over graphite on laid paper, 336 x 500 (13¼ x 19¹¹/₁₆)**

**Inscribed on the verso at lower left in graphite: *slot de Cuillemborgh***

**Watermark: Strasbourg lily with number 4 and initials WR below (cf. Heawood 1761, 1762, 1768, 1769)**

**Woodner Collections**

In 1646 and 1647 and possibly in a few years thereafter, Roelant Roghman produced numerous drawings of castles and feudal manors in the provinces of Holland and Utrecht, probably at the request of an important patron. This monumental series originally contained 245 drawings or more, of which about 220 now survive.[1] Many of them can be found in public collections throughout Europe; and a considerable number remain in private hands, though important castle drawings by Roghman seldom appear on the market.[2] Roghman's drawings stand out because of their impressive scale, robust draftsmanship, and the prudent balance between generalizations and details. His series of topographical renderings preceded the numerous fashionable drawings by Josua de Grave, Valentijn Klotz, Cornelis Pronk, and Jan de Beijer, and is still considered an unsurpassed achievement.

The patron for this important commission has been the subject of much speculation. Egbert Pelinck suggested that it may have been the Amsterdam burgomaster Cornelis Bicker van Zwieten; Ben Broos, however, claimed that the owner of Spijk mansion, Cornelis van Aerssen van Sommelsdijk, might be a better candidate.[3] Laurens Baeck, the grandfather of Hillebrand Bentes, the first known owner of the drawings, has been mentioned repeatedly, but Baeck died in 1642. Recently it has been conjectured that the patron was Dr. Joan Blaeu (1596–1673), a well-known publisher,[4] who compiled a famous atlas of the United Provinces around 1650 and was manifestly interested in Dutch antiquities. Not only had Roghman's father been employed by Blaeu as an engraver, but Blaeu served as the guardian of Albert Bentes, whose son Hillebrand owned Roghman's drawings. Perhaps Blaeu had planned to publish a systematic series of engravings of castles and manor houses (indeed one drawing, Zuylen Castle, was etched by Roelant's sister Geertruyd[5]). If that were so, then the project must have been abandoned.

When Roghman made his first drawings of castles in 1646, probably traveling from Amsterdam to Leiden and then on to Rotterdam and Utrecht, he was just nineteen years old.[6] In 1647 he must have visited Culemborg (also called Kuijlenburg), on the southern bank of the Lek River, about 30 kilometers southeast of Utrecht. Presumably he went that year to the north of Holland, along the dunes to the area west of Rotterdam, and finally inland to the eastern parts of Holland and Utrecht.[7]

Roghman portrayed Culemborg Castle in three drawings from two viewpoints. He recorded the main building once from a position near the entrance gate and looking north (Teylers Museum, Haarlem). He did a drawing of the gate with the outer court and the stables beyond from the same vantage point looking east (Museum Boymans-van Beuningen, Rotterdam);[8] and in the Woodner drawing the castle is portrayed from the north, from a strip of land between the Lek River and the moat. Roghman was standing so close to the building that the perspective is somewhat distorted and the structure of the castle is rather unclear, compared, for example, with the bird's-eye view in Blaeu's Atlas (fig. 1). Two minor details, however, accurately define the position of the draftsman: the belfry of the town hall can be noted to the far right, and the steeple of the church of Saint John can be seen over the slanted roof of the right part of the buildings along the outer court. These two landmarks can be traced easily in the city plan in Blaeu's Atlas.

Roghman's drawing served as a model for an engraving by Jacobus Schijnvoet, published in a survey of Netherlandish antiquities, *Schatkamer der Nederlandsse oudheden* by Ludolf Smids (Amsterdam, 1711). In the print there is more space to the left of the castle. It is possible that the drawing has been cut at the left side, for Roghman used paper for this part of his series that measured at least 358 by 507 mm and had a watermark of a shield with a French lily.[9] This means that the Woodner drawing may indeed have lost a little at the top and at one side.

73

**FIGURE 1**

*Bird's Eye View of Culemborg,* from Blaeu's Atlas, Rijksprentenkabinett, Rijksmuseum, Amsterdam

In 1647 the castle belonged to Heinrich Volrad von Waldeck (1642–1665), whose father inherited it in 1639 from Floris II van Pallandt, a well-known adviser to Prince Frederick Henry of Orange. In 1652 Waldeck received some charming letters from his twelve-year-old sister Amalia Catharina in Berlin, who wrote to her "sweet and most beloved brother" about how she liked the Brandenburg court but liked Culemborg "a thousand times better."[10] In 1672, when the French invaded the Netherlands and destroyed many sites, the castle is thought to have been seriously damaged. Thereafter the Waldecks used a house within the walls of Culemborg. In 1720 the Dutch possessions of the Waldeck family were sold to the city of Nijmegen and gradually the buildings were demolished. In 1735 shiploads of bricks were transported to Muiden to reinforce the dike of the Zuiderzee, and this was considered the end of Culemborg Castle.

• *Wouter Th. Kloek* •

**NOTES**

1.  It is difficult to establish an accurate accounting of the original series of drawings. The first inventory, the so-called List of Bentes, counts 247 sheets, but in fact, because of inaccuracies, mentions 245. It is possible that there were even more, for only two drawings of "Kuijlenburg" are noted, whereas three are now known. For the surviving drawings it is again difficult to fix the exact number. The first volume of Van der Wyck et al. 1989 mentions 222. A few, however, are only known in copies (e.g., Van der Wyck, no. 135); two drawings representing Geervliet Manor turned out to be fragments of a single drawing (nos. 51 and 53), and

a hitherto unknown drawing was reconstructed from two smaller sheets (2:135, no. 14*).

2.  *Wijnestein* (Van der Wyck et al. 1989, 1: no. 214) was auctioned in Amsterdam at Christie's on 15 November 1993, lot 95.

3.  Pelinck in Fockema Andreae et al. 1952, 57; Broos in exh. cat. Amsterdam 1983, 179, 191. See also Van der Wyck et al. 1989, 1:6.

4.  Van der Wyck et al. 1989, 1:7.

5.  Van der Wyck et al. 1989, 1: no. 219, and 2:1.

6.  For a detailed biography, see S.A.C. Dudok van Heel and M. J. Bok in Van der Wyck et al. 1989, 2:6–14.

7.  Van der Wyck et al. 1989, 2:115.

8.  Van der Wyck et al. 1989, 1: nos. 98, 100.

9.  Van der Wyck et al. 1989, 2:131 n. 7.

10.  This letter, a remarkable mixture of German and Dutch, is quoted in Beltjes and Schipper 1988, 121, a book that also deals with the iconography of Culemborg.

**PROVENANCE**

Hillebrand Bentes; Christian van der Hoeck; Anthonie van der Hoeck; Cornelius Ploos van Amstel, Amsterdam (1726–1798) (sale, Amsterdam, van der Schley… Roos, 3 March 1800, part of Album KK, lots 1–6, consisting of 248 drawings, to Roos); probably sale L. Dupper Wzn, Dordrecht, 28–29 June 1870, lot 277, to Buffa; (Bernard Houthakker, Amsterdam); Woodner Collections (Shipley Corporation).

**EXHIBITIONS**

Amsterdam 1972, no. 40; Woodner, New York 1973–1974, no. 83; Woodner, Malibu 1983–1985, no. 53; Woodner, Munich and Vienna 1986, no. 64; Woodner, Madrid 1986–1987, no. 76; Woodner, London 1987, no. 66; Woodner, New York 1990, no. 81.

**LITERATURE**

Van Alkemade [1646/1647]; Beltjes and Schipper 1988, 119, fig. 89; Van der Wyck et al. 1989 1:2, 9, 16 n. 1, 119, 248, no. 99; 2:116, 134; Sumowski 1979–1992, 10:4990–4991.

# 74 The Adoration of the Shepherds

**1650/1655, oil on laid paper, laid down, 412 x 609 (16 ¼ x 24)**

**Inscribed on the mount at lower center in pen and brown ink: *Bene Castigli:***

**Woodner Collections**

*The Adoration of the Shepherds* is a splendid example of a unique medium that Castiglione, an extraordinarily inventive artist, seems to have devised early in the 1630s and for which he is perhaps most admired today. Known as brush drawings, these works, in which the artist combined drying oil and rather coarsely ground reddish brown or brown pigment directly on paper, were no doubt intended to emulate the oil sketches on panel by Peter Paul Rubens and Anthony van Dyck that Castiglione would have known in his early years in Genoa or in Rome. He produced hundreds of these virtuoso pieces throughout his career. Highly finished works in themselves, in no sense preparatory for other compositions, they are often enriched with accents of colorful red, blue, ocher, or green and are in effect like small paintings on paper. The same streak of technical originality that drove Castiglione to conceive this unique combination of drawing and painting also led him to create the first known examples of the monotype print process, apparently to execute the first soft-ground etching (a century and a half before the technique came into common use), and to introduce the influence of Rembrandt into Italian printmaking.[1]

Like most of Castiglione's brush drawings, the Woodner sheet cannot be related directly to any dated work, but on the basis of the composition and the handling of paint it can be placed in the early to middle 1650s. The brushwork is sure, fluid, lively, and lyrical, far more mature than the dense, sober, and rather dry handling of paint in what appear to be his earliest brush drawings. Yet it does not show the remarkably swift, abbreviated, staccato quality of the works from near the end of the artist's life in the late 1650s and early 1660s, in which brush strokes seem to dissolve into flurries of rapid motion. The composition of the Woodner sheet is likewise typical of the broad, loosely classicizing arrangements of figures before colonnaded backdrops that Castiglione used certainly by the late 1640s.

Vestiges of the wide range of influences that merged in the formation of this versatile artist's style over a quarter century are apparent in the Woodner *Adoration*. By the end of his formative years in Genoa in the late 1620s Castiglione's manner was rooted in a Flemish-Genoese naturalist tradition that emphasized crowds of animals and heaps of still-life objects, meticulously rendered as to their various textures of fur, feathers, cloth, and metal, in the foregrounds of often tumultuous compositions. The sheep, goats, and fowl accompanying the worshiping shepherds here recall these early animal motifs, which the artist never abandoned. After Castiglione's move to Rome—sometime before 1632—and his contact during the 1630s with the intellec-

tual and classicizing idioms of Nicolas Poussin and Pietro Testa, his early manner changed dramatically toward a more orderly and organized grouping of figures parallel to the picture plane, as can be seen in the Woodner drawing. Many of his compositions are loosely based on those of Poussin, and many of his subjects are drawn from that artist's paintings, with motifs from classical antiquity—such as herms, sarcophagi, vases, altars, sculptured reliefs, plinths, and columns—piled up or overturned in a picturesque and decadent chaos that is decidedly unlike Poussin. By the time of Castiglione's second documented stay in Rome from 1647 to 1651, his style was transformed yet again, toward a sort of "ecstatic" baroque grand manner in which the influences of Pietro da Cortona, Giovanni Lanfranco, and Gian Lorenzo Bernini can be seen and in which saints or angels often hover in the air gesticulating wildly in adulation or rapture, as do the angels seen here above the Holy Family.

Castiglione's style by the mid-1650s thus combines an earthy naturalism with a dramatic emotional intensity, and his subject matter ranges from romantic evocations of the splendor of the ancient past to pessimistic meditations on the fragility of human life, the futility of human endeavor, and the ephemeral nature of all earthly things and accomplishments. The Woodner *Adoration of the Shepherds* seems to fall midway between the artist's well-known altarpiece of the subject in the church of San Luca in Genoa, dated 1645 (fig. 1),

74

**FIGURE 1**

Giovanni Benedetto Castiglione,
*The Adoration of the Shepherds,*
San Luca, Genoa

**FIGURE 2**

Giovanni Benedetto Castiglione,
*The Adoration of the Shepherds,*
The Royal Collection © Her
Majesty Queen Elizabeth II

and a number of brush drawings of the
scene that can be placed in the early 1660s
(fig. 2). As is the case with many of his
favorite themes, he repeated the subject
more than a dozen times in painting and
in drawing.  • *Ann Percy* •

**NOTE**

1.  On Castiglione and soft-ground etching see Blunt
1971, 474–475. For biographical information and bib-
liography on Castiglione see Blunt 1954; Percy in exh.
cat. Philadelphia 1971; *Lettere e altri documenti* 1971,
1973, 1975; Borroni and Algeri 1979, 84–89; Bellini in
exh. cat. Milan 1982; and exh. cat. Genoa 1990, esp.
13–28 (Timothy Standring, "La vita e l'opera di Gio-
vanni Benedetto Castiglione," which is the fullest
and most up-to-date account of the artist's career).

**PROVENANCE**

C. R. Rudolf (sale, London, Sotheby's, 4 July 1977, lot
107); Woodner Collections (Shipley Corporation).

**EXHIBITIONS**

Woodner, Malibu 1983–1985, no. 30; Woodner, Munich
and Vienna 1986, no. 31; Woodner, Madrid 1986–1987,
no. 39; Woodner, London 1987, no. 29; Woodner, New
York 1990, no. 37.

# 75 Kneeling Man Bound to a Tree

c. 1685/1695, red chalk heightened with white on
gray-brown laid paper, 490 x 305 (19 ⁵/₁₆ x 12)

**Woodner Collections**

The Woodner drawing of a kneeling nude
man belongs to the class of drawings
known as "academies," so named in honor
of the places where most such drawings
of posed male nudes were made. In Paris,
where the Woodner figure was likely drawn,
life-drawing classes were offered to quali-
fied students at the Académie royale from
the moment it was founded in 1648. They
were considered so fundamentally impor-
tant to the formation of young artists that
two-hour sessions were held on every nor-
mal working day, a program that continued
uninterrupted until 1791. Amazingly, places
were provided for as many as 120 students
to work at one time.[1]

The Woodner drawing was previously
attributed to Charles Le Brun (1619–1690),
one of the founders of the Académie royale
and the artistic leader in France in the sec-
ond half of the seventeenth century. Com-
parison with other drawings by Le Brun
shows, however, that the execution is not
his.[2] His influence, though, is strongly felt
in the style of the drawing and the powerful
proportions of the figure, suggesting that
the artist who made it had perhaps been
trained in Le Brun's studio. The command-
ing presence of the figure, the forceful
application of the red chalks for both the
contours and the interior modeling, and
the overall spirit of the drawing further in-
dicate that it was probably made during
the last quarter of the seventeenth century.
Its author would therefore have been a
contemporary of Jean Jouvenet, Antoine
Coypel, Louis de Boullogne, and other
artists of the generation that led French art
into the eighteenth century. All of these
artists made comparable academy draw-
ings, but the particular characteristics of
their draftsmanship differ from those found
in the Woodner drawing.[3]

On occasion, in the course of com-
pleting an academy drawing, an artist
would create a setting for the nude figure,
thus transforming a drawing produced as
a learning exercise into a more serious
subject drawing. Sometimes the addition
of attributes and accessories changed
anonymous male nudes into recognizable
historical or mythological personages or
gave them allegorical meanings. In the case
of the Woodner drawing, however, the fig-
ure is given no specific identification be-
yond its captive state. The title has in the
past been given as *Prometheus Bound*,[4] but
Prometheus, who stole fire from the gods,
was said to have been punished by being
tied to a mountain top, not to a tree. Such
elaborated academies were particularly
common in the 1680s and 1690s, the likely
period in which the Woodner drawing was
made. • *Margaret Morgan Grasselli* •

**NOTES**

1. For more information about life-drawing classes at
the Académie royale in Paris, see Pevsner 1940, 82–109,
and James Henry Rubin's introduction to exh. cat.
Princeton 1977, 17–42.

2. Woodner exh. cat., New York 1973–1974, no. 91,
compares this drawing to a number of nude studies
at the Louvre that were catalogued in 1913 under Le
Brun's name but were not in fact by him. Guiffrey
and Marcel 1913, 78, considered all of these drawings
(nos. 6775, 6780, 6781, 6788, 6792, 6800, 6803, 6810,
6817, 6871) to be part of a large group of isolated figure
studies that were "sans grand intérêt et dont l'attri-
bution à Le Brun reste douteuse…."
3. Schnapper 1974, figs. 195, 201–205 (Jouvenet); Gar-
nier 1989, figs. 41, 42, 80 (Coypel); exh. cat. Princeton
1977, no. 7, and Schnapper and Guicharnaud [n.d.],
no. 41 (Boullogne).
4. Woodner exh. cat., New York 1973–1974, no. 91.

**PROVENANCE**
Woodner Collections (Dian and Andrea Woodner).

**EXHIBITIONS**
Woodner, New York 1973–1974, no. 91 (as Charles Le
Brun); New York 1986a.

75

EIGHTEENTH CENTURY

# 76  A Putto Stealing Venus' Floral Wreath

Son of the painter Noël Coypel
(1628–1707), Antoine Coypel
studied with his father and spent
two years (1673–1675) in Italy
during his father's tenure as
director of the French Academy
in Rome. Young Coypel's contact
there with the art of Correggio
(q.v.) was especially important
in the development of his style
and palette. He was admitted
to the Académie royale in 1681,
and under the patronage of
the Orléans family he enjoyed a
highly successful official career
as one of the leading artists of
his day. Named Premier peintre
to the duc d'Orléans in 1688, he
became director of the Académie
royale in 1714 and was appointed
Premier peintre to the king
the next year. He is best known
for his grand decorations of the
Gallery of Aeneas in the Palais
Royal (1702–1705; 1715–1717)
and the chapel at Versailles
(1709–1710).

**c. 1708, red, white, and black chalks on blue laid paper, squared for transfer, laid down, 329 x 241 (12 ¹⁵⁄₁₆ x 9 ½)**

**Inscribed at lower right in pen and brown ink: *84*; and on mount at center left in graphite: *Coypel***

**Woodner Collections**

Previously thought to be related to Coypel's decoration of the Gallery of Aeneas in about 1703–1704,[1] *A Putto Stealing Venus' Floral Wreath* is actually one of eighteen surviving studies made by Coypel in preparation for a large ceiling fresco, *Putti Triumphing over the Gods* (now in the Banque de France depot, Asnières), which was completed in 1708.[2] Venus' pose is largely the same in the painting, with changes made only to the position of the left arm and the arrangement of the draperies across her lap. To clarify the goddess' identity, Coypel added a swan to the painting, placing it on the cloud below her and positioning it so that its left wing would support her left foot. The putto above Venus' left shoulder in the Woodner drawing also appears in the painting, though both the pose of his head and his expression are altered there to give him a more mischievous demeanor.

The fresco presents an unusual variation on the theme of the Triumph of Love, with dozens of playful putti teasing the gods by stealing their attributes. Not even Venus is immune, for though the putto in the Woodner drawing seems to be crowning her with a floral wreath, his naughty expression in the painting makes it clear that he is actually stealing it.

The ceiling was commissioned by Coypel's principal patron, the duc d'Orléans, to decorate a salon of the house he had built in 1704 for his mistress, Mlle de Séry, Comtesse d'Argenton. The fresco was removed from the Hôtel d'Argenton (now destroyed) after the house was purchased by the Banque de France at the turn of this century. It was discovered intact only a few years ago in a warehouse belonging to the Banque de France in Asnières, outside Paris. Although the commission and the subject were known from old references and descriptions, the ceiling had never been engraved or photographed prior to being placed in storage. It was therefore unknown to modern art historians until an extensive series of photographs was published in 1989.[3]

All but one of the eighteen known drawings for *Putti Triumphing over the Gods* were executed in a rich combination of red, black, and white chalks,[4] and all were squared for transfer in black chalk, as was Coypel's usual practice. The Woodner study, though, was the only one executed on blue paper. *Trois-crayons* was Coypel's preferred medium, and he used it to great effect from very early in his career.[5] He was, in fact, its greatest master in France prior to Antoine Watteau (1684–1721), working in a highly personal style that combined firmly sculptural forms with bold coloristic effects. On the Woodner sheet he chose to use just a few touches of black, relying on dense orange-red sanguine and generous amounts of white to create a warmly human yet suitably regal Venus for his ceiling. • *Margaret Morgan Grasselli* •

**NOTES**

1. See Woodner exh. cat., New York 1990, 248, no. 95.
2. For a history and photographs of the ceiling see Garnier 1989, no. 110, figs. 308, 309, 311, 317, 319, 320, 322, 326, 327, 329, 330, 332, 333, 335. The related drawings are all catalogued and reproduced by Garnier (nos. 414–431, figs. 310, 312–316, 318, 321, 323–325, 328, 331, 334, 336–339). With the exception of the Woodner sheet, all of the drawings related to *Putti Triumphing over the Gods* are in the collection of the Louvre.
3. See note 2, above.
4. A study for a seated god (Pluto or Neptune?) (Garnier 1989, no. 422) was executed in red chalk with white heightening.
5. *Trois-crayons* drawings by Coypel are known for projects that are datable to 1680 (a study for an engraved portrait of La Voisin) and 1681 (a study for Coypel's reception piece for the Académie royale); see Garnier 1989, figs. 4 and 9.

**PROVENANCE**

Baron Louis-Auguste de Schwiter, Paris [1805–1889] (Lugt 1768) (sale, Paris, Hôtel Drouot, 20–21 April 1883, lot 26); (Strölin et Bayser, Paris); Woodner Collections (Shipley Corporation).

**EXHIBITIONS**

Woodner, New York 1973–1974, no. 92; Woodner, Malibu 1983–1985, no. 57; Woodner, Munich and Vienna 1986, no. 77; Woodner, Madrid 1986–1987, no. 92; Woodner, London 1987, no. 75; Woodner, New York 1990, no. 95.

**LITERATURE**

Garnier 1989, no. 414.

76

# 77 Scene from the Commedia dell'Arte *(recto)*
# Ornamental and Architectural Studies *(verso)*

*Gillot first trained with his father, the decorator and painter André-Jacques Gillot (d. 1711), and continued his training in Paris with Jean-Baptiste Corneille (1649–1695). In 1715 he was admitted to the Académie royale with a painting of* Christ about to be Nailed to the Cross, *but otherwise he painted few history subjects. Many of his themes were borrowed from the theater. He was also an inventive designer of ornaments and arabesques, many of them published as prints. He was a printmaker and etched a number of his own compositions; he designed and etched book illustrations, notably a series of sixty-eight prints for the 1719 edition of the* Fables de La Motte. *He is now known principally as the teacher of Antoine Watteau (1684–1721).*

**c. 1705/1710, pen and brown ink with gray wash on laid paper (recto); pen and brown ink over traces of graphite (verso), 159 x 214 (6 ¼ x 8 ⁷/₁₆)**

**Woodner Collections**

Claude Gillot's career as a draftsman, painter, and printmaker encompassed a wide variety of activities and subjects, from history painting, book illustration, allegorical arabesques, and ornamental designs to satiri-

**FIGURE 1**
Claude Gillot, *Scene from the Italian Comedy,* location unknown

cal prints (in which, literally, satyrs and nymphs imitated the lives and actions of humans), weird images of witchcraft and magic, and, above all, scenes from theatrical productions. Gillot was, in fact, enthralled by the theater, especially the hilariously irreverent commedia dell'arte and its offshoots at the annual fairs of Saint-Germain and Saint-Laurent. He not only chose to represent scenes from actual plays in his art but also designed costumes and may

once have directed a marionnette show.[1]

Gillot's paintings and prints of theater scenes are invariably humorous interpretations of stage situations that he actually saw, but it was in his drawings that he captured most fully the comic zest and physical energy of the Italian comedians. His spirited pen work and agile, slender figures on tiny pointed feet were perfectly suited to the representation of a style of theater in which the lively gestures and posturings of the actors were as expressive as the words they spoke.

Because the characters of the Italian comedies were mainly stock figures whose roles and costumes were well established, the personnae in Gillot's theatrical compositions can usually be identified, even if the play and scene cannot. In the Woodner drawing, for example, the central figure is the boastful yet cowardly Scaramouche, who appears to be smoothing his moustache as he looks into a mirror. At the far right stands the comic servant Pierrot talking with the troublemaker Harlequin, who is identifiable by the awkward, akimbo position of his right arm. The woman cannot be identified because there is nothing particularly distinctive about her costume, though her prominence in the composition suggests that she was one of the female leads, perhaps Colombine or Isabella. The man with the plumed hat has also eluded identification, though it is possible that he is one of the principal stock characters, such as Mezzetin, who may be mascarading as some-

77 RECTO

77 VERSO

<br>

one else, perhaps a captain.[2] The other two figures, both crouching, appear to be servants.

The plays performed by the Italian comedians and their emulators were very numerous and often not written down, thus neither the scene nor the play that inspired the Woodner drawing has been identified. It was previously called *The Illness of Harlequin,* but since the central figure is clearly Scaramouche—and Harlequin is barely recognizable at the right—that identification now seems unlikely.

Closely related to the Woodner sheet in both execution and composition is another Italian comedy drawing by Gillot (fig. 1),[3] with a seated woman completing her toilette, surrounded by several figures. Indeed that drawing, which is almost exactly the same size as the Woodner sheet, could conceivably be its pendant, for the two compositions are remarkably similar in several ways: the central figures in both drawings are preening before a mirror; both scenes are set in architectural interiors; swags of drapery billow across one corner of each (on opposite sides); and both feature seven figures. In addition, all of the figures are sketched with the same combination of freely calligraphic strokes of the pen and quick touches of wash. These two studies are among Gillot's liveliest renderings of theatrical scenes and are sketched with more verve and spontaneity than a group of more finished theatrical drawings that were made in preparation for prints.[4] The pen work and the washes in those works are more deliberate and settled and appear to represent a later stage in Gillot's

preparatory process than the Woodner study and its mate. Whereas the scene of the woman's toilette may eventually have been transformed into a slightly different episode from the same play and made into a print (fig. 2), the Woodner composition does not seem to be related to any other drawings or prints by Gillot and may not have been developed any further.

On the verso of the Woodner drawing, on the lower half of the page, are a series of border and frame designs with arabesque and rinceaux decorations, and above these some quick sketches of pedestals, column bases, and entablatures supported by small nude figures. None of these sketches, which have the offhand character of random jottings, has yet been connected with any individual works by Gillot, though they are similar to the kinds of ornament and architectural details that appear in print after print by this artist. • *Margaret Morgan Grasselli* •

**FIGURE 2**

Gabriel Huquier, *Mezetin comprend bien qu'il luy faut du secours,* after Claude Gillot, National Gallery of Art, Washington, Mark J. Millard Architectural Collection

**NOTES**

1. Populus 1930, 25, notes that Campardon 1877, 1:381, refers to Gillot as an "entrepreneur de spectacles."
2. In the print *D'un fidelle valet voilà le caractère,* engraved by Gabriel Huquier after Gillot, Polichinelle is dressed as a captain, wearing a less elaborate plume on a hat with an upturned brim (Populus 1930, no. 351).
3. Pen and brown wash, 154 x 205 mm, formerly in the collection of Jacques Guérin, sold in Paris, 20–21 December 1922, lot 41.
4. See, for example, Populus 1930, figs. 34, 36, 70 (all in the Louvre).

**PROVENANCE**

(Strölin et Bayser, Paris); Woodner Collections (Shipley Corporation).

**EXHIBITIONS**

Woodner, New York 1973–1974, no. 95; Woodner, Malibu 1983–1985, no. 56; Woodner, Munich and Vienna 1986, no. 78; Woodner, Madrid 1986–1987, no. 93; Woodner, London 1987, no. 76; Woodner, New York 1990, no. 96.

# 78  Christ Led Captive from a Palace

*Architect, painter, decorator, and stage designer, Giuseppe was the son of Ferdinando Galli Bibiena (1657–1743), whose work he continued and developed. Giuseppe worked in Venice and Vicoforte but was primarily active outside Italy. In many cities of Germany and principally in Vienna he was entrusted with the designing of catafalques and theatra sacra as well as opera sets, the organization of entertainments, and the decoration of theaters. He was charged with organizing the celebrations for the marriage in Dresden in 1719 of the future Augustus III, elector of Saxony and king of Poland, to Maria Josepha of Austria. In 1740 Bibiena's* Architetture, e Prospettive, *dedicate alla Maestà di Carlo Sesto, Imperator de' Romani, was published in Augsburg with fifty engravings after his designs. Together with his son, he decorated the interior of the new theater at Bayreuth in 1748 and redecorated the opera house in Dresden two years later.*

**1740/1745, pen and brown ink, brown and gray wash (for the architecture); pen and black ink (foreground), pen and gray ink (background), both with brown wash for the figures, 608 x 401 (23 15/16 x 15 3/4)**

**Woodner Collections**

The palatial architecture of this drawing, with its lofty arches, zigzag staircase and balustrades, decorative volutes, and above all its perspective, makes it a fine example of theatrical designs by the Bibiena family. It well illustrates their trademark viewpoint, seeing a scene not squarely from the front but from a side angle, and it shows the outstanding effect of extending the apparent space of the design by creating a sense of further rooms radiating to the left and right beyond the immediately visible space.[1]

The specific activity in this grand architecture is from the Passion story: Christ is bound and led from the enthroned judge toward the crowd waiting with the Cross. Representations of dramatic moments from the Passion set into elaborate imaginary architecture like this were known in Vienna as *theatra sacra* and were produced in the court chapel on Good Friday. Giuseppe Bibiena apparently began to design and construct such *theatra sacra* by 1717 and counted them among his most important works. Thus, when he published a book of engravings after his major works of architectural design, *Architetture, e Prospettive,* no fewer than eight of the forty designs finished by 1740 were for *theatra sacra,* the others being fifteen designs for

catafalques and seventeen for theater sets.[2]

This particular drawing has long been considered to be by Giuseppe Bibiena and identified as a preparatory drawing for plate 8 in part III of the *Architetture, e Prospettive* (fig. 1).[3] There are clear comparisons in the basic structure of the central architecture and in the general disposition of figures. There are also, however, many differences between the drawing and the engraving: in foreground setting, in architectural details, and in the specific delineation, costumes, and gestures of the figures. It would be extraordinarily improbable for a professional printmaker like J. A. Pfeffel, who engraved this plate, to alter so much in engraving a drawing. Thus this drawing is best regarded not as preparatory but as related to the engraving in some other way. In fact the prominent use of bollards, the flat arch at the lower right, and the coffered barrel vaults in the background all relate this drawing less to plate 8 in part III than to plate 8 in part I (fig. 2). Further, the immediacy of the action continuing into the foreground, with no proscenium arch and no central foreground monstrance, also relate this drawing to plate 8 of part II (fig. 3). The drawing thus seems to combine elements present in several of Giuseppe Bibiena's designs, as seen in his *Architetture, e Prospettive.*

In comparison with drawings frequently attributed to Giuseppe Bibiena, this drawing is of high quality. The architecture thrusts the figures dramatically forward, but it is also grand in its amplitude and decoration, with the constantly changing

direction and echoing forms of the balustrades being especially effective. In addition, the drawing of the figures, with their variety of spirited gestures and costumes, ranks particularly high among the works of the Bibienas.

In general, to say a drawing is in the style of the Bibienas, or even in the style of a specific family member, is fairly easy. But to move from that to a reasoned attribution to a particular artist is one of the thorniest problems in the connoisseurship of eighteenth-century drawings. In the case of Giuseppe Bibiena the problem is made even more difficult by the volume of his prints and their wide availability for copying and adapting by not only Italian but also German and Austrian followers. Moreover, the style of drawings normally attributed to Giuseppe Bibiena involves careful and regular—even ruled—lines, as well as even and carefully placed brown and gray washes. This is one of the easiest of the Bibiena styles to imitate, raising further difficulties about specific attributions to Giuseppe himself.

To find absolutely secure attributions for Giuseppe one might hope for true preparatory drawings for engravings after his designs. No such drawings in reverse of the plates have yet been published. There are some drawings in the same direction as the plates and identical in their forms;[4] but while a professional engraver could certainly produce a plate in reverse, the absence of even a slight variation from the prints gives one pause about accepting

78

**FIGURE 1**

Johann Andreas Pfeffel, after Giuseppe
Galli Bibiena, plate 8 from part III
of *Architetture, e Prospettive*, National
Gallery of Art, Washington, Mark
J. Millard Architectural Collection

**FIGURE 2**

Johann Andreas Pfeffel, after Giuseppe
Galli Bibiena, plate 8 from part I
of *Architetture, e Prospettive*, National
Gallery of Art, Washington, Mark
J. Millard Architectural Collection

these drawings as preparatory for rather than as copies of the prints. Finally, some drawings attributed to Giuseppe show basic relations to plates of the *Architetture, e Prospettive,* but with interesting variations in detail, rather similar to this drawing.[5] Such inspiration, with variations, however, would be quite appropriate for a good follower as well as for the artist himself.[6]

Thus for attribution one is forced to rely on a more general judgment. Given its high quality and style of line and wash, and its clear relation to plates in the *Architetture, e Prospettive,* the Woodner drawing seems best regarded as a fine example of Giuseppe Bibiena's work for the Vienna court chapel, probably toward the end of his time in that city, 1740–1745. • *Andrew Robison* •

## NOTES

1. See Hyatt Mayor 1945.
2. See Saxon 1969, 105–118.
3. All previous Woodner catalogues.
4. Mariani 1940, nos. 116 and 117 (pls. 4 and 3); Muraro and Povoledo 1970, no. 78.
5. Kelder in exh. cat. Philadelphia 1968, no. 37.
6. Attempting to use preliminary sketches to establish attributions is equally frustrating. The relationship with those sketches is frequently unclear. For example, the Bibiena sketchbook at the Houghton Library may well be by Giuseppe, but the only sketch clearly for a *theatrum sacrum* (folio 206 recto) bears no specific relation to the Woodner drawing. Otherwise, every sketch that could be related to a *theatrum sacrum* (e.g., folios 10 recto, 42 recto, 77 verso) is a more general palatial courtyard or interior equally appropriate for a generic stage design of a palace; and no drawings in the Houghton sketchbook are specifically related to the distinctive forms of the Woodner drawing.

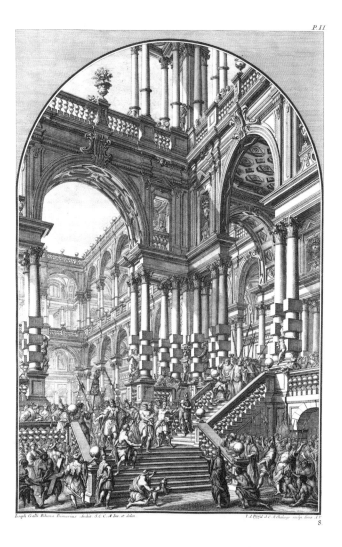

*P. II*

*Joseph Galli Bibiena Primarius Archit. S. C. C. M. Inv. et delin.*      *I. A. Pfeffel S. C. M. Chalcogr. sculp. Aug. Vind. A.°*

8

## FIGURE 3

Johann Andreas Pfeffel, after Giuseppe Galli Bibiena, plate 8 from part II of *Architetture, e Prospettive,* National Gallery of Art, Washington, Mark J. Millard Architectural Collection

## PROVENANCE

Possibly A. Tardieu, Paris [1818–1879] (Lugt 183b); Woodner Collections (Shipley Corporation).

## EXHIBITIONS

Woodner, New York 1973–1974, no. 75; Woodner, Malibu 1983–1985, no. 33; Woodner, Munich and Vienna 1986, no. 33; Woodner, Madrid 1986–1987, no. 41; Woodner, London 1987, no. 30; Woodner, New York 1990, no. 38.

# 79 Saint Mary Magdalene Lifted up by Angels

*After an early training with Gregorio Lazzarini (1655–1730), Tiepolo worked closely in the first decade of his career with Nicolò Bambini (1651–1736). His commissions were confined to the palaces and churches of Venice and the Veneto until 1731, when his reputation spread to Milan. By 1736 he was wanted for work in the Royal Palace at Stockholm. From 1740 on he developed his mature style, often associated with the name of Veronese, which culminates in the great decoration of the Residenz in Würzburg, from early 1751 to late 1753. From 1754 to 1762 he was again highly productive in the Veneto and even executed projects for St. Petersburg. Then he was called to Spain to carry out important commissions for the Spanish Court at Madrid and Aranjuez. A superb draftsman and the master of a rapid and brilliant style, Tiepolo was the premier Venetian history painter of the eighteenth century and dominated decorative painting in Europe during his lifetime.*

**c. 1740, pen and brown ink with brown wash over black chalk on laid paper, 437 x 292 (17 3/16 x 11 1/2)**

**Woodner Collections**

*The Golden Legend* of Jacopo da Voragine, the source of many engaging stories of the early saints, relates that the Magdalene, retiring to a mountain cave in Provence for the last thirty years of her life, was lifted up to heaven by the angels seven times a day, at the canonical hours, to hear the chants of the heavenly hosts; she thus needed no other bodily nourishment.

The Woodner drawing came from the so-called Orloff Album,[1] which consisted almost entirely of large formal drawings on religious subjects, primarily devoted to the Life of the Virgin and the ministry of Christ. Toward the end of the series were three variations on the very unusual theme of Mary Magdalene lifted up by angels.[2] In the first of these she carries a slender Cross; in the second she leaves a skull and book on the ground; and in the Woodner drawing only a skull remains, but these attributes amply establish the identity of the subject.

Very few of the drawings from the Orloff Album relate to paintings or decorations by Tiepolo; most were independent works of art and not preparatory for other projects. It may not be irrelevant to note, though, that in 1739 Pietro Monaco began to publish his handsome series of engravings of *Storie sacre*, including a set of early religious drawings by Tiepolo; this might have suggested the possibility of a series of engravings on a restricted set of religious themes.[3] On the other hand, the three drawings of the Magdalene lifted up by angels have a looseness and exploratory character that suggests they might have been studies for a painting.

Tiepolo painted only one picture related to the story of Mary Magdalene,[4] the early *Penitent Magdalene* (Lauro collection, Naples), though several small devotional pictures of this subject were painted by Giovanni Battista Piazzetta and his associates.[5] The only monumental version was painted by Giovanni Battista Pittoni for the church of La Maddalena at Parma, a project in which Tiepolo was also involved.[6] I have not been able to trace any other representations of Saint Mary Magdalene lifted up by angels in eighteenth-century Venice,[7] but one can hardly dismiss the notion that Tiepolo's interest in the theme was somehow linked to his association with the church of La Maddalena in the late 1730s.

In the middle 1740s Tiepolo undertook a number of projects that involved flying figures, for which many preparatory drawings survive. One may cite the numerous ceilings on the theme of Nobility and Virtue dated between 1742 and 1745, and their related drawings, as well as the remarkable series of flying angels in the Morgan Library that can be linked with the ceiling of the Scalzi of 1745.[8] The style of the present drawing seems decisively earlier, and closer to the preparatory drawings for the Palazzo Clerici in Milan of 1740; hence a date of c. 1740 seems appropriate. • *George Knox* •

**NOTES**

1. See Knox 1961. The album appears to have been an acquisition of Gregory Vladimirovitch Orloff (1777–1826) and was sold in 1920, together with a collection of pictures, by his descendant Prince Alexis Orloff.
2. Knox 1961, nos. 70, 71, 72, lists these among the drawings dated 1750–1760, a date that is revised here.
3. Knox 1965, 389–396. Such a series was already contemplated by Jacopo Amigoni and Giuseppe Wagner (not published) and later continued by Piazzetta and the young Francesco Bartolozzi; see Knox in exh. cats. Venice 1983, no. 89, and Washington 1983–1984, nos. 94, 96.
4. The *Golden Legend* appears to have been published very rarely in the seventeenth and eighteenth centuries. The last Venetian edition in Latin appeared in 1519. There was no English edition between 1527 and 1878; no French edition between 1511 and 1843; and no Italian edition between 1613 and 1849.
5. See Gemin and Pedrocco 1993, 509 (no. 42 in the list of attributed works); and Knox 1992, 69–71, nos. 58, 104.
6. Knox 1985a, 114–124.
7. For non-Venetian examples, see Pigler 1956, 1:457–458.
8. The ceiling drawings are discussed at length in Knox 1978, 78–80. Many of the Morgan angels remain unpublished, but see Knox 1968, pl. 44; exh. cat. Cambridge 1970, no. 39; and exh. cat. New York 1971, 117.

**PROVENANCE**

Gregory Vladimirovitch Orloff [1777–1826]; Prince Alexis Orloff [b. 1867] (sale, Paris, Galerie Georges Petit, 29–30 April 1920, lot 114); André Aucoc (sale, Paris, 3 July 1941, lot 25); (Paul Prouté, S.A., Paris, 1983); (August Laube, Zurich); Woodner Collections (Dian and Andrea Woodner).

**EXHIBITIONS**

Woodner, Cambridge 1985, no. 82; Woodner, Munich and Vienna 1986, no. 36; Woodner, Madrid 1986–1987, no. 44; Woodner, London 1987, no. 33; Woodner, New York 1990, no. 41.

**LITERATURE**

Knox 1961, 275, no. 72; Prouté 1983, no. 19.

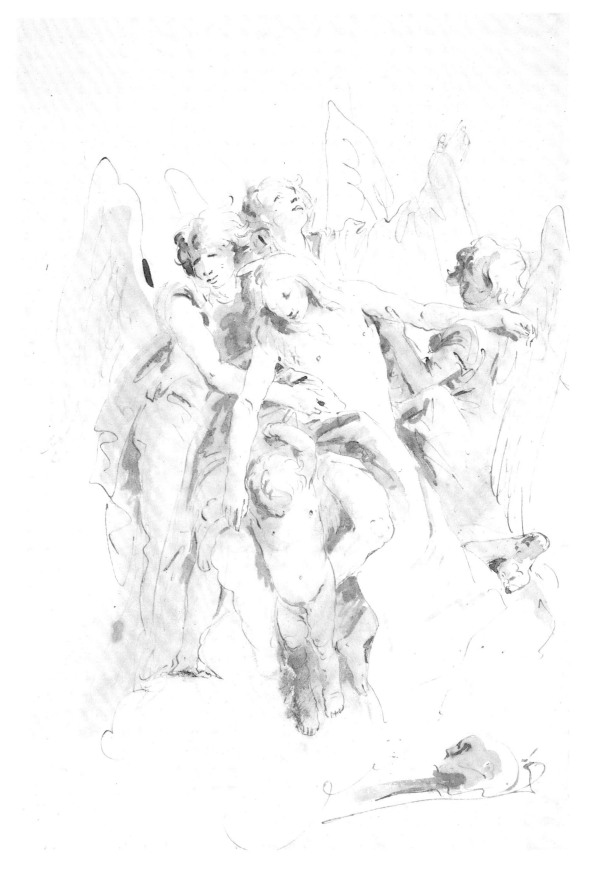

79

# 80 Venus and Cupid Finding the Body of Adonis

**1740/1742, pen and brown ink with brown wash over black chalk on laid paper, 408 x 285 (16 ¹/₁₆ x 11 ¼)**

**Watermark: Initials PA with three-leaf clover (cf. Heawood 3100–3102)**

**Woodner Collections**

This drawing, which came to light quite recently, has an unusual subject with no direct parallel in Tiepolo's painted oeuvre. In truth, mythologies are rare in his work, yet here he tells the story of the discovery of the dead Adonis with a remarkable economy of means, omitting the elaborate detail offered by Ovid at the end of book 10 of the *Metamorphoses*.

A considerable tradition of mythological imagery blossomed in Venice toward the end of the seventeenth century and is perhaps most prominent in the work of Antonio Pellegrini.[1] Enthusiasm for the story of Adonis may have derived from two poems in *La Galleria* by the Cavaliere Marino, published in Venice in 1619, which celebrated two paintings by Pier Francesco Morrazone and Francesco Maria Vanni.[2] The scene was also described in detail in canto 18 of Marino's enormously long epic, the *Adone*, published in Paris in 1623 with a dedication to Marie de Medicis. In the mid-seventeenth century Venice became the center of a Marino cult, promoted by Giovan Francesco Loredan and the "Accademia degl'incogniti."[3] Indeed, in the great room of Ca' Loredan at San Stefano, the story of Venus and Adonis, based on Marino, had been depicted in a large frieze by Filippo Zanimberti.[4] Also known to be directly based upon the text of the *Adone* is Luca Giordano's important painting, *Meeting of Venus and Adonis* (Vancouver Art Gallery). In eighteenth-century Venetian painting, however, the death of Adonis was a rare subject.[5]

Perhaps the most interesting comparison to be made between the Woodner drawing and a painting by Tiepolo is with the *Rinaldo Enchanted by Armida* of 1742 (Art Institute of Chicago) in which, once again, Cupid plays a role; the treatment of trees and the background and foreground are also comparable.[6] But the Woodner composition is a completely visualized entity, which suggests that it was a creation in its own right rather than an exploratory study for a painting. The arrangement is Tiepolo's typical arabesque, with the figures floating in the center of the page.

An appropriate date for the drawing is determined by comparison with other works by Tiepolo. The pose of Venus is familiar from the early *Temptation of Saint Anthony* (Brera, Milan).[7] The more exaggerated rightward swaying of the torso may also be noted in both a drawing of *Mars and Venus* (fig. 1) and the painting for which it is a study, *Apollo Ruling the Heavens* (Kimbell Art Museum, Fort Worth). Other scholars have seen a link between Cupid here and the putto in *Apollo and Daphne* (Louvre, Paris), a painting that is not unlike the present composition in its general structure and theme.[8] All of these comparisons point to a date between 1740 and 1742, which also seems appropriate to the style of drawing.[9] • *George Knox* •

**NOTES**

1. Knox 1995, pls. 8, 11–12, 44–49; see also Sebastiano Ricci's decorations in the Palazzo Pitti.
2. Also note the version by Nicolas Poussin at Caen; see exh. cat. Paris 1994a, no. 17.
3. See Loredan 1633 and Loredan 1649.
4. Described at length in Ridolfi 1648, 2:275.
5. See Knox 1988, 85–86; and exh. cat. Vancouver 1989, no. 1, for Luca Giordano. Pigler 1956, 2:244–247, cites only one Venetian picture of the death of Adonis, by Antonio Bellucci (Kunsthistorisches Museum, Vienna).
6. For this picture see Knox 1978, 53–72; and Gemin and Pedrocco 1993, 356–360, no. 288.
7. Gemin and Pedrocco 1993, no. 69.
8. See exh. cat. Fort Worth 1993, no. 29, for *Apollo Ruling the Heavens*; and Gemin and Pedrocco 1993, no. 301, for the Louvre picture, with a suggested dating of 1744–1745. (I prefer Morassi's date, of c. 1740 for the Louvre painting, which was recorded in a drawing also in the Louvre by the young Francesco Guardi; see Knox, forthcoming).
9. Other scholars have considered the Woodner drawing much later, after 1759.

**PROVENANCE**

(Artemis Ltd., London); Woodner Collections (Dian and Andrea Woodner).

**EXHIBITIONS**

Woodner, Cambridge 1985, no. 84; Woodner, Munich and Vienna 1986, no. 37; Woodner, Madrid 1986–1987, no. 45; Woodner, London 1987, no. 34; Woodner, New York 1990, no. 42.

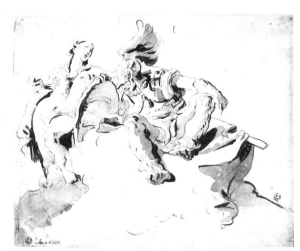

**FIGURE 1**

Giovanni Battista Tiepolo, *Mars and Venus,* Fondazione Horne, Florence

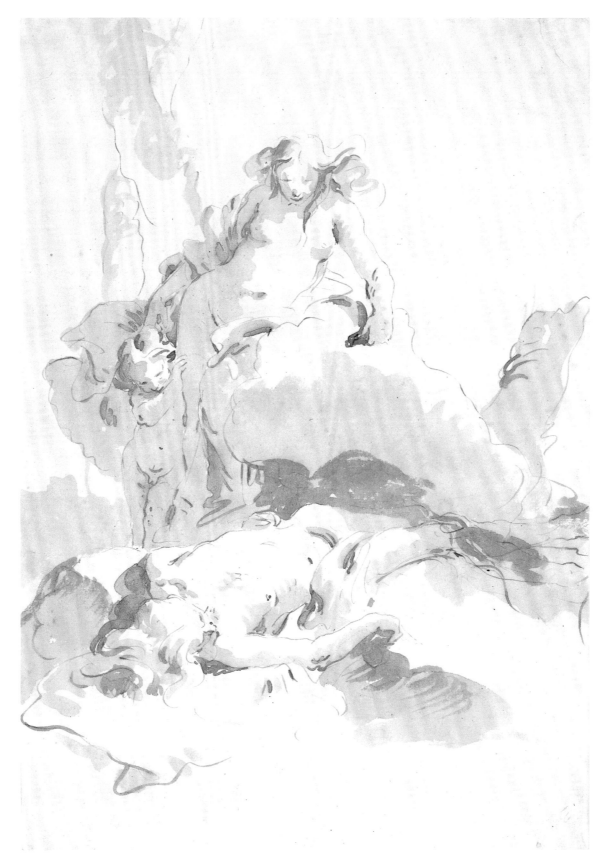

# 81  Head of a Young Soldier

c. 1743, red chalk heightened with white on blue
paper, top corners made up (red chalk rubbing on
verso), 243 x 168 (9 9/16 x 6 5/8)

Inscribed by Domenico Tiepolo at lower left verso
in pen and brown ink: *Xrs 48 / No. 3799* (cut off)

Watermark: Rosa (?)

Woodner Collections

In 1980 this drawing was linked with a study
for a young soldier wearing a breastplate in
Stuttgart (fig. 1).[1] Already in 1970 the Stutt-
gart drawing had been associated with
two large paintings at Archangelskoye near
Moscow, specifically with the one depicting
the *Banquet of Antony and Cleopatra,* which
included two halberdiers in similar costume.[2]
This connection received further support
in 1980, when L. Savinskaya noted that the
subject of one of the four narrow side
pieces that once flanked the large pictures,
now lost, depicted "a soldier and slave with
plates."[3] Both the date and the original
location of the Russian Antony and Cleo-
patra project are much disputed (see dis-
cussion under cat. 82 below), but it is here
maintained that 1743, the date indicated
on a compositional drawing (National-
museum, Stockholm) shows that the pro-
ject was under consideration in that year.[4]
The close association of the Woodner
drawing to a similar red chalk drawing in
the Ashmolean Museum, Oxford,[5] which
is a study for the head of a crouching
soldier in the fresco of *The Continence of*

*Scipio* in the Villa Cordellina at Montecchio
Maggiore, near Vicenza, confirms this, for
a letter dated 26 October 1743 from Tiepolo
to Algarotti suggests that the ceiling of the
villa might be finished within a couple of
weeks. Given the lateness of the year, the
villa's wall frescoes might have been post-
poned until the spring of 1744. Since there
is a blurred reverse image of the Woodner
drawing rubbed off onto the verso of the
Ashmolean drawing, there is every reason
to suppose that these two drawings, among
the earliest and the finest of their kind in
the Tiepolo oeuvre, were executed at much
the same time on adjacent leaves of the
same sketchbook.

The Woodner head was one of 619
chalk drawings sold by H. G. Gutekunst of
Stuttgart on 27 March 1885, from the collec-
tion of the "late secretary Beyerlen." Beyerlen
was a son-in-law of Giovanni Domenico
Bossi (1765–1853), a miniaturist of inter-
national renown, who appears to have
acquired them from Domenico Tiepolo
(1727–1804) toward the end of the latter's
life. This provenance is demonstrated by
the code written by Domenico in ink on
the verso, giving an inventory number and
a price in kreutzers.[6] It was part of 14 lots,
212 chalk drawings, bought by Dr. O. Eisen-
mann of Kassel, and was then acquired by
Wilhelm Lübke (1826–1893), an art historian
of Stuttgart (other Eisenmann drawings
went to Edward Habich of Kassel). After
Lübke's death his drawings were purchased,
along with his library, by Joseph Baer and
Sons, booksellers of Frankfurt, who, after

the First World War, offered the drawings
to the Munich Print Room. In the early
1920s the group began to be dispersed by
the dealer Gaspari of Munich and Dr. Hans
Wendland of Lugano.[7] The Woodner draw-
ing was first published in a catalogue of
the Savile Gallery in London in 1930, which
included eight such red chalk studies.

In the early 1970s a sketchbook of chalk
drawings came to light that had been miss-
ing from the Martin von Wagner Museum
in Würzburg since the Second World War.
The "Würzburg Sketchbook" consisted of
apprentice copies by Lorenzo Tiepolo, mostly
of heads, including a copy of the present
drawing, though by the time the volume got
back to Würzburg, this particular copy was
missing. It demonstrated, however, that the
Woodner drawing has been considerably
cut down at the bottom, on the right, and
more slightly on the left.[8] • *George Knox* •

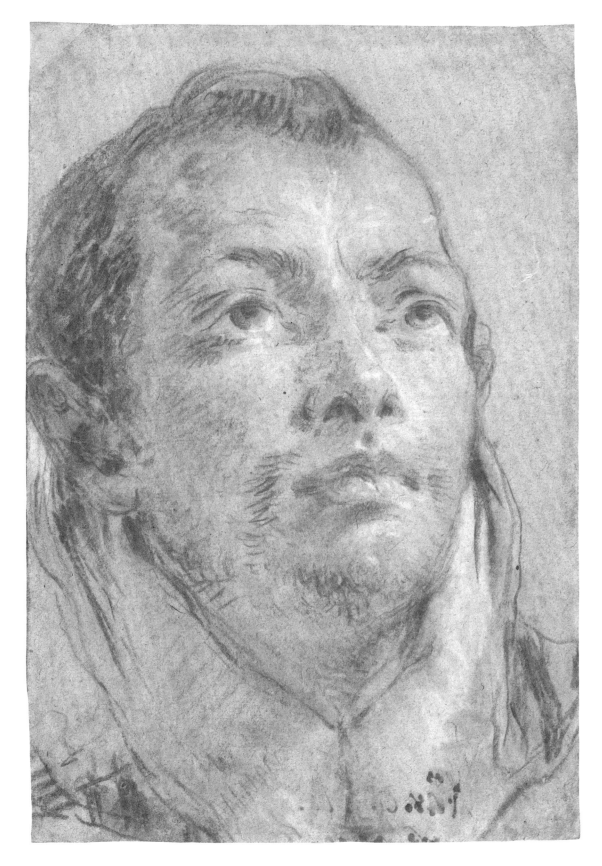

81

### NOTES

1. Knox 1980b, no. M.629, pl. 185.

2. Exh. cat. Stuttgart 1970, nos. 70, 182, 204, fig. IIIa. Note that in 1970 I had not begun to question the date 1747 on the Archangelskoye *Meeting of Antony and Cleopatra*; see subsequently Knox 1980b, M.76, M.138, M.343, M.701, G.19.

3. Savinskaya 1980, 64–69.

4. Knox 1974, 378–390; Knox 1980a, 35–55.

5. Parker 1956, 536, no. 1080; Knox 1980b, no. M.662, pl. 18. Parker was the first to notice that the Oxford drawing bears on its verso a blurred offset of the head from the Woodner page.

6. For a discussion of these numbers see exh. cat. Stuttgart 1970, nos. 8, 9 (facsimile of the pages of the sale cat., repro. p. 198); and Knox 1980b, 205.

7. The remaining drawings were dispersed in the Wendland sale in Berlin in April 1931; see Knox 1980b, 202, nos. M.556–576.

8. Knox 1960/1975, pls. 9, 10; Knox 1980b, nos. M.629, H.73, pls. 185, 186.

### PROVENANCE

Giovanni Domenico Tiepolo; Giovanni Domenico Bossi; Carl C.F. Beyerlen (sale, Stuttgart, H. G. Gutekunst, 27 March 1885); Dr. O. Eisenmann, Kassel; Wilhelm Lübke, Stuttgart; (Joseph Baer and Sons, Frankfurt); Dr. Hans Wendland, Lugano; (Savile Gallery, London, 1930); Sir Francis Barlow; Huntington Hartford (sale, London, Sotheby's, 1 July 1971, lot 63); Woodner Collections (Shipley Corporation).

### EXHIBITIONS

London 1930a, no. 34; Woodner, New York 1973–1974, no. 68; Woodner, Malibu 1983–1985, no. 32; Woodner, Munich and Vienna 1986, no. 34; Woodner, Madrid 1986–1987, no. 42; Woodner, London 1987, no. 31; Woodner, New York 1990, no. 39.

### LITERATURE

Parker 1956, 536; Knox 1980b, 284, no. M.629; also 178, 251, 287, under nos. H.73, M.343, and M.662; MacAndrew 1980, 314, under no. 1080.

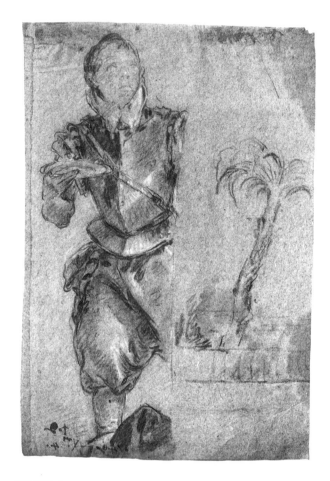

**FIGURE 1**

Giovanni Battista Tiepolo, *Study for a Page*, Staatsgalerie, Graphische Sammlung, Stuttgart

# 82  The Meeting of Antony and Cleopatra

**c. 1742, pen and brown ink with brown wash over black chalk on laid paper, 355 x 261 (13 15/16 x 10 1/4)**

**National Gallery of Art, Woodner Collection 1991.182.2**

During a period that can be extended to 1742–1747 or narrowed to 1743–1744, Tiepolo was deeply involved in three projects on the theme of Antony and Cleopatra: a series of seven canvases for the decoration of a grand room, first recorded in St. Petersburg in 1800 as part of the Yousoupoff collection but surely begun in 1743;[1] a canvas of *The Banquet of Antony and Cleopatra,* begun in 1743 and completed and sent to Dresden in March 1744 (National Gallery of Victoria, Melbourne); and the celebrated frescoes covering the walls and ceiling of Ca' Labia in Venice, datable, I believe, to the summer of 1744.[2] These dates are controversial[3]— only the Melbourne picture is adequately documented—and part of the interest of the Woodner drawing is the light it may throw on the problem.

This relatively finished drawing is generally described as a study for *The Meeting of Antony and Cleopatra,* one of two great canvases in the Yousoupoff collection at Archangelskoye, near Moscow—the surviving elements of the Russian suite of pictures —or more precisely for the preparatory oil sketch in the Wrightsman Collection, New York (fig. 1).[4] The connection with the latter is obvious, although the drawing lacks that exploratory quality characteristic of a true *primo pensiero.* A second drawing of very

similar character (Metropolitan Museum of Art, New York), also associated with the Wrightsman sketch, shows the two figures in much the same attitude but not quite so intimately engaged. That design includes the essential detail of the pyramid on the right.[5]

True preliminary studies for the Wrightsman oil sketch appear to be lacking, but a number exist for its companion piece, the *Banquet of Antony and Cleopatra* (National Gallery, London), made in preparation for the Archangelskoye picture of the same subject.[6] There appears to be a first idea for the whole composition in the Victoria and Albert Museum;[7] and an important drawing of the overall design (Nationalmuseum, Stockholm) bears the date 1743, thus going far toward establishing a general date for the inception of the Antony and Cleopatra project.[8]

The Woodner sheet is executed in a style that is characteristic of many drawings in the Orloff, Horne, and Biron Albums of Tiepolo drawings.[9] These are broadly associated with the frescoed ceiling of the Palazzo Clerici in Milan of 1740, which fits in well stylistically with the Yousoupoff *Meeting of Antony and Cleopatra.* Though often said to bear the date 1747, the Russian picture may be more convincingly argued to be a work for which negotiations opened prior to 1743. Many of these drawings, particularly those in the Orloff and Horne Albums, cannot be related to any specific painting and appear to be independent works.

By the end of 1743 the fine *Banquet of Antony and Cleopatra* now in Melbourne

was well advanced, and a number of studies are known (Fondazione Horne, Florence, inv. 6310; Victoria and Albert, London; and Civico Museo Sartorio, Trieste).[10] These drawings are true preliminary studies, in a vigorous new style that is quite distinct from the more calculated manner of the Woodner drawing.

With respect to the frescoes of Ca' Labia, one may cite several studies (Metropolitan Museum, New York). Only one is related to the frescoes of the great room, whereas others are studies for two independent ceilings of *Zephyr and Flora* and *Bacchus and Ariadne.*[11] More particularly, one may cite a drawing in the Victoria and Albert Museum that might indeed be a first idea for the figure of Cleopatra in the Ca' Labia *Meeting of Antony and Cleopatra.*[12] These again are all true preliminary studies.

Both the Woodner drawing and the Metropolitan study related to the Wrightsman sketch should be dated c. 1742, certainly no later. This helps to substantiate an early date, c. 1743, for the Russian Antony and Cleopatra picture, giving it apparent priority over both the Melbourne painting of 1743–1744 and the frescoes of Ca' Labia, even though these, in my opinion, were certainly undertaken before the ceiling of the Scalzi, which is documented to the summer of 1745. • *George Knox* •

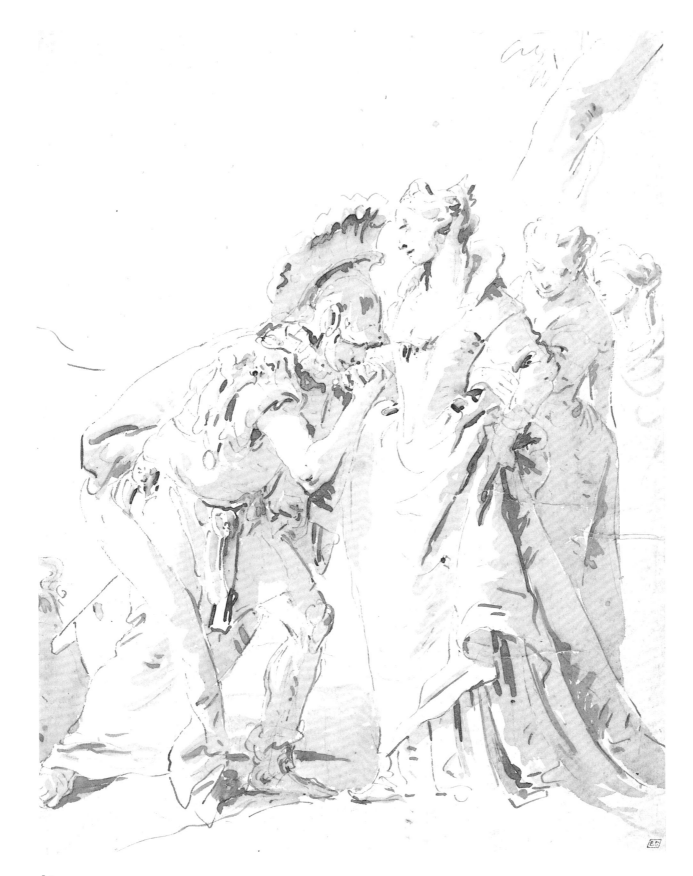

82

## NOTES

1. For the general problem of the Russian pictures see Knox 1980a, 35–55; and Savinskaya 1980, 64–69. The original location of these important paintings is not known. Knox 1974, 378–390, suggested that the two surviving Russian pictures—on the themes of the meeting and the banquet of Antony and Cleopatra— might have been associated with the Palazzo Vecchia at Vicenza; this was based on Jean-Honoré Fragonard's record of the two sketches for these paintings (now Wrightsman Collection, New York, and National Gallery, London) in that building in the eighteenth century. Later it became clear that the two paintings were part of a group of seven, including four narrow side pieces (lost, but brief descriptions survive; see cat. 81) and a ceiling (*Apollo Ruling the Heavens*, Fort Worth, might be the sketch for it), purchased in St. Petersburg in 1800. Knox 1980a proposed that the group might have been commissioned for the great room of the Summer Palace at St. Petersburg, given that it was nearing completion in 1742 and was pulled down in 1797. It is now established, however, that the Melbourne *Banquet* was imported into Russia in 1800, and it is possible that the Yousoupoff suite of paintings was also imported at that time.

2. For the Dresden picture see Gemin and Pedrocco 1993, 308; for the Ca' Labia frescoes see Knox 1980b, 14–18.

3. Pignatti 1982, 70–141, accepts without question the very questionable date of 1747 on the Yousoupoff *Meeting,* as do other scholars, and he proposes 1746–1747 for Ca' Labia; Levey 1986, 143–166, accepts 1746–1747 for Ca' Labia but ignores the Russian pictures; Gemin and Pedrocco 1993, 394–398, 400–401, place Ca' Labia in the summer of 1746 and retain the date 1747 for the Russian pictures; Beverly Brown in exh. cat. Fort Worth 1993, 250–255, takes essentially the same position. None of these scholars addresses the evidence in a completely satisfactory way.

4. See Fahy 1971, 736–749, for the Wrightsman oil sketch. In the Russian picture, the attitude of Antony is altered quite radically.

5. Bean and Griswold 1990, no. 233.

6. For a full discussion see exh. cat. Fort Worth 1993, no. 35, though I cannot agree with the dating there proposed.

7. Knox 1960/1975, no. 85; at that time I still had not questioned the date of 1747 for the Russian *Banquet.*

8. Knox 1974, pl. 48; Bjurström 1979, no. 222.

9. For Orloff see the sale cat., Paris, Galerie Georges Petit, 29–30 April 1920, lots 70–165 (drawings now dispersed). For Horne see Ragghianti Collobi in exh. cat. Florence 1963. For Biron see Bean and Griswold 1990, nos. 92–132, listing forty-one drawings as loosely associated with the Palazzo Clerici.

10. Work on the Melbourne *Banquet* is discussed in Algarotti's letter to Count Bruhl, dated 31 January 1744. For the studies see Hadeln 1927, no. 48; and exh. cat. Florence 1963, no. 122 (7) (Fondazione Horne); Knox 1960/1975, nos. 71, 72, 73 (Victoria and Albert); and Vigni 1942, nos. 57, 57*bis,* 58, 59; and Vigni 1972, nos. 114, 114*bis,* 115, 116 (Trieste).

11. See Bean and Griswold 1990, nos. 210, 225, 226. See also drawings in the Pierpont Morgan Library (exh. cat. New York 1971, nos. 113, 116); the University of Birmingham (see Barber Institute 1952, 196); and sale cat., New York, Christie's, 13 January 1987, lot 60; the Birtschansky collection (exh. cat. Paris 1952, no. 6);

Pobé sale cat., Basel, 1979, lot 96; the Lehman Collection (Byam Shaw and Knox 1987, no. 76); and Joan K. Davidson (exh. cat. Cambridge 1970, 36). An important general compositional study at Trieste has hitherto gone unnoticed (Vigni 1942, no. 105; and Vigni 1972, no. 96).

12. See Knox 1960/1975, no. 85, for the Victoria and Albert drawing; Gemin and Pedrocco 1993, no. 375, for the fresco. Note that the Edinburgh sketch (no. 375a) is there shown reversed.

## PROVENANCE

E. Calando, Paris [d. 1899 or before] (Lugt 837); private collection (sale, London, Christie's, 12 April 1983, lot 98); Woodner Collections (Dian and Andrea Woodner); given to NGA, 1991.

## EXHIBITIONS

Woodner, Cambridge 1985, no. 82; Woodner, Munich and Vienna 1986, no. 35; Woodner, Madrid 1986–1987, no. 43; Woodner, London 1987, no. 32; Woodner, New York 1990, no. 40.

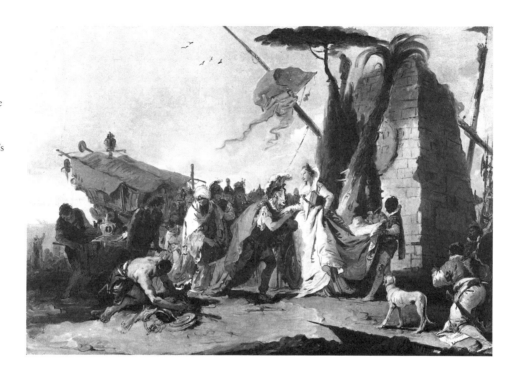

# 83  The Portico of the Pantheon

*Piranesi was a printmaker, archeologist, polemicist, and would-be architect. After studying architecture and stage design in Venice, he traveled to Rome in 1740 in the retinue of a Venetian ambassador and published his first series of etchings there in 1743:* Prima Parte di Architetture, e Prospettive. *With the exception of a short stay in Venice in 1744 and a longer one from 1745 to 1747, he worked exclusively in Rome. Beyond several further series of imaginary designs, he took Roman architecture with its splendid ancient and modern buildings and archeological remains as the subject of his principal series of etchings, including* Le Vedute di Roma *of 1748 – 1778 (135 Roman views) and* Le Antichità Romane *of 1756.*

**1750s and early 1760s, pen and dark brown ink with gray and gray-brown wash over red chalk, overall: 211 x 302 (8 ¼ x 11 ¹³⁄₁₆), composed of three pieces of paper glued together vertically (left 211 x 84; center 210 x 186; right 210 x 74)**

**For inscription on verso see fig. 2**

**Watermark in central section: Star in circle with Latin cross (cf. Briquet 6089)**

**Woodner Collections**

The fiery swiftness and sureness of this drawing, combined with its extreme perspective and coloristic richness, make it a fine indication of those qualities admired in Piranesi's draftsmanship from his own time to the present day.

The Pantheon, begun in 27 BC by Marcus Agrippa, was rebuilt by Hadrian between 118 and 128 AD, and then altered again by Lucius Septimius Severus and Caracalla in the 3rd century. It is one of the greatest, best preserved, and architecturally most interesting and influential buildings to survive from ancient Rome. Thus, in subject as well as in composition, which heightens the enormous scale of the building, this drawing exemplifies Piranesi's lifelong devotion to the magnificence of Roman architecture.

In the general context of Piranesi's work, the construction of this drawing is unusually complex, being composed of three pieces of different types of paper. The central piece of fine and older paper shows the original drawing. The artist indicated this was a finished drawing by enclosing it within rough framing lines, approximately 205 x 155 mm; and this is the only section to include figures or figural groups at the bottom. This central section of the portico accurately shows the great doorway, the Corinthian pilasters before the door, the first two Corinthian columns out from the front, and parts of the two flanking niches. Piranesi did not show the actual open arcades above the cornices of the columns, however. Instead, inspired by the one range of a coffered, barrel-vaulted arch above the pilasters, Piranesi created two coffered, barrel-vaulted ceilings that extend all the way forward and presumably indicate three such ceilings over each of the three main sections of the portico. Thus his drawing is a partial fantasy, or perhaps a suggested reconstruction of the portico, indicating Piranesi's constant interest throughout his career not only in accurately studying the details of ancient structures but also in creatively adapting and improving them.

To this original drawing Piranesi added a piece of contemporary fine paper on the left and a contemporary heavier paper on the right and then expanded the scene. While the drawing materials are generally the same, both of Piranesi's additions show similar and subtle changes from the original section, which indicate at least a somewhat different date for the additions: a darker and more blunt red chalk; darker gray wash on the left and added across the bottom of all three sheets; swifter and sketchier pen lines and wash; and no indication of figures. The additions complete the portrayal of both the flanking niches of the façade, more of the pilasters and columns, and part of the receding left exterior wall of the portico.

Piranesi etched a number of frontal views of the Pantheon or its portico.[1] Of these the location of the spectator in the original central section of this drawing makes it close to one of the smaller plates in volume 1 of *Le Antichità Romane*, published 1756 (fig. 1). The relation to the etching of the original drawing (or of the expanded drawing with the two additions) is not close enough in size, perspective, or detail to call the drawing preparatory, or even clearly preliminary to the etching. As a related drawing, however, the probable date of the small etching, c. 1755, is still relevant. Further, on stylistic grounds, the exact technique of the central section[2] makes it close to a number of Piranesi's drawings that were made as early as 1748 – 1750,[3] though those characteristics appear to continue throughout the next decade.[4] Thus the central framed drawing is surely from the 1750s.

Regarding the revisions to his drawing, close study of the right side yields a new though fragmentary addition to Piranesi's oeuvre as well as a clue to its date. The verso of the right side (fig. 2) shows a section from a large, carefully written pen inscription and a fragment of a red chalk drawing. This latter is in fact part of Piranesi's prep-

83

**FIGURE 1**

Giovanni Battista Piranesi, *Veduta interna del Pronao del Pantheon,* plate xv, fig. 1 from *Le Antichità Romane* (volume 1), National Gallery of Art, Washington, Gift of Mr. and Mrs. Earl H. Look

**FIGURE 2**

Verso of cat. 83 (detail), red chalk with pen and brown ink inscription

aratory drawing for his etched view of the fountainhead of the Acqua Giulia, plate III of *Le Rovine del Castello dell'acqua Giulia,* published 1761 (fig. 3). One clearly recognizes the foremost left wall with its particular damages at top and bottom, its receding section on the right above the two stone steps, the distinctive indentations in the background wall, and the pen letter *F* to indicate the niche. Furthermore, the drawing is the same size as the etching; and red chalk was Piranesi's preferred medium for such a preparatory work, since it could be offset onto the grounded copper plate as a guide and thus reappear in impressions in the same direction as the original drawing. Modest as it is, this fragment is nonetheless the only preparatory drawing for the etchings of the *Acqua Giulia* that has yet come to light, and its clear purpose gives a *terminus post quem* for Piranesi's additions to the original Pantheon drawing, c. 1761.

Beyond their date, it remains an open question why Piranesi took such trouble with the expansions to his original drawing. Earlier in his career he had carefully prepared many of his smaller architectural fantasies for sale or some formal use, mounting them on thick paper with brown framing lines and signing them "Piranesi." In a number of those cases he revised the earlier drawings by adding figures or additional washes. I recall no case of such mounted drawings, however, in which he actually expanded the paper of the basic drawing, especially beyond its original framing lines, and here there is no signature.

Nonetheless, Piranesi was always practical with his time; so one must presume that the *Portico of the Pantheon* was prepared for gift or sale, or, more speculatively but more intriguingly, prepared with his suggestion for elegant revisions to the portico ceiling, just at a time in the early 1760s when Piranesi expected much in architectural as well as graphic patronage from his fellow Venetian, Pope Clement XIII.

About 1767–1768 Piranesi decided to etch another plate of the front of the Pantheon, this time a close-in view of just the portico (fig. 4). To prepare the new view he again took up this drawing, now with its additions, and used its expanded composition to set the exact parameters for the large *veduta.* While the etching is much larger than the drawing, the extent of all its edges and the perspective on the columns match the drawing exactly. Naturally, Piranesi eliminated the coffered, barrel-vaulted

ceilings of the drawing and reinstituted the open arcades above the cornices of the columns, as they were in fact. As was his practice, Piranesi probably made a full-scale red chalk drawing of the scene to transfer it to the grounded plate, which would mean the final use of this drawing should be called preliminary rather than preparatory for the print. In any case, the Woodner drawing provides a fascinating example of the frugality and multiple uses of a single work by a constantly revising artist.
• *Andrew Robison* •

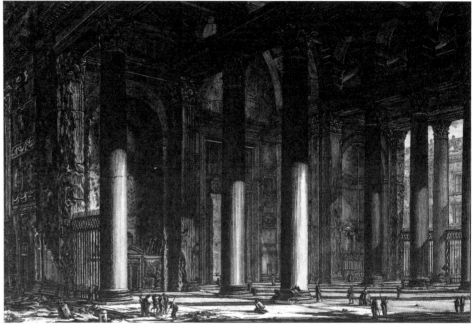

**FIGURE 3**

Giovanni Battista Piranesi, plate III, fig. 1 from *Le Rovine del Castello dell'acqua Giulia,* National Gallery of Art, Washington, Mark J. Millard Architectural Collection

exact delineation of the figures with swift elliptical bulbs, and their minuscule relation to the architecture.

**NOTES**

1. The most relevant five are: in *Le Antichità Romane,* 1: pls. XIIII and XV (published 1756); in the large *Le Vedute di Roma, Veduta del Pantheon d'Agrippa* (published 1761); in the *Campus Martius,* pl. XXIII (published 1762); and a second large veduta, *Veduta interna del Pronao del Panteon* (published 1767–1768).

2. The spindly pen lines; coloristic relation of red underdrawing with pen and brown ink and brown and gray-brown wash; use of thick-nibbed pen with dark brown ink to pick out details and emphasize certain edges; serrated line for edges of cornices; the

3. For example, drawings in a private collection and in Dresden (Robison 1986, figs. 38, 40).

4. For example, the large architectural fantasy in the Ashmolean Museum datable to the mid-1750s (exh. cat. Oxford 1992, no. 41); or the two small studies for etchings of architectural fantasies (Focillon 1918, 123 and 128), which were etched no earlier than 1757 but more likely later, since they were first published in the early 1760s (exh. cat. New York 1993–1994, nos. 26, 27).

**PROVENANCE**

(Eva Dencker-Winkler, Zurich); Woodner Collections (Dian and Andrea Woodner).

**EXHIBITIONS**

Woodner, Munich 1986, no. XIV; Woodner, Madrid 1986–1987, no. 48; Woodner, London 1987, no. 37; Woodner, New York 1990, no. 46.

**FIGURE 4**

Giovanni Battista Piranesi, *Veduta interna del Pronao del Panteon,* National Gallery of Art, Washington, Mark J. Millard Architectural Collection, acquired with assistance from the Morris and Gwendolyn Cafritz Foundation

# 84  A Façade with Bizarre Ornaments

**c. 1769, pen and brown ink with brown wash over black chalk on laid paper, laid down on old cardboard, 601 x 472 (23 ½ x 18 ⁹⁄₁₆)**

**Signed at upper left in brown ink: *Piranesi. f.*; inscribed at lower right in brown ink: *Bought of Piranesi / in Rome March 1770 / by Joseph Rose***

**National Gallery of Art, Woodner Collection 1991.182.17**

This powerful design shows just how far Piranesi was willing to go to defend the artist's need to be an inventive creator in the reuse of classical forms rather than a mere copyist or imitator of such forms. He had already announced this theme in the dedication for his first publication, the 1743 *Prima Parte di Architetture, e Prospettive,* and he defended the thesis throughout his life.[1]

The Woodner drawing was specifically made in preparation for plate v in Piranesi's *Parere su l'Architettura* (fig. 1). This treatise was originally published in 1765, as one of three polemical works, with an architectural headpiece and tailpiece and three plates that reproduce Etruscan friezes. Sometime later six more plates were added to the treatise, five showing façades very similar to this in style. All are signed *Cavaliere Piranesi,* and thus all were finished after Piranesi was given that title in October 1766, confirmed by papal brief in January 1767. Careful analysis of the successive states of Piranesi's etched *Catalogo delle Opere* shows that, in fact, he increased the price for these three

treatises from 12 to 22 *paoli* at the same moment he completed and priced his *Diverse Maniere d'adornare i Cammini.* The *Cammini* was published in 1769, so that year can reasonably be taken as the date for the addition of the six new plates to the *Parere,* justifying a higher price. This then gives the approximate date of their preparatory drawings.[2]

The *Parere* treatise fits into a long progression of Piranesi's polemical arguments against a rising tide of proponents for the supremacy of ancient Greek architecture over Roman.[3] Beginning with Marc-Antoine Laugier's 1753 *Essai sur l'architecture,* a multinational group including Julien-David Leroy, Allan Ramsay, Johann Joachim Winckelmann, and Pierre Jean Mariette praised what they saw as the Greeks' primitive, noble, and beautiful simplicity of structure and ornament. In opposition to this, Piranesi at first defended the austere and magnificent simplicity and strength of primitive Roman stonework in the earliest water systems and foundations (which he saw deriving from native Etruscan architecture before any Greek influence) as well as the originality of the inventive and imaginative variations of ornament in later Roman architectural decoration. By the mid-1760s, though, Piranesi rose above this Greco-Roman controversy, not changing his preference for the Roman but expanding his positive interest and use of motifs from many ancient Mediterranean cultures, including Greek and Egyptian as well as Etruscan and Roman of all periods.

Piranesi's final view, and indeed the most coherent with his lifelong defense of free and creative adaptation, is succinctly stated in the introduction to his 1769 *Cammini:* "an artist, who would do himself honour, and acquire a name, must not content himself with copying faithfully the ancients, but studying their works he ought to shew himself of an inventive, and, I had almost said, of a creating Genius; And by prudently combining the Grecian, the Tuscan, and the Egyptian together, he ought to open himself a road to the finding out of new ornaments and new manners." Indeed, this is just what one sees in this drawing, a mélange of widespread ancient motifs as well as motifs from what Piranesi thought more specifically to be primitive Etruscan (the "Greek key" and wave-patterned friezes), evocative of Etruscan or Greek (the rigid fluted columns), Egyptian (the ankh symbol), and what Piranesi would consider "later Etruscan" or Roman (the acanthus volutes and specifically the split-tailed monster in the central oval, which is based on a Roman gem; fig. 2).[4] Other motifs here may have specific sources yet to be found, or may be attributed to Piranesi's fantasy in creating "new ornaments and new manners" such as the profile head (Hercules?) with a seated owl nesting in the tail of the headdress, the strangely vague reclining animal (the wolf of Romulus and Remus?), or the bizarre sandaled feet, especially the one with the snake curling between its toes and into its severed ankle.

Beyond these individual ancient

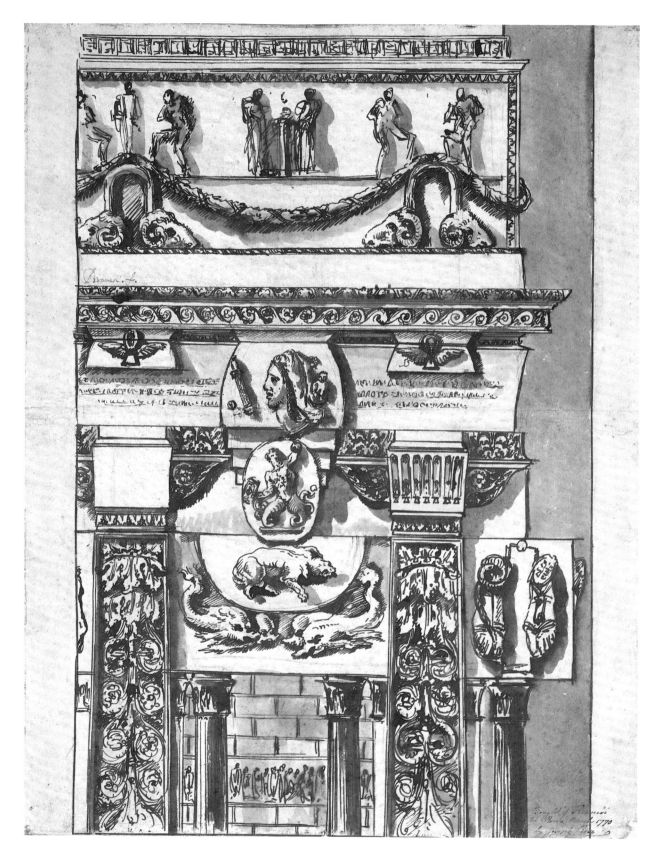

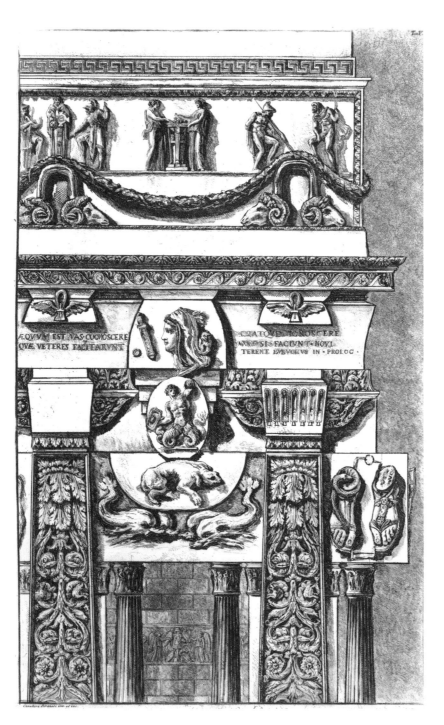

motifs, the Woodner drawing is a splendid example of Piranesi's bold and swift style of pen work, especially remarkable in the figures on the capitals and on the friezes at bottom and top. His brilliant touches of dark wash model and enhance the forms. Finally, Piranesi always insisted that ornament, regardless of its amount or variety, should be adapted to the basic lines and divisions of architectural forms. This is achieved here, in spite of the quantity and prominence of bizarre ornaments, by clear emphasis on the vertical bounds of columns and pilasters, the crisp horizontals separating friezes, and the sharp edges of cornices.

When he came to make the etching, Piranesi reversed the image on the copper plate so it printed impressions in the same direction as the drawing. Careful comparison shows not only the addition of ancient costumes to the figures in the top frieze, but also numerous minor changes in the decorative motifs that were basically determined in the drawing. The major changes from the preparatory drawings for several of these *Parere* plates are the additions of quotations emphasizing Piranesi's views about creative adaptation rather than slavish imitation. Here the quote is from Terence: "It is right to know yourself, and to ignore what the ancients have made if the moderns can make it." • *Andrew Robison* •

**FIGURE 2**

Roman imperial period, *Giant,* carnelian intaglio gem (magnified), The Metropolitan Museum of Art, New York, Gift of John Taylor Johnston

**NOTES**

1. Robison 1986, 12, 15, and n. 80.
2. Three further preparatory drawings for these plates are known: for plates VI and VIII (Kunstbibliothek, Berlin; see Jacob 1975, nos. 869 and 870); and for plate VII (now with David Tunick Inc., New York). Berlin also has a closely related drawing, of similar subject, date, and style (Jacob 1975, no. 867), and there is another in the British Museum (inv. 1908.6.16.44; see Bettagno 1978, no. 37).
3. For a good recent survey see Wilton-Ely 1993, chap. 2, "The Architecture of Polemics."
4. Hugo Chapman identified the source for Piranesi's split-tailed figure; see Richter 1971, no. 249. Chapman's unsigned but excellent entries for the Christie's sale cat., London, 4 July 1989, nos. 104, 105, including this drawing and the Tunick drawing, contain much further information, and especially interesting notes about the original purchaser, Joseph Rose, a plasterer with close ties to Robert Adam. It is provocative to think of Rose creating a wall decoration from such a façade as this, or even part of it, in deeply carved plaster relief.

**PROVENANCE**

Purchased from the artist by Joseph Rose, Rome, March 1770; private collection (sale, London, Christie's, 4 July 1989, no. 105); Woodner Collections (The Ian Woodner Family Collection, Inc.); given to NGA, 1991.

# 85  Portrait of a Young Man

*Perronneau trained with Charles-Joseph Natoire (1700–1777) and the engraver Laurent Cars (1699–1771) but quickly turned from printmaking to painting portraits in oils and pastels. In August 1746 he was agréé, or provisionally accepted, at the Académie royale and submitted oil portraits of the artists J. B. Oudry (1686–1755) and L.-S. Adam l'aîné (1700–1759) as his reception pieces nearly seven years later. In November 1754 Perronneau married Louise-Charlotte Aubert, daughter of Academician and pastel artist Louis François Aubert (d. 1755), and they had two sons. Because fellow pastel portraitist Maurice-Quentin de La Tour (1704–1788) dominated the Parisian scene, Perronneau sought commissions in Europe and Russia. His extended travels and the waning popularity of pastel portraiture contributed to his lack of critical and commercial success in Paris.*

**c. 1753, pastel on blue laid paper mounted to board, 554 x 455 (21¹³/₁₆ x 17¹⁵/₁₆)**

**Inscribed at upper right in graphite: *Perronneau***

**National Gallery of Art, Woodner Collection 1991.182.7**

Jean-Baptiste Perronneau has been called one of the most perceptive and skillful pastel portraitists of the eighteenth century.[1] During his lifetime, however, three factors kept him from attaining the recognition his talent deserved: his rivalry with Maurice-Quentin de La Tour; the scathing criticism of Denis Diderot; and his extended absences from Paris.

By the time of his provisional acceptance at the Académie royale in 1746, Perronneau was an upcoming talent whose presence in Paris caused concern for his more established rival La Tour,[2] prompting the latter in 1750 to undertake to prove his greater talent. Reportedly, La Tour asked to sit for a portrait by Perronneau, and the younger artist reluctantly agreed. Then without Perronneau's knowledge, La Tour embarked on a self-portrait that was close in pose and feeling. When both were hung at the 1750 Salon, it is said that La Tour was shown clearly to be the superior artist, and Perronneau was publicly humiliated. The story may be apocryphal,[3] but it expresses the reality of Perronneau's relationship with La Tour. This was exacerbated by Diderot's unabashed admiration for La Tour and his malicious and personal attacks on Per-

ronneau's art. Indeed, even when Diderot had to admit that works by Perronneau were good, he went on to insult the artist by protesting that Perronneau could not be capable of producing work of such high quality.[4]

Facing keen competition from La Tour for portrait commissions in Paris and withering attacks from Diderot, perhaps it is not surprising that Perronneau spent so much time traveling. He would return to Paris to visit his family and to participate in the Salons. Otherwise, he stayed for long periods in Italy, Holland, and Russia, which prevented him from defending himself against Diderot's criticisms and from courting the favor of potential patrons in the city. His death as a virtual unknown in an Amsterdam inn seems a poignant end for such a promising artist.

The Woodner sheet is a proud affirmation of Perronneau's great skill as a pastel portraitist. It portrays a firm-jawed young man in a full frontal pose, obviously a person of considerable presence. It is not an idealized portrait, but one of keen psychological penetration, as the subject stares frankly out at the viewer. It is also beautifully executed. Typical of Perronneau's technique are the bold touches of pastel laid over blended colors, which create fluttering surface effects. These touches also give the face volume, defining in particular the texture of the hair, the shape of the nose, and the corners of the eyes and mouth. Contemporary critics often complained that Perronneau used too much blue in the shadows and hair, and in fact a hint of blue

can be seen here around the sitter's right ear. The depiction of the lace at his collar is wonderfully tactile, and the twisted forms and pretty patterning soften the seriousness of the sitter's pose and expression.

Regrettably, the sitter in this portrait remains unknown, as is the case with a good number of the subjects in Perronneau's pastels. Partly because so many of Perronneau's sitters are unidentified, the dating of his works has proven a challenge. Costumes and hairstyles sometimes help establish approximate dates, as do comparisons with dated or datable works. In the case of the Woodner drawing, stylistic similarities with a portrait of a member of the Journu family indicate a plausible date of c. 1753.[5] • *Ann M. MacNary* •

**NOTES**

1. Roland Michel 1987, 43. Otherwise there is virtually no recent scholarship on this interesting artist.
2. Goncourt 1948, 168.
3. MacFall 1909, 115.
4. Vaillat and Ratouis de Limay 1923, 88.
5. The connection was made in Woodner exh. cat., New York 1973–1974; repro. in Vaillat and Ratouis de Limay 1909, pl. 19.

**PROVENANCE**

(Galerie Heim, Paris); Woodner Collections (The Ian Woodner Family Collection, Inc.); given to NGA, 1991.

**EXHIBITIONS**

Woodner, New York 1973–1974, no. 105; Los Angeles 1976, no. 156.

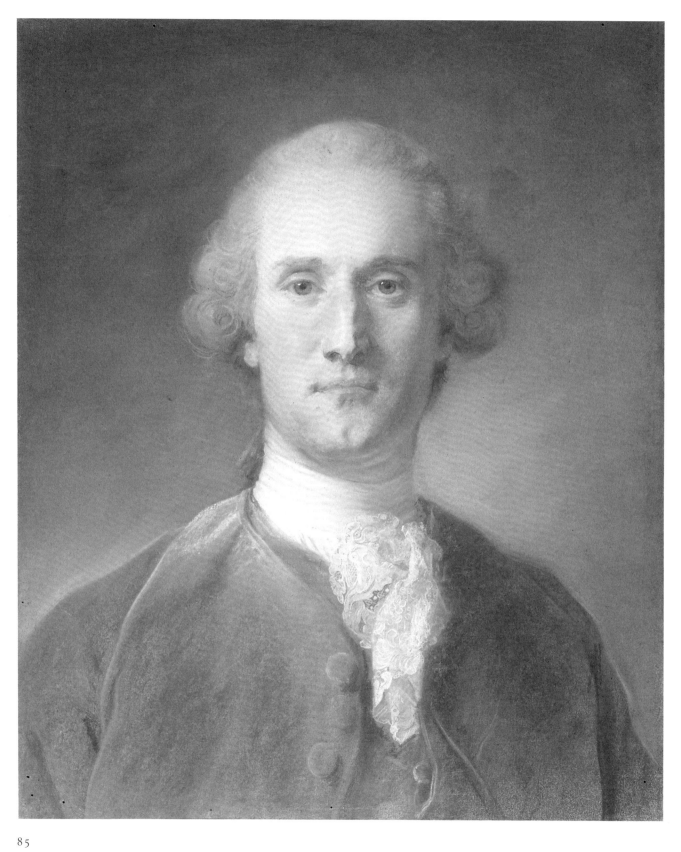

85

# 86  A Young Lady in a Yellow Gown with Blue Ribbons

**c. 1767, pastel on blue paper mounted to canvas, 614 x 505 (24 ⅛ x 19 ⅞)**

**National Gallery of Art, Gift of Ian Woodner 1986.79.2**

As in the Woodner drawing of the gentleman by Perronneau (cat. 85), the sitter in this portrait is unidentified. The young woman is seated at a slight angle but turns her head to look directly at the viewer with a somewhat lazy expression. Though the two Woodner portraits by Perronneau are not pendants, they are treated similarly. Here too the artist laid down accent lines over the blended pastel to create a shimmering surface effect, but he used the technique more extensively here and with more freedom. Unblended pastel strokes not only define the sitter's hair but accentuate her cheeks, nose, ears, the areas around her eyes, and eyebrows. Perronneau has also added a blue scribble in the background to the right of her head. The bright blue, yellow, and white of her garment are applied in a loose, impressionistic way. This work, distinguished by freer handling of the medium, portrays the sitter with remarkable sympathy and truth.

The tradition of pastel portraiture carried on in the work of Perronneau and Maurice-Quentin de La Tour had deep roots in the French portrait drawings of the sixteenth century (see cat. 60). But it had been revitalized at the beginning of the eighteenth century by Venetian artist Rosalba Carriera (1675–1757), who took Paris by storm in 1720–1721 with her beautiful pastel portraits. Historically, the pastel medium has proven to be especially effective for portraits. With a minimum of blending, artists could evoke soft flesh tones, the liveliness of light-dappled silk, and the lushness of velvet. In addition, the brilliance of the color is retained over time, more so than with any other graphic material. And a multitude of colors was commercially available.[1] Since pastel requires no vehicle, such as water or oil, the pigment is applied dry, directly to the support, and the artist sees the result immediately. Sitters thus benefited in that artists could complete their portraits without the lengthy sittings required for oil portraiture, and the pastel portraits were considerably less expensive. In the eighteenth century especially pastels rivaled oil paintings in popularity,[2] and even today they are referred to as "pastel paintings."

For all its vitality and freshness, the disadvantage of pastel is its friability; it is prone to rubbing and loss and must therefore be handled with great care. Perronneau understood both the advantages and limitations of the medium and used it to brilliant effect in this as in all of his pastel portraits. • *Ann M. MacNary* •

**NOTES**

1. Because mixing pastel colors on the paper can produce a rather muddy effect, it is important to apply the widest possible range of tones in separate strokes.
2. The intense palette of pastels often caused them to greatly diminish oil paintings hung next to them, which led the Académie royale to ban works in this medium in Salons. Walker 1983, 191.

**PROVENANCE**

Jacques Doucet, Paris [1853–1929] (sale, Paris, Galerie Georges Petit, 5–8 June 1912, lot 91); purchased by Ian Woodner; given to NGA, 1986.

**EXHIBITIONS**

Woodner, New York 1973–1974, no. 104.

**LITERATURE**

Vaillat and Ratouis de Limay 1923, 199, no. 90.

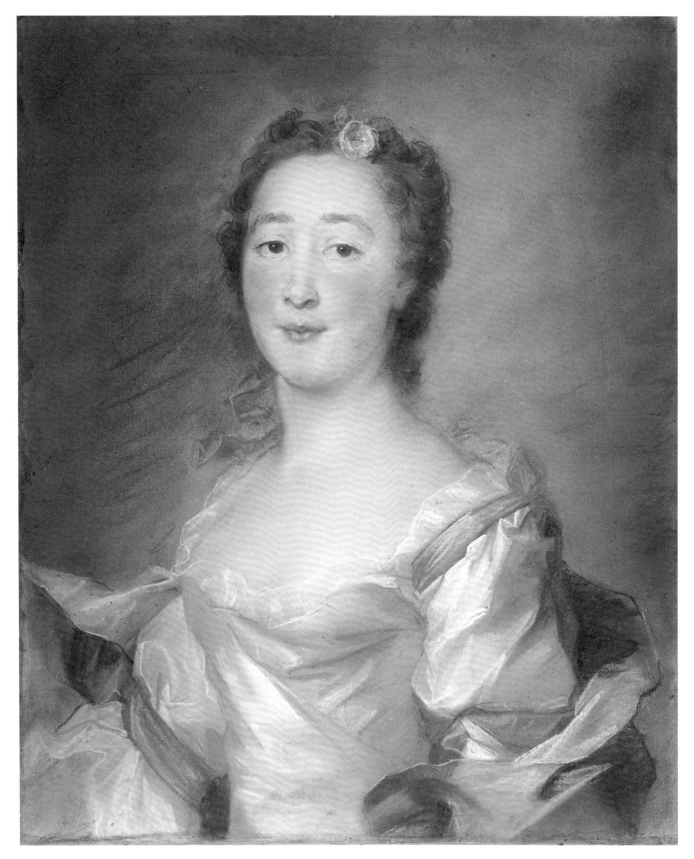

86

# 87  Draftsmen Outdoors

*Son of a dessinateur du roi,
Gabriel began drawing at the
Académie de Saint-Luc in Paris
in 1745. He was first listed as a
student at the Académie royale
in 1758 under Etienne Jeaurat
(1699–1789) and Hyacinthe
Collin de Vermont (1693–1761),
though he had competed for but
failed to win the Prix de Rome in
history painting in 1752–1754.
He then gave up his academic
ambitions and wandered around
Paris, sketching aspects of daily
life. He also sketched exhibited
works in the margins of Salon
and sales catalogues. From 1747
until possibly 1774 he was a pro-
fessor of drawing, proportions,
and allegory at the architecture
academy of Jean François Blon-
del. He also taught at and be-
came director of the Académie
de Saint-Luc in 1776, its last year.
Thousands of drawings by Saint-
Aubin survive, but only about
twenty paintings and fifty rare
etchings.*

**c. 1760, black chalk and stumping on laid paper, 169 x 229 (6⅝ x 9)**

**Signed at lower right in graphite: *St Aubin*; inscribed, probably by Charles-Germain de Saint-Aubin, at lower center in pen and brown ink: *G. St Aubin. del.*; at lower center in graphite: *1780*; on the verso at lower left in graphite: *19729***

**Watermark: FINDE A PALHION / FOREST 1742 (cf. Heawood 3399)**

**National Gallery of Art, Gift of Ian Woodner 1982.81.1**

This evocative, apparently plein-air sketch captures the essence of the style of Gabriel de Saint-Aubin, one of the most compelling of eighteenth-century Parisian draftsmen. Drawn spontaneously, on the spot, the simple and graceful composition features two draftsmen ardently at work under parasols, while two attractive young women, and perhaps a picnic basket, wait by the side.[1]

Saint-Aubin is best known today for his many drawings and prints of daily life in mid-eighteenth-century Paris.[2] He was born into an artistic family: his father Germain, older brother Charles-Germain, and younger brothers Augustin and Louis-Michel were all professional artists; the women in the family also drew and painted. The family's hopes that Gabriel might be a great history painter were crushed when he failed three times to win the Prix de Rome, causing him to turn from his academic aspirations and oil painting to the felicitous

creation of drawings of all aspects of activity in his native Paris, a city he seems never to have left.

In choosing a career devoted primarily to the graphic arts, Saint-Aubin joined a tradition best represented in France by the works of Jacques Callot (1592–1635). The same sense of spirited, lively figures in a defined, believable space can be found in the innovative prints and drawings of both artists, working over a century apart. But Saint-Aubin's on-the-spot reporting of Parisian life was also filtered through the rococo vision of one of the greatest drafts-men of the century, Antoine Watteau (1684–1721), whose elegant, rounded line informed drawings such as this. Indeed, this intimate scene of artists at work, graced by a charming pair of young women, might be seen as a modernized urban *fête galante*, and as such it belongs to one of the strong-est early strains in Saint-Aubin's art.

In 1760 and shortly thereafter Saint-Aubin focused a great deal of attention on painted, drawn, and etched compositions of Parisian boulevard life. Among his most successful paintings are *La Parade du Bou-levard* (National Gallery, London) and *La Réunion du Boulevard* (Musée du Perpi-gnan). The contours that loosely describe the figures and their features in these paint-ings also appear in related drawings, such as the *Vue de Boulevard* (Lugt Collection, Institut néerlandais, Paris).[3]

The Woodner drawing bears Saint-Aubin's signature, at lower right, and two later inscriptions: *G. St. Aubin. del.*, pro-

bably in the hand of his older brother, who annotated many of Saint-Aubin's drawings;[4] and *1780*, in a weak and awkward hand. The latter recalls the late date on a drawing of the artist's studio (fig. 1),[5] ostensibly exe-cuted in the year of his death. This drawing is described by his brother Charles-Germain as the "Dernier dessin de St. Aubin." It has been interpreted by M. A. Staring as an alle-gory by the artist on his approaching death, incorporating symbols of repentance, rather than as a sketch from nature.[6] The date 1780 is particularly persuasive in this case, as it is inscribed twice on the compo-sition: first at lower left, neatly following the artist's monogram signature, and then larger and more legibly at right, in a hand that could possibly be the same as that on the Woodner sheet.

In spite of the late date on the Wood-ner drawing, it is possible that the drawing originated in an earlier period c. 1760, as seems appropriate on stylistic grounds — or possibly even earlier based on its 1740s watermark — but that Saint-Aubin or someone else annotated the sheet with the year of his death. Alternatively, it could be a drawing that the artist actually made in that last year, one that, like the view of his studio, represented an allegory of the artist, a reflection on happier days. If this were so, the drawing could not have been done out-of-doors, for Saint-Aubin died at his brother's house on 9 February 1780 after a long illness. Although executed with great verve and naturalism, this scene could cer-tainly derive from memory or conjecture.

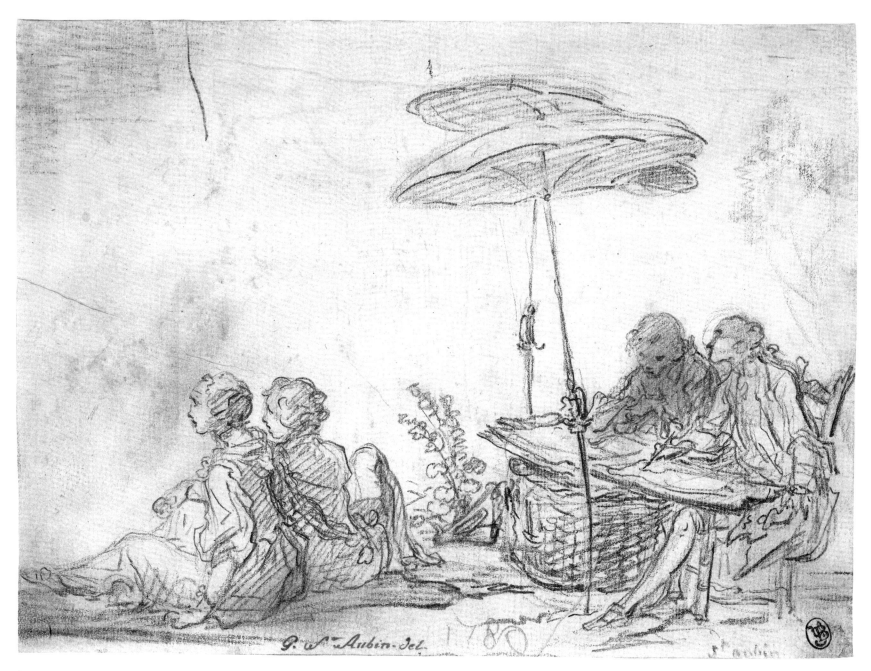

**FIGURE 1**

Gabriel Jacques de Saint-Aubin,
*La Chambre de Gabriel de Saint-Aubin,
rue Jean-de-Beauvais,* Courtesy of
the Trustees of the British Museum,
London

Whether the date 1780 was placed on a later
or an earlier drawing, by the artist or an-
other hand, it serves as a reminder of the
artist's mortality and sets this drawing
apart as an emblem of his life. • *Suzanne
Folds McCullagh* •

**NOTES**

1. Exh. cat. London 1982, no. 34, erroneously described
the scene as four gentlemen drawing.
2. Dacier 1929–1931 remains the most accessible
source on the artist. See also exh. cat. Middletown
1975; and McCullagh 1981.
3. See Dacier 1929–1931, 1: pls. IV, V, VI.
4. Although it is relatively easy to recognize Gabriel's
unorthodox and crabbed handwriting, it is more diffi-
cult to distinguish that of his two brothers. A family
album known as the *Livre des Saint-Aubin* was de-
scribed in the Hippolyte Destailleur sale cat. (Paris,
26–27 May 1893, 32 under no. 111/2, 33, repro.). In it
may be discerned the elegant hand of Charles-Germain
de Saint-Aubin, who assembled the album, documented
many of Gabriel's odd habits, and annotated many of
his drawings. For a full discussion see McCullagh 1981.
5. See Dacier 1929–1931, 1: pl. XL, and McCullagh 1981,
2: fig. 350, illustrating the drawing and its inscriptions.
6. Cited in Dacier 1929–1931, 2:76, no. 461.

**PROVENANCE**

Alfred Beurdeley, Paris [1847–1919] (Lugt 421); Stieglitz
Library, St. Petersburg; Hermitage Museum, St. Peter-
burg, after 1926; private collection (sale, Paris, Hotel
George V, 9 December 1981, lot 60); (Artemis Fine Arts
Ltd., London, 1982); purchased by Ian Woodner; given
to NGA, 1982.

**EXHIBITIONS**

London 1982, no. 34.

**LITERATURE**

Dacier 1929–1931, 2:62, no. 407 (10).

# 88  Avenue of Cypresses at Villa d'Este

*Fragonard studied first with Jean-Siméon Chardin (1699–1779), then with François Boucher (q.v.). He won the Prix de Rome in 1752 and attended the École royale des élèves protégés in Paris before spending nearly five years at the French Academy in Rome, 1756–1761. He was admitted as a provisional member of the Académie royale in 1765 but never completed his reception piece. He turned away from history painting and the grand manner, preferring to paint and draw landscapes, portraits, genre scenes, and gallant subjects. After failing to satisfy Mme du Barry with his ensemble of fourteen paintings for Louveciennes —now considered his masterpiece (Frick Collection, New York)—Fragonard returned to Italy in 1773–1774 with his patron Bergeret de Grancourt. From 1792 to 1797, with the support of Jacques-Louis David (1748–1825), Fragonard served on the Commission du Muséum Central and played an important role in founding what is now the Louvre.*

**c. 1760/1765, pen and brown ink with brown wash and pen and gray ink with gray wash over red chalk counterproof on laid paper, 456 x 342 (17 ¹⁵/₁₆ x 13 ⁷/₁₆)**

**Inscribed on the verso of the mount at lower right in pen and brown ink:** *Près Tivoli, vue du Palais et jardin de la / villa d'Este prise du côté / de l'entrée dans la parterre / Bâtie vers l'an 1540. / Fragonard no 199*

**Woodner Collections**

During the summer of 1760 Jean-Honoré Fragonard, then a *pensionnaire* at the French Academy in Rome, spent several weeks at the Villa d'Este in Tivoli with his friend and patron, the Abbé de Saint-Non (1727–1791). The famous gardens surrounding the villa and the town's picturesque ruins inspired Fragonard to produce a remarkable series of large-scale, red chalk landscapes, which rank among the most admired drawings of the eighteenth century.[1] The stateliest and most imposing of these is *Avenue of Cypresses* (fig. 1), for which Fragonard had positioned himself toward the end of the central pathway in the garden and looked back toward the villa through the "rotunda of cypresses." It is a measure of Fragonard's satisfaction with this drawing that he chose to exhibit it with at least one other drawing from the Tivoli series in the Salon of 1765.[2] Furthermore, he made two other versions of it: a replica in brown wash, with some changes in the figures in the distance and new figures added to the foreground (fig. 2);[3] and the Wood-

ner drawing, which is Fragonard's own reworking with ink and washes of a red chalk counterproof pulled from the original red chalk drawing—and therefore in reverse to it.

Of the three versions, each one distinctly different from the other two in medium and handling, the Woodner drawing is the boldest in visual effect. That is due in large part to Fragonard's use of unusually rich brown washes over a counterproof that was already, in and of itself, intensely colorful and complete. Further enhancing the power of the Woodner version is the lively array of dots, flicks, dabs, and strokes with which the washes were applied, and the swift, crisp pen lines that pick out bits of foliage and clarify some of the contours. In addition, because the Woodner sheet is about an inch and a half shorter than the original drawing in Besançon, the cypresses in this version fill the page more fully and thus seem closer to the viewer than in either of the other two versions.[4]

At least four other reworked counterproofs of Fragonard's Tivoli views are known.[5] It is logical to suppose that all of these were made either shortly after the red chalk landscapes in 1760 or perhaps a little later in response to Fragonard's success at the Salon of 1765.[6] Although Fragonard's wash drawings are notoriously difficult to date, the presence of considerable pen work in the reworked counterproofs militates in favor of a date in the 1760s rather than later in Fragonard's career, when he only rarely

resorted to the pen to pick out the details of his wash drawings.[7] Moreover, in those later works the washes are applied more fluidly and in translucent layers.

Countless artists made pilgrimages to the town of Tivoli and the gardens of the Villa d'Este both before and after Fragonard's visit there, but the most memorable image of all is his view of the famous stand of cypresses that dominated the center of the gardens. Fragonard himself returned to Tivoli with his friend and patron Bergeret de Grancourt on 2 April 1774,[8] but apparently made no drawings then. Certainly it would have been difficult for him to surpass the monumental vision of the *Avenue of Cypresses* he had first created fourteen years earlier and had recreated in two other similarly unforgettable versions thereafter.
• *Margaret Morgan Grasselli* •

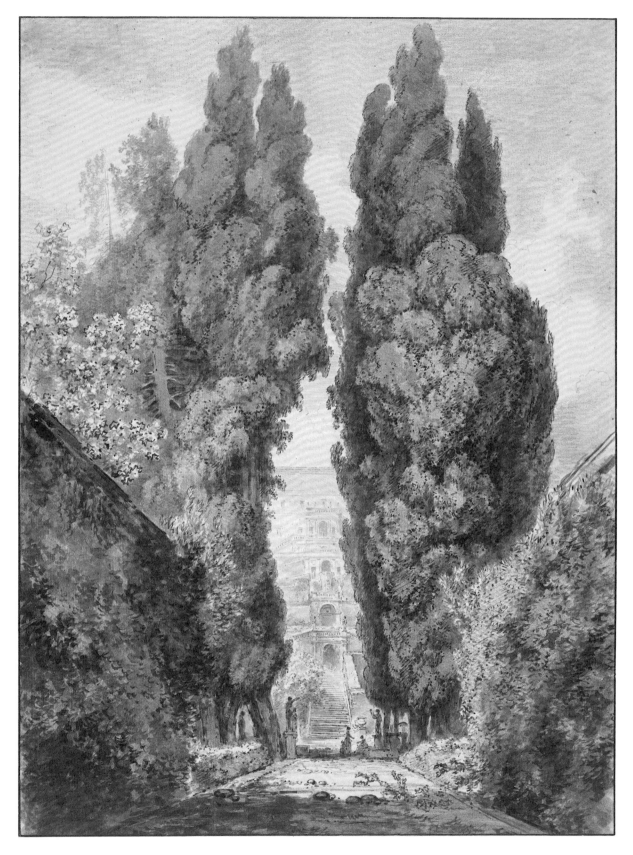

88

**FIGURE 1**

Jean-Honoré Fragonard, *Avenue of Cypresses,* Musée des Beaux-Arts et d'Archéologie, Besançon

**FIGURE 2**

Jean-Honoré Fragonard, *Avenue of Cypresses,* Graphische Sammlung Albertina, Vienna

**NOTES**

1. Ten of the Tivoli views are now preserved in the Musée des Beaux-Arts et d'Archéologie, Besançon. All were reproduced in exh. cat. Rome 1990–1991, nos. 61–68, 70–71.

2. Red chalk over traces of black chalk, 495 x 365 mm, inv. D.2842. Although a former owner, Pierre-Adrien Pâris, noted in 1806 that all ten were exhibited at the Salon of 1765 ("Catalogue de mes livres…," Bibliothèque Municipale de Besançon, MS 1806), only two were mentioned in the Salon catalogue (no. 178). That one of these was *Avenue of Cypresses* is confirmed by a quick sketch made by Gabriel de Saint-Aubin in his copy of the Salon catalogue (Louvre, Paris; repro. in exh. cat. Paris 1987–1988, 107, fig. 6).

3. Brush and brown wash over black chalk, 465 x 343 mm, inv. 12.735.

4. It is not known whether the Woodner sheet was trimmed when it was placed on its mount, or whether the counterproof was taken on a sheet that was already smaller than the Besançon original.

5. Three of these reworked counterproofs were taken from drawings now in Besançon (Ananoff 1961–1970,

2: nos. 868, 892, 920, figs. 229, 711, 244). A fourth was taken from an original that has apparently not survived (Ananoff, 4: no. 2261, fig. 588; and exh. cat. Rome 1990–1991, colorplate 20).

6. Rosenberg and Cuzin, in exh. cat. Rome 1990–1991, under no. 73, suggested that Fragonard reworked the counterproofs several years after his return to Paris in 1761.

7. Very close in handling to the Tivoli views is another series of reworked counterproofs by Fragonard, his illustrations to the *Contes de La Fontaine* (Petit Palais, Paris); see exh. cat. Paris 1992–1993, 191–273, nos. 128–184 (repro. in color). All were done in pen and brown ink with brown wash over black chalk counterproofs, and all measure around 204 x 140 mm. These drawings, too, were most likely made in the 1760s, as Eunice Williams was the first to point out; see exh. cat. Washington 1978–1979, under no. 53; and exh. cat. Paris 1992–1993, 193.

8. *Bergeret et Fragonard* 1895, 279–281. Bergeret spent only a day at Tivoli and apparently devoted very little time to the gardens themselves, which did not seem to impress him unduly. A plan to return to spend eight days to see the sights around Tivoli apparently remained unfulfilled.

**PROVENANCE**

Private collection (sale, Paris, Hôtel Drouot, 29 November 1985, lot 61); Woodner Collections (Dian and Andrea Woodner).

**EXHIBITIONS**

Woodner, Munich and Vienna 1986, no. XIII; Woodner, Madrid 1986–1987, no. 100; Woodner, London 1987, no. 83; New York 1989a *(hors catalogue);* Woodner, New York 1990, no. 104.

**LITERATURE**

Roland Michel 1987, 32, fig. 23; exh. cat. Paris 1987–1988, under no. 30, fig. 2; exh. cat. Rome 1990–1991, 115, under no. 66.

# 89 Bust of an Old Man

*Born in Tournus, Greuze arrived in Paris around 1750. He exhibited at the Salon for the first time in 1755, as an associate member of the Académie royale. Following two years in Italy (1755–1757), the artist enjoyed phenomenal success with his moralistic genre pictures through the mid-1760s. Barred from the Salon of 1767 for failing to present his reception painting, Greuze decided to become a history painter, startling everyone by showing in 1769* Septimius Severus and Caracalla. *The presumed inadequacies of this painting led the members of the Académie to grant Greuze full membership merely as a genre painter. Outraged, the artist dissociated himself from the organization. In his later years he returned to subjects of contemporary life but imbued them with the seriousness and grand scale of history painting. As portraitist and draftsman, Greuze ranks among the finest of his age.*

**Probably 1763, red, black, and white chalks with stumping, wetting, and erasure on light brown laid paper, 466 x 376 (18 ⅜ x 14 ¹³/₁₆)**

**Woodner Collections**

This powerful, life-sized *Bust of an Old Man* is an independent work Greuze executed after the central figure in his painting *Filial Piety* (fig. 1), which was exhibited at the Salon of 1763, purchased by Catherine II in 1765 for the Imperial Academy of Fine Arts,

**FIGURE 1**
Jean-Baptiste Greuze, *Filial Piety*, The Hermitage Museum, St. Petersburg

and is now in the Hermitage.[1] The sheet fully demonstrates the artist's prowess as a draftsman and explains the lasting popularity of his drawings among connoisseurs from his own day down to the present.

Greuze's painting depicts nine members of a family grouped around an aged, paralyzed man reclining in a chair, his upper back supported by a bolster, his legs by a footstool. The subject's mouth hangs open and his eyes are fixed in an exchange with those of a concerned young man at

his left who leans forward to serve him some broth with an egg in it.

Surviving studies for the full figure of the old man (fig. 2) and for his bust (fig. 3) relate more closely to the figure in the painting than the Woodner sheet does. The most significant differences in these drawings made from a model are the parted lips, the eyes turned up more sharply to the left, the soft cap worn by the figure, and the wide collar of the dressing gown. In contrast to these preparatory works, the subject in the Woodner drawing radiates a sense of beatific resignation rather than speechless fright, his Cupid's-bow lips possess the perfection of youth rather than the sag of a stroke victim, and his hair flows softly back with the lightness of incense rather than being entangled in a sweaty mass of curls. It would seem that Greuze, knowing that he had captured from life an image of horrific fascination, decided that he could make of it a more visually palatable and touching image through a euphemistic refinement of detail and a shameless demonstration of his bravura drawing technique in *trois-crayons*.

A crayon-manner engraving made after the Woodner sheet by an unknown artist and identified as being sold by the eighteenth-century print dealer Janinet (fig. 4) testifies to the early recognition of the drawing's importance and also explains the existence of a number of feeble imitations of it, such as one recently on the art market (fig. 5). Students in Greuze's day customarily used such reproductive prints as models for copying in the early stages of their training.

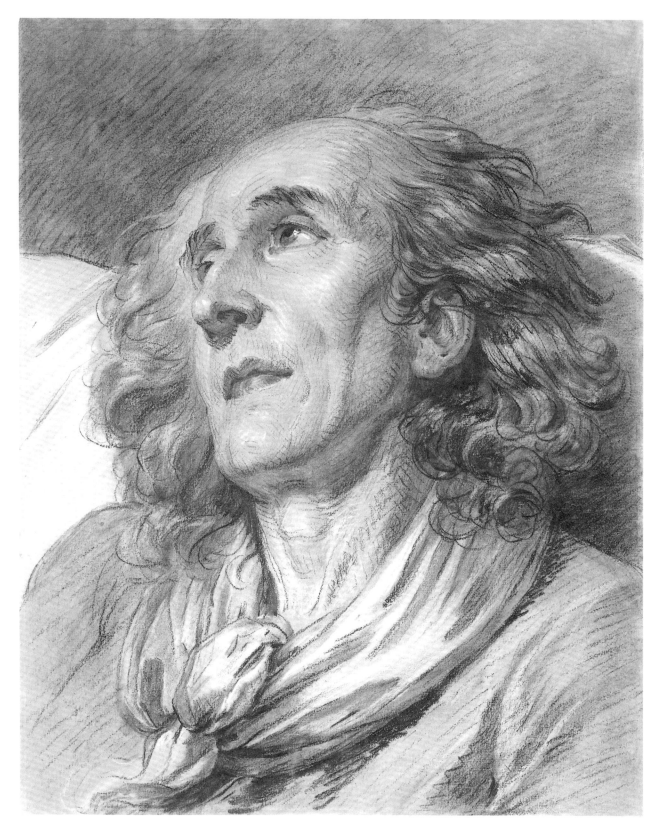

**FIGURE 2**

Jean-Baptiste Greuze, *The Paralytic*, Stichting Hannema-de Stuers Fundatie, Wijhe, The Netherlands

**FIGURE 3**

Jean-Baptiste Greuze, *Bust of an Old Man*, Statens Museum for Kunst, Copenhagen

From a close examination of the Woodner *Bust of an Old Man*, it would seem that Greuze made his initial drawing lightly in red chalk, defining the contours of the head and the lines of the hair along the left side, the crest of the shoulder at the right (which he later raised), and the outlines of the lips. He then worked alternately in red, black, and white chalk in dizzying, spiral cross-hatchings to define the structure of the head and wattled neck, the bulging mass of the scarf, and the extraordinary maelstrom of the hair. The soft, unified textures of the dressing gown and upper background were achieved through a combination of stumping and wetting the chalks to produce unified tannish pink and gray tones. Finally, highlights of black were applied in parallel lines across the background to suggest spatial recession, around the nose—which functions as a monumental prow defining the anatomy of the whole head—the telling vein at the temple, and the feathery eyebrows. Touches of white further accent the bridge of the nose and its tip, suggest the indentation below the Adam's apple, the knot of the scarf, and—most importantly—give the left eye its moist, tearful character.

As was the case with all his greatest drawings, Greuze returned to his subject one final time to grind his black chalk almost violently into the paper in order to accentuate the mass of the chin at the left, to bring out the form of the beautiful shell-like ear, and to make the scarf billow up. It is these touches in particular that make the drawing carry so successfully at a distance and confer upon it the quality of a remarkable, independent work of art.
• *Edgar Munhall* •

**NOTE**

1. The most complete discussions of Greuze's painting are to be found in exh. cat. Paris 1984 – 1985, 232 – 237; and exh. cat. Paris 1986 – 1987, no. 318.

**PROVENANCE**

Destouches (sale, Paris, 5 March 1847, lot 48); Mahérault (sale, Paris, 27 – 29 May 1880, lot 102); Charles Brück (his sale, Paris, Hôtel Drouot, 2 February 1917, lot 59); David David-Weill, Neuilly [1871 – 1952]; (Wildenstein and Co., Inc., New York); Cranbrook Academy of Art, Bloomfield Hills, Michigan (sale, London, Sotheby's, 13 July 1972, lot 13); Woodner Collections (Shipley Corporation).

**EXHIBITIONS**

New York 1944, no. 45; Woodner, New York 1973 – 1974, no. 110; Los Angeles 1976, no. 158; Woodner, Malibu 1983 – 1985, no. 58; Woodner, Munich and Vienna 1986, no. 83; Woodner, Madrid 1986 – 1987, no. 98; Woodner, London 1987, no. 81; Woodner, New York 1990, no. 102.

**LITERATURE**

Henriot 1926 – 1928, 3:213 – 214, pl. 1; exh. cat. Hartford 1976 – 1977, under no. 31.

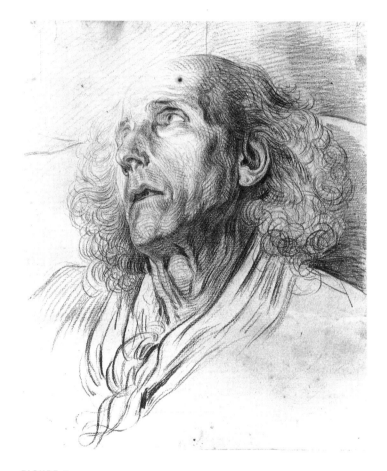

**FIGURE 4**

Engraving after Greuze, *Bust of an
Old Man*, Bibliothèque nationale,
Paris

**FIGURE 5**

Drawing after engraving in fig. 4,
Sophie Marcellin, Paris

# 90  Reclining Satyr

*Born in Rouen, the son of a
painter, Deshays studied there at
the free School of Drawing run
by Jean-Baptiste Descamps (1706–
1791). He moved to Paris to study
first with Hyacinthe Collin de
Vermont (1693–1761), then with
Jean-Baptiste Restout (1732–
1799), and finally with François
Boucher (q.v.), one of whose
daughters he later married. He
won the Prix de Rome in 1751
and attended the École royale
des élèves protégés in Paris
before going to Italy to study at
the French Academy in Rome,
1754–1758. He was agréé by
the Académie royale in Paris
upon his return in 1758 and was
elected to full membership the
following year. Deshays was
quickly established as the lead-
ing religious painter of his
generation but died in 1765 at
the age of thirty-six.*

**1758 / 1765, black chalk with stumping,
heightened with white on brown laid paper,
500 x 390 (19 11/16 x 15 3/8)**

**Watermark: ILEPORC(?) 1758 / GDEROIWEN(?)**

**Woodner Collections**

Previously thought to be by François Boucher,
this energetic study of a satyr seems instead
to be the work of his pupil and second son-
in-law, Jean-Baptiste Deshays (his other
son-in-law was Pierre-Antoine Baudouin;
see cat. 92). Although no related painting
has yet been discovered, Deshays' author-
ship is proven by comparison with a trio of
academy drawings in the Hessisches Lan-
desmuseum, Darmstadt, all of which bear
inscribed attributions to Deshays.[1]

The Darmstadt academies are all exe-
cuted in the same combination of media
as the Woodner drawing, on similarly large

**FIGURE 1**
Verso of cat. 90, counterproof in black and
white chalks

sheets of brown paper. More important,
the chalks in those drawings are used in
very much the same way to describe the fig-
ures and their powerful musculature, com-
bining flowing black contour lines, a dense
web of short black hatchings, bold pictor-
ial use of the stump, and quick touches of
white heightening. Comparison of the
Woodner *Reclining Satyr* with the Darm-
stadt *Reclining Male Nude with a Sword in
His Hand* is striking, partly because of dis-
tinct similarities in the poses, but also be-
cause of close parallels in the treatment
of specific details—in the structure of the
area of the neck, shoulders, and upper
chest, for example, and the particular way
the arms are drawn and articulated. Nearly
identical in both drawings is the shape of
the large bulge of muscle at the top of the
right arm.

The drawings do differ in the greater
finish and the denser use of the chalks in
the Darmstadt sheet, particularly in the
background. But that drawing is a highly
finished academy, complete in itself, while
the *Reclining Satyr*, with its visible penti-
menti showing alternate positions for the
left leg and slightly rougher execution over-
all, seems to have been made as a working
study in preparation for a more elaborate
composition, which has yet to be identified.
On the basis of the watermark, which bears
the date 1758, the Woodner drawing may
be placed in the last few years of Deshays'
short life. That happens to be the period
during which Deshays was most closely
allied with Boucher, whose daughter he

married in 1758, and this explains to some
extent the reflections of Boucher's influ-
ence in the drawing and its former attri-
bution to him.

The counterproof on the verso (fig. 1),
which includes an academy study of a
reclining male nude and—with the paper
rotated 180 degrees—the corner of a low
bed or couch, also seems to be the work of
Deshays.[2] Again, though, neither study is
related to any known paintings or tapestry
designs by him. The delineation of the fig-
ure, in particular, is consistent both with
that of the *Reclining Satyr* on the recto and
with the academies in Darmstadt as well
as other known academies by Deshays.[3]
• *Margaret Morgan Grasselli* •

**NOTES**
1. Inv. 128–130. All three are reproduced in the Gerns-
heim Corpus of Drawings, nos. 132529, 132530, and
132532. The last one is most comparable to the Wood-
ner *Satyr*.
2. In previous Woodner catalogues (New York 1973–
1974 and New York 1990) the verso was considered to
be the work of another hand.
3. Other academies by Deshays are reproduced in
Sandoz 1977, 22–25, figs. 6–9. Particularly close in
spirit to the counterproof on the verso of the Wood-
ner drawing is Sandoz's fig. 7 (location unknown).

**PROVENANCE**
Woodner Collections (Dian and Andrea Woodner).

**EXHIBITIONS**
Woodner, New York 1973–1974, no. 101 (here and sub-
sequently as François Boucher); Woodner, New York
1990, no. 101.

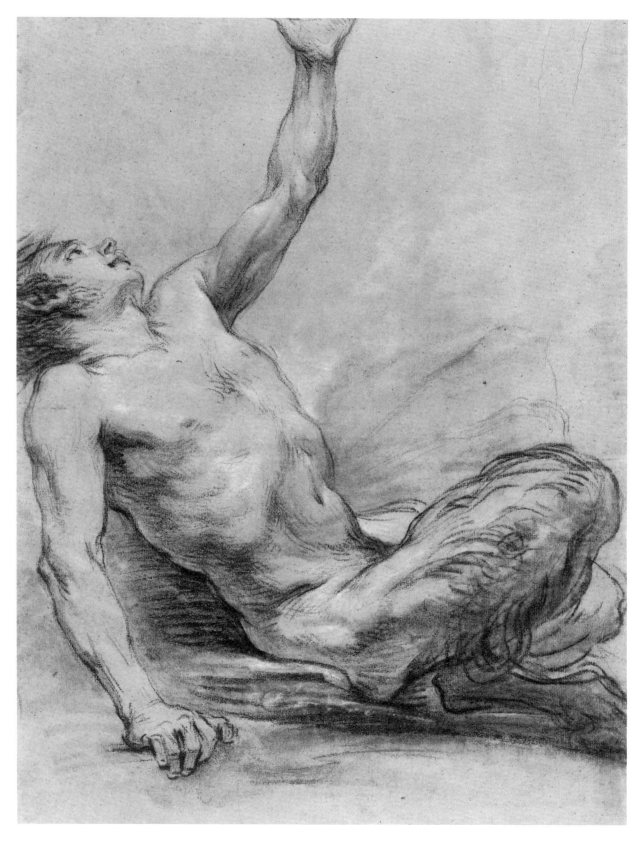

90

# 91  Seven Amorini

*Boucher received his first training from his father, Nicolas Boucher (d. 1743), an embroidery designer, and later with François Lemoyne (1688–1737). From 1723 to 1728 he worked mainly in the workshop of the engraver Jean-François Cars (1665–1763), producing drawings for the engravers and also making some etchings himself, especially after the drawings of Antoine Watteau (1684–1721). He had won the Prix de Rome in 1723 but only traveled to Italy in 1727–1731. In 1734 he entered the Académie royale and began a spectacular official career, fueled in the 1750s by the support of the king's favorite, Mme de Pompadour. In 1765 he was appointed both* Premier peintre *to the king and director of the Académie royale.*

*His pastorales, gallant subjects, allegories, and mildly erotic mythological scenes enjoyed tremendous popularity in his time, in spite of the resounding criticism of Diderot and others who preferred more high-minded art with a strong moral message.*

**1765, black and white chalks on gray-brown laid paper, laid down, 258 x 856 (10 ⁵⁄₁₆ x 33 ¹¹⁄₁₆)**

**Signed at lower right in black chalk: *f. Boucher 1765. f.***

**Woodner Collections**

Mischievous cherubs and winsome children were favorite subjects of François Boucher throughout his career, to the point that his "putti pictures" constituted a separate genre within his oeuvre. No other artist, with the possible exception of Jacob de Wit (1695–1754), depicted children so frequently to parody adult activities; to allegorize the seasons, the times of day, the four elements, and the arts; to enliven, observe, attend, and comment on mythological and historical events; or simply to show them doing the things children do.[1]

In the Woodner drawing seven winged putti have just completed an archery contest. Several arrows have missed the mark, but one has pierced the heart at the target's center. As the exulting victor waits to be crowned with a laurel wreath, one of the losers at lower right has broken his arrows and cries while two others fly away. Although the unabashed charm of both the cherubs and the composition makes light of any serious message, the drawing's subject has clear mythological and allegorical overtones: the archery paraphernalia and the heart-shaped bull's-eye imply a connection with Cupid and his arrows of love, while the results of the contest suggest that there are both winners and losers in the game of love.

The long, low, arched shape of the Woodner drawing suggests a possible connection with an overdoor decoration, but no painted version is known. It has been compared in the past to a set of three rectangular paintings made by Boucher in 1764, one of which shows three putti engaged in an archery match (formerly in the collection of Baronne Renée de Becker, Rome). The poses of the putti, however, are all different, and the relationship between the paintings and the Woodner drawing, which was only made in the following year, seems to go no further than a general similarity of subject.[2]

The high degree of finish of the Woodner drawing, plus the signature and date at lower right, may in fact indicate that the drawing was not made in connection with any of Boucher's paintings but was made for a different purpose altogether. On the one hand, he could have made it as a model for a print in the new "crayon-manner" technique, which imitated the look of chalk drawings. Although no engraving of the Woodner drawing is known, such prints after Boucher's drawings were tremendously popular, and hundreds of them were published during his lifetime and shortly after his death.[3] Alternatively, Boucher could simply have made the drawing as a work of art in its own right. More than any other artist before him, Boucher made finished drawings that were intended to be sold, collected, and displayed in the same way as small cabinet pictures. His choice of a blue paper (now gray-brown) for this composition also suggests that he was thinking in terms of a work that would stand on its own.[4] Indeed, when the drawing was sold in 1777, just twelve years after it was made, it was *sous verre* (under glass) and undoubtedly mounted, perhaps even on its present mount. • *Margaret Morgan Grasselli* •

**NOTES**

1. On Boucher and his predilection for putti and cupids see Laing in exh. cat. New York 1986–1987, 127–129, no. 15.
2. The paintings are reproduced in Ananoff and Wildenstein 1976, 240, nos. 589–591. The Woodner drawing is likewise unrelated to two other drawings by Boucher with similar archery subjects, both now known only through prints; see Jean-Richard 1978, nos. 362, 684.
3. See Jean-Richard 1978, which includes 1,648 individual prints by and after Boucher.
4. The paper is described as blue in sale cat, Randon de Boisset, Paris, 27 February 1777, lot 356. Microscopic examination of the drawing has confirmed that the paper was originally blue.

**PROVENANCE**

Randon de Boisset (sale, Paris, 27 February 1777, lot 356); Baron Alphonse de Rothschild, Vienna; Nathaniel de Rothschild, Vienna; (Rosenberg and Stiebel, New York); Sydney J. Lamon, New York (sale, London, Christie's, 27 November 1973, lot 317); Harry Michaels (sale, London, Christie's, 11 December 1979, lot 158); (Thomas Agnew and Sons, Ltd., London, with Spencer Samuels, New York); Woodner Collections (Shipley Corporation).

**EXHIBITIONS**

Montreal 1953, no. 173; St. Petersburg 1982–1983, no. 27; Woodner, Malibu 1983–1985, no. 59; Woodner, Munich and Vienna 1986, no. 82; Woodner, Madrid 1986–1987, no. 97; Woodner, London 1987, no. 80; Woodner, New York 1990, no. 100.

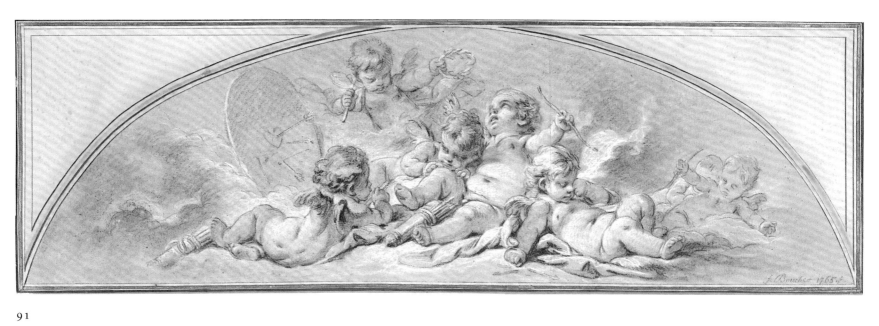

91

# 92  The Honest Model

*The son of a little-known en-graver, Baudouin studied with François Boucher (q.v.), whose younger daughter he married in 1758. He devoted himself pri-marily to the production of mini-atures and highly finished drawings in gouache. Agréé by the Académie royale in 1761 and elected to full membership in 1763, he exhibited at all the Salons in the 1760s. Although he occasionally made portraits and history subjects, he acquired his reputation with mildly erotic boudoir scenes, which were pop-ular with the court and the public and were often engraved. Critics like Diderot and Grimm, however, roundly criticized his work as too licentious and lack-ing in the moral message of the works of his near contemporary, Jean-Baptiste Greuze (q.v.). Baudouin was only forty-six when he died, reportedly because of his libertine lifestyle.*

**1769, gouache with touches of graphite on vellum, 406 x 357 (16 x 14 1/16)**

**Signed at lower center in pen and brown ink:**
*AP* **[in monogram]** *Baudoüin*

**National Gallery of Art, Gift of Ian Woodner
1983.100.1**

Baudouin's highly finished gouache of *The Honest Model* was the subject of considerable commentary and discussion when it was exhibited at the Salon in 1769.[1] The theme of the drawing was clearly set out in a carved legend attached to the top of the original frame (now lost): *Quid non cogit Egestas?* (What does not Poverty compel one to do?). Yet Baudouin left some of the details of his scene sufficiently ambiguous to allow wide differences of interpretation. Most discussion and controversy centered on the identity of the older woman—whether the model's mother or a ruthless procuress—and the meaning of the moment depicted. The model has been posing for some time, as the well-advanced painting on the easel indicates, so why has she suddenly collapsed? Has her mother just arrived on the scene, unaware until now of what her daughter was willing to do to earn money for her family? Or did the mother, driven by poverty, allow her daughter to pose nude, with herself serving as chap-erone, until finally overcome by shame? The expressions of both women seem to belie Diderot's notion (shared by others) that the older woman is "an ignoble creature who engages in some vile business."[2] But re-gardless of *their* relationship and emotional state, the artist is clearly unhappy with the turn of events and vehemently protests the imminent departure of his model.

One of the most interesting, and now perhaps somewhat entertaining, criticisms that was leveled at Baudouin in response to the *Honest Model* was Baron Grimm's asser-tion that Baudouin was as "libertine in his brush as he [was] with his morals."[3] Cer-tainly Baudouin's interpretation of the scene is caught up more in the actions of the fig-ures—and especially of the nude model—than in their psychological states, and the moral lesson is obscured by the attention lavished on the details of the studio interior and the corresponding lack of emphasis on facial expressions. But even if Baudouin was caught up in the anecdotal aspects and mild eroticism of the scene and paid as much attention to the furniture as to the figures, he did not entirely lose sight of the moral purpose of the scene and created a lively yet tender image that was much admired by most of his contemporaries. Diderot, how-ever, thought that such moralizing subjects were better left to his own favorite painter, Jean-Baptiste Greuze, who would certainly have produced a more solemnly edifying work in which the moral message would have been clearly and forcefully conveyed. Indeed, two years earlier, Diderot and Greuze had even discussed the possibility of Greuze's painting this very subject, and Diderot wrote down his vision of the scene.[4]

An earlier, sketchier version of the Woodner composition was on the London art market in 1983 (fig. 1).[5] In that drawing the poses of the figures were already close to Baudouin's final solution, but the paint-ing on the easel was very different and looked rather more like the work of Carl Vanloo than of Boucher. The style of the furniture was already fairly well established, but the room decor in general was not yet fully realized. The Woodner version was reproduced quite faithfully in a print, pub-lished in 1772 by Jean-Michel Moreau and Jean-Baptiste Simonet (fig. 2), which in-cluded one significant change in the posi-tion of the older woman's head.

The Woodner drawing bears impres-sive witness to Baudouin's position as one of the great *gouachistes* of the eighteenth century and underlines his strong debt to his teacher and father-in-law, François Boucher. Indeed, the paintings hanging on the studio walls of Baudouin's young artist and the unfinished work on the easel re-flect Baudouin's intimate knowledge of Boucher's art.[6] He was one of the last and best of Boucher's followers, but within less than a year of the exhibition of the *Honest Model* in the Salon of 1769, both he and his father-in-law were dead and the high rococo style was already falling out of favor.
• *Margaret Morgan Grasselli* •

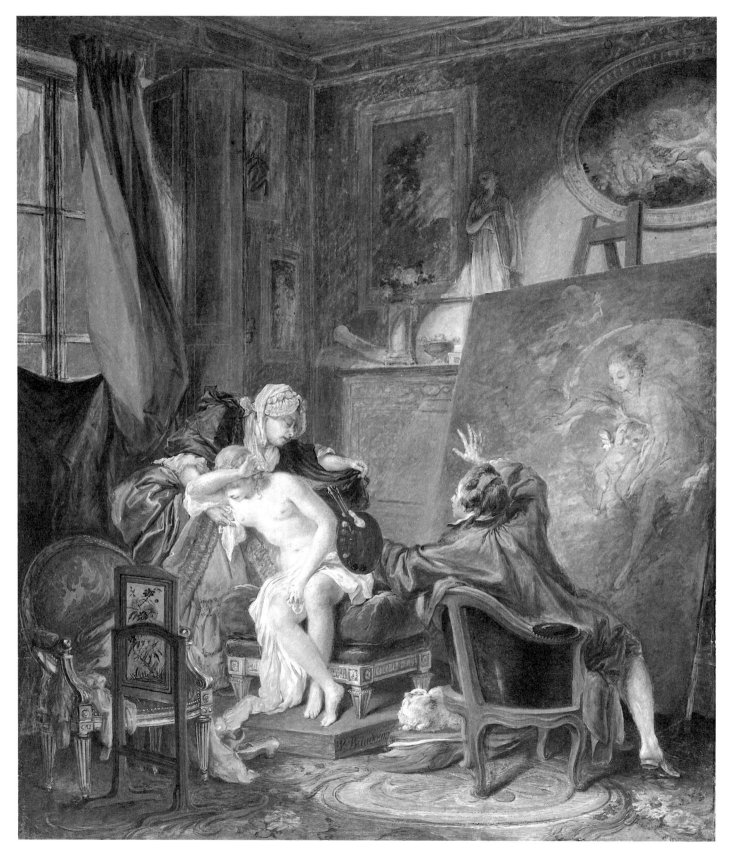

92

LE MODELE HONNÈTE

## NOTES

1. See the first ten references under Literature, below.
2. In Seznec and Adhémar 1957–1967, 4:94.
3. In Seznec and Adhémar 1957–1967, 4:94–95.
4. Diderot mentions his discussions with Greuze in his notes about a painting by Lagrenée in the Salon of 1767 (quoted in exh. cat. Paris 1984–1985, 294). After Baudouin's picture appeared in the Salon of 1769, Greuze claimed that Baudouin had stolen his subject (Grimm in Seznec and Adhémar 1957–1967, 4:94).
5. See exh. cat. London 1983, 55 (repro. p. 32). This version is slightly smaller than the Woodner drawing, measuring 392 x 330 mm, and is painted with thinner washes and a stronger black chalk underdrawing.
6. Diderot tried—unsuccessfully—to steer Baudouin away from the influence of his father-in-law (whom Diderot loathed) and continued to harp on the subject even as late as 1769. Writing specifically in relation to the Salon of 1769, Diderot criticized Baudouin for following too closely the example of "this most dangerous of models…. In your place, I would prefer to be a poor little original than a great copyist" (see Seznec and Adhémar 1957–1967, 4:95).

## PROVENANCE

Mlle Testard (sale, Paris, 22 January 1776, no. 30); M. Prault (sale, Paris, 27 November 1780, no. 41); M. Groult; Mrs. George Blumenthal, New York; Baroness Wrangell (sale, London, Sotheby's, 26 November 1970, no. 93); (William H. Schab Gallery, New York); purchased by Ian Woodner; given to NGA, 1983.

## EXHIBITIONS

Paris 1769, no. 68; New York 1972, no. 67; Woodner, New York 1973–1974, no. 106; Los Angeles 1976, no. 157; Atlanta 1983, no. 79; Paris 1984–1985, no. 34.

## LITERATURE

*Lettre sur l'exposition,* 1769, 29; [Daudet de Jossan] 1769, 35–36; [Cochin] 1769, 28–29; Fréron 1769, 301; Grimm and Diderot in Seznec and Adhémar 1957–1967, 4:94, 95; "Sallon du Louvre," 1769, 151; *L'Avant-Coureur,* 1769, 610; *Sentimens,* 1769, 14; Boulmiers 1769, 1:188–189; Bachaumont 1780, 13, 57; Bocher 1875, 36–37, 53, 55; Dighton and Lawrence 1923, 1:35–37; Bukdahl 1980, 219, 285, 385; Bukdahl 1982, 276–277; exh. cat. Dijon 1982–1983, 196–197, fig. 346.

# 93 Self-Portrait

*The son of a surgeon, Claude Hoin studied at the drawing school of François Devosge (1732–1811) in his native Dijon and then with Jean-Baptiste Greuze (q.v.) in Paris. He lived in Paris for about thirty years and exhibited at the Salon de la Corréspondance in 1779, 1782, and 1783. He served as professor of drawing at the École militaire and in 1785 was appointed painter to the king's brother. He never became a member of the Académie royale but was admitted as a corresponding member to the academies of several provincial cities, including Dijon, Toulouse, Lyons, and Rouen. He returned to Dijon in 1802 and became professor of drawing at the local lycée. In 1811 he was appointed curator of the Dijon museum. Hoin made his mark as a portraitist, especially in pastels and miniatures, and was known also for his highly finished pastorales and genre scenes drawn in gouache and watercolor.*

**c. 1780, red and black chalks and pastel with stumping on gray-brown laid paper, 510 x 375 (20 ¹/₁₆ x 14 ¾)**

**Watermark: Unidentified mark resembling a dagger**

**Woodner Collections**

Although Claude Hoin enjoyed a successful career as a portraitist, miniaturist, and *gouachiste,* his reputation was completely eclipsed in the nineteenth century, so that even works that bore his signature were occasionally attributed to other better-known artists.[1] He was rehabilitated at the turn of the century in a four-part article published in the *Gazette des Beaux-Arts*[2] and has since enjoyed a measure of popularity among collectors and connoisseurs of French eigh-

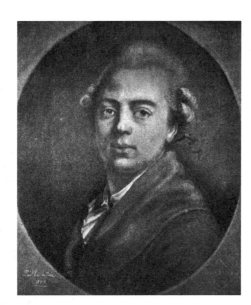

teenth-century art. By 1963 he was well enough regarded to be honored in his native Dijon with a monographic exhibition that featured 111 of his works.[3]

Although the combination of media in the Woodner drawing is unusual for a portrait by Hoin, who was prone to make more finished pastels or elaborate black chalk head studies heightened with white on bright blue prepared paper,[4] the attribution is secure. Indeed, Hoin used a similar combination of red and black chalks augmented by two or three colored chalks in some other drawings, including one of his most alluring, a *Young Woman with a Blue Ribbon* (Musée des Beaux-Arts, Dijon).[5] The touches of stumping in both drawings are also comparable, though more extensive in the Dijon drawing.

Further supporting the attribution of the Woodner drawing is the identification of the sitter as Hoin himself. Hoin is known to have made many self-portraits in a variety of media over the course of his career,[6] and even included a self-portrait in one of his allegorical gouaches, *An Artist Adoring a Statue of Virtue.*[7] Comparison of the Woodner portrait with a pastel made in 1775 when Hoin was twenty-five years old (fig. 1) confirms the identification, for the facial structure and the features are recognizably the same, even to the slight squareness and outward thrust of the lower lip and the small indentation at the tip of the nose.[8] The hairstyle, too, is the same, but because Hoin appears to be slightly older and heavier in the Woodner drawing, it can perhaps

be dated a few years later than the other, c. 1780. By contrast with the somewhat somber, self-conscious pastel of 1775, the Woodner likeness is livelier and more charming, with a lightness of both touch and spirit that add to its appeal.
• *Margaret Morgan Grasselli* •

**NOTES**

1. Goncourt 1881, 1:91, noted that Hoin's name had sunk into oblivion and that "experts so mistrusted the lack of renown of his name…that they auctioned his gouaches, completedly signed, under the name of Fragonard."

2. See Portalis 1899 and 1900.

3. Exh. cat. Dijon 1963.

4. See exh. cat. Dijon 1963, nos. 47, 56, 63, pls. XI–XIII (pastel portraits); nos. 77, 78, 81, pls. XVI, XVIII, XIX (black and white chalk portraits).

5. See exh. cat. Dijon 1963, no. 76, pl. XVII.

6. See Portalis 1900, 22–23, who mentions a number of self-portraits and reproduces one from 1808 (p. 21). Other self-portraits are reproduced in Portalis 1899, 442, 449. Two are reproduced in exh. cat. Dijon 1963 (nos. 40, 63), while several others are mentioned (nos. 26, 33, 44, 45, 59, 60, 88). One other, in the collection of Emile Wolf, is reproduced in exh. cat. St. Petersburg 1982–1983, no. 44.

7. The allegory was first reproduced and discussed by Portalis 1899, 457, 460–461. It was sold at Sotheby's, New York, 10 January 1995, no. 168.

8. Reproduced in Portalis 1899, 449 (listed as belonging to Mme Fernandez).

**PROVENANCE**
Woodner Collections (Dian and Andrea Woodner).

**EXHIBITIONS**
Woodner, New York 1973–1974, no. 112.

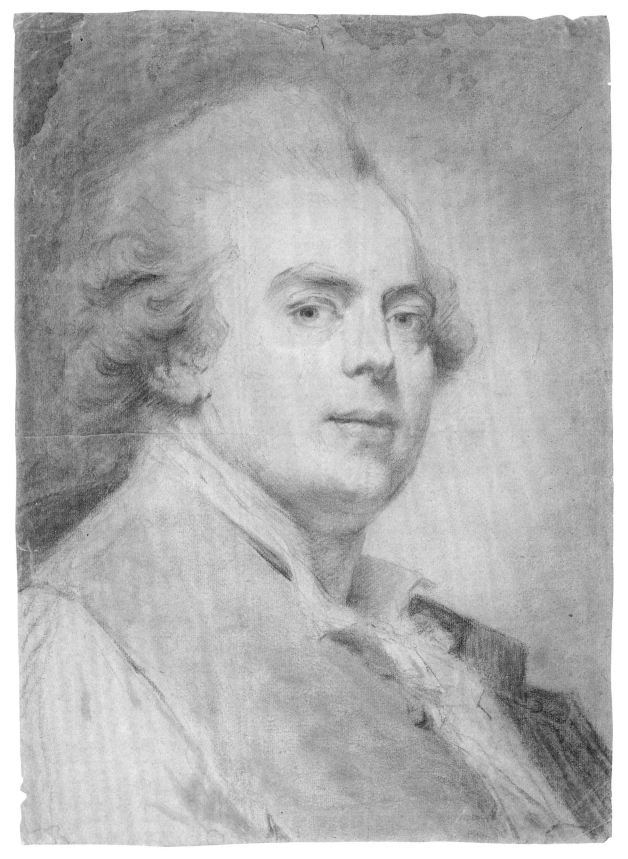

93

# 94  The Parting of Saints Peter and Paul

*The oldest son, pupil, and collaborator of Giovanni Battista Tiepolo (q.v.), Domenico, as he signed himself, painted fourteen Via Crucis scenes and ten other religious subjects for the Oratorio del Crocefisso at San Polo, Venice, from 1747 to 1749, displaying his strength and sensitivity as a religious artist. One of his greatest achievements in secular art is the fresco decoration of the Foresteria at the Villa Valmarana, Vicenza, of 1757. Domenico worked with his father and his brother Lorenzo (1736–1776) in Würzburg, 1750–1753, and in Madrid, 1762–1770. Until the mid-1780s he continued to produce oil paintings and frescoes. For the last twenty years of his life he concentrated above all on drawing. His swan song as a painter was the fresco decoration (now in the Ca' Rezzonico, Venice) of the family villa at Zianigo, executed between 1791 and 1799. Domenico was also a prolific etcher who reproduced both his father's work and his own designs.*

**Early 1790s, pen and brown ink with brown wash over charcoal on laid paper, 471 x 371 (18⁹⁄₁₆ x 14⁵⁄₈)**

**Signed at lower right in brown ink: *Dom.º Tiepolo f.***

**Watermark: Hand with sword and initial W**

**National Gallery of Art, Woodner Collection 1993.51.5**

Both this drawing and *The Raising of Tabitha* (cat. 95) come from an extensive series of large, elaborate, finished drawings of biblical subjects, probably dating from the early 1790s. The drawings are primarily concerned with the lives of Christ, the Virgin, and the Apostles, for which Domenico's sources were the New Testament and apocryphal traditions.[1] Of these drawings, 138 were purchased *en bloc* in Venice in 1833 and later bound in an album known as the Recueil Fayet (Louvre, Paris).[2] Eighty-two others (probably including cat. 95) were in the collection of Roger Cormier of Tours, sold in Paris in 1921. Smaller groups of the drawings were owned mainly by other nineteenth-century French collectors, prominent among them Jean-François Gigoux, an artist-dealer of Besançon who had at least seventeen, including this one;[3] and Charles Fairfax Murray, another artist-amateur, who counted eight of the works from this series among his large holdings of Tiepolo drawings (now Pierpont Morgan Library, New York).[4] A second substantial group of drawings was probably brought from Venice to France in the nineteenth century, perhaps even assembled at an early stage as a selection parallel to those purchased by M. Fayet.

The scene represented in the Woodner drawing shows Saints Peter and Paul, both of whom were executed in the reign of Nero (54–68 AD), probably in the persecution of 64 AD: Peter was crucified, and Paul beheaded (his privilege as a Roman citizen). The earliest traditions view Peter and Paul as pioneers in the organization of the Christian community in Rome, and they are often paired together in art. Domenico drew numerous episodes from the lives of both saints in his Large Biblical Series, including their martyrdoms.[5]

As an independent work of art, depicting both a sacred narrative and a moment of high drama, this drawing was made for close study. Domenico conceived the composition almost in terms of relief sculpture.[6] A large, tightly knit crowd of Roman soldiers is packed across the central area, and pools of dark shadow alternate with brightly lit surfaces, providing a polished, sculptural effect. The extremely low viewpoint and steep upward foreshortening of the platform upon which the executioner waits recall the perspective devices of bronze reliefs. Certain elaborately clad or vigorously gesturing figures stand out from the central mass, parting the crowd and allowing room for the main event, the farewell of the two saints. This moment of friendship and solace is silhouetted against a characteristic motif of a Veneto town, with a classical building flanked by a campanile—a reference to Palladian architecture, which neatly combines allusions to Rome and Christianity.[7] The stillness at the left side of the composition—the immobile plumed soldier, the spectators tensely awaiting the execution—contrasts with the action and noise of the right side—the trumpeter, prancing horse, and drummer boys—where the martyrdom will take place. Saint Peter's right hand curves protectively around Saint Paul's shoulder: the executioner, already drawing his sword, glances down more or less at the nape of the victim's neck. There is both tenderness and poignancy in the scene, not just in the clumsy embrace of the two old men but also in the wistful expression of the drummer boy and the apparent unease of the two men in turbans at the left.

Domenico's richly layered technique echoes the complexity of the narrative. Charcoal underdrawing maps out the composition and is clearly visible under the area of mountains and clouds, while various indications can be made out beneath the figure groups. There Domenico used the chalk more lightly and may have slightly erased some of it so as to increase the dazzling effect of the areas of blank paper. Shades of brown wash are brushed on in subtly graduated layers in the sky to suggest depth and luminosity; the visibility of the underdrawing adds liveliness and variegation to this area.
• *Catherine Whistler* •

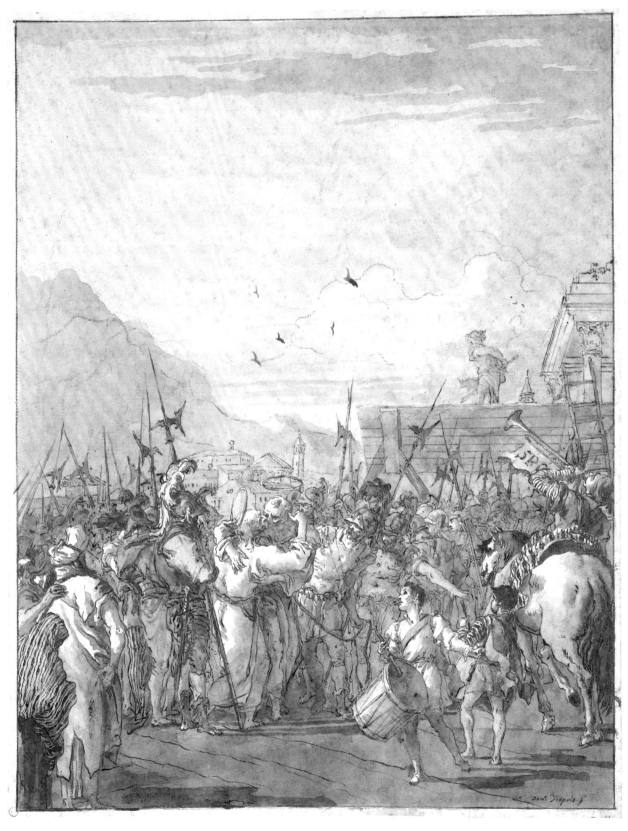

94

**NOTES**

1. See Byam Shaw 1962, 36–37, for the most important account of this series.

2. Chennevières 1892, 140, describes how the artist Camille Rogier, a passionate admirer of the Tiepolos, persuaded M. Fayet to buy a loose bundle of drawings by Domenico.

3. Eight were sold in Paris, E. Féral, 20–23 March 1882, lots 172–179, while nine others are at Besançon. One of the Gigoux drawings sold in 1882, *The Apostles' Creed,* is now in the National Gallery of Art, Washington (inv. 1991.92.1). A large number of now scattered drawings passed through the hands of Parisian dealers long before the Cormier sale; Chennevières 1892, 106–118, discusses the taste for Giovanni Battista Tiepolo's work among Parisian collectors and lists some collectors of Domenico's drawings.

4. Fairfax Murray 1905–1912, 4: nos. 145–151 (the eighth is not reproduced); Fairfax Murray gives no information on their provenance.

5. At least eleven other scenes from the Life of Saint Paul and twelve from the Life of Saint Peter are known (judging from the reproductions in the Witt Library, London) outside of those in the Recueil Fayet.

6. Throughout his career Domenico painted subsidiary fresco scenes as monochrome (grisaille) medallions or reliefs, particularly in the case of subjects taken from the antique or from the Bible.

7. This is rather similar to the church of the Redentore in Udine, which appears in an earlier drawing by Domenico; see Knox 1973, 78–79.

**PROVENANCE**

Jean-François Gigoux, Besançon [1806–1894] (sale, Paris, Féral, Hôtel Drouot, 20 March 1882, lot 174); private collection (sale, London, Christie's, 9 December 1986, lot 64); (Kate Ganz Ltd., London, 1987); Woodner Collections (The Ian Woodner Family Collection, Inc.); given to NGA, 1993.

**EXHIBITIONS**

London 1987a, no. 34; Woodner, London 1987 *(hors catalogue);* Woodner, New York 1990, no. 44; Woodner, Washington 1993–1994.

**LITERATURE**

Byam Shaw 1962, 36.

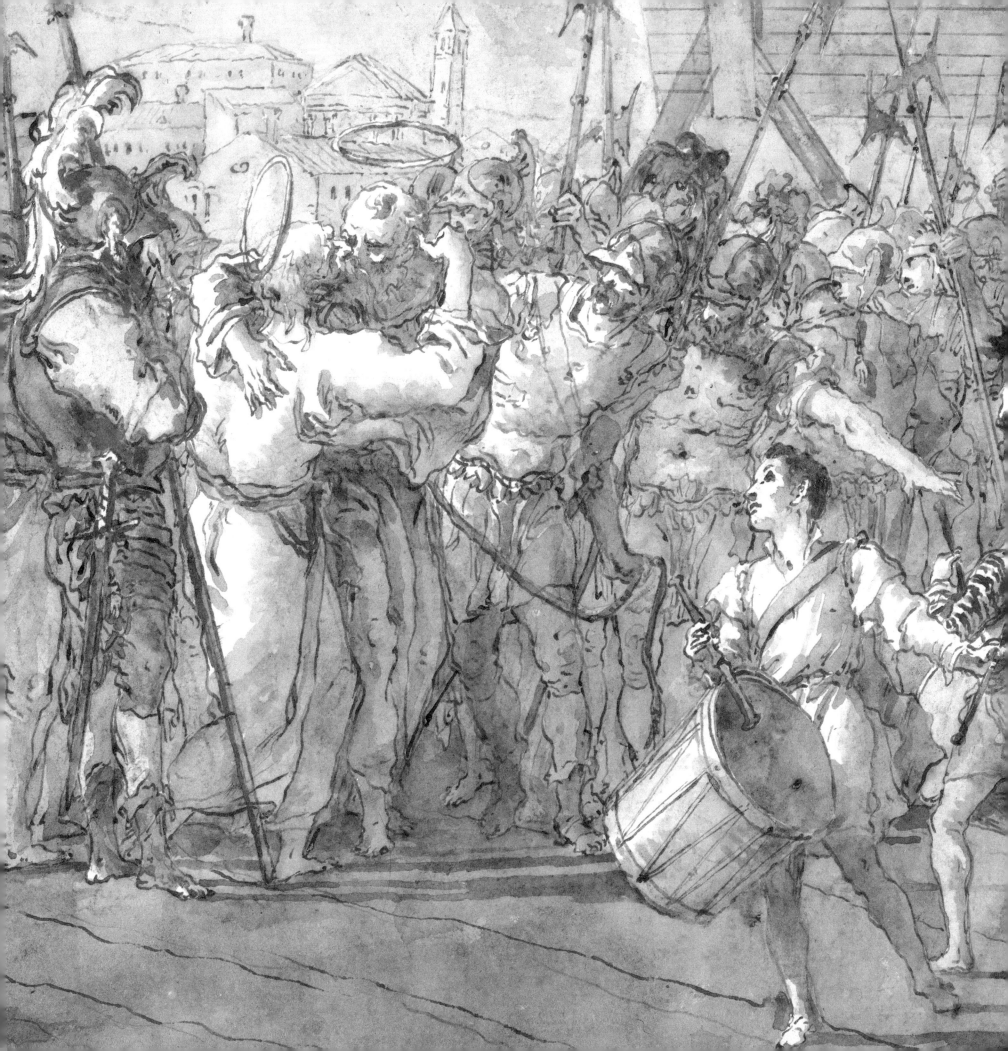

# 95  The Raising of Tabitha

**Early 1790s, pen and brown ink with brown wash
over charcoal on laid paper, 489 x 381 (19¼ x 15)**

**Watermark: Flaming sun with initials EGA**

**Woodner Collections**

This drawing probably comes from the
Cormier collection at Tours, which was sold
in 1921; and it may be identifiable with a
drawing described in the sale catalogue as
an Apostle miraculously curing a sick
woman.[1] The Large Biblical Series to which
this drawing belongs (described under cat.
94) is unique in both its enormous size—
comprising at least 250 drawings—and its
range of subjects. It is also highly original,
both for the lavish, masterly pen and wash
technique and for the inventive approach to
the stories. Domenico's preference is for the
realistic and the humane (often to the point
of seeming strident or gauche). Some of his
drawings examine the psychological ten-
sion of an orthodox subject, such as Christ
remonstrating with the three Apostles at
Gethsemane,[2] or successive moments in the
same narrative, as with a pair of drawings
showing the raising of the son of the widow
of Nain and the immediate reactions to the
miracle.[3] The same figures and motifs crop
up from one drawing to another, so that
Domenico's quirky sense of adventure is
curtailed by a restricted cast of characters
and settings.

The range and variety of Domenico's
subject matter and handling are apparent
when one compares the *Parting of Saints
Peter and Paul* (cat. 94) to this drawing:
the cool, dark tones of that crowded, tragic
scene in a landscape are here replaced by
warm golden brown washes, and a shaft of
sunlight illuminates a group of larger-scale
figures caught up in a miracle. The han-
dling of the *Raising of Tabitha* is freer and
more rapid, with a painterly use of the
washes creating rich effects in the other-
wise austere architectural background.
Domenico changed the position of the arch
of the doorway, moving it farther to the
left; much grainy underdrawing in charcoal
is visible beneath the figures, adding a
tremulous air to the scene.

Domenico was clearly intrigued by
the somewhat laconic accounts in the Acts
of the Apostles of miracles and visions that
must have transfixed the small, early com-
munity of Christians. Here Tabitha, a widow
renowned for her good deeds, is brought
back from the dead (Acts 9:36–42). With
Saint Peter's charged gesture—his com-
manding right hand at the center of a cen-
trifugal figure composition—a kind of
balletic energy sweeps through the specta-
tors on his right, and they sway and spring
back in their reactions of awe and joy.[4]
Domenico's realism is particularly apparent
in the expression of Tabitha, who has just
sat up (as the biblical text recounts) and
whose puzzled features are still appropri-
ately half-shrouded in shadow. It is this
sense of empathy with his chosen subject
that gives Domenico's biblical series such
extraordinary impact. • *Catherine Whistler* •

**NOTES**

1. Sale, Paris, Galerie Georges Petit, 30 April 1921, lot
76. This had also been associated with a drawing in the
Heinemann collection, New York; see Stampfle and
Denison 1973, no. 105; but the protagonist there is Christ,
who is always clearly distinguishable in this series.
2. One of the drawings is now in the Washington Uni-
versity Gallery of Art, St. Louis (Cormier sale, lot 69);
another (Cormier sale, lot 40) was sold in London at
Sotheby's, 6 July 1987, lot 10; a third was recently auc-
tioned in London at Christie's, 19 April 1994, lot 114.
A drawing now in the National Gallery of Art, Wash-
ington (inv. 1987.48.2), called *Christ Climbing Mount
Tabor with Peter, James, and John*, is probably also part
of this group.
3. The first is at the Musée Bonnat, Bayonne (inv.
1309); the second was sold in Paris at Hôtel Drouot,
14 December 1938, lot 10.
4. A distant source for the young woman rushing
forward on the right may be the Magdalene in Titian's
*Pietà* (Accademia, Venice); the profile head of an
open-mouthed, shouting man looks back to a famous
motif invented by Leonardo da Vinci.

**PROVENANCE**

Probably Roger Cormier, Tours (sale, Paris, Galerie
Georges Petit, 30 April 1921, possibly lot 76); Woodner
Collections (Shipley Corporation).

**EXHIBITIONS**

Woodner, New York 1973–1974, no. 73; Los Angeles
1976, no. 74; Woodner, Malibu 1983–1985, no. 35;
Woodner, Munich and Vienna 1986, no. 38; Woodner,
Madrid 1986–1987, no. 46; Woodner, London 1987,
no. 35; Woodner, New York 1990, no. 43.

95

# 96  Punchinellos Hunting Waterfowl

**1800/1804, pen and brown ink with brown wash over charcoal on laid paper, 351 x 474 (13 ¹³/₁₆ x 18 ¹¹/₁₆)**

**Signed at lower right in pen and brown ink: *Domo Tiepolo f*; numbered at upper left in pen and brown ink: *3*, and in graphite: *2* [forming the number 32]**

**Watermark: Three crescents (cf. Heawood 865, 869–871, 879)**

**Woodner Collections**

Punchinello, a stock figure from the commedia dell'arte associated with comic performances and the license of Carnival, is the protagonist in a series of drawings by Domenico, *Divertimento per li ragazzi (Amusements for the Young)*, from c. 1800 onward, which form a kind of artistic testament.[1] Unlike the other late series, the 104 Punchinello drawings include an elaborate title page, suggesting that the drawings were intended to be leafed through and appreciated as a sequence of animated, witty, beautifully executed images. Domenico may also have felt that some explanation was needed for his unusual odyssey through the life and adventures of a raffish, picaresque antihero, with scenes moving from the farcical to the satirical—hence the mock-innocent title. The drawings are numbered by a near-contemporary hand, possibly but not necessarily Domenico's, and the numbering may reflect a shuffling into place of the drawings after completion of the series rather than a logical order; it certainly does not give us the order of their

execution.[2] Their provenance is unknown before 1920, when 103 of the drawings were put on sale at Sotheby's, loose rather than bound into an album.[3]

The Punchinello drawings probably grew in number (in the manner of his earlier series) as Domenico explored further permutations of subjects and situations with a given set of characters—including Punchinello's family life, foreign travels, and various occupations, his mischievous nature, his social successes, and his many humiliations. A plethora of identical spindly Punchinellos takes on different roles as supporting chorus, skittish companions, or even authoritative personages. Numerous figures and motifs from the genre scenes or other drawings populate the narratives,[4] as Domenico deploys earlier and recent inventions in a shifting, playful manner, drawing on a vocabulary evolved over a long career. Thus the embrace of the two Punchinellos in *Punchinello's Farewell to Venice* (fig. 1) owes much to the main motif in the *Parting of Saints Peter and Paul* (cat. 94); elsewhere Domenico quite clearly refers to his own and his father's earlier works with humorous self-mockery.

Domenico's rapid, confident technique can be clearly seen in *Punchinellos Hunting Waterfowl*. The artist made a loose, grainy sketch with charcoal in an utterly summary manner, then changed his mind over several details as he built up the composition with layers of golden wash. Thus he rearranged the positions of some of the ducks

at this stage (traces of curved shorthand indications of charcoal can be seen in the water), while various changes were made to the position of the left arm, and gun of the main Punchinello figure. Domenico's highly developed sense of the ridiculous is encapsulated here: Punchinello looks up, startled to discover that he has actually shot one of the waterfowl, and this growing alarm is registered in the attitudes of his companions, particularly the Punchinello on the right whose jumpy, knock-kneed stance mirrors the shocked pose of the unfortunate bird. The flurry among the caricatured ducks below is echoed by Domenico's deliberately fussy, calligraphic treatment of the water. This is in sharp contrast to his more atmospheric *veduta* passage in fig. 1. Two other drawings show hunting scenes,[5] out of a large number depicting Punchinello's country pursuits in which he is usually uneasy in the presence of animals. Marcia E. Vetrocq pointed out that Domenico might have known a painting of duck hunting by Pietro Longhi (now in the Fondazione Querini Stampalia, Venice), and that the pair of waterfowl turn up in a drawing of an *Oriental Horseman* (fig. 2).[6]

While a variety of sources for representations of Punchinello, from the graceful to the lewd, were available to Domenico,[7] including his father's humorous drawings of greedy Punchinelli, he made this zestful figure his own in the fresco decoration of a Punchinello room in his private villa at Zianigo in 1797.[8] Efforts to interpret the

**FIGURE 1**

Giovanni Domenico Tiepolo,
*Punchinello's Farewell to Venice,*
National Gallery of Art,
Washington, Gift of Robert
H. and Clarice Smith

Punchinello frescoes and the drawings they inspired in the light of contemporary social and political developments have proved elusive.[9] Their Carnival spirit, earthy sense of humor, and playful ambiguities give the Punchinello drawings an enduring fascination. • *Catherine Whistler* •

## NOTES

1. Gealt and Vetrocq in exh. cat. Bloomington 1979 and Gealt 1986 are invaluable studies of the character of the series.

2. Byam Shaw 1962, 56–57, also discussed inconsistencies with the numbering. Knox 1983, 126, 128 n. 12, suggests that the numbering is by Domenico and, pointing out that the number *32* appears on *Punchinello Picking Apples* (Mr. and Mrs. Powis Jones, New York), as well as on *Punchinello Hunting Waterfowl*, believes that indecision over the numbering indicates that the sequence of the drawings was of significance to Domenico.

3. Byam Shaw 1962, 52, 53, gives details of the outcome of the sale and describes the impact of the drawings on Sacheverell Sitwell, who longed to buy them.

4. Exh. cat. Bloomington 1979 (no. S25) notes this kind of repetition in *Punchinello's Funeral Barque*, which incorporates motifs from a drawing in the Large Biblical Series now at the Musée des Beaux-Arts, Besançon.

5. *The Stag Hunt* and *The Boar Hunt* (exh. cat. Bloomington 1979, nos. S37 and S38) both make reference to the prints of Stefano della Bella.

6. Exh. cat. Bloomington 1979, 72.

7. Greco 1990 illustrates seventeenth- and eighteenth-century examples.

8. The frescoes are now at the Ca' Rezzonico, Venice; see Pedrocco 1988.

9. Mariuz 1986, 265–273.

## PROVENANCE

Private collection (sale, London, Sotheby's, 6 July 1920, lot 41); (P. & D. Colnaghi, London); Richard Owen, Paris; private collection (sale, Paris, Palais Galleria, 16 June 1967, lot K); (William H. Schab Gallery, New York); Woodner Collections (Shipley Corporation).

## EXHIBITIONS

Paris 1921; Woodner, New York 1973–1974, no. 71; Bloomington 1979, no. 18; Woodner, Malibu 1983–1985, no. 36; Woodner, Munich and Vienna 1986, no. 39; Woodner, Madrid 1986–1987, no. 47; Woodner, London 1987, no. 36; Woodner, New York 1990, no. 45.

## LITERATURE

Byam Shaw 1962, 55; Knox 1983, 128; Gealt 1986, no. 62.

FIGURE 2

Giovanni Domenico Tiepolo,
*Oriental Horseman and Another Figure,*
The Pierpont Morgan Library,
New York, Gift of Mr. Janos Scholz

# 97 A View of the Bay of Naples with Mounts Vesuvius and Somma

*Lusieri's earliest known works are Roman views dating from 1781. By 1782 he was active in Naples, where he achieved prominence in the next two decades, especially with travelers on the Grand Tour. The artist's Neapolitan success was cut short by Napoleon's late-century advances on the peninsula, and in 1799 he accepted an offer from the 7th Earl of Elgin to act as his agent and draftsman in Athens, embarking on a contract that extended until his death. As Elgin's agent, Lusieri became hopelessly embroiled in the prolonged business of transferring the Parthenon marbles to England, a responsibility that overwhelmed his artistic activity. Although Lusieri was under obligation to make drawings for Elgin of the ancient Greek sites, few were ever completed. Two years following Lusieri's death, a frustrated Lord Elgin negotiated a settlement with the artist's heirs, acquiring a sizeable body of Lusieri's works, all made prior to his employ with Elgin.*

**1782/1794, watercolor with pen and black ink over graphite on laid paper mounted to paperboard, 628 x 938 (24 ³⁄₄ x 36 ¹⁵⁄₁₆)**

**Woodner Collections**

This expansive view of the Bay of Naples, looking east toward Mounts Vesuvius and Somma, faithfully records the radiant light of southern Italy, the tawny hues of Neapolitan stone and stucco buildings, and the precise topography of late eighteenth-century Naples. As it was originally conceived, the Woodner sheet complements another watercolor of similar size. Joined, they chronicle an even broader, more sweeping view of the bay (fig. 1):[1] beginning with the Casino del Pignatelli's portico in the left foreground, spanning the shoreline promenade known as the Chiaia (now the Via Caracciolo), ascending the hillside crowned by Castel Sant'Elmo (at the sheets' join), and sloping downward to the Castel dell'Ovo on the promontory's outermost tip. Occupying the lower fifth of the Woodner drawing and spilling over to the companion sheet (barely visible in reproduction) is a graphite sketch of the quay at Mergellina, where Neapolitans gather to enjoy the Mediterranean breeze.[2]

The Woodner watercolor and its counterpart, now in a British private collection, were acquired by Lord Elgin in 1824 as part of a group of some 140 watercolors, drawings, and sketches by Lusieri. When twenty of the watercolors were offered at Sotheby's in 1986, the present sheet and its counterpart were given consecutive lot numbers, but their connection seems to have gone unnoticed. Such was also the case with four other sheets in the sale, all later related by Leonardo Di Mauro;[3] it is with sound reasoning that Nicola Spinosa points out that many of Lusieri's single-sheet watercolors may have been conceived as components of larger compositions. Indeed, Lusieri's largest surviving work, now at the J. Paul Getty Museum, is a panoramic view of Naples from 1791 that comprises eighteen joined sheets extending nearly nine feet.

In the eighteenth century Italy was a requisite stop on the Grand Tour, a pilgrimage judged indispensable to a gentleman's education—so much so that Samuel Johnson remarked that "a man who has not been in Italy is always conscious of an inferiority."[4] Rome was deemed the southernmost stop on the peninsula until the rediscovery of Pompeii in 1748 and Herculaneum ten years later; by 1760 Naples and its environs had been appended to the Tour. People came to behold its natural beauty and lush vegetation; they marveled at Vesuvius, which rocked the city throughout the second half of the century; they delighted in the city's courtly entertainments and scouted (if not plundered) its surrounding ancient sites.

The English especially were undaunted travelers and tireless collectors, whose demand for souvenirs advanced the genre of view-painting in Italy. Early in the century wealthy travelers to Rome commissioned views by Gaspar van Wittel; later Canaletto's *vedute* were coveted. In Naples during the last half of the century acclaimed view-painters were Antonio Joli, Jacob Philipp Hackert, Pierre Jacques Volaire, and Lusieri, whose eye-catching realism was justly praised. The Welsh painter Thomas Jones, writing from Naples in 1782, commented that Lusieri's drawings "were deservedly admired for their Correctness and strict attention to Nature, and many of them [are] purchased by Our English Cavaliers."[5] Lusieri's patrons constituted an illustrious list of British nobles,[6] including the connoisseur Sir William Hamilton, British envoy to the Bourbon court of Naples. It was Hamilton, in fact, who recommended Lusieri to Lord Elgin.[7]

Lusieri had ties with British artists who flocked to Naples after midcentury, and there is much about his work that is characteristically British. Most striking is the prominent use of watercolor, though his luminous tones and carefully rendered topography are also worthy indicators. Like the watercolors of topographical artists from across the Channel, Lusieri's could justly be called "tinted drawings." What sets him apart is his trained focus on realism, especially at a time when British artists were moving toward romanticism. The exceptional clarity of his views and the pre-

97

cision of detail are actually more suggestive of his contemporary and *capo* among painters in Naples, the German Philipp Hackert, than of British artists such as John Robert Cozens, Thomas Jones, or Francis Towne, all of whom spent time in the city in the 1780s.

The double-sheet panorama of Naples from Mergellina highlights Lusieri's uncommon vision, which enabled him to see farther and with greater clarity than most. His focus was penetrating and all-inclusive: as remote as are the ashen ravines of Vesuvius and Mount Somma, some nine miles in the distance, they are rendered as distinctly as the tiered hillside in the middle ground and the stratified rock ledge, called *il tufo giallo,* in the foreground. Under close inspection one can even identify Sir William Hamilton's Palazzo Sessa, a three-storied, flat-roofed, white building, situated a mile or more across the bay (diagonally to the left of the triangular-sailed felucca on the Woodner sheet).[8] Add to this the dramatic cropping of the Casino del Pignatelli at the left, and one understands why Lusieri's work has enjoyed renewed attention in recent decades. His wide-angle vistas, shown as if through a camera lens, seem curiously modern.

A discussion of the present work must address its unfinished state, a condition all too common in Lusieri's watercolors. Lord Byron had high praise for Lusieri, calling him "an Italian painter of the first eminence," but he complained that his works "are almost all unfinished."[9] Lusieri's exacting standards undoubtedly interfered with his productivity. Detailed underdrawings were made on the spot, and he held firm to the principle that colors be applied out-of-doors. Although contemporary accounts continually harp on his unhurried progress, it was conceded that his was a "tardiness of the most scrupulous accuracy."[10]

The present work was formerly thought to have been executed between 1782 and 1799, the years Lusieri was active in Naples,[11] but Vesuvius' profile bespeaks a date prior to 1794. It was in June of that year that a violent eruption leveled the volcano's summit, reducing its height by one-ninth. The Woodner drawing, in distinction, shows Vesuvius' pinnacle still firmly intact.

• *Judith Brodie* •

**NOTES**

1. See Rossana Muzii's entry on the combined views in exh. cat. London 1990, 128.
2. The attraction of the quay, located at the foot of the hillside of Posilipo, is recounted in the Abbé de Saint-Non's unparalleled travelogue of 1781–1786: "Il l'est sur-tout pour la promenade dans les beaux jours. Le soleil qui se trouve de bonne-heure caché par les hauteurs du Pausilippe, & les vents qui s'élèvent presque toujours du côté de la mer, ajoutants à la fraîcheur qu'ils viennent y chercher" (1:93).
3. Spinosa and Di Mauro 1989, no. 182.
4. Boswell 1791, 307.
5. Oppé 1951, 112.
6. Lusieri's patrons included Lord Cawdor, Sir Richard Colt Hoare of Stourhead, Lord Palmerston, Lord Bruce (later Ailesbury), Sir William Forbes of Pitsligo, and Lord Elgin. See Williams 1982, 492–496; and Williams 1987, 459.
7. St. Clair 1967, 28.
8. Plotted by examining the Getty's Lusieri, *A View of the Bay of Naples, Looking Southwest from the Pizzofalcone towards Capo di Posilipo,* a spectacular view taken from Hamilton's Palazzo Sessa, and cross-referencing it to the Woodner sheet. Additional information was inferred from Knight 1993.
9. Byron 1812, canto 2, stanza 12, n. 6.
10. Clarke 1816, pt. 2, sec. 3, p. 14, n. 3.
11. Woodner exh. cat., New York 1990, no. 47.

**PROVENANCE**

The artist's heirs; purchased by the 7th Earl of Elgin [1824–1841]; by descent to the 11th Earl of Elgin and the 15th Earl of Kincardine (sale, London, Sotheby's, 30 June 1986, lot 110); Woodner Collections (Dian and Andrea Woodner).

**EXHIBITIONS**

Naples 1990, 147 (repro.), 407; London 1990, 83 (repro.), 128; Woodner, New York 1990, no. 47.

**LITERATURE**

Spinosa 1987, no. 342, pl. 75; Spinosa and Di Mauro 1989, 161–162, no. 183, pl. 109; De Seta 1992, 185 (repro.).

# 98 Mascaras crueles (Cruel Masks) *(recto)*
# Brujas à volar (Witches Preparing to Fly) *(verso)*

*Goya trained in Saragossa, then in Madrid where Giovanni Battista Tiepolo (q.v.) and Anton Raphael Mengs (1728–1779) were working for Charles III. A journey to Italy in 1770/1771 and study of the works of Velázquez (1599–1660) and Rembrandt (q.v.) were formative influences, and he largely rejected the fashionable neoclassical style. Goya painted many tapestry cartoons for the royal palaces (1775–1792) and was also active as a religious painter and portraitist. A member of the Royal Academy of San Fernando (1780), he became First Court Painter to Charles IV in 1799. Left profoundly deaf in 1793 by a severe illness, Goya was drawn to enlightened, liberal circles, and his art became more original and independent. His albums of drawings and series of etchings reflect his critical, moral views. His official commissions virtually ceased after 1800, and he spent his final years (1824–1828) in self-imposed exile in Bordeaux.*

**1796/1797, brush and black ink with gray wash and scraping on laid paper, 237 x 150 (9 ⁵/₁₆ x 5 ⁷/₈)**

*recto*
**Inscribed by Goya across the top in brush and gray ink: *mascaras 55*; and below this in pen and brown ink: *crueles*; numbered at upper right (by Javier Goya?) in pen and a different brown ink: *10*.**

*verso*
**Inscribed by Goya at upper left in brush and gray ink: *56*, and at lower center *Brujas*; added at lower right in pen and brown ink: *à bolar* [for *volar*, to fly]; numbered at upper right (by Javier Goya?) in pen and a different brown ink: *9*.**

**Watermark: Strasbourg bend (fragment)**

**National Gallery of Art, Woodner Collection 1991.182.10.a,b**

Goya seems to have begun making his uniquely original series of drawings in 1796. The first of his eight journal-albums, known as Album A or the Sanlúcar Album, was drawn in brush and wash in a small notebook.[1] Goya used it during his much-discussed stay with the Duchess of Alba on her Andalusian estate at Sanlúcar de Barrameda in the summer of 1796. He probably began a second, larger book of drawings— to which the Woodner sheet belonged— in Cadiz, where he is recorded in ill health, in his own lodgings, later that year and until at least the end of January 1797.[2] He

no doubt continued this album on his return to Madrid, and the drawings in Album B, also called the Madrid Album, evolve from outdoor and indoor scenes that record or reflect on daily life to images that become progressively more caricatural and moralizing in tone. Almost twenty of these album drawings, including the verso of the present sheet, were transformed through subsequent preparatory drawings into the images that Goya executed in etching and aquatint for his first major series of prints, *Los Caprichos*, published at the beginning of 1799.

The Woodner page from the Madrid Album is of particular importance because it marks the first appearance in Goya's graphic work of the titles he added to the majority of his albums and used for most of his series of prints. Following pages 51/52 and 53/54, whose locations and subjects are unknown, this is the first sheet on which such titles occur, drawn with the brush in pale gray ink with, in each case, additions in pen and iron gall ink (now brown, but originally black). It is also one of the first sheets in which the limits of the compositions are defined by a rectangular area of wash, corresponding with what was later to become the format of the etched and aquatinted designs of the prints of *Los Caprichos*.[3] The sheet, unevenly trimmed along the left edge, may show a trace of a binding hole toward the bottom.[4] Numbers were added in pen and ink on both sides of the sheet, probably by Goya's son Javier, or

perhaps by his grandson Mariano.[5]

In the composition on the recto of the Woodner sheet, which is only distantly related to some of the *Caprichos* prints, a woman dressed as a *maja* stands before two grotesquely masked men. With her head turned away from them and eyes cast up to heaven, her generously displayed bosom is the focus of the male masks' gazes as they gesture with raised right hands. But the black carnival mask held by the *maja* and surrounded by the calculated play of hands is actually the central element in the composition. The *maja's* breasts were originally almost bare, modeled by a curving shadow over which Goya added further touches to reduce the daring décolletage. A dark shadow, suggesting a veil falling from her head, may also have been added to attenuate the thrusting outlines of her torso with its tiny waist and swelling hips, while scraping and retouching lengthened her skirt and almost eliminated the traces of her turned out feet.[6] One of the ass's ears protruding from the bonnet worn by the leering, Silenus-like figure in the foreground appears to have been extended. The figure in the middle wears *quevedos*, antiquated spectacles that symbolized old-fashioned attitudes.

This composition recalls one of the *Sueño* (Dream) drawings later used by Goya for plate 14 of *Los Caprichos*. In this, a simpering maiden is faced with a choice between two rich but repellent old suitors who clasp or raise their hands as they con-

Mascaras
Crueles

98 RECTO

à helar

template her ample bosom, "and the poor girl doesn't know which to choose," according to Goya's manuscript title on the drawing.[7] Here, however, the despairing or perhaps exasperated expression of the unmasked beauty appears closer in mood to that of the young woman in plate 9 entitled *Tantalus.*

The scene on the verso of the Woodner sheet is the first known reference in the Madrid Album to witchcraft, the theme that became such an important focus in later drawings. It originally faced another such scene on page 57 of the Madrid Album (fig. 1).[8] Both drawings were used for similarly successive prints in *Los Caprichos,* plates 69 and 70 (fig. 2), for which Goya made preparatory *Sueño* drawings.[9] In this early version of his design Goya seats a young female with a vixen mask on the shoulders of a goat-legged creature who grasps her left leg. With both hands raised, she gazes at the brightly lit pages of a great book, held open by pincers wielded by two chanting figures. These "celebrants" wear bishops' miters similar to penitential or inquisitorial *corozas* (pointed hats) and are seated on a kind of altar the front surface of which is decorated with a frieze of demonic, open-mouthed heads. A skull lies on the ground near the satyr's cloven hooves, and both satyr and "vixen" are discharging foul matter or wind.

The drawing's symbolism and significance—demonic, sexual, and social—have been extensively discussed by Eleanor A. Sayre,[10] but it is worth commenting on some of its particular technical character-

istics. Goya first sketched the design very lightly, then went on to make numerous alterations. The composition originally extended laterally almost to the edges of the sheet, and the top of the "altar" followed a more horizontal plane. The chanting "cleric" on the left is seen to wear breeches and stockings, although this is veiled by a later wash that coincided with the redefining of the limits of the composition and the indication of a border line at left and below, where it just overlaps part of the original title *Brujas.*[11] As on the recto drawing, Goya made use of scraping to alter his design, radically transforming the head of the "vixen" witch and scraping away a dark area at the base of her neck (perhaps an object rather than a shadow) as well as part of her left hand.[12] Since the interpretation of Goya's prints and drawings is in part dependent on the visible evidence of the development of his ideas, this remarkable drawing and its subsequent elaboration in the *Sueño* drawings and *Caprichos* print provide the key to an ever clearer understanding of the artist's intentions. • *Juliet Wilson-Bareau* •

**NOTES**

1. The apt description of Goya's bound or unbound notebooks as "journal-albums" was first coined in Sayre 1958, 120. See Gassier 1973, 17–44, for Album A.

2. Gassier 1973, 45.

3. Where these areas of wash, or in some cases border lines, occur on earlier sheets, they were clearly added within compositions that extended to the lateral limits of the page. The verso of the present sheet is an example of this.

4. The maximum sheet size given by Sayre in exh. cat. Boston 1989, xcvi, is 237 x 148 mm.

5. When Goya died in Bordeaux in 1828, Javier inherited all the works not already assigned to him by a division of property effected in 1812. At an unspecified date before he died in 1854, he reorganized all the album drawings, disbinding them, and mounting them onto sheets of pink paper that he assembled into three large volumes. Later either he or his son Mariano broke up these three and formed other smaller albums. One such album remained intact, the Fortuny album, now in the Metropolitan Museum, New York (see Wehle 1941). Two others, totaling 106 drawings, were dispersed at auction in Paris in 1877 and provided the source for most of the album drawings outside the Prado and Metropolitan Museum collections. Gassier 1972, in publishing the 1877 sale cat., identified many drawings from the sale, and others continue to come to light. The three albums were numbered, each in a different way, and where these numbers have not been subsequently trimmed or erased, it is possible to reconstruct the two albums dispersed in 1877 (one numbered at upper center of the sheets, the other at upper right with a curved line, or bracket, below, which distinguishes this series from the Fortuny album). See Gassier 1973, 15–16.

6. Goya's use of retouching and scraping in the drawings of Album B was noted as early as 1860 by Valentín Carderera (p. 224), who had wanted to become a pupil of Goya's and who owned most of the Goya drawings now in the Prado: "In the later sheets of this series [Album B], Goya evidently enjoyed developing stronger chiaroscuro effects in his compositions. These are the first drawings known to me in which highlights were created by scraping with the point of a knife, a method employed with such skill by the English watercolorists." [author's translation]

*Devota profesion.*

7. *Sueño 15*, entitled *Son[?] Señoritos a cual mas rico, y la pobre no sabe a qual escoger* (They are gentlemen, one as rich as the other, and the poor girl doesn't know which to choose), with a second title over this: *Sacrifico del Ynteres* (Sacrifice of interest). Gassier and Wilson 1971, nos. 479, 480; Gassier 1975, no. 51; exh. cat. Madrid 1992–1993, nos. 22, 23.

8. Gassier and Wilson 1971, no. 417; Gassier 1973, no. 62. Like the Woodner drawing originally on the facing page, this composition was first titled *Brujas,* before Goya added a succinct phrase (in this case *à recoger*— Preparing to Convene), and then a quite distinct explanatory title at the top of the sheet: *La tia chorriones enciende la Óguera (*Old Auntie Bellows Lights the Fire).

9. Gassier and Wilson 1971, nos. 589–593; Gassier 1975, nos. 41, 42 (third Dream) and 46 (seventh Dream).

10. In exh. cat. Boston 1989, no. 59.

11. The *Sueño* drawings based on the Woodner sheet (Gassier and Wilson 1971, nos. 592, 593; Gassier 1975, nos. 41, 42) confirm the alterations of the cleric's dress by showing him wearing an ankle-length robe, as in the etching, *Los Caprichos*, plate 70 (fig. 2 above). The overlapping of part of the *B* and the dot on the *j* of *Brujas* supports what other drawings also appear to suggest, namely that the brush and wash numbers and titles were added when the designs were first sketched on the sheets.

12. The use of scraping in the Madrid Album to erase or alter passages of drawing or to create half-tones in areas of dark wash could suggest that Goya was already experimenting with etching in 1796–1797—in which scraping is often used—and that he may have been thinking in terms of an etched and aquatinted series of prints before beginning work on the preparatory *Sueño* drawings.

**PROVENANCE**

Javier Goya [d. 1854], then Mariano Goya, Madrid; probably Román Garreta, Madrid; Paul Lebas (sale, Paris, Hôtel Drouot, 3 April 1877, lot 72); purchased by Baron E. de Beurnonville (sale, Paris, Hôtel Drouot, 16–19 February 1885, lot 51, to the dealer Philipe); private collection, Paris; Alfred Strölin, Lausanne, by September 1933; Woodner Collections (Dian and Andrea Woodner); given to NGA, 1991.

**EXHIBITIONS**

Martigny 1982, nos. 13, 14; Washington 1986–1987a (recto only); Woodner, London 1987, no. 106; Madrid 1988, no. 58 (verso only); Woodner, New York 1990, no. 140; Washington 1992, no. 45 (recto only); Madrid 1992–1993, no. 59 (verso only).

**LITERATURE**

Sayre 1958, 117–133; Sayre 1964, 28; Gassier and Wilson 1971, nos. 415, 416; Gassier 1972, 114, no. 72; Gassier 1973, nos. 60, 61; Sayre in exh. cat. Madrid 1988, 113, and in exh. cat. Boston 1989, xcvi.

# 99  Mendigos que se llevan solos en Bordeaux (Beggars Who Get about on Their Own in Bordeaux)

**1824/1827, black chalk on greenish laid paper, 193 x 140 (7 ⁵⁄₈ x 5 ¹⁄₂)**

**Inscribed at upper right in black chalk: *29,* and across bottom in black chalk: *Mendigos q.ᵉ selleban solos en / Bordeaux.* Inscribed on the verso at lower center by another hand in graphite: *Goya***

**Watermark: Three-leaf clover on heart**

**National Gallery of Art, Woodner Collection 1993.51.9**

Goya spent the last four years of his life in France, where he continued to draw with unabated enthusiasm and imaginative verve. Over one hundred drawings appear to have constituted two distinct albums, known as the Bordeaux Albums (Albums G and H), of which Album G is characterized by titles, usually placed below the drawings, and is thought to be the earlier of the two.[1] They were probably executed over a fairly long period, between Goya's installation in Bordeaux in September 1824 and his death there in April 1828. While one of the drawings in Album G refers to a sight he had seen in Paris in the summer of 1824, another, in the second half of Album H, portrays a "living skeleton" seen at the fair in Bordeaux "in the year 1826."[2]

Goya left Spain in June 1824 on the pretext of visiting a spa in France for health reasons. In fact, his voluntary "exile" at the age of seventy-eight was apparently under-

taken for political and personal reasons: partly to escape the tyrannical rule of Ferdinand vii, who had regained absolute power in 1823 after a three-year period of constitutional government; and partly because Goya's companion of many years, Leocadia Weiss, may herself have been forced to seek refuge in France because of her political opinions.[3]

In the two Bordeaux albums Goya abandoned the brush and wash techniques he had used exclusively in his earlier albums, turning to black chalk and perhaps lithographic crayon.[4] His use of chalk or crayon here has been ascribed to his probable intention to produce a new set of *caprichos* in lithography, following publication in the winter of 1825 of the magnificent lithographic prints known as the *Bulls of Bordeaux.*[5] It may also have been due at least in part to Goya's age and failing eyesight and the consequent difficulty of manipulating a technique that requires great physical control. The remarkable precision of the Bordeaux drawings, in spite of Goya's impressionistic handling of the chalk and evidence of extensive pentimenti and reworking, would have been more difficult to achieve with the washes and scraping he had used so effectively in the earlier albums.

The opening pages of Album G are full of variety, with a predominance of the semi-allegorical, semi-satirical scenes that had appeared in many of Goya's earlier albums. The Woodner page belongs to a group of

drawings offering humorous or thought-provoking views of various means of transport. Four of them show a form of "back pack" sedan chair, while in another a man trundles a wheelbarrow containing what appears to be a figure under a cloth, his *Coche barato y tapado* (Cheap Covered Carriage) mocked by three women in the background.[6] The Woodner study of a crippled man in a cart comes in the middle of the group, while two pages later Goya illustrated an old woman hunched up in a dogcart, with the title *Yo lo he visto en Paris* (I Saw This in Paris).

Drawn from memory, the scenes depicted in Album G are conveyed with emotional intensity rather than strict accuracy. Although the more distant wheel on the beggar's cart in the Woodner drawing is larger than the nearer one and leans at a dangerous angle, Goya vividly portrays the cart's mechanism, showing the beggar turning the handles that advance the large wheels, and one of the freely articulated little wheels on the rear corners, serving to balance the whole contraption. The scene is dominated by the facial expression and apparent movement of the beggar, who leans forward, glancing toward the viewer as he wheels quickly past. Even the strap of his begging bowl, slung over the backrest, echoes the forward propulsion of his cart. Goya's title may well have a double meaning, as he presents these beggars *que se llevan solos*—"who get about on their

Mendigos q.<sup>e</sup> selleban solos en
Bordeaux

99

own" — as people who can, in the Spanish phrase, *llevanse solos,* "fend for themselves,"[7] a tribute to the independent spirit even among beggars in Bordeaux, the city that harbored so many of Goya's liberal friends in exile. • *Juliet Wilson-Bareau* •

## NOTES

1. See Sayre 1958, 133.

2. Album G, folio 31, and Album H, folio 45 (Gassier and Wilson 1971, nos. 1736, 1806). See Gassier 1973, 501–502, nos. 389, 460.

3. See Núñez de Arenas 1950, 256–265. On Goya's death in 1828, his son Javier brought virtually all of his father's possessions, including the works executed in Bordeaux, back to Madrid, leaving Leocadia with the household effects and a small sum of money. Gassier 1973, 502–503, suggests that a group of drawings that included the two Woodner album sheets (cats. 99 and 100) may have remained with Leocadia and passed to "a certain Hyadès, army inspector in Bordeaux," and thence to Jules Boilly from whose collection they were sold in 1869 in a factitious album that also included pages from the Sanlúcar Album. Alternatively, since the dates are unclear, this group of Bordeaux Album sheets could also have been taken to Madrid by Javier in 1828, or by Leocadia when she returned there in 1833, in which case they would have been acquired by Boilly in Madrid, and by Hyadès following the Boilly sale in Paris.

4. Sayre in exh. cat. Boston 1989, cxxv, pointed out that Goya wetted the chalk to produce certain effects in his drawings but discounted the use of lithographic crayon in these late albums.

5. For Goya's choice of technique, see Gassier 1973, 499–500; Sayre 1958, 133. For the *Bulls of Bordeaux* and related lithographs, see exh. cat. Madrid 1993–1994, 332.

6. Pages 24, 26–28 (27 being a rediscovery that was not included in Gassier and Wilson 1971 or in Gassier 1973; see Gassier 1978, fig. 6).

7. See Mena Marqués in exh. cat. Madrid 1988–1989, no. 167.

## PROVENANCE

Javier Goya [d. 1854] and/or Mariano Goya, Madrid, or Leocadia Weiss, Bordeaux (to 1833) and Madrid; Jules Boilly, purchased in Madrid or France[?] (sale, Paris, Hôtel Drouot, 19–20 March 1869, lot 48, an album of twenty drawings, to Leurceau); Hyadès, Bordeaux [possibly reverse Boilly/Hyadès collections; see note 3, above]; private collection, Paris; Alfred Strölin, Lausanne, by 1933; Woodner Collections (The Ian Woodner Family Collection, Inc.); given to NGA, 1993.

## EXHIBITIONS

Stuttgart 1980–1981, no. 214; Woodner, London 1987 *(hors catalogue);* Boston 1989, no. 167; Woodner, New York 1990, no. 143; Woodner, Washington 1993–1994.

## LITERATURE

Mayer 1933, 382 (repro.), 384; Mayer 1934, 21; Gassier and Wilson 1971, no. 1734; Gassier 1973, no. 387.

# 100  Loco furioso (Raving Lunatic)

**1824/1827, black chalk on grayish laid paper, 193 x 145 (7 ⅝ x 5 ¹¹/₁₆)**

**Inscribed at upper center in black chalk: *Loco furioso 3*; at lower left in graphite: *Goya*; on the verso at lower center in black chalk: *Goya***

**Watermark: Three-leaf clover on heart**

**Woodner Collections**

While Goya's earlier albums had dwelled on the plight of beggars, who first made their appearance in a tapestry cartoon of 1778,[1] "madmen" were also a recurrent theme in his work from the time of his critical illness in 1793 when he lost his hearing. One of the little paintings on tin plate executed during his convalescence was of a *Corral de locos* (Yard with Lunatics), as Goya himself titled it, describing it as "a scene I once saw in Saragossa." He also included a prison scene in this set of pictures based on *capricho* (fantasy) and invention.[2] It is clear from his paintings and drawings that Goya reflected endlessly on the shifting boundaries between rational and irrational behavior, between freedom of expression and personal liberty on the one hand and the "incarceration" of minds and bodies through madness or the mad exercise of power. Many drawings in his earlier albums parallel the striking allegories of madness in Goya's celebrated painting in the Royal Academy of San Fernando, Madrid,[3] and in Bordeaux he returned to this theme in some of his most remarkable drawings.

A crazed and violent lunatic had already appeared on page 17 of Album G, followed on the next page by a pathetic creature suffering from delusions—of the horns attached to his head ("He says he was born with them, and keeps them on for life")—although there is also an element of wry humor here.[4] The slippage between the craziness of real life and the world of the crazed lunatic is underlined in the album by the drawing that concludes the series devoted to forms of transport (see cat. 99) and introduces a series of thirteen drawings on the theme of madness. A man had been rash enough to go into the street on roller skates, and Goya shows him about to topple over on his *locos patines* (crazy skates), hair and arms flying, while a newfangled velocipede, perhaps the cause of his upset, is driven off in the distance (fig. 1). This is innocent fun, but the next page introduces the *Loco furioso,* the raving lunatic kept behind bars because of his unbalanced mind and violent outbursts.[5]

Goya's portrayal of the most deranged lunatics appears profoundly sympathetic, with the suggestion that they are as much victims of their inhumane treatment as of their own delusions. The madman in this drawing is confined within his cell by huge iron bars, presumably indicating a window set into a blank wall. Pentimenti indicate that Goya reduced the image to the shape of the window, allowing no extension, no indication of shapes and forms beyond the rigid vertical and horizontal constraints of the iron bars, against which the softly

urgent, diagonal forms of the naked human body are seen, the torso bent forward, fingers gripping the hard iron, the highlighted arm reaching through but hanging hopelessly down. Like a wild animal, the caged lunatic has forced his head between the bars and gazes up toward the light—light of day, or light of reason—that illuminates his tormented features. Is he truly insane, locked within the pattern of his inner delusions, or has he been brought to this pass simply by unorthodox behavior and beliefs? Another, more fearful *Loco furioso* on a later page is seen half-slumped, half-crouching in a dark hellhole of a cell, recalling the scenes of imprisoned victims of the Inquisition in one of Goya's earlier albums.[6] Attention has been drawn to the influence of new attitudes to madness in the early years of the nineteenth century,[7] but Goya's interest in the subject is more profound and more personal as he explores the implications of the lunatic's world, which holds up a distorting mirror to any rational construction of a well-ordered universe.
• *Juliet Wilson-Bareau* •

### NOTES

1. See Gassier and Wilson 1971, nos. 85, 380, 1244, 1248, 1261, 1273, 1420, 1488.

2. Exh. cat. Madrid 1993–1994, 189–190, 200–203, nos. 42, 43.

3. Exh. cat. Madrid 1993–1994, no. 98.

4. Gassier and Wilson 1971, nos. 1725, 1726; Gassier 1973, nos. 378, 379.

5. Although the Woodner sheet bears only the number 3 with no trace of erasure, another drawing also numbered 3 properly belongs at the beginning of the album (Gassier and Wilson 1971, no. 1713; Gassier 1973, no. 367). The madman in the Woodner drawing clearly belongs within the group of thirteen drawings on pages 33 to 45, for which no other page specifically numbered 33 is known (a page 33 does exist for Album H).

6. Album G, folio 40, Gassier and Wilson 1971, no. 1745; Gassier 1973, no. 398. See Album C, folios 93–114; Gassier and Wilson 1971, nos. 1329–1349; Gassier 1973, nos. 238–258.

7. See Mena Marqués in exh. cats. Madrid 1988 and Boston 1989, no. 168.

### PROVENANCE

Javier Goya [d. 1854] and/or Mariano Goya, Madrid, or Leocadia Weiss, Bordeaux (to 1833) and Madrid; Jules Boilly, purchased in Madrid or France[?] (sale, Paris, Hôtel Drouot, 19–20 March 1869, lot 48, an album of twenty drawings, to Leurceau); Hyadès, Bordeaux [possibly reverse Boilly/Hyadès collections; see cat. 99, note 3]; private collection, Paris; Alfred Strölin, Lausanne, by 1933; private collection, New York; Woodner Collections (Shipley Corporation).

### EXHIBITIONS

Woodner, New York 1973–1974, no. 116; Stuttgart 1980–1981, no. 215; Frankfurt 1981, 219; Woodner, Malibu 1983–1985, no. 61; Woodner, Munich and Vienna 1986, no. 105; Woodner, Madrid 1986–1987, no. 122; Woodner, London 1987, no. 107; Boston 1989, no. 168; Woodner, New York 1990, no. 141.

### LITERATURE

Mayer 1933, 382, 383 (repro.); Mayer 1934, 22; Gassier and Wilson 1971, no. 1738; Gassier 1973, no. 391; Held 1980, 141.

**FIGURE 1**

Francisco de Goya, *Locos patines (Crazy Skates)*, Museum of Fine Arts, Boston, Arthur Tracy Cabot Fund

# 101 The Public in the Salon of the Louvre, Viewing the Painting of the "Sacre"

*Son of the sculptor and trades-man Arnould Joviste Polycarpe Boilly (1733 – after 1791), the young Boilly set himself up as a painter in Douai from 1775. From 1779 he worked in Arras, and in 1785 he settled in Paris, where he was known as a painter of gallant subjects and portraits. He overhauled his art during the French Revolution, a change most notably signaled by his 1794 painting of the* Triumph of Marat *(Lille). With his sharp wit and humor he captured the social effects of the Revolution and Napoleonic age and became one of the first painters of mod-ern urban life in France. From 1791 to 1824 he exhibited regularly at the Salons, where he appealed to a popular audience as well as to connoisseurs. He effectively retired from painting in 1824 and devoted the last part of his life to managing his financial investments.*

**Begun 1808, pen and black ink with gray wash and watercolor over traces of graphite on laid paper, 595 x 803 (23 ⁷/₁₆ x 31 ⁵/₈)**

**National Gallery of Art, Woodner Collection 1991.182.8**

This elaborate watercolor is the final pre-paratory study for the painting of the same name (fig. 1). The exhibition of Jacques-Louis David's *Coronation of the Emperor and Empress,* his so-called *Sacre* (Louvre, Paris), was a major event in Paris in 1808 because it afforded ordinary people their first glimpse of Napoleon's glamorous coronation. Just as David's painting func-tioned as an eye-witness account of the event, so Boilly's painting "documents" the unveiling of that official version of history. David's painting stands in for the specta-tor's actual presence at the coronation and presents the viewing of art as a means of bearing witness to history. The choice of subject speaks to Boilly's own fascination with themes of viewing and spectatorship.[1]

Boilly's work points up the contrast between the dignitaries who attended Napoleon's coronation ceremony in 1804 and the socially diverse crowd that viewed David's painting in 1808. In the galleries military men mingle with civilians, workers stand alongside members of the middle class, and the young mix with the old. His image of social diversity was indebted to a liberal ideal of the French Revolution,

which David had championed and Boilly himself had first pictured in the *Triumph of Marat* (fig. 2).[2] This liberal vision surely contributed to David's ready approval of Boilly's request to reproduce the *Sacre.*[3]

*The Public in the Salon of the Louvre* belongs to a group of paintings by Boilly that emphasizes public recognition of art-ists and their work. Beginning in 1798 with *A Reunion of Artists in Isabey's Studio* (Louvre, Paris), he celebrated illustrious colleagues such as the sculptors Houdon and Cartellier. In the *Public in the Salon of the Louvre* that most famous of artists, David, does not himself appear but is rep-resented instead by his art. Indeed, David's painting was so famous at the time that Boilly did not need to name its author in the original title of his work.[4] Boilly was seeking reflected glory by associating him-self with celebrities of the art world. At the same time, his own growing artistic ambi-tions were evidenced by his development of complex multiple-figure compositions such as this. The lionization of modern artists was a new phenomenon in France and guaranteed Boilly's paintings an eager viewing public. It is likely that he was work-ing up the subject of the crowd viewing David's *Sacre* for popular consumption at the Salon, presumably that of either 1810 or 1812, though he did not exhibit the painting publicly until 1826. It was shown at a char-ity exhibition in a commercial gallery that still welcomed Napoleonic subjects when

they were no longer politically in favor.

This watercolor served as a study of the overall movement and disposition of the scene, an overview that was necessary because Boilly worked by piecing composi-tions together from individual figures and figure groups. The Woodner drawing was probably preceded by two oil studies that block out three and four figures (figs. 3 and 4) and followed by another that alters de-tails such as the hairdo of the woman seen from the rear (fig. 5).[5] Once the basic layout was established by the Woodner drawing, Boilly worked to break up the strong hori-zontal division and add more visual interest to the scene. In the painting he raised mili-tary hats, some children, and gesturing hands above the crowd so that their thrust focuses attention on the central episode of David's painting, Napoleon crowning Josephine.

A major change between the drawing and painting is the particularity of the figures in the painting compared with their more generalized features in the drawing. This has prompted critics, scholars, cura-tors, and dealers to engage in a guessing game of "who's who," trying to match up the specific figures in the painting with well-known personalities of the day, famous artists, and intimates of Boilly's circle.[6] This is characteristic of audiences' responses to genre scenes—and is to some degree understandable in the case of Boilly, because he often did use family and friends as

101

**FIGURE 1**

Louis-Léopold Boilly, *The Public in the Salon of the Louvre, Viewing the Painting of the "Sacre,"* private collection, New York

models for his subject paintings. Here, for example, he included a profile likeness of himself at the extreme right, near a portrait of the playwright and drama critic François Hoffman. He had, moreover, just created a pantheon of living artists in his sketch for *Napoleon Awarding Cartellier the Cross of the Legion of Honor* (Musée Napoléon, Arenenberg), exhibited at the Salon of 1808.[7] Boilly's usual practice, however, was to use distinctive faces for the "typical" figures in his genre scenes. He would recycle portraits of interesting faces and life studies, regardless of who the sitters were. In moving from the watercolor to the painting of the *Public in the Salon of the Louvre,* he referred to his

earlier portrait sketch of Hoffman (Musée des Beaux-Arts, Lille) made for *A Reunion of Artists in Isabey's Studio,* a profile self-portrait, a commissioned portrait of Dr. Antoine Dubois, and a study of a flower seller (the last two formerly Didier Aaron, Paris) used in the *Arrival of the Stagecoach in the Courtyard of the Messageries* (1803; Louvre, Paris).[8] It is more likely that through this practice Boilly was aiming for plausibility, not portraiture. His creation of generally recognizable types lent his scenes the realism that was complimented at the time as "truthful."[9]

The Woodner watercolor was owned by Boilly's friend and supporter, the distinguished writer Antoine-Vincent Arnault, a cousin of the artist's second wife. Arnault owned many Napoleonic subjects, including Boilly's *Napoleon Awarding Cartellier the Cross of the Legion of Honor* mentioned above, *Conscripts of 1807 Parading Past the Saint Denis Gate* (Musée Carnavalet, Paris), and *Reading of the Bulletin of the Grande Armée* (Saint Louis Art Museum).[10]

• *Susan L. Siegfried* •

**FIGURE 3**
Louis-Léopold Boilly, *A Family: Study for "The Public in the Salon of the Louvre,"* Musée des Beaux-Arts, Quimper

**FIGURE 2**
Louis-Léopold Boilly, *Triumph of Marat,* Musée des Beaux-Arts, Lille

## NOTES

I am grateful to Étienne Bréton and Pascal Zuber for sharing new details of the provenance and exhibition history of this watercolor with me and for allowing me to include them here.

1. Discussed at length in Siegfried 1995.
2. For a detailed discussion of the *Triumph of Marat* see Siegfried in exh. cat. Lille 1988–1989, 6–13.
3. Wildenstein 1973, 180, no. 1545.
4. Boilly's painting was originally exhibited and published with the title *Le public au salon du Louvre, regardant le tableau du "Sacre"* (exh. cat. Paris 1826, 5, no. 14). Schinkel recorded the same title in his journal of 1826 after seeing the painting in Paris (Bindman and Riemann 1993, 202 n. 59). The original title is revived here.
5. The *Figure Group* of four was last recorded in the catalogue of the Wassermann sale, Berlin, Lepke, 8–12 June 1920, no. 65, pl. 5. A study for three figures that cannot certainly be identified with the three known oil sketches is mentioned as formerly belonging to Paul Marmottan (Frick Art Reference Library, 520-1a, Boilly, "Genre. Polite").
6. Harrisse 1898, 25, and Marmottan 1913, 124, were responsible for the idea that Boilly filled the crowd with portraits. This tradition was renewed when the painting reappeared on the art market in 1984 and has been further encouraged by recent exhibitions of related studies. See exh. cat. Paris 1984, 50, no. 24; and Woodner exh. cats. since 1986.
7. See Chaudonneret 1981, 185–192.
8. The portrait studies for *Isabey's Studio* are reproduced in exh. cat. Lille 1988–1989, 70–77, no. 20.

I discuss Boilly's introduction of self-portraits into genre scenes in exh. cat. London 1991, 22, 28. Boilly might have referred to a portrait of Dr. François-Joseph Gall (location unknown), inventor of phrenology, rather than to his portrait of Dubois, physician to the Empress Marie-Louise; it is difficult to tell which, since these portraits resemble each other. Both portraits were engraved (Bibliothèque nationale, Paris, DC 43, T.1, H.716, and Oa. 19 fol., t.15, M.12095), so either the paintings or engravings could have served as models. Similarly, Boilly could have referred to either an oil study (cited) or a drawing of the flower seller; the latter is reproduced in Harrisse 1898, no. 883, facing p. 163.
9. See, for example, Landon 1814, 99.
10. Sale cat., Paris, 15–18 April 1835, nos. 18, 19, 20 (Woodner drawing), 21.

## PROVENANCE

Antoine-Vincent Arnault (sale, Paris, Coutelier, 15–18 April 1835, lot 20); W. W. Hope (sale, Paris, Pouchet, 12 June 1855, lot 32); Eugène Tondu (sale, Paris, Pillet, 24 April 1865, lot 39); Émile Delagarde, by 1930; E. M. Hermès; private collection (sale, Paris, Hôtel Drouot, 28 November 1984, lot 1); Woodner Collections (Dian and Andrea Woodner); given to NGA, 1991.

## EXHIBITIONS

Paris 1928, no. 111; Paris 1930, no. 101; Woodner, Cambridge 1985, no. 107; Woodner, Munich and Vienna 1986, no. 85; Woodner, Madrid 1986–1987, no. 101; Woodner, London 1987, no. 84; New York 1989, no. 5; Woodner, New York 1990, no. 105.

## LITERATURE

Harrisse 1898, 24–25, no. 1145; Marmottan 1913, 123; Mabille de Poncheville 1931, 117; Chatelain 1973, 192–193 (repro.); Eliel 1985, 39–42; Duret-Robert 1985, 92 (repro.); Horii 1990, 124 (repro.).

**FIGURE 5**

Louis-Léopold Boilly, *The Print
Amateurs*, Musée du Louvre, Paris

**FIGURE 4**

Louis-Léopold Boilly, *Group of
Figures,* Courtesy of the Courtauld
Institute of Art, London

# 102  Philippe Mengin de Bionval

*The son of an architect and stuccadore, Ingres first trained at the Toulouse Academy, then in the Paris studio of Jacques-Louis David (1748–1825), and finally at the École des Beaux-Arts. In 1801 he won the Prix de Rome and remained in Rome from 1806 to 1820. He then spent four years in Florence before returning to Paris in 1824. Except for six more years in Rome as director of the French Academy there (1835–1841), Ingres spent the rest of his long, successful career in Paris. He received numerous commissions for historical and religious paintings, many from the state, and is still regarded as one of the greatest portraitists of all time. His art was deeply rooted in the classical and High Renaissance traditions he studied so avidly during his sojourns in Italy, and he adhered to strong neoclassical ideals of line and form throughout his life.*

**1812, graphite on wove paper, 256 x 196 (10 ⅛ x 7 ¾)**

**Signed at lower right in graphite:** *Ingres a Rome / 1812*

**National Gallery of Art, Woodner Collection 1991.182.21**

The identification of the sitter as Philippe Mengin de Bionval is traditional and came from the sitter's family, in whose possession the drawing remained until 1985. Nothing further is known about this young Frenchman who sat for Ingres in Rome in 1812, beyond what the portrait itself indicates. One can guess from the size and number of his collars and his forward-swept hairstyle, for example, that he was a modish young gentleman, but the intense gaze of his deep-set eyes suggests that he had a serious and perhaps studious side to his character as well. The drawing was most likely made on commission, one of many such that Ingres made to support himself during his first fourteen-year stay in Rome.

The presentation of Mengin de Bionval in perfect profile connects the Woodner drawing with a small series of arresting portrait drawings made by Ingres between 1810 and 1812, in which the sitters are all presented in profile facing to the left.[1] Presumably, Ingres was interested, for that very limited period, in exploring the artistic and expressive possibilities and complexities of the profile pose, a pose he had used earlier for his first portrait drawings in the 1790s, but with markedly different results.[2] Whereas those small, early profile portraits in circular or oval format clearly belonged to the eighteenth-century tradition of medallion portrait prints and drawings by such artists as Augustin de Saint-Aubin and Charles-Nicolas Cochin II, the larger, rectangular profile portraits in Ingres' later series had a more modern flavor, combining the classical purity of the profile pose with some of the spirit of the new romanticism. For whatever reason, Ingres virtually abandoned profile portraits soon after drawing Mengin de Bionval. Only three later ones are known—made in 1814, 1816, and 1841—none of which has quite the same intensity as those in the 1810–1812 group.[3] Ingres continued to use profile poses for many of the figures in his history paintings, however, presumably because they heightened the classical flavor of—and were appropriate to—the ancient history subjects he loved best.

Like so many of Ingres' graphite portraits, that of Mengin de Bionval is a study in precision and subtlety. The planes, curves, and hollows of the face are drawn with the most delicate touches of a finely sharpened pencil, with some careful blending and smudging of the lines to give the skin an alabaster smoothness. Characteristically, Ingres drew Mengin de Bionval's face with minute care and almost photographic clarity, while executing the rest of the drawing with a freer touch. The hair, for example, is suggested with a combination of fine hatchings and loose, wavy lines, while the clothing is even more broadly sketched, with just a few strokes for the outlines and some rough scribbles and hatchings to give them shape. Attention is thus focused on the physical likeness, and the exquisite finish and sculptural relief of the face is intensified. It is a measure of Ingres' consummate skill as a portraitist and draftsman that he could create with the simplest means such a striking drawing of someone whom he may only have known for the time it took to execute the portrait.

• *Margaret Morgan Grasselli* •

**NOTES**

1. See Naef 1977–1980, 4: nos. 58–60, 62, 64, 66, 67–70, 80–81. Only the last two, a lost portrait of Beljame and a portrait of Mlle Albertine Hayard, later Mme Pierre-Athanase Chauvin (now in the collection of Maria Luisa Caturla, Madrid), were made in 1812, the same year as the portrait of Mengin de Bionval. For a discussion of the profile group see Naef 1:203.
2. See Naef 1977–1980, 1:35–51; 4: nos. 2–7, 10–15, 18–22, 24–25 (the last two rectangular in format).
3. See Naef 1977–1980, 4: nos. 109, 184; 5: no. 385.

**PROVENANCE**
Family of the sitter (sale, Paris, Nouveau Drouot, 16 December 1985, lot 3); (Marianne Feilchenfeldt, Zurich); Woodner Collections (The Ian Woodner Family Collection, Inc.); given to NGA, 1991.

**EXHIBITIONS**
Woodner, New York 1990, no. 106.

# 103  Two Studies of Virgil

**c. 1812/1815 and c. 1825/1827, graphite on five joined sheets of paper, 438 x 309 (17 1/4 x 12 3/16)**

**Inscribed at center right in graphite: *ombres sourdes / et tranchantes*; and vertically along the margin at lower right: *ombre demi teinte / clair au bord sourd***

**National Gallery of Art, Woodner Collection 1993.51.8**

In 1811 Ingres was commissioned by General Alexandre-Sextius Miollis, the French governor of Rome under Napoleonic rule, to paint a *Virgil Reading the Aeneid to Augustus* for the Villa Aldobrandini. The painting (fig. 1) was apparently completed the next year. But as he often did, Ingres continued to rethink the composition over the next decades.[1] He produced at least two other painted versions, authorized a print by Charles Pradier (fig. 2), and made several drawings of both the composition as a whole (fig. 3) and of individual details.[2] In about 1835, when Ingres returned to Rome as the director of the French Academy there, he even bought the 1812 painting back from the Borghese family with the intention of incorporating his revisions into the composition. Some of the original paint was scraped off and changes were painted in by Ingres' pupils under his supervision. Although the picture was left incomplete at Ingres' death, it was altered sufficiently beforehand that it is now impossible to determine its original appearance in 1812.

Although both studies on the Woodner sheet are related to the figure of Virgil in Ingres' various versions of *Virgil Reading the Aeneid,* they were surely made in two different sessions. The draped figure was drawn in a fine, silvery graphite on a smooth white paper, while the nude was sketched with a softer, darker graphite on a paper of similar weight and quality but slightly creamier in tone. (The difference in the drawings can be seen most clearly where the detail study of the nude figure's right hand almost touches the neck of the draped figure.[3]) It is likely that Ingres' execution of the two drawings was separated by as much as several years, for the lighter touch and more delicate handling of the draped study is consistent with Ingres' style during the 1810s, while the more robust execution, larger forms, and more imposing physical presence of the nude figure suggest a date for that study in the 1820s.

Subtle but distinct differences in the poses of the two figures support the notion that they were made at separate times during Ingres' prolonged development of *Virgil Reading the Aeneid.*[4] In the earliest versions of the composition, Virgil is intent on his reading, looking down at the scroll, and not yet aware of Octavia's reaction to his mention of her dead son, Marcellus. Both of his feet are flat on the floor. The draped figure on the Woodner sheet, though unfortunately cut just at the level of the eyes, seems to belong to this earliest stage of the composition. Indicative of an early date are the unresolved form of the scroll in Virgil's right hand and the absence of his left hand, which in all other versions (except the other on the Woodner page) is visible, and held to his chest. Further, the silhouette of Virgil's draped form in the Woodner sheet is virtually identical to the outlined figure of Virgil included in a compositional drawing in the Fogg Art Museum, Cambridge, which has been dated as early as 1812 and no later than 1815 (fig. 3).[5] One more detail that suggests an earlier date is the arrangement of the draperies around the arms and shoulders, which is bulkier and more complicated in the Woodner study than in all the other versions of Virgil's toga; and nowhere else are the poet's chest and arms left bare.

In the next stage of development Ingres altered Virgil's pose to show him looking questioningly across at Augustus but still standing flat-footed. The nude figure's gaze toward the right places that study squarely in this second phase. The earliest known work in which Virgil looks at the emperor in this manner is a drawing in the Musée Bonnat, Bayonne; it was signed by Ingres and dated 1815 on the verso.[6] In that version, as in the Woodner study, Virgil holds the very end of his scroll between his thumb and forefinger, a detail that is changed in later renderings of the composition—including all states of Pradier's engraving and the reworked Toulouse picture—to show the scroll partly rolled up in Virgil's grasp. The flat-footed stance, meanwhile, seems to have endured in Ingres' work on the composition until after Pradier produced a first version of his authorized engraving, probably between 1825 and 1827.[7] The final state of the print (fig. 2),

103

**FIGURE 1**

Jean-August-Dominique Ingres,
*Virgil Reading the Aeneid to
Augustus,* Musée des Augustins,
Toulouse

published in 1832, presents one of the last
changes to Virgil's pose, in which his left
foot is moved back behind the right and the
left heel is raised from the floor. A further
refinement, which first appears in Ingres'
corrections to Pradier's early version of the
print (though it is not known when Ingres
made those corrections) but then seems to
disappear until Ingres' watercolor of 1850,
is a slight downward turn in Virgil's gaze

so that he is looking at the swooning Olivia
rather than at Augustus.[8]

It is not known when the two studies
on the Woodner page were brought to-
gether to form this composite sheet. It may
well have been done during Ingres' lifetime
and perhaps even by Ingres himself, though
it is highly doubtful that he was responsible
for the weak completion of the draped
figure's head at upper right and the nude
figure's legs at lower left. Because Ingres'
studies for his history paintings were true
working drawings that were much used and
consulted, irregularly trimmed and dam-
aged sheets and pages with torn and ragged
edges were common in his studio.[9] But the
Woodner sheet, in which two separate but
related studies were brought together to
form a new sheet, is unusual in his oeuvre.
• *Margaret Morgan Grasselli* •

**NOTES**

1.  For the evolution of Ingres' *Virgil Reading the Aeneid
to Augustus,* see exh. cat. Louisville 1983–1984, 28–30,
52–59; and exh. cat. Rome 1993–1994, 62–64, no. 16.
2.  All painted versions, the final version of the Pradier
print, an earlier one corrected by Ingres, as well as sev-
eral compositional and figure studies are reproduced
in exh. cat. Louisville 1983–1984, 28–29, 52–59,
160–166 (nos. 9–15).
3.  When the composite sheet was formed, someone
apparently added a few touches of soft, black graphite
to extend the nude Virgil's scroll onto the sheet bear-
ing the draped Virgil.
4.  Ingres' work on *Virgil Reading the Aeneid* followed a
complex course, which has proven difficult to recon-
struct and should not be oversimplified. The evidence
of the drawings, paintings, and prints, however, sug-
gests that the evolution of the figure of Virgil was rela-
tively simple and involved only minor changes over
the years. See exh. cat. Louisville 1983–1984, 54.

5. In exh. cat. Cambridge 1967, no. 20, the drawing is dated c. 1812. In exh. cat. Louisville 1983–1984, 53, a date of c. 1812–1815 is given.

6. Repro. in exh. cat. Louisville 1983–1984, 52, fig. 3.

7. A unique, early impression in the Bibliothèque nationale, Paris (inv. A.A.5rés), was corrected by Ingres; repro. in exh. cat. Louisville 1983–1984, 164, no. 13.

8. Repro. in exh. cat. Louisville 1983–1984, 59, 164.

9. See exh. cat. Rome 1993–1994, for several examples, including nos. 16, 21, 44, 49, 68, 70, 72, and 85.

**PROVENANCE**

Artist's estate (Lugt 1477); private collection (sale, Saumur, Ségéron, 20 November 1988); Woodner Collections (The Ian Woodner Family Collection, Inc.); given to NGA, 1993.

**EXHIBITIONS**

Woodner, New York 1990, no. 107; Woodner, Washington 1993–1994.

# 104  Mademoiselle Borderieux

**1857, graphite heightened with white, with blue wash (added later?) on gray-brown wove paper mounted on wood board, 352 x 270 (13 ⅞ x 10 ⅝)**

**Signed at center right in graphite: *Ingres Del / 1857.***

**Woodner Collections**

Slightly smaller than life-size, this portrait stands out in Ingres' oeuvre, not only for the unaccustomed scale but for the unusual combination of media. Why Ingres chose to depart from his customary formats so late in his career—he was seventy-seven when he made this drawing—is not known. The inclusion of a signature and date suggest that the portrait was made as an independent work and not in preparation for a painting.[1]

The identification of the sitter as Mlle Borderieux dates from 1870,[2] but little else is known about her. If information that apparently came from the family in 1977 when the drawing first appeared on the market is correct,[3] she later married a M. Émile Richemond, about whom even less is known.[4] Further unconfirmed but plausible information indicates that in the portrait Mlle Borderieux is wearing the veil she wore on the occasion of her first communion, which, because she was a Protestant, she took when she was between sixteen and eighteen years of age.

The religious context of the portrait accounts in large part for the Madonna-like presentation of the model, who bears an uncanny resemblance to the Virgin in Ingres' *Virgin with the Host,* several ver-sions of which he painted between 1841 and 1866.[5] The drawing is most closely compa-rable to a graphite and white chalk drawing on tracing paper from 1863, which shows the bust of the Virgin from that painting (fig. 1).[6] In both drawings the idealized oval of the head and the symmetrical parting of the hair hark back to the Madonnas of Raphael, the artist whose work most pro-foundly influenced Ingres' throughout his career. But even if Ingres simplified and emphasized the oval shape of Mlle Bor-derieux's head, he gave her an unexpected touch of character by the somewhat rueful expression and quizzical tilt of her mouth.

In keeping with the scale of the draw-ing, Ingres' touch is larger and his pencil lines broader and softer than in his smaller portraits, creating a very different effect (see cat. 102). Although Ingres occasionally used touches of white in his portrait draw-ings, increasingly so after about 1840, the bold touches of white in this drawing are unusually free.[7] Typical of Ingres' later work are the curious patches of shading extending from the outer corners of the eyes, his interpretation of the Renaissance technique of sfumato (literally "smoked"), which served to soften the features. The same idiosyncrasy is found even more markedly in Ingres' small, somewhat eerie oil portrait of Jeanne-Elisabeth Hittorf Gaudry from 1864 (fig. 2).[8] The stark geo-metry and almost confrontational pre-sentation of these women's heads suggest that in his later years Ingres was taking the canons of idealized beauty he had learned from Raphael to a new level of sim-plification.

Although the blue watercolor in the Woodner drawing was apparently not applied by Ingres,[9] it is interesting to note that Delaborde, as early as 1870, mentioned that the drawing was executed in graphite with some *teintes d'aquarelle,* which have now disappeared. • *Margaret Morgan Grasselli* •

104

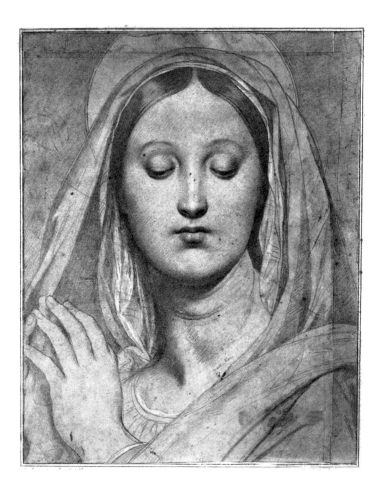

**FIGURE 1**

Jean-Auguste-Dominique Ingres,
*Study for "Virgin with the Host,"*
National Gallery of Canada, Ottawa

**NOTES**

1. Naef 1977–1980, 5:370, has pointed out that the placement of the signature at the right indicates that the drawing was intended from the beginning to be framed as an oval, and indeed the oval shape of the browned area of the paper suggests that the drawing was framed that way for many years.

2. Delaborde 1870, no. 265: "*Borderieux* (Mademoiselle). Tête de grandeur naturelle, dessinée à la mine de plomb avec quelques légères teintes à l'aquarelle. Ce dessin est signé: *Ingres del.* 1857."

3. Naef 1977–1980, 5: no. 445, quotes information provided by the dealer (Dubourg) who first handled the drawing when it came on the market. Part of the information presumably came from the family.

4. In tenuous support of this information, it is worth noting that when the drawing was exhibited in 1905, it was again identified as a portrait of Mlle Borderieux, belonging to a "Mme R***." In addition, on the back of the original drawing tablet to which the drawing itself is still adhered, the name "Richemond" is inscribed in an old-fashioned hand.

5. Zanni 1990, no. 114, in which the Moscow version, made in 1841, is reproduced. Other versions are in the Louvre, two private collections in London, and the Musée Bonnat, Bayonne.

6. Repro. in exh. cat. Louisville 1983–1984, 207, no. 56

7. Striking examples are the double portrait of the *Comtesse Marie d'Agoult and Her Daughter Claire* (private collection, Paris) as well as *Mme Jean-Baptiste-Joseph Dominique Ramel* and *Comte de Nieuwerkerke* (both Fogg Art Museum, Harvard University); see Naef 1977–1980, 5: nos. 412, 428, 439.

8. Repro. in Zanni 1990, no. 114.

9. If the blue watercolor were original, it would show the same light damage as the paper, with the most significant fading occurring in the central oval area that was most exposed to light over the years. Since it shows no such fading, the watercolor must have been added after the drawing was reframed to show the whole page. Presumably the blue washes were added to mitigate the jarring visual effect of the light damage.

**PROVENANCE**

In 1905, in the possession of "Mme R***," presumed to be Mme Richemond, née Mlle Borderieux; by descent through her family until 1977; (Jacques Dubourg, Paris); (Marianne Feilchenfeldt, Zurich); Woodner Collections (Dian and Andrea Woodner).

**EXHIBITIONS**

Paris 1867, no. 314; Paris 1905, no. 62; Woodner, Cambridge 1985, no. 108; Woodner, Munich and Vienna 1986, no. 87; Woodner, Madrid 1986–1987, no. 103; Woodner, London 1987, no. 86; Woodner, New York 1990, no. 109.

**LITERATURE**

Blanc 1870, 240; Delaborde 1870, 13, no. 424; Naef 1977–1980, 3: 460, 5:214, no. 445.

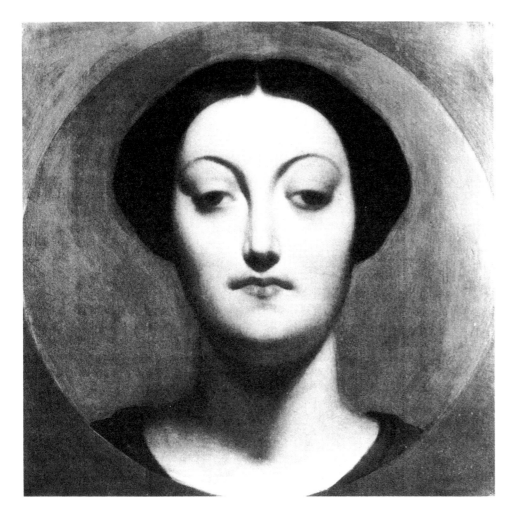

# 105 Self-Portrait

**c. 1855, red chalk on laid paper, 310 x 233 (12 ¼ x 9 ³/₁₆)**

**National Gallery of Art, Woodner Collection 1991.182.23**

*Degas had very little academic training as an artist and was essentially self-taught. He traveled extensively in Italy from 1856 to 1859, visiting relatives in Naples and Florence and copying works by the old masters. In 1872–1873 he visited his family in New Orleans. Degas began his career as a portraitist and history painter, but his friendships with artists such as Manet, Whistler, Tissot, and the future impressionists led him toward racecourse subjects (from the early 1860s), scenes of the theater and ballet (from 1867), paintings of contemporary life, and studies of women bathing and dressing. He exhibited at seven of the eight impressionist exhibitions, missing that of 1882. He worked in and experimented with a wide range of media, from painting and pastel to etching, lithography, monotype, and sculpture. Because of failing eyesight, he seems to have stopped working around 1907.*

This self-portrait is one of the best-known of the many drawings and paintings Degas made of himself between 1854 and 1858. His interest in this form of self-assessment was natural in an artist between twenty and twenty-four years of age, particularly one who enjoyed drawing the members of his family—two brothers and two sisters, father, uncles, aunts, and cousins—and who also often copied the self-portraits of other artists. In this case, in using red chalk very easily and economically, he gives the impression of being well-bred and cultivated. Against the warm cream paper, the red chalk suggests a fragility that is appropriate for such a subtle exposure of the artist's own vulnerability.

Degas became twenty-one in 1855, the year he probably made this drawing. It is closely related to a painted half-length self-portrait showing him with a piece of charcoal in his hand (Musée d'Orsay, Paris). Although the Woodner drawing is only of the head, the slight raising of the right eyebrow and the highlight underneath are so close to those in the painting that the relationship appears certain. Whether the drawing preceded the painting as a study or followed it as an additional exploration has not been as easy to determine. Three sketches for the painting appear in a notebook that Theodore Reff dates 1854/1855,[1] but it is generally agreed that the painting probably dates from 1855, because of the influence of a *Self-Portrait* by Ingres (Musée Condé, Chantilly), which was shown in the Exposition Universelle in Paris that summer.[2]

Degas' painted self-portrait lacks the ease, bravado, and physical allure of the Ingres. It is slightly awkward, somewhat defensive, even diffident. On the other hand, if it is compared with a portrait Degas painted of himself a year earlier, *Self-Portrait with a Palette* (private collection, Paris), the artist does assume a greater dignity and aplomb. In the few months, perhaps a year at the most, that separated the two paintings, Degas had given up shirtsleeves for bourgeois dress and had his hair cut more suavely. His face is also thinner, as it may actually have been with the loss of adolescent fat or because of the fabled hardships of a winter in an attic room in exile from his family in 1854/1855.[3] A certain petulance or moodiness is common to both of Degas' self-portraits, but in the 1855 painting the emotion is contained within a more sophisticated shell that suggests some desire on the artist's part to conform to the ambitions of his father, who had changed the spelling of their name from Degas to De Gas when he moved to Paris from Naples to establish a branch of his father's Neapolitan bank.

Much of the veneer of bourgeois ambition in the painting comes from the stance and the dress. In the drawing, however, only a hint is given of the broad collar and the jabot at the artist's neck. Although some of the surface of the chalk has been lost, one can still see that the large round eyes, like the mouth and the tip of the nose, are given special attention. The hair has been brushed back to show more of his brow, and a growing maturity is hinted at by light hatching that suggests facial hair and the shadow of a moustache. Degas has revealed his complex state of mind at a critical moment of his life. He had left the École de Droit where his father had insisted he study, and had been accepted—perhaps was already a student—at the École des Beaux-Arts, where he would be no more diligent. In the summer of 1856 he would leave for Italy where his serious self-education would begin. • *Jean Sutherland Boggs* •

**NOTES**

1. Bibliothèque nationale, Paris, DC 327 dc réserve, Carnet 20, 58B, 84, 85; see Reff 1972, no. 2.
2. Repro. in Zanni 1990, no. 9.
3. Fevre 1949, 25–27. This niece of Degas—her mother was Marguerite De Gas—lived with the artist the last year of his life; she is so sentimental that her accounts have to be considered critically.

**PROVENANCE**

Artist's estate (Lugt 657); René de Gas (brother of the artist); (sale Paris, Hôtel Drouot, 10 November 1927, no. 12, repro.); (Paul Rosenberg & Co., New York); John Nicholas Brown, Providence [1900–1979], 3 December 1929; (David Tunick Inc., New York); Woodner Collections (The Ian Woodner Family Collection, Inc.); given to NGA, 1991.

**EXHIBITIONS**

Buffalo 1935, no. 113; Philadelphia 1936, no. 58; Cambridge 1962, no. 5; St. Louis 1967, no. 1; Woodner, London 1987, no. 91; Tokyo 1988–1989, no. 9; Woodner, New York 1990, no. 115; Zurich 1994–1995, 162, no. 23 (repro. in color).

**LITERATURE**

Guérin 1931; Mongan 1932, 63, fig. 3; Rosenberg 1959, 107–108, fig. 197.

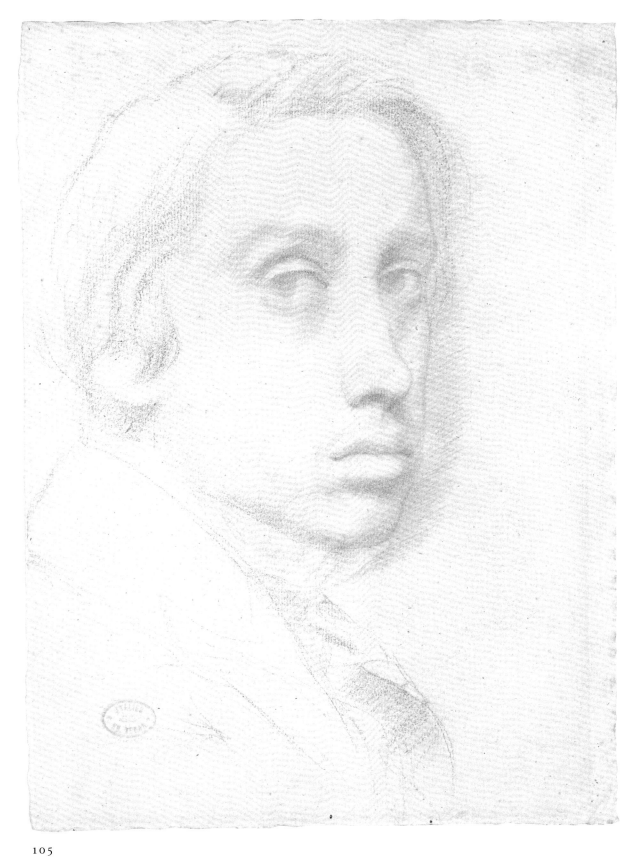

105

# 106 Fantasy Farmhouse

*Apparently self-taught, Rodolphe Bresdin was exclusively a print-maker and draftsman. He grew up in Paris and followed a bohemian lifestyle, even serving as the model for Champfleury's 1845 novel,* Chien-Caillou, *a romantic portrait of an eccentric, poverty-stricken artist. Bresdin left Paris in 1849 and eventually settled in Toulouse for around nine years. He returned briefly to Paris in 1861, spending the rest of the 1860s in and around Bordeaux, where he became a member of the Société des Amis des Arts and taught the young Odilon Redon (q.v.). In 1873 Bresdin emigrated to Canada but returned penniless to France four years later. After working for a time as a street laborer in Paris, he abandoned his family in 1881 and moved to a garret in Sèvres. Most of Bresdin's drawings and prints are small and are marked by a profusion of detail and a personal imagery fired by a romantic, pantheistic imagination rather than direct observation of nature.*

**1853, pen and black ink with gray wash, touches of red-brown crayon, and scraping on Bristol board, 597 x 455 (23 ½ x 17 ¹⁵/₁₆)**

**Inscribed near door at center in pen and black and brown inks: *R*[reversed]*B 1853*; scratched at lower left: *JB*; inscribed at lower right in brown ink: *jᴵʸ Benazech fecit*; embossed circular BRISTOL PAPER stamp at lower right**

**National Gallery of Art, Woodner Collection 1991.182.22**

One of the most common themes throughout Bresdin's career was the depiction of the villages and individual habitations of the rural working class from which he himself came. He was the son of a tanner and spent his early years in the small village of Le Fresne, on the north bank of the Loire River between Nantes and Angers, before moving with his family to Paris in the early 1830s. While these scenes do parallel the contemporary French fascination for seventeenth-century Dutch genre painting, they were also surely inspired by Bresdin's own living situations and embellished with his characteristic fantasy.[1] His so-called peasant interiors of the later 1850s and 1860s are obsessively crammed with objects, children, animals, and birds—virtually no space in home or picture is left unfilled.[2] When he was living in Toulouse during the 1850s, he at first stayed for some two years in a farmer's leaky cabin, before taking relatively more luxurious accommodations in a ground-floor lodging consisting of two rooms facing onto a small garden. According to his first biographer Alcide Dusolier, it included the first bed he had had in five years.[3]

The Woodner drawing is a grand example of the type of exterior scene favored by Bresdin, the clearest parallel being perhaps his most ambitious drawing, *Fantastic Village Scene*, dated 1857, in the Hague (fig. 1).[4] The two are nearly identical in size and format, the largest by far of Bresdin's finished drawings and matched by only one of his prints.[5] Both drawings are executed in virtually the same technique on identical sheets of Bristol board, embossed with the maker's stamp. The compositions are essentially the same, portraying the courtyard of a farmhouse or a group of houses, with people and animals arrayed in the windows, doorways, and across the foreground. One specific element is shared by both: the doorway, stacked wood, shutter, and two pigs at the right edge of the Woodner sheet appear in reverse at the lower left of the Hague drawing, indicating a correspondence or direct transfer of this particular motif.[6]

There are also important differences between the two drawings. Bresdin fully signed and dated the Hague sheet twice, once in the center on the building's façade and again at the bottom edge. Further, he signed the open shutter at the left *Bresdin* and inscribed two personal mottoes: *Le dernier des Cailloux* and *siempre el mismo*.[7] Uncharacteristically for a major drawing, no such full signatures or annotations appear on the Woodner sheet; only a shaky monogram and date appear in the center of the principal façade.[8] Additionally, at the bottom there are a monogram and full signature of a certain J. Benazech, whom cataloguers have assumed to be a previous owner. Although it is true that there is no knowledge of a practicing artist of that name, the implication of the word *fecit* (made) is difficult to ignore.[9]

Accepting the date of 1853 for the Woodner drawing produces an awkward four-year gap between the two sheets. Four other drawings of similar subjects securely dated during that very period provide some stylistic comparison, while exhibiting an increasing complexity leading toward the Hague composition. A rare watercolor and a pen and wash drawing of a village with a tall church steeple and clock tower are both dated 1853; they are considerably smaller than the Woodner drawing and do not betray close stylistic parallels to it.[10] A somewhat closer resemblance is belied in a larger 1855 pen and wash drawing also in the Hague of a *Fantastic Habitation*, also executed on Bristol board.[11] Another drawing of a fantastic building dated 1856 recently appeared at auction.[12]

Clearly the large 1857 composition in the Hague is the work closest in spirit, technique, and ambition to the Woodner sheet, but the latter betrays an overall awkwardness of composition and technique that may or may not result from being an early attempt at an ambitious composition. It seems to have been roughly assembled from different elements, without an overall

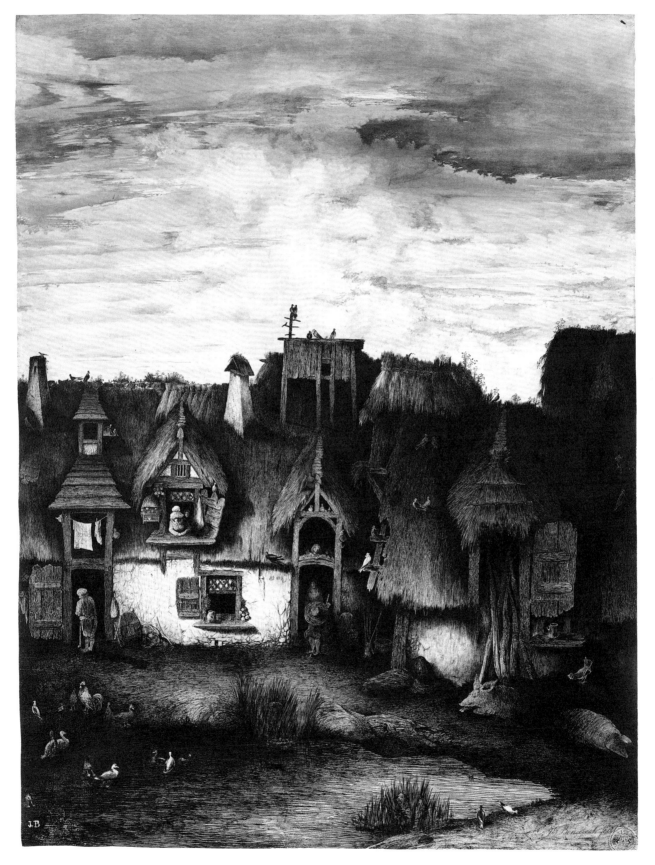

106

**FIGURE 1**

Rodolphe Bresdin, *Fantastic
Village Scene,* Gemeentemuseum,
The Hague

conception. As cited above, the section
at the right containing the pigs does relate
directly to the Hague sheet; the left half of
the Woodner building may have been put
together from similar elements to those
seen in the upper left portion of the other
drawing. Bresdin often worked in such a
manner, but he usually wove his borrow-
ings together into a seamless whole (see
cats. 107, 108), as in the spatially complex
sheet in the Hague. It is possible that Bres-
din collaborated with a student on the
Woodner drawing, producing an impres-
sive drawing nevertheless; it is also possible
that a student took an unfinished sheet by
the master and closely followed his style
in completing the composition.[13] • *David
P. Becker* •

**NOTES**

1. See, among others, Ten Doesschate Chu 1974, 69–71.
Her section on Bresdin contains biographical inaccu-
racies but worthwhile visual observations.

2. See Van Gelder 1976, 1:62–65, 2: nos. 86, 92, 93, figs.
56, 58–65.

3. Van Gelder 1976, 1:61.

4. See Van Gelder 1978, 172–176.

5. The Hague sheet measures 600 x 458 mm. Most of
Bresdin's known drawings are executed in pen and ink
on tracing paper and serve both as his "sketchbooks"
and as sources for transferring motifs in drawing and
printmaking. Most of these have been cut into sepa-
rate pieces, at times very small ones. The largest uncut
multiple-sketch sheet known to this writer measures
491 x 308 mm and includes dozens of tracings of
scenes of martyrdoms, North American Indians, and
natural landscape forms (Harvard University Art
Museums, inv. 1994.72). The largest known drawing
on tracing paper is the preparatory study for *The
Good Samaritan* lithograph (Gemeentemuseum, The
Hague, inv. T31-1929; repro. in Van Gelder 1976, 1:76,
fig. 76). The print itself measures 564 x 444 mm (Van
Gelder 1976, 2:66, no. 100).

6. Technical examination reveals an area of reddish
brown crayon underneath the pig in the Woodner
sheet, reinforcing the idea of a transfer. Bresdin regu-
larly used this method to effect transfers, but the lines
are always extremely thin and precise, which is not
the case here.

7. The first saying ("the last of the pebbles") relates
to Bresdin's nickname, Chien-Caillou, which often
appears on his works; the second ("always the same")
appears on at least three of his prints (Van Gelder
1976, 2: nos. 92, 93, 122).

8. The initials and date on the Woodner drawing are
not characteristic of Bresdin's customary writing style
and are made up of two different colors of ink. When
the sheet was purchased by Ian Woodner in 1987,
the *J* in both sets of initials was read as being "trans-
posed…over a reversed R" (report dated January 1988
from Martina Yamin, conservator, in curatorial files).

9. There is evidence of a Bénazech family living in
Toulouse at the time. According to the *Catalogue
général des livres imprimés de la Bibliothèque nationale*
(Paris, 1897– ), 10:669–670, a certain Jean Bénazech
authored at least five books published in Toulouse
between 1855 and 1866.

10. The watercolor (Gemeentemuseum, The Hague)
is reproduced in color in Van Gelder 1976, 1:2 (fron-
tispiece); the pen drawing was on the art market with
Galerie Brame et Lorenceau, Paris, in 1992 (repro.
in exh. cat. Paris 1990). The two works are the culmi-
nation of a series of studies and tracings ultimately
derived from an etching by Adolphe Hervier (see
Van Gelder 1976, 1:99–91, figs. 89–95.)

11. Repro. in Van Gelder 1976, 1:69, fig. 70.

12. New York, Sotheby's, 20 February 1992, lot 133
(repro.); it had previously appeared in a sale in
Monaco, Sotheby's, 1 December 1989, lot 543 (repro.).

13. In a letter of 13 September 1982 to an unknown
recipient, Dirk van Gelder discussed the Woodner
sheet, declaring it to be an "enigma that I cannot…
resolve" (photocopy in curatorial files). He was per-
plexed by the identity of Benazech, the four-year gap
between the two large drawings, and the heavy use of
the deep black ink in the Woodner drawing, which he
notes had not been used in earlier works by Bresdin.

**PROVENANCE**

Gerard White, Paris; Woodner Collections (The Ian
Woodner Family Collection, Inc.); given to NGA, 1991.

**EXHIBITIONS**

Woodner, New York 1990, no. 112 (as Bresdin).

# 107 Oriental Horsewoman
# 108 Oriental Horseman

*cat. 107*

**1858, pen and black ink and gray wash on wove paper, 277 x 182 (10⁷⁄₈ x 7³⁄₁₆)**

**Signed at lower right in pen and black ink: *rodolphe Bresdin / 1858***

*cat. 108*

**1858, pen and black ink on wove paper, 278 x 180 (10¹⁵⁄₁₆ x 7¹⁄₁₆)**

**Signed at lower center in pen and black ink: *rodolphe Bresdin 1858***

**Woodner Collections**

The decade of the 1850s was a period of relative stability and considerable productivity for Bresdin. Living in Toulouse at that time, he acquired his first steady patronage and embarked on his first fully assured prints, among them *The Comedy of Death* (1854) and *The Flight into Egypt* (1855). In 1860–1861 he developed and executed his master lithograph *The Good Samaritan,* which he took to Paris in the spring of 1861 to show at the Salon.[1] In his prints and drawings of the Toulouse period Bresdin exploited several recurring genre and landscape themes, such as encounters with Death, obsessively delineated peasant interiors, elaborate village scenes (see cat. 106), the Holy Family in fantastic wilderness forests, and exotically garbed riders singly or in vast armies traversing desolate rocky landscapes.

The "oriental rider" was a theme Bresdin returned to time after time, and the two Woodner drawings are among his most highly resolved compositions of this subject, in addition to being prime examples of the most refined drawings of his career. They were each developed from a long series of preparatory drawings and intricately layered tracings of earlier drawings and, ultimately, of printed illustrations by other artists. With identical dimensions and dates, closely related landscape elements,

**FIGURE 1**

Jacques Adrien Lavieille, *Lieutenant General Galbois,* after Auguste Raffet, The Metropolitan Museum of Art, New York, Rogers Fund

and complementary poses, the two drawings seem clearly to have been conceived as a pendant pair.[2]

Bresdin's preoccupation with orientalist subject matter was of course very much in tune with many contemporary French artists, a fascination harking back to the Napoleonic conquest of Egypt and reflecting the growing French desire for images of northern Africa and the Near East. Bresdin was undoubtedly influenced by Eugène Delacroix and later orientalizing painters such as Alexandre Decamps and Prosper Marilhat,[3] but his singular aesthetic and eccentricities also set him quite apart from more academic artists. Bresdin's most identifiable visual sources are not found in grand Salon paintings but in illustrated books and periodicals of the time, many of which reflected prevailing artistic concerns, to be sure, but more importantly served his own search for spiritual and political identification with his isolated riders.

Both Bresdin's sources and the particular titles he gave his exhibited works reveal this search, if at times in a topsy-turvy fashion. His heroes were the leaders of indigenous resistance to domination by colonial powers, struggles often extensively reported in contemporary periodicals. Several of his titles specifically refer to two such topical figures. When exhibited in the 1861 Salon, *The Good Samaritan* lithograph was listed as *Abd el-Kader Aiding a Christian,* in homage to the famed Algerian emir

107

**FIGURE 2**

Rodolphe Bresdin, *Russian Cavalry*,
The Art Institute of Chicago, Gift of
the Print and Drawing Club

(1808–1883) who had fought the French occupation of his country for many years and, more specifically, to his humanitarian actions while in exile in Damascus, saving a great number of Christians and Jews from massacre by Muslim forces in 1860.[4] Bresdin exhibited a drawing in the same Salon entitled *Schamyl in His Youth*, which portrayed the celebrated religious and military leader (c. 1795–1871) who fought the Russians in his native Caucasus, in present-day Dagestan and Chechnya.[5] Both of these figures afforded Bresdin ample opportunities to clothe his own ideals with their contemporary examples.

The specific graphic origins of the riders in the Woodner drawings are found in portraits of French generals from a publication commemorating part of the Algerian campaign, *Journal de l'expédition des Portes de Fer*, written by Charles Nodier and issued in Paris from the Imprimerie Royale in 1844. It was richly illustrated with wood engravings after drawings by Auguste Raffet, Adrien Dauzats, and Alexandre Decamps, which served Bresdin as a rich source of landscape motifs, equestrian portraits, and native North African dress and custom. He made at least thirteen direct tracings from engravings in the Nodier volume, several of which he later used for his own compositions. This was a common practice for him; the majority of extant Bresdin drawings are executed on tracing paper and are clearly traced from similar illustrations.[6]

The Woodner drawing of the male rider began its life as the Lieutenant

General Galbois, in a wood engraving after Raffet (fig. 1), which was directly traced by Bresdin (fig. 2). The French general's uniform disappeared, however, and the figure was depicted wearing an elaborate headdress and a rifle slung across his shoulder. In a large pen and ink drawing on tracing paper dated 1857 (Art Institute of Chicago) the horse and rider (and two closest riders behind) were then transferred, reversed, and placed before a battle raging in a vast mountainous valley.[7] Bresdin further developed the composition into a highly finished pen and wash drawing of the same year (private collection, New York).[8]

The Woodner drawing, executed a year later, is a slightly smaller variant in which the battle has been eliminated and the landscape closed in, particularly at the left. The central rider's headgear has changed, his rifle has switched shoulders, and the two horsemen following close behind have been eliminated. A single rider has been inserted in the middle ground to the left. Based on the commanding presence of the single male rider and the relatively specific costumes of his accompanying riders, resembling those of horsemen of the Caucasus, either the Woodner or the New York drawing would surely seem to be the very drawing of Schamyl that Bresdin exhibited in the 1861 Salon.[9]

The duc d'Orléans (fig. 3), son of Louis Philippe and leader of the Algerian expedition, is—improbably—the ultimate prototype for the Woodner female rider, as is evident in a tracing (fig. 4) in which the

French general was similarly transformed into an exotically uniformed freedom fighter.[10] Bresdin switched the rider's gender in a more elaborate pen drawing on tracing paper, also in the Woodner collections; she is garbed in a flowing dress and feathered turban. A crowd of people in a rocky landscape was incorporated in the background, within a panoramic horizontal landscape. That study was closely followed by a highly finished pen and wash version dated 1857 (Gemeentemuseum, The Hague).[11]

By reusing and developing his tracings, Bresdin then produced a version of his female rider within a vertical format, and in reverse to the original. An 1858 pen and ink drawing on tracing paper (Achenbach Foundation, San Francisco) is the direct precursor to the Woodner drawing.[12] The rider is virtually identical to the finished drawing of the year before, with very small decorative variations; the primary change is the considerably heightened, mountainous landscape behind, which becomes contiguous with that in the pendant Woodner drawing of the male rider.

Beyond their intricately layered construction process, the Woodner drawings exhibit a remarkable range of specific qualities of draftsmanship characteristic of Bresdin's most accomplished works. The obsessive yet delicate attention to facial features and decorative details of the principal riders well rewards magnification, as do the variety and profusion of landscape elements, supplemented by the virtual horde of figures in the background of the

drawing of the horsewoman. Curiously, the sky is the only major difference between the two drawings, as that over the male rider is executed in tight swirls of pen and ink only, without the brush and wash technique used in the female rider. Further, only in the latter sheet do Bresdin's trademark birds populate the sky.

Bresdin developed several further compositions from these exotic riders, again switching the gender of the female rider in at least two other instances. A major composition, seen in two drawings of 1859 (Rijksprentenkabinet, Amsterdam, and Bibliothèque nationale, Paris) represents a large caravan of "oriental" riders in a panoramic landscape, featuring a male and female pair in the foreground. In this work, traditionally called *The Cortege,* the *male* rider is derived from the same prototype as the Woodner female rider, and the new female rider is descended from yet another illustration in the Nodier book.[13] Finally, Bresdin used the prototype of the female rider in the Woodner pair for his two major etchings on the "oriental rider" theme: one of a man dated 1861, and a woman dated 1866.[14] Indeed, the composition of the 1866 etching would seem to be modeled on that of the Woodner drawing.

The 1866 date of Bresdin's most elaborate etching on this subject is significant, for it is the theme of riders in rocky landscapes that was a major inspiration and preoccupation of his student at this time, Odilon Redon, who was to become a disciple of the older artist and responsible

in major part for preserving his reputation. Redon's first prints consisted of etchings made under Bresdin's tutelage in 1865–1866, and several of them depicted riders, singly or in groups, in quite desolate, rocky landscapes.[15] Both artists felt a strong personal resonance with the theme of lonely, outcast warriors and their people struggling against the forces of "civilization," and often being forced to flee them. • *David P. Becker* •

**FIGURE 4**

Rodolphe Bresdin, *Oriental Rider,* The Metropolitan Museum of Art, New York, J. B. Neumann Collection of Bresdin

**NOTES**

1. Van Gelder 1976, 2: nos. 84, 85, 100

2. This writer knows of no other such prominent pairs of works in Bresdin's oeuvre, with the possible exception of two lithographs of bathers with Death in 1857 (Van Gelder 1976, 2: nos. 89, 90).

3. Bresdin was greatly influenced by Decamps' major oil of the *Defeat of the Cimbrians* (1833) and related works; he directly copied at least one motif from Marilhat for the camel in his print of *The Good Samaritan* (Becker 1993, 43–46).

4. No. 413 on p. 53 of the published checklist of the Salon. For a detailed study of this print see Becker 1983, 7–14, and Becker 1993.

5. No. 415 on p. 53 of the Salon checklist. For a brief biography of Schamyl (also Shamil), see Houtsma et al. 1987, 7:306–307. A striking equestrian portrait of Schamyl was published in the French journal *L'Illustration* 23, no. 588 (3 June 1854), 340. Following Montesquiou's reference in his 1913 publication on Bresdin, Peter Hahlbrock and others have noted the connections between the figure of Schamyl and Bresdin's imagery (Montesquiou/Hahlbrock 1977, 112–113; Druick and Zegers in exh. cat. Chicago 1994–1995, 52). Margret Stuffmann has suggested more generally that Bresdin was influenced at this time by reports from the Crimean War (exh. cat. Frankfurt 1977, 104).

6. This writer has identified three other specific sources; see Becker 1983, 8–10, and Becker 1993.

7. Inv. 1963.811; repro. in Van Gelder 1976, 1:38, fig. 25. See also Peters in exh. cat. Cologne 1972–1973, cat. 18.2, and Stuffmann in exh. cat. Frankfurt 1977, cat. 49.

8. Repro. in exh. cat. The Hague 1978–1979, 159, no. 142.

9. See the illustrations cited above in note 5 for typical costumes. Montesquiou/Hahlbrock 1977, 112, no. 8, identifies another sheet, traditionally titled *Le Cortège,* in the Bibliothèque nationale, Paris (repro. in Van Gelder 1976, 1:29, fig. 17), with the Schamyl title.

10. Inv. 51.504.25; repro. in exh. cat. Cologne 1972–1973, 43, no. 18.11 (*sic*—actually no. 18.1).

11. Drawings from the Woodner collection and the Hague (inv. T32-1970); repro. in Van Gelder 1976, 1:26–27, figs. 14–15.

12. Inv. 1982.2.46; repro. in Van Gelder 1976, 1:25, fig. 13. Van Gelder reads the date as 1856, but close examination reveals the later figure.

13. Repro. in Van Gelder 1976, 1:28–29, figs. 16–17. This female rider is originally traced from Raffet's equestrian portrait of an Algerian, Colonel Youssof, facing p. 30 of the *Journal* (tracing in the Art Institute of Chicago, inv. 1949.61). Peters in exh. cat. Cologne 1972–1973, 42, and others have suggested that the Chicago drawing is a copy of Théodore Chassériau's 1845 painting *Ali Ben Hamed, Caliph of Constantine, and His Escort* (Musée National, Versailles); but actually Bresdin's source in the Raffet illustration had appeared in 1844.

14. Van Gelder 1976, 2: nos. 99, 121. Van Gelder and others are clearly mistaken in identifying the latter print as a male rider.

15. See esp. Mellerio 1913, nos. 2–4, 6–10; and Harrison 1986, nos. 1–3, 7–11, and 15. For the most recent discussion of this theme in Redon's early work see exh. cat. Chicago 1994–1995, 56–61.

**PROVENANCE**

(Paul Prouté, S. A., Paris); Woodner Collections (Shipley Corporation).

**EXHIBITIONS**

Woodner, Malibu 1983–1985, nos. 64A, 64B; Woodner, Munich and Vienna 1986, nos. 89, 90; Woodner, Madrid 1986–1987, nos. 105, 106; Woodner, London 1987, nos. 89, 90; Woodner, New York 1990, nos. 113, 114.

**LITERATURE**

Prouté 1978, pt. 2, no. 99 (repro.).

# 109  Madame Ditte

*The son of an artist, Fantin-Latour moved with his family to Paris in 1841. His formal training was fragmentary and included a year studying with Horace Lecoq de Boisbaudran (1802–1897), a brief period at the École des Beaux-Arts (1854–1855), and copying in the Louvre. Fantin-Latour's subjects fall into three categories: flower pieces, large group portraits of his friends and acquaintances, and imaginary scenes often based upon musical subjects, especially the operas of Richard Wagner. He worked in a variety of media, from oils and pastel, to conté crayon, charcoal, and pen and ink, to lithography and etching. He exhibited at the Salon des Refusés of 1863, and from 1864 until 1900 was a regular exhibitor at the Paris Salon. He also established strong links with England and exhibited from 1862 at the Royal Academy annual exhibitions and from 1881–1882 with the Society of British Artists.*

**1867, black conté crayon, black chalk and blue pastel, stumping and erasure, with touches of white (in the eyes) on laid paper, oval: 450 x 350 (17 ¹¹/₁₆ x 13 ¾)**

**Inscribed at right in crayon: *h. Fantin / 67***

**Watermark: Shield with initials HP and HALLINES (cf. exh. cat. Boston 1984 – 1985, 260, no. 9); fragmentary countermark: UDELIST**

**National Gallery of Art, Woodner Collection 1991.182.9**

Besides the flowers and still-lifes for which he was most famous, Henri Fantin-Latour painted a number of portraits over the course of his career, the most remarkable and ambitious ones being the group portraits that included his artist and writer friends, such as *Hommage à Delacroix* (1864), *Un atelier aux Batignolles* (1870), *Le coin de table* (1872), and *Autour du Piano* (1885) (all Musée d'Orsay, Paris). He also painted several portraits of his family and closest friends and made numerous painted and drawn portrait studies of himself. Commissioned portraits for the aristocracy and the *haute bourgeoisie*, however, in which he felt he had to compromise his art to satisfy the patron and the sitter, were anathema to him: "It is horrible to make portraits to please the public. Ah! how sorry I am for you, papa, that you passed so much time at this task, how frightful it is!"[1] Yet for some months in 1867 he seems to have been persuaded to work on a few commissioned portraits, most notably of members of the Fitz-James family. The portrait drawing in the Woodner Collection, dated 1867 and said to represent Mme Ditte (according to an old inscription on the back of the old frame), appears to have been made during that same brief period. It is presented in the same frontal, bust-length format as Fantin's likenesses of four of the Fitz-James children.[2]

A portrait drawing of a Mme Ditte was included in the catalogue of Fantin's oeuvre compiled by his widow in 1911, but the dimensions cited ("*environ* 25 x 20 cm") are considerably smaller than those of the Woodner portrait. Since commissioned portraits generally remained in the families of the sitters, Mme Fantin-Latour may have had only incomplete information about them.[3] Her uncertainty about the dimensions of the portrait of Mme Ditte, as indicated by the unusual use of *environ* (about), makes it seem likely that she did not have access to the drawing when she was writing the catalogue and that her memory of it—if indeed she ever saw it—was inexact. Her further description of the portrait as *demi-nature* (half life-size), however, does correspond to the scale of the likeness itself.

If the Woodner drawing was made on commission (though no documentary evidence remains) and was therefore intended to stand as a finished work in itself, that would explain to a great extent the uncommon dryness and sobriety of its execution and perhaps also the oval format. It is so different from the freer studies Fantin made of himself[4]—and it stands so uniquely alone in his oeuvre—that it is easy to understand why doubts about its authorship might be entertained. Nevertheless, subtle but strong indicators of Fantin's hand can be detected in the thin, sharp, unblended lines that define the eyebrows, the eyes, and the shaded side of the nose, for similar touches are found, albeit more boldly, in some of his self-portraits (e.g., Phillips Collection, Washington, and Musée de peinture et de sculpture, Grenoble).[5] Further, the delicate handling of the shadows in the face, in which the light of the paper is never quite obliterated, calls to mind Fantin's lithographs, the first of which he made in 1862. Several curving strokes incised with either a sharp needle or a stylus into the right shoulder of Mme Ditte's dress may also reflect his earlier work in lithography and his frequent use of scraping in his prints. Two other parallel, nearly vertical strokes are incised below the notch in her collar. What purpose these almost-invisible marks were intended to serve can no longer be divined, but they are only one more distinctive feature in an unexpectedly complex combination of techniques.

Nothing at all is known about Mme Ditte, except that she may have been born Marie Duché and her husband's given name may have been Henri.[6] The portrait itself gives no other clue to her identity, although it may tell more about the circumstances of its manufacture than might first be apparent. The utter plainness of the

109

presentation and the absence of adornment or jewelry of any kind are certainly exceptional in a commissioned portrait and would ordinarily suggest that Mme Ditte was either very poor or of a serious turn of mind. Alternatively, one could imagine that she was in mourning, thus accounting for the overall gravity of the likeness, but in the nineteenth century even bereaved women wore special mourning jewelry. One other possibility is that the portrait was drawn posthumously and that Fantin made it without a live model before him. Indeed, the rough generalization of the dress, the comparative dullness of the eyes, the somberness of the overall image, and perhaps even the oval format might best be explained by supposing that Fantin was working from a photograph.[7] Without further information about the mysterious Mme Ditte, it is impossible to determine which of these hypotheses, if any, is the proper explanation for the unusual appearance of the Woodner portrait. • *Margaret Morgan Grasselli* •

**NOTES**

1. Letter from Fantin to his father, dated 12 September 1864, quoted in the original French in exh. cat. Paris 1982–1983, 102.
2. All reproduced in exh. cat. Paris 1982–1983, 107.
3. This observation was made in exh. cat. Paris 1982–1983, 102.
4. Several of Fantin's self-portraits are reproduced in exh. cat., Paris 1982–1983, nos. 1, 4, 6–9, 11–12.
5. Exh. cat. Paris 1982–1983, nos. 11, 12.
6. The inscription on the old backing of the frame has been partially obliterated and is difficult to decipher completely. "Mme. Henri Ditte/née Marie Duché" is the most likely reading of it.
7. This idea was first suggested by Constance McCabe, conservator of photographs at the National Gallery of Art, who was struck by the particular look of the drawing, which reminded her of old photographs (oral communication, January 1995).

**PROVENANCE**

(Galerie Durand-Ruel, Paris, 1945); Tullah Hanley (Mrs. Edward Hanley), 1962; given by her to Elizabeth Molnar, 1965; Woodner Collections (Dian and Andrea Woodner); given to NGA, 1991.

**EXHIBITIONS**

Woodner, Malibu 1983–1985, no. 109 (shown in Washington and thereafter, *hors catalogue*; included on Cambridge checklist); Woodner, Munich and Vienna 1986, no. 93; Woodner, Madrid 1986–1987, no. 109; Woodner, London 1987, no. 93; Woodner, New York 1990, no. 120.

**LITERATURE**

Fantin-Latour 1911, no. 309.

# 110  Cactus Man (Plante grasse)

*Redon was brought up in isolation from his immediate family on his father's estate at Peyrelebade in the Landes, a desolate coastal area whose landscape was to haunt him throughout his life. He first trained briefly, and unsuccessfully, as an architect and then in 1864 as a painter in Paris under Jean-Léon Gérôme (1824–1904). He returned to Bordeaux, where he studied with Rodolphe Bresdin (q.v.). He lived in Paris after 1870 but returned to the southwest of France for long periods each year. During the 1870s he devoted himself almost exclusively to charcoal drawings he called* noirs *(blacks) through which he evolved his distinctive, private language of myth and symbol. He started making lithographs in 1879, creating 166 prints over the next twenty years. After 1890 he worked increasingly in pastel and oil. His work received critical acclaim from leading writers of the French symbolist and decadent movements and influenced the Nabis and artists in Belgium and the Netherlands.*

**1881, various charcoals, with stumping, wiping, erasing, incising, and sponge work, on light brown wove paper, 490 x 322 (19 5/16 x 12 11/16)**

**Signed at lower left in black chalk: *ODILON REDON*; inscribed by another hand at lower center in graphite: *7***

**Woodner Collections**

The head in this remarkable drawing "emerges from a container in which, as in a bas relief, an Amazon crushes an indeterminate figure. The plant simulates the head of a man, with hair like thorns." Thus in his account book Redon described this work, also listing it in the chronology of his charcoal drawings under the year 1881 as "Plante grasse…(cactus)." Like other compelling "noirs" Redon made during the period 1880–1882—such as *Strange Flower* (Art Institute of Chicago), *The Smiling Spider* (Louvre, Paris), and *Marsh Flower* (Kröller-Müller Museum, Otterlo)[1]—the drawing now known as *Cactus Man* may be understood in the light of the contemporary interest in those links in the chain of being thought to connect two distinct realms of life, creatures of which it was considered difficult to determine whether they were more animal than plant or vice versa. This had been the focus of the work of botanist Armand Clavaud (1828–1890), Redon's friend and mentor in Bordeaux in the 1860s. Similarly, it had been part of Rodolphe Bresdin's imaginative world; and it was a theme Redon explored to express his long-standing fascination with humanity's origin in unconscious nature and its subsequent evolution.

For the present drawing, among the artist's most memorable reflections on the humble origins of mankind, Redon drew upon a variety of sources, including popular caricature and his own earlier work. Bull-necked, with thick, blunted features, the figure bursts forth phallically from its container like a jack-in-the-box. The frieze decorating the box serves as commentary, as in some of Redon's other contemporary drawings. Stylistically it invokes civilization and rationality, but its subject, as Redon's description leaves no doubt, is barbarism. This scene of conflict—apparently between the sexes—underscores humanity's natural violence in a form that simultaneously pays tribute to its creative potential. The head of *Cactus Man* similarly combines the brutish and the sensitive. It is the creature's apparent awareness of his unevolved state, of his being captive to his nature, that seems to occasion the pathos. His hair "like thorns" suggests that he is, in fact, a re-presentation of the traditional theme of Christ as Man of Sorrows, which Redon himself had treated in recent drawings.[2]

At once monstrous and sympathetic, this sheet is, like many of Redon's signal works, a personal manifesto. Writing on Delacroix just three years earlier, Redon had noted that it was not until the great romantic artist had freed himself of the "classical ties" that bound him to the "relief of things"—to visible reality—that he could understand that his true path lay in the "representation of inner life."[3] *Cactus Man* represents not only the process of Redon's own artistic breakthrough but the result: an expressive art that fulfills the artist's ambition to reconcile physical imperfection with the dignity of the human spirit, Christian patrimony with modern truths.  • *Douglas W. Druick* •

**NOTES**

1. Repro. in exh. cat. Chicago 1994–1995, 150, 152, 153, figs. 46, 50, 52.
2. See, for example, the *Christ* in the Musée d'Art Moderne, Brussels (repro. in exh. cat. Chicago 1994–1995, 116, fig. 78).
3. Redon 1961 ed., 173–174.

**PROVENANCE**

Sold to Ambroise Vollard, Paris, 10 February 1899; Marquis de Boilly, Paris; private collection, London; (Matthiesen Gallery, London, by 1959); Woodner Collections (Shipley Corporation).

**EXHIBITIONS**

London 1959, no. 15; New York 1961–1962, no. 100; Venice 1962, no. 36; New York 1967; New York 1970, no. 134; Woodner, Malibu 1983–1985, no. 69; Jerusalem 1985–1986, no. 20; Bordeaux 1985, no. 40; Woodner, Munich and Vienna 1986, no. 95; Woodner, Madrid 1986–1987, no. 112; Woodner, London 1987, no. 97; Washington 1988a, no. 37; Portland 1988; Tokyo 1989, no. 61; Barcelona 1989–1990, no. 58; Madrid 1990, no. 66; Woodner, New York 1990, no. 125; Memphis 1990, no. 5; Lausanne 1992, no. 73; Chicago 1994–1995, 154, no. 64, fig. 56.

**LITERATURE**

Berger 1965, pl. 621; Seznec 1972, 289, fig. 187; Hobbs 1977, 21, pl. 13; Wilson 1978, 25, pl. 12; Vialla 1988, 64, repro. 92; Eisenman 1992, 194, fig. 133; Jirat-Wasiutynski 1992, fig. 2.

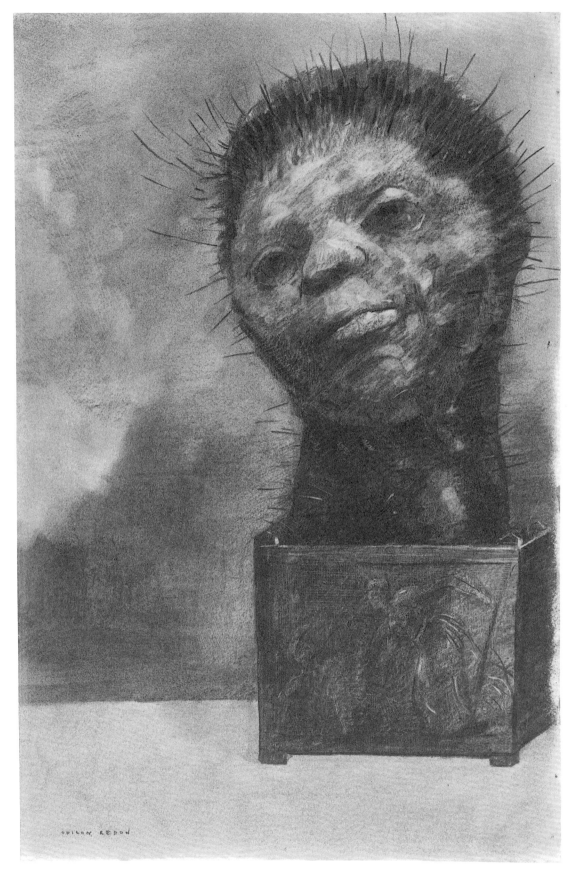

110

# 111 Pittacus the Tyrant in War Costume: Study for the Opera "Sappho"

*The son of an architect, Moreau trained in the atelier of François Picot (1786–1868) at the École des Beaux-Arts. He was influenced by Eugène Delacroix (1798–1863) and was close to Théodore Chassériau (1819–1856) and Pierre Puvis de Chavannes (1824–1898). Between 1857 and 1859 he traveled to Italy, where he studied and copied antiquities and paintings (Carpaccio, Michelangelo, Poussin), and met other artists, including Edgar Degas (q.v.) and Élie Delaunay (1828–1891). After his initial success at the Salon between 1864 and 1869, adverse criticism led Moreau to absent himself until 1876. On the death of Delaunay in 1891, he was appointed professor chef d'atelier at the École des Beaux-Arts. Taking his subject matter from the Bible and from classical and oriental mythology, Moreau built up a highly personal visual language that earned him a place as one of the forerunners of French symbolist art.*

**1883, graphite with watercolor on wove paper, 331 x 182 (13 ¹/₁₆ x 7 ³/₁₆)**

**Initialed by the artist at lower right in graphite: -GM-; and annotated by him: *Casque or ailes* [crossed out] *plumes* [written above] *bleues / Baudrier / baton de commandement / rouge saturne / Cuirasse & jambieres / en or manteau & / tunique blancs ornements / noir & or. / PITTACUS- / Tyran-- / Costume de Guerre*; inscribed by the artist at lower left in graphite: *Opéra de Sapho –***

**Woodner Collections**

In a letter of 3 August 1883 M. Regnier, an administrator of the Paris Opéra, asked Gustave Moreau to provide a few costume designs for an upcoming production of Charles Gounod's *Sappho*:

"We are going to stage, as you no doubt know, *Sappho* at the Opéra; we would like, if possible, to escape from the hackneyed antique commonly used in the theater; there is no one better than yourself to assist in this task, and, emboldened by our mutual friend [Élie] Delaunay, I come to ask you in the name of our Director Vaucorbeil, if you would give us four or five sketches for the principal characters from the work of Gounod and Augier. We are performing the piece in only a few months, and if you are favorably inclined toward our request, I will in due course call upon the collaboration of your knowledge and your good will…."[1]

Then in a letter of 31 October 1883 Regnier

requested a meeting with Moreau: "We are beginning to work on the costumes of *Sappho*, and we want to take advantage of the kind promise that you had made to us…."[2]

Regnier's request was not a true commission, for the existing documents do not have this formal aspect and make no reference to any payment. It was, rather, a solicitation for help from an artist whose classical education, like his fecund imagination, were well known. Moreau would not have wanted to compromise his reputation as a painter in so modest a task as designing costumes for an opera: he had been an unsuccessful candidate for admission to the Académie des Beaux-Arts in 1882 and intended to present himself as a candidate again. It is possible, though, that he wanted to earn some goodwill by coming to the aid of Academicians who would be voting the next time he presented his candidacy—Gounod and Delaunay among them.

The story of the Greek poetess Sappho was familiar to Moreau, who had depicted episodes from her life as early as the 1860s, especially Leucade's leap from the rocks and Sappho's death. He proceeded to make more than twenty costume drawings for Gounod's opera,[3] all dealing with the five principal characters—Sappho, Glycère, Phaon, Pittacus, and Pythéas—except for a ballet costume for Mlle Subra.[4] Moreau had probably executed a first series before the meeting requested on 31 October 1883; presumably he made a revised set afterward,

for each of the designs is known in at least two versions. Eugène Lacoste (1818–1908), the usual costume designer for the Opéra, then adapted Moreau's designs, giving the costumes a practical form for execution by the props department and costume makers.[5]

The Woodner drawing is a design for the war costume of Pittacus, the tyrant of Mytilene, but it is quite different from the costume rendered by Lacoste and actually used in act 2, scene 2, of the opera. That was closer to a second, simpler version by Moreau (formerly Roger Marx collection; sold at Sotheby's in London on 15 March 1989, lot 128; fig. 1). Lacoste perhaps knew both versions by Moreau, for his drawing, now in the Bibliothèque de l'Opéra (fig. 2),[6] bears a notation to "omit the leggings," which appear in the Woodner version but not in the other. Because the conception of the Woodner costume is more complex than that of the ex-Marx version and is so different from Lacoste's final design, it most likely belonged to Moreau's first set of drawings for the *Sappho* costumes, and was thus made prior to 31 October 1883.

Remarkably, Moreau made no mention of this series of costume designs in the list of his works recorded in 1884 in his "red notebook."[7] Perhaps conscious of his reputation as a history painter, he did not wish to advertise his participation in this project, for at a time when he habitually signed his works with his first and last names in their entirety, he chose to inscribe only his ini-

Opéra de Sapho

PITTACUS
Tyran

Costume de guerre

**FIGURE 1**

Gustave Moreau, *Costume Design for Pittacus for the Opera Sappho,* Courtesy of Sotheby's, London

**FIGURE 2**

Eugène Lacoste, *Costume Design for Pittacus for the Opera Sappho,* Bibliothèque de l'Opéra, Paris

tials on the costume drawings.[8] Nevertheless, as the Woodner sheet bears witness, Moreau's watercolor designs, of far higher quality than those by Lacoste, show how seriously he responded to the request for help from his friends at the Opéra.[9]

• *Geneviève Lacambre* •

### NOTES

1. Archives of the Musée Gustave Moreau, Paris.
2. Archives of the Musée Gustave Moreau, Paris. Gounod's opera *Sappho* (called *Sapho* in French), his first with a libretto by Émile Augier, premiered on 16 April 1851. Restaged unsuccessfully in 1876, it was reworked by Gounod in the summer of 1883. Although the new version was received rather coolly at the dress rehearsal, the opening on 2 April 1884 was a success. See Prudhomme and Dandelot 1911, 199–205.
3. Mathieu 1976, nos. 294–316.
4. Moreau's ballet costume is similar to the one Lacoste created for the eight Asiatic slaves; see Mathieu 1976, nos. 313, and esp. 315, and the watercolor by Lacoste (Bibliothèque de l'Opéra, Paris, D216/37, folio 85 [Sapho, no. 38]).
5. It seems incorrect to say that the projects by Moreau were not retained but replaced outright by those of Lacoste; see Bouyer 1901, 51 (cited in Mathieu 1976, 341). The idea of Moreau's inability to complete the commission is reiterated by every author since Mathieu. For Lacoste's drawings see Wild 1987, 245–246.
6. Bibliothèque de l'Opéra, Paris, D216/37, folio 100 (Sapho, no. 53).
7. Archives of the Musée Gustave Moreau, Paris (Arch / GM 500, 72–79).
8. He did the same for his *Stations of the Cross* for the church of Notre-Dame at Decazeville in 1862, another commission for which he wished to remain anonymous; see exh. cat. Nice 1991, nos. 35–48.
9. Part of Moreau's charge was "to encourage the acceptance of exact restitutions of historical costumes by a public accustomed by the neo-Greeks from the middle of this [19th] century to seeing represented an antiquity all in white and flax gray"(Wild 1987, 246). He thus suggested a wide range of colors in the annotations of his watercolors, many of which Lacoste adopted.

### PROVENANCE

Private collection (sale, Paris, Hôtel Drouot, 4 March 1932, lot 99); (purchased by Galerie Jean-Claude Gaubert, Paris); Woodner Collections (Shipley Corporation).

### EXHIBITIONS

Paris 1973, no. 50; Paris 1973a; Woodner, Malibu 1983–1985, no. 65; Woodner, Munich and Vienna 1986, no. 91; Woodner, Madrid 1986–1987, no. 107; Woodner, London 1987, no. 88; Woodner, New York 1990, no. 111.

### LITERATURE

Mathieu 1977, 348, no. 309.

# 112  Deux Élégantes (Two Elegant Women)

*The son of an artist, Picasso trained at the School of Fine Arts (La Llotja) in Barcelona in 1895 and at the Royal Academy of San Fernando in Madrid from 1897. He went to Paris for the first time in 1900 and settled there in 1904. After his "Blue" (1902–1905) and "Rose" (1905–1906) periods, during which he severely restricted his palette, Picasso was a leader of the cubist movement, heralded by his controversial Demoiselles d'Avignon (1907, Museum of Modern Art, New York). He created his first papiers collés in 1912 and from 1917 became involved in ballet and theater design. From 1917 his work returned to a more classical, figurative style, but he also exhibited at the first surrealist show in Paris in 1925. In 1937 he painted Guernica as his statement of outrage at the atrocities of the Spanish Civil War. Throughout his long life Picasso was an extremely prolific and inventive painter, sculptor, printmaker, and book illustrator, who profoundly affected the course of twentieth-century art.*

1900, charcoal with stumping and erasure on wove paper, 414 x 245 (16⁵⁄₁₆ x 9⁵⁄₈)

Signed at lower left in pen and brown ink: – *P. Ruiz Picasso –*; inscribed at lower left in blue pencil: *1900*

**Woodner Collections**

Picasso's first acquaintance with modernism dates from the turn of the century. In 1899 the artist joined the community of the Catalan avant-garde in Barcelona and for the next several years divided his time between Barcelona and Paris, with a five-month sojourn to Madrid in 1901. During this period Picasso abandoned the various provincial realist tendencies that had governed his formative work and adapted recent developments in post-impressionism and symbolism. Drawing was an essential instrument in his gradual assimilation and reinterpretation of modern style.

Inscribed with the date 1900, the present drawing was probably produced in

**FIGURE 1**

Pablo Picasso, *Le Moulin de la Galette*, Solomon R. Guggenheim Museum, New York, Thannhauser Collection, Gift, Justin K. Thannhauser

either Barcelona or Paris, which Picasso visited for the first time between late October and late December of that year.[1] The artist's work in Barcelona had been largely taken up with the bohemian milieu of Els Quatre Gats, the tavern that served as a clubhouse for the *modernista* movement, as well as with studies for unrealized narrative paintings on fin-de-siècle themes of dissolution and despair. Sketches for publicity illustrations that he created for the cabaret, however, show fashionable women in large, decorated hats that clearly relate to the figures in *Deux Élégantes*. In Paris Picasso elaborated his iconography of the demimondaine: *lorettes, cocottes,* and courtesans in fancy dress, such as those that appear in the Woodner drawing. Picasso would pursue this subject matter through middle to late 1901, including the hiatus in Madrid (from January to May of that year) and his second trip to Paris, which immediately followed. After that time the modish decadence of this imagery was largely displaced by the brooding solemnity of his "Blue" period. With regard to iconography, two important paintings are especially relevant: the figure of the French *élégante* first emerges in the *Moulin de la Galette* from 1900 (fig. 1),[2] a heady nocturnal image of the crowded dance hall that Picasso probably painted during the early part of his first Paris trip; more specifically, the models for the Woodner drawing closely resemble the elaborately attired sitter with her parasol and enormous pleated *toque* in Picasso's large, formidable *Lady in Blue* (fig. 2), painted in Madrid in early 1901.

While Picasso observed these subjects at bars and theaters in Montmartre, he also extracted them from popular illustration, in which such figures were common fare. Théophile-Alexandre Steinlen and Henri de Toulouse-Lautrec, two celebrated painter-illustrators who specialized in the Montmartre scene, have long been identified as prominent models for Picasso's early work in Paris, just as they had been for artists of *modernista* persuasion at Els Quatre Gats among whom Picasso had already begun to practice this form of draftsmanship. In addition, John Richardson has recently shown that Picasso almost certainly drew from George Bottini, a popular artist of the period (now virtually forgotten), whose oeuvre was essentially devoted to the fashionable Montmartre demimonde.[3] Bottini includes lesbian couples in his iconography of the bar and *maison close,* and this may well be the subject of the Woodner sheet. Bottini's style, however, is precious and evanescent, while Picasso's work in this idiom is marked by vigorous drawing, a sharp contrast in chiaroscuro, and a firm, unbroken contour line. Picasso's approach to physiognomy in this context is also rather more expressly caricatural. These elements, art-nouveau devices that belong to the tradition of Steinlen and Lautrec, distinguish *Deux Élégantes.* Formally, sumptuous pattern and texture in this sheet further elicit a quasi-coloristic effect from the black-and-white charcoal medium.

Ultimately, Picasso's early modernism

was essentially a draftsman's language of line rather than color. Bold and reductive, this style was shaped not only by professional illustrators but by the demands of illustration as a métier, which he pursued intermittently during this period. In addition to the illustrations for Els Quatre Gats, some of Picasso's work for *Arte Joven,* a Spanish modernist magazine in Madrid, clearly relates in manner and subject to *Deux Élégantes.*[4] The drawing also corresponds to portraits of *café-concert* celebrities he created for the Parisian magazine *Frou-Frou* in the summer of 1901,[5] broadly brushed ink sketches that emphasize bold patterns and animated silhouettes over subtle characterization. Finally, while he largely abandoned this style during 1901, it appears that Picasso would continue to recycle drawings from this period for popular illustration. One such image, showing two fashionably dressed women, was recently discovered in a July 1902 issue of the Parisian daily *Gil Blas.*[6] There is no evidence, however, that the Woodner drawing itself was originally intended or subsequently used for reproduction. • *Jeffrey S. Weiss* •

### NOTES

1. Regarding the signature on *Deux Élégantes,* Picasso had been using "P. Ruiz Picasso" (and "P.R. Picasso") since 1895. Sometime after early 1901, around the time of his exhibition in Paris at the Vollard gallery, he dropped the patronymic "Ruiz."

2. Richardson 1991, 1:167.

3. Richardson 1991, 1:173. For Bottini see exh. cat. Oxford 1984.

4. For an example see Palau i Fabre 1981, cat. 524.

5. For a discussion of the *café-concert* drawings see

Daix 1971; and Richardson 1991, 1:201–203. Picasso signed these illustrations "Ruiz;" Richardson surmises that by this time the artist's ambitions motivated him to dissociate the name "Picasso" from commercial art.

6. My thanks to Marilyn McCully, who discovered this illustration (and tentatively dates it during the fall of 1901), for drawing it to my attention. I have also benefited from her thoughts concerning the Woodner drawing.

### PROVENANCE

Private collection, Switzerland; (Galerie Nathan, Zurich); Woodner Collections (Dian and Andrea Woodner).

### EXHIBITIONS

Bern 1984, no. 101; Woodner, Munich and Vienna 1986, no. 107; Woodner, Madrid 1986–1987, no. 124; Woodner, London 1987, no. 111; Woodner, New York 1990, no. 146.

REFERENCES AND INDEX

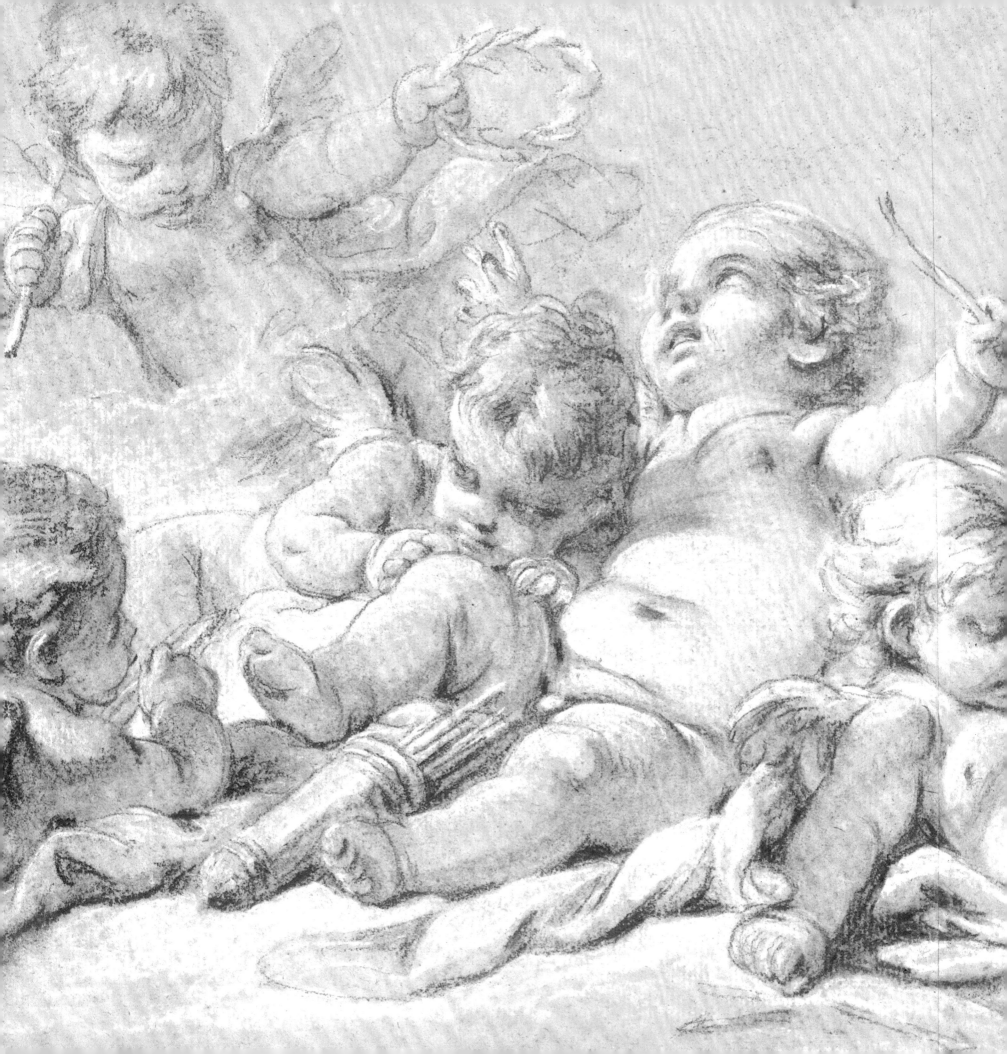

# References

**PUBLICATIONS**

Adhémar 1973
Jean Adhémar, "Les portraits dessinés du 16ᵉ siècle au Cabinet des Estampes," *Gazette des Beaux-Arts* 82 (September 1973), 121–198.

Aguiar 1962
A. de Aguiar, *Genealogia da Infante Don Fernando por Antonio de Hollande e Simão Bening* (Lisbon, 1962).

Alpers 1984
Svetlana Alpers, "Seeing and Believing," *Art and Antiques* (April 1984), 70–79.

Ames-Lewis 1986
Francis Ames-Lewis, *The Draftsman Raphael* (New Haven and London, 1986).

Ananoff 1961–1970
Alexandre Ananoff, *L'oeuvre dessiné de Jean-Honoré Fragonard, 1732–1806. Catalogue raisonné*, 4 vols. (Paris, 1961–1970).

Ananoff and Wildenstein 1976
Alexandre Ananoff and Daniel Wildenstein, *François Boucher*, 2 vols. (Lausanne and Paris, 1976).

Anderson 1951
Mary Désirée Anderson, *Looking for History in British Churches* (London, 1951).

Anderson 1968
Lilian Armstrong Anderson, "Copies of Pollaiuolo's *Battling Nudes*," *Art Quarterly* 31 (1968), 155–167.

Andrews 1968
Keith Andrews, *National Gallery of Scotland: Catalogue of Italian Drawings* (Cambridge, 1968).

Annesley 1978
Noël Annesley, "Raphael's *Charge to Saint Peter*," *Christie's Review of the Season* (London, 1978), 96.

Anzelewsky 1964
Fedja Anzelewsky, "Peter Hemmel und der Meister der Gewandstudien," *Zeitschrift des deutschen Vereins für Kunstwissenschaft* 18 (1964), 43–53.

Anzelewsky 1971
Fedja Anzelewsky, *Albrecht Dürer. Das malerische Werk* (Berlin, 1971).

Anzelewsky and Mielke 1984
Fedja Anzelewsky and Hans Mielke, *Albrecht Dürer. Kritischer Katalog der Zeichnungen. Die Zeichnungen alter Meister im Berliner Kupferstichkabinett* (Berlin, 1984).

Armstrong 1976
Lilian Armstrong, *The Paintings and Drawings of Marco Zoppo* (New York, 1976).

Armstrong 1993
Lilian Armstrong, "Marco Zoppo e il Libro dei Disegni del British Museum. Riflessioni sulle teste all'antica," in B. Giovannucci Vigi, ed., *Marco Zoppo* (Bologna, 1993), 79–95.

Arslan 1952
Edoardo Arslan, "Due disegni e un dipinto di Carpaccio," *Emporium* 116 (September 1952), 109–113.

*L'Avant-Coureur* 1769
"Exposition des peintures...," *L'Avant-Coureur* 39 (25 September 1769), 609–617.

Avery and Barbaglia 1981
Charles Avery and Susanna Barbaglia, *L'opera completa del Cellini* (Milan, 1981).

Avril and Reynaud 1993
François Avril and Nicole Reynaud, *Les manuscrits à peintures en France 1440–1520* (Paris, 1993).

Baccheschi 1971
Edi Baccheschi, *L'opera completa di Guido Reni* (Milan, 1971).

Bachaumont 1780
L. Petit de Bachaumont, "Salon de 1769," in *Mémoires secrets* (London, 1780).

Balis et al. 1989
A. Balis, M. Diaz Padrón, C. van de Velde, and H. Vlieghe, eds., *De vlaamse schilderkunst in het Prado* (Antwerp, 1989).

Bambach Cappel 1994
Carmen Bambach Cappel, "On 'La testa proportionalmente degradata'—Luca Signorelli, Leonardo, and Piero della Francesca's *De Prospectiva Pingendi*," in Elizabeth Cropper, ed., *Florentine Drawing at the Time of Lorenzo the Magnificent*, Papers from a Colloquium Held at the Villa Spelman, Florence, 1992 (Bologna, 1994), 17–43.

Barber Institute 1952
*Catalogue of the Paintings, Drawings, and Miniatures in the Barber Institute of Fine Arts* (Cambridge, 1952).

Bartsch
Adam von Bartsch, *Le peintre-graveur*, 21 vols. (Vienna, 1803–1821).

Basan 1775
Pierre-François Basan, *Catalogue raisonné des différens objets de curiosités dans les sciences et les arts, qui composaient le Cabinet de feu Mr. Mariette...* (Paris, 1775).

Baumeister 1914
Engelbert Baumeister, "Eine Zeichnung von Dürer," *Jahrbuch der königlich preussischen Kunstsammlungen* 53 (1914), 224.

Bean 1960
Jacob Bean, *Les dessins italiens de la Collection Bonnat* (Paris, 1960).

Bean 1969
Jacob Bean, review of Keith Andrews, *National Gallery of Scotland: Catalogue of Italian Drawings*, in *Master Drawings* 7 (1969), 55–57.

Bean and Griswold 1990
Jacob Bean and William Griswold, *Eighteenth-Century Italian Drawings in the Metropolitan Museum of Art* (New York, 1990).

Becker 1983
David P. Becker, "Rodolphe Bresdin's *Le Bon Samaritain*," *Nouvelles de l'estampe* 70–71 (1983), 7–14.

Becker 1993
David P. Becker, "On Camels in Art: Bresdin's *Good Samaritan*," *Print Quarterly* 10 (1993), 43–46.

Beenken 1928
H. Beenken, review of *Zeichnungen von Albrecht Dürer in Nachbildungen*, in *Jahrbuch für Kunstwissenschaft* 5 (1928), 111–116.

Béguin 1969
Sylvie Béguin, review of Henri Zerner, *L'École de Fontainebleau. Gravures*, in *Revue de l'Art* 5 (1969), 103–107.

Bellori 1672
Giovanni Pietro Bellori, *Le vite de' pittori, scultori, et architetti moderni* (Rome, 1672).

Bellosi 1985
Luciano Bellosi, "Su alcuni disegni italiani tra la fine del due e la metà del quattrocento," *Bolletino d'arte* 70 (1985), 12–18.

Beltjes and Schipper 1988
P.J.W. Beltjes and P. W. Schipper, *Culemborg beeld van een Stad* (Culemborg, 1988).

Benesch 1926–1941
Otto Benesch, *Beschreibender Katalog der Handzeichnungen in der Graphischen Sammlung Albertina*, 6 vols. (Vienna, 1926–1941).

Benesch 1935
Otto Benesch, *Rembrandt. Werk und Forschung* (Vienna, 1935).

Benesch 1947
Otto Benesch, *Rembrandt: Selected Drawings* (New York, 1947).

Benesch 1954–1957
Otto Benesch, *The Drawings of Rembrandt*, 6 vols. (London, 1954–1957).

Benesch 1964
Otto Benesch, "Neuentdeckte Zeichnungen von Rembrandt," *Jahrbuch der Berliner Museum* 6 (1964), 105–150.

Benesch 1970
Otto Benesch, *Rembrandt. Werk und Forschung* (Lucerne, 1970).

Benesch 1973
Otto Benesch, *The Drawings of Rembrandt*, revised and expanded by Eva Benesch, 6 vols. (London, 1973).

Berenson 1903
Bernard Berenson, *The Drawings of the Florentine Painters*, 2 vols. (London, 1903).

Berenson 1938
Bernard Berenson, *The Drawings of the Florentine Painters*, 3 vols., amplified ed. (Chicago, 1938).

Berenson 1961
Bernard Berenson, *I disegni dei pittori fiorentini*, 3 vols., revised and amplified ed. (Milan, 1961).

Berger 1965
Klaus Berger, *Odilon Redon: Fantasy and Color* (New York, 1965).

Bergeret and Fragonard 1895
*Bergeret et Fragonard. Journal inédit d'un voyage en Italie, 1773–1774...* (Paris, 1895).

Bernhard 1978
Marianne Bernhard, *Hans Baldung Grien. Handzeichnungen, Druckgraphik* (Munich, 1978).

Bernt 1980
Walther Bernt, *Die niederländischen Maler und Zeichner des 17. Jahrhunderts*, 5 vols. (Munich, 1980).

Betcherman 1970
L.-R. Betcherman, "The York House Collection and Its Keeper," *Apollo* 92 (October 1970), 250–259.

Bettagno 1978
Alessandro Bettagno, *Disegni di Giambattista Piranesi* (Venice, 1978).

Bindman and Riemann 1993
David Bindman and Gottfried Riemann, eds., *Karl Friedrich Schinkel: "The English Journey"* (New Haven and London, 1993).

Bjurström 1979
Per Bjurström, *Italian Drawings* (Stockholm, 1979).

Blanc 1870
Charles Blanc, *Ingres. Sa vie, ses oeuvres* (Paris, 1870).

Blankert 1982
A. Blankert, *Ferdinand Bol: Rembrandt's Pupil* (Doornspijk, 1982).

Blunt 1954
Anthony Blunt, *The Drawings of G. B. Castiglione and Stefano della Bella in the Collection of Her Majesty the Queen at Windsor Castle* (London, 1954).

Blunt 1971
Anthony Blunt, "The Inventor of Soft-ground Etching: Giovanni Benedetto Castiglione," *Burlington Magazine* 113, no. 821 (August 1971), 474–475.

Bober and Rubinstein 1986
Phyllis Pray Bober and Ruth Rubinstein, *Renaissance Artists and Antique Sculpture: A Handbook of Sources* (London, 1986).

Bocher 1875
Emmanuel Bocher, *Catalogue raisonné des estampes, eaux-fortes, pièces en couleur, au bistre, et au lavis, de 1700 à 1800, 11, Pierre-Antoine Baudouin* (Paris, 1875).

Bock 1921
Elfried Bock, *Die Deutschen Meister* in Max Friedländer, ed., *Die Zeichnungen alter Meister im Kupferstichkabinett. Staatliche Museen zu Berlin*, 2 vols. (Berlin 1921).

Bologna 1977
Ferdinando Bologna, *Napoli e le rotte mediterranee della pittura da Alfonso il Magnanimo a Ferdinando il Cattolico* (Naples, 1977).

Boon 1978
Karel G. Boon, *Netherlandish Drawing of the Fifteenth and Sixteenth Centuries*, 2 vols. (The Hague, 1978).

Boon 1992
Karel G. Boon, *The Netherlandish and German Drawings of the 15th and 16th Centuries of the Frits Lugt Collection*, 3 vols. (Paris, 1992).

Bora 1987
Giulio Bora, "Per un catalogo dei disegni dei Leonardeschi Lombardi. Indicazioni e problemi di metodo," *Raccolta Vinciana* 22 (1987), 139–182.

Bora 1991
Giulio Bora, "I disegni dei leonardeschi e il collezionismo milanese," in M. T. Fiorio and Pietro C. Marani, eds., *I leonardeschi a Milano. Fortuna e collezionismo* (Milan, 1991), 206–217.

Borroni and Algeri 1979
Favia Borroni and Giuliana Algeri, "Giovanni Benedetto Castiglione," in *Dizionario biografico degli italiani* 22 (Rome, 1979), 84–89.

Borsook 1961
Eve Borsook, "Decor in Florence for the Entry of Charles VIII of France," *Mitteilungen des Kunsthistorischen Institutes in Florenz* 10 (December 1961), 106–122.

Boskovits 1968a
Miklòs Boskovits, "Eln Vorlaufer des spätgotischen Malerei in Florenz. Cenni di Francesco di Ser Cenni," *Zeitschrift für Kunstgeschichte* 31 (1968), 273–292.

Boskovits 1968b
Miklòs Boskovits, "Mariotto di Nardo e la formazione del linguaggio tardo-gotico a Firenze negli anni intorno al 1400," *Antichità Viva* 7, no. 6 (1968), 21–31.

Boskovits 1968c
Miklòs Boskovits, "Sull'attività giovanile di Mariotto di Nardo," *Antichità Viva* 7, no. 5 (1968), 3–13.

Boskovits 1975
Miklòs Boskovits, *Pittura fiorentina alla vigilia del Rinascimento, 1370–1400* (Florence, 1975).

Boskovits 1977
Miklòs Boskovits, "Una ricerca su Francesco Squarcione," *Paragone* 28, no. 325 (1977), 40–70.

Boswell 1791
James Boswell, *Life of Samuel Johnson LL.D.* (London, 1791, reprint 1952).

Boulmiers 1769
Chevalier des Boulmiers, "Exposition des peintures, sculptures, et gravures de MM. de l'Académie royale, dans le salon du Louvre 1769," *Mercure de France* (October 1769), 177–203.

Bouyer 1901
Raymond Bouyer, "Peintres mélomanes," *Le Ménestrel* (17 February 1901), 1–2.

Bredius 1892
Abraham Bredius, "De schilder Johannes van de Cappelle," *Oud-Holland* 10 (1892), 26–40.

Bredt 1921
E. W. Bredt, *Rembrandt-Bibel. Altes Testament, Neues Testament* (Munich, 1921).

Bremen Dokumentation 1992
*Dokumentation der durch Auslagerung im 2. Weltkrieg vermissten Kunstwerke der Kunsthalle Bremen* (Bremen, 1992).

Briquet
Charles Moïse Briquet, *Les Filigranes. Dictionnaire historique des marques du papier dès leur apparition vers 1282 jusqu'en 1600*, 4 vols. (Geneva, 1907; reprint with addenda, Amsterdam, 1968).

Brockhaus 1885
Heinrich Brockhaus, "Leonardo da Bisuccio," in *Gesammelte Studien zur Kunstgeschichte. Eine Festgabe zum 4. Mai 1885 für Anton Springer* (Leipzig, 1885), 52–58.

Brown 1987
David Alan Brown, *Andrea Solario* (Milan, 1987).

Brugnoli 1974
Pierpaolo Brugnoli, *Maestri della pittura Veronese* (Verona, 1974).

Boskovits 1975
Miklòs Boskovits, *Pittura fiorentina alla vigilia del Rinascimento, 1370–1400* (Florence, 1975).

Buchner 1927
Ernst Buchner, "Studien zur mittelrheinischen Malerei und Graphik der Spätgotik und Renaissance," *Münchner Jahrbuch für bildende Kunst* 4 (1927), 220–325.

Buddensieg 1976
Tilmann Buddensieg, "Criticism of Ancient Architecture in the Sixteenth and Seventeenth Centuries," in *Classical Influences on European Culture, AD 1500–1700* (Cambridge, 1976), 335–348.

Bukdahl 1980
E. M. Bukdahl, *Diderot critique d'art. Théorie et pratique dans les salons de Diderot, 1* (Copenhagen, 1980).

Bukdahl 1982
E. M. Bukdahl, *Diderot critique d'art. Diderot, les salonniers, et les éstéticiens de son temps, 11* (Copenhagen, 1982).

Bulgari 1974
Costantino G. Bulgari, *Argentieri, gemmari, e orafi d'Italia. Parte quarta, Emilia* (Rome, 1974).

Bush 1976
Virginia Bush, *Colossal Sculpture of the Cinquecento* (New York, 1976).

Bussmann 1969
Hildegard Bussmann, "Vorzeichnungen Francesco Salviatis. Studien zum zeichnerischen Werk des Künstlers," dissertation, Free University, Berlin (1969).

Butts 1985
Barbara Rosalyn Butts, "'Dürerschüler' Hans Süss von Kulmbach," dissertation, Harvard University, Cambridge (1985).

Byam Shaw 1962
James Byam Shaw, *The Drawings of Domenico Tiepolo* (London, 1962).

Byam Shaw 1983
James Byam Shaw, *The Italian Drawings of the Frits Lugt Collection*, 3 vols. (Paris, 1983).

Byam Shaw and Knox 1987
James Byam Shaw and George Knox, *The Robert Lehman Collection VI: Italian Eighteenth-Century Drawings* (Princeton, 1987).

Byron 1812
George Gordon, 6th Baron Byron, *Childe Harold's Pilgrimage*, 3rd ed. (London, 1812).

Campardon 1877
E. Campardon, *Spectacles de la Foire* (Paris, 1877).

Cancogni and Perocco 1967
Manlio Cancogni and Guido Perocco, *L'opera completa del Carpaccio* (Milan, 1967).

Carderera 1860
Valentín Carderera, "François Goya. Sa vie, ses dessins, et ses eaux-fortes," *Gazette des Beaux-Arts* 7 (1860), 215–227.

Carli 1960
Enzo Carli, *Il Pintoricchio* (Milan, 1960).

Caroli 1991
Flavio Caroli, *Leonardo. Studi di fisiognomica* (Milan, 1991).

Cavazzocca Mazzanti 1912
Vittorio Cavazzocca Mazzanti, "I pittori Badile," *Madonna Verona. Bollettino del Museo Civico di Verona* 6, no. 2 (April–June 1912), 11–28, 65–84.

Cellini 1983 ed.
Benvenuto Cellini, *The Autobiography of Benvenuto Cellini*, ed. Charles Hope and Alessandro Nova (Oxford, 1983).

Chatelain 1973
Jean Chatelain, *Dominique Vivant Denon et le Louvre de Napoléon* (Paris, 1973).

Chaudonneret 1981
Marie-Claude Chaudonneret, "Napoléon remet la Légion d'Honneur au sculpteur Cartellier par Boilly," *Thurgauische Beiträge zur vaterländischen Geschichte* 118 (1981), 185–192.

Chennevières 1892
Henry de Chennevières, *Les Tiepolo* (Paris, 1892).

Ciaranfi 1932
Anna Maria Ciaranfi, "Lorenzo Monaco miniatore, 1," *L'Arte* 35 (1932), 285–399.

Clark 1935
Kenneth Clark, *A Catalogue of the Drawings of Leonardo da Vinci in the Collection of His Majesty the King at Windsor Castle* (London, 1935).

Clark and Pedretti 1968–1969
Kenneth Clark and Carlo Pedretti, *The Drawings of Leonardo da Vinci in the Collection of Her Majesty the Queen at Windsor Castle*, 2 vols., 2nd rev. ed. (London, 1968–1969).

Clarke 1816
Edward Daniel Clarke, *Travels in Various Countries of Europe, Asia, and Africa* (London, 1816).

[Cochin] 1769
[C. N. Cochin], *Réponse de M. Jérôme rapeur de tabac a M. Raphaël, peintre de l'Académie de S. Luc...* (Paris, 1769).

Colvin 1897
Sidney Colvin, "Über einige Zeichnungen des Carpaccio in England," *Jahrbuch der königlich preussischen Kunstsammlungen* 18 (1897), 193–204.

Cox-Rearick 1981
Janet Cox-Rearick, *The Drawings of Pontormo*, 2 vols. (New York, 1981).

Dacier 1929–1931
Émile Dacier, *Gabriel de Saint-Aubin. Peintre, dessinateur, et graveur (1724–1780)*, 2 vols. (Paris and Brussels, 1929–1931).

Daix 1971
Pierre Daix, "Quand Picasso dessinait pour la presse parisienne," *Les lettres françaises* (3 March 1971), 24–25.

[Daudet de Jossan] 1769
*Lettres sur les peintures, gravures, et sculptures qui ont été exposées cette année au Louvre. Par M. Raphaël, peintre, de l'Académie de S. Luc…* (Paris, 1769).

Davis 1981
Frank Davis, "Legends with a Light Touch," *Country Life* 169 (14 May 1981), 1326–1327.

Degenhart and Schmitt 1968
Bernhard Degenhart and Annegrit Schmitt, *Corpus der italienischen Zeichnungen, 1300–1450*, pt. 1, *Süd- und Mittelitalien*, 4 vols. (Berlin, 1968).

Degenhart and Schmitt 1980
Bernhard Degenhart and Annegrit Schmitt, *Corpus der italienischen Zeichnungen, 1300–1450*, pt. 2, *Venedig. Addenda zu Süd- und Mittelitalien*, 4 vols. (Berlin, 1980).

Degenhart and Schmitt 1990
Bernhard Degenhart and Annegrit Schmitt, *Corpus der italienischen Zeichnungen, 1300–1450*, pt. 2, *Venedig. Jacopo Bellini*, 4 vols. (Berlin, 1990).

De Grazia 1985
Diane De Grazia, "Refinement and Progression of Barocci's *Entombment*: The Chicago Modello," *Museum Studies* 12, no. 1 (1985), 31–41.

Delaborde 1870
Henri Delaborde, *Ingres. Sa vie, ses travaux, sa doctrine* (Paris, 1870).

Delacre 1934
Maurice Delacre, "Le dessin dans l'oeuvre de van Dyck," *Mémoires de l'Académie Royale de Belgique*, 2nd ser., 3 (1934), 125–126.

Delteil 1909
Loys Delteil, *Catalogue des crayons français du 16e siècle composant la collection de M. Ch[arles] W[ickert]* (sale catalogue, Paris, Galerie Georges Petit, 3 May 1909).

De Nicolò Salmazo 1993
A. de Nicolò Salmazo, *Il soggiorno padovano di Andrea Mantegna* (Padua, 1993).

De Seta 1992
Cesare de Seta, *L'Italia del Grand Tour. Da Montaigne a Goethe* (Naples, 1992).

Dethloff 1992
Diana Dethloff, "Patterns of Drawing Collecting in Late Seventeenth- and Early Eighteenth-Century England," in *Drawing, Masters and Methods: Raphael to Redon*, Papers for the Ian Woodner Master Drawings Symposium at the Royal Academy of Arts (London, 1992), 197–207.

Di Giampaolo 1991
Mario di Giampaolo, *Parmigianino. Catalogo completo* (Florence, 1991).

Dighton and Lawrence 1923
B. L. Dighton and H. W. Lawrence, *French Engravings of the Eighteenth Century in the Collection of Joseph Widener, Lynnewood Hall*, 4 vols. (London, 1923).

Dimier 1925
Louis Dimier, *Histoire de la peinture de portrait en France au 16e siècle*, 2 vols. (Paris, 1925).

Dodgson 1898–1911
Campbell Dodgson, *The Dürer Society*, 12 vols. (London, 1898–1911).

Dodgson 1923
Campbell Dodgson, *A Book of Drawings Formerly Ascribed to Mantegna* (London, 1923) [facsimile reproductions of an album of drawings in the British Museum].

Dodgson 1929
Campbell Dodgson, "Hans Hoffmann: A Squirrel," *Old Master Drawings* 4 (1929), 50–51.

Dreyer 1988
Peter Dreyer, *Sandro Botticelli. Illustrationen zu Dantes Göttlicher Komödie* (Berlin, 1988).

Drobná 1956
Zoroslava Drobná, *Die gotische Zeichnung in Böhmen* (Prague, 1956).

Duret-Robert 1985
François Duret-Robert, "Deux longueurs d'avance pour Madame Vigée-Le Brun," *Connaissance des Arts* 395 (January 1985), 92.

Dvořáková et al. 1964
V. Dvořáková, J. Krása, A. Merhautová, and K. Stejskal, *Gothic Mural Painting in Bohemia and Moravia 1300–1378* (London, 1964).

Eckert and Imhoff 1971
W. Eckert and C. von Imhoff, *Willibald Pirckheimer. Dürers Freund im Spiegel seiner Lebens, seiner Werke, und seiner Umwelt* (Cologne, 1971).

Egger 1905
Hermann Egger, *Codex Escurialensis* (Vienna, 1905).

Eisenberg 1989
Marvin Eisenberg, *Lorenzo Monaco* (Princeton, 1989).

Eisenman 1992
Stephen F. Eisenman, *The Temptation of Saint Redon: Biography, Ideology, and Style in the Noirs of Odilon Redon* (Chicago, 1992).

Eisler 1918
Max Eisler, *Rembrandt als Landschafter* (Munich, 1918).

Eliel 1985
C. S. Eliel, "Form and Content in the Genre Works of Louis-Léopold Boilly," dissertation, New York University, Institute of Fine Arts (1985).

Emiliani 1985
Andrea Emiliani, *Federico Barocci (Urbino 1535–1612)*, 2 vols. (Bologna, 1985).

Enggass 1980
Carlo Cesare Malvasia, *The Life of Guido Reni*, trans. C. and R. Enggass (University Park, PA, 1980).

Erasmus 1971 ed.
Erasmus, *Praise of Folly*, trans. Betty Radice (Harmondsworth, 1971).

Fahy 1968
Everett Fahy, "The Master of Apollo and Daphne," *Museum Studies* 3 (1968), 21–41.

Fahy 1971
Everett Fahy, "Tiepolo's *Meeting of Anthony and Cleopatra*," *Burlington Magazine* 113 (December 1971), 736–749.

Fahy 1976
Everett Fahy, *Some Followers of Domenico Ghirlandaio* (New York, 1976).

Fahy 1993
Everett Fahy, "Late Fifteenth-Century Florentine Painting," *Burlington Magazine* 135 (February 1993), 169–171.

Fairfax Murray 1905–1912
Charles Fairfax Murray, *Drawings by the Old Masters: Catalogue of the J. Pierpont Morgan Collection*, 4 vols. (London, 1905–1912).

Falk 1979
Tilman Falk, *Katalog der Zeichnungen des 15. und 16. Jahrhunderts im Kupferstichkabinett Basel, 1, Das 15. Jahrhundert* (Basel and Stuttgart, 1979).

Fantin-Latour 1911
Mme Fantin-Latour, *Catalogue complet, 1849–1904, de Fantin-Latour* (Paris, 1911).

Fenyö 1965
Ivan Fenyö, *Norditalienische Handzeichnungen aus dem Museum der Bildenden Künste* (Budapest, 1965).

Ferino-Pagden 1981
Sylvia Ferino-Pagden, "Gli affreschi della *Madonnucia* in San Martino a Campo e l'enigma di Andrea d'Assisi detto l'Ingegno," *Esercizi* 4 (1981), 68–85.

Ferrari 1961
M. L. Ferrari, *Il Romanino* (Milan, 1961).

Fevre 1949
Jeanne Fevre, *Mon oncle Degas* (Geneva, 1949).

Filedt Kok 1990
Jan Piet Filedt Kok, "Jacques de Gheyn II: Engraver, Designer, and Publisher," pts. 1 and 2, *Print Quarterly* 7, nos. 3 and 4 (1990), 248–281, 370–396.

Filedt Kok 1993
Jan Piet Filedt Kok, "Hendrick Goltzius: Engraver, Designer, and Publisher, 1582–1600," in *Goltzius Studies: Hendrick Goltzius (1558–1617)* (Zwolle, 1993), 159–218.

Fiocco 1930
Giuseppe Fiocco, *Carpaccio* (Paris, 1930).

Fiocco 1958
Giuseppe Fiocco, *Carpaccio* (Novara, 1958).

Fiorio 1990
Maria Teresa Fiorio, *Bambaia* (Florence, 1990).

Fiorio and Marani 1991
Maria Teresa Fiorio and Pietro C. Marani, eds., *I leonardeschi a Milano. Fortuna e collezionismo* (Milan, 1991).

Firmin-Didot 1875–1877
Ambroise Firmin-Didot, *Les graveurs de portraits en France*, 2 vols. (Paris, 1875–1877).

Fischel 1917 (pt. 1)
Oskar Fischel, "Die Zeichnungen der Umbrer. Teil 1," *Jahrbuch der königlich preussischen Kunstsammlungen* 38 (1917), 1–72.

**Fischel 1917 (pt. 2)**
Oskar Fischel, "Die Zeichnungen der Umbrer. Teil II," *Jahrbuch der königlich preussischen Kunstsammlungen* 38 (1917), supplement 1–188.

**Fischel and Oberhuber 1972**
Oskar Fischel and Konrad Oberhuber, *Raphael Zeichnungen IX. Entwürfe zu Werken Raphaels und seiner Schule im Vatican 1511/12 bis 1520* (Berlin, 1972).

**Fischer 1990**
Chris Fischer, "Fra Bartolommeo e il suo tempo," in *La chiesa e il convento di San Marco a Firenze*, 2 vols. (Florence, 1990), 2:179–211.

**Flechsig 1928–1931**
Eduard Flechsig, *Albrecht Dürer. Sein Leben und seine künstlerische Entwicklung*, 2 vols. (Berlin, 1928–1931).

**Fleming-Williams 1965**
Ian Fleming-Williams, "John Skippe: Notes on His Life and Travels," *Master Drawings* 3 (1965), 268–275.

**Focillon 1918**
Henri Focillon, *Giovanni Battista Piranesi. Essai de catalogue raisonné de son oeuvre* (Paris, 1918).

**Fockema Andreae et al. 1952**
Sybrandus Johannes Fockema Andreae, J.G.N. Renaud, and E. Pelinck, *Kastelen, ridderhofsteden en buitenolaatsen in Rijnland* (Leiden, 1952).

**Forlani Tempesti 1970**
Anna Forlani Tempesti, *Capolavori del Rinascimento. Il primo cinquecento toscano* (Milan, 1970).

**Forlani Tempesti 1991**
Anna Forlani Tempesti, *The Robert Lehman Collection V: Italian Fifteenth- to Seventeenth-Century Drawings* (Princeton, 1991).

**Frangi 1992**
Francesco Frangi, *Savoldo. Catalogo completo dei dipinti* (Florence, 1992).

**Freedberg 1963**
Sydney Freedberg, *Andrea del Sarto*, 2 vols. (Cambridge, 1963).

**Frerichs 1971**
L.C.J. Frerichs, "Nouvelles sources pour la connaissance de l'activité de graveur des trois Tiepolo," *Nouvelles de l'estampe* 4 (1971), 213–228.

**Fréron 1769**
E. C. Fréron, "Exposition des peintures, sculptures, and gravures de Messieurs de l'Académie royale," *L'année littéraire* 5 (4 September 1769), 301.

**Friedländer 1916–1917**
Max J. Friedländer, "Der niederländische Glasmaler Aerdt Ortkens," *Amtliche Berichte aus den königliche Kunstsammlungen* 38 (1916–1917), 161–167.

**Friedländer 1967–1976**
Max J. Friedländer, *Early Netherlandish Painting*, 14 vols. (Leiden, 1967–1976).

**Friedländer 1969**
Max J. Friedländer, *Early Netherlandish Painting* (New York, 1969).

**Friend 1943**
A. M. Friend Jr., "Dürer and the Hercules Borghese Piccolomini," *Art Bulletin* 25 (1943), 43–49.

**Fröhlich-Bum 1956**
L. Fröhlich-Bum, "Handzeichnungen alter Meister in London," *Die Weltkunst* 26 (June 1956), 10.

**Fusco 1982**
Laurie S. Fusco, "The Use of Sculptural Models by Painters in Fifteenth-Century Italy," *Art Bulletin* 64 (1982), 176–194.

**Gabelentz 1922**
Hans von der Gabelentz, *Fra Bartolomeo und die Florentiner Renaissance*, 2 vols. (Leipzig, 1922).

**Ganz 1937**
Paul Ganz, *Die Handzeichnungen Hans Holbein d. J.: Kritischer Katalog* (Berlin, 1937).

**Ganz 1939**
Paul Ganz, *Les dessins de Hans Holbein le jeune. Catalogue raisonné*, 2 vols. (Geneva, 1939).

**Ganz 1943**
Paul Ganz, *Handzeichnungen Hans Holbein der jüngere in Auswahl* (Basel, 1943).

**Garnier 1989**
Nicole Garnier, *Antoine Coypel (1661–1722)* (Paris, 1989).

**Garzelli 1985**
Annarosa Garzelli, *Miniatura fiorentina del rinascimento, 1440–1525, un primo censimento*, 2 vols. (Florence, 1985).

**Gassier 1972**
Pierre Gassier, "Une source inédite de dessins de Goya en France au 19ᵉ siècle," *Gazette des Beaux-Arts* 80 (1972), 109–120.

**Gassier 1973**
Pierre Gassier, *The Drawings of Goya: The Complete Albums* (London, 1973).

**Gassier 1975**
Pierre Gassier, *Les dessins de Goya* (New York, 1975).

**Gassier 1978**
Pierre Gassier, "A propos de deux dessins inédits de Goya. Du travail et des hommes," *L'Oeil*, no. 280 (November 1978), 24–29.

**Gassier and Wilson 1971**
Pierre Gassier and Juliet Wilson, *The Life and Complete Work of Francisco Goya* (New York, 1971).

**Gathorne-Hardy 1902**
A. E. Gathorne-Hardy, *Descriptive Catalogue of Drawings… in the Possession of the Honorable A. E. Gathorne-Hardy* (London, 1902).

**Gazzola and Cuppini 1970**
Pietro Gazzola and Maria Teresa Cuppini, *Pitture murali restaurate* (Verona, 1970).

**Gealt 1986**
Adelheid M. Gealt, *Domenico Tiepolo: The Punchinello Drawings* (New York, 1986).

**Gebarowicz and Tietze 1929**
M. Gebarowicz and Hans Tietze, eds., *Albrecht Dürers Zeichnungen in Lubomirski-Museum in Lemberg* (Vienna, 1929).

**Gemäldegalerie Dresden 1992**
*Gemäldegalerie Dresden. Alte Meister. Katalog der ausgestellten Werke* (Dresden and Leipzig, 1992).

**Goncourt 1881**
Edmond de Goncourt, *La maison d'un artiste*, 2 vols. (Paris, 1881; new ed. 1919).

**Garnier 1989 / Gemin and Pedrocco 1993**
Massimo Gemin and Filippo Pedrocco, *Giambattista Tiepolo. I dipinti, opera completa* (Venice, 1993).

**Gere 1960**
John Gere, "Two Late Fresco Cycles by Perino del Vaga: The Massimi Chapel and the Sala Paolina," *Burlington Magazine* 102 (January 1960), 9–19.

**Gere and Turner 1983**
John Gere and Nicholas Turner, *Drawings by Raphael* (London, 1983).

**Getty Journal 1988**
"Acquisitions/1987: Drawings," *J. Paul Getty Museum Journal* 16 (1988), 162–175.

**Giltaij 1988**
Jeroen Giltaij, *The Drawings by Rembrandt and His School in the Museum Boymans-van Beuningen* (Rotterdam, 1988).

**Giovannucci Vigi 1993**
B. Giovannucci Vigi, ed., *Marco Zoppo*, Atti del Convegno internazionale de studi sulla pittura del quattrocento Padano, Cento (Bologna, 1993).

**Glück 1931**
Gustav Glück, ed., *Van Dyck*, Klassiker der Kunst 13 (New York, 1931).

**Goldman 1988**
Jean Goldman, "An Unpublished Drawing by Federico Barocci for *The Entombment*," *Master Drawings* 26, no. 3 (1988), 249–252.

**Gombrich 1954**
Ernst H. Gombrich, "Leonardo Grotesque Heads: Prolegomena to Their Study," in *Leonardo. Saggi e ricerche* (Rome, 1954), 197–219.

**Gombrich 1976**
Ernst H. Gombrich, *The Heritage of Apelles* (London, 1976).

**Gombrich 1986**
Ernst H. Gombrich, *L'eredità di Apelle. Saggi sull'arte del rinascimento* (Turin, 1986).

**Goncourt 1948**
Edmond and Jules de Goncourt, *French 18th-Century Painters*, trans. Robin Ironside (New York, 1948).

**Gould 1976**
Cecil Gould, *The Paintings of Correggio* (Ithaca, 1976).

**Grassi 1956**
Luigi Grassi, *Il disegno italiano dal trecento al seicento* (Rome, 1956).

**Greco 1990**
F. C. Greco, ed., *Pulcinella maschera del mondo* (Naples, 1990).

**Gruber 1994**
Alain Gruber, ed., *The History of Decorative Arts: The Renaissance and Mannerism in Europe* (New York, 1994).

**Gruyer 1886**
Gustave Gruyer, *Fra Bartolommeo della Porta et Mario Albertinelli* (Paris, 1886).

**Guérin 1931**
Marcel Guérin, *Dix-neuf portraits de Degas par lui-même* (Paris, 1931).

**Guiffrey and Marcel 1913**
Jean Guiffrey and Pierre Marcel, *Inventaire général des dessins du Musée du Louvre et du Musée de Versailles. École française. VIII. Le Brun-Leclerc.* (Paris, 1913).

**Guinness 1899**
H. Guinness, *Andrea del Sarto* (London, 1899).

**Haberditzl 1909**
F. M. Haberditzl, "Klassiker der Kunst in Gesamtausgaben Bd. XIII. Van Dyck. Des Meisters Gemälde in 537 Abbildungen. Herausgegeben von Emil Schaeffer. Stuttgart und Leipzig 1909," *Kunstgeschichtliche Anzeigen*, no. 1 (1909), 58–66.

**Hadeln 1925**
Detlev Freiherr von Hadeln, *Venezianische Zeichnungen des Quattrocento* (Berlin, 1925).

**Hadeln 1927**
Detlev Freiherr von Hadeln, *Handzeichnungen von G. B. Tiepolo* (Munich, 1927).

Hall 1974
James Hall, *Dictionary of Subjects and Symbols in Art* (London, 1974).

Halm 1931
Peter Halm, "Das unvollendete Fresko des Filippino Lippi in Poggia a Caiano," *Mitteilungen des Kunsthistorischen Institutes in Florenz* 3 (July 1931), 393–427.

Harprath 1978
Richard Harprath, *Papst Paul III als Alexander der Grosse* (Berlin, 1978).

Harrison 1986
Sharon R. Harrison, *The Etchings of Odilon Redon* (New York, 1986).

Harrisse 1898
Henry Harrisse, *L.-L. Boilly peintre, dessinateur, et lithographe. Sa vie et son oeuvre 1761–1845* (Paris, 1898).

Haverkamp-Begemann 1961
Egbert Haverkamp-Begemann, review of Otto Benesch, *The Drawings of Rembrandt*, in *Kunstchronik* 14 (January–March 1961), 10–14, 19–28, 50–57, 85–91.

Haverkamp-Begemann 1974
Egbert Haverkamp-Begemann, "Dutch and Flemish Figure Drawings from the Collection of Harry G. Sperling," *Master Drawings* 12 (1974), 35–37.

Hayward 1967/1968
J. F. Hayward, "A Newly Discovered Bronze Modello by Benvenuto Cellini," *Art at Auction: The Year at Sotheby's and Parke-Bernet* (1967/1968), 260–266.

Heawood
Edward Heawood, *Watermarks, Mainly of the 17th and 18th Centuries* (Hilversum, 1957).

Heikamp 1966
Detlef Heikamp, "In margine alla *Vita di Baccio Bandinelli* del Vasari," *Paragone* 19 (1966), 51–62.

Heinemann 1937–1941
Rudolf Heinemann, *Stiftung Sammlung Schloss Rohoncz*, 3 vols. (Lugano, 1937–1941).

Held 1980
Jutta Held, *Francisco de Goya in Selbstzeugnissen und Bilddokumenten* (Hamburg-Rembeck, 1980).

Henriot 1926–1928
Gabriel Henriot, *Collection David-Weill. Dessins*, 3 vols. (Paris, 1926–1928).

Herbert 1976
John Herbert, ed., *Christie's Review of the Season* (New York, 1976).

Heseltine 1903
J. P. Heseltine, *Reproductions of Original Drawings in Colour from the Collection of J. P. Heseltine* (Bushey, 1903).

Hind 1938 and 1948
A. M. Hind, *Early Italian Engraving*, 7 vols. (London, 1938 and 1948).

Hindman forthcoming
Sandra Hindman, *A Catalogue of the Northern European Miniatures of the Robert Lehman Collection in the Metropolitan Museum of Art, New York* (New York, forthcoming).

Hobbs 1977
Richard Hobbs, *Odilon Redon* (London, 1977).

Hofer 1947
Philip Hofer, "A Newly Discovered Book with Painted Decorations from Willibald Pirckheimer's Library," *Harvard Library Bulletin* 1 (1947), 66–75.

Hofstede de Groot 1906
Cornelis Hofstede de Groot, *Die Handzeichnungen Rembrandts* (Haarlem, 1906).

Hollstein
F.W.H. Hollstein, *Dutch and Flemish Etchings, Engravings, and Woodcuts, c. 1450–1700*, 43 vols. (Amsterdam, 1949—).

Holst 1974
Christian von Holst, "Fra Bartolommeo und Albertinelli. Beobachtungen zu ihrer Zusammenarbeit am *Jüngsten Gericht* aus Santa Maria Nuova und in der Werkstatt von San Marco," *Mitteilungen des Kunsthistorischen Institutes in Florenz* 18 (1974), 273–318.

Holzberg 1987
Niklas Holzberg, *Willibald Pirckheimer. Griechischer Humanismus in Deutschland* (Munich, 1987).

Henriot 1926–1928
Toshio Horii, "From the Age of Refinement to the World of the Tempest," in Jean Starobinski et al., *Revolution in Fashion: European Clothing, 1715–1815* (New York, 1990), 123–125.

Houtsma et al. 1987
M. Th. Houtsma et al., eds. *E. J. Brill's First Encyclopedia of Islam 1913–1936*, 9 vols. (Leiden, 1987, photo reproduction).

Humfrey 1983
Peter Humfrey, *Cima da Conegliano* (Cambridge, 1983).

Hyatt Mayor 1945
A. Hyatt Mayor, *The Bibiena Family* (New York, 1945).

*Illustrated Bartsch*
Adam von Bartsch, *The Illustrated Bartsch*, Walter L. Strauss, gen. ed., 164 vols. (New York, 1972–1992).

Jacob 1975
Sabine Jacob, *Italienische Zeichnungen der Kunstbibliothek Berlin* (Berlin, 1975).

Jaffé 1966
Michael Jaffé, *Van Dyck's Antwerp Sketchbook*, 2 vols. (London, 1966).

Jaffé 1994
Michael Jaffé, *The Devonshire Collection of Italian Drawings*, 4 vols. (London, 1994).

Jean-Richard 1978
Pierrette Jean-Richard, *L'oeuvre gravé de François Boucher dans la Collection Edmond de Rothschild* (Paris, 1978).

Jirat-Wasiutynski 1992
Vojtech Jirat-Wasiutynski, "The Charcoal Drawings of Odilon Redon," in *Drawing, Masters and Methods: Raphael to Redon*, Papers for the Ian Woodner Master Drawings Symposium at the Royal Academy of Arts (London, 1992), 145–158.

Joachim and McCullagh 1979
Harold Joachim and Suzanne Folds McCullagh, *Italian Drawings in the Art Institute of Chicago* (Chicago and London, 1979).

Joannides 1983
Paul Joannides, *The Drawings of Raphael* (Los Angeles, 1983).

Joannides 1993
Paul Joannides, *Masaccio and Masolino: A Complete Catalogue* (London, 1993).

Jones and Penny 1983
Roger Jones and Nicholas Penny, *Raphael* (New Haven and London, 1983).

Kai Sass 1976
Else Kai Sass, "À la recherche d'un portrait disparu de Christian II, roi de Danemark, peint par Albrecht Dürer en 1521," *Hafnia: Copenhagen Papers in the History of Art* (1976), 163–184.

Kauffmann 1926
H. Kauffmann, "Zur Kritik der Rembrandtzeichnungen," *Repertorium für Kunstwissenschaft* 47 (1926), 157–178.

Kaufmann 1985
Thomas DaCosta Kaufmann, "A Census of Drawings from the Holy Roman Empire, 1540–1680, in North American Collections," *Central European History* 18, no. 1 (1985), 70–114.

Kemp 1984
Martin Kemp, "Geometrical Perspective from Brunelleschi to Desargues: A Pictorial Means or an Intellectual End?" *Proceedings of the British Academy* 70 (1984), 89–132.

Kemp 1986
Martin Kemp, "Simon Stevin and Pieter Saenredam: A Study of Mathematics and Vision in Dutch Science and Art," *Art Bulletin* (June 1986), 237–252.

Keyes 1976
George S. Keyes, "A New Titian Drawing," *Arte Veneta* 30 (1976), 167–172.

Kirschbaum 1968–1976
Engelbert Kirschbaum, *Lexicon der christlichen Ikonographie*, 8 vols. (Rome, 1968–1976).

Knab et al. 1983
Eckhart Knab, Erwin Mitsch, and Konrad Oberhuber, *Raphael. Die Zeichnungen* (London, 1983).

Knapp 1903
Fritz Knapp, *Fra Bartolommeo della Porta und die Schule von San Marco* (Halle, 1903).

Knapp 1907 and 1928
Fritz Knapp, *Andrea del Sarto* (Leipzig, 1907; 2nd ed., 1928).

Knight 1993
Carlo Knight, "Hamilton's Lusieris," *Burlington Magazine* 135 (August 1993), 536–538.

Knoblock 1882
Kindler von Knoblock, *Der alte Adel im Oberelsass* (Berlin, 1882).

Knox 1960/1975
George Knox, *Tiepolo Drawings in the Victoria and Albert Museum* (London, 1960; 2nd ed., 1975).

Knox 1961
George Knox, "The Orloff Album of Tiepolo Drawings," *Burlington Magazine* 103 (June 1961), 269–275.

Knox 1965
George Knox, "A Group of Tiepolo Drawings Owned and Engraved by Pietro Monaco," *Master Drawings* 3, no. 4 (1965), 389–396.

Knox 1968
George Knox, "G. B. Tiepolo and the Ceiling of the Scalzi," *Burlington Magazine* 110 (July 1968), 394–398.

Knox 1973
George Knox, *Un quaderno di vedute di Giambattista e Domenico Tiepolo* (Milan, 1973).

Knox 1974
George Knox, "Giambattista Tiepolo: Variations on the Theme of Anthony and Cleopatra," *Master Drawings* 12, no. 4 (1974), 378–390.

Knox 1976
George Knox, "Francesco Guardi as an Apprentice in the Studio of Giambattista Tiepolo," in Ronald C. Rosbottom, ed., *Studies in Eighteenth-Century Culture* 5 (Madison, 1976), 29–39.

Knox 1978
George Knox, "The Tasso Cycles of Giambattista Tiepolo and Gianantonio Guardi," *Museum Studies* 9 (1978), 49–95.

Knox 1979
George Knox, "Pagani, Pellegrini, and Piazzetta: From Ca' Corner to 'The Elms,'" *Apollo* 110 (November 1979), 428–437.

**Knox 1980a**
George Knox, "Anthony and Cleopatra in Russia: A Problem in the Editing of Tiepolo Drawings," in William Blissett, ed., *Editing Illustrated Books* (New York, 1980), 35–55.

**Knox 1980b**
George Knox, *Giambattista and Domenico Tiepolo: A Study and Catalogue Raisonné of the Chalk Drawings* (Oxford, 1980).

**Knox 1983**
George Knox, "Domenico Tiepolo's Punchinello Drawings: Satire, or Labor of Love?" in J. D. Browning, ed., *Satire in the 18th Century* (New York, 1983), 124–146.

**Knox 1985a**
George Knox, "Piazzetta, Pittoni, and Tiepolo at Parma," *Arte veneta* 39 (1985), 114–124.

**Knox 1985b**
George Knox, "Sebastiano Ricci at Burlington House: A Venetian Decoration 'alla Romana,'" *Burlington Magazine* 127 (September 1985), 600–609.

**Knox 1988**
George Knox, "A New Painting for Vancouver: Luca Giordano's *Meeting of Venus and Adonis*," *RACAR* 15, no. 1 (1988), 85–86.

**Knox 1992**
George Knox, *Giovanni Battista Piazzetta, 1682–1754* (Oxford, 1992).

**Knox 1995**
George Knox, *Antonio Pellegrini, 1675–1741* (Oxford, 1995).

**Knox, forthcoming**
George Knox, "Francesco Guardi in the Studio of Giambattista Tiepolo," *Atti del congresso su Guardi* (forthcoming).

**Koch 1941**
Carl Koch, *Die Zeichnungen Hans Baldung Griens* (Berlin, 1941).

**Koreny and Oberhuber 1986/1987**
Fritz Koreny and Konrad Oberhuber, "Albrecht Dürer und Hans Hoffmann. Die Flügelstudien in Wien, Bamberg, Bayonne, und der Ian Woodner Family Collection, New York," *Jahrbuch der kunsthistorischen Sammlungen in Wien* (1986/1987), 17–21.

**Koschatzky and Strobl 1971**
Walter Koschatzky and Alice Strobl, *Die Dürerzeichnungen der Albertina* (Salzburg, 1971).

**Kossoff 1965**
F. Kossoff, "Romanino in Brescia," *Burlington Magazine* 107 (1965), 514–521.

**Krüger 1992**
Klaus Krüger, *Der frühe Bildkult des Franziskus in Italien* (Berlin, 1992).

**Kurz 1937**
Otto Kurz, "Giorgio Vasari's *Libro de' Disegni*," *Old Master Drawings* 12 (1937), 1–15.

**Kurz 1955**
Otto Kurz, *Bolognese Drawings of the 17th and 18th Centuries in the Collection of Her Majesty the Queen at Windsor Castle* (London, 1955).

**Kwakkelstein 1993**
M. K. Kwakkelstein, "Teste di vecchi in buon numero," *Raccolta Vinciana* 25 (1993), 39–62.

**Laclotte 1967**
Michel Laclotte, "Rencontres franco-italiennes au milieu du 15e siècle," *Acta Historiae Artium Academiae Scientaiarum Hungaricae* 13 (1967), 33–41.

**Ladis 1982**
Andrew Ladis, *Taddeo Gaddi* (Columbia, MO, 1982).

**Landolt 1972**
Hanspeter Landolt, *100 Meisterzeichnungen des 15. und 16. Jahrhunderts aus dem Basler Kupferstichkabinett* (Basel, 1972).

**Landon 1814**
Charles Landon, *Annales du Musée et de l'École moderne des Beaux-Arts. Salon de 1814* (Paris, 1814).

**Larsen 1988**
Erik Larsen, *The Paintings of Anthony van Dyck*, 2 vols. (Freren, 1988).

**Lauts 1962**
Jan Lauts, *Carpaccio: Paintings and Drawings, Complete Edition* (London, 1962).

**Leprieure et al. 1909**
Paul Leprieure, A. Perate, and P.-A. Lemoisne, *Catalogue raisonné de la collection Martin Le Roy*, 5 (Paris, 1909).

**Lettere e altri documenti**
*Lettere e altri documenti intorno alla storia della pittura*: vol. 1, *Il Grechetto a Mantova*; vol. 2, *G. B. Castiglione detto il Grechetto*; vol. 3, *G. B. Castiglione detto il Grechetto*, Fonti per la storia della pittura 1–3 (Genoa, 1971, 1973, 1975).

**Lettre sur l'exposition**
*Lettre sur l'exposition des ouvrages de peinture et de sculpture au Sallon du Louvre 1769* (Rome, 1769).

**Levenson et al. 1973**
J. A. Levenson, K. Oberhuber, and J. L. Sheehan, *Early Italian Engravings from the National Gallery of Art* (Washington, 1973).

**Levey 1986**
Michael Levey, *Giambattista Tiepolo: His Life and Work* (New Haven and London, 1986).

**Levi D'Ancona 1958**
Mirella Levi D'Ancona, "Some New Attributions to Lorenzo Monaco," *Art Bulletin* 40 (September 1958), 175–191.

**Levi D'Ancona 1962**
Mirella Levi D'Ancona, *Miniatura e miniatori a Firenze dal 14 al 16 secolo. Documenti per la storia della miniatura* (Florence, 1962).

**Levi D'Ancona 1978**
Mirella Levi D'Ancona, "I corali di S. Maria degli Angeli, ora nella Biblioteca Laurenziana e le miniature da essi asportate," in *Miscellanea di studi in memoria di Anna Saitta Revignas* (Florence, 1978), 213–235.

**Levi D'Ancona 1994**
Mirella Levi D'Ancona, *The Illuminators and Illuminations of the Choir Books from Santa Maria degli Angeli and Santa Maria Nuova and Their Documents* (Florence, 1994).

**Lieb and Stange 1960**
Norbert Lieb and Alfred Stange, *Hans Holbein der ältere* (Munich, 1960).

**Lightbown 1986**
Ronald Lightbown, *Mantegna* (Oxford, 1986).

**Lippmann and Hofstede de Groot 1888–1911**
Friedrich Lippmann and Cornelis Hofstede de Groot, *Original Drawings by Rembrandt Harmensz. van Rijn Reproduced in Phototype*, 4 vols. (Berlin and elsewhere, 1888–1911).

**Lippmann and Winkler 1883–1929**
Friedrich Lippmann and Friedrich Winkler, *Zeichnungen von Albrecht Dürer in Nachbildungen*, 7 vols. (Berlin, 1883–1929).

**Lipton 1974**
Deborah Lipton, "Francesco Squarcione," dissertation, New York University, Graduate School of Arts and Sciences (1974).

**Lombardi 1983**
Sandro Lombardi, *Jean Fouquet* (Florence, 1983).

**Longhi 1952**
Roberto Longhi, "Ancora sulla cultura del Fouquet," *Paragone* 27 (1952), 56–57.

**Loredan 1633**
Giovan Francesco Loredan, *Vita del Cavaliere Marino* (Venice, 1633).

**Loredan 1649**
Giovan Francesco Loredan, *Le glorie degl' incogniti* (Venice, 1649).

**Lowry 1979**
Martin Lowry, *The World of Aldus Manutius: Business and Scholarship in Renaissance Venice* (Ithaca, NY, 1979).

**Ludwig and Molmenti 1906**
Gustavo Ludwig and Pompeo Molmenti, *Vittore Carpaccio. La vita e le opere* (Milan, 1906).

**Lugt**
Frits Lugt, *Les marques de collections de dessins et d'estampes* (Amsterdam, 1921); *Supplément* (The Hague, 1956).

**Lugt 1920**
Frits Lugt, *Mit Rembrandt in Amsterdam* (Berlin, 1920).

**Lugt 1931**
Frits Lugt, "Beiträge zu dem Katalog zu den niederländischen Handzeichunungen in Berlin," *Jahrbuch der königlich preussischen Kunstsammlungen* 52 (1931), 36–80.

**Lugt 1949**
Frits Lugt, *Inventaire général des dessins des écoles du nord*, 2 vols. (Paris, 1949).

**Lyons 1972**
Leonard Lyons, "The Lyons Den," *New York Post* (27 March 1972), 31.

**Mabille de Poncheville 1931**
André Mabille de Poncheville, *Boilly* (Paris, 1931).

**MacAndrew 1980**
Hugh MacAndrew, *Catalogue of the Collection of Drawings in the Ashmolean Museum, III, Italian Schools, Supplement* (Oxford, 1980).

**MacFall 1909**
Haldane MacFall, *The French Pastellists of the Eighteenth Century* (London, 1909).

**Maggs Brothers 1941**
Maggs Brothers, *French Books and Prints, Incunabula, Bibles, and Bindings, Catalogue No. 709* (London, 1941).

**Magnussen 1958–1959**
Ib Magnussen, "Willibald Pirckheimer og Albrecht Dürer. Et Nyt Fund," *Fund og Forskning i det kongelige Biblioteks Samlinger* 5–6 (1958–1959), 110–120.

**Malvasia 1841 ed.**
Carlo Cesare Malvasia, *Felsina pittrice* (Bologna, 1678; 1841 ed.).

**Mariani 1940**
Valerio Mariani, *I Bibiena scenografi* (Florence, 1940).

**Marino 1623**
Giambattista Marino, *Adone* (Paris, 1623).

**Mariuz 1986**
Adriano Mariuz, "I disegni di Pulcinello di Giandomenico Tiepolo," *Arte Veneta* 40 (1986), 265–273.

**Marmottan 1913**
Paul Marmottan, *Le peintre Louis Boilly (1791–1845)* (Paris, 1913).

**Massing 1983**
Jean Michel Massing, "The Influence of Erasmus: Text and Image in a French Pre-Emblematic Manuscript," in J. B. Trapp, ed., *Manuscripts in the Fifty Years after the Invention of Printing* (London, 1983), 75–82.

**Massing 1987**
Jean Michel Massing, "The Illustrations of Lucian's *Images Vitae Aulicae*," *Journal of the Warburg and Courtauld Institutes* 50 (1987), 214–219.

Massing 1990
Jean Michel Massing, *Du texte à l'image. La calomnie d'Apelle et son iconographie* (Strasbourg, 1990).

Massing 1995
Jean Michel Massing, *Erasmian Wit and Proverbial Wisdom: An Illustrated Moral Compendium for François 1er* (London, 1995).

Mathieu 1976
Pierre-Louis Mathieu, *Gustave Moreau* (Fribourg, 1976).

Mathieu 1977
Pierre-Louis Mathieu, *Gustave Moreau: Complete Edition of the Finished Paintings, Watercolours, and Drawings* (Oxford, 1977).

Mayer 1933
August L. Mayer, "Dibujos Desconocidos de Goya," *Revista Española de Arte*, no. 7 (September 1933), 376–384.

Mayer 1934
August L. Mayer, "Some Unknown Drawings by Francisco Goya," *Old Master Drawings* 9, no. 34 (September 1934), 20–22.

McCullagh 1981
Suzanne Folds McCullagh, "The Development of Gabriel de Saint-Aubin (1724–1780) as a Draughtsman," 2 vols., dissertation, Harvard University, Cambridge (1981).

McEvansoneya 1994
Philip McEvansoneya, "Van Dyck and the Duchess of Buckingham's Collection: New Documents Relating to York House," *Apollo* 140 (December 1994), 30–32.

McKillop 1974
Susan Regan McKillop, *Franciabigio* (Berkeley and Los Angeles, 1974).

McLellan 1992
Dugald McLellan, "Luca Signorelli's Last Judgment Fresco Cycle at Orvieto: An Interpretation of the Fears and Hopes of the Commune and People of Orvieto at a Time of Reckoning," 2 vols., dissertation, University of Melbourne (1992).

Meder 1919
Joseph Meder, *Die Handzeichnung. Ihre Technik und Entwicklung* (Vienna, 1919).

Mellen 1971
P. Mellen, *Jean Clouet* (London, 1971).

Mellerio 1913
André Mellerio, *Odilon Redon* (Paris, 1913).

Miller 1991
Michael Miller, "A Madonna and Child from Pintoricchio's Sienese Period," *Bulletin of the Cleveland Museum of Art* 78, no. 8 (December 1991), 326–359.

Mode 1972
Robert L. Mode, "Masolino, Uccello, and the Orsini 'Uomini Famosi,'" *Burlington Magazine* 114 (June 1972), 369–378.

Möhle 1942
Hans Möhle, review of Carl Koch, *Die Zeichnungen Hans Baldung Griens*, in *Zeitschrift für Kunstgeschichte* 10 (1942), 214–221.

Möhle 1959
Hans Möhle, "Hans Baldung Grien zur Karlsruher Baldung-Ausstellung Sommer 1959," *Zeitschrift für Kunstgeschichte* 22, no. 2 (1959), 124–132.

Molmenti 1909
Pompeo Molmenti, *G. B. Tiepolo* (Milan, 1909).

Monaco 1745
Pietro Monaco, *Raccolta di…storie sacre*, vol. 1, with 55 plates (Venice, 1739), vol. 2, with 57 additonal plates (Venice, 1745).

Monbeig Goguel 1978
Catherine Monbeig Goguel, "Francesco Salviati e il tema della resurrezione di Cristo," *Prospettiva* 13 (1978), 7–23.

Mongan 1932
Agnes Mongan, "Portrait Studies by Degas in American Collections," *Bulletin of the Fogg Art Museum* 1, no. 4 (May 1932), 62–68.

Montesquiou/Hahlbrock 1977
Robert de Montesquiou, *Rodolphe Bresdin der Unentwirrbare*, ed. Peter Hahlbrock (Berlin, 1977).

Morassi 1959
A. Morassi, "Alcuni disegni inediti del Romanino," *Festschrift Karl M. Swoboda zum 28. Januar 1959* (Vienna and Wiesbaden, 1959), 189–192.

Moreau-Nelaton 1924
Étienne Moreau-Nelaton, *Les Clouets et leurs émules*, 3 vols. (Paris, 1924).

Mortari 1992
Luisa Mortari, *Francesco Salviati* (Rome, 1992).

Müller 1988
Christian Müller, *Hans Holbein d. J.: Zeichnungen aus dem Kupferstichkabinett der öffentlichen Kunstsammlung Basel* (Basel, 1988).

Müller Hofstede 1973
Justus Müller Hofstede, "New Drawings by Van Dyck," *Master Drawings* 11 (Summer 1973), 154–159.

Müller Hofstede 1994
Justus Müller Hofstede, "Van Dyck's Authorship Excluded: The Sketchbook at Chatworth," in Susan J. Barnes and Arthur K. Wheelock Jr., eds., *Van Dyck 350*, Studies in the History of Art 46, National Gallery of Art, Washington (Hanover and London, 1994), 49–60.

Munich *Erläuterungen* 1983
*Alte Pinakothek München, Erläuterungen zu den ausgestellten Gemälden* (Munich, 1983).

Münz 1937
Ludwig Münz, "Maes, Aert de Gelder, Barent Fabritius, und Rembrandt: I. Die Kompositionsskizzen von Nicolaes Maes aus seiner Lehrzeit bei Rembrandt," *Die graphischen Künste* 2, no. 3 (1937), 95–108.

Münz 1961
Ludwig Münz, *Bruegel: The Drawings* (London, 1961).

Muraro and Povoledo 1970
Maria Teresa Muraro and Elena Povoledo, *Disegni teatrali dei Bibiena* (Venice, 1970).

Muraro 1966
Michelangelo Muraro, *Carpaccio* (Florence, 1966).

Muraro 1977
Michelangelo Muraro, *I disegni di Vittore Carpaccio*, Corpus graphicum 2 (Florence, 1977).

Musper 1952
H. T. Musper, *Albrecht Dürer. Der gegenwärtige Stand der Forschung* (Stuttgart, 1952).

Naef 1977–1980
Hans Naef, *Les portraits dessinés de J.A.D. Ingres*, 5 vols. (Bern, 1977–1980).

Natali and Cecchi 1989
Antonio Natali and Alessandro Cecchi, *Andrea del Sarto. Catalogo completo* (Florence, 1989).

Neil 1988–1989
Ketti Neil, "St. Francis of Assisi, the Penitent Magdalen, and the Patron at the Foot of the Cross," *Rutgers Art Review* 9–10 (1988–1989), 83–110.

Nepi Sciré and Marani 1992
Giovanna Nepi Sciré and Pietro C. Marani, eds., *Leonardo and Venice* (Milan, 1992).

Nesselrath 1982
Arnold Nesselrath, "Antico and Montecavallo," *Burlington Magazine* 124 (June 1982), 353–357.

NGA Guide 1992
*National Gallery of Art, Washington* (New York, 1992).

Nova 1981
Alessandro Nova, "Francesco Salviati and the 'Markgrafen' Chapel in S. Maria dell'Anima," *Mitteilungen des Kunsthistorischen Institutes in Florenz* 3 (1981), 355–372.

Nova 1986
Alessandro Nova, "Girolamo Romanino. Introduzione e un catalogo ragionato," dissertation, Università degli Studi di Milano (1986).

Nova 1994
Alessandro Nova, *Girolamo Romanino* (Turin, 1994).

Nova 1995
Alessandro Nova, "The Drawings of Girolamo Romanino, Part 1," *Burlington Magazine* 137 (1995), 159–168.

Núñez de Arenas 1950
M. Núñez de Arenas, "Manojo de noticias. La suerte de Goya en Francia," *Bulletin hispanique* 3 (1950), 256–265.

Oberhuber 1983
Konrad Oberhuber, "Sur quelques dessins germaniques," *Connaissance des Arts* 376 (1983), 76–81.

Oettinger and Knappe 1963
Karl Oettinger and Karl-Adolphe Knappe, *Hans Baldung Grien und Albrecht Dürer in Nürnberg* (Nuremberg, 1963).

Offenbacher 1938
Émile Offenbacher, "La bibliothèque de Willibald Pirckheimer," *La Bibliofilia* 40 (1938), 241–263.

Olsen 1962
Harald Olsen, *Federico Barocci* (Copenhagen, 1962).

Oppé 1931
A. P. Oppé, "Antony van Dyck (1599–1641)," *Old Master Drawings* 5 (March 1931), 70–73.

Oppé 1951
A. P. Oppé, ed., "The Memoires of Thomas Jones," *The Walpole Society* 32 (1951), 1–143.

Osten 1983
Gert von der Osten, *Hans Baldung Grien. Gemälde und Dokumente* (Berlin, 1983).

Pächt 1929
Otto Pächt, *Österreichische Tafelmalerei der Gotik* (Augsburg, 1929).

Palau i Fabre 1981
Josep Palau i Fabre, *Picasso: Life and Work of the Early Years 1881–1907* (Oxford, 1981).

Paliaga 1995
F. Paliaga, "Giovanni Paolo Lomazzo. I disegni 'caricati' di Leonardo e le origini delle 'pitture ridicole,'" *Raccolta Vinciana* 26 (1995).

Panofsky 1943
Erwin Panofsky, *Albrecht Dürer*, 2 vols. (Princeton, 1943).

Panofsky-Soergel 1984
Gerda Panofsky-Soergel, "Postscriptum to Tommaso Cavalieri," in *Scritti di Storia dell' arte in onore di Roberto Salvini* (Florence, 1984), 399–406.

Parker 1927
K. T. Parker, *North Italian Drawings of the Quattrocento* (London, 1927).

Parker 1936
K. T. Parker, *The Famous Collection of Old Master Drawings Formed by the Late Henry Oppenheimer, Esq., F.S.A.* (sale catalogue, Christie's, London, 13–14 July 1936).

Parker 1945
K. T. Parker, *The Drawings of Hans Holbein in the Collection of His Majesty the King at Windsor Castle* (Oxford and London, 1945).

Parker 1956
K. T. Parker, *Catalogue of the Collection of Drawings in the Ashmolean Museum II: Italian Schools* (Oxford, 1956).

Parma Armani 1986
Elena Parma Armani, *Perino del Vaga, l'anello mancante. Studi sul manierismo* (Genoa, 1986).

Parronchi 1969
Alessandro Parronchi, "Une tête de satyre de Cellini," *Revue de l'Art* 5 (1969), 43–45.

Pauli 1908
Gustav Pauli, "Zeichnungen Van Dycks in der Bremer Kunsthalle," *Zeitschrift für bildende Künste* 43, n.s. 19 (1908), 82–88.

Pauli 1919
Gustav Pauli, "Die Dürer-Literatur der Letzten drei Jahre," *Repertorium für Kunstwissenschaft* 41 (1919), 1–34.

Pedrocco 1988
Filippo Pedrocco, *Giandomenico Tiepolo a Zianigo* (Villorba, 1988).

Pepper 1984
D. Stephen Pepper, *Guido Reni: A Complete Catalogue of His Works with an Introductory Text* (Oxford, 1984).

Perlingieri 1992
Ilya S. Perlingieri, *Sofonisba Anguissola: The First Great Woman Artist of the Renaissance* (New York, 1992).

Perrig 1977
Alexander Perrig, *Die "Michelangelo"-Zeichnungen Benvenutos Cellinis* (Frankfurt, 1977).

Peters 1965
H. A. Peters, "Bemerkungen zu oberitalienischen Zeichnungen des 15. und 16. Jahrhunderts," *Wallraf-Richartz-Jahrbuch* 27 (1965), 129–190.

Petrioli Tofani 1991
Annamaria Petrioli Tofani, *Gabinetto disegni e stampe degli Uffizi. Inventario. Disegni di Figure. 1* (Florence, 1991).

Pevsner 1940
Nikolaus Pevsner, *Academies of Art: Past and Present* (Cambridge, 1940; reprint 1973).

Philip 1957
I. G. Philip, "Balthazar Gerbier and the Duke of Buckingham's Pictures," *Burlington Magazine* 99 (1957), 155–156.

Piccard 1978
Gerhard Piccard, ed., *Wasserzeichen Anker. Abteilung V, Oberitalien—Raum Venezia* (Stuttgart, 1978).

Pigler 1956
André Pigler, *Barockthemen*, 2 vols. (Budapest, 1956).

Pignatti 1963
Terisio Pignatti, review of Jan Lauts, *Carpaccio: Paintings and Drawings*, in *Master Drawings* 1 (1963), 47–53.

Pignatti 1981
Terisio Pignatti, *Disegni antichi del Museo Correr di Venezia II* (Venice, 1981).

Pignatti 1982
Terisio Pignatti, *Palazzo Labia a Venezia* (Turin, 1982).

Pillsbury 1978
Edmund P. Pillsbury, "The Oil Studies of Federico Barocci," *Apollo* 108 (September 1978), 170–173.

Pilz 1930
Kurt Pilz, "Das graphische Werk der Jost Amman," dissertation, Nuremberg (1930).

Pilz 1940
Kurt Pilz, *Fränkische Heimat* 19, no. 1 (1940).

Pilz 1962
Kurt Pilz, "Hans Hoffmann. Ein Nuremberger Dürer Nachahmer aus der zweiten Hälfte der 16. Jahrhunderts," *Mitteilungen des Vereins für Geschichte der Stadt Nürnberg* 51 (1962), 236–272.

Pilz 1970
Kurt Pilz, "Willibald Pirckheimers Kunstsammlung und Bibliothek," in Karl Borromäus Glock, ed., *Willibald Pirckheimer, 1470–1970. Dokumente, Studien, Perspektiven* (Nuremberg, 1970), 93–110.

Pope-Hennessy 1974
John Pope-Hennessy, *Fra Angelico* (London, 1974).

Pope-Hennessy 1982
John Pope-Hennessy, "A Bronze Satyr by Cellini," *Burlington Magazine* 124 (1982), 406–412.

Pope-Hennessy 1985
John Pope-Hennessy, *Cellini* (New York, 1985).

Popham 1946
A. E. Popham, *The Drawings of Leonardo da Vinci* (London, 1946).

Popham 1957
A. E. Popham, *Correggio's Drawings* (London, 1957).

Popham 1971
A. E. Popham, *Catalogue of the Drawings of Parmigianino*, 2 vols. (New Haven and London, 1971).

Popham and Fenwick 1965
A. E. Popham and K. M. Fenwick, *European Drawings in the Collection of the National Gallery of Canada* (Toronto, 1965).

Popham and Pouncey 1950
A. E. Popham and Philip Pouncey, *Italian Drawings in the Department of Prints and Drawings in the British Museum* (London, 1950).

Popham and Wilde 1949
A. E. Popham and Johannes Wilde, *Italian Drawings of the 15th and 16th Centuries in the Collection of His Majesty the King at Windsor Castle* (London, 1949).

Populus 1930
Bernard Populus, *Claude Gillot (1673–1722). Catalogue de l'oeuvre gravé* (Paris, 1930).

Portalis 1899 and 1900
Baron Roger Portalis, "Claude Hoin," *La Gazette des Beaux-Arts*, 22, 3rd per. (1899), 441–461; 23 (1900), 10–24, 203–216, 293–309.

Posthius 1563
Johannes Posthius, *Iohan Posthii Germershemii tetrasticha in Ovidii Metam. Lib. xv. quibius accesserunt Vergilij Solis figurae elegantiss. iam primum in lucem editae* (Frankfurt am Main, 1563; reprint 1569).

Pratesi 1993
Giovanni Pratesi, ed., *Repertorio della scultura fiorentina del seicento e settecento*, 3 vols. (Turin, 1993).

Prokopp 1983
Mária Prokopp, *Italian Trecento Influence on Murals in East Central Europe, Particularly Hungary* (Budapest, 1983).

Prouté 1978
Paul Prouté, S. A., *Catalogue "Centenaire,"* 2 vols. (Paris, 1978).

Prouté 1983
Paul Prouté, S.A., *Catalogue "Signac"* (Paris, 1983).

Prudhomme and Dandelot 1911
J.-G. Prudhomme and A. Dandelot, *Gounod (1818–1883). Sa vie et ses oeuvres d'après des documents inédits* (Paris, 1911).

Ragghianti 1946
Carlo Ludovico Ragghianti, *Commenti di Critica d'Arte* (Bari, 1946).

Ragghianti Collobi 1974
Licia Ragghianti Collobi, *Il "Libro de' Disegni" del Vasari*, 2 vols. (Florence, 1974).

Rave 1938
P. O. Rave, *Deutsche Landschaft in fünf Jahrhunderten deutscher Malerei* (Berlin, 1938).

Réau 1958
Louis Réau, *Iconographie de l'art chrétien, III, Iconographie des saints* (Paris, 1958).

Redon 1961 ed.
[Odilon Redon], *À Soi-Même. Journal (1867–1915). Notes sur la vie, l'art, et les artistes* (Paris, 1961).

Reff 1972
Theodore Reff, *The Notebooks of Degas* (Oxford, 1972).

Reitlinger 1927
H. S. Reitlinger, "An Unknown Collection of Dürer Drawings," *Burlington Magazine* 1, no. 288 (1927), 153–159.

*Rembrandt Corpus*
J. Bruyn, B. Haak, S.H. Levie, P.J.J. van Thiel, and E. van de Wetering, *A Corpus of Rembrandt Paintings*, 3 vols. (Dordrecht, Boston, and London, 1982–1989).

Reynaud 1989
Nicole Reynaud, "Barthélemy d'Eyck avant 1450," *Revue de l'Art* 84 (1989), 22–43.

Richardson 1991
John Richardson, *A Life of Picasso, I, 1881–1906* (New York, 1991).

Richter 1901
Jean Paul Richter, *Catalogue of Pictures at Locko Park* (London, 1901).

Richter 1971
Gisela M.A. Richter, *Engraved Gems of the Romans* (London, 1971).

Ridolfi 1648
Carlo Ridolfi, *Le mera viglie dell'arte* (Venice, 1648).

Riemann 1944
Arnold Riemann, *Die älteren Pirckheimer* (Leipzig, 1944).

Ripa 1644
Cesare Ripa, *Iconologia, of uytbeeldingen des Verstands…* (Amsterdam, 1644).

Rizzi 1971
Aldo Rizzi, *Etchings of the Tiepolos* (London, 1971).

Roberts 1992
Jane Roberts, "The Early History of the Collecting of Drawings by Leonardo da Vinci," in Giovanna Nepi Sciré and Pietro C. Marani, eds., *Leonardo and Venice* (Milan, 1992), 155–178.

Robinson 1869
J. C. Robinson, *Descriptive Catalogue of the Drawings by the Old Masters, Forming the Collection of John Malcolm of Poltalloch, Esq.* (London, 1869).

Robison 1986
Andrew Robison, *Piranesi: Early Architectural Fantasies, A Catalogue Raisonné of the Etchings* (Washington, 1986).

Roland Michel 1987
Marianne Roland Michel, *Le dessin français au 18ᵉ siècle* (Fribourg, 1987).

Rosenberg 1959
Jakob Rosenberg, *Great Draughtsmen from Pisanello to Picasso* (Cambridge, 1959).

Rosenthal 1929
Erwin Rosenthal, "Dürer Buchmalereien für Pirckheimers Bibliothek," *Jahrbuch der preussischen Kunstsammlungen* 49 (1929), 1–54.

Rosenthal 1930
Erwin Rosenthal, "Dürers Buchmalereien für Pirckheimers Bibliothek. Ein Nachtrag," *Jahrbuch der preussischen Kunstsammlungen* 51 (1930), 175–178.

Rossi 1975
Paola Rossi, *I disegni di Jacopo Tintoretto*, Corpus graphicum 1 (Florence, 1975).

Roth 1992
Michael Roth, "Die Zeichnungen des 'Meister der Coburger Rundblätter,'" dissertation, Free University, Berlin (1988), microfiche ed. (1992).

Roth 1992a
Michael Roth, "Die Zeichnungen des sog. 'Meisters der Gewandstudien' und ihre Beziehung zur Strassburger Glas- und Tafelmalerei des späten 15. Jahrhunderts," in Rüdiger Becksmann, ed., *Deutsche Glasmalerei des Mittelalters II. Bildprogramme, Auftraggeber, Werkstätten* (Berlin, 1992), 153–172.

Rowlands 1985
John Rowlands, *The Paintings of Hans Holbein the Younger* (Oxford, 1985).

Rowlands 1993
John Rowlands, *Drawings by German Artists…in the British Museum: The Fifteenth and the Sixteenth Century by Artists Born before 1530* (London, 1993).

Royalton-Kisch 1992
Martin Royalton-Kisch, "Rembrandt's Landscape Drawings," in *Drawing, Masters and Methods: Raphael to Redon*, Papers for the Ian Woodner Master Drawings Symposium at the Royal Academy of Arts (London, 1992), 114–135.

Ruggeri 1976
Ugo Ruggeri, *Maestri lombardi e lombardo-veneti del Rinascimento. Biblioteca di disegni, I* (Florence, 1976).

Ruhmer 1966
E. Ruhmer, *Marco Zoppo* (Vicenza, 1966).

Rupprich 1966
Hans Rupprich, ed., *Dürer. Schriftlicher Nachlass*, 3 vols. (Berlin, 1966).

Russell 1984
Francis Russell, review of Andrew Ladis, *Taddeo Gaddi* (1982), in *Journal of the Royal Society of Arts* (March 1984), 278–279.

Ruurs 1982
Rob Ruurs, "Saenredam constructies," *Oud Holland* 96 (1982), 97–121.

Ruurs 1985
Rob Ruurs, review of *Dutch Church Painters: Saenredam's Great Church at Haarlem*, in *Oud Holland* 99, no. 2 (1985), 161–164.

Ruurs 1987
Rob Ruurs, *Saenredam: The Art of Perspective* (Amsterdam, Philadelphia, and Groningen, 1987).

Rylands 1988
Philip Rylands, *Palma il Vecchio. L'opera completa* (Milan, 1988).

Saccomani 1979
Elisabetta Saccomani, "Ancora su Domenico Campagnola. Una questione controversa," *Arte Veneta* 33 (1979), 43–49.

Saccomani 1982
Elisabetta Saccomani, "Domenico Campagnola disegnatore di Paesi. Dagli esordi alla prima maturità," *Arte Veneta* 36 (1982), 81–99.

Saccomani 1991
Elisabetta Saccomani, "Apports et précisions au catalogue des dessins de Domenico Campagnola," in *Disegno. Actes du colloques du Musée des Beaux-Arts de Rennes 1990* (Rennes, 1991), 31–36.

St. Clair 1967
William St. Clair, *Lord Elgin and the Marbles* (London, 1967).

Saint-Non 1781–1786
Jean Claude Richard, abbé de Saint-Non, *Voyage pittoresque ou description des royaumes de Naples et de Sicile*, 4 vols. (Paris, 1781–1786).

"Sallon du Louvre" 1769
"Sallon du Louvre," *Affiches, annonces, et avis divers* 38 (20 September 1769), 150–151.

Scarpellini 1984
Pietro Scarpellini, *Perugino* (Milan, 1984).

Schade 1974
Werner Schade, *Die Malerfamilie Cranach* (Dresden, 1974).

Schadendorf 1964
Wulf Schadendorf, *Eine Proportionsstudie aus dem Jahre 1500* (Fürth, 1964).

Schadendorf 1969
Wulf Schadendorf, *Eine Zeichnung Dürers von 1492/1493* (Nuremberg, 1969).

Savinskaya 1980
L. Savinskaya, "Paintings by G. B. Tiepolo at Archangelskoye," *Iskoustvo* 5 (1980), 64–69.

Saxl 1942
Fritz Saxl, "A Spiritual Encyclopedia of the Later Middle Ages," *Journal of the Warburg and Courtauld Institutes* 5 (1942), 82–134.

Saxl and Meier 1953
Fritz Saxl and Hans Meier, *Verzeichnis astrologischer und mythologischer illustrierter Handschriften des Lateinischen Mittelalters, III. Handschriften in Englischen Bibliotheken*, 4 vols. (London, 1953).

Saxon 1969
Arthur H. Saxon, "Giuseppe Galli-Bibiena's *Architetture e Prospettive*," *Maske und Kothurn* 15, no. 2 (1969), 105–118.

Sayre 1958
Eleanor A. Sayre, "An Old Man Writing: A Study of Goya's Albums," *Bulletin of the Museum of Fine Arts, Boston* 56 (1958), 117–133.

Sayre 1964
Eleanor A. Sayre, "Eight Books of Drawings by Goya, I," *Burlington Magazine* 106 (1964), 19–30.

Sayre 1966
Eleanor A. Sayre, "Goya's Bordeaux Miniatures," *Bulletin of the Museum of Fine Arts, Boston* 64 (1966), 84–123.

Sayre 1971
Eleanor A. Sayre, *Late Caprichos of Goya* (New York, 1971).

Scharf 1935
Alfred Scharf, *Filippino Lippi* (Vienna, 1935).

Schatborn 1985
Peter Schatborn, *Catalogue of the Dutch and Flemish Drawings in the Rijksmuseum IV: Drawings by Rembrandt, His Anonymous Pupils, and Followers* (The Hague, 1985).

Scheller 1962
R. W. Scheller, "Uomini famosi," *Bulletin van het Rijksmuseum Amsterdam* 10 (1962), 56–67.

Scheller 1963
R. W. Scheller, *A Survey of Medieval Model Books* (Haarlem, 1963).

Schilling 1922
Edmund Schilling, *Altdeutsche Handzeichnungen aus der Sammlung Lahmann* (Munich, 1922).

Schilling 1934
Edmund Schilling, *Altdeutsche Meisterzeichnungen* (Frankfurt am Main, 1934).

Schilling 1954
Edmund Schilling, "Werkzeichnungen Dürers zur *Grünen Passion*," *Berliner Museum* 4 (1954), 14–24.

Schmitt 1974
Annegrit Schmitt, "Francesco Squarcione als Zeichner und Stecher," *Münchner Jahrbuch der bildenden Kunst* 25 (1974), 205–213.

Schnapper 1974
Antoine Schnapper, *Jean Jouvenet (1644–1717) et la peinture d'histoire à Paris* (Paris, 1974).

Schnapper and Guicharnaud
Antoine Schnapper and Hélène Guicharnaud, *Louis de Boullogne 1654–1733*. Cahiers du dessin français, no. 2 (Paris, [n.d.]).

Schnelbögl 1966
Fritz Schnelbögl, "Life and Work of the Nuremberg Cartographer Erhard Etzlaub," *Imago Mundi* 20 (1966), 11–26.

Scholten 1904
H. J. Scholten, *Musée Teyler à Haarlem. Catalogue raisonné des dessins des écoles française et hollandaise* (Haarlem, 1904).

Scholz 1958
Janos Scholz, "On Brescian Renaissance Drawings," in *Essays in Honor of Hans Tietze 1880–1954* (Paris, 1958), 411–418.

Schönbrunner and Meder 1896–1908
Josef Schönbrunner and Joseph Meder, *Handzeichnungen alter Meister aus der Albertina und anderen Sammlungen*, 12 vols. (Vienna, 1896–1908).

Schöne 1938
Wolfgang Schöne, *Dieric Bouts und seine Schule* (Berlin and Leipzig, 1938).

Schwartz and Bok 1990
Gary Schwartz and Marten Jan Bok, *Pieter Saenredam: The Painter and His Time* (The Hague, 1990).

*Sentimens* 1769
*Sentimens sur les tableaux exposés au Salon* (Paris, 1769).

Sereville and Saint-Simon
É. de Sereville and F. de Saint-Simon, *Dictionnaire de la noblesse française* (Paris, [n.d.]).

Seznec 1972
Jean Seznec, "Odilon Redon and Literature," in *French 19th-Century Painting and Literature*, ed. Ulrich Finke (New York, 1972), 280–298.

Seznec and Adhémar 1957–1967
Jean Seznec and Jean Adhémar, eds., *Diderot Salons*, 4 vols. (Oxford, 1957–1967).

Shearman 1965
John Shearman, "Raphael's Unexecuted Projects for the Stanze," in *Walter Friedländer zum 90. Geburtstag* (Berlin, 1965), 158–180.

Shearman 1965a
John Shearman, *Andrea del Sarto*, 2 vols. (Oxford, 1965).

Shearman 1972
John Shearman, *Raphael's Cartoons in the Collection of Her Majesty the Queen and the Tapestries for the Sistine Chapel* (London, 1972).

Shell 1989
Jamie Shell, "New Haven: The Sforza Court," *Burlington Magazine* 131 (April 1989), 318.

Shoemaker 1975
Innis Howe Shoemaker, "Filippino Lippi as a Draughtsman," 2 vols., dissertation, Columbia University, New York (1975).

Siegfried 1995
Susan Siegfried, *The Art of Louis-Léopold Boilly: Modern Life in Napoleonic France* (New Haven and London, 1995).

Simpson 1966
W. A. Simpson, "Cardinal Giordano Orsini…Patron of the Arts: A Contemporary Panegyric and Two Descriptions of the Lost Frescoes in Monte Giordano," *Journal of the Warburg and Courtauld Institutes* 29 (1966), 135–159.

Slive 1965
Seymour Slive, *Drawings of Rembrandt*, 2 vols. (New York, 1965).

Sonkes 1969
Micheline Sonkes, *Dessins du 15e siècle. Groupe van der Weyden* (Brussels, 1969).

Spicer Durham 1979
Joaneath Ann Spicer Durham, "The Drawings of Roelandt Savery," dissertation, Yale University, New Haven (1979).

Spinosa 1987
Nicola Spinosa, *Pittura napoletana del settecento dal rococò al classicismo* (Naples, 1987).

Spinosa and Di Mauro 1989
Nicola Spinosa and Leonardo Di Mauro, *Vedute napoletane del settecento* (Naples, 1989).

Sricchia Santoro 1986a
Fiorella Sricchia Santoro, *Antonello e l'Europa* (Milan, 1986).

Sricchia Santoro 1986b
Fiorella Sricchia Santoro, review of Charles Sterling, *Enguerrand Quarton le peintre de la Pietà d'Avignon* and M. Laclotte and D. Thiébaut, *L'École d'Avignon*, in *Prospettiva* 44 (1986), 78–88.

Stählin 1990
Karl Stählin, *Zapiski Jacoba Stählina ob iziatchnyk i musstvah v Rossis* (Moscow, 1990).

Stampfle and Denison 1973
Felice Stampfle and Cara Denison, *Drawings from the Collection of Lore and Rudolf Heinemann* (New York, 1973).

Stadler 1936
Franz Stadler, *Hans von Kulmbach* (Vienna, 1936).

Stange 1934–1961
Alfred Stange, *Deutsche Malerei der Gotik*, 11 vols. (Munich and Berlin, 1934–1961; Kraus reprint, 1969).

Stange 1967–1970
Alfred Stange, *Kritisches Verzeichnis der Deutschen Tafelmalerei vor Dürer*, 3 vols. (Munich, 1967–1970).

Starcky 1988
Emmanuel Starcky, *Inventaire général des dessins des écoles du nord. Supplément* (Paris, 1988).

*Stift und Feder*
*Stift und Feder. Zeichnungen von Kunstler aller Zeiten und Länder in Nachbildungen*, 17 fasc. (Frankfurt, 1917–1931).

Strauss 1972
Walter L. Strauss, *Albrecht Dürer: The Human Figure, the Complete "Dresden Sketchbook"* (New York, 1972).

Strauss 1974
Walter L. Strauss, *The Complete Drawings of Albrecht Dürer*, 6 vols. (New York, 1974).

Strauss 1977
Walter L. Strauss, *Hendrik Goltzius 1558–1617: The Complete Engravings and Woodcuts*, 2 vols. (New York, 1977).

Strauss 1980
Walter L. Strauss, *Albrecht Dürer: Woodcuts and Woodblocks* (New York, 1980).

Strauss 1982
Walter L. Strauss, *The Complete Drawings of Albrecht Dürer*, supplement 2 (New York, 1982).

Strauss 1985
Walter L. Strauss, "Dürer in Vienna?!" *Drawing* 7, no. 3 (1985), 61–64.

Strieder 1982
Peter Strieder, *Albrecht Dürer: Paintings, Prints, Drawings* (New York, 1982).

Strong 1902
S. A. Strong, *Reproductions of Drawings by Old Masters in the Collection of the Duke of Devonshire at Chatsworth* (London, 1902).

Suida 1929
Wilhelm Suida, *Leonardo und sein Kreis* (Munich, 1929).

Sumowski 1979–1992
Werner Sumowski, *Drawings of the Rembrandt School*, 10 vols. (New York, 1979–1992).

Sumowski 1983
Werner Sumowski, *Gemälde der Rembrandtschüler*, 6 vols. (Landau-Pfalz, 1983).

Swarzenski and Schilling 1924
Georg Swarzenski and Edmund Schilling, *Handzeichnungen alter Meister aus deutschem Privatbesitz* (Frankfurt am Main, 1924).

Swillens 1935
P.T.A. Swillens, *Pieter Janszoon Saenredam* (Amsterdam, 1935).

Tarnove 1976
Elizabeth Tarnove, *The Drawings of Van Dyck*, Master Draughtsman Series (Alhambra, CA, 1976).

Ten Doesschate Chu 1974
Petra Ten Doesschate Chu, *French Realism and the Dutch Masters: The Influence of Dutch Seventeenth-Century Painting on the Development of French Painting between 1830 and 1870* (Utrecht, 1974).

Testa 1986
Judith Testa, *The Beatty Rosarium: A Manuscript with Miniatures by Simon Bening*, 2 vols. (Doornspijk, 1986).

Thausing 1882
Moritz Thausing, *Albrecht Dürer. Geschichte seines Lebens und seiner Kunst*, 2 vols. (London, 1882).

Thomas 1959
Bruno Thomas, "Die Müncher Harnischvorzeichnungen im Stil François Ier," *Jahrbuch der kunsthistorischen Sammlungen in Wien* 55 (1959), 31–74.

Thomas 1965
Bruno Thomas, "Die Münchner Harnischvorzeichnungen mit Rankendekos des Étienne Delaune," *Jahrbuch der kunsthistorischen Sammlungen in Wien* 61 (1965), 41–90.

Tietze et al. 1933
Hans Tietze, Erika Tietze-Conrat, Otto Benesch, and K. Garzarolli-Thurnlack, *Die Zeichnungen der deutschen Schulen. Beschreibender Katalog der Handzeichnungen in der Graphischen Sammlung Albertina* IV (Vienna, 1933).

Tietze 1947
Hans Tietze, *European Master Drawings in the United States* (New York).

Tietze and Tietze-Conrat 1928–1938
Hans Tietze and Erika Tietze-Conrat, *Kritisches Verzeichnis der Werke Albrecht Dürers*, 2 vols. in 3 (vol. 1, Augsburg, 1928; revised and reprinted, Basel, 1937–1938, adding vols. 2–3).

Tietze and Tietze-Conrat 1944
Hans Tietze and Erika Tietze-Conrat, *The Drawings of Venetian Painters* (New York, 1944; reprint 1970).

Todini and Zanardi 1980
Francesco Todini and Bruno Zanardi, *La Pinacoteca Comunale di Assisi. Catalogo dei dipinti* (Florence, 1980).

Toesca 1952
Ilaria Toesca, "Gli 'Uomini famosi' della Biblioteca Cockerell," *Paragone* 25 (1952), 16–20.

Toesca 1970
Ilaria Toesca, "Di nuovo sulla 'Cronaca Cockerell,'" *Paragone* 239 (1970), 62–66.

Urbánková and Stejskal 1977
E. Urbánková and K. Stejskal, *Pasionál Premyslovny Kunhuty* (Prague, 1977).

Vaillat and Ratouis de Limay 1909 and 1923
Léandre Vaillat and Paul Ratouis de Limay, *J. B. Perronneau (1715–1783), Sa vie et son oeuvre* (Paris, 1909; 2nd ed., 1923).

Valentiner 1925–1934
Wilhelm R. Valentiner, *Rembrandt. Des Meisters Handzeichnungen,* Klassiker der Kunst, 2 vols. (Stuttgart and Berlin, 1925–1934).

Valeri 1922
Francesco Malaguzzi Valeri, *Leonardo da Vinci e la scultura* (Bologna, 1922).

Van Alkemade [1646/1647]
Cornelis van Alkemade, "Register van Adelyke Huijsen, Kastelen, etc., gelegen in Holland, Utregt, Gelderland etc. getekent door Roeland Roghman meest in de jaren 1646 en 1647" (manuscript inventory in Rijksprentenkabinet, Amsterdam, n.d.)

Van Bastelaer 1908
René van Bastelaer, *Les Estampes de Pierre Bruegel l'ancien* (Brussels, 1908).

Van de Waal
H. van de Waal, *Iconclass: An Iconographic Bibliography Classification System*, 9 vols. (Amsterdam, 1981—).

Van de Wyck et al. 1989
H.W. M. van de Wyck, J. W. Niemeijer, and W. T. Kloek, *De Kasteeltekeningen van Roelant Roghman*, 2 vols. (Alpen aan den Rijn, 1989).

Van Gelder 1976
Dirk van Gelder, *Rodolphe Bresdin*, 2 vols. (The Hague, 1976).

Van Gelder 1978
Dirk van Gelder, "*Scène de village fantaisiste* by Rodolphe Bresdin," *Master Drawings* 16 (Summer 1978), 172–176.

Van Hengel 1982
S.J.H. van Hengel et al., *Colf. Kolf. Golf. Van middeleeuws volksspel tot moderne sport* (Zutphen, 1982).

Van Mander 1604
Karel van Mander, *Het Schilder-Boeck* (Haarlem, 1604).

Van Marle 1923–1938
Raimond van Marle, *The Development of the Italian Schools of Painting*, 19 vols. (The Hague, 1923–1938).

Van Mierlo 1989
Th. M. van Mierlo, "De Avercamps en hunbetekenis voor de topografische kennis over Kampen," *IJsselakademie*, 12, no. 1 (1989), 6–13.

Van Migroet 1989
Hans van Migroet, *Gerard David* (Antwerp, 1989).

Van Regteren Altena 1959
I. Q. van Regteren Altena, "Een bladzijde uit een Italiaanse codex van omsteeks 1445," *Bulletin van het Rijksmuseum* 7 (1959), 82–83.

Vasari 1906 ed.
Giorgio Vasari, *Le vite de' più eccellenti pittori, scultori, ed architecttori…*, ed. G. Milanesi, 9 vols. (Florence, 1906).

Vasari 1966 ed.
Giorgio Vasari, *Le vite de' più eccellenti pittori, scultori, ed architettori*, ed. Rosanna Bettarini and Paola Barocchi, 6 vols. in 9 (Florence, 1966–1987).

Vasari Society
*The Vasari Society for the Reproduction of Drawings by Old Masters*, 27 vols. (1905–1935).

Vecchioni 1926
Pio Emilio Vecchioni, "La chiesa delle Croce e Sagramento in Sinigaglia e la *Deposizione* di Federico Barocci," *Rassegna Marchigiana* 5 (1926), 497–503.

Venturi 1939
Adolfo Venturi, ed., *I disegni e i manoscritti di Leonardo da Vinci pubblicati dalla Reale Commissione Vinciana. I disegni, v* (Rome, 1939).

Vey 1958
Horst Vey, *Van-Dyck-Studien* (Cologne 1958).

Vey 1962
Horst Vey, *Die Zeichnungen Anton van Dycks*, 2 vols. (Brussels, 1962).

Vialla 1988
Jean Vialla, *La vie et l'oeuvre d'Odilon Redon* (Paris, 1988).

Vigni 1942
Giorgio Vigni, *Disegni del Tiepolo* (Padua, 1942).

Vigni 1972
Giorgio Vigni, *Disegni del Tiepolo* (Trieste, 1972).

Vincent 1962–1966
Madeleine Vincent, "Une Trinité d'un Maître Strasbourgeoise au Musée des Beaux Arts," *Bulletin des Musées et Monuments Lyonnais* 3 (1962–1966), 357–382.

Vitzthum 1966
Walter Vitzthum, review of *Drawings from New York Collections, 1965–1966*, in *Burlington Magazine* 108 (February 1966), 109–110.

Voelkle and Wieck 1992
William M. Voelkle and Roger S. Wieck, *The Bernard H. Breslauer Collection of Manuscript Illuminations* (New York, 1992).

Vöge 1950
W. Vöge, *Jörg Syrlin der Ältere und seine Bildwerke, II. Band, Stoffkreis, und Gestaltung* (Berlin, 1950).

Von Pfeil 1995
Daniela von Pfeil, "Der Pleydenwurff-Wolgemut Kreis. Studien zu fränkischen Zeichnungen vor Dürer unter Berücksichtigung der Tafelmalerei," dissertation, Technische Universität, Berlin (1995).

Vosmaer 1877
Carel Vosmaer, *Rembrandt. Sa vie et ses oeuvres* (The Hague, 1877).

Waagen 1866–1867
G. F. Waagen, *Die vornehmsten Kunstdenkmäler in Wien*, 2 vols. (Vienna, 1866–1867).

Walker 1983
John Walker, *Portraits: Five Thousand Years* (New York, 1983).

Wayment 1967
Hilary Wayment, "A Rediscovered Master: Adrian van den Houte, Part 1," *Oud Holland* 82 (1967), 172–202.

Wayment 1968
Hilary Wayment, "A Rediscovered Master: Adrian van den Houte, Part 2," *Oud Holland* 83 (1968), 71–94.

Wayment 1969
Hilary Wayment, "A Rediscovered Master: Adrian van den Houte, Part 3," *Oud Holland* 84 (1969), 257–269.

Wehle 1941
Harry B. Wehle, "Fifty Drawings by Francisco Goya," *Metropolitan Museum of Art Papers* 7, 2nd ed. (1941), 5–16.

Weigel 1854
Rudolph Weigel, *Handzeichnungen berühmter Meister aus der Weigel'schen Kunstsammlung in treuen in Kupfer gestochenen Nachbildungen* (Leipzig, 1854).

Welcker 1933
Clara J. Welcker, *Hendrick Avercamp en Barent Avercamp. "Schilders tot Campen"* (Zwolle, 1933).

Welcker/Hensbroek-van der Poel 1979
Clara J. Welcker, *Hendrick Avercamp en Barent Avercamp. "Schilders tot Campen,"* revised by D. J. Hensbroek-van der Poel (Amsterdam 1979).

Wethey 1969
Harold E. Wethey, *The Paintings of Titian, I, The Religious Paintings* (London and New York, 1969).

Wethey 1987
Harold E. Wethey, *Titian and His Drawings* (Princeton, 1987).

White 1973
Christopher White, "*An Oriental Ruler on His Throne* and *The Entombment*: Two New Drawings by Albrecht Dürer," *Master Drawings* 11, no. 4 (Winter 1973), 365–3/4.

White and Boon 1969
Christopher White and Karel G. Boon, *Hollstein's Dutch and Flemish Etchings, Engravings, and Woodcuts*, vols. 18–19, *Rembrandt van Rijn* (Amsterdam, 1969).

White and Crawley 1994
Christopher White and Charlotte Crawley, *The Dutch and Flemish Drawings of the Fifteenth to the Early Nineteenth Centuries in the Collection of Her Majesty the Queen at Windsor Castle* (Cambridge, 1994).

Wild 1987
Nicole Wild, *Bibliothèque nationale. Département de la Musique, Décors et costumes du 19e siècle, 1, Opéra de Paris* (Paris, 1987).

Wildenstein 1973
Daniel and Guy Wildenstein, *Louis David. Recueil de documents complémentaires au catalogue complet de l'oeuvre de l'artiste* (Paris, 1973).

Williams 1982
C. I. M. Williams, "Lusieri's Surviving Works," *Burlington Magazine* 953 (August 1982), 492–496.

Williams 1987
C. I. M. Williams, "Lusieri's Masterpiece?" *Burlington Magazine* 129 (July 1987), 457–459.

Wilson 1978
Michael Wilson, *Nature and Imagination: The Work of Odilon Redon* (New York, 1978).

Wilton-Ely 1993
John Wilton-Ely, *Piranesi as Architect and Designer* (New York, 1993).

Wimmer 1935
G. Wimmer, *Rembrandts Landschafts-Zeichnungen* (Frankfurt am Main, 1935).

Winkler 1913
Friedrich Winkler, *Der Meister von Flémalle und Rogier van der Weyden* (Strasbourg, 1913).

Winkler 1926–1927
Friedrich Winkler, "Stadtkölnische Buchmaler-Werkstätten in 15. Jahrhundert," *Wallraf-Richartz Jahrbuch* 3–4 (1926–1927), 123–129.

Winkler 1927
Friedrich Winkler, "The Collection of Dürer Drawings at Lemberg (Galicia)," *Old Master Drawings* 2, no. 6 (October 1927), 17–19.

Winkler 1930a
Friedrich Winkler, "Ein kölnisches Gebetbuch aus der Mitte des 15. Jahrhunderts," *Wallraf-Richartz Jahrbuch*, n.s. 1 (1930), 110–113.

Winkler 1930b
Friedrich Winkler, "Skizzenbücher eines unbekannten rheinischen Meisters um 1500," *Wallraf-Richartz Jahrbuch*, n.s. 1 (1930), 123–152.

Winkler 1932
Friedrich Winkler, "Dürerstudien III. Verschollene Meisterzeichnungen Dürers," *Jahrbuch der preussischen Kunstsammlungen* 53 (1932), 68–89.

Winkler 1936–1939
Friedrich Winkler, *Die Zeichnungen Albrecht Dürers*, 4 vols. (Berlin, 1936–1939).

Winkler 1942
Friedrich Winkler, *Die Zeichnungen Hans Süss von Kulmbachs und Hans Leonhard Schäufeleins* (Berlin, 1942).

Winkler 1957
Friedrich Winkler, *Albrecht Dürer. Leben und Werk* (Berlin, 1957).

Winkler 1959
Friedrich Winkler, *Hans von Kulmbach. Leben und Werk eines fränkischen Künstlers der Dürerzeit* (Kulmbach, 1959).

Winkler 1962
Friedrich Winkler, "Das Gebetbuch des Kardinals Albrecht von Brandenburg," *Aachener Kunstblätter* 24/25 (1962), 7–107.

Winkler 1964
Friedrich Winkler, *Das Werk Hugo van der Goes* (Berlin, 1964).

Winner 1968a
Matthias Winner, "Federskizzen von Benvenuto Cellini," *Zeitschrift für Kunstgeschichte* 31 (1968), 293–304.

Winner 1968b
Matthias Winner, "Zum Apoll vom Belvedere," *Jahrbuch der Berliner Museen* 10 (1968), 181–199.

Winzinger
Franz Winzinger, *Die Zeichnungen Martin Schongauers* (Berlin, 1962).

Winzinger 1970
Franz Winzinger, "Unbekannte Werke des Hans Süss von Kulmbachs und Hans Leonhard Schäufeleins," *Zeitschrift deutschen Vereins für Kunstwissenschaft* 24 (1970), 61–70.

Wölfflin 1905
Heinrich Wölfflin, *Die Kunst Albrecht Dürers* (Munich, 1905).

Wölfflin 1920
Heinrich Wölfflin, "Dürer und Cima da Conegliano," *Der Kunstwanderer* (December 1920).

Young 1967
Mahonri Sharp Young, "Treasures in Gramercy Park," *Apollo* 85 (March 1967), 171–181.

Zanni 1990
Annalisa Zanni, *Ingres. Catalogo completo dei dipinti* (Florence, 1990).

Zeri et al. 1984
F. Zeri, M. Natale, and A. Mottola Molfino, *Dipinti toscani e oggetti d'arte dalla collezione Vittorio Cini* (Vicenza, 1984).

Zerner 1969
Henri Zerner, *The School of Fontainebleau: Etchings and Engravings* (New York, 1969).

Zschelletzschky 1975
Herbert Zschelletzschky, *Die "Drei Gottlosen Maler" von Nürnberg. Sebald Beham, Barthel Beham, und Georg Pencz. Historische Grundlagen und ikonologische Probleme ihrer Graphik zu Reformations- und Bauernkriegszeit* (Leipzig, 1975).

## EXHIBITIONS

*(catalogue authors in parentheses)*

Amsterdam 1956
*Rembrandt*, Rijksmuseum; and Boymans Museum, Rotterdam.

Amsterdam 1972
*Master Drawings Exhibited by Bernard Houthakker 1972*, Bernard Houthakker.

Amsterdam 1983
*The Impact of a Genius: Rembrandt, His Pupils, and Followers in the Seventeenth Century*, Kunsthandel K. and V. Waterman; and Groninger Museum, Groningen (Albert Blankert et al.).

Amsterdam 1991–1992
*Seventeenth-Century Dutch Drawings: A Selection from the Maida and George Abrams Collection*, Rijksprentenkabinet, Rijksmuseum, and tour (William W. Robinson).

Amsterdam 1992
*Een wereldreiziger op papier. De atlas van Laurens van der Hem (1621–1678)*, Koninklijk Paleis te Amsterdam (Roelof van Gelder and Jan van der Waals).

Antwerp 1960
*Antoon van Dyck. Tekeningen en olieverfschetsen*, Rubenshuis; and Museum Boymans-van Beuningen, Rotterdam (R. A. d'Hulst and Horst Vey).

Atlanta 1983
*The Rococo Age: French Masterpieces of the Eighteenth Century*, High Museum of Art (Eric M. Zafran).

Augsburg 1965
*Hans Holbein der Ältere und die Kunst der Spätgotik*, Rathaus.

Austin 1988–1989
*The Sforza Court: Milan in the Renaissance 1450–1535*, Archer M. Huntington Art Gallery, University of Texas, and tour.

Barcelona 1989–1990
*Odilon Redon (1840–1916). La Colección Ian Woodner*, Museo Picasso.

Basel 1960
*Die Malerfamilie Holbein in Basel*, Kunstmuseum.

Basel 1974
*Lukas Cranach. Gemälde, Zeichnungen, Druckgraphik*, Kunstmuseum (Dieter Koepplin and Tilman Falk).

Bergamo 1982
*Grafica del '500, 2°. Milano e Cremona*, Accademia Carrara.

Berlin 1970
*Rembrandt legt die Bibel aus*, Staatliche Museen Preussischer Kulturbesitz (Christian and Astrid Tümpel).

Berlin 1973
*Vom späten Mittelalter bis zu Jacques Louis David: Neuerworbene und neubestimmte Zeichnungen in Berliner Kupferstichkabinett*, Kupferstichkabinett, Staatliche Museen Preussischer Kulturbesitz.

Berlin 1975
*Pieter Bruegel d. Ä. als Zeichner*, Kupferstichkabinett, Staatliche Museen Preussischer Kulturbesitz (Hans Mielke).

Berlin 1983
*Orangerie '83: Deutscher Kunsthandel im Schloss Charlottenburg*, Orangerie, Schloss Charlottenburg.

Berlin 1991–1992
*Rembrandt: The Master and His Workshop. Drawings and Etchings*, Altes Museum; and Rijksmuseum, Amsterdam (Peter Schatborn).

Bern 1984
*Der junge Picasso. Frühwerk und blaue Periode*, Kunstmuseum (Jürgen Glaesemer).

Bloomington 1979
*Domenico Tiepolo's Punchinello Drawings*, Indiana University Art Museum; and Stanford University Museum of Art, Palo Alto (Adelheid Gealt and Marcia E. Vetrocq).

Bologna 1969
*Mostra di Nicolò dell'Abate*, Palazzo dell' Archiginnasio (Sylvie Béguin).

Bordeaux 1985
*Odilon Redon. 1840–1916*, Galerie des Beaux-Arts.

Bordeaux 1989
*Le port des lumières. La peinture à Bordeaux 1750–1800*, Musée des Beaux-Arts.

Boston 1984–1985
*Edgar Degas: The Painter as Printmaker*, Museum of Fine Arts; and Philadelphia Museum of Art (Sue Welsh Reed and Barbara Stern Shapiro).

Boston 1989
*Goya and the Spirit of Enlightenment*, Museum of Fine Arts; and Metropolitan Museum of Art, New York (Alfonso E. Pérez Sánchez and Eleanor A. Sayre).

Brescia 1939
*La pittura Bresciana del rinascimento*, Istituto italiano d'arti grafiche (Fausto Lechi and Gaetano Panazza).

Brescia 1965
*Mostra di Girolamo Romanino*, Duomo Vecchio di Brescia, and tour (Gaetano Panazza).

Buffalo 1935
*Master Drawings Selected from the Museums and Private Collections of America*, Albright Art Gallery (Agnes Mongan).

Cambridge 1962
*Forty Master Drawings from the Collection of John Nicholas Brown*, Fogg Art Museum, Harvard University.

Cambridge 1967
*Ingres: Centennial Exhibition 1867–1967, Drawings, Watercolors, and Oil Sketches from American Collections*, Fogg Art Museum, Harvard University (Agnes Mongan and Hans Naef).

Cambridge 1970
*Tiepolo: A Bicentenary Exhibition, 1770–1970*, Fogg Art Museum, Harvard University (George Knox).

Chicago 1994–1995
*Odilon Redon: Prince of Dreams, 1840–1916*, Art Institute of Chicago, and tour (Douglas Druick et al.).

Cleveland 1978
*The Graphic Art of Federico Barocci: Selected Drawings and Prints*, Cleveland Museum of Art; and Yale University Art Gallery, New Haven (Edmund P. Pillsbury and Louise S. Richards).

Cleveland 1989–1990
*From Fontainebleau to the Louvre: French Drawings from the Seventeenth Century*, Cleveland Museum of Art (Hilliard T. Goldfarb).

Cologne 1972–1973
*Die schwarze Sonne des Traums. Radierungen, Lithographien und Zeichnungen von Rodolphe Bresdin (1822–1885)*, Wallraf-Richartz Museum; and Städelsches Kunstinstitut, Frankfurt (Hans Albert Peters).

Cologne 1978
*Die Parler und der Schöne Stil 1350–1400: Europäische Kunst unter den Luxemburgern*, Museen der Stadt (Anton Legner, ed.).

Detroit 1983
*From a Mighty Fortress: Prints, Drawings, and Books in the Age of Luther, 1483–1546*, Detroit Institute of Arts, and tour (the exhibition was presented in 1981–1982) (Christiane Andersson and Charles Talbot, eds.).

Dijon 1963
*Claude Hoin, Dijon, 1750–1817: Peintures, gouaches, miniatures, pastels, dessins, gravures*, Musée des Beaux-Arts.

Dijon 1982–1983
*La peinture dans la peinture*, Musée des Beaux-Arts (Pierre Georgel and Anne Marie Locaq).

Edinburgh 1969
*Italian 16th-Century Drawings from British Private Collections*, Merchants' Hall (Yvonne tan Bunzl, Keith Andrews, John Gere, Philip Pouncey, and Julien Stock).

Edinburgh 1984
*Dutch Church Painters: Saenredam's "Great Church at Haarlem" in Context*, National Gallery of Scotland (Hugh MacAndrew et al.).

Essen 1988–1989
*Prag um 1600: Kunst und Kultur am Hofe Rudolfs II*, Villa Hügel; and Kunsthistorisches Museum, Vienna.

Florence 1963
*Disegni delle Fondazione Horne in Firenze*, Palazzo Strozzi (Licia Ragghianti Collobi).

Florence 1969
*Da Dürer a Picasso: Mostra di disegni della Galleria Nazionale del Canada*, Gabinetto disegni e stampe degli Uffizi.

Florence 1976
*Tiziano e il disegno veneziano del suo tempo*, Gabinetto disegni e stampe degli Uffizi (W. R. Rearick).

Florence 1982
*Disegni umbri del rinascimento da Perugino a Raffaello*, Gabinetto disegni e stampe degli Uffizi (Sylvia Ferino-Pagden).

Florence 1986
*Disegni di Fra Bartolommeo e della sua scuola*, Gabinetto disegni e stampe degli Uffizi (Chris Fischer).

Florence 1986a
*Disegni italiani del tempo di Donatello*, Gabinetto disegni e stampe degli Uffizi (Alessandro Angelini).

Florence 1986–1987
*Andrea del Sarto 1486–1530. Dipinti e disegni a Firenze*, Palazzo Pitti (Alessandro Cecchi).

Florence 1992–1993
*Maestri e botteghe: Pittura a Firenze alla fine del quattrocento*, Palazzo Strozzi (Mina Gregori, Antonio Paolucci, Cristina Acidini Luchinat).

Fort Worth 1993
*Giambattista Tiepolo: Master of the Oil Sketch*, Kimbell Art Museum (Beverly Louise Brown).

Frankfurt 1977
*Französische Zeichnungen aus dem Art Institute of Chicago*, Städelsches Kunstinstitut, and tour (Margret Stuffmann, ed.).

Frankfurt 1981
*Goya. Zeichnungen und Druckgraphik*, Städelsches Kunstinstitut (Margret Stuffmann).

Genoa 1955
*100 Opere di van Dyck*, Palazzo dell'Accademia (R. A. d'Hulst et al.).

Genoa 1990
*Il Genio di Giovanni Benedetto Castiglione: Il Grechetto*, Musée dell'Accademia Ligustica di Belle Arti.

Glasgow 1953
*Drawings by Bolognese and Other Masters Lent from a Glasgow Collection*, Glasgow City Art Gallery.

's-Gravenhage 1980
*Ovidius herschapen. Geïllustreerde uitgaven van de Metamorphosen in de Nederlanden uit de zestiende, zeventiende en achttiende eeuw*, Rijksmuseum Meermanno-Westreenianum (A.W.A. Boschloo et al.).

Haarlem 1985
*De Bavo Te Boek*, Frans Halsmuseum.

The Hague 1978–1979
*Rodolphe Bresdin 1822–1885*, Gemeentemuseum (Dirk van Gelder and John Sillevis).

Hamburg 1965
*Zeichnungen alter Meister aus deutschem Privatbesitz*, Kunsthalle.

Hartford 1973–1974
*One Hundred Master Drawings from New England Private Collections*, Wadsworth Athenaeum, and tour (Franklin W. Robinson).

Hartford 1976–1977
*Jean-Baptiste Greuze, 1725–1805*, Wadsworth Athenaeum, and tour (Edgar Munhall).

Jerusalem 1977
*Old Master Drawings: A Loan from the Collection of the Duke of Devonshire*, Israel Museum.

Jerusalem 1985–1986
*Odilon Redon, The Ian Woodner Collection*, Israel Museum.

Karlsruhe 1959
*Hans Baldung Grien*, Staatliche Kunsthalle (Jan Lauts, ed.).

Karlsruhe 1992
*Christus und Maria. Auslegungen Christlicher Gemälde der Spätgotik und Frührenaissance aus der Karlsruher Kunsthalle*, Staatliche Kunsthalle (Horst Vey, Ines Dresel, and Dietman Lüdke).

Lausanne 1992
*Odilon Redon. La Collection Woodner*, La Fondation de l'Hermitage.

Leeds 1868
*National Exhibition of Works of Art*, City Art Gallery.

Lille 1988–1989
*Boilly, 1761–1845: Un grand peintre français de la Révolution à la Restauration*, Musée des Beaux-Arts.

London 1869
*Albrecht Dürer and Lucas van Leyden*, Burlington Fine Arts Club.

London 1896
*Catalogue of an Exhibition of English Medieval Paintings and Illustrated Manuscripts*, Society of Antiquaries.

London 1897
*Monuments of Typography and Xylography; Books of the First Half Century of the Art of Printing*, Bernard Quaritch.

London 1906
*Early German Art*, Burlington Fine Arts Club.

London 1929
*Exhibition of Dutch Art 1450–1900*, Royal Academy of Arts.

London 1930
*Exhibition of Italian Art 1200–1900* (a commemorative catalogue [Lord Balniel and Kenneth Clark, eds.] and a catalogue of selected works of *Italian Drawings Exhibited at the Royal Academy* [A. E. Popham] were published in 1931 with different numbering).

London 1930a
*Drawings by Old Masters*, Savile Gallery.

London 1938
*Catalogue of the Exhibition of 17th-Century Art in Europe*, Royal Academy of Arts.

London 1949
*Old Master Drawings from Chatsworth*, Arts Council of Great Britain (A. E. Popham).

London 1950–1951
*Catalogue of the Exhibition of Works by Holbein and Other Masters of the 16th and 17th Centuries*, Royal Academy of Arts (Ellis K. Waterhouse).

London 1953
*Drawings by Old Masters*, Royal Academy of Arts (K. T. Parker and James Byam Shaw).

London 1957
*Exhibition of Old Master Drawings*, P. & D. Colnaghi and Co., Ltd.

London 1959
*Odilon Redon 1840–1916: A Loan Exhibition of Paintings, Pastels and Drawings in Aid of the Corneal Graft and Eye Bank Research*, Matthiesen Gallery.

London 1969
*Old Master Drawings from Chatsworth: A Loan Exhibition from the Devonshire Collection*, Royal Academy of Arts (A. E. Popham).

London 1969a
*Exhibition of Old Master and English Drawings*, P. & D. Colnaghi and Co., Ltd.

London 1969b
*European Drawings from the National Gallery of Canada, Ottawa*, P. & D. Colnaghi and Co., Ltd. (Myron Laskin).

London 1970
*Drawings from the Teylers Museum, Haarlem*, Victoria and Albert Museum (I. Q. van Regteren Altena and P. W. Ward-Jackson).

London 1971–1972
*Loan Exhibition of Drawings by Old Masters from the Collection of Mr. Geoffrey Gathorne-Hardy*, P. & D. Colnaghi and Co., Ltd., and tour.

London 1972
*Flemish Drawings of the Seventeenth Century from the Collection of Frits Lugt, Institut néerlandais, Paris*, Victoria and Albert Museum, and tour (Carlos van Hasselt).

London 1973
*Old Master Drawings Presented by Lorna Lowe*, National Book League.

London 1973a
*Master Drawings Presented by Adolphe Stein*, H. Terry-Engell Gallery.

London 1973b
*Fanfare for Europe*, Christie's.

London 1973–1974
*Old Master Drawings from Chatsworth: A Loan Exhibition from the Devonshire Collection*, Victoria and Albert Museum (James Byam Shaw).

London 1982
*Master Prints and Drawings 15th to 19th Centuries*, Artemis Fine Art Limited.

London 1983
*La douceur de vivre: Art, Style and Decoration in 18th-Century France*, Wildenstein.

London 1985
*Old Master Drawings*, P. & D. Colnaghi and Co., Ltd.

London 1987
*Old Master Drawings*, P. & D. Colnaghi and Co., Ltd.

London 1987a
*Italian Drawings 1500–1800*, Kate Ganz Ltd.

London 1989
*Master Drawings 1500–1900*, Kate Ganz Ltd.

London 1990
*In the Shadow of Vesuvius: Views of Naples from Baroque to Romanticism, 1631–1830*, Accademia Italiana delle Arti e delle Arti Applicate (Giuliano Briganti, Nicola Spinosa, and Lindsay Stainton).

London 1991
*Spectacle and Display in Boilly's "L'Entrée du Jardin Turc,"* Matthiesen Fine Art Ltd.; and Stair Sainty Matthiesen, New York (Susan Siegfried).

London 1992
*Andrea Mantegna*, Royal Academy of Arts; and Metropolitan Museum of Art, New York.

London 1992a
*Drawings by Rembrandt and His Circle in the British Museum*, British Museum (Martin Royalton-Kisch).

London 1993–1994
*Old Master Drawings from Chatsworth*, British Museum (Michael Jaffé).

London 1994–1995
*The Glory of Venice: Art in the Eighteenth Century*, Royal Academy of Arts; and National Gallery of Art, Washington (Jane Martineau and Andrew Robison, eds.).

London 1994–1995a
*The Painted Page: Italian Renaissance Book Illumination, 1450–1550*, Royal Academy of Arts; and Pierpont Morgan Library, New York (Jonathan J. G. Alexander, ed.).

Los Angeles 1976
*Old Master Drawings from American Collections*, Los Angeles County Museum of Art (Ebria Feinblatt).

Louisville 1983–1984
*In Pursuit of Perfection: The Art of J.A.D. Ingres*, J. B. Speed Art Museum; and Kimbell Art Museum, Fort Worth (Patricia Condon, Marjorie B. Cohn, and Agnes Mongan).

Madrid 1988
*Goya y el espíritu de la ilustración*, Museo del Prado (Alfonso E. Pérez Sánchez and Eleanor A. Sayre).

Madrid 1990
*Odilon Redon: Colección Ian Woodner*, Fundación Juan March.

Madrid 1992–1993
*Goya. La década de Los Caprichos: Dibujos y aguafuertes*, Real Academia de Bellas Artes de San Fernando (Juliet Wilson-Bareau).

Madrid 1993–1994
*Goya, Truth and Fantasy: The Small Paintings*, Museo del Prado, and tour (Juliet Wilson-Bareau and Manuela B. Mena Marqués).

Manchester 1961
*Old Master Drawings from Chatsworth*, City Art Gallery.

Manchester 1961a
*German Art, 1400–1800, from Collections in Great Britain*, City Art Gallery.

Martigny 1982
*Goya dans les collections suisses*, Fondation Pierre Gianadda (Pierre Gassier).

Memphis 1990
*Odilon Redon*, Dixon Art Gallery and Gardens.

Middletown 1975
*Prints and Drawings by Gabriel de Saint-Aubin*, Davison Art Center, Wesleyan University (Victor Carlson, Richard Field, and Ellen d'Oench).

Milan 1958
*Arte Lombarda dai Visconti agli Sforza*, Palazzo Reale.

Milan 1982
*L'opera incisa di Giovanni Benedetto Castiglione*, Castello Sforzesca (Paolo Bellini).

Milan 1988
*Arte in Lombardia: Tra gotico e rinascimento*, Palazzo Reale (Miklòs Boskovits).

Milwaukee 1989–1990
*Renaissance into Baroque: Italian Master Drawings by the Zuccari, 1550–1600*, Milwaukee Art Museum; and National Academy of Design, New York (James Mundy).

Modena 1989
*Disegni Emiliani del Rinascimento*, Cassa di Risparmio di Modena (Mario di Giampaolo and Marco Tanzi).

Montreal 1953
*Five Centuries of Drawings*, Montreal Museum of Fine Arts.

Naples 1990
*All'ombra del Vesuvio: Napoli nella veduta europea dal quattrocento all'ottocento*, Castel Sant'Elmo (Giuliano Briganti et al.).

Newark 1960
*Old Master Drawings*, Newark Museum (Elaine Evans Gerdts and William H. Gerdts).

New Haven 1994
*Vasari's Florence: Artists and Literati at the Medicean Court*, Yale University Art Gallery (Maia W. Gahtan and Philip J. Jacks).

New York 1944
*French Pastels and Drawings from Clouet to Matisse*, Wildenstein and Co.

New York 1959
*Great Master Drawings of Seven Centuries*, M. Knoedler and Co., and Columbia University.

New York 1961–1962
*Odilon Redon/Gustave Moreau/Rodolphe Bresdin*, Museum of Modern Art; and Art Institute of Chicago.

New York 1962
*Master Drawings in the Collection of Walter C. Baker*, Metropolitan Museum of Art (Claus Virch).

New York 1965–1966
*Drawings from New York Collections 1: The Italian Renaissance*, Metropolitan Museum of Art (Jacob Bean and Felice Stampfle).

New York 1966
*Master Drawings*, Jacques Seligmann & Co.

New York 1967
*100 Years of Fantastic Drawings*, Bianchini Gallery.

New York 1970
*Symbolists*, Spencer A. Samuels and Co., Ltd.

New York 1971
*Drawings from New York Collections III. The 18th Century in Italy*, Metropolitan Museum of Art (Jacob Bean and Felice Stampfle).

New York 1972
*Master Prints and Drawings from the Fifteenth to the Twentieth Centuries*, William H. Schab Gallery.

New York 1974
*Master Drawings and Prints from the Italian Renaissance and Baroque and from Northern Schools*, William H. Schab Gallery.

New York 1977–1978
*Rembrandt and His Century: Dutch Drawings of the Seventeenth Century from the Collection of Frits Lugt, Institut néerlandais*, Pierpont Morgan Library; and Institut néerlandais, Paris (Carlos van Hasselt).

New York 1983–1984
*Renaissance Painting in Manuscripts: Treasures from the British Library*, Pierpont Morgan Library, and tour (Thomas Kren, ed.).

New York 1986
*Gothic and Renaissance Art in Nuremberg 1300–1550*, Metropolitan Museum of Art; and Germanisches Nationalmuseum, Nuremberg.

New York 1986a
*Master Drawings from the Drawing Society's Membership*, Hirschl and Adler.

New York 1986–1987
*François Boucher, 1703–1770*, Metropolitan Museum of Art; and Grand Palais, Paris (Alastair Laing).

New York 1987
*Drawings by Raphael and His Circle from British and North American Collections*, Pierpont Morgan Library (John A. Gere).

New York 1987a
*Old Master Drawings*, Colnaghi.

New York 1989
*1789: French Art during the Revolution*, Colnaghi (Alan Wintermute, ed.).

New York 1989a
*Exploring Rome: Piranesi and His Contemporaries*, Pierpont Morgan Library (no catalogue; see New York 1993–1994, below).

New York 1991
*The Drawings of Anthony van Dyck*, Pierpont Morgan Library; and Kimbell Art Museum, Fort Worth (Christopher Brown).

New York 1992
*An Exhibition of Old Master Drawings*, Colnaghi; and P. & D. Colnaghi and Co., Ltd., London.

New York 1993–1994
*Exploring Rome: Piranesi and His Contemporaries*, Pierpont Morgan Library; and Centre Canadien d'Architecture, Montreal (Cara D. Denison, Myra Nan Rosenfeld, and Stephanie Wiles).

New York 1994
*European Master Drawings from the Collection of Peter Jay Sharp*, National Academy of Design (William L. Barcham).

New York 1994a
*Sixteenth-Century Italian Drawings in New York Collections*, Metropolitan Museum of Art (William Griswold and Linda Wolk-Simon).

New York 1994–1995
*Painting and Illumination in Early Renaissance Florence, 1300–1450*, Metropolitan Museum of Art (Laurence B. Kanter et al.).

New York 1995
*The Luminous Image: Painted Glass Roundels in the Lowlands, 1480–1560*, Metropolitan Museum of Art (Timothy B. Husband).

Nice 1991
*Gustave Moreau et la Bible*, Musée national Message biblique Marc Chagall (Guillaume Ambroise, Geneviève Lacambre, and Pierre-Louis Mathieu).

Northampton 1978
*Antiquity in the Renaissance*, Smith College Museum of Art, MA (Wendy Stedman Sheard).

Notre Dame 1970
*The Age of Vasari*, University Art Gallery, University of Notre Dame; and University Art Gallery, State University of New York, Binghamton (Michael Milkovich and Dean A. Porter, eds.).

Nottingham 1957
*Paintings and Drawings from Chatsworth*, University Art Gallery.

Nottingham 1960
*Paintings and Drawings by Van Dyck*, University Art Gallery (Oliver Millar).

Nottingham 1968
*Pictures from Locko Park*, University Art Gallery.

Nuremberg 1928
*Albrecht Dürer Ausstellung*, Germanisches Museum.

Nuremberg 1971
*Albrecht Dürer 1471–1971*, Germanisches Nationalmuseum.

Ottawa 1973
*Fontainebleau: Art in France, 1528–1610*, National Gallery of Canada (Sylvie Béguin, ed.).

Ottawa 1980
*The Young Van Dyck*, National Gallery of Canada (Alan McNairn).

Oxford 1984
*George Bottini: Painter of Montmartre*, Miami University Art Museum, OH (Edna Carter Southard).

Oxford 1992
*Old Master Drawings from the Ashmolean Museum*, Ashmolean Museum (Christopher White, Catherine Whistler, and Colin Harrison).

Padua 1991
*Da Bellini a Tintoretto: Dipinti dei Musei Civici di Padova dalla metà del quattrocento ai primi del seicento*, Musei Civici (Alessandro Ballarin and Davide Banzato, eds.).

Paris 1769
*Salon of 1769*, Musée du Louvre.

Paris 1826
*Ouvrages de peinture exposés au profit des Grecs*, Galerie Lebrun.

Paris 1867
*Ingres*, École des Beaux-Arts.

Paris 1905
*Salon d'Automne. Oeuvres d'Ingres*, Grand Palais.

Paris 1921
*"Divertimento per li ragazzi" par Giovanni Domenico Tiepolo*, Musée des Arts décoratifs.

Paris 1928
*La vie parisienne au 18e siècle*, Musée Carnavalet.

Paris 1930
*Exposition L.-L. Boilly*, Jacques Seligmann & Fils.

Paris 1949
*De van Eyck à Rubens. Les maîtres flamands du dessin*, Bibliothèque nationale.

Paris 1952
*Tiepolo et Guardi. Exposition de peintures et dessins provenant de collections françaises publiques et privées*, Galerie Cailleux.

Paris 1962
*Le dessin italien dans les collections hollandaises*, Institut néerlandais, and tour (Frits Lugt).

Paris 1972–1973
*L'École de Fontainebleau*, Grand Palais.

Paris 1973
*Aspects du 19ᵉ siècle français*, Galerie du Fleuve.

Paris 1973a
*Sources du fantastique*, Galerie Jean-Claude Gaubert.

Paris 1982–1983
*Fantin-Latour*, Grand Palais, and tour (Douglas Druick and Michel Hoog).

Paris 1983–1984
*Raphael dans les collections françaises*, Grand Palais.

Paris 1984
*Louis Boilly, 1761–1845*, Musée Marmottan (Marianne Delafond).

Paris 1984–1985
*Diderot & l'art de Boucher à David, Les Salons. 1759–1781*, Hôtel de la Monnaie.

Paris 1986–1987
*La France et la Russie au siècle des lumières*, Grand Palais (Annie Angremy et al).

Paris 1987–1988
*Fragonard*, Grand Palais; and Metropolitan Museum of Art, New York (Pierre Rosenberg).

Paris 1990
*Quinzième Biennale Internationale des Antiquaires*, Grand Palais.

Paris 1992–1993
*Fragonard et le dessin français au 18ᵉ siècle dans les collections du Petit Palais*, Petit Palais.

Paris 1993
*Le siècle de Titien: L'age d'or de la peinture à Venise*, Grand Palais.

Paris 1993a
*"Le Christ à la colonne" d'Antonello de Messine*, Musée du Louvre (Dominique Thiébaut).

Paris 1994
*Fra Bartolommeo et son atelier. Dessins et peintures des collections françaises*, Musée du Louvre (Chris Fischer).

Paris 1994a
*Nicolas Poussin, 1594–1665*, Grand Palais (Pierre Rosenberg and Louis Antoine Prat).

Philadelphia 1936
*Degas 1834–1917*, Pennsylvania Museum of Art (Henry P. McIlhenny).

Philadelphia 1950–1951
*Masterpieces of Drawing: Diamond Jubilee Exhibition*, Philadelphia Museum of Art.

Philadelphia 1968
*Drawings by the Bibiena Family*, Philadelphia Museum of Art (Diane M. Kelder).

Philadelphia 1971
*Giovanni Benedetto Castiglione: Master Draughtsman of the Italian Baroque*, Philadelphia Museum of Art (Ann Percy).

Portland 1988
*Odilon Redon: Masterpieces from the Woodner Collection*, Portland Museum of Art, OR.

Princeton 1977
*Eighteenth-Century French Life-Drawing: Selections from the Collection of Mathias Polakovits*, Art Museum, Princeton University (James Henry Rubin).

Princeton 1979
*Van Dyck as Religious Artist*, Art Museum, Princeton University (John Rupert Martin and Gail Feigenbaum).

Princeton 1982–1983
*Holy Roman Empire, 1540–1680: A Selection from North American Collections*, Art Museum, Princeton University, and tour (Thomas DaCosta Kaufmann).

Richmond 1979–1980
*Treasures from Chatsworth: The Devonshire Inheritance*, Virginia Museum of Fine Arts, and tour.

Rome 1981–1982
*Gli affreschi di Paolo III a Castel Sant'Angelo: Progetto ed esecuzione 1543–1548*, 2 vols., Museo Nazionale de Castel Sant'Angelo (Filippa M. Aliberti Gaudioso and Eraldo Gaudioso).

Rome 1984
*Raffaello architetto*, Palazzo dei Conservatori (Christoph Luitpold Frommel, Stefano Ray, and Manfredo Tafuri).

Rome 1990–1991
*J. H. Fragonard e H. Robert a Roma*, Villa Medici (Pierre Rosenberg and Jean-Pierre Cuzin).

Rome 1993–1994
*Le retour à Rome de Monsieur Ingres. Dessins et peintures*, Villa Medici; and Espace Electra, Paris.

Rotterdam 1948–1949
*Tekeningen van Jan van Eyck tot Rubens*, Boymans Museum (J. C. Ebbinge Wubben).

Rotterdam 1974
*Duitse Tekeningen 1400–1700*, Museum Boymans-van Beuningen (A.W.F.M. Meij).

Rotterdam 1974a
*Dessins flamands et hollandais du dix-septième siècle*, Museum Boymans-van Beuningen; and Institut néerlandais, Paris (Carlos van Hasselt and A.W.F.M. Meij).

Rotterdam 1990–1992
*Fra Bartolommeo, Master Draughtsman of the High Renaissance: A Selection from the Rotterdam Albums and Landscape Drawings from Various Collections*, Museum Boymans-van Beuningen, and tour (Chris Fischer).

St. Louis 1967
*Drawings by Degas*, City Art Museum of St. Louis, and tour (Jean Sutherland Boggs).

St. Petersburg 1982–1983
*Fragonard & His Friends: Changing Ideals in Eighteenth-Century Art*, Museum of Fine Arts, St. Petersburg, FL (Marion Lou Grayson).

Stockholm 1956
*Rembrandt*, Nationalmuseum.

Stuttgart 1970
*Tiepolo: Zeichnungen von Giambattista, Domenico und Lorenzo Tiepolo*, Graphische Sammlung Staatsgalerie (George Knox and Christel Thiem).

Stuttgart 1980–1981
*Goya in der Krise seiner Zeit*, Würtembergerischer Kunstverein; and Kunstverein, Munich.

Stuttgart 1993
*Meisterwerke massenhaft. Die Bildhauerwerkstatt des Niklaus Weckmann und die Malerei in Ulm um 1500*, Würtembergisches Landesmuseum.

Stuttgart 1994
*Neues vom Weisskunig. Geschichte und Selbstdarstellung Kaiser Maximilians I in Holzschnitten*, Staatsgalerie Stuttgart (Hans-Martin Kaulbach).

Tokyo 1975
*Old Master Drawings from Chatsworth: A Loan Exhibition from the Devonshire Collection*, National Museum of Western Art.

Tokyo 1988–1989
*Degas*, Isetan Museum of Art, and tour.

Tokyo 1989
*Odilon Redon 1840–1916*, National Museum of Modern Art, and tour (Kunio Motoé, ed.).

Toledo 1941
*French Drawings and Watercolors*, Toledo Museum of Art, OH.

Udine 1965
*Disegni del Tiepolo*, Loggia del Lionello (Aldo Rizzi).

Ulm 1995
*Bilder aus Licht und Farbe: Meisterwerke spätgotischer Glasmalerei*, Ulmer Museum (Brigitte Reinhardt and Michael Roth).

Utrecht 1961
*Pieter Jansz. Saenredam*, Centraal Museum.

Vancouver 1989
*Eighteenth-Century Venetian Art in Canadian Collections*, Vancouver Art Gallery (George Knox).

Venice 1962
*Retrospettivo Odilon Redon*, XXXI Biennale Internazionale d'Arte.

Venice 1963
*Vittore Carpaccio*, Palazzo Ducale (Pietro Zampetti).

Venice 1976
*Disegni di Tiziano e della sua cerchia*, Fondazione Giorgio Cini (Konrad Oberhuber).

Venice 1976a
*Tiziano e la silografia veneziana del cinquecento*, Fondazione Giorgio Cini (Michelangelo Muraro and David Rosand).

Venice 1983
*G. B. Piazzetta: Disegni, incisioni, libri, manoscritti*, Fondazione Giorgio Cini (George Knox).

Venice 1985
*Disegni veneti di collezioni olandesi*, Fondazione Giorgio Cini, and tour (Bernard Aikema and Bert W. Meijer, eds.).

Vicenza 1990
*I Tiepolo e il settecento vicentino*, Basilica Palladiana, and tour.

Vienna 1979
*Die Zeit der frühen Habsburger—Dome und Klöster 1279–1379*, Wiener Neustadt.

Vienna 1981
*Guido Reni: Zeichnungen*, Graphische Sammlung Albertina.

409

Vienna 1985
*Albrecht Dürer und die Tier- und Pflanzenstu-
dien der Renaissance*, Graphische Sammlung
Albertina (Fritz Koreny).

Washington 1962–1963
*Old Master Drawings from Chatsworth:
A Loan Exhibition from the Devonshire
Collection*, National Gallery of Art, and tour
(A. E. Popham).

Washington 1967–1968
*Fifteenth- and Sixteenth-Century European
Drawings*, National Gallery of Art, and tour
(A. Hyatt Mayor).

Washington 1969–1970
*Old Master Drawings from Chatsworth*,
National Gallery of Art, and tour (James
Byam Shaw).

Washington 1978–1979
*Drawings by Fragonard in North American
Collections*, National Gallery of Art, and tour
(Eunice Williams).

Washington 1983
*Raphael and America*, National Gallery of
Art (David Alan Brown).

Washington 1983–1984
*Piazzetta: A Tercentenary Exhibition of Draw-
ings, Prints, and Books*, National Gallery of
Art (George Knox).

Washington 1984
*Correggio and His Legacy*, National Gallery
of Art (Diane De Grazia).

Washington 1986–1987
*The Age of Bruegel: Netherlandish Drawings
of the Sixteenth Century*, National Gallery of
Art (John Hand, J. Richard Judson, William
Robinson, and Martha Wolf).

Washington 1986–1987a
*Goya: The Condesa de Chinchón and Other
Paintings, Drawings, and Prints from Spanish
and American Private Collections and the
National Gallery of Art*, National Gallery of
Art (unpaginated brochure).

Washington 1988
*Michelangelo Draftsman*, National Gallery
of Art (Michael Hirst).

Washington 1988a
*Odilon Redon: Masterpieces from the Woodner
Collection*, Phillips Collection.

Washington 1990
*Rembrandt's Landscapes: Drawings and Prints*,
National Gallery of Art (Cynthia Schneider
et al.).

Washington 1991
*Art for the Nation: Gifts in Honor of the 50th
Anniversary of the National Gallery of Art*,
National Gallery of Art.

Washington 1992
*Dürer to Diebenkorn: Recent Acquisitions of
Art on Paper*, National Gallery of Art (Andrew
Robison et al.).

Washington 1994
*Fanciful Flourishes: Ornament in European
Graphic Art and Related Objects, 1300–1800*,
National Gallery of Art (Virginia Clayton).

Wellesley 1993–1994
*Flemish Drawings in the Age of Rubens:
Selected Works from American Collections*,
Davis Museum and Cultural Center, Wellesley
College, Wellesley, Massachusetts; and Cleve-
land Museum of Art (Anne-Marie Logan).

Woodner exh. cats.
Full references for all previous exhibitions of
the Woodner drawings are given on p. 22.

Zurich 1973
*Fünfzig Jahre Kunsthandelsverband der
Schweiz*, Kunsthaus.

Zurich 1994–1995
*Degas Portraits*, Kunsthaus; and Kunsthalle,
Tübingen (Felix Baumann and Marianne
Karabelnik, eds.).

# Artist Index

## PHOTO CREDITS FOR COMPARATIVE ILLUSTRATIONS

Amsterdam, Rijksmuseum, cats. 63, 70, 73; Augsburg, Städtische Kunstsammlung, cat. 23; Berlin, Kupferstichkabinett, Staatliche Museen, cats. 14, 71; Besançon, Musée des Beaux-Arts et Archéologie, cat. 88; Boston, Courtesy of the Museum of Fine Arts, cats. 45, 100, 103; Cambridge, Fogg Art Museum, Harvard University, cat. 103; Chicago, Courtesy of The Art Institute of Chicago, cats. 5, 108; Copenhagen, Statens Museum for Kunst, cat. 89; Dresden, Kupferstichkabinett der Staatlichen Kunstsammlungen, cats. 8, 55; Edinburgh, National Gallery of Scotland, cat. 68; Florence, Fondazione Horne, cat. 80; Florence, Gabinetto disegni e stampe degli Uffizi, cats. 6, 10, 21; Florence, Palazzo Pitti, cat. 41; Genoa, Gasparini, cat. 74; Gotha, Schlossmuseum, cat. 23; Haarlem, Gemeentearchief, cat. 68; The Hague, Gemeentemuseum, cat. 106; Hamburg, Foto Hamburg/Art Resource, NY, cat. 4; Klosterneuberg, Stiftsmuseum, cat. 1; Leipzig, Sächsische Landesbibliothek, cat. 15; London, British Library, cat. 1; London, British Museum, cats. 7, 8, 11, 12, 87; London, Courtesy of Sotheby's, cats. 49, 97, 111; London, © The Board of Trustees of the Victoria and Albert Museum, cat. 52; London, Witt Library, Courtauld Institute of Art, cats. 38, 101; Lyons, Musée des Beaux-Arts, cat. 13; Madrid, Museo del Prado, cat. 65; Madrid, Museo Nacional Centro de Arte Reina Sofia, cat. 112; Malibu, J. Paul Getty Museum, cat. 47; Munich, Staatliche Graphische Sammlung, cats. 52, 57; Munich, Staatsgemäldesammlungen, cat. 38; New York, Art Resource, cats. 2, 5, 6, 9a, 9f, 9h, 9i, 22, 33, 37, 48, 51, 62, 103; New York, The Metropolitan Museum of Art, cats. 52, 63, 82, 84, 101, 108; New York, The Pierpont Morgan Library, cats. 2, 4, 20, 31, 45, 65, 96; New York, Eric Pollitzer, cats. 40, 49; New York, © The Solomon R. Guggenheim Foundation, New York, cat. 112; New York, Jim Strong, cats. 33, 90; New York, Wildenstein, cat. 92; New York, Woodner Collections, cats. 12, 14, 15, 17, 18; Ottawa, National Gallery of Canada, cat. 104; Oxford, Ashmolean Museum, cat. 32; Paris, Bibliothèque de l'Opéra, cat. 111; Paris, Bibliothèque nationale, cats. 51, 89; Paris, Luc Joubert, cat. 98; Paris, Frits Lugt Collection, Institut néerlandais, cats. 67, 69; Paris, Musée du Louvre, cats. 21, 34, 101, 104; Paris, Photographie Giraudon, cats. 43, 101; Quimper, Musée des Beaux-Arts, cat. 101; St. Petersburg, Hermitage Museum, cat. 89; Stockholm, Statens Konstmuseer, Nationalmuseum, cat. 20; Stuttgart, Staatsgalerie, Graphische Sammlung, cat. 81; Vienna, Graphische Sammlung Albertina, cats. 15, 59, 88; Vienna, Kunsthistorisches Museum, cats. 9j, 66; Washington, National Gallery of Art, cats. 1, 7, 9e, 11, 14, 16, 19, 25, 31, 45, 67, 70, 71, 77, 78, 83, 84, 92, 96, 98; Wijhe, The Netherlands, Stichting Hannema-de Stuers Fundatie, cat. 89; Windsor, The Royal Collection © Her Majesty Queen Elizabeth II, cats. 12, 34, 54, 66, 74